Arshile Gorky

Arshile Gorky
A RETROSPECTIVE

Edited by

MICHAEL R. TAYLOR

Essays by

HARRY COOPER

JODY PATTERSON

ROBERT STORR

MICHAEL R. TAYLOR

KIM SERVART THERIAULT

Chronology by

MELISSA KERR

PHILADELPHIA MUSEUM OF ART

in association with

YALE UNIVERSITY PRESS

New Haven and London

Published on the occasion of the exhibition
Arshile Gorky: A Retrospective

Philadelphia Museum of Art
October 21, 2009–January 10, 2010

Tate Modern, London
February 10–May 3, 2010

The Museum of Contemporary Art, Los Angeles
June 6–September 20, 2010

The exhibition was organized by the Philadelphia Museum of Art
in association with Tate Modern, London, and The Museum of
Contemporary Art, Los Angeles.

The international tour was made possible by the Terra Foundation
for American Art. The U.S. tour was supported by The Lincy
Foundation and the National Endowment for the Arts, and by an
indemnity from the Federal Council on the Arts and the Humanities.

In Philadelphia, the exhibition was made possible by The Pew Center
for Arts and Heritage, through the Philadelphia Exhibitions Initiative,
and the Neubauer Family Foundation. Additional funding was pro-
vided by the Dadourian Foundation, The Robert Montgomery Scott
Fund for Exhibitions, and the Friends of Arshile Gorky, a group of
generous individuals.

The exhibition catalogue was made possible by Larry Gagosian
and The Andrew W. Mellon Fund for Scholarly Publications,
with additional support provided by Furthermore: a program
of the J. M. Kaplan Fund.

Jacket front: Arshile Gorky, *The Artist and His Mother*, 1926–36 (plate 32)
Jacket back: Arshile Gorky, *Agony*, 1947 (plate 165)
Frontispiece: Arshile Gorky, New York, mid-1930s, courtesy of Maro Gorky and
 Matthew Spender
Page 158: Arshile Gorky, detail of *Self-Portrait*, c. 1928 (plate 6)
Page 174: Arshile Gorky, detail of *Organization*, 1933–36 (plate 66)
Page 248: Arshile Gorky, detail of *The Plow and the Song II*, 1946 (plate 147)

Produced by the Publishing Department
Philadelphia Museum of Art
Sherry Babbitt
The William T. Ranney Director of Publishing
2525 Pennsylvania Avenue
Philadelphia, PA 19130
www.philamuseum.org

Published by the Philadelphia Museum of Art in association with
Yale University Press, New Haven and London

Yale University Press
302 Temple Street
P.O. Box 209040
New Haven, CT 06520-9040
www.yalebooks.com

Edited by Kathleen Krattenmaker
Design and production by Don Quaintance, Public Address Design, Houston
Design and production assistance by Elizabeth Frizzell
Typography composed in Locator and Whitman
Index by Jennifer Vanim
Color separations, printing, and binding by EBS (Editoriale Bortolazzi-Stei),
 Verona, Italy

Library of Congress Cataloging-in-Publication Data

Gorky, Arshile, 1904–1948.
 Arshile Gorky : a retrospective / edited by Michael R. Taylor ; essays by Harry Cooper
. . . [et al.].
 p. cm.
 Published on the occasion of an exhibition held at the Philadelphia Museum of Art,
Oct. 21, 2009–Jan. 10, 2010, the Tate Modern, London, Feb. 10–May 3, 2010, and the
Museum of Contemporary Art, Los Angeles, June 6–Sept. 20, 2010.
 Includes bibliographical references and index.
 ISBN 978-0-87633-213-9 (pma cloth) — ISBN 978-0-87633-214-6 (pma paper) —
ISBN 978-0-300-15441-2 (yale cloth) 1. Gorky, Arshile, 1904–1948—Exhibitions.
I. Taylor, Michael R., 1966– II. Cooper, Harry, 1959– III. Philadelphia Museum of Art.
IV. Tate Modern (Gallery) V. Museum of Contemporary Art (Los Angeles, Calif.) VI. Title.
 N6537.G65A4 2009
 759.13—dc22
 2009027692

CONTENTS

LENDERS TO THE EXHIBITION

Albright-Knox Art Gallery, Buffalo

The Allen Memorial Art Museum, Oberlin College, Oberlin, Ohio

Harry W. and Mary Margaret Anderson

The Art Institute of Chicago

Ms. Andrea Balian, Ms. Katherine Balian, Dr. Bruce Berberian,
 and Mr. Mark Berberian

Vartkess and Rita Balian

The Baltimore Museum of Art

Doreen and Gilbert Bassin

Timothy Baum

Blanton Museum of Art, The University of Texas at Austin

The Brooklyn Museum

Donald L. Bryant, Jr. Collection

Calouste Gulbenkian Foundation, Lisbon

The Honorable and Mrs. Joseph P. Carroll

Chrysler Museum of Art, Norfolk, Virginia

Curtis Galleries, Minneapolis

Dallas Museum of Art

The Detroit Institute of Arts

Diocese of the Armenian Church of America (Eastern)
 on Deposit at the Calouste Gulbenkian Foundation, Lisbon

Barney A. Ebsworth

Aaron I. Fleischman

Marcel and David Fleiss, Galerie 1900–2000, Paris

Frederick R. Weisman Art Foundation

David Geffen

Glenstone

Grey Art Gallery, New York University Art Collection

Peggy Guggenheim Collection, Venice

Mr. and Mrs. Stanley R. Gumberg

Harvard University Art Museums, Fogg Art Museum,
 Cambridge, Massachusetts

Samuel and Ronnie Heyman

High Museum of Art, Atlanta

Mr. and Mrs. J. Tomilson Hill

Hirshhorn Museum and Sculpture Garden, Smithsonian Institution,
 Washington, D.C.

Indiana University Art Museum, Bloomington

Carroll Janis

Kolodny Family Collection

L&M Arts, New York

Mr. and Mrs. Meredith Long

Los Angeles County Museum of Art

Stephen Mazoh

The Menil Collection, Houston

The Metropolitan Museum of Art, New York

Mildred Lane Kemper Art Museum,
 Washington University in St. Louis

Minneapolis Institute of Arts

Musée nationale d'art moderne, Centre Georges Pompidou, Paris

Museo Thyssen-Bornemisza, Madrid

The Museum of Contemporary Art, Los Angeles

The Museum of Fine Arts, Houston

The Museum of Modern Art, New York

National Gallery of Art, Washington, D.C.

National Gallery of Canada, Ottawa

The Newark Museum, Newark, New Jersey

North Carolina Museum of Art, Raleigh

Paula Cooper Gallery, New York

Gerald and Kathleen Peters

Ellen Phelan and Joel Shapiro

Philadelphia Museum of Art

San Francisco Museum of Modern Art

Seattle Art Museum

Solomon R. Guggenheim Museum, New York

Tate Modern, London

The University of Arizona Museum of Art, Tucson

Whistler House Museum of Art, Lowell Art Association, Inc.
 (est. 1878), Lowell, Massachusetts

Whitney Museum of American Art, New York

Yale University Art Gallery, New Haven, Connecticut

And private individuals

as of July 22, 2009

In keeping with the Philadelphia Museum of Art's long-standing dedication to modern art, we are delighted and privileged to host this retrospective exhibition of the work of one of its greatest practitioners, Arshile Gorky. As the first comprehensive survey devoted to the artist in nearly three decades, the exhibition and its accompanying catalogue provide a umellnique opportunity to explore afresh the full extent of his achievement. Since the last Gorky retrospective, mounted at the Solomon R. Guggenheim Museum in 1981, three biographies of the artist have shed new light on his life and artistic production, particularly the impact of his Armenian heritage, necessitating a critical reevaluation of his work. Accordingly, this exhibition offers a new assessment of Gorky's contribution to twentieth-century art, bringing together some 180 objects, including paintings, sculpture, and works on paper, many of which have not been incorporated in past retrospectives, as well as numerous others that have never been published or exhibited. Every aspect of Gorky's work is represented, from his earliest experiments with Impressionism and the structural rigor of the paintings of Paul Cézanne in the mid-1920s to his prolonged engagement with Cubism in the 1930s and the Surrealist-inspired burst of creativity that dominated the final decade of his life and left us with so many breathtakingly beautiful paintings and colored drawings.

We owe our warmest thanks to Michael R. Taylor, the Muriel and Philip Berman Curator of Modern Art at the Philadelphia Museum of Art, who formulated plans for this exhibition in 2004, following the Museum's acquisition of Gorky's 1927 painting *Woman with a Palette* earlier that year. His long-standing admiration for the artist's work, and his personal commitment to presenting it as fully and thoughtfully as possible, are evident in all aspects of the exhibition and catalogue. Preparing this retrospective and publication with such care and intelligence, while at the same time meeting with equal sensitivity and professionalism the heavy demands of several other exhibition projects, required extraordinary dedication and energy. His work was made not only possible but also infinitely richer through the essential collaboration of the artist's widow, Agnes "Mougouch" Gorky Fielding. Her participation in this endeavor has been gratifying to all involved, and we extend to Mougouch our deepest appreciation for her time, her

enthusiasm, and her critical support of our efforts. We would also like to thank other members of the artist's family, including his daughters, Maro and Natasha, and Maro's husband, the Gorky biographer Matthew Spender, who have helped us in many different ways throughout the development of this project and have thus been essential participants in its successful realization.

Our colleagues at the institutions that will host this exhibition after it closes in Philadelphia—Nicholas Serota, Sheena Wagstaff, and Matthew Gale at Tate Modern, London; and Charles E. Young and Paul Schimmel at the Museum of Contemporary Art, Los Angeles—have been most enthusiastic, and we are grateful for their collegiality. We join Michael Taylor in also expressing our deep appreciation to the scholars who have contributed to this catalogue: Harry Cooper, Claire Howard, Melissa Kerr, Jody Patterson, Robert Storr, and Kim Servart Theriault. To the many collectors, public institutions, and commercial galleries who have graciously consented to part with their treasured works of art for such an extended period, we offer our sincerest thanks. Their devotion to Gorky's work and his powerful legacy, and their eagerness to participate in this landmark retrospective, are truly remarkable.

To say in these economically challenging times that the financial support we have received for this exhibition has been outstanding would be an understatement. The Museum has been fortunate to receive substantial grants from several foundations, without whose assistance this exhibition and catalogue would not have been possible. We are tremendously grateful to The Pew Center for Arts and Heritage, through the Philadelphia Exhibitions Initiative, and the Neubauer Family Foundation, whose invaluable support of this project affirmed our belief that it was the right time to review and reassess Gorky's work. The Museum has also been fortunate to receive substantial grants from the National Endowment for the Arts, The Lincy Foundation, and the Dadourian Foundation, to all of whom we convey our deepest gratitude for their superb generosity. Additional funding for the Philadelphia venue was provided by The Robert Montgomery Scott Fund for Exhibitions and by the Friends of Arshile Gorky, a wonderful group of committed individuals who recognized the importance of this project and supported our efforts to understand the artist's Armenian identity and elucidate how this was expressed in his work. In the United States, the exhibition has also benefited from an indemnification grant from the Federal Council on the Arts and the Humanities, while the international tour was made possible by the Terra Foundation for American Art. The catalogue was supported by Larry Gagosian and The Andrew W. Mellon Fund for Scholarly Publications, and by Furthermore: a program of the J. M. Kaplan Fund. Together, these generous foundations, institutions, and individuals have allowed us to realize the first comprehensive survey of Gorky's oeuvre in nearly thirty years, one that will reacquaint many with the extraordinary range of his output and, just as importantly, offer a new generation of visitors their first in-depth view of his remarkable body of work.

Timothy Rub
The George D. Widener Director and Chief Executive Officer

ACKNOWLEDGMENTS

This catalogue, published on the occasion of the Arshile Gorky retrospective organized by the Philadelphia Museum of Art and also appearing at Tate Modern, London, and the Museum of Contemporary Art, Los Angeles, was conceived both as a record of the exhibition and as a scholarly reassessment of the artist's work and legacy. During his short lifetime, Arshile Gorky (c. 1902–1948) created a richly varied oeuvre that entailed a number of stylistic shifts before he finally arrived at his signature painting style in the final decade of his life. The Herculean task of creating a coherent retrospective from such a diverse body of work has been both challenging and deeply rewarding. Initial research for this exhibition began five years ago, following the Philadelphia Museum of Art's acquisition of Gorky's 1927 painting *Woman with a Palette*, and led to a long selection process and much archival research. Along the way, I was fortunate to work with many talented individuals, whose labors have brought much to this presentation.

First and foremost, I would like to thank the artist's widow, Agnes "Mougouch" Gorky Fielding, and two daughters, Maro and Natasha, who gave unstintingly of their time, patience, hospitality, and friendship over the past five years. Mougouch also waived the reproduction fees for this catalogue, for which I am extremely grateful. Maro's husband, Matthew Spender, a great authority on Gorky's life and work, acted as a vital source of information throughout the course of the project. I am thankful to the entire Gorky family for so generously sharing with me their archival materials and for providing us with important documents and photographs, several of which are reproduced here for the first time. It was a great pleasure to get to know each of them during my many research trips to Europe over the past few years, and I am immensely appreciative of their generosity in granting me unprecedented access to Gorky's library, archive, and photo album, and for lending so many important works of art to the exhibition.

A project of this magnitude does not happen without a great deal of help, much generosity, and huge sacrifices of time and energy from a variety of friends and colleagues. At the Philadelphia Museum of Art, I was fortunate to have an enthusiastic and insightful champion in our late director, Anne d'Harnoncourt, who wholeheartedly supported the idea of a retrospective on Arshile Gorky from the very beginning. Her inspirational efforts on behalf of the project were essential to its final realization, which was carried out under the leadership of her successor, Timothy Rub. I would also like to extend my sincere thanks to Alice Ohanessian Beamesderfer, our Associate Director for Collections and Project Support, who served as the Museum's Interim Head of Curatorial Affairs before Timothy's arrival, for her steadfast support and encouragement of this project, the first of its kind to fully explore Gorky's identity as a displaced survivor of the Armenian Genocide. In addition to her many other efforts, Alice was instrumental in coordinating the Museum's outreach to the Armenian-American community. Gail Harrity, Chief Operating Officer, also fully understood the importance and timeliness of the undertaking. In the Department of Special Exhibitions, Suzanne Wells, aided by Zoë Kahr, provided invaluable assistance with the myriad details that a traveling exhibition of this size requires. Innis Howe Shoemaker, John Ittmann, Peter Barberie, and Shelley Langdale, in the Department of Prints, Drawings, and Photographs, supplied generous assistance with Gorky's works on paper, a number of which were expertly framed by Sharon Hildebrand.

A special debt of gratitude is also owed to Joseph J. Rishel, the Gisela and Dennis Alter Curator of European Painting before 1900, for inviting me to write an essay on Gorky's early Cézanne-inspired paintings for the catalogue of his landmark *Cézanne and Beyond* exhibition of 2009. The research and writing that this essay entailed constituted a crucial step in my engagement with the critical debates that have surrounded the artist's work since his death in 1948. I would also like to thank my colleagues in the Museum's Conservation Department—Nancy Ash, Scott Homolka, Andrew Lins, Melissa S. Meighan, Suzanne P. Penn, Michael J. Stone, and Mark S. Tucker—for their help with the works of art in the exhibition. Suzanne merits particular thanks for her superb restoration of Gorky's painting *Woman with a Palette*, which will be shown for the first time in this exhibition.

This book would not have been realized without the Publishing Department of the Philadelphia Museum of Art. Sherry Babbitt, the William T. Ranney Director of Publishing, guided the catalogue with tremendous grace and good humor under conditions made all the more difficult by compressed deadlines. Likewise, Kathleen Krattenmaker

edited the catalogue with great sensitivity and intelligence, working tirelessly, and with unbelievable meticulousness, to ensure that this publication maintained the high standards of scholarly excellence that have been the hallmark of this Museum over the years. Aiding her were Mary Cason, Sarah Noreika, and Jennifer Vanim, who also deserve warm thanks. Don Quaintance of Public Address Design created the handsome design of this catalogue and also handled the complicated production work with great aplomb. With the assistance of Elizabeth Frizzell, Don created a truly outstanding catalogue, for which I am deeply grateful. Our own esteemed production manager, Rich Bonk, generously lent his expertise along the way. A wealth of new digital photography for the book was expertly undertaken by Graydon Wood, Andrea Nuñez, and Jason Wierzbicki of the Museum's Photography Studio. Thanks also go to Conna Clark, Holly Frisbee, and Amanda Jaffe in the Department of Rights and Reproductions for their help with permissions and photography requests.

In the Department of Education, Marla Shoemaker and her staff, especially Mary Teeling, Carolyn Macuga, and Matthew Palczynski, were instrumental in producing an informative and engaging audio tour and developing educational programming to accompany the exhibition, including a study day and a series of lectures and film screenings. These events would not have been possible without the dedication and expertise of Camille Focarino and her staff in the Special Events Department. Norman Keyes, Elisabeth Flynn, Lindsay Warner, and Sara Moyn in the Department of Marketing and Public Relations, worked tirelessly to get the word out through advertising and the press, and Suzette Sherman, Jessica Sharpe, and Caitlin DeMarco in the Membership and Visitor Services Office coordinated the efforts to bring new audiences to the exhibition, especially from the Armenian-American community. In the Department of Editorial and Graphic Design, Ruth Abrahams, Sid Rodriguez, Laurie Tappen, and Maia Wind conceived the exhibition graphics and promotional materials with great skill and sensitivity, while Bill Ristine and Jaime Bramble of Information Services designed a user-friendly exhibition Web page for the museum's Web site. I also wish to express my profound appreciation to our installations designer, Jack Schlechter, and his team—Andrew Slavinskas and Kate Higgins—for working with me to create a daring exhibition design informed by Armenian church architecture and Frederick Kiesler's installation for the 1947 *Bloodflames* exhibition at the Hugo Gallery in New York.

In the Museum's Department of Development, Kelly O'Brien, Mimi Stein, Peter Dunn, Beth Shapiro, and Kate Brett worked hard to find funding for the exhibition and catalogue. Danial Elliott and his staff in the Museum Library, especially Rick Sieber, Mary Wassermann, Linda Martin-Schaff, and Evan Towle, were particularly helpful with research and interlibrary loan requests, while Susan Anderson granted me access to numerous letters and documents related to Julien Levy and Albert Eugene Gallatin that are housed in the Museum's Archives. In the Office of the Registrar, special thanks go to Irene Taurins, Wynne Kettell, Linda Yun, and Mary Grace Wahl for handling the innumerable details involved in arranging the transportation and insurance of loans from this country and abroad, and for successfully applying for an indemnity from the Federal Council on the Arts and the Humanities to cover the show. My gratitude likewise goes to Martha Masiello and her team in the Department of Installations and Packing, who handled and installed the works of art in the exhibition with the utmost care. Lastly, this publication and exhibition would not have been possible without the supreme dedication and unflagging energy of the staff in the Department of Modern and Contemporary Art. My most heartfelt thanks go to Carlos Basualdo for his insightful comments and sympathetic ear during our discussions of Gorky and modern art. I am also grateful to Adelina Vlas, Miesha Harris, Erica Battle, Ashley Carey, Jennifer Wilkinson, Roberta Nuzzaci, Elizabeth Donato, and Jennifer Ginsberg, who all embraced this project with great enthusiasm.

Beyond the Museum's walls, I would like to thank my colleagues at the institutions that will host this exhibition after it closes in Philadelphia. I am grateful to Sir Nicholas Serota and Sheena Wagstaff for coordinating the transfer of the Gorky retrospective to the Tate Modern in London, where it was installed by Matthew Gale, and to Paul Schimmel and Charles E. Young for bringing the exhibition to the Museum of Contemporary Art, Los Angeles. I extend my heartfelt thanks for their interest in and support of this exhibition project. I am also greatly

indebted to the catalogue authors—Harry Cooper, Melissa Kerr, Jody Patterson, Robert Storr, and Kim Servart Theriault—for sharing their invaluable research and for their insights into the artist's work, all of which has resulted in a broad range of new scholarship on Gorky. Melissa, through her position with the Arshile Gorky Foundation, was also extremely helpful in acquiring photographs and pulling together the Exhibition History for this catalogue.

This extensive undertaking would not have been possible without the munificent support of the project's major funders, whose vision and generosity at a time of economic hardship are truly commendable. The international tour has been supported by the Terra Foundation for American Art, while the tour within the United States was supported by The Lincy Foundation, the National Endowment for the Arts, and an indemnity from the Federal Council on the Arts and the Humanities. In Philadelphia, the exhibition was made possible by The Pew Center for Arts and Heritage, through the Philadelphia Exhibitions Initiative, and the Neubauer Family Foundation. Additional funding was provided by the Dadourian Foundation, The Robert Montgomery Scott Fund for Exhibitions, and the Friends of Arshile Gorky, a group of deeply committed individuals, many of them Armenian-Americans like Gorky. They were led by the admirable trio of Nancy Hovnanian, Alma Paone, and Joan Momjian, who worked indefatigably to raise funds and promote awareness of the exhibition. The exhibition catalogue was made possible by Larry Gagosian and The Andrew W. Mellon Fund for Scholarly Publications, with additional support provided by Furthermore: a program of the J. M. Kaplan Fund. The combined efforts of these foundations and individuals affirmed the importance of presenting Gorky's work in the most thorough and effective fashion possible.

No exhibition of this scale and importance can be mounted without an extra level of generosity from private collectors and institutions.

I am immensely beholden to the lenders who so graciously agreed to part with their cherished and fragile works of art so that Gorky's achievement could be enjoyed by the public, both in the United States and Europe. These lenders' dedication to the artist is apparent throughout this catalogue and the exhibition it accompanies. In particular, our colleagues at museums throughout this country and Europe have been unfailingly generous. I also extend my immeasurable gratitude to my fellow Gorky scholars, as well as to the art historians, biographers, curators, and writers who have worked on the artist and his milieu, especially David Anfam, Dore Ashton, Michael Auping, Peter Balakian, Ruth Bowman, Éric de Chassey, Isabelle Dervaux, John Elderfield, Ann Gibson, John Golding, Hayden Herrera, Jim Jordan, Michael Leja, Gail Levin, Nouritza Matossian, Ara Merjian, Harry Rand, Eliza Rathbone, Martica Sawin, Richard Shiff, Matthew Spender, Dickran Tashjian, Ann Temkin, Ana Vasconcelos e Melo, and the late Melvin P. Lader. I thank all these colleagues for sharing with me their expertise on Gorky's life and work, and for their unwavering support throughout the preparation of the exhibition and catalogue. I also thank the many individuals who have expressed enthusiasm for the project and helped facilitate our research and negotiations for the loan of works of art. Their number includes William Acquavella, Bente Arnild, Karekin Arzoomanian, Timothy Baum, Frances Beatty, Dr. Bruce Berberian, Mark Borghi, Thomas Branchick, Vivian Bullaudy, Haley Rose Cohen, Lisa Denker, Jean Edmonson, Larry Gagosian, Kathy and James Goodman, Paul Gray, Ronald Greenberg, Agnes Gund, Taffy Holland, Dodie Kazanjian, Archbishop Khajagbarsamian, Matthew Marks, Stephen Mazoh, Jason McCoy, Robert Mnuchin, David Nash, Francis Naumann, David Nissinson, Michael Rosenfeld, Sandy Rower, Jack Rutberg, Christopher Schwabacher, Claudia Stone, John Tancock, Jacqueline Tran, John van Doren, Waqas Wajahat, Meredith Ward, Joan T. Washburn,

Judith Young-Mallin, and, at the Austrian Frederick and Lillian Kiesler Private Foundation, Dieter Bogner, Monika Pessler, and Gerd Zillner.

I was privileged, once again, to work with the irrepressible and irreplaceable Claire Howard, who as the research assistant for the project not only created the excellent bibliography for this catalogue, but also worked closely with me on all aspects of the retrospective and its accompanying publication. Claire assumed numerous responsibilities in connection with the day-to-day work that is essential for the success of any major loan exhibition. These included creating a database of works in the exhibition, drafting loan letters, planning educational programs, and gathering photographs for the catalogue, all of which she carried out with her customary dedication, attention to detail, resourcefulness, diplomacy, and good humor. Finally, I would like to thank my wife, Sarah Powers, for sharing my enthusiasm for this project and accompanying me on several research trips to London and Siena. She was endlessly patient with my near obsession with Gorky and his art. As always, I have been the lucky beneficiary of her consistently sound advice and loving encouragement. Also deserving special mention is my one-year-old daughter, Emma Rose, whose boundless energy and high spirits inspired me to finish this catalogue. She loves dogs (which she calls "woof woofs") of all shapes and sizes, and I can't wait to show her Gorky's two paintings of *The Pirate*, which depict a seated mongrel scratching himself.

Michael R. Taylor
The Muriel and Philip Berman Curator of Modern Art

ESSAYS

Rethinking Arshile Gorky

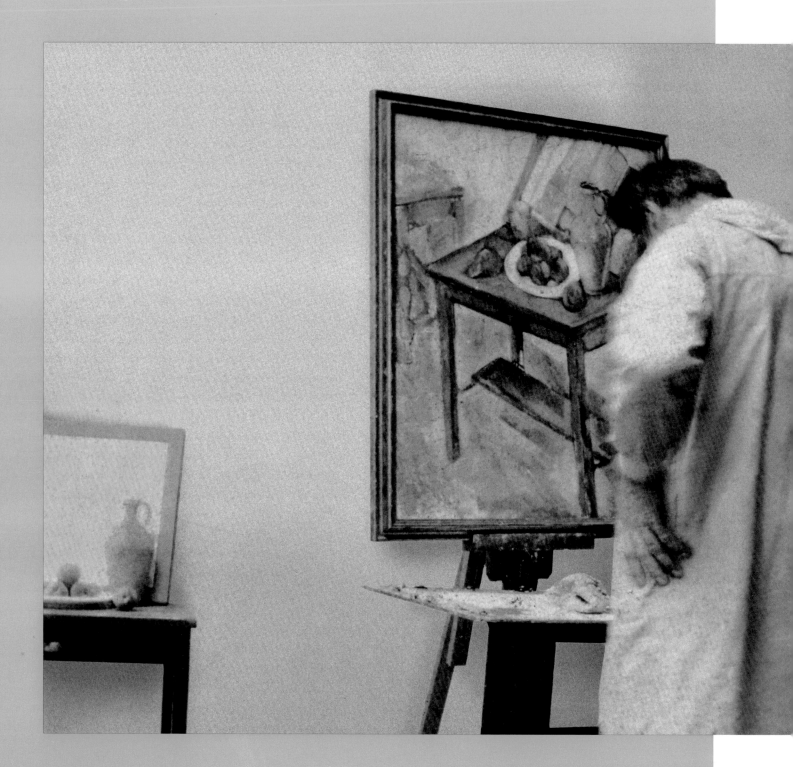

This timely exhibition and catalogue celebrate the extraordinary life and work of Arshile Gorky (c. 1902–1948),[1] a seminal figure in the movement toward abstraction that ultimately transformed American art. The nearly two hundred paintings, drawings, and sculptures included here reveal Gorky's development as an artist and the evolution of his unique visual vocabulary and mature painting style. Long considered an "artist's artist," Gorky's compelling work and often tragic life hold an intense fascination for the public as well. His popularity can be gauged by the fact that no fewer than three major biographies have appeared in the past decade, beginning in 1998 with the publication of Nouritza Matossian's *Black Angel: A Life of Arshile Gorky*, followed by Matthew Spender's *From a High Place: A Life of Arshile Gorky* in 1999, and culminating with Hayden Herrera's *Arshile Gorky: His Life and Work*, published in 2003.[2] These carefully researched biographies shed new light on Gorky's Armenian heritage and have built upon existing studies of his work by art historians such as Jim Jordan, Melvin P. Lader, and Harry Rand.[3]

The present retrospective is the first comprehensive survey of Gorky's work since Diane Waldman organized a retrospective of the artist at the Solomon R. Guggenheim Museum, New York, in 1981. There have been other, smaller Gorky exhibitions in the intervening years, most notably Michael Auping's 1995 *Arshile Gorky: The Breakthrough Years* in Fort Worth, Texas, and Washington, D.C., and the large exhibition of Gorky's drawings at the Whitney Museum of American Art, New York, and the Menil Collection, Houston, in 2003–4. However, the new biographical information that has come to light in the twenty-eight years since the Guggenheim retrospective has confirmed Gorky's singular importance as an artist, while also providing new contexts for understanding his work.

Arshile Gorky was born Vosdanig Adoian around 1902 (there are differing accounts of the actual date) in the village of Khorkom, near Lake Van, in an Armenian province on the eastern border of Ottoman Turkey. His childhood appears to have been a fairly happy one, despite the departure of his father for the United States in 1908 and the continued threat of religious persecution and death at the hands of the Turks. When he was a young teenager, Gorky witnessed firsthand the systematic ethnic cleansing of his people, the minority Armenians, by Turkish troops, who in 1915 drove him and his immediate family, along with thousands of others, out of Van on an eight-day march to the frontier of Caucasian Armenia. These traumatic events culminated in his mother's death from starvation in March 1919, during a winter of severe deprivation for the Armenian refugees. In 1920, Gorky and his younger sister Vartoosh immigrated to the Boston area, where they joined their father and siblings, who had left Turkish Armenia before the worst of the genocide. Vosdanig soon changed his name to Arshile Gorky in honor of the famed Russian writer Maxim Gorky, a great advocate for the Armenian cause,[4] and moved to New York City to invent a new life for himself.

Gorky's early work has been characterized as a succession of dialogues with artists, both living and dead, whose paintings, drawings, and sculpture he sought to emulate and ultimately to transcend. The dominant figure among the modern masters in his pantheon was Paul Cézanne, whose paintings exerted a powerful influence on him in the 1920s, before giving way in the following decade to the work of Pablo Picasso, Henri Matisse, Fernand Léger, and Joan Miró. Cézanne's influence can still be felt, however, in many of Gorky's greatest paintings of the 1940s, in which the veils of evanescent color and allover composition of biomorphic forms suggest an underlying structure strongly reminiscent of the French painter's landscape compositions and tabletop still lifes. In *Scent of Apricots on the Fields* (1944; plate 122), for example, the freely improvised forms of fruits, vegetables, plants, and flowers are clearly discernible in an upturned tabletop arrangement that owes a profound debt to Cézanne's still lifes (see fig. 9).

Although Gorky's paintings of the 1920s and early 1930s frequently invoke Cézanne's work, along with that of Picasso, Matisse, and

FIG. 1
Arshile Gorky painting in his studio on Sullivan Street, New York, c. 1927. Courtesy of Maro Gorky and Matthew Spender

other of his artistic heroes, it is not through slavish imitation or parody, as his detractors have often claimed,[5] but rather through a process of direct observation akin to the teaching methods of the nineteenth-century Académie des Beaux-Arts in Paris, where students learned the lessons of the old masters by faithfully copying paintings in museums or making sketches from plaster casts in the classroom. Gorky's own sporadic attempts to study art in an academic setting always ended prematurely. Although he enrolled in a number of art schools in Boston and New York, he rarely completed more than a semester of study and in many cases dropped out after the first week, so he did not benefit from the kind of formal training that his close friend Willem de Kooning, for example, received in Rotterdam at the Academie van Beeldende Kunsten (Academy of Visual Arts). Even so, as de Kooning ruefully admitted: "I had more legitimate schooling in Holland but the things I was supposed to know he knew much better. He had an uncanny instinct for all art."[6]

Gorky was "a great connoisseur of painting" whose formidable knowledge was largely acquired through a patient and sustained study of the history of art through reproductions in magazines and books and repeated trips to museums and galleries in New York and other East Coast cities, where he voraciously absorbed the techniques of the painters he discovered.[7] The art historian Meyer Schapiro remembered frequently bumping into Gorky in museums and galleries in New York, where he would be "fixed in rapt contemplation of pictures with that grave, searching look that was one of the beauties of his face. As some poets are great readers, Gorky—especially among painters—was a fervent scrutinizer of paintings."[8] It was this passionate study and emulation of the art of the past that gave Gorky his encyclopedic understanding of the history of Western painting, from Paolo Uccello to Cézanne, which far surpassed that of his better-educated peers in the fledgling American avant-garde.

Gorky's long hours of study fed his burning ambition to become a great artist, but without an instructor on hand to guide him he had no option but to choose suitable role models on whom to base his artistic persona. For his initial "tutor" in modern art, he chose Cézanne, whose own work had been informed by years of untutored study at the Musée du Louvre and other institutions in Paris and his native Provence. Cézanne's heroic life story as an essentially self-taught artist who triumphed over adversity after years of personal struggle and critical neglect made the stubborn, brooding, temperamental French painter the perfect father figure for Gorky to emulate during his early years as an artist.[9] Indeed, almost an entire generation of American artists who came of age during the 1920s and 1930s, many of them uprooted immigrants like Gorky, felt a strong personal identification with Cézanne, whose impenetrable personality and indefatigable commitment to the pursuit of his personal vision mirrored their own efforts to develop an authentically American style of painting. What sets Gorky's work apart from that of such contemporaries as Charles Demuth, Marsden Hartley, and Max Weber is the degree to which he assimilated Cézanne's subject matter and distinctive painting style. An accomplished autodidact, Gorky reworked some of Cézanne's best-known paintings in his quest to fully understand his forebear's working methods.

Through a slow but deliberate acculturating process, Gorky internalized Cézanne's techniques and imagery and distilled them into his own artistic practice (fig. 1). He appears to have been less interested in Cézanne's so-called constructive stroke (short, straight brushstrokes applied in a parallel manner), preferring instead to investigate the spatial inconsistencies found in his work. Gorky's paintings of the mid- to late 1920s are filled with visual paradoxes that stress the artificial nature of painting, as seen, for example, in *Pears, Peaches, and Pitcher* (c. 1928; plate 7), in which the still-life elements appear to float in a shallow, ambiguous space. In this canvas, the extreme tilting of the tabletop toward the picture plane thrusts the objects into a direct confrontation with the viewer, who perceives the upturned plate, pitcher, pears, peaches, apples, and lemon simultaneously yet from seemingly multiple viewpoints.

Gorky's dedication to the idea of being revolutionary in art through independent study and emulation of an established master echoes Cézanne's admiration for Eugène Delacroix, particularly during his formative period in the late 1860s and early 1870s, when he executed several copies and variations of works by the great Romantic artist.[10] Indeed, Gorky's lifelong admiration for Cézanne may have been enhanced by his identification with the self-taught and appropriative

aspects of his career, which included heeding Delacroix's advice to copy paintings in Paris museums as a means of study.[11] It is surely no coincidence that Gorky studied Cézanne's work at a time when he was a relatively marginal, isolated figure, earning his living as an art teacher while painting and drawing in his spare time.

The phenomenon of autodidacticism was one of the defining hallmarks of the interwar period. In the aftermath of World War I, young artists and writers from divergent social and economic backgrounds who sought access to "high" culture no longer saw it as a tomb guarded by a few privileged elite, but rather as a sanctuary or temple accessible to the initiated, regardless of social status or educational background.[12] An autodidact like Gorky, though an outsider, could find his own route to culture, most often through public institutions such as New York's Museum of Modern Art and the Whitney Museum of American Art, which opened in 1929 and 1931, respectively, and the Metropolitan Museum of Art, which offered free admission and protection from inclement weather (especially important factors during the Great Depression). Museums thus nurtured the ambitions of interwar autodidacts, allowing them to carry out their individual programs of cultural education. There can be little doubt that these hallowed art institutions—along with the many commercial art galleries that opened in New York during these years—provided the stimulus that encouraged artists like Gorky toward greater formal experimentation in their work.

The literary historian Rosemary Chapman has argued that the phenomenon of autodidacticism between the two world wars "cannot be seen independently of the class basis both of the provision of education and of subsequent access to culture."[13] As an alienated outsider, Gorky's thirst for knowledge and desire for culture were no doubt hindered by his precarious financial circumstances, as well as by his status as a newly arrived immigrant. Like the "Self-Taught Man" ("l'Autodidacte") in Jean-Paul Sartre's novel *La Nausée* (*Nausea*; 1938), Gorky and many of the aspiring writers and artists who were his contemporaries were excluded from the fee-paying educational establishment by social and economic factors, leaving them with no option but to achieve their educational aims through bookstores, public museums, and municipal libraries, all of which offered free but unstructured alternatives to

the academic rigors of the university or fine-arts academy. However, the rigid organization of these institutions presented serious barriers to the interwar autodidact, who could only wander at random through the maze of books or works of art on display. The simple alphabetical classification system employed by public libraries, for example, prevents the Self-Taught Man from searching for books by theme or subject. Sartre's character has little formal education to guide him in his choice of authors or titles and instead employs a cumulative approach to knowledge and culture. Forced to go along with the standardized organization of the library's open shelves, the Self-Taught Man assigns himself the task of reading all the books in alphabetical order, a systematic approach that ultimately provides him with a severely limited understanding of the history of ideas, which he can only comprehend in alphabetical order.[14]

As a primarily self-taught artist, Gorky shared a similar learning process with Sartre's existential antihero, although his innate talent, iron will, and obstinate determination to succeed place him far beyond the Self-Taught Man's plodding, mediocre mind, which can only understand the world through systems of classification and naming. Like Sartre's character, Gorky may have viewed books and works of art as objects of devotion that allowed him to avoid the realization of his own loneliness and psychological vulnerability. He was fortunate, however, that his intuitive understanding and indefatigable passion for painting—what de Kooning called his built-in "Geiger counter of art"[15]—helped him to navigate his way through the history of art and culture in a critical, informed manner, as evidenced by his choice of Cézanne as his intellectual and artistic role model. Gorky's obsession with the recalcitrant Cézanne coincided with his move from Boston to New York in 1924, a time of self-invention for him, when he adopted the persona of the neglected genius who suffers for his art. Numerous friends and colleagues later recalled that he played this bohemian role to perfection, becoming for them the living embodiment of the melancholy, rebellious painter of modern life.

While living in New England, Gorky had experimented with the techniques and optical effects of French Impressionism, as seen in *Park Street Church, Boston* (1924; plate 1), and he briefly attended the New

FIG. 2
Arshile Gorky. *Untitled (Beach Scene)*, c. 1925.
Oil on canvas, 18 x 22 inches (45.7 x 55.9 cm).
Private collection, courtesy of the Hollis Taggart
Gallery, New York

England School of Design at 248 Boylston Street, Boston, directed by Douglas John Connah, who introduced him to the work of John Singer Sargent. The agitated brushwork of Gorky's *Beach Scene* (fig. 2) is greatly indebted to Sargent's bravura painting style, suggesting that the American painter may have been the first artist whom Gorky emulated to the point of self-identification.[16] In the summer of 1925 he gave this painting to Merlin Carlock, a friend of his at the Grand Central School of Art in New York. According to Carlock, Gorky told him that he had painted it while vacationing on the French Riviera.[17] In reality, he had never visited France and had gleaned his knowledge of the Côte d'Azur solely through secondhand accounts and the paintings of Sargent and others. His scene of frolicking bathers getting their feet wet in the ocean on a windy day had instead been made in New England during the previous summer. This tall tale, only one of many, was in keeping with Gorky's efforts to invent a new life for himself in New York as a Paris-trained, radical modernist.

Once in New York, Gorky quickly moved beyond his interest in Sargent and Impressionism, finding new inspiration in the life and work of Cézanne, who better suited his notion of bohemian radicalism. As a newly appointed instructor at the New School of Design, located on Broadway at Fifty-second Street, Gorky instilled in his students a passion for drawing and painting, and he complemented his classroom sessions with visits to the Metropolitan Museum of Art, where he lectured on the techniques of the old masters and such modern artists as Cézanne and Auguste Rodin. Mark Rothko, one of his students at the New School, recalled that Gorky conducted his class with an air of authority and held them to very high standards. Although Rothko later

complained that Gorky "was overcharged with supervision," he was deeply impressed by his dramatic persona and intense obsession with painting, as well as with the copies he made after Frans Hals and other old masters, which he would bring into the classroom to demonstrate how one could learn by re-creating the art of the past.[18]

In the fall of 1925, Gorky enrolled as a fine-arts student at the Grand Central School of Art, located on the top floor of the Grand Central Terminal Building on Forty-second Street.[19] Founded in 1924 by Sargent and Edmund W. Greacen, the school offered a thorough training in the craftsmanship of art, with a special concentration on drawing from life—a method that undoubtedly would have appealed to Gorky, who had developed an uncompromising belief that a strong command of drawing was essential to great art. Gorky was no ordinary student; he had by this time acquired an exhaustive knowledge of the history of art and intuitively sensed the direction that modern art should take, especially after his recent exposure to Cézanne's paintings in the Metropolitan Museum of Art. He so greatly impressed Greacen, the school's director, with his knowledge of painting and his innate talent that he was soon appointed as an instructor of the sketch class, and the following academic year he was hired as a full-time teacher.

The school's annual report for 1926–27 noted that the new faculty member (then spelling his name Arshele) was born in Nizhin Novgorod, Maxim Gorky's birthplace and the medieval cultural center of Russia; that he had studied at the School of Nizhin Novgorod, followed by additional training at the Académie Julian in Paris under Paul Albert Laurens; and that he had also taken art classes in Boston and New York. An added notation stated that he had been "represented in many exhibitions."[20] Most of this biographical information was pure fantasy,[21] but it contained enough half-truths to go unchallenged, and it no doubt added to the mystique surrounding him at the school. Standing around six feet four inches tall, with jet-black hair, dark, pensive eyes, a well-groomed mustache, and a heavy foreign accent, Gorky must have seemed a striking figure—almost the epitome of the Romantic artist—to his students and fellow faculty members. His passionate advocacy for modern art was also notable, and was surely a factor in his hiring, especially since the great majority of the school's faculty members were

FIG. 3
Arshile Gorky, *After Rodin*, 1925. Oil on linen,
33⁵/₁₆ x 29³/₈ inches (84.6 x 74.6 cm). Collection
of Stephani and Stuart Denker

21

RETHINKING ARSHILE GORKY

still painting in the outmoded styles of William Merritt Chase, Thomas
Dewing, J. Alden Weir, and other American Impressionists.

Gorky's fictional biography in the school's annual report was
accompanied by a reproduction of one of his recent paintings (fig. 3).
This work has previously been described as an academic study of
female nudes, but it can now be securely identified as a painting of
Rodin's marble figure group *Pygmalion and Galatea*, which had been on
view at the entrance to the Rodin Gallery at the Metropolitan Museum
of Art since May 1912 (fig. 4).[22] The choice was a particularly apt one
for an instructor of "Antique, Still Life and Figure Composition" and
demonstrated two of Gorky's key concerns: the value of working from
paintings or sculpture in a museum setting, and a concentration on the
work of modern masters. Rodin's erotically charged rendering of the
myth from Ovid's *Metamorphoses*, which depicts the moment when
Pygmalion sees the first stirrings of life in his carved ivory statue of
Galatea, may also have served as a metaphor for Gorky, connecting
artistic production with the creation of life itself. This allegory for artis-
tic creation anticipates the images of unbridled eroticism in his paint-
ings and drawings of the 1940s, in which elemental forms, in their
fecundity, function as surrogates for the forces of nature.

Another painting Gorky probably executed around this time is
Study after an Antique Sculpture (plate 4). This stunning watercolor is
of a beautiful marble Aphrodite in the Metropolitan Museum of Art
that is believed to be a Roman copy of Kallimachos's famous Greek
original of the late fifth century B.C. (fig. 5).[23] Although headless, arm-
less, and discolored by fire, the sculpture is notable for the trans-
parency of the sleeveless chiton worn by the goddess, which is fastened
on the right shoulder, leaving the left breast bare. It may have been the
challenge of re-creating this diaphanous garment, as well as his aware-
ness of Cézanne's long interest in making paintings after plaster casts
and sculpture, such as the *Venus de Milo* in the Louvre, that inspired
Gorky to make his rendition in watercolor. It is also possible that the
watercolor was prompted by the French artist's many drawings and
paintings of the swelling forms and curvaceous contours of a standing
Cupid formerly attributed to the seventeenth-century Provençal sculp-
tor Pierre Puget, of which Cézanne owned a plaster replica.[24]

FIG. 4
Auguste Rodin (French, 1840–1917). *Pygmalion and
Galatea*, 19th–20th century (modeled in 1889; executed
about 1908–9). Marble, height 38¼ inches (97.2 cm);
width 35 inches (88.9 cm); depth 30 inches (76.2 cm).
The Metropolitan Museum of Art, New York. Gift of
Thomas F. Ryan, in memory of William M. Laffan, 1910

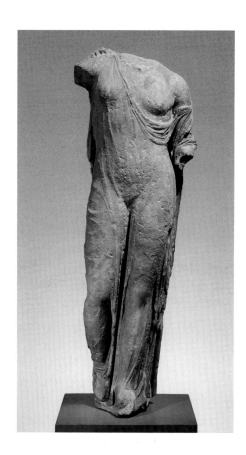

Gorky's assiduous study of Cézanne's watercolor techniques is evident in his provocative use of the untouched buff paper for the color of the marble and in the thinly washed contours of his standing figure, which are heightened through a nimbus of vivid blues and greens that give the sculpture a crystalline intensity. The animated quality of the sculpture is enhanced by the multiple lines that delineate its forms, adding a sense of vibrant movement, while the unworked areas of the sheet lend the draped classical figure an unexpected airy translucence. The loose, spontaneous application of transparent planes of glowing, prismatic color suggests that Gorky had recently seen Cézanne's watercolors in commercial art galleries in New York, or at Albert Eugene Gallatin's recently opened Gallery of Living Art, since reproductions of the time would not have conveyed the exuberance and energy of these works on paper.

Gorky's painting *The Antique Cast* (1926; plate 3) also incorporates what appears to be a plaster cast of an ancient marble sculpture, this time a reclining male nude that has been identified as a headless torso—a personification of the Ilissos or Kephissos River—from the west pediment of the Parthenon in Athens.[25] However, the painting's striking palette of hot, fauvist colors, in which the plaster body with its vermilion

highlights emerges from a background of Venetian red, suggests that the source for the work was not a plaster cast of the type found in artists' studios and art schools, but rather an early painting by Henri Matisse known today as *Still Life with Greek Torso*. Gorky owned a color reproduction of this 1908 painting (fig. 6), which at that time was in the collection of the National Gallery in Berlin, and his variation displays striking similarities with, but also significant differences from, the original. The basic composition with the antique torso and the two-handled amphora has been retained, but Gorky has placed much greater emphasis on the figure, which is only loosely delineated in Matisse's painting. Gorky's rendering of the torso in heavy impasto imbues it with a sense of weight and dimensionality—enhanced by flurries of white brushstrokes that also help to denote a three-dimensional sculpture rather than the flat, somewhat lifeless object seen in Matisse's painting. In Gorky's version, the reclining torso is set against a monochrome red background, again focusing attention on the figure, which in Matisse's work is surrounded by fruit in front of a variegated blue and purple background. Perhaps because his name was not among the artist-heroes that Gorky listed in his well-known statement to the art dealer Julien Levy (see below), Matisse has long been an overlooked or under-appreciated source for his work, but the influence of the French fauvist's saturated pigments and unexpected colors is apparent even in such late paintings by Gorky as *Water of the Flowery Mill* (1944; plate 118), with its luminous stained and dripped surfaces, as well as in earlier works like *The Antique Cast*.

In an interview in the *New York Evening Post* published in September 1926, shortly after his appointment at the Grand Central School of Art, Gorky expressed his reverence for Cézanne as a rule-breaker who had challenged tradition and reformulated the art of painting: "Cézanne is the greatest artist, shall I say, that has lived. The old masters were bound by convention and rule to painting certain things—saints, the Madonna, the crucifixion. Modern art has gone ahead widely and developed as it never had a chance to in the hands of the old masters."[26] This statement coincided with Gorky's earliest efforts to come to terms with the radical nature of Cézanne's paintings through an intense, self-imposed apprenticeship that continued until 1928,

FIG. 6
Color reproduction of Henri Matisse's *Still Life
with Greek Torso* (1908), formerly in the collection
of Arshile Gorky. Courtesy of Maro Gorky and
Matthew Spender

23

RETHINKING ARSHILE GORKY

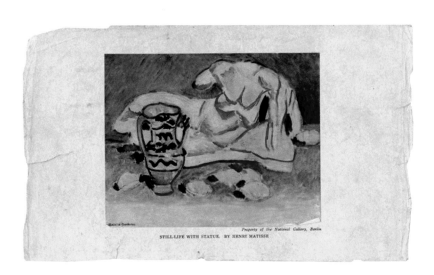

STILL-LIFE WITH STATUE. BY HENRI MATISSE

although its effects were long-lasting, as he later suggested in his dec-laration to Levy: "I was *with* Cézanne for a long time…and now natu-rally I am *with* Picasso."[27]

As part of his apprenticeship, Gorky sought out books and maga-zine articles on Cézanne and other modern artists at public libraries and specialty bookshops such as Erhard Weyhe's gallery and bookstore at 794 Lexington Avenue, which also sold his work intermittently.[28] Despite his limited means, he acquired a formidable collection of books, magazines, and reproductions of modern paintings, and by the late 1920s his personal library contained some of the most important early critical studies of Cézanne,[29] including a well-thumbed 1922 edi-tion of Julius Meier-Graefe's *Cézanne und sein Kreis* (*Cézanne and His Circle*) that he almost certainly acquired through Weyhe.[30] According to Arthur Revington, who studied with Gorky at the Grand Central School in 1927, he used these books as teaching tools to introduce his pupils to Cézanne and modern art.[31]

It was Gorky's firsthand experience of working through the formal complexities of Cézanne's paintings—and fully grasping how they bal-ance on a knife-edge between art and artifice, between sculpted space and ineluctable flatness—that gave him the confidence to pursue a career as a modern artist. Making his own variations on a Cézanne still life or landscape allowed him to grapple with the formal innovations of his chosen mentor, whose work he experienced through the act of re-creation. Gorky's early studies after antique and modern sculptures were quickly followed by a dynamic series of self-portraits, landscapes,

and still lifes in which he demonstrated his knowledge and understanding of Cézanne's work in all genres. In his self-portraits, we see Gorky take on the chiseled, rustic features and truculent personality of the artist he would affectionately call "Papa Cézanne."[32] Gorky went to such great lengths to model himself on the French master that his decision to grow a beard in the late 1920s may have been a conscious attempt to adopt Cézanne's bearded physiognomy and rustic identity.

Gorky's self-fashioning after the solitary, reclusive genius of Aix-en-Provence can be seen again in a self-portrait of about 1928 (plate 6), in which he depicts himself in sober workman's clothes, with an open collar and unbuttoned vest that sug-gest the bohemian artist hard at work. In this painting Gorky employed many of the hallmarks of Cézanne's style and palette, but he also made significant departures from his mentor's self-portraits. For example, the smoldering, inward-searching gaze of Gorky's portrait lends the image an aura of sadness that is absent from Cézanne's portraits of himself, which instead display the stoic calm and steely resolve of an artist who is assured of his place in history.

In a similar way, Gorky's landscapes of the 1920s—in which the lush countryside is rendered in a loose patchwork of greens, blues, oranges, and yellows (see plate 2)—were informed by Cézanne's paint-ings of mountains and forests. Gorky's warm palette, applied with feathery, directional brushstrokes, effectively conjures the sun-drenched landscape of Aix-en-Provence, despite the fact that he had never set foot on the baked earth of southern France. His fertile imag-ination allowed him to see Cézanne's countryside in the most mundane of places, such as Staten Island, where he would often visit a sweet-heart named Nancy in the second half of the 1920s, before her father broke off the relationship.[33] Like Henri Rousseau's invented jungle scenes, Gorky's Cézanne-inspired landscapes were figments of his imagination, but they are no less convincing and heartfelt for that. Although frequently dismissed as mere pastiches of the French mas-ter's work, these early paintings always bear the hallmarks of Gorky's distinctive vision and should be appreciated as original works of art in their own right.[34]

FIG. 7
Arshile Gorky. *Landscape, Staten Island*, 1927–28.
Oil on canvas, 32⅛ x 34 inches (81.6 x 86.4 cm).
Collection of Richard Estes

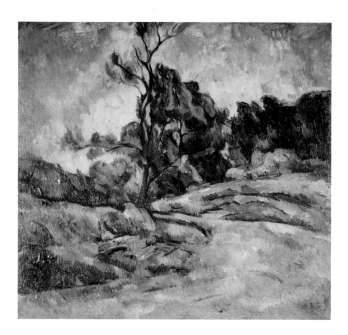

The artist and critic Elaine de Kooning vividly remembered Gorky's early passion for Cézanne, which led him to paint outdoors in Central Park and Staten Island: "Gorky's first love was Cézanne, and often through the years he would set up his easel in Central Park and, after frightening away intrusive onlookers with a fierce scowl, make little landscapes that demonstrate, in the softly clumped brushstrokes and hacked-out edges, a profound understanding of that Master."[35] *Landscape, Staten Island* (1927–28; fig. 7) is an example of Gorky's attempts to re-create the vibrant coloring and vigorous execution of some of Cézanne's greatest landscape paintings, in this case *Turn in the Road* (c. 1881; Museum of Fine Arts, Boston), which he could have studied through black-and-white reproductions before beginning his own painting out-of-doors. Once he returned to his studio, he would compare his finished work with the original to see how successfully he had imitated the structural balance and perspective in Cézanne's painting. We can even sense a competitive rivalry in these works. According to Elaine de Kooning, Gorky was always investigating the ages of Raphael, Ingres, and Cézanne when they made certain pictures, in the hope that his own precocity as an artist would match or even surpass theirs.[36]

Gorky's competition and identification with his artist-heroes may also have informed his *Self-Portrait at the Age of Nine* (1928; plate 5), which recasts Cézanne's celebrated portrait of *Louis Guillaume* (c. 1882; fig. 8), a painting that he almost certainly saw in January 1928 in the *Loan Exhibition of Paintings by Paul Cézanne* at the Wildenstein Galleries in New York. This exhibition of twenty-four of Cézanne's paintings included works from public and private collections in the United States, as well as a choice selection of paintings from the famed collection of Egisto Fabbri that were consigned by the French dealer Paul Rosenberg, who at that time operated the modern wing of the Wildenstein Galleries. Given the historical importance of this exhibition, which followed closely on the heels of the publication in the previous year of Roger Fry's *Cézanne: A Study of His Development* and the English translation of Julius Meier-Graefe's monograph,[37] it is perhaps no coincidence that 1928 marked the high point of Gorky's engagement with the Master of Aix. Previously, he had been able to study the small number of Cézannes in the Metropolitan Museum of Art, the Brooklyn Museum, the Gallery of Living Art, and possibly the Barnes Foundation in Merion, Pennsylvania, but the sudden opportunity for prolonged study of more than twenty of the French artist's greatest paintings left an indelible mark on his subsequent work.

In her preface to the Wildenstein catalogue, Maud Dale, the wife of the prominent banker and art collector Chester Dale (who had recently purchased the portrait of *Louis Guillaume* and lent it to the Wildenstein exhibition), emphasized Cézanne's heroic development and his status as an alienated outsider, praising his "unusual tenacity and faculty for application in the long solitary evolution of his genius."[38] The previous year, the Chicago art critic C. J. Bulliet had likewise underlined Cézanne's morbidly sensitive nature, which led him to desert Paris and "become a hermit of his native Aix, where he worked out, in agony, his art salvation."[39] These accounts mirror the drama inherent in Gorky's genesis as a tormented, self-taught artist operating outside the mainstream. He no doubt would have recognized his own plight as an impoverished Armenian immigrant and talented yet unrecognized artist in the descriptions of Cézanne's personal suffering, and he may have taken some solace in Dale's conclusion that "only within

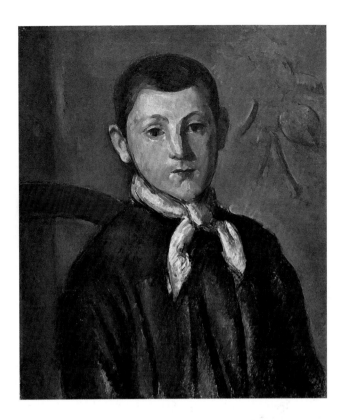

himself was [Cézanne] to find the answer to the problems that tormented him…[S]olitude became an absolute necessity, his long life a search that never ended until his death."[40]

Cézanne's *Louis Guillaume* was one of the great highlights of the Wildenstein exhibition and was repeatedly singled out for praise in reviews of the show. Although Gorky would have been aware of Cézanne's portrait of the pursed-lipped youth through black-and-white reproductions in his possession, his *Self-Portrait at the Age of Nine* unmistakably displays a keen knowledge of the original, suggesting that it was painted in 1928.[41] The knotted neckerchief in Cézanne's picture, for example, which looks uniformly white in reproductions, actually contains a chromatic range of green, blue, and purple highlights, which Gorky deployed to great effect in his own painting. Similarly, the skin tones of the boy's face in Cézanne's painting are deftly accentuated with flashes of green and purple that would have been lost in black-and-white reproductions, but that are repeated in exaggerated form in Gorky's portrait of himself as a wistful young boy, in which the child's ruddy complexion is exacerbated by flecks and patches of red paint, especially in the areas of the nose and forehead.

In his re-creation of the portrait of the son of Antoine Guillaume, a shoemaker and friend who lived next door to Cézanne in Paris, Gorky cast himself in the role of the melancholic youth. The young Vosdanig Adoian, as Gorky was known at age nine, inhabits almost the entire canvas, the chair back and floral-patterned wallpaper of Cézanne's painting having been eliminated, thus focusing our attention on the boy's introspective gaze and his sad, almost anguished appearance. Gorky may also have had in mind a physical resemblance between his younger self and Cézanne's portraits of his son, Paul, in which the boy is similarly constructed through a set of interlocking ellipses, as seen in the oval shape of the head and the arcs of the hairline, eyebrows, and ears. These formal similarities between Cézanne's close-up composition of his beloved son and Gorky's *Self-Portrait at the Age of Nine* reveal unexpected meanings, as we see Gorky constructing a new identity not just as a disciple of Cézanne but also as his son and heir. Taking this argument one step further, the art historian Hayden Herrera suggested that Gorky may have reinvented his childhood self in terms of what he imagined Cézanne to have been like as a child growing up in the south of France: "Gorky's portrait is a sort of cry for foredestined genius: into this sad, knowing youth Gorky has projected all his own retrospective longing for his Armenian childhood, and possibly—since this child is both Gorky and Cézanne—his ambition for his own future as a proven master and Cézanne's equal."[42]

Having rejected his own father for failing to support his family during the tragic events of World War I, including the Armenian Genocide that led to his mother's early death from starvation, Gorky may have constructed a private fantasy in which his true father was Cézanne, making him the rightful heir to the modernist legacy of the Master of Aix. "Papa Cézanne" thus became the father who would not fail or abandon him—in other words, a truer father than his own, as well as a fiercely determined personality whose example could guide and protect him during the long years of his self-imposed artistic apprenticeship.

Still Life with Skull (c. 1927–28; plate 8), arguably Gorky's most important painting of the late 1920s, evokes the grave mood of Cézanne's fatalistic still lifes featuring skulls and other *memento mori*. This painting imaginatively re-creates Cézanne's *Pyramid of Skulls* (c. 1898; private collection), in which a human skull is surrounded by a composition of pears and apples on a plate set on a partially draped tabletop.[43] In Gorky's painting, the skull's bulging, spherical form and hollow eye

sockets create visual rhymes with the rounded joints of the leg bone beneath it, echoing the rhythms of line, shape, and color in many of Cézanne's still lifes. Gorky placed his skull on a chair, nestled within the folds of a piece of heavy drapery densely painted with agitated brushstrokes of sienna brown and deep viridian green, with touches of purple throughout.

Gorky's inclusion of brightly patterned fabric in *Still Life with Skull* suggests that he was aware of Cézanne's frequent inclusion of Oriental carpets in his still-life paintings. Juxtaposed with the opulent colors and sharp creases of the heavily brocaded fabric, Cézanne's skulls take on the deathly pallor of bleached bone. The warm brown and yellow-ocher tonalities of the human bones and cranium in Gorky's painting, on the other hand, create a morbid atmosphere that goes beyond the *memento mori* tradition invoked by Cézanne's canvas. While a painting of a solitary skull or group of skulls fits easily within the conventions of Dutch and Flemish *vanitas* still lifes, with their references to the transience of human existence, Gorky's macabre addition of further human remains—possibly a thigh bone and femur—and the mummified appearance of the skull suggest that he may have used this iconography of death and decay to address the horrors he had witnessed in Turkish Armenia during World War I (see figs. 20, 21). This reading of a personalizing of the motif is supported by Gorky's placement of a stack of canvas stretchers against the wall to the right of the chair and a table or shelf to the left, as well as his suggestion of other paintings behind the chair. These objects identify the site as the artist's studio and thus reinforce the notion that the painting is a statement on Gorky's own brush with death during the Armenian Genocide.

Pears, Peaches, and Pitcher (c. 1928; plate 7) is another example of Gorky's increasingly adept crystallizations of Cézanne's structural principles. This spare composition is loosely based on Cézanne's painting *Jug and Fruit* (1893–94; fig. 9), although Gorky has deviated from his source in a manner that suggests a growing confidence in his own abilities. Adding a personal flavor to Cézanne's still life, Gorky replaced the jug with an earthenware pitcher and moved this object to the right to create a pared-down composition that is even more somber and severe than Cézanne's original. A photograph of Gorky painting a Cézannesque still life in his Sullivan Street studio in about 1927 (see fig. 1) reveals that this pitcher was a studio prop of his, rather than an object copied from a Cézanne painting. Like Cézanne, Gorky has given as much vitality to the space in and around the pitcher, plate, and fruit as to the objects themselves, and has made each shape and its shadow appear to lie side by side in a shallow, sketchily defined abstract space—rendered in vigorous, directional brushstrokes—that is suggestive of a tabletop set against a blank wall, although the upper edge of the table is undefined and inconsistent. This painting demonstrates that Gorky had fully grasped this pictorial device, which Cézanne used to manipulate the spatial ambiguity of his paintings and address the flatness of the picture plane, and suggests that his apprenticeship to the French artist was coming to an end by the late 1920s. It was at this point that he shifted his focus to the pictorial complexities of Cubism, which would preoccupy him for more than a decade.

The view that Gorky's borrowings and departures from the work of Cézanne, Picasso, and other modern masters in his experimental reinterpretations of the 1920s and 1930s are merely derivative copies, parodies, or pastiches fails to grasp the radical nature of his self-imposed discipleships to these artists and serves only to impoverish his art. Rather, Gorky emerges in this exhibition and catalogue as a quintessential self-taught artist of the interwar years whose steadfast allegiance to other artists' visions was a means of self-creation.[44] Gorky's early paintings did not embrace mainstream modern art's cult of innovation and originality, and thus they demonstrate his strangeness, his uniqueness within the cultural milieu of New York in the early decades of the twentieth century.

Yet, as an exiled survivor of the Armenian Genocide, Gorky's life and art embody key twentieth-century historical and theoretical concerns, such as immigration, trauma, memory, and identity construction. As Kim Servart Theriault's essay in this volume demonstrates, Gorky's work was informed by the harrowing experiences of his childhood in Turkish Armenia, and issues of displacement and identity are apparent in his progressive assimilation of various modes of avant-garde painting, through which he was able to construct a new identity for himself and, by extension, his family, both living and dead. Poignant portraits

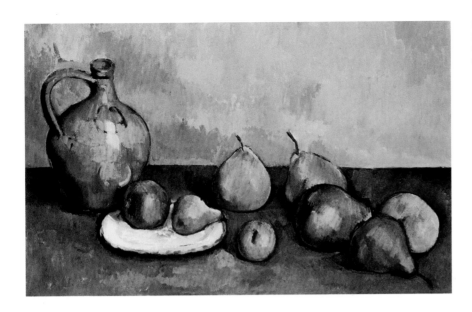

of himself and family members painted in the 1930s, especially the two versions of *The Artist and His Mother* (plates 32, 33) and the portraits of his sisters Vartoosh and Akabi (plates 25, 41), underscore the important role of autobiography in Gorky's art, which would become essential to his mature works. These portraits also reveal how much he had gleaned from the voluptuous neoclassical paintings that Picasso made in the early 1920s (see figs. 11, 12), as well as from their source, the portraits of Jean-Auguste-Dominique Ingres, with their ivory-smooth surfaces and visible pentimenti.[45]

A large, ambitious painting by Gorky titled *Woman with a Palette* (plate 10), illustrated here for the first time, is similarly indebted to the work of Picasso and Ingres. This canvas was completed in 1927 and sold not long afterward to the architect Maxfield Franz Vogel (known to his friends as Mac), who shared an apartment with Willem de Kooning and fellow artists Robert Jonas and Bart van der Shilling at 40 Union Square in the early 1930s.[46] The sale of the painting is believed to have taken place in 1932, since Gorky moved into his own studio just down the street, at 36 Union Square, around this time. *Woman with a Palette* was in Mac Vogel's possession by early 1933, when he met Gladys Liroff, an art student and a close friend of the dancer and model Juliet Browner, who would become de Kooning's girlfriend in the following year (and later marry Man Ray). Since Liroff recalled that the painting was already in her husband's possession by the time they married on December 1, 1933, after a ten-month romance, we can securely date its sale prior to that date. Vogel later acquired a Cubist still life by Gorky and an early painting by de Kooning as a means of supporting his friends financially during the lean years of the Great Depression.

Woman with a Palette was previously known only through related studies featuring a seated, heavyset woman holding a palette and paintbrush in a studio setting with easels and canvases (plates 9, 11). It was presumed lost or destroyed until 2004, when the architect's daughter, Louise Vogel, contacted the Philadelphia Museum of Art, which acquired the work later that year. *Woman with a Palette* is of crucial importance for understanding Gorky's painting techniques of the 1920s, since many of his other works of this time, such as the two versions of *The Artist and His Mother*, underwent substantial revisions in the 1930s and early 1940s, as he continually revised, erased, and repainted the compositions in line with his emulation of Ingres's reworked surfaces. Gorky may also have intentionally left these paintings in a state of incompletion, since to finish either work would be to acknowledge that his beloved mother was gone forever.

The formal composition of *Woman with a Palette* anticipates later paintings such as *Portrait of Master Bill* (c. 1937; plate 35), which depicts a man seated in a similarly ambiguous architectural space, his rounded face shown in three-quarters view. The correspondences between the two paintings perhaps suggest that Gorky used *Woman with a Palette*, or its related studies, as the basis for this portrait of his friend, a Swedish housepainter and carpenter whose first name has often led to his misidentification as "Bill" de Kooning.[47] In both of these paintings, the figure's prominent nose and eyebrow are formed by a single, sweeping curve, ultimately derived from early works of Picasso, such as his 1906 *Self-Portrait* (also known as *Self-Portrait with a Palette*; fig. 10), with its stylized eyelids and brows. Widely reproduced and exhibited in the 1920s, *Self-Portrait with a Palette* resonates strongly with Gorky's *Portrait of Master Bill*. Both works, for example, were preceded by preliminary studies that placed a paintbrush in the figure's right hand, but in the final paintings the brush was eliminated. In Picasso's *Self-Portrait*, the palette, held with a single finger, is the only clue to the artist's profession, suggesting that he was so confident of his magisterial, even magical powers as a painter that he had no need of the mediating element of the brush. In Gorky's *Portrait of Master Bill*, on the

FIG. 10
Pablo Picasso (Spanish, 1881–1973). *Self-Portrait*, 1906. Oil on canvas, 36³/₁₆ x 28⅞ inches (91.9 x 73.3 cm). Philadelphia Museum of Art. A. E. Gallatin Collection, 1950

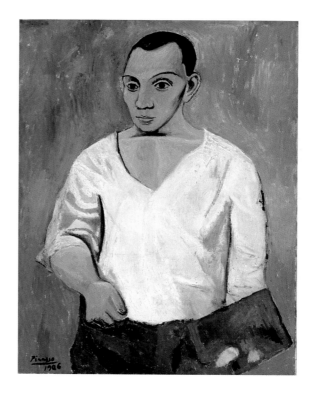

other hand, the presence of the palette may denote the work as an allegory of painting, or even a surrogate self-portrait of the artist, given its origins in Picasso's famous self-portrait.

Woman with a Palette also looks back to Picasso's monumental, neoclassical figures of the early 1920s, such as *Three Women at the Spring* (1921; fig. 11). The heavy folds of the garment worn by the woman in Gorky's painting can be compared to the Greco-Roman drapery worn by the three massive, friezelike figures in Picasso's painting, as well as to other works from the same period, such as *The Spring* (1921; fig. 12). The enormous right arm of the woman in the latter painting anticipates the oversize arm and clawlike hand with curled fingers in Gorky's painting, where they overwhelm the rest of the simply rendered body.

A crucial "missing link" in his development, *Woman with a Palette* provided Gorky with a point of departure for a large sequence of Cubist paintings and works on paper of the late 1920s and early 1930s (see plates 18–23) that reveal his systematic immersion in the styles and techniques of European modernism, as well as the growing independence of his line and color in representations of actual objects. The format of the painting, in which a seated personage holds a palette in a shallow, nondescriptive architectural setting, is repeated in his *Abstraction with a Palette* (c. 1930–31; plate 21), where the palette becomes almost as important and certainly as large as the seated figure, who can again be read as a surrogate for the artist in his studio. A related lithograph, *Painter and Model (The Creation Chamber)* (1931; plate 23), underscores this point by surrounding the figure with easels and works of art.

The secondary title of Gorky's lithograph refers to his studio on Union Square, where he worked from the early 1930s until his death in 1948. The phrase "creation chamber" also provides us with a wonderful framework for understanding Gorky's creative process, as he moved from preliminary studies to full-scale paintings, frequently returning to his sketches and drawings to solve formal problems. Several groupings or series included in this catalogue illustrate Gorky's process in the studio—his "creation chamber"—as he worked toward the realization of individual paintings, such as *Agony* (plates 159–65), or explored thematic motifs, as in *The Plow and the Song* and *The Betrothal* series (plates 144–49, 170–74).

It was as Gorky was moving into a period of increasing abstraction in the early 1930s that he developed a number of ties to the city of Philadelphia, thus making the Philadelphia Museum of Art a particularly suitable venue for this ambitious retrospective. The artist's connection with the city appears to date back as early as 1932, when he first became acquainted with the Philadelphia industrialist and art collector Bernard Davis (1892–1973), who would become a generous patron of his work, as well as a close friend and advisor. Born in Kiev, Davis had lost both of his parents by the age of ten, and in 1913 he immigrated with his two brothers, Leon and Richard, to the United States, following a brief spell in Paris during which he studied engineering. The orphaned children were adopted by Golda Nobel of Philadelphia, and Bernard was educated at Temple University in the north of the city, where he studied business administration before beginning his career in the textile industry by running a modest rug-cleaning company. From these humble origins, the Philadelphia entrepreneur quickly amassed a considerable fortune in the manufacture of textiles, upholstery fabrics, and tapestries through his company, La France Industries, which was located in the Frankford section of Philadelphia.[48]

In 1919, Davis's passion for art and education led him to begin assembling a large collection of important modern paintings, drawings,

FIG. 11
Pablo Picasso. *Three Women at the Spring*, 1921. Oil on canvas, 80¼ x 68½ inches (203.9 x 174 cm). The Museum of Modern Art, New York. Gift of Mr. and Mrs. Allan D. Emil, 1952

FIG. 12
Pablo Picasso. *The Spring*, 1921. Oil on canvas, 25¼ x 35⅜ inches (64 x 90 cm). Moderna Museet, Stockholm

29

RETHINKING ARSHILE GORKY

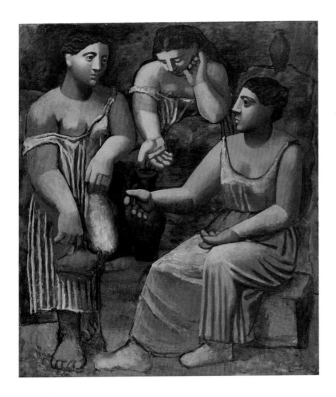

and sculpture that he displayed in his small museum at the Frankford textile mills. Known as La France Art Institute, the not-for-profit institution was explicitly modeled on Albert C. Barnes's plans for a foundation to promote education and appreciation of the fine arts, which would open in nearby Merion in 1922. In 1923, Davis expanded the outreach of his museum by opening La France Art School in an adjacent room of the same building, which was located at 4420 Paul Street in Philadelphia. The art school and museum were intended to provide his more than six hundred textile workers with a stimulating learning environment, which he hoped would increase their productivity and broaden their horizons. Well aware of his own rags-to-riches story, Davis hoped that by offering free tuition for art classes at La France Art School, he would give his employees a tool with which to carve out their own future success.[49]

When making art purchases in New York, or on buying trips to Europe, Davis was advised by the Philadelphia painter Henry McCarter, as well as by his brother, Richard Davis, who ran the Crillon Galleries in Philadelphia in the early 1930s while also editing the avant-garde magazine *Formes*. (Gorky was an avid reader of this publication, which kept him up-to-date on the latest developments in modern art.) By the time Gorky first visited La France Art Institute in the early 1930s, Davis

had formed a formidable collection with the help of his brother and McCarter, a modern painter who taught at the Pennsylvania Academy of the Fine Arts in Philadelphia. On display during Gorky's stay were paintings by Georges Braque, Giorgio de Chirico, André Derain, Fernand Léger, Louis Marcoussis, Jean Metzinger, and Joaquín Torres-García, drawings and watercolors by Paul Cézanne, Albert Gleizes, and Pablo Picasso, and sculpture by Jacques Lipchitz and Ossip Zadkine. A Jewish immigrant from the Ukraine, Zadkine shared Davis's religious and cultural background, and soon after their first meeting in Paris—arranged through the Russian painter Georges Annenkoff in 1927—he became a particular favorite of the Philadelphia millionaire.[50] Of all the artists included in Davis's collection, only Gorky would be more highly represented than Zadkine; between 1934 and 1940, Davis acquired at least ten paintings by Gorky, including *Still Life (Composition with Vegetables)* (c. 1928; plate 14), *Abstraction with a Palette* (c. 1930–31; plate 21), and *Composition: Horse and Figures* (c. 1934; plate 63).

Exactly how Davis met Gorky is not known, but it was through the Philadelphia collector that Gorky met his first wife, Marny George.[51] On February 29, 1934, at the opening of the *First Municipal Art Exhibition* at the Forum Gallery in the new RCA Building in New York, Davis and his longtime girlfriend, Irmgard Erik, a Danish-born dancer with the

FIG. 13
Giorgio de Chirico's painting *Horse* (1928)
reproduced in the *Pennsylvania Museum Bul-
letin* 29, no. 161 (March 1934), p. 52. Courtesy
of the Philadelphia Museum of Art Library

FIG. 14
Gorky in his studio at 36 Union Square, New York, in
1933, with a number of his *Nighttime, Enigma, and
Nostalgia* drawings on the wall behind him. Courtesy
of Maro Gorky and Matthew Spender

Ziegfeld Follies, introduced Gorky to the blond Midwesterner, whom he would marry shortly thereafter. In the spring of 1934, the couple spent their honeymoon with Davis and Irmgard at their house at 1914 Rittenhouse Square, during which time Gorky visited the Pennsylvania Museum of Art (now the Philadelphia Museum of Art) and the Barnes Foundation. Davis kept part of the large collection of modern art that he had assembled under the name of La France Art Institute at his Rittenhouse Square house, including several Cubist paintings by Gorky, which were theatrically displayed amid the fashionable Art Deco furnishings.

One of the most important works in Davis's collection was on loan to the Pennsylvania Museum of Art during the time of Gorky's honeymoon. Giorgio de Chirico's *Horse* (fig. 13), also known as *Greek Fantasy*, was included in the museum's humorously titled exhibition *Horse Show*, which was organized by Henri Marceau, the museum's associate director. Gorky was clearly impressed by this large equestrian painting, for he made his own version of its composition of a horse flanked by standing figures (plate 63). Gorky's painting was preceded by detailed drawings that carefully followed de Chirico's original design, but he deviated from the classical drapery and columns of *Horse* in the finished work, which added another figure behind the animal's hindquarters.

Although dated "1928" on the verso, *Composition: Horse and Figures* has been redated to circa 1934 in this catalogue, since the earlier date refers to the year that de Chirico painted *Horse*. Gorky may even have completed his painting in Philadelphia. Robert Nobel, Davis's cousin, remembered that he became "a sort of artist-in-residence around 1934, making drawings and paintings in the Rittenhouse Square home, while also taking his new wife to the local museums."[52]

After his company went bankrupt in 1937, following a dramatic fall in the demand for textiles as a result of the Great Depression, Davis sold most of his collection at auction[53] and turned his attention to stamp collecting, which he pursued with a passion equal to his earlier interest in modern art.[54] However, he continued to support Gorky and his work, even paying for the cocktail reception of his first solo exhibition at the Julien Levy Gallery, New York, in March 1945. Although he was no longer able to buy new paintings, Davis did retain some of his favorite early Gorky paintings, later donating several of them to prominent American museums, including *Abstraction with a Palette*, which he gave to the Philadelphia Museum of Art in 1942, and *Composition: Horse and Figures*, which he presented to the Museum of Modern Art (MoMA), New York, in 1950 in memory of the artist. The Philadelphia

Museum of Art subsequently acquired two additional major works by Gorky that are included here: *Dark Green Painting* (c. 1948; plate 182), and the recently acquired *Woman with a Palette* (1927; plate 10).

The Philadelphia Museum of Art's extraordinary collection of modern art provides a unique context for understanding Gorky's work, since it includes many paintings from Albert Eugene Gallatin's collection, which had so inspired Gorky over the years, among them Léger's *The City* (1919; see fig. 62), Picasso's *Self-Portrait with a Palette* (1906; see fig. 10), Giorgio de Chirico's *The Fatal Temple* (1914; see fig. 16), and André Masson's *Cockfight* (1930; see fig. 72).[55] Gorky became familiar with the Gallatin Collection during the 1920s and 1930s, when it was on display at the Gallery of Living Art at New York University. He was a frequent visitor to the gallery and often made paintings and drawings directly inspired by the avant-garde art he encountered there. De Chirico's painting *The Fatal Temple*, for example, provided the inspiration for a series of more than eighty drawings and two paintings that Gorky made between 1931 and 1934 (plates 42–49, 51–55), many of them as studies for a never realized mural for the Public Works of Art Project (PWAP) titled "1934." By 1933, these black-and-white drawings covered a wall of his Union Square studio (fig. 14). Gorky derived the later *Nighttime, Enigma, and Nostalgia* title for this series from similar titles of early paintings by de Chirico, such as *The Nostalgia of the Infinite* (1912; MoMA) and *The Enigma of Fatality* (1914; Kunstmuseum Basel). The word *énigma* is even written above the fish mold in de Chirico's *The Fatal Temple*, supplying the most probable source for the ultimate title of the series.

In the early 1940s, Gorky returned to the imagery of the *Nighttime, Enigma, and Nostalgia* series in a design for the Jewish Chapel at Rikers Island Penitentiary in New York (c. 1941–42; plate 50). His preliminary sketch for the project was for two mural panels intended to flank a raised platform and large backdrop in the chapel. The panel on the left was to be a rendition of the *Nighttime, Enigma, and Nostalgia* theme, and the panel on the right, a variation of *Painting* (1936–37; plate 71),

another of his compositions from the 1930s. Gorky also submitted a design for a stained-glass window for the chapel, which was given preliminary approval by the New York Art Commission but was later rejected because of its nonrepresentational content. Gorky's murals were ultimately rejected as well, after having twice been approved, and in June 1942 the commission was offered to his fellow artist Jean Xceron, who executed two panels titled *Abstraction in Relation to Surrounding Architecture* (fig. 15). Gorky later gave his sketch for the Rikers Island project to his sister Vartoosh, but not before covering it with Surrealist drawings related to his illustrations for André Breton's anthology of poems *Young Cherry Trees Secured against Hares* (1946; see plates 127–30). These doodles, as well as the symbols and numbers that accompany them, also recall the calligraphic diagrams found in de Chirico's *The Fatal Temple* (fig. 16), which had first inspired the *Nighttime, Enigma, and Nostalgia* series.

Gallatin had acquired *The Fatal Temple* in 1927 from the Galerie Jeanne Bucher in Paris, and the painting was exhibited in the inaugural installation of the Gallery of Living Art, which opened on December 12 of that year. Located in the South Study Hall of New York University's main building at 100 Washington Square East in Greenwich Village, the Gallery of Living Art was free to the public and was located just a stone's throw from Gorky's second-floor studio at 47A Washington

FIG. 15
Jean Xceron (American, 1890–1967). *Abstraction in Relation to Surrounding Architecture*, 1942. Oil on canvas. Two panels installed in the Jewish Chapel, Rikers Island Penitentiary, New York. Present location unknown

FIG. 16

Giorgio de Chirico (Italian, born Greece, 1888–1978). *The Fatal Temple*, 1914. Oil on canvas, 13⅛ x 16⅛ inches (33.3 x 41 cm). Philadelphia Museum of Art. A. E. Gallatin Collection, 1947

Square South, on the corner of Sullivan Street, where he moved around 1927.[56] Why Gorky was drawn to de Chirico's small, enigmatic painting has until now remained something of a mystery, since his work in the early 1930s had moved beyond figuration into the realm of Cubist abstraction. The composite imagery found in *The Fatal Temple,* which has long been recognized as one of de Chirico's most important Metaphysical paintings, particularly fascinated and puzzled James Thrall Soby. The well-known collector and scholar of de Chirico's work believed that the artist's use of words, calligraphy, and an elongated, "primitive" face on a blackboard made the painting an important precursor to Surrealist painting of the 1920s.[57]

Gorky's obsessive interest in de Chirico's canvas must have gone beyond the work's seminal combination of word and image, however, since this alone seems unlikely to have inspired a four-year-long investigation of its pictorial structure and composition. I would propose an alternative reason for Gorky's personal identification with the painting, namely, the role of portraiture and memory in *The Fatal Temple.* De Chirico's canvas depicts his mother, Gemma de Chirico (née Cervetto), a powerful matriarchal figure who is instantly recognizable from photographs and other paintings by de Chirico. Her contiguous profiles are set to the right of the chalkboard that so impressed Soby, which also contains an outlined image of de Chirico himself, complete with a dissected brain and accompanied by the words *joie* (joy) and *souffrance* (suffering). When Gorky saw *The Fatal Temple* for the first time, presumably in the winter of 1927–28, shortly after the public opening of the Gallery of Living Art, he had already embarked on two large-scale paintings on the theme of the artist and his mother (plates 32, 33). This focus may explain why he was so drawn to de Chirico's mysterious painting, with its suggestion of the joy and suffering of the mother-and-son relationship.

Although the compartmentalized composition remained the same throughout the *Nighttime, Enigma, and Nostalgia* series, Gorky's earliest studies on the theme situated his own profile and its shadow in place of those of Gemma de Chirico (see plate 42), while the profile portrait of de Chirico on the trapezoidal blackboard was replaced by an abstract composition of interlocking, biomorphic shapes. The calligraphy found in *The Fatal Temple* was also eliminated, although the fish mold was retained in the earliest drawings of Gorky's series, albeit reduced to skeletal form (see plates 42, 44, 45). As the art historian Pepe Karmel has noted, "The interlacing forms that appear on the blackboard in Gorky's pictures have nothing in common with the simple, self-contained forms in the corresponding area of De Chirico's canvas. They look back, generally, to the biomorphic vocabulary of 1920s Surrealism and, specifically, to the interlace style invented by Picasso in his 1926 canvases *The Milliner's Workshop* and *Artist and Model.* In the early 1930s, these pictures remained in Picasso's studio and had not yet been reproduced; Gorky must therefore have absorbed their influence via an intermediary."[58] Karmel's proposal of a 1933–34 print by Georges Braque as this intermediary source for the *Nighttime, Enigma, and Nostalgia* series remains thoroughly unconvincing, however, given the secure dating of the series to 1931, leading Karmel to admit that it was possible that the "close resemblance between Braque's composition and Gorky's lies in a common source, as yet unidentified."[59]

FIG. 17
Gaston-Louis Roux (French, 1904–1988). *Composition*,
1927. Oil on canvas, 14^{15}/$_{16}$ x 18^{1}/$_{16}$ inches (37.9 x 45.9 cm).
Philadelphia Museum of Art. A. E. Gallatin Collection, 1946

33

RETHINKING ARSHILE GORKY

In my opinion, this unidentified source for Gorky's conflation of de Chirico's metaphysical imagery with that of biomorphic Surrealism can be found in Gaston-Louis Roux's 1927 painting *Composition* (fig. 17), which hung alongside *The Fatal Temple* in the initial installation at the Gallery of Living Art, and which was still on view in the early 1930s when Gorky began his *Nighttime, Enigma, and Nostalgia* series. Given the close proximity of the two paintings on the wall of the gallery, it is entirely possible that the compositions coalesced in Gorky's mind when he returned to the studio to begin work on the sketches and drawings for his series, which utilize elements from both paintings, as well as drawings by Picasso. Although the two Picasso paintings that Karmel proposed as possible influences for the *Nighttime, Enigma, and Nostalgia* works were not reproduced or exhibited in the United States before Gorky began work on his series, he would have been aware of comparable drawings by Picasso from the same period through his copy of Waldemar George's *Picasso: Dessins* (Paris, 1926). Several of the black-and-white drawings reproduced in this book contain interlocking forms and cross-hatching similar to those found in Gorky's drawings.

Gorky found a more immediate source, however, in Roux's shallow, compressed architectural space and his vocabulary of flat, abstract interlocking shapes, akin to cut-out pieces of a jigsaw puzzle, which are repeated in the curvilinear forms of Gorky's sketches and drawings for the series. Similarly, Roux's palette of green, warm browns, creams, and blacks resonates with the two *Nighttime, Enigma, and Nostalgia* paintings (c. 1933–34; plates 54, 55). Although highly regarded in the late 1920s, Roux soon fell into obscurity. His lack of critical or commercial success probably explains why no scholar has previously discovered the crucial impact of his 1927 painting on Gorky's work of the early 1930s.

The *Nighttime, Enigma, and Nostalgia* series was a distinct departure from Gorky's earlier experiments with the techniques and imagery of Cézanne and other modern masters. While his paintings of the 1920s remained recognizably close to their original sources, the *Nighttime, Enigma, and Nostalgia* series moved farther and farther from its sources in de Chirico, Picasso, and Roux as it progressed, to the point where the two paintings on the theme can be considered among the most original of Gorky's early accomplishments. Working through

another painter's style no longer meant holding himself back, as it had in the 1920s, when he subsumed his own personality in his adept assimilation of the work of other artists.

Gorky's new degree of self-assurance manifested itself not only in his work, but also beyond the studio, as he began to take a prominent position in New York's cultural scene, thanks in part to his patron and friend Bernard Davis. It was almost certainly through the Philadelphia textile magnate that Gorky made the acquaintance of C. Philip Boyer, who directed the Mellon Galleries at 27 South Eighteenth Street in Philadelphia. In February 1934, shortly before Gorky met Marny George, Boyer gave him his first solo exhibition at the Mellon Galleries, during which the artist gave a lecture on "Plastic Forms of Modern Painting."[60] A brief announcement for the exhibition of thirty-seven paintings appeared in the *Philadelphia Inquirer*, written by the newspaper's art critic C. H. Bonte: "At the Mellon until February 15 are oils by Arshile Gorky, a nephew, they say, of the novelist Maxim, and those who are looking for sensations in contemporary art, strongly derivative as these may be, will not be disappointed in the Gorky output."[61]

A week later, the same reviewer wrote an extensive and, for that time, extremely enlightened review of Gorky's "astounding abstractions," commenting on their brilliant color and emphasizing their daring modern style. Perhaps as a result of having attended Gorky's lecture, Bonte spoke knowledgeably about his debt to Cubism and the sources of his predominantly nonrepresentational work, which he ascribed to the earlier examples of such artists as Albert Gleizes, Fernand Léger, Jacques Lipchitz, Jean Metzinger, and Pablo Picasso, all of whom were strongly represented in Bernard Davis's collection. In conclusion, he warned, "Look at [Gorky's paintings] with an open mind and do not be tempted to say: 'It may be art, but I don't understand it.' That's too old a line to be pulled in these days. M. Gorky gave a lecture at the galleries on Monday afternoon and those who were present declare he made everything quite clear."[62] Bonte also astutely observed that although Gorky was "said to be a relative of the novelist Maxim Gorky, in [that] case he has adopted the pen name of the renowned Alexy Peshkov."[63] Few other writers of the time seem to have been aware that "Maxim Gorky" was the pseudonym of Alexei Maksimovich Peshkov. Bonte's knowledge of this fact allowed him to cast aspersions on Gorky's insistence that he was related to the famous Russian writer, since no cousin or blood relative would have shared Maxim Gorky's chosen name.

Several of Gorky's friends and supporters wrote brief statements for his 1934 exhibition at the Mellon Galleries, which were printed in the accompanying checklist. The art critic Holger Cahill (later director of the Federal Art Project), the artist Stuart Davis, the architect Frederick Kiesler, and the writer Harriet Janowitz (later Janis) presented different aspects of Gorky's art and personality, with Cahill commenting, for example, that "Arshile Gorky has an extraordinary inventiveness and fertility in creating special arrangements both precise and harmonious, and he contributes to contemporary American expression a note of intellectual fantasy which is very rare in the plastic art of this country."[64] In the following year, Boyer mounted his second exhibition of Gorky's work at the Mellon Galleries, which in the interim period had relocated to Broad Street Station in Philadelphia. Opening on October 13, 1935, this exhibition consisted almost exclusively of drawings from the *Nighttime, Enigma, and Nostalgia* series. The art critic for the *Phila-delphia Record* praised the "basic black-and-white character of this painter's design sense," before noting that the "drawings gain a sense of juxtaposed forms through clever hatchings that curve volumes and surfaces from deep black to white or vice versa."[65] Gorky's relationship to modern European art was dutifully noted by the reviewer, who ended the article by quoting Kiesler's statement in the checklist of the previous year's show at the Mellon Galleries: "Unswerving critical reason seeks the quintessence of Picasso-Miro, drunkenly to absorb them, only to exude them again in deep slumber, after such a feast."[66]

It was thus in Philadelphia that Gorky first gained a reputation as a modern artist. His solo exhibitions at the Mellon Galleries paved the way for his first one-person show in New York, which opened at the Guild Art Gallery on December 16, 1935. Anna Walinska, the co-owner of the gallery, had known Gorky for several years and had accompanied him on field trips to the Metropolitan Museum of Art, where he had explained to her his theories of modern art and design. When Walinska and her business partner Margaret Le Franc opened the Guild Art Gallery in October 1935, Gorky was included in the inaugural group exhibition, which coincided with his second one-person show at the Mellon Galleries. In the following month, on November 12, 1935, Gorky signed a three-year contract with the Guild Art Gallery that gave Walinska and Le Franc exclusive rights to the exhibition and sale of his art.[67] Walinska immediately began organizing an exhibition of eighteen of Gorky's drawings that opened just a few weeks later. It seems likely, given that it shared the same subject and took place less than two months later, that the New York exhibition was identical to the Philadelphia show. Holger Cahill's earlier statement for Gorky's 1934 show at the Mellon Galleries was reprinted in the Guild Art Gallery's exhibition catalogue, suggesting another connection between Boyer's and Walinska's endeavors.

Gorky's 1935 solo exhibition at the Guild Art Gallery established his credentials as one of the leading modern artists in New York. Fernand Léger, who was in New York to attend a retrospective of his own work at MoMA, had stopped by the newly opened Guild Art Gallery to see the inaugural exhibition, which included two still lifes by Gorky that Léger praised as "original and a distinct addition to the field of abstraction."[68] The gallery used Léger's comments to publicize its second showing of

Gorky's work, issuing a press release that linked its exhibition with the French artist's retrospective. Just as he had in Philadelphia, Gorky gave a lecture, titled "Principles of Composition in Abstract Art," which took place at the gallery on December 22, 1935, while his show was still up.

These lectures, coupled with the enthusiastic press release placing Gorky on the same qualitative level as Léger, ensured that his solo exhibition attracted considerable attention in the press. Emily Genauer, the art critic for the *New York Post*, provided the best assessment of the complexities of Gorky's drawing techniques and the powerful effects of his meticulous compositions, which she claimed were "based on a highly personal ideology. Gorky has an odd manner of almost completely covering his picture surface with thousands of little cross-hatched lines. On this practically black surface float weird, fantastic forms that, having no apparent or obvious meaning, are nevertheless so carefully set in their appointed place they carry the eye deep into the composition, achieve an exquisite balance of shape and tone (amazing how much color the artist has introduced into these black-and-whites), and set the whole arrangement into vibrating, arresting movement."[69]

Gorky's exploration of Cubist and modernist abstraction, as exemplified by the *Nighttime, Enigma, and Nostalgia* series, coincided with his work for the Federal Art Project (FAP) of the Works Progress Administration (WPA). During the difficult years of the Great Depression, he supported himself by working as a mural painter for the PWAP and FAP, while continuing to pursue his own work in his Union Square studio, creating paintings such as *Organization* (1933–36; plate 66). Harry Cooper's essay in this catalogue offers a definitive account of this important painting and the studies that led to it (plates 64, 65), which can be seen as the highpoint of Gorky's engagement with Cubism in the mid-1930s. In *Organization,* and in other paintings and drawings of the 1930s, the kidney-shaped palette remained a pervasive motif, symbolizing the artist's profession and his work in the studio.

As Jody Patterson demonstrates in her essay in this catalogue, Gorky's commitment to left-wing politics during the 1930s has been downplayed in the literature on the artist but is crucial to our understanding of the controversial sequence of ten murals on the theme of modern aviation that he created in 1936–37 for the Administration Building of Newark Airport (plates 84, 85). Although still engaged with the Cubist vocabulary of Picasso and Braque, the mechanized forms of these murals also reveal a debt to the work of Léger, especially his monumental painting *The City* (1919; see fig. 62). Gorky owned a color reproduction of this painting that he had clearly studied intensely, since it is covered with his paint-smeared fingerprints.

The large-scale murals and related studies on the theme of aviation that Gorky created for the FAP/WPA (plates 76–85) signaled his emergence as an abstract painter of great promise. In the early 1940s, his prominent position in the New York art scene brought Gorky into contact with several members of the Surrealist group, who had been forced to flee Europe during World War II. His subsequent close friendship with the leader of the exiled group, the Surrealist poet André Breton, who wrote eloquently about his paintings, made a deep and lasting impression on him. Gorky's burgeoning relationship with the Chilean-born Surrealist Roberto Matta during these years also contributed to the development of his mature style. Matta encouraged Gorky to improvise and to experiment with biomorphic forms rendered with thinned-out, vaporous washes of color, in contrast to the heavy impasto of his Cubist works of the previous decade, and he introduced him to the Surrealist technique of automatic drawing, which Gorky deftly mastered.

In the numerous "breakthrough" landscapes that Gorky produced at Crooked Run Farm, near Lincoln, Virginia, in the early 1940s, his working method consisted of making quick sketches in the fields that he would expand upon in highly finished, semiabstract drawings and paintings completed back in the studio. In the final canvases, images of plows, waterfalls, flowers, insects, and other motifs take the form of delicately drawn biomorphic shapes floating amid vibrant, liquid colors. In paintings such as *Cornfield of Health* (1944; plate 117) and *Love of the New Gun* (1944; plate 116), Gorky separated color from drawn line, so that they each became individual components. The lush vegetation of the Virginia countryside and, later, rural Connecticut reminded him of his Armenian homeland, and for the next seven years, until his death in 1948, he painted highly original abstractions that combined memories of his childhood, especially the gardens, orchards, and wheat fields of Khorkom, with direct observations from nature to

create imaginary landscapes remarkable for their evocative power and fecundity of organic forms.

As I hope to have demonstrated in my own contribution to this volume, Gorky's paintings of the mid- to late 1940s can only be understood within the context of Surrealism's engagement with the natural world since its formation in Paris in 1924. Gorky's freely improvised paintings and drawings—although initially indebted to the work of Matta, André Masson, and Joan Miró, all of whom used the natural environment as a touchstone for their artistic practice—eventually developed into a highly original form of Surrealist automatism, in which recognizable imagery, such as waterfalls, flowers, and insects, became the basis of an abstract visual language replete with an explosive, erotic energy.

Gorky's important role in the international Surrealist movement throughout the 1940s and beyond has been downplayed in the literature on the artist, which has instead overemphasized his links with the nascent Abstract Expressionist group. This deliberate diminishment of Gorky's interest in Surrealism and his close friendships with Surrealist artists and writers, such as Breton, Masson, and Matta, as well as Max Ernst, Frederick Kiesler, Wifredo Lam, and Isamu Noguchi, began shortly after his death and has continued to the present day. Most of the earliest critical and biographical accounts of Gorky's life and work were written by artists, art critics, and former students, such as Willem and Elaine de Kooning, Harold Rosenberg, and Ethel Schwabacher, who knew him during the 1930s, before his encounter with the exiled Surrealist group. Their unwillingness to fully acknowledge Gorky's engagement with Surrealism was exacerbated by the subsequent books and articles that his nephew, Karlen Mooradian, published on Gorky's life and work. Mooradian was openly hostile to the Surrealist movement and presented his uncle as an Armenian nationalist whose work could only be understood through the traditional forms of Armenian culture, such as frescoes and other forms of church decoration, as well as illuminated manuscripts. Mooradian went so far as to fabricate a series of letters that Gorky purportedly wrote to his sister Vartoosh Mooradian, Karlen's mother, in which he extols the beauty and traditions of their former homeland while disparaging Western art, especially Surrealism. These forgeries had an enormous impact on the subsequent literature on the artist, since scholars believed that the anti-Surrealist diatribes came from Gorky himself. It was not until 1998 that Nouritza Matossian was able to show conclusively that twenty-nine of the letters once believed to be by Gorky were written by Karlen.[70] The authors of this catalogue have had the opportunity to reexamine Gorky's life and career without the manipulation of his nephew's misleading words, thus initiating a new era of scholarship on the artist.

In the mid-1940s, Gorky—now married to Agnes Magruder and the proud father of two young daughters—was at his happiest and most prolific, and was finally beginning to draw critical acclaim. This tranquil period was interrupted, however, by a series of tragic events that began in January 1946 with a devastating fire in his Connecticut studio; he lost a large number of his recent paintings in the blaze, as well as several cherished books and other possessions. In the same year, he underwent a painful and debilitating operation for rectal cancer. Then, in mid-June 1948, with their marriage already deteriorating, his wife had a brief affair with his friend and mentor, Matta. Later that month, Gorky was involved in a serious car accident—in a vehicle driven by his dealer, Julien Levy—that left him with a broken neck and temporarily paralyzed his painting arm. Not long afterward, his wife left him, taking their children with her. In physical and emotional agony, Gorky hung himself on July 21, 1948.

We are fortunate that he left behind such an impressive body of work, which has secured his reputation as the last of the great Surrealist painters and an important precursor to Abstract Expressionism. As Robert Storr's essay in this volume makes clear, Gorky's work has had a profound legacy, reflected in his impact on contemporary artists since the 1950s, especially American painters, from Willem de Kooning and Richard Diebenkorn to Elizabeth Murray and Carroll Dunham. Now a new generation of artists—and viewers—will have the opportunity to experience Gorky's complex, influential, and often deeply moving body of work in fresh and exciting ways.

1. For an overview of the varying accounts of Gorky's birth date, see p. 366 n. 1 below.

2. Nouritza Matossian, *Black Angel: A Life of Arshile Gorky* (London: Chatto and Windus, 1998); Matthew Spender, *From a High Place: A Life of Arshile Gorky* (New York: Alfred A. Knopf, 1999); and Hayden Herrera, *Arshile Gorky: His Life and Work* (New York: Farrar, Straus and Giroux, 2003).

3. Harry Rand, *Arshile Gorky: The Implications of Symbols* (London: Prior, 1981); Jim M. Jordan and Robert Goldwater, *The Paintings of Arshile Gorky: A Critical Catalogue* (New York: New York University Press, 1982); and Melvin P. Lader, *Arshile Gorky* (New York: Abbeville, 1985).

4. For the origins of Gorky's first name, Arshile, see Spender, *From a High Place*, p. 60.

5. Gorky's harshest detractor after his death was Emily Genauer, the outspoken art critic of the *New York Herald Tribune*, who described his Cézanne-derived work as "second-rate" and "a blatant parroting of some one else's style." See [Emily Genauer], "Gorky, Was He Tops or Second Rate?" *Art Digest* 25, no. 8 (January 15, 1951), p. 9.

6. William de Kooning, quoted in Karlen Mooradian, "Interview with Willem de Kooning," in "A Special Issue on Arshile Gorky," *Ararat* 12 (Fall 1971), p. 49.

7. Harold Rosenberg, "Arshile Gorky: The Last Move," *Hudson Review*, Spring 1960, p. 103.

8. Meyer Schapiro, introduction to Ethel K. Schwabacher, *Arshile Gorky* (New York: Macmillan for the Whitney Museum of American Art, 1957), p. 11. The artist's younger sister, Vartoosh, similarly recalled that during his early years in New York in the 1920s, Gorky would "always take me to museums and we would walk until our feet could move no longer. He would often simulate a telescope with his hands to study paintings. 'This way,' he told me, 'you can see only what you want, only the face, and you can study it more.' And he would sit and draw there and I would sit next to him and watch. His entire mind, morning and night, was concerned with art." See Karlen Mooradian, "A Sister Recalls: An Interview with Vartoosh Mooradian," in "A Special Issue on Arshile Gorky," p. 16.

9. Gorky's knowledge of Cézanne was no doubt informed by the art criticism of his time, which tended to romanticize the life and work of the French artist, who emerges in these accounts as a mysterious, ill-tempered, somewhat reclusive figure, oblivious to fame and utterly dedicated to his art. American critics in the 1920s discussed Cézanne's accomplishment almost exclusively in terms of a heroic struggle that was compounded by his tenacious and irascible personality. Forbes Watson,

for example, highlighted Cézanne's "disheartening struggle" as well as his "social irritability and brusqueness" in a review of a Cézanne exhibition at the Wildenstein Galleries in New York in 1928; Watson, "New York Exhibitions," *Arts Magazine* 13, no. 2 (February 1928), p. 107.

10. See Sara Lichtenstein, "Cézanne and Delacroix," *Art Bulletin* 46, no. 1 (March 1964), pp. 55–67.

11. Ibid., p. 56. For more on Cézanne's copies at the Louvre, see Theodore Reff, "Copyists in the Louvre, 1850–1870," *Art Bulletin* 46, no. 4 (December 1964), p. 555. As Reff correctly surmised, Cézanne's copies after Delacroix's *Dante and Virgil* and *Liberty Leading the People* were painted in the Musée du Luxembourg, as the originals did not enter the Louvre until 1874.

12. See Rosemary Chapman, "Autodidacticism and the Desire for Culture," *Nottingham French Studies* 31, no. 2 (Autumn 1992), p. 84.

13. Ibid.

14. The Self-Taught-Man's autodidactic project ends in shame and failure, after he commits an act of pederasty that leads to his ejection from the library, thus dashing his hopes for self-improvement. As Angela Kershaw has argued, Sartre's ever-blushing character is doomed to self-destruction from the start, "since bourgeois culture decrees that the autodidact should be ashamed of his attempts to accede to learning: the autodidact internalizes this shame, and recreates himself as a shameful individual in the persona of the criminal. It is almost a crime to be an autodidact, a crime against the bourgeoisie, an infraction of the bourgeois educational code." See Kershaw, "Autodidacticism and Criminality in Jean-Paul Sartre's *La Nausée* and Edith Thomas's *L'Homme Criminel*," *Modern Language Review* 96, pt. 3 (July 2001), p. 689. The question remains how a self-taught artist such as Gorky managed successfully to overcome the tremendous impediments placed in his way and thus avoid becoming a victim of existing power structures.

15. Willem de Kooning told Harold Rosenberg that Gorky was "a Geiger counter of art. In a room in the museum, he always ran to the right painting, and in the painting he always picked the really interesting thing"; Rosenberg, *Arshile Gorky: The Man, the Time, the Idea* (New York: Horizon, 1962), pp. 26–27.

16. According to Ethel M. Cooke, who was Gorky's drawing teacher at the New School of Design in Boston, Sargent was an artist whom Gorky greatly admired. Indeed, Gorky used to carry a book about Sargent under his arm: "I imagine he slept with it under his pillow. He was that sort of student." He may even have met the American artist, since he later told his second wife,

Mougouch, that Sargent had given him his paint brushes. See Herrera, *Arshile Gorky: His Life and Work*, p. 120.

17. See Merlin E. Carlock to William C. Seitz, November 2, 1962, William C. Seitz Papers, Museum Archives, The Museum of Modern Art, New York.

18. See James E. B. Breslin, *Mark Rothko: A Biography* (Chicago: University of Chicago Press, 1993), p. 56. Gorky's *Lady in the Window*, which he based on a version of Frans Hals's *Malle Babbe* in the collection of the Metropolitan Museum of Art, may have been one of the works that he brought into the classroom. Gorky's interpretation of Hals's famous painting of a leering, drunken woman, an owl perched incongruously on her shoulder, reveals his early interest in using works from public collections as formal exercises through which to discover the underlying structures of famous paintings, including works by Cézanne that were available to him in public collections in and around New York in the mid- to late 1920s.

19. Despite his teaching experience at the New School of Design, Gorky felt that he had more to learn as an artist. On January 9, 1925, he enrolled in a life-drawing class taught by Charles Hawthorne at the National Academy of Design. Although he quit after the first session—presumably because he was so adept at working from the model that there was little else for him to learn—Hawthorne would play an important role in his development. In the mid-1920s, Hawthorne participated in the Grand Central Art Galleries exhibitions, which were organized under the aegis of the Grand Central School of Art, and it was almost certainly Hawthorne who suggested to Gorky that he should study there. See Gorky's curriculum vitae, which he sent to the Museum of Modern Art in August 1945; Arshile Gorky file, Archives of the Department of Painting and Sculpture, The Museum of Modern Art, New York.

20. Grand Central School of Art, New Yor, *Annual Report, 1926–1927*, p. 19; Archives, Arshile Gorky Foundation.

21. Gorky clearly based his claims to have studied at the Académie Julian on the real-life experiences of his former teacher and mentor in Boston, Douglas John Connah, who had studied with Jean-Paul Laurens, the father of Paul Albert Laurens (listed as Albert Paul Laurens in Gorky's dubious educational record in the Grand Central School of Art's *Annual Report*), at the small liberal arts school on the left bank of the Seine, which had been a haven for American Impressionist painters since the 1880s. Jean-Paul Laurens, a narrative academic painter whose works were prominently displayed in the Pantheon in Paris, insisted on detailed drawing as the underpinning of all great painting, a

lesson that was clearly passed on to Gorky through Connah. See Catherine Fehrer, "New Light on the Académie Julian and Its Founder (Rodolphe Julian)," *Gazette des Beaux-Arts* 103 (May–June 1984), pp. 207–16.

22. See Clare Vincent, "Rodin at the Metropolitan Museum of Art: A History of the Collection," *Metropolitan Museum of Art Bulletin* 38, no. 4 (Spring 1981), p. 7.

23. This sculpture was said to have been found in the Tiber River and was imported to the United States around 1900 by the financier Charles T. Barney. While in Barney's possession, it was damaged in a fire, hence its discoloration. Beginning in 1921 it was on loan to the Metropolitan Museum of Art, which acquired it in 1932. See Gisela M. A. Richter, *Metropolitan Museum of Art, New York, Catalogue of Greek Sculptures* (Oxford: Clarendon, 1954), p. 58.

24. Although Cézanne's painting *Still Life with Plaster Cupid* was widely reproduced at the time, Gorky's water-color feels closer in spirit and execution to a sketch of the plaster cupid, surrounded by a halo of dark color, in which the small, armless figure appears to lurch forward. This work was reproduced in his cherished copy of Julius Meier-Graefe's *Cézanne und sein Kreis* (Munich: R. Piper, 1922), p. 206.

25. See Schwabacher, *Arshile Gorky*, p. 33.

26. Gorky, quoted in "Fetish of Antique Stifles Art Here Says Gorky Kin," *New York Evening Post*, September 15, 1926. This newspaper article identified the artist as the cousin of the Russian writer Maxim Gorky (whose real name was Alexei Maksimovich Peshkov). For an excellent discussion of the multiple implications of Arshile Gorky's pseudonym, see Kim S. Theriault, "Arshile Gorky's Self-Fashioning: The Name, Naming, and Other Epithets," *Journal of the Society for Armenian Studies* 15 (2006), pp. 141–56.

27. Julien Levy, *Memoir of an Art Gallery* (New York: G. P. Putnam's Sons, 1977), p. 283.

28. According to Weyhe, Gorky was so desperate to acquire an expensive art book that he asked the book-seller and art dealer to sell one of his paintings, which Weyhe did for around $750. Gorky was so pleased with the amount that he gave Weyhe a painting as a gift and began selling his work through the gallery. See Karlen Mooradian, *The Many Worlds of Arshile Gorky* (Chicago: Gilgamesh, 1980), p. 216.

29. Gorky's library contained the following books on Cézanne: Julius Meier-Graefe, *Cézanne und sein Kreis*; Roger Fry, *Cézanne: A Study of His Development* (London: Hogarth, 1927); Fritz Novotny, *Cézanne* (New York:

Oxford University Press, 1937); Raymond Cogniat, *Cézanne* (New York: French Library of Fine Arts, French and European Publications, 1939); and Lionello Venturi, *Paul Cézanne Watercolours* (Oxford: Bruno Cassirer, 1944). Gorky also owned numerous reproductions of Cézanne's work, including a portfolio of fifteen high-quality facsimiles that were published in Munich in 1912 by R. Piper and Company as *Paul Cézanne: Mappe*. Many of these facsimiles have Gorky's own drawings on the verso, confirming his excitement at seeing for the first time such works as *Madame Cézanne in a Red Armchair* and the final version of *The Large Bathers*. He also owned a color reproduction, from an as yet unidentified Russian magazine, of Cézanne's *The Smoker* of about 1891. I am grateful to Agnes "Mougouch" Gorky Fielding, Matthew Spender, Maro Gorky, and Natasha Gorky for sharing this information on Gorky's library with me.

30. In February 1928, Weyhe paid for Meier-Graefe to visit New York and other American cities to promote the English translation of his monograph on Cézanne. For more on the German art historian's month-long trip to the United States, see Carl Zigrosser, *A World of Art and Museums* (Philadelphia: Art Alliance Press, 1975), p. 46. Gorky may have attended some of the many dinners and events that Weyhe organized for Meier-Graefe during this publicity tour.

31. "When I went there in 1927, Gorky was already speaking about Cézanne, so we looked at the book by Meier-Graeffe [*sic*], the German critic who wrote on Cézanne"; Arthur Revington, quoted in Matossian, *Black Angel*, p. 151. Sirun Mussikian, a model at the Grand Central School of Art, also remembered that Gorky "talked a lot about cubes and cones and cylinders," a recollection that confirms his passion for Cézanne's work and compositional techniques; ibid., p. 172. In a letter to Émile Bernard on April 15, 1904, Cézanne commented that "natural forms all tend to the sphere, the cone and the cylinder"; see Fry, *Cézanne: A Study of His Development*, p. 52.

32. Schwabacher, *Arshile Gorky*, p. 66. Gorky's remark may have been prompted by Matisse's famous statement that "Cézanne is the father of us all"; see Alfred H. Barr, Jr., *Matisse: His Art and His Public* (New York: The Museum of Modern Art, 1951), p. 87.

33. According to Stergis M. Stergis, a Greek artist whom Gorky befriended at the Grand Central School of Art, Gorky wanted to marry Nancy, but her father, a retired captain of an ocean liner, put a stop to the relationship after taking note of Gorky's poverty. See Matossian, *Black Angel*, p. 162.

34. See Michael R. Taylor, "Learning from 'Papa Cézanne': Arshile Gorky and the (Self-)Invention of the Modern Artist," in *Cézanne and Beyond*, ed. Joseph J. Rishel and Katherine Sachs, exh. cat. (Philadelphia: Philadelphia Museum of Art in association with Yale University Press, 2009), pp. 407–24.

35. Elaine de Kooning, "Gorky: Painter of His Own Legend," *ARTnews* 49, no. 9 (January 1951), pp. 63–64. His fellow painter Václav Vytlačil recalled that Gorky liked to paint his Cézanne-inspired landscapes near the pond in Central Park, across from the Plaza Hotel. See Diane Waldman, "Arshile Gorky: Poet in Paint," in *Arshile Gorky, 1904–1948: A Retrospective*, exh. cat. (New York: Harry N. Abrams in collaboration with the Solomon R. Guggenheim Museum, 1981), p. 21. A photograph taken in the late 1920s of Gorky hunched over a painting on an easel in front of one of the tunnels that run through Central Park confirms his presence there; see ibid., p. 18.

36. See Elaine de Kooning, "Gorky: Painter of His Own Legend," p. 40.

37. Fry, *Cézanne: A Study of His Development*; Julius Meier-Graefe, *Cézanne*, trans. J. Holroyd-Reece (London: E. Benn, 1927).

38. Maud Dale, preface to *Loan Exhibition of Paintings by Paul Cézanne, 1839–1906* (New York: Wildenstein Galleries, 1928), n.p.

39. C. J. Bulliet, *Apples to Madonnas: Emotional Expression in Art* (Chicago: Pascal Covici, 1927), p. 43.

40. Dale, preface to *Loan Exhibition of Paintings by Paul Cézanne*, n.p.

41. Jim M. Jordan dated the work to 1927, thinking that Gorky may have seen the reproduction of Cézanne's portrait of *Louis Guillaume* in Christian Zervos's article "Idéalisme et naturalisme dans la peinture moderne, II.—Cézanne, Gauguin, Van Gogh," *Cahiers d'art* 2 (1927), p. 334. See Jordan and Goldwater, *The Paintings of Arshile Gorky*, p. 22. Cézanne's painting was also reproduced as "Knabenbildnis / 1879" in Meier-Graefe's *Cézanne und sein Kreis*, p. 136. However, Gorky's painting suggests a familiarity with the original work's palette and finish, which would have been impossible to discern in black-and-white reproductions. I have thus dated Gorky's painting to 1928, based on the inclusion of the Cézanne portrait in the Wildenstein exhibition that year.

42. Hayden Herrera, "Gorky's Self-Portraits: The Artist by Himself," *Art in America* 64, no. 2 (March–April 1976), pp. 58–59.

43. See Frances Spalding, *Roger Fry: Art and Life* (London: Granada, 1980), p. 256.

44. Willem de Kooning recalled that Gorky disdained originality in painting during the earliest years of their friendship: "Gorky used to say, 'very original' about some of my work but the way he said it didn't sound so good, you understand what I mean. Because you have a lot of original art which is not very good art. There's a difference between being original and being a great artist, or being original and breaking the rules." See Mooradian, "Interview with Willem de Kooning," p. 50.

45. Melvin P. Lader, "Graham, Gorky, de Kooning, and the 'Ingres Revival' in America," *Arts Magazine* 52, no. 7 (March 1978), pp. 94–99.

46. See Mark Stevens and Annalyn Swan, *De Kooning: An American Master* (New York: Alfred A. Knopf, 2004), p. 118.

47. Spender, *From a High Place*, p. 299. According to Spender, Gorky gave art lessons to "Master Bill" in exchange for having his studio painted.

48. By 1921, Davis was the sole owner of La France Industries, which had a well-equipped factory, weaving both tapestries and pile fabrics with 150 Jacquard power looms. By the end of that decade La France Industries had an annual business of some $10 million, and it had doubled that volume by the early 1930s, when the company was underwritten by a syndicate of bankers. See Herman Blum, "The Arresting Mr. Davis," in Blum, *One Star Final: Marginal Notes of a Cub Reporter at the Turn of the Century and Later When He Became a Manufacturer and Political Pundit; Interviews with the Great and Near Great That Did Not Make the Front Pages of the Newspapers* (Philadelphia: Blumhaven Library and Gallery, 1953), p. 197.

49. "Gobelin Tapestries Reproduced," *Textile World*, February 3, 1923, p. 359. According to this article, "In furthering the revival of tapestry weaving as an art, and also to assist in the development of a school of distinctively American design, the company has established what is known as the La France Art Institute. Here free tuition is offered to those who desire to participate in the work the company has undertaken, and those who possess latent talent have an opportunity to develop it along proper lines of artistic expression."

50. Bernard Davis to Ionel Jianou, December 14, 1963; Archives, Musée Zadkine, Paris.

51. See Herrera, *Arshile Gorky: His Life and Work*, p. 230.

52. Author's telephone conversation with Robert Nobel, September 14, 2005.

53. Davis's collection was sold in three parts, at separate auctions held at Samuel T. Freeman & Co. in Philadelphia in 1937: "Valuable Modern Paintings by Famous Artists of the French Contemporary School," March 31–April 1, 1937; "Part II: Modern Art, Sculpture, African and Chinese Art, Furniture, Tapestries, Icons, Stained Glass, Pewter, of the Collection Exhibited by La France Art Institute," April 12–13, 1937; "Part III: Original Drawings, Watercolors, Prints, of the Collection Exhibited by La France Art Institute," April 22, 1937.

54. In 1948, Davis opened the National Philatelic Museum at his alma mater, Temple University, to house his collection of rare stamps in a former bank building at Broad and Diamond Streets, Philadelphia. Although no longer his sole passion, Davis remained interested in modern art, and in 1957 he established the short-lived Avant-Garde Art Gallery at 164 Lexington Avenue, New York, which showed up-and-coming young artists, including Thomas Chimes, Jessie Drew-Bear, and William Scharf, as well as early paintings by Gorky and other modern painters whose work he had collected in the 1920s and 1930s. In 1959, Davis retired to Miami, Florida, with his new girlfriend, Creeland Rowland, whom he would marry on her deathbed in 1963. There, he established the Miami Museum of Modern Art in a crumbling, three-story house on North Bayshore Drive, overlooking Biscayne Bay, for which he served as president and curator, as well as picture hanger, bookkeeper, tour guide, and jack-of-all-trades. Davis lived at the museum, which comprised what was left of his collection of modern art, including paintings by Gorky, Leon Kelly, and John Graham, and sculpture by Ossip Zadkine, while also showcasing the work of such younger artists as Elenora Chambers, Dorothy Gillespie, and Purvis Young. In the mid-1960s, Davis reunited with Irmgard Erik, who had since married the Philadelphia radio star Phil Baker. After Baker died in 1963, Irmgard moved to Miami and became associate director of the Miami Museum of Modern Art. The couple married shortly before Davis's death in 1973.

55. For more on the Gallatin collection, which was donated to the Philadelphia Museum of Art in 1952, see Anne d'Harnoncourt, "A. E. Gallatin and the Arensbergs: Pioneer Collectors of Twentieth-Century Art," *Apollo* n.s. 99, no. 149 (July 1974), pp. 52–56; and Gail Stavitsky, "The A. E. Gallatin Collection: An Early Adventure in Modern Art," *Philadelphia Museum of Art Bulletin* 89, nos. 379–80 (Winter–Spring 1994).

56. The artist Saul Schary remembered meeting Gorky in 1927 and visiting his studio, "which fronted on Washington Square South. And you had to sort of go around the side to get to his studio entrance." See Mooradian, *The Many Worlds of Arshile Gorky*, p. 203.

57. James Thrall Soby to Anne d'Harnoncourt, January 26, 1968, object file for Giorgio de Chirico's *The Fatal Temple*, Department of Modern and Contemporary Art, Philadelphia Museum of Art.

58. Pepe Karmel, "Arshile Gorky: Anatomical Blackboard," *Master Drawings* 40, no. 1 (Spring 2002), p. 10. Picasso's *Milliner's Workshop* is in the collection of the Musée nationale d'art moderne, and *Artist and Model* is in the Musée Picasso, Paris.

59. Ibid.

60. According to the *Philadelphia Inquirer* this lecture was scheduled to take place at 4.30 PM on February 5, 1934; C. H. Bonte, "In Gallery and Studio," *Philadelphia Inquirer*, February 4, 1934.

61. Ibid.

62. C. H. Bonte, "In Gallery and Studio," *Philadelphia Inquirer*, February 11, 1934.

63. Ibid.

64. Holger Cahill's statement in the catalogue for Gorky's exhibition at the Mellon Galleries, February 2–15, 1934; Library, The Museum of Modern Art, New York.

65. "Exhibition Talks Planned by Boyer," *Philadelphia Record*, October 13, 1935, sec. 4.

66. Ibid. For the original statement by Kiesler (translated by Heinz Norden), see the catalogue for Gorky's exhibition at the Mellon Galleries, February 2–15, 1934; Library, The Museum of Modern Art, New York.

67. A copy of this contract is included in the Guild Art Gallery records, [ca. 1935–39], Archives of American Art, Smithsonian Institution, Washington, D.C.

68. Walinska and Le Franc reported Léger's comments in a letter to Alfred H. Barr, Jr., the director of the Museum of Modern Art, dated November 20, 1935; ibid.

69. Emily Genauer, "Exhibitions in Galleries are Widely Dissimilar," *New York Post*, December 21, 1935.

70. Matossian, Appendix, *Black Angel*, pp. 496–98.

Exile, Trauma, and Arshile Gorky's
The Artist and His Mother

The Armenian immigrant we know as Arshile Gorky decided to become an artist, whereas most newcomers did menial jobs, worked in factories, or ran small businesses. His unusual decision eventually led him to New York City, where he made fundamental contributions to American modernism through his adaptations of works by other artists and his abstractions inspired by combinations of forms that he observed around him in his new world and remembered from his past. Gorky's predicament as an immigrant and the trajectory of his development as an artist were quintessentially modern and indicative of an American experience that critics such as Harold Rosenberg and Clement Greenberg would codify in the 1950s.[1] Gorky exemplified the interdependence of art and life, the artist's existential struggle, and the necessity of previous art-historical themes and styles to the progress of modernist art.

Gorky's status as a displaced person and his transfigurative approach to art can readily be traced through his frequent repetition of the theme of the artist and his mother. The Whitney Museum of American Art's painting of the subject (plate 32), which Gorky owned throughout his life, and its sister version in the National Gallery of Art in Washington, D.C. (plate 33), are perhaps most telling of his working methods and style, but numerous studies and related drawings are also informative of his approach to the subject.

The compositions are based on a photograph taken in 1912 in the city of Van in what is now eastern Turkey (Turkish Armenia) before the culmination of the Armenian Genocide in 1915 (figs. 18, 19).[2] At that time Armenians, who had inhabited the region for centuries, were largely literate, educating their children in their own schools or at schools run by Christian missionaries. Many Armenians embraced progress, trade, and other cultures, particularly those of France and Russia, and flourished from the exchange. Along with upper-class Turkish citizens who had traveled to Europe or were educated there, they became interested in technology and in the arts, which were an integral part of European life at the end of the nineteenth century.

At the same time, the Turkish or Ottoman Empire, then in its waning days—it was known as "the sick man of Europe"—became suspicious of the Christian West and North. The Turkish government became preoccupied with the Armenians, a non-Muslim people in

their midst, killing some 200,000 from 1894 to 1896, one of whom was Gorky's mother's first husband. Armenians became constant targets for reasons that were largely social and economic in nature.[3] Raids, including one on Van in 1908 during which one of Gorky's half-sisters, his mother's eldest child, was killed, were common. Horrific survivor accounts testify to individuals being flayed, disemboweled, torn apart, crucified, raped, and burned alive.[4] The escalating religious, political, and ethnic intolerance amid growing pan-Turkism led to the execution of at least 20,000 Armenians in 1909 alone, the majority of whom were male community and church leaders. Although prohibited from owning guns, and with no legal rights as Christians in a Muslim country, Armenian resistance groups formed and fought back.

The formally posed mother and son in the photograph, dressed in their finest clothing—he in a Chesterfield coat and she in a flowered silken pinafore[5]—perhaps appear out of place against the tragedies then befalling the Armenians with increasing frequency. The photograph shows the archetypal mother, here looking stiff and uncomfortable, and the dutiful son who, thrust into an unfamiliar setting, squirms a bit, shifting the weight of his right foot slightly behind him as if prepared to make his exit. The artificiality of their positioning in front of the photographer's backdrop of a mantel painted onto cloth underscores the contrived nature of the scene. Young Gorky, known then by his birth name, Vosdanig Manoog Adoian, holds a bouquet, a characteristic indicator of a poetic disposition, while his mother, Shushan, sits rigidly frontal, looking directly at the camera. Her wistfully sad gaze, as she peers out of her head shawl, betrays her hardships.

By the time of the photograph, it had been four years since Gorky's father, Setrag Adoian, had left his family, land, and home village of Khorkom, located on the shores of Lake Van, to join his first son, Hagop, Gorky's older half-brother, in the United States. Both had left by 1908 to avoid a Turkish military draft of Armenian men that likely would have resulted in their enslavement on brigades that worked conscripted soldiers to death. Gorky's mother had the photograph taken specifically to send to Setrag, perhaps to remind him of his younger son and his obligation to protect the family he had left behind. In his long absence, Shushan suffered abuse from Setrag's family, particularly from

FIG. 18
Gorky and his mother, Van city, Turkish
Armenia, 1912 (detail of fig. 19)

his younger brother and his wife, prompting her to leave the family home in 1910 with her children. The young Gorky, his half-sister Akabi (called Ahko), his older sister, Satenig, and his younger sister, Vartoosh, accompanied their mother to Van, a fairly large regional city not far away.[6]

As Setrag's son and Shushan's only son in a patrilineal society, Gorky may have been able to lay claim to the family farm in Khorkom, which included a house and orchards, in his father's and older half-brother's absence. In reality, however, the chances were more likely that the land would have been seized by Turks, and indeed, after the ultranational Young Turk government took over in 1913, the Armenians living in Khorkom,[7] along with those in the rest of Turkey, were forcibly removed. What were referred to as "resettlements" were in fact sanctioned killings of the indigenous Armenian population in Turkey and a continuation and expansion of the government-organized ethnic cleansing of the past two decades. In 1915 an official, methodical slaughter ensued.[8] The Turks, with the help of Kurds who had begun inhabiting the region during times of political unrest, waged what can only be called genocide. Armenians were subjected to human-rights violations that included executions of entire towns, starvation, torture, willful attacks by marauders, "biological absorption,"[9] and the brutalization, rape, and enslavement of women and children.

Gorky's immediate family survived the attacks on Van in 1915 but were forced out on a "death march" along with other Armenians toward the Russia-protected area to the east, outside of Turkey in the area in and surrounding the city of Erevan (present-day Yerevan), Armenia (figs. 20, 21). Members of the family found work, with Gorky doing carpentry in an American-run orphanage, and the children occasionally were able to attend school. In 1916 Gorky's two older sisters, Akabi and Satenig, were able to flee to the United States with the help of Akabi's new husband and what little money Gorky's father had sent from America. During the next few years, Gorky, his mother, and Vartoosh, like other refugees, struggled to survive. Turkey was blockading food supplies sent by the West that were meant as humanitarian aid for the Armenians, and in 1919 Gorky's mother starved to death, one of approximately a quarter of a million casualties. Family lore states that she died while dictating a letter to her husband claiming that she could never leave her homeland.[10]

FIG. 19
Gorky and his mother, Van city, Turkish Armenia, 1912. Courtesy of Dr. Bruce Berberian

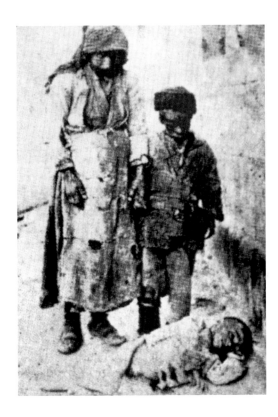

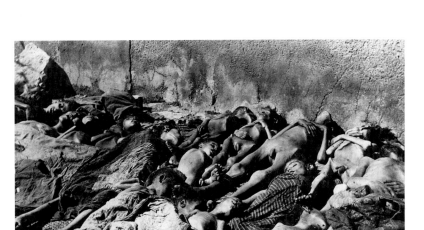

FIG. 20
An Armenian woman and child mourning
a young boy during the deportation of
Armenians by the Turks, second half of
the 1910s. Courtesy of AFP/Getty Images

FIG. 21
The bodies of Armenian children massacred
in Turkey during World War I, c. 1915. Hulton
Archive. Photograph by Armin T. Wegner.
Courtesy of Getty Images

Taken away with the many others who had died of starvation and disease, Shushan was buried in a mass grave. The children spent some time with family friends in Tiflis (present-day Tbilisi) and, with their help and money received from their family in the States, were able to book passage on the S.S. *Presidente Wilson*. They arrived in the United States in March 1920 and were reunited with their sisters, who took them to their home near Boston in Watertown, Massachusetts, a factory town with a large population of Armenian immigrants. Gorky lived briefly with his father on his half-brother's farm in Providence, Rhode Island, but he soon became estranged for reasons that remain unclear but were very likely related to his anger over his mother's death and his father's long absence. He must have wondered why it had taken Setrag so long to retrieve them, and whether his brother had played a role in delaying the sending of sufficient funds. It is also possible that the two elder Adoian men, who both had factory jobs, disapproved of Gorky's resistance to their lifestyle and his interest in art, his constant picture-drawing, something he had been doing since childhood.

But if Gorky partially blamed his father for his mother's death, his own inability to save her, as the de facto man of the family despite his youth, must have haunted him as well, as he pondered what Shushan would have thought of his new life in America. Some biographical accounts suggest that she had not only supported his interest in the arts

but encouraged it. Her memory may thus have countered the opposition he seemed to face in his chosen vocation. Almost immediately upon his arrival in the United States, Gorky had begun to establish a career as an artist by using the paintings and other works of art he saw in museums and in books as subjects for his own drawings and paintings. Art historians have long traced his sources, often mistaking what he was doing for copying, while acknowledging that he enlisted the styles of other artists or used reproductions of their work as models for his own. His impressionistic *Park Street Church* (1924; plate 1) was painted *en plein air* following the Impressionists' example; *Staten Island* (1927; plate 2) absorbed elements of Paul Cézanne, particularly the houses in his paintings of Mont Sainte-Victoire; and *Still Life (Composition with Vegetables)* was based on the Synthetic Cubist works of Pablo Picasso (c. 1928; plate 14). In the spirit of an immigrant learning a new language in a new country, Gorky amassed a visual vocabulary that could be incorporated into his own compositions. Indeed, he was largely self-taught, and he was successful enough at it that by 1924 he was an instructor at Boston's New School of Design and was able to teach at the sister school in New York after moving there in 1925 to pursue his art.

In two early studies he made after antique sculptures—a time-honored academic tradition—we see that already his approach to the objects was one of revision rather than merely replication. In a 1920s

charcoal and watercolor sketch of a sculpture in the Metropolitan Museum of Art (plate 4), he elongated the torso and set off aspects of the anatomy with pure line rather than through modeling. Line also plays an important role in *The Antique Cast* (1926; plate 3), a painting in which the composition toys with traditional proportions and concepts of pictorial space in the modernist mode, and the added texture and reds and pinks give the polished classical form an aspect of decay.

In addressing the theme of the artist and his mother, Gorky also worked out new arrangements from the source, using the photograph as a visual cue for his multiple engagements with the subject (plates 26–33). The implications of the theme in relation to his personal story are expansive. His rediscovery of the photograph of himself with his mother, some years after his arrival in the States and more than a decade after it had been sent to his father, must have excavated deeply buried feelings and led to reflections about the traumatic circumstances of that time and the events that caused his mother's death. Gorky's biographers seem to agree that he found the picture at Akabi's home in Watertown in 1926, during a visit there from New York.[11] He apparently asked to borrow the photograph, promising to give it back when he was done with it, but he never did. Instead, he kept it in his studio and drew and painted compositions based on it throughout his life.

Gorky fashioned and refashioned the photographic image on paper and canvas many times, in the same way that he refashioned the works of other artists, and his identity. He became his own artistic creation, adopting a pseudonym that provided him with an artistic lineage before moving to New York City, living in a studio there surrounded by paint and canvases, and giving contradictory and contrived information about his background and art training. He conjured an artistic pedigree that included training in Paris with Vasily Kandinsky—a place he had never been and an artist he had never met. Stephen Greenblatt, in his book *Renaissance Self-Fashioning*, notes that from as early as the sixteenth century, literary figures identified "the fashioning of human identity as a manipulable, artful process."[12] The practice of self-fashioning is a historic one among artists, who have not uncommonly created their own mythologies by inventing stories about their training, proficiency in art, professional associations, and experience.[13]

Choosing another artist's surname, that of Maxim Gorky, itself a pseudonym,[14] underscored Gorky's act of self-creation.[15] By this appropriation he escaped identification as a victim and some level of discrimination,[16] and he gave himself an opportunity to start again with a new identity, a fresh persona. His renaming was a self-fashioning of the type Greenblatt has explored—a creative act that was, arguably, a rehumanization in the aftermath of genocide and a reassertion of the self following displacement in a new world.[17] Gorky's renaming may also represent one of the initial steps in rebuilding a life in the wake of trauma.

Gorky's fierce desire to become an artist and his constant engagement with art and acts of art making, coupled with his background, reveals social, cultural, and historical elements of modernism. "In choosing his vocation," Harold Rosenberg has explained, "the immigrant chooses whom he shall become."[18] Having been subjected to the twentieth century's first incident of ethnic cleansing, Gorky may have wished to evade his traumatic past and counter the destruction he had witnessed through acts of creation. Being an artist had the additional virtue of separating him from other Armenian immigrants, including his father and half-brother, who were for the most part laborers who took refuge in their own community. And perhaps his vocation also addressed the condition of genocide itself. Cathy Caruth has written about the aftermath of trauma, pointing out that such episodes are not simply events but rather structures of experience.[19] Immersing oneself completely in any new experience, such as art, is an alternative to re-experiencing the trauma of a past life and its associated identities; it is a form of restructuring. Immigrants in particular, whether or not their experiences have been tragic, make specific decisions to balance their practical survival with their cultural, creatively adapting to their new and often different lives. Gorky's art lent itself to an emergent restructuring experience because it was itself the product of restructuring, such as when he rearranged components of another artist's composition or reinterpreted nature or the man-made environment (previously judged to be "all wrong") in his own work.[20] If, like Gorky, one exchanged previous experiences for new ones structured creatively, in his case in the pursuit of art, perhaps trauma could be overcome, or at least averted for a time.

In approaching the theme of the artist and his mother, one of his most poignant engagements with his past, Gorky began by sketching his mother's face and conceptualizing a painted composition.[21] Prompted by the photograph, and possibly by emerging memories as well, he drew Shushan often in quick notations that dispensed with detail and shading.[22] In a drawing in the National Gallery of Art (fig. 22), he used a thick line and repeated overdrawing to flesh out her features. Her eyes here are slightly uneven, and although this could be interpreted as the mistaken result of rapid rendering, Gorky placed his mother's eyes similarly in each subsequent composition as an intentional expressive device that intensified her gaze. In a drawing of his mother's face in the Whitney (plate 27), the eyes are shaped in a way that echoes the curve of the head shawl, whose own shape is emphasized by its duplicated outline, giving the drawing added depth. Gorky appears to have considered carefully where to place the scarf and how to render the thickness and number of its folds, since in the photograph the stiff cowl projects in a way that is unclear. Like a true modernist, Gorky took only what was essential, simplifying the composition by removing the confusing neckline but maintaining the head shawl as a frame for his mother's face. In an unpublished ink drawing of the same subject he almost for-

goes the headscarf, which is only schematically rendered, focusing instead on Shushan's heavily hatched facial features (fig. 23).

In his many drawings on the subject of the artist and his mother, Gorky remade the photograph almost as he remade his life. The compositions express a smooth transition from past to present, photograph to work of art, image of the old world to product of the new. His refashioning of the image paralleled his own self-fashioning, which addressed his displacement while also being entirely modern.

Gorky's aesthetically negotiated survival strategy was subject to constant translation and revision. There are many possible responses to trauma, including acting out and working through.[23] Like most Armenians at the time, Gorky rarely mentioned his ordeal.[24] He gave different versions of his mother's death or avoided conversations about her altogether, which for those unfamiliar with his tragedy could be interpreted unfavorably.[25] When not vague, Gorky could be intentionally misleading about his parents, claiming that his father was dead when he was living in nearby Providence, Rhode Island, and that his mother had died of a dog bite (one of the explanations he gave his second wife).[26] But Gorky could not completely refashion himself or totally obscure his past. Within his methodical approach to visual language

and his appropriation of an artistic genealogy there are nuances of his past, and works such as *The Artist and His Mother* imply that the trauma he experienced was ever present in his life, while not explicitly betraying his particular tragedy.

In choosing his mother as a subject for his art, Gorky reconnected with her on a basic level. She became part of an artistic problem to be solved, bringing her back into his life on a day-to-day basis. His way of working through his memories can be understood in the context of his cultural heritage—of his past in a mostly preindustrial storytelling culture in which listeners were left to envision events as they were related, and in which, like most cultures with a medieval Christian tradition, a portrait acted as a symbolic presence. The art historian Hans Belting has explained that "in the medieval context the image was the representative symbol of something that could be experienced only indirectly in the present."[27] Restorying loss in the manner that he did, by creating a new framework for his experiences within the perimeters of his canvases, Gorky was able to retain his links to the past while outwardly refashioning himself. The postcolonial theorist Homi Bhabha has defined such an "in-between" state as a binary existence, in which "private and public, past and present, the psyche and the social develop an interstitial intimacy. It is an intimacy that questions binary divisions through which such spheres of social experience are often spatially opposed. These spheres of life are linked through an 'in-between' temporality."[28]

As an immigrant, Gorky was subject to a "social spatiality,"[29] that is, he existed within a social hierarchy that assigned him a tangential position.[30] Bhabha explains that an individual in such interstitial spatiality represents "a hybridity, a difference 'within', a subject that inhabits the rim of an 'in-between' reality. And the inscription of this borderline existence inhabits a stillness of time and a strangeness of framing that creates the discursive 'image.'"[31] Gorky was, in fact, as an outsider in a new place, always somewhat in-between—public and private, past and present, psyche and social—and reluctant to pin himself down, never stating, for example, where he was actually from. Having experienced a dramatic rupture from his previous life, identity, and homeland, art and the state of being an artist offered him a means to reconfigure his world from the vantage point of his in-between state.

The discursiveness of this in-between state played out in Gorky's handling of the photograph. Although his connection to this image was intensely personal, he was able to view it as a formal arrangement to be dissected. For Gorky, adhering to modernist principles, the photograph was at once an intimate artifact and a collection of forms that could be replicated, adapted, or removed. With a Baudelairean concern for the internal, private world and a modernist sensitivity to the picture plane, he seemed to embrace the artist Maurice Denis's warning that "it is well to remember that a picture—before being a battle horse, a nude woman, or some anecdote—is essentially a plane surface covered with colors assembled in a certain order."[32] Cognizant of the modernist repertoire through his artistic explorations, Gorky used the photograph as a building block for an exciting and powerful project.

In the drawings of himself as a boy that he based on the photograph, and that he likely used as studies for *The Artist and His Mother* paintings, he took liberties with space and began to work out compositions that reflected a new interpretation of the past through alterations of form. In an undated drawing (plate 26), he rendered himself as the boy in the photograph fairly accurately, including hints of the buttons on the coat, but he omitted parts of the left arm, hand, and foot and erased the top of the left shoulder, thereby dematerializing the space—and part of the boy's body—adjacent to the mother in the photograph. The ghost image of the erasure creates an impression of dissipating form and perhaps, roundaboutly, conveys a fleeting past and separation from his mother. The boy is softly sketched, with only certain outlines defined, such as the right foot, part of the uneven left collar (emphasizing his discomfort), and the vertical coat fastening. In a previously unpublished double-image sketchbook drawing of the boy (fig. 24), Gorky changed the positioning of the figures. The left figure's face is tilted and blank, and his contrapposto stance directs attention toward the absent seated mother. The right image turns the boy in blocky profile, dropping his left shoulder in a manner that communicates sorrow.[33]

A similar sorrow can be found in most of Gorky's self-portraits. In his *Self-Portrait at the Age of Nine* (1928; plate 5), perhaps a study for *The Artist and His Mother* compositions, he painted himself at around

FIG. 24
Arshile Gorky, *Untitled (Study for "The Artist and His Mother")*, undated. Pencil on paper, 10 x 8 inches (25.4 x 20.3 cm). Private collection

47

THE ARTIST AND HIS MOTHER

the same age he was in the photograph. Here he focused on the face, with its somewhat dazed expression, revealing melancholy mainly through the tilt of the head. A greater guardedness can be seen in his self-portrait as an adult (1928; plate 6), in which he rendered himself actually turning away from the frontal plane of the picture, as if protecting himself from the viewer's gaze. Despite a certain bravado the artist maintained in his social interactions, his self-portraits evidence an uneasiness.

Gorky was an exile, a particular kind of immigrant affected by transculturation and the impossibility of returning to the homeland. His life and his connection to his past had been decisively fractured both by his displacement to the United States and by his estrangement from the Armenian community through his decision to pursue art. The Armenian immigrant attitude—indeed, the mantra that had infiltrated culture in the United States in general—was to keep one's nose to the grindstone, as the adage goes, and concentrate on one's job and doing good work.[34] Success would mark one's survival and triumph over unfavorable odds. Although this referred mainly to the realms of business and industry, Gorky applied the same dedication and powerful drive to his art making.

Ironically, before their arrival in the United States, many immigrants, but especially Armenians, had led agrarian or simple trade-based lives steeped in folklore, connection to nature, and interest in the arts. Gorky is known to have participated in woodcarving and the decorating of Easter eggs in Turkish Armenia, and he was likely exposed to church decorations and illuminated manuscripts (figs. 25, 26)—all important parts of Armenian cultural traditions—before he came to the United States. His decision to pursue art was in many ways more authentic to his heritage and past experiences than it was to the circumstances of his life in America.[35] However, his choice was also consistent with the times in his new country, where immigrants and first-generation Americans were a driving force behind American modernism.[36]

Gorky engaged with his new world largely through the medium of art. Besides teaching at the New School of Design, he gave private lessons and avidly explored the art museums and galleries in New York. He had discovered the portraits of John Singer Sargent and studied

FIG. 25
The Church of the Holy Cross (Surb Khach), 10th century
(915–21), Aghtamar Island, Lake Van, eastern Turkey
(historic western Armenia). Reproduced from H. F. B.
Lynch, *Armenia: Travels and Studies*, vol. 2, *The Turkish
Provinces* (London: Longmans, Green, and Co., 1901),
fig. 141. Courtesy of the National Association for Armenian
Studies and Research, Inc., Belmont, Massachusetts

Frans Hals at the Museum of Fine Arts in Boston. In New York, he sought out the paintings of Jean-Auguste-Dominique Ingres and analyzed the works of Nicolas Poussin in the Metropolitan Museum of Art, also devouring compositions by Paul Cézanne, Henri Matisse, Fernand Léger, and Picasso in modern art galleries. Earning respect for his broad knowledge of art and his exceptional abilities, Gorky became part of a burgeoning artistic community that included such friends as the painters John Graham, Stuart Davis, and Willem de Kooning, the photographer Wyatt Davis, and the sculptor Isamu Noguchi.

In his paintings Gorky adapted the world to fit his changing artistic vision as much as his shifting memories. In *Two Studies for "The Artist and His Mother"* (plate 28), he adjusted the positions of the figures' heads for expressive purposes, reconsidered the figures' placement by dislocating the boy slightly behind the mother, changed the background, and moved the group back from the picture plane.[37] After completing one large drawing of the theme (plate 29), he squared the paper, measuring out a grid of one-inch squares to calculate the composition's transfer to canvas, a fairly common method used by artists throughout history. His mathematical notations are visible on the right side and top edge of this drawing. Although dated "9/18/34" at the bottom center, the drawing is believed to date from 1926, after Gorky had already begun at least one of the paintings. A rust-colored paint splotch on the mother's arm might indicate that the drawing was present during the painting process and thus support its commonly assumed link to the National Gallery painting.

Just as Gorky adjusted photographic details for compositional effect in his drawings, so he also made slight shifts from drawing to painting. For instance, he removed the boy's cuffs, visible in the graphed drawing, and obscured the boy's right fingers in both paintings (plates 32, 33). In the drawing, the mantletop in the background forms a straight, horizontal line, but Gorky made it uneven in the paintings (a Cézannesque effect), effectively breaking up the setting. He transferred other aspects of the drawing more loyally: The erasures above the boy's right eye, to the right of the boy's leg, and on the mother's left shoulder are carried over into the Whitney version (plate 32). When he translated the image into paint, he reduced the folds of the sleeves and

FIG. 26
Manuscript page from Yervand Shahaziz's
Hin Yerevane (Old Yerevan), p. 203. Courtesy
of the Zohrab Institute, New York

removed the patterning of the dress, which is visible in both the original photograph and the graphed drawing. He tried to discover ways to activate the composition by repeating shapes and solidifying or de-emphasizing forms. In the drawing, the curl of flowers in the boy's hand is mimicked by the curl of the handkerchief in his right pocket, and again in the mother's head shawl. The mother's left arm is more complete than her right, and her hands and the front of her body below the knees have been left undefined. Such alterations are modernist conventions that elevate the artist's conception over perception.

Gorky's many sketches inspired by the photograph were generally meant to inform his paintings, but they also stand alone as works of art. A remarkable charcoal drawing of his mother (plate 30) reveals a sensitivity for and connection to his subject that belies strictly formal conventions and pays homage to his past. Gray paint splatters on the surface of this large, full-sheet representation of his mother's face, which is drawn slightly off-center and approximately the same size as the figure in the painted compositions, may indicate that it was used for one of the *Artist and His Mother* paintings.[38] Gorky's sophisticated handling of the medium and his exceptional drawing abilities are evident in this tender rendition. He changed the original drawn composition by outlining and erasing, using these devices to add dimension and produce a subtle texture, while still capturing the hint of pain in his mother's enigmatic expression.

The same Mona Lisa–like mystery inhabits a similarly sized version of the drawing, rendered in pencil (plate 31). Lighter, and seemingly less complete, this interpretation is more delicate and softer than the charcoal version, appearing romanticized, even Pre-Raphaelite in effect, in the way that distant memories can be idealized. In this drawing, Gorky's mother looks much younger and more vibrant than the woman with the direct gaze in the photograph and both of the *Artist and His Mother* paintings. It may be that the photograph sparked for Gorky a memory of his mother from a different, happier time. Roland Barthes, in his *Camera Lucida*, describes looking through a box that had belonged to his mother before her death and finding a photograph that allowed him to write about her, so that "her memory will last at least the time of my own notoriety."[39] Barthes's found photograph, like the one that Gorky found of himself and his mother, led him back to a lost time but became transhistorical through the legacy of his work.[40]

Gorky could draw from memory, easily recalling an image, but it seems that at some point he needed a visual cue, such as a photograph, illustration, scene in nature, or another artist's work, as a prompt. The philosopher Paul Ricoeur has described the process of remembering as "not only welcoming, receiving an image of the past, [but] also searching for it, 'doing' something."[41] Gorky's recovered memories might find their way into compositions or portraits that seemingly had nothing to do with his past, or that joined his past with his present, as when he worked on portraits of family members. He often embarked on paintings of his sisters, whom he saw fairly frequently. He visited Setanig and Akabi in Watertown, and Vartoosh lived with him in his New York City studio, along with her husband and child, for a while in the 1930s. He liked to have his sisters model for sketches that he would use later, or to begin paintings of them while they were together, but he did not always render them as they had appeared at the time. In *Portrait of Ahko* (plate 41), for example, believed to date from 1937 and completed in a style similar to the National Gallery's version of *The Artist and His Mother*, Gorky formulated a composition that included a headdress that might refer back to one he remembered his mother wearing at Ahko's wedding in 1910, when he was a young boy. Time, in this sense, is not necessarily linear. Gorky made representations that crossed time and combined many remembrances of his mother. In the midst of his detachment from the traumatic circumstances that led to his exile, he tried to capture the sweetness of a past and a childhood that he had experienced before the Armenian Genocide.

Gorky's process of drawing, painting, and repainting versions of his mother might suggest not so much a working through or an acting out of trauma as a repetitive immersion in memories of events that had occurred prior to the Armenian Genocide and his coming to the United States. Stories about Gorky painting the Whitney canvas over and over, and then scraping it down with a razor blade or washing it in a bathtub to achieve a smooth surface sheen, are common. He layered, removed, and shifted colors and sections numerous times (fig. 27). In one sense, he was "wiping the slate clean," starting over with every new rendition

FIG. 27
Detail of *The Artist and His Mother* (plate 32),
left edge of the canvas, during recent conser-
vation at the Whitney Museum of American
Art, New York, indicating repeated changes to
the background color of the painting.
Photograph by Matthew Skopek, 2008

Exile...is the unhealable rift forced between a human being and a native place, between the self and its true home: its essential sadness can never be surmounted. And while it is true that literature and history contain heroic, romantic, glorious, even triumphant episodes in an exile's life, these are no more than efforts meant to overcome the crippling sorrow of estrangement. The achievements of exile are permanently undermined by the loss of something left behind forever.[42]

The bifurcated condition of displacement that led Gorky to grapple with his place and purpose in the world was successfully expressed through works such as *The Artist and His Mother*. It is possible, too, that as long as he was making art, he could suspend his estrangement through an ability to "exist" in two places and times at once, to reconcile his in-between state through the medium of his pictures.

Perhaps nowhere else in Gorky's oeuvre has his intermediate condition been so eloquently expressed as in *The Artist and His Mother* paintings. There seems to be something about the figures and their relationship to which we are not made privy but that we are able to sense. Knowing Gorky's story, we might interpret the figures as confronting the absent father for whom the photograph was intended; see tragedy in the mother's face because we know how she died; and wonder if the son's distance from the mother indicates his efforts to disassociate himself from a traumatic past. Despite Gorky's attempts to hark back to a happier time prior to his mother's death, melancholy pervades the paintings. Even someone unaware of the specific details of his life, or the story of the paintings themselves, can sense sorrow and estrangement through the formal qualities of the compositions, the relationship between the figures, and their relationship to the viewer.

In the Whitney's version of the painting (plate 32), there is an inherent tension between the figures that is created by the negative space between them. The figures do not touch but are kept apart by a narrow band in the very top layer of paint, most likely added in the painting's final stages. The boy's head is slightly crooked, and his right foot points to the right edge of the picture plane; his legs are parted as if he is ready to exit, effectively capturing the anxiety of the boy in the photograph. As in other renditions, the mother sits gazing straight ahead. The boy's coat consists of multiple blocks of color, while the

of the composition. But it might be more accurate to say that as he wiped, scraped, and repainted there always remained a residue of past compositions that contributed to the overall build-up and composition of the work. Just as Gorky was a sum of his experiences— traumatic, displaced, artistic—the works he created included erasures, underlayers, and accumulations of previous renderings, making them of both the past and the present and also representative of the "in-betweenness" of his social existence in the terms that Homi Bhabha defined.

Echoing other fastidious personal habits, such as his practice of frequently and meticulously scrubbing his studio's hardwood floor, Gorky's working method, particularly in this painting, could resemble obsession. Such preoccupation with order is often a byproduct of trauma or uncertainty. Gorky's studio and art comprised the place where he felt most comfortable, his safe haven, becoming his home and the center of his interstitial existence during his permanent exile, and in defiance of the constancy of his in-between state. The literary theorist Edward Said has referred to exile as an insurmountable force that is ever present in an exile's life:

mother's dress is a fairly homogenous white with layers of paint added to create depth. Her left shoulder disappears into the background, painted over in a way that renders an effect similar to the erasures in the earlier drawings, and her eyes, as in the drawings, are slightly unbalanced, with her left pupil a fraction larger than her right. Gorky reduced details in the painting, only loosely defining the boy's right fingers around his abstracted bouquet (fig. 28), and he painted out the other hands so as not to distract from the visual hierarchy of the bodies. The faces appear fairly flat but have a subtle texture from the paint strokes, as Gorky shaped them without detail or shading, a method of working found in other of his figural paintings from the period. His *Portrait of Vartoosh* (1933–34; plate 25), for example, is similarly lacking in detail and shading, with the cheeks and chin shaped with medium-thick grayish brushstrokes over the green-tinged underpainting and with heavy facial outlines and iconic features.

The Whitney painting of the theme was especially important to Gorky. He kept it throughout his life, and often it was the only painting hanging on his studio walls. The art collector Isobel Grossman was one of many visitors to his studio who saw it there in the mid-1930s. As she recounts: "I noticed a single painting hanging on the otherwise pictureless walls. It was a portrait of Gorky as a young child with his mother. When I referred to the strong and noble woman and to the poor little boy, my sentence was interrupted and I was informed that the painting was not for sale. I felt that I had somehow inadvertently intruded into his private world."[43]

The same compelling qualities are found in the National Gallery's version of the subject (plate 33). Painted in hues of pink, salmon, red, and tan, in contrast to the darker bluish hues of the Whitney version, its forms are flatter and more dematerialized than in the other painting, possibly because it is unfinished. Gorky's wife remembers that he pulled it out to work on as late as 1942, long after he had stopped painting figural works, although he was still drawing portraits of his family and friends.[44] The idea that it is not in its final stage is supported by recent conservation of the Whitney painting, which appears to have underpainting of a color similar to the National Gallery version.[45] In its current state, it resembles other paintings from the 1930s, such as

the bulbous *Portrait of Master Bill* (c. 1937; plate 35), which, like *The Artist and His Mother* paintings, consists of variegated colors, dissociative blocks of forms representing the figure, and undefined hands. It may be that Gorky, like many other artists, switched back and forth between paintings, returning to older compositions when a new thought, method, or manner of resolution struck him.

The lack of solidity in the forms of the National Gallery painting exploits Gorky's belief in the mutability of natural forms and his tendency to dislocate them within the space of the canvas. The arms of the two figures touch ever so slightly in this version; the boy's left arm drops to the mother's right and is almost painted over hers. His body partially turns away, but his gaze is directed outward from the picture plane. The mother's left shoulder is also lowered slightly. In this painting of the subject Gorky removed more details, making the flowers in the boy's right hand almost unrecognizable and whitening the mother's face. The structuring of the composition with color rather than line creates internal movement and engages the eye. The boy's lap is the same color as the mother's upper arm. The light color of her dress seems almost to have washed over his left foot, acting like a scrim.

52
FIG. 29
Detail of *The Artist and His Mother*, National
Gallery of Art, Washington, D.C. (plate 33)

KIM SERVART THERIAULT

Gorky created hints of fingers on her hand in the same way that he shaped both faces with thin, directional brushstrokes, a technique he was exploring in his abstract work of the 1930s, such as *Image in Khorkom* (c. 1934–36; plate 60), but with much heavier impasto. The lighter touch is evident in a number of his figural works from around the same time, such as the *Portrait of Vartoosh* just mentioned (plate 25) and *Portrait of Myself and My Imaginary Wife* (1933–34; plate 24), which share the melancholy of the works on the artist and his mother theme.

The mother's face in the National Gallery painting, drained of expression, betrays loss—of individuals or homeland—and perhaps reflects death (fig. 29).[46] Reliving or depicting trauma can be problematic because it perpetuates victimhood,[47] but Gorky's hint of it, through abstracted compositional elements, seems to address it effectively, conveying emotion to the viewer. In the constructive spirit of his self-creation, the reconfigured elements and abstracted forms also conjure modern art practice and the lessons that he likely learned from studying and adapting the work of other artists. Reconfiguration is also, metaphorically, part of negotiating exile. As Edward Said has explained:

Exile…is fundamentally a discontinuous state of being. Exiles are cut off from their roots, their land, their past.… Exiles feel, therefore, an urgent need to reconstitute their broken lives, usually by choosing to see themselves as part of a triumphant ideology or a restored people. The crucial thing is that a state of exile free from this triumphant ideology—designed to reassemble an exile's broken history into a new whole—is virtually unbearable, and virtually impossible.[48]

Gorky's work is a figurative reassembling of time, space, and place. His "in-betweenness" informed his style, as, for example, when he embraced the reductive qualities of such modernists as Cézanne, Matisse, Léger, Picasso, and Piet Mondrian, whose efforts to portray the plastic elements of form echoed the iconic qualities of medieval, Byzantine, and Egyptian art that he spent time viewing in the Metropolitan Museum of Art, possibly because the simplified forms reminded him of the Armenian art of northeastern Turkey and Yerevan (fig. 30). Such historic forms and the milieu of his past were already part of his visual vocabulary. As in the exotic and past cultures that the moderns studied, such as the African, Iberian, Japanese, and Middle Eastern, in which the image ranked higher than the narrative, an abstracted or less-defined image could, through its ambiguity, be more relevant to the experience of those viewing Gorky's paintings than the particular story of the artist himself, even if he used his story as a basis.

The artist and his mother paintings and drawings, although obviously centered around Gorky's specific experiences, can also act as "punctums" for the viewer, as any successful work of art does. In Barthes's formulation, a punctum is defined in a photograph as a visual detail that pierces or punctuates the viewer's experience (or, in a broader sense, related to time, as the "lacerating emphasis of…'that-has-been'"), instigating multiple possible responses and interpretations depending on how it is subjectively experienced by each individual.[49] When Gorky obtained the photograph of his mother and himself, it acted as a punctum, reminding him of his past but also perpetuating that past in his present and into his future. Barthes explains that the punctum "is a kind of subtle *beyond*—as if the image launched desire beyond what it permits us to see: not only toward 'the rest' of the [image, that which we do not see within the frame of the photograph], not only

FIG. 30
Manuscript leaf from a Gospel book, 1290–1330.
Armenian; written in Armenian and painted possibly in
the Lake Van region, Vaspurakan (now eastern Turkey).
Ink and tempera on parchment, 8⅞ x 13⅛ inches
(22.5 x 33.3 cm). The Metropolitan Museum of Art, New
York. Gift of Dr. J. C. Burnett, 1957

toward the fantasy of a *praxis* [or action], but toward the absolute excellence of a being, body and soul together."[50] The photograph simultaneously reflected Gorky's life, his mother's death, his new world, and the destruction of his old world. The paintings and drawings on the theme were, in effect, a remarkable catalyst for ameliorating his in-between state, and in some way, if only during the process of creating *The Artist and His Mother* images, were a resolution to his trauma.

Although the photograph of himself with his mother acted as punctum for Gorky, the works that it inspired reach far beyond the world of art. Knowledge of his personal story is not necessary to connect with his works, although it helps to inform our understanding of their history. For those who experienced the Armenian Genocide or were directly affected by it, however, the pictures on the artist and his mother theme become a proxy for their own emotions and are experienced in an intensely personal way. When the Whitney recently lent its version of the painting to the Diocese of the Armenian Church in New York for display, people wept in front of it. For Armenians who

know Gorky's story, the emotions of the painting are painfully evident because they are part of their own personal histories. "Emotion, which is suffering," the concentration-camp survivor Viktor Frankl has said, "ceases to be suffering as soon as we form a clear and precise picture of it."[51] For fellow survivors, Gorky's work bears witness to the trials of the Armenian Genocide and to the Armenian people's survival and triumph in a new country.[52]

Non-Armenians who engage with his work are also generally able to perceive its unresolved trauma. Ironically, through his pursuit of art and the manifestations of his in-between state—his name change, inaccurate life details, and hidden trauma—Arshile Gorky has ultimately brought as much attention to the Armenian Genocide as have those who have made deliberate efforts in this direction. Even more significant is the possibility that any work on the theme of the artist and his mother provides viewers with an understanding of the universal effects of genocide and its impact on its victims, their offspring, and humankind.

Throughout his career, Gorky tended to repeat the compositions that had a direct link to his past, making works such as *Image in Khorkom* (plates 56–60), *Garden in Sochi* (plates 93–97), and *The Plow and the Song* (plates 144–49) function in ways similar to *The Artist and His Mother* paintings, as they too point toward aspects of his history, acting as references to the places he was forced to leave behind. In these works, Gorky continued his process of restructuring and recombining elements of the observed and remembered into new, modernist compositions. While he could not completely remedy his exile, entirely remake his identity, or forget his trauma—despite his creative refashionings or silence on the subject—the working through of his dislocation, disjuncture, and displacement as revealed in his practice, and especially in the works on the theme of the artist and his mother, challenges the dichotomy of his bifurcated existence to pointed and poignant effect.

1. I am referring here to seminal essays such as Clement Greenberg's "American-Type Painting," *Partisan Review* 22, no. 2 (Spring 1955), pp. 179–96, and Harold Rosenberg's "The American Action Painters," *ARTnews* 51, no. 8 (December 1952), pp. 22–23, 48–50.

The ideas in the present essay derive from recent research and from my work on the artist over the past fifteen years. Expanded versions of my discussion can be found in Kim S. Theriault, *Rethinking Arshile Gorky* (University Park, Pa.: Pennsylvania State University Press, forthcoming), and "Re-placing Arshile Gorky: Exile, Identity and Abstraction in Twentieth-Century Art" (Ph.D. diss., University of Virginia, Charlottesville, 2000).

2. Richard G. Hovannisian, ed., *The Armenian Genocide: History, Politics, Ethics* (New York: St. Martin's, 1992); Vahakn N. Dadrian, *The History of the Armenian Genocide: Ethnic Conflict from the Balkans to Anatolia to the Caucasus*, 4th rev. ed. (New York: Berghahn Books, 2003); Yves Ternon, *The Armenians: History of a Genocide*, trans. Rouben C. Cholakian, 2nd ed. (Delmar, N.Y.: Caravan Books, 1981).

3. Although the Armenian Genocide is often described as having been caused by religious tensions between Christians and Muslims, or has been explained, especially by the Turkish government, as necessary to prevent rebel insurgency, its main cause could be attributed to the desire to overtake the economic success of the Armenians and appropriate their ancestral lands.

4. See Noel and Harold Buxton, *Travels and Politics in Armenia* (New York: Macmillan, 1914), and Donald E. Miller and Lorna Touryan Miller, *Survivors: An Oral History of the Armenian Genocide* (Berkeley: University of California Press, 1993).

5. Gorky's mother is commonly described as wearing an embroidered apron in this painting because of a remark the artist made about his mother's embroidered apron when referring to another painting, *How My Mother's Embroidered Apron Unfolds in My Life* (1944; plate 115). But aprons, however beautifully embroidered, as they characteristically were by Armenian women, were generally utilitarian and likely would not have been worn for such an important occasion as the photograph. Rather, his mother is probably wearing something more akin to a church outfit or garment, like Gorky's coat, that was meant to dress up more ordinary attire.

6. For biographical information on the artist, see Karlen Mooradian, *Arshile Gorky Adoian* (Chicago: Gilgamesh, 1978) and *The Many Worlds of Arshile Gorky* (Chicago: Gilgamesh, 1980). Additional accounts of the artist's life, based on the previous two sources but varying in approach and with additional information, are Nouritza Matossian, *Black Angel: A Life of Arshile Gorky* (London: Chatto and Windus, 1998); Matthew Spender, *From a High Place: A Life of Arshile Gorky* (New York: Alfred A. Knopf, 1999); and Hayden Herrera, *Arshile Gorky: His Life and Work* (New York: Farrar, Straus, and Giroux, 2003).

7. Khorkom had been resettled with Muslims from other regions.

8. For contemporary accounts of what became known as the Armenian Genocide, see Henry Morgenthau, *Ambassador Morgenthau's Story* (Garden City, N.Y.: Doubleday,

Page, 1918), and Clarence D. Ussher, with Grace H. Knapp, *An American Physician in Turkey: A Narrative of Adventures in Peace and War* (Boston: Houghton Mifflin, 1917).

9. Here I refer to the practice in which Armenian women were married off to Turkish or Kurdish men, or Armenian children were informally adopted by sympathetic Turkish or Kurdish families. They may have survived, but they lost their familial ties, identities, and religion. Kurdish nomads, organized by the Turkish government, were often the agents of the terrible acts, since they, like the Turks, stood to gain land, wealth, and status by removing the Armenians from the region.

10. Mooradian, *Arshile Gorky Adoian*, p. 148.

11. Although this is the commonly accepted version of events, it is possible that Gorky took the photograph from his father during the brief period when he lived with him in his half-brother's home in Providence, Rhode Island, in the early 1920s.

12. Stephen Greenblatt, *Renaissance Self-Fashioning: From More to Shakespeare* (Chicago: University of Chicago Press, 1983), p. 2.

13. See Ernst Kris and Otto Kurz, *Legend, Myth, and Magic in the Image of the Artist: A Historical Experiment* (New Haven, Conn.: Yale University Press, 1979).

14. Maxim Gorky's real name was Alexei (Aleksey/Aleksei) Maksimovich Peshkov.

15. For a more detailed discussion of Arshile Gorky's renaming, and a semiotic elaboration of his pseudonym's social and cultural implications, see Kim S. Theriault, "Arshile Gorky's Self-Fashioning: The Name, Naming, and Other Epithets," *Journal of the Society for Armenian Studies* 15 (2006), pp. 141–56.

16. It was fairly acceptable to be identified as Russian, or in relation to Maxim Gorky, who was widely read in New York circles.

17. A full discussion on the dehumanizing aspects of genocide can be found in Henry C. Theriault, "Rethinking Dehumanization in Genocide," in *The Armenian Genocide: Cultural and Ethical Legacies,* ed. Richard Hovannisian (New Brunswick, N.J.: Transaction, 2007), pp. 27–40.

18. Harold Rosenberg, *Arshile Gorky: The Man, the Time, the Idea* (New York: Horizon Press, 1962), p. 36.

19. Cathy Caruth, introduction to *Trauma: Explorations in Memory*, ed. Cathy Caruth (Baltimore: Johns Hopkins University Press, 1995), p. 4.

20. See Spender, *From a High Place*, p. 72.

21. The sequence of the drawings and paintings inspired by the photograph is unknown. Gorky may have gone back and forth between drawings and paintings, using studies to help resolve challenges he encountered in paint.

22. See Aristodemos Kaldis, interview with Karlen Mooradian, in Mooradian, *The Many Worlds of Arshile Gorky*, pp. 154–55. The reported quickness of the renderings makes sense for the young Gorky, who is known to have speed-sketched images of U.S. presidents during intermissions at the Majestic Theatre in Boston for money.

23. Dominick LaCapra, "Trauma, Absence, Loss," *Critical Inquiry* 25, no. 4 (Summer 1999), p. 713.

24. See Anie Kalayjian and Siroon P. Shahinian, "Recollections of Aged Armenian Survivors of the Ottoman Turkish Genocide," in "Resilience in Ethnic Experiences with Massive Trauma and Violence," ed. Flora Hogman, special issue, *Psychoanalytic Review* 85, no. 4 (August 1998), pp. 87–97. In this study the investigators determined that three out of four survivors of the Armenian Genocide never spoke of their experiences.

25. Traumatic experiences can manifest themselves in a survivor's acts in ways that are often unknown to the survivor himself, or that can be misunderstood by others. See Cathy Caruth, *Unclaimed Experience: Trauma, Narrative, and History* (Baltimore: Johns Hopkins University Press, 1996), p. 2.

26. Agnes Gorky Fielding, the artist's widow, stated in a telephone conversation on May 8, 2009, that the "dog bite" story was only one of many stories Gorky told about his mother's death.

27. Hans Belting, *Likeness and Presence: A History of the Image before the Era of Art*, trans. Edmund Jephcott (Chicago: University of Chicago Press, 1996), pp. 10–11.

28. Homi K. Bhabha, *The Location of Culture* (London: Routledge, 1994), p. 19. Although Bhabha refers to the literature of coloured South Africa and the displacement of individuals within that society, the concept of hybridity carries over to the displaced exile existing within a new social and cultural sphere.

29. For a complete discussion of the concept of social spatiality, see Edward W. Soja, *Postmodern Geographies: The Reassertion of Space in Critical Social Theory* (London: Verso, 1989).

30. Being an immigrant in the United States during the modern industrial age was complex. In addition, immigrants have almost always faced resistance from American citizens, despite their own immigrant lineage. Attempts to quell the influx of newcomers to the United States have included denying entrance to certain ethnicities and races, implementing literacy requirements, and establishing maximum quotas for various countries and regions. Once an immigrant has arrived in the United States, citizenship is not guaranteed, leaving the individual in a somewhat disconnected, in-between state. Immigrants therefore exist outside their countries of origin but are not yet members of the country in which they are building new lives.

31. Bhabha, *The Location of Culture*, p. 19.

32. Maurice Denis, "Maurice Denis, from 'Definition of Neotraditionalism,' 1890," in *Theories of Modern Art: A Sourcebook by Artists and Critics*, ed. Herschel B. Chipp, with contributions by Peter Selz and Joshua C. Taylor (Berkeley: University of California Press, 1968), p. 94.

33. This is similar to the relationship seen in Gorky's *Portrait of Myself and My Imaginary Wife* (1933–34; plate 24), in which he portrayed himself with an imagined ideal of a woman to fulfill his desire to marry. In the past I have interpreted the woman as representing an Armenian ideal and a life in Armenia that could never exist because of the genocide. See Kim S. Theriault,

"The Art of Exile: Arshile Gorky, Displacement, and Identity," paper presented at the annual meeting of the College Art Association, New York, February 1997; and Theriault, "Images of Women in Arshile Gorky's Art," paper presented at the Middle Atlantic Symposium in the History of Art, National Gallery of Art, Washington, D.C., April 1998.

34. For a detailed study of the generational Armenian-American ethnic experience, see Anny Bakalian, *Armenian-Americans: From Being to Feeling Armenian* (New Brunswick, N.J.: Transaction, 1993).

35. We are not quite sure what Gorky was exposed to, or which or how many of these activities he participated in, but we can assume that since they are a traditional part of the Armenian heritage recalled by immigrants, and since a number of these practices were perpetuated in the United States (such as decorating Easter eggs), Gorky must have been exposed to at least some. See Mooradian, *Arshile Gorky Adoian*, chap. 5 (pp. 99–161), for a more detailed discussion of the possibilities.

36. Harold Rosenberg discussed the significance of the role of immigrants in the development of American modernism, and specifically Gorky's role, in *Arshile Gorky: The Man, the Time, the Idea*, p. 22. See also Raymond Williams, "The Metropolis and Modernism," in *The Unreal City: Urban Experience in Modern European Literature and Art*, ed. Edward Timms and David Kelley (Manchester, England: Manchester University Press, 1985), p. 21.

37. In reference to such adjustments to the artist and his mother compositions, Melvin Lader has stated that Gorky "made significant changes for compositional, stylistic, and expressive purposes, resulting in a powerfully moving image"; Melvin P. Lader, *Arshile Gorky* (New York: Abbeville, 1985), p. 35.

38. This drawing also has a late date. It is currently believed to have been made in 1938, but the drawing was dated by the artist in a scrawl that could be either 1926 or 1936.

39. Roland Barthes, *Camera Lucida: Reflections on Photography*, trans. Richard Howard (New York: Hill and Wang, 1981), p. 63.

40. The notion of the "transhistorical," or the transcending of historical bounds, is explained in Nancy K. Miller, *Bequest and Betrayal: Memoirs of a Parent's Death* (New York: Oxford University Press, 1996), p. 14.

41. Paul Ricoeur, *Memory, History, Forgetting*, trans. Kathleen Blamey and David Pellauer (Chicago: University of Chicago Press, 2006), p. 56.

42. Edward W. Said, "Reflections on Exile," in *Reflections on Exile and Other Essays* (Cambridge, Mass.: Harvard University Press, 2000), p. 173.

43. Isobel Grossman, "If Memory Serves: Guest Curator's Preface," in *Arshile Gorky: Drawings to Paintings*, exh. cat. (Austin: University of Texas Art Museum, 1975), p. 12.

44. Telephone conversation with Agnes Gorky Fielding, June 23, 2008.

45. I thank Matthew Skopek, assistant conservator at the Whitney Museum of American Art, New York, for this information, which he relayed in August 2008.

46. Melvin Lader has described this as a death mask; Lader, "Arshile Gorky's *The Artist and His Mother*: Further Study of Its Evolution, Sources, and Meaning," *Arts Magazine* 58, no. 5 (January 1984), p. 102.

47. Dominick LaCapra, *Writing History, Writing Trauma* (Baltimore: Johns Hopkins University Press, 2001), p. 28.

48. Said, "Reflections on Exile," p. 177.

49. Barthes, *Camera Lucida*, pp. 27, 43, 96. Elsewhere, Barthes speaks of the "evidential force" of the photograph (p. 89).

50. Ibid., p. 59.

51. Viktor E. Frankl, *Man's Search for Meaning* (New York: Pocket Books, 1984), p. 95.

52. According to theorists and experts who have studied genocide and its aftermath, as long as the Turkish government continues to deny the methodical killing and forced displacement of more than one million ethnic Armenians, the Armenian Genocide is perpetuated throughout subsequent generations.

To Organize Painting

To think of ways of *disorganizing* can be a form of organization.
—Franz Kline to Selden Rodman, 1956[1]

Titles

We are told that Arshile Gorky did not care much about titles.[2] I am skeptical. After all, he spent considerable effort on his own title, his name. Born Vosdanig Adoian in Turkish Armenia, he spun autobiographical tales around the Russian-sounding pseudonym he invented for himself.[3] Why wouldn't he attend just as seriously to the titles of his works?

The most obviously original aspect of a painting that obsessed Gorky from 1933 to 1936, becoming one of the few masterpieces of his protracted "early" years, is its name. By the time he sent it to the third Whitney Biennial at the end of 1936, he had titled it *Organization* (plate 66).[4] The choice is odd. Gorky might have fallen back (as he often did) on that well-established name for an abstract canvas, *composition*, followed by a number or letter if the work formed part of a group. That was the option established by Piet Mondrian from the late 1910s on, when his art abandoned specific reference to the visible world.[5] Then there was the ubiquitous *abstraction*, which Gorky also used. The third main option, favored by artists such as El Lissitzky and László Moholy-Nagy, but not Gorky, was *construction*.

It is to Mondrian that *Organization* pays much of its tribute, with Picasso getting even more. "I am *with* Picasso," Gorky declared shortly before starting the painting.[6] Francis Picabia was an important influence on the studies for *Organization*, and Jean (Hans) Arp is acknowledged in the curved shape with target at the painting's very center. Fernand Leger's *The City* (1919; see fig. 62), Stuart Davis's *Eggbeater* series (1927–30; see fig. 63), and certain motifs of Max Ernst also lie behind the painting. And yet *organization* is not associated with any of these artists.[7] In naming his painting, then, Gorky was careful not to

privilege one source over another, which means that he was being deliberately original in a work that exploited sources to the point of shunning originality.[8]

The word *organization* was certainly in Gorky's artistic lexicon. In a 1931 essay on Davis, he wrote: "This artist, whether he paints eggbeaters, streets, or pure geometrical organizations, expresses his constructive attitude toward his successive experiences."[9] Gorky spoke of the "dialectical organization of forms" during an interview about his Newark Airport murals in 1936 or 1937,[10] and his own essay on the murals makes clear that he meant the word *dialectical* in a roughly Hegelian sense, to refer to the simultaneous cancellation and elevation known as sublation: "These objects [hangar, ladder, gasoline truck, scales, fire extinguisher] I have dissected and reorganized in a homogeneous organization."[11]

And yet Gorky used *organization* as a title rarely.[12] Why was this word in such apparent disfavor as a name for works of art? Its meaning is not much different from that of *composition*, the most obvious alternative. *Organization* might suggest a somewhat looser kind of arrangement or order, but if it does, it is only because it lacks *composition*'s long history in aesthetic discourse on painting, from the early years of the French Royal Academy, founded in 1648, to the Soviet composition-construction debates held in 1921 at Moscow's Institute of Artistic Culture.

Perhaps modern painters avoided *organization* precisely because it was in such lively circulation elsewhere. Two spheres of special usage in the interwar years, economics and psychology, come to mind. For Soviet economic planners, the concept of "scientific organization of production" was a central tenet, explicitly derived from the American discipline of productive efficiency known as Fordism.[13] The word had a complementary meaning, especially in capitalist regimes, where it denoted the unionizing of a workforce or the mobilization of those in any field to pursue common interests. This last sense would have been more than familiar to Gorky, who was involved with the Artists' Union and the Artists' Committee of Action, groups that sought to help their members make a living, to take political positions on issues of the day, and somehow to balance the two (with much debate and schism: the Committee split from the Union in 1934 and soon disbanded). Thanks to economic

FIG. 31
Gorky at work on *Organization* in his studio at 36 Union Square, New York, 1934–35 (detail; fig. 33). Courtesy of the National Archives and Records Administration, Washington, D.C.

changes too obvious to mention, all these uses of *organization* now seem a bit dated.

A second sphere of usage, that of psychoanalysis, is even quainter today, but it was common in the 1920s, particularly in the United States, where interest in Sigmund Freud was then at its apogee. Whether or not Gorky read Freud, he would have known his basic theory from artists connected with Surrealism, such as John Graham.[14] A key Freudian concept was that of libidinal organization. Following the polymorphous sexuality of childhood, with its oral, anal, and phallic stages, the focusing of pleasure in the male and female genitals marked the advent of genital organization, or sexual maturity. The psychobiologism (and perhaps phallocentrism) of Freud's usage is reflected in the root *organ*. To organize, if we take the structure of the word literally, is to make (or make into) an organ, a part of a body. Genital organization, then, is not simply the focusing of pleasure in the genitals; it is the very definition and creation of the genitals as such, their organizing. Whether or not Freud intended this strong sense of the word, it nicely reflects the power he ascribed to the libido in shaping our experience of the body.[15]

And yet the word refuses to settle easily into the realm of the body. Etymology pulls it back into that of labor. *Organ* is from *organon*, the Greek word for tool or instrument, and is closely related to *ergon*, Greek for work. (Hence *erg*, *ergonomics*, and *energy*.) To organize is to work, or work up, some material, to apply labor and tools to it. For convenience, let us call this workerly sense of *organization* the ergonic, and the other sense, the bodily one, the organic. Between them, the ergonic and the organic capture a fundamental duality in Gorky's masterpiece. Its much-worked surface, scored and dragged, layered and troweled, declares the work that went into it, and at the same time the painting makes insistent reference to bodies and their parts.[16]

Both spheres of meaning of *organization* figured prominently in the thinking of Gorky's then-mentor, the Russian émigré painter John Graham, whose eccentric, Socratic magnum opus, *System and Dialectics of Art*, was first published in 1937, in both French and English editions. That was the year after Gorky finished *Organization*, but no doubt he had already heard Graham's ideas in conversation, for he had spent many hours with Stuart Davis at the older artist's feet, to the point that the trio was dubbed the Three Musketeers.[17]

Graham's answer to the sixth question of his catechism—"What is a work of art?"—concludes: "It must be an organism and to be an organism it must function." The next question—"How is a work of art produced?"—elicits this answer: "*a*) analysis or penetration; *b*) discovery or revelation; and *c*) organization."[18] Normally, that last word would have a strictly formalist valence (in the hands of a Roger Fry or a Clive Bell), but coming on the heels of the reiterated word *organism*, and with the help of *penetration*, it takes a psychobiological turn that goes far deeper than clichés of organic form, instead calling up sex, the libido, and the unconscious, which together constitute a leitmotif in the text. And yet Graham quickly qualifies this trope, arguing (in the tenth question) that talent is "*just an animal ability*... until mind and intuition build it up into a source of organized expression."[19] Here Graham turns *organization* from biology (the human "animal") toward another preoccupation of his treatise, the importance of work, and the experience of work, in making art. For example, to answer one of his final questions—"What is the Language of Form?"—he offers the surprising example of a chair whose beauty derives from the "sufferings, deceptions, apprehensions and hopes of the diligent maker by hand" as well as those of the "people who have used it."[20]

Labor was the necessary dialectical counterweight to spontaneity and the unconscious for Graham, and this was not lost on Gorky. The sculptor David Smith recalled "watching a painter, Gorky, work over an area edge probably a hundred times... without changing the rest of the picture, based on Graham's account of the import in Paris of the 'edge of paint.'"[21] It is quite possible that *Organization* was this very painting, one of Gorky's thickest, and made while he and Smith were close. Gorky was proud of the weight of his paintings' many layers,[22] which seem to literalize Graham's injunction to "build it up into a source of organized expression" (that is, if we replace *talent* with *painting* as the antecedent of *it*). This injunction, with its use of the adjectival form of *organization*, in turn recalls a famous phrase of Cézanne's, a tireless painter-worker and hero to both Gorky and Graham: "the logic of organized sensation."[23]

If in choosing his title Gorky was underscoring the ergonic in Graham's concept of *organization*, perhaps in the same breath he was sending a message about work to Davis, with whom he had just broken over the issue of commitment. Gorky had been active with Davis in organizing artists in the early 1930s, even designing a large towerlike construction for a protest march (see fig. 56), but he was never fully on board and often played the crank at meetings by bringing up aesthetic issues in the middle of political discussions. In the fall of 1936, when Davis founded the Artists' Congress in reaction to Communist party influence over the Artists' Union, Gorky "stayed out of it," after which he and Davis "were hardly on speaking terms."[24] Given this context, Gorky might have intended the title of his painting as a retort to Davis: *This* is the kind of organization, and the kind of labor, that really counts.[25]

Whether or not these private messages of the title were in fact sent, or received, the twin implications of *organization*, the ergonic and the organic, reach well beyond the Three Musketeers. They suggest the duality of advanced painting in the 1930s, which, one can say without too much oversimplification, was divided between two competing camps: abstraction (the ergonic, the labor of construction) and surrealism (the organic, the play of biomorphism). The polarity was famously summarized by the two exhibitions that Alfred H. Barr, Jr., organized at the Museum of Modern Art in 1936, the year in which Gorky was finishing his painting: *Cubism and Abstract Art* in the spring and *Fantastic Art, Dada, Surrealism* at year's end.[26]

According to the standard account of Gorky's work of the early and mid-1930s, it was split between these two camps: "He veered between the Surrealism of the *Nighttime, Enigma, and Nostalgia* drawings [plates 42–49, 51–55] and the clarity and rigor of his Synthetic Cubist canvases."[27] And the standard conclusion is that the former quickly triumphed: "Gorky's interest in rigorous geometry was shortlived, for he soon turned towards freer expression and more fluid organic form."[28] But "clarity and rigor" is far too untroubled a description of *Organization*, which is pulled both ways at once. Here lies the genius of Gorky's title, for while it does not privilege any particular artist or source, it reflects the two main currents that the painting so ambitiously seeks to harness. And again Graham served as a model, in fluently "moving from cubist constructions to agitated organic forms," although he never attempted the synthesis in a single canvas.[29]

Perhaps Gorky's ambition was not quixotic, for the two faces of the word *organization* are not so far apart. It was not only Graham who suggested their unity; Freud did too, given that the problem of genital organization was at base an economic one: how to direct a fixed quantity of energy toward those organs that would ensure work that counted—that is, the reproduction of the species. This raised a further economic problem, that of sublimation: how to redirect some of that unruly energy into nonsexual channels in order to ensure psychic and social stability. Sublimation is at the root of the dialectic of desire and work in Graham's treatise—a dialectic nicely encapsulated by the word *urge*, also from *ergon*, which denotes both instinctual drive and physical force. Let us bear in mind this mutual entanglement (in our very language) of desire and labor, of the body and work, as we ask just what sort of stability, however temporary, Gorky achieved in his *Organization*, or, to put it another way, what kind of working body the painting still offers us.

First Agon (Sources)

There exist two photographs of *Organization* in progress, one showing Gorky and Willem de Kooning standing shoulder to shoulder next to the painting, as if they had both done it (fig. 32), and another, a later one, judging from the progress of the composition, in which Gorky puts brush to canvas (fig. 33). These will help us chart the development of the painting, but let us begin by noting a feature of the second photograph that is easy to overlook. There are several drawings on the wall just to the left of the painting in the later photograph, one of which is legible enough to be identified with Gorky's *Nighttime, Enigma, and Nostalgia* series—a series that, in soliciting the dreamscapes and biomorphic forms of Surrealism, is often held up as the polar opposite of *Organization*. And yet there it is, reminding us that Gorky's work on that series (1931–34) overlapped for a year with his work on *Organization* (1933–36). Indeed, the drawing is pinned up so close to the canvas as to suggest that Gorky was working *from* it, or at the very least keeping an eye on it.

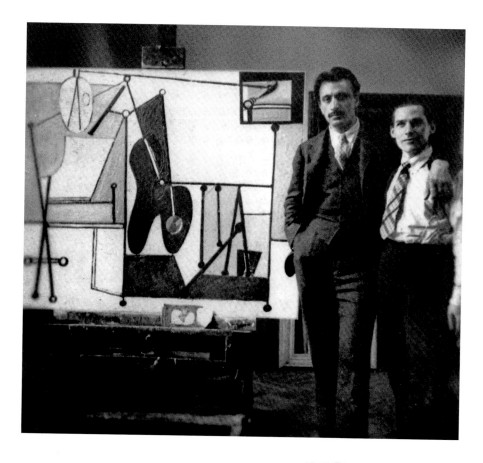

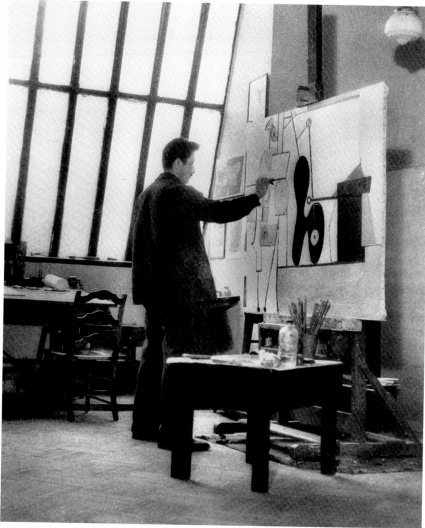

FIG. 32
Gorky and Willem de Kooning in Gorky's Union
Square studio, with the unfinished painting
Organization in the background, 1934. Courtesy
of the Frances Mulhall Achilles Library, Whitney
Museum of American Art, New York

FIG. 33
Gorky at work on *Organization* in his studio at 36
Union Square, New York, 1934–35. Courtesy of
the National Archives and Records
Administration, Washington, D.C.

FIG. 34
Pablo Picasso (Spanish, 1881–1973). *The Studio*, 1927–28. Oil on canvas, 59 x 91 inches (149.9 x 231.2 cm). The Museum of Modern Art, New York. Gift of Walter P. Chrysler, Jr., 1935

FIG. 35
Pablo Picasso (Spanish, 1881–1973). *Painter and Model*, 1928. Oil on canvas, 51⅛ x 64¼ inches (129.8 x 163 cm). The Museum of Modern Art, New York. The Sidney and Harriet Janis Collection, 1967

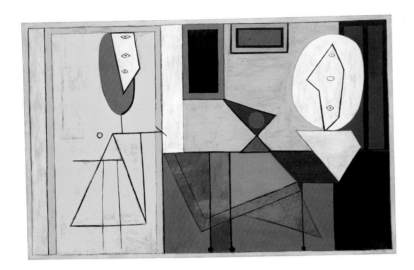

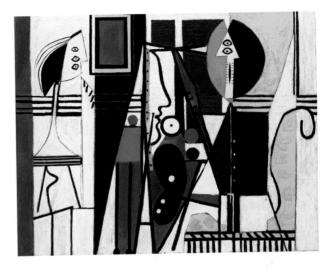

"The painter has many things in his head, or around him, or in his studio," wrote the philosopher Gilles Deleuze in his essay on Francis Bacon. (Admittedly this is an odd point of departure for a painting like *Organization*, and yet it will help us keep the violence of Gorky's work, its agon, in view.) Deleuze continues: "Now everything he has in his head or around him is already in the canvas, more or less virtually, more or less actually, before he begins his work…so that the painter does not have to cover a blank surface but rather would have to empty it out, clear it, clean it."[30]

With Gorky's early work, and *Organization* above all, this is exactly half true: There were many things "in" the canvas already, but rather than eliminating them one by one, the artist tasked himself with making them cohabit. The work this entailed might explain the almost absurdly thick facture of the work. To follow the more normal procedure of eliminating unwanted areas by scraping them down would have been easy; to build the painting layer upon layer, changing course by painting over previous layers rather than eliminating them, would force the issue of synthesis, incorporating a synthetic ambition into the very structure of the work. This seems a more credible explanation of the painting's brutal thickness than Gorky's repeated insistence on his desire for a hard, durable surface, for he was enough of a craftsman to

know that layering can result in just the opposite, the sort of cracks that now travel the work's surface.[31]

What are the various images that preexisted *Organization* and that threaten to crack it open, so to speak? To answer, we must take the polarity proposed by Barr's pair of 1936 exhibitions and briefly tease apart each of their terms. "Cubism and abstract art" is itself a duality that, for our purposes, can be defined by two names: Picasso and Mondrian. It has often been observed that *Organization* relies on two Picassos in particular, both of which were readily available to Gorky in New York: *The Studio* (1927–28; fig. 34) and *Painter and Model* (1928; fig. 35).[32] In both pictures, the figures are fully locked into an abstract matrix, justifying Barr's linkage of such late Cubist work with abstraction. We will return to these shortly. As for Mondrian, most relevant are his Neoplastic paintings of the 1920s in which a central square or near-square is connected by short line segments to the edges of the canvas. In addition to knowing such works from reproductions, Gorky could have seen a classic example in Katherine Dreier's collection, *Composition with Red, Blue, Yellow, and Black* (1929; fig. 36).[33] If we look at *Organization* through such a filter, eliminating all curved or diagonal lines and adding a few segments to complete certain horizontals and verticals, we arrive at just such a schema: a large white rectangle, nearly square, its center

FIG. 36
Piet Mondrian (Dutch, 1872–1944). *Composition with Red,
Blue, Yellow, and Black*, 1929. Oil on canvas, 17¾ x 17⅞ inches
(45.1 x 45.3 cm). Solomon R. Guggenheim Museum, New York.
Gift, Estate of Katherine S. Dreier, 1953
© 2009 Mondrian/Holtzman Trust c/o HCR International Warrenton VA USA

located slightly above and to the right of the center of the canvas, flanked by yellow, tan, gray, and green rectangles.[34]

The other side of Barr's equation, the Dada/Surrealism side, can be teased apart, equally schematically for our purposes, into two further names: Arp and Picabia. (No doubt Joan Miró and Marcel Duchamp are also behind *Organization*, but the relationship does not seem as specific.) The central black form with its hairpin curves generally suggests Arp's work after 1917, when his experience of nature at a Swiss resort inspired a turn to organic abstract form. What secures the relation to Arp is the target shape within the form: Arp had inserted just such a target in *The Navel Bottle*, one of seven black-and-white lithographs he called *Arpaden* (Arp things) that were published in the fifth issue of the magazine *Merz* in 1923 (fig. 37). There are obvious similarities between the two black forms as well, in the way they narrow and swell. The relationship between bodies and their orifices, the theme of the portfolio, is one that *Organization* takes up. It has, in Arp's terms, many navels.

The presence of Picabia is more hidden, and can best be detected by looking at Gorky's ten surprising graphic studies for *Organization*, in particular the largest and most finished of the group (plate 64). At first glance this drawing has little to do with the final painting, but there are several elements in common: the straight lines ending in filled or empty rings, which I will call ball-stopped lines; the central biomorphic form; and the vertical concatenation at left, which, with the help of the other studies, can be read as a figure, less in the proto-Surrealist sense of an abstracted biomorphic form (Arp) than in the Dadaist sense of a mechanical equivalent of biological processes (Picabia). In *De Zayas! De Zayas!* one of a series of "portraits" that Picabia made in 1915 for the inaugural issue of *291* (the journal that he launched with Marius de Zayas), the body is conceived as a diagram of arcane connections between a corset, a spark plug, and some kind of engine (fig. 38). In the figure at the left of his drawing, Gorky placed a similar diagram, perhaps of an electrical circuit with transformer, surmounting four other diagrams that suggest (though who can say?) the phases of the moon, the points of the compass, or the structure of the atom. The obscure energy charted by both drawings is linked to the female body, but whereas in the Picabia drawing that body was the love object of the

FIG. 37
Jean (Hans) Arp (French, born Germany, 1886–1966). *Die Nabelflasche* (*The Navel Bottle*) from "7 Arpaden," 1923. One from a portfolio of seven lithographs, composition (irreg.): 16⅜ x 9¾ inches (41.6 x 24.8 cm); sheet: 17¾ x 13¾ inches (45.1 x 34.9 cm). Publisher: Merzverlag (Kurt Schwitters), Hannover, Germany. Printer: unknown. Edition: 50. The Museum of Modern Art, New York. Gift of J. B. Neumann, 1939

male sitter/subject (thanks to the spark plug–corset connection and the sexual connotation of *je suis venu*), in the Gorky drawing the female body *is* the principal figure, for the double curve of the electrical circuit also describes pendulous breasts, as another, smaller study makes amply clear (fig. 39).

Gorky was conflicted in his use of Picabia's model. While he was clearly interested in Picabia's rearticulation of the body as a set of abstract mechanical or electrical relations (an interest visible not just in the inclusion of the electrical circuit but in his use of machined lines throughout the drawing), he was unwilling to give up mimesis, as witnessed by not only the breasts but also the masklike head above them. (Other elements of the drawing have been related, convincingly, to the look of bicycle parts.)[35] In short, Gorky crossed two incompatible logics: Arp's biomorph, which was underwritten by resemblance, however humorously attenuated, and Picabia's mecanomorph, which rejected resemblance, achieving reference via words and diagrams instead. The clash of logics is clear in the finished painting, above all where the black biomorph is riven by diagrammatic lines. Two lines are set deeply into the biomorph, indicating that Gorky carefully painted around them as he built up the form, and yet this form still threatened to engulf them, prompting him to repaint the lines in thick gray strokes against the black ground. Other lines have indeed been engulfed

(painted over) by the biomorph, but they are visible in certain angles of light as pure texture (fig. 40).

An equally sharp clash or incoherence results from Gorky's crossing the logics of Picasso and Mondrian. In both *The Studio* and *Painter and Model* (see figs. 34, 35), the picture plane is conceived traditionally, as a vertical section through the horizontal cone of vision. Indeed, Picasso literalized or primitivized this conception in these paintings by resting figures and objects on the bottom of the picture, thus cementing the equation of gravity with the pictorial field. Mondrian did everything to challenge this "naturalist" model, not simply by refusing specific reference to the visible world but by creating series that, through inversions and reversals, deny top and bottom even as a matter of abstract balance. That Mondrian painted with his canvas laid flat on a tabletop, using easels for display only, was both cause and effect of this horizontalization of the pictorial field. Picasso's two works, on the other hand, are manifestos of the verticality of representation, whether for sculpture (*The Studio* equates the triple-eyed head at left with a triple-eyed bust at right, both finely balanced on a point as if to emphasize their erectness) or for painting (in *Painter and Model*, the intersection of the artist's horizontal gaze with the vertical canvas is literally central to the work).

A glance at the two photographs of *Organization* in progress suggests that its general trajectory was from Picasso to Mondrian. At the

FIG. 38
Francis Picabia (French, 1879–1853). *De Zayas! De Zayas!* Illustration for the journal *291*, July–August 1915. Courtesy of the Research Library, The Getty Research Institute, Los Angeles

FIG. 39
Arshile Gorky, Study for *Organization*, c. 1936. Pen and ink on paper, 11 x 14½ inches (27.9 x 36.8 cm). Private collection

FIG. 40
Detail of *Organization* (plate 66),
oblique view

stage represented in the photograph with de Kooning (see fig. 32), the first state, the work is in thrall both to Picasso's device of the ball-stopped line and to his theme of the artist in the studio. At upper right, a painting-in-the-painting seems to capture and refract a gaze coming from the oval-eyed oval head of the figure at left. In the smaller study for the painting (see fig. 39), this sight line terminates at a tilted canvas on which Gorky inscribed his first name. With the help of these clues, we can read a whole scene in the painting's first state: the multi-armed painter, a kind of puppet master, wielding his palette, is in turn connected to an easel (signaled, as in *Painter and Model*, by an A shape) that supports the painting-in-the-painting.[36] (Gorky's elimination of the model from Picasso's triad of painter-model-canvas may be a critique of the latter's attachment to the motif, his reservations about abstraction.) The frequent use of ball-stopped lines turns the linear net-

work into a kind of drawing in space, further emphasizing the vertical nature of the depiction, its status as a scene.

In the second photograph (see fig. 33), the painting-in-the-painting is gone and the whole right side of the canvas, not far from its final state, is simplified into planes, which makes the Mondrian-like structure more obvious. On the other hand, the "figure" at left (just where Gorky seems to be working) has become clearer. Stacked shapes cohere in a sort of body, and the head, less schematic now, composed of two eyelike shapes, an oval and a quarter circle, is supported by a stemlike neck and elevated almost to the top of the canvas, where it is better aligned with the sight line just mentioned. Gorky would preserve most aspects of this figure in the final work while making several changes to reduce its readability (apparently feeling it had become a little too clear): removing one of the two legs (which further empha-sizes its birdlike character[37]); replacing the head with a black eye mask (a feature to which we will return); and inserting an aggressive black quadrilateral into the torso.

In the end, *Organization* wants to have it both ways, to be both scene and diagram. The black curved form rests firmly on a horizontal line, just like the bowl of fruit in *The Studio*, and the leg of the figure drops its balled foot to the very bottom of the canvas, as do the table legs in both Picassos. And yet the compositional schema Gorky took from Mondrian cancels all gravity and space, especially in the way the large central white square stops short of the top edge, refusing to sug-gest a back wall (in contrast to *The Studio*). Instead, that square flips up, suggesting a tabletop viewed from above, perhaps a billiard table on which someone has been busy figuring angles of incidence and reflec-tion. Vestigial figurative elements huddle on the margins of this depth-exterminating middle, producing kinds of imbalance antithetical to Mondrian's equilibrium. (And yet Mondrian was capable of creating compositional clots too, as in *Fox-trot B* [1929; Yale University Art Gallery, New Haven, Connecticut], another painting Gorky could have seen in the Dreier collection.) It is no accident that the figure(s) at left seems to face away from the center, or that the brown plinth at right, in a waste of its own solidity, supports nothing but the empty gray bowl incised within it. The circular fruits that rested so safely and centrally on

FIG. 41
Francis Bacon (English, 1909–1992).
Study for Running Dog, c. 1954. Oil on
canvas, 60⅛ x 45¹⁵⁄₁₆ inches (152.7 x 116.7
cm). National Gallery of Art, Washington,
D.C. Given in memory of Charles Edward
Rhetts by his wife and children, 1976

table and bowl in the Picasso paintings have been scattered by Gorky's horizontalizing of the picture plane. For an unambiguous assertion of the viewpoint implied here, see *Aerial Map* (1936–37; plate 85), one of two surviving large canvases Gorky painted for Newark Airport. Just as his work on the *Nighttime, Enigma, and Nostalgia* series intersected with the beginning of his work on *Organization*, so the Newark commission overlapped with its conclusion. I suspect Gorky was relieved to have found a subject that would justify the kind of diagrammatic space he was ambivalently attempting in *Organization*, right down to its vocabulary of lines, circles, and targets.

Second Agon (Textures)

What are we to make of such an apparently programmatic attempt to achieve such a doubly unlikely result—not just the "wedding of abstraction and surrealism" (as has often been said of Gorky's work) but also the internal resolution of each of those terms, effected, respectively, by crossing the vertical plane of representation with the horizontal and by crossing the biomorph with the mecanomorph?[38] One answer would be to credit Gorky's general stance at the time against originality—as in his statement of 1932–33, "I was *with* Cézanne for a long time, and now naturally I am *with* Picasso"[39]—but with a caveat: rather than a serial apprentice, Gorky was a simultaneous one, not minding the incompatibilities among his various masters. But there is another possibility, one that is truer to my sense that something eccentric is stirring in the painting. What if, contrary to all his demurrals on the subject of originality, Gorky was struggling in *Organization* to escape his masters, to avoid what Deleuze calls the cliché?

> There is a first, prepictorial figuration: it is on the canvas and in the painter's head, in what the painter wants to do, before the painter begins, in the form of clichés and probabilities. This first figuration cannot be completely eliminated; something of it is always conserved. But there is a second figuration: the one that the painter obtains, this time as a result of the Figure, as an effect of the pictorial act.[40]

For Deleuze, the physical act of making a painting allowed Bacon some escape from art history. But the painting cannot be just any painting; it must be a painting of the figure, for only the encounter with flesh can

inspire the painter to an equal physicality in his own act, the result of which will be a new image of the body: "The body without organs," writes Deleuze, referring to one of his best-known concepts, "is opposed less to organs than to that organization of organs we call an organism."[41] It is a body without structure, composed only of rhythms and spasms, nerves and flesh (fig. 41), more animal than human. It is, above all, *disorganized*: "The face lost its form by being subjected to the techniques of rubbing and brushing that disorganize it and make a head emerge in its place."[42]

We could not be farther, it seems, from *organization*, from Gorky's *Organization*. Deleuze criticizes geometric abstract painting, citing the example of Mondrian, because "the abstract forms are part of a new and purely optical space that no longer even needs to be subordinate to

FIG. 42
Detail of *Organization* (plate 66),
center, right

FIG. 43
Detail of *Organization* (plate 66), center,
right

manual or tactile elements."[43] But this is a misreading of Mondrian's work, one that (in fairness to Deleuze) was common until a Mondrian retrospective in 1994 demonstrated the importance to his work of specific physical surfaces and obsessive revising labor.[44] If, as Deleuze asserts, it is "manual labor" and "manual traits" that allow the figurative artist to escape previous pictorial conventions,[45] then he should grant the same emancipating possibility to an equally physical but more abstract painting such as *Organization*.

Let us take a closer look at the physical character of *Organization*. It is marked by sets of oppositions. First, there is the contrast between brushed areas and those where paint has been applied with a palette knife, leaving a smooth surface (fig. 42). These latter, reading from left to right, include the red rectangle at far left, the irregular white vertical shape to its right, the yellow polygon with red-and-black target to *its* right, the tall white rectangle to *its* right, the pinkish shape that cradles the upper right side of the black biomorph, and the gray semicircle within the brown polygon. Other areas are brushed (except for the large yellow rectangle at right, which is both brushed and knifed), but these too can be divided (fig. 43)—into areas of enamel-like paint that

do not hold fine traces of brushwork (the green shapes, the blacks, the brown) and areas of apparently more standard oil paint that do (the whites, yellows, grays, and oranges, except where they have been knifed on). A third opposition is between areas in which underlayers are visible (this includes knifed areas, like the yellow rectangle, which has green visible beneath it, and brushed areas, such as the gray-over-green contour below the signature; fig. 44) and, more commonly, areas where the paint is opaque. Another set of oppositions concerns the treatment of edges. Some interfaces of shapes are clean and sharp, as between the brown shape and its gray semicircle (which Gorky seems to have added on top of the brown by painting against a template, leaving a raised ridge of gray); between the same brown shape and the green one to its left; and between the black quadrilateral at left and both its gray outline and the yellow circle that interrupts it. In most other cases, interfaces are rough. Another opposition occurs between edges created by a contour line and those created by the direct conjunction of shapes. This opposition aligns with the previous one in some cases (conjunctions imply clean edges; contours imply rough edges), but not all, as the thick gray contour (the one around the black

shape) nicely demonstrates: it has a smooth interface with the black shape inside it, and a rough one with the white shapes outside it (fig. 45). Yet another opposition is found between areas where there is a marked difference in relief (many of the whites as well as the black biomorph are raised in relation to their neighbors) and those that are in plane with one another. And so on.

These oppositions are not different in kind from those that Deleuze found in Bacon: "As for the textures, the thick, the dark, and the blurry, they are already preparing for the great technique of local scrubbing… with a rag, whisk broom or brush…. [T]he rest of the painting is systematically occupied by large fields…of bright, uniform, and motionless color."[46] But with Bacon, the situation is much simpler: there are two basic kinds of textures, and they are assigned to the figure and its field, whereas in Gorky a whole mechanism of textural difference is deployed to cancel the figure-field distinction, and in particular to prevent the many whitish areas from becoming mere neutral background.

To return to our question: How might this sort of manual labor have helped Gorky to escape the artists in which he had steeped himself? In Bacon's case, Deleuze cites the violence and randomness of mark making as liberating; in Gorky's case, it is perhaps the sheer plurality of surface. Mondrian had a particular kind of touch in the late 1920s, Picasso another in the 1927–28 paintings we have considered, but in *Organization* Gorky has many. He may have claimed to a fellow painter that he built up his layers to achieve "a surface smooth, like 'glahss,'" but in fact he achieved many surfaces in *Organization*, none of them glassy.[47] The same logic of crossing that we have seen in Gorky's use of visual models applies when it comes to factural ones. Thus his surface both is and is not like Picasso's: *Organization* employs the dragged textures characteristic of *The Studio*, but that painting is quite thin and unlabored, while Gorky's is the opposite. In fact, in *Organization* Gorky adopted a practice of layering taken from Mondrian— whose fields are often visibly built of multiple strata, one brushed horizontally, another vertically—but without Mondrian's suave final surface. Once again, what results in *Organization* is a crossing of wires that appears both incoherent and deliberate.

FIG. 44
Detail of *Organization* (plate 66), far right

FIG. 45
Detail of *Organization* (plate 66), center, left

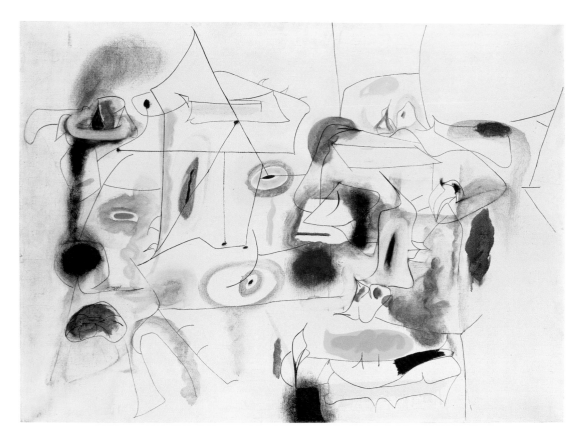

FIG. 46
Arshile Gorky, *Child's Companions*,
1945. Oil on canvas, 34⅛ x 46⅛ inches
(86.7 x 117.2 cm). Private collection.
Courtesy of Massimo Martino

Germ

Does anything emerge from this labor, other than the pale freedom of mutual cancellation? For Deleuze's Bacon, the answer is yes: "A probable visual whole (first figuration) has been disorganized and deformed by free manual traits that, by being reinjected into the whole, will produce the improbable visual Figure (second figuration)."[48] *Disorganization* is not the right word for Gorky, however. His operation, whether on sources or textures, is one of sustained opposition; its contradiction is methodical. Finding a dialectical payoff to this labor of opposing and crossing might be too much to hope for (although it is just what Deleuze claims for Bacon—the destruction/re-creation of the figure). What does emerge for Gorky, at least, is something personal, something that Deleuze calls "a germ of order or rhythm."[49]

Several features of *Organization* are germinative for Gorky's later work. One might point to a characteristic rhythm, a matter of hairpin curves and attenuated forms; or to a particular compositional schema involving a figure-cum-*repoussoir* in the near foreground looming over a centered horizon; or to the use of probing, sensing lines and associated targets that turn the composition into a kind of neural network

(as, for example, in Gorky's *Child's Companions* of 1945; fig. 46). The curator Diane Waldman found "a new openness...evoked by the areas of white which suggest expansion and the separation rather than the overlapping of forms. The punctuation of the surface with widely dispersed forms of varied shape, size and color [is] the first instance of what Gorky would later call 'spotting.'"[50]

But none of this is what Deleuze means by "germ." His concept is not so different from the traditional idea of a painter's touch: it is (in the case of his description of van Gogh) "the set of straight and curved hatch marks that raise and lower the ground, twist the trees, make the sky palpitate."[51] This touch, this fundamental manual procedure, is found in an encounter with the medium so physical as almost to deny vision altogether: "The fact itself, this pictorial fact that has come from the hand, is the formation of a third eye, a haptic eye," writes Deleuze in the penultimate sentence of his book.[52] Something of this invasion of the optic by the haptic can be sensed in Picasso's *Painter and Model*, not only in the shadows and eclipses wedged throughout the scene but in the way the artist grasps the focal cone of his own gaze at its double vertex.

In *Organization* the germ emerges, appropriately, at a climax of physical resistance, namely, where Gorky has painted and repainted the wide contour lines that define so much of the painting. These lines are made by a different kind of layering than the color planes, where paint is generally slathered on so as to hide the underlying field. In the contours, on the other hand, the brush drags over the previous line underneath as it redraws it, leaving it partly visible. Look at the black horizontal line in the center of the canvas (fig. 47); this rough texture is simultaneously a matter of vision (irregular edges) and touch (bumpy relief). The line, in a word, is ragged, and the reason seems to be that the weave of the canvas, rather than being hidden, gets preserved and magnified with each subsequent stroke, as paint collects on the tops of the threads and dries before the next campaign. (What suggests the expression of the canvas weave is the regularity of the bumps along these lines.) This roughened texture is characteristic of Gorky's work through the early 1940s, when his discovery of other tools (the liner brush of the sign painter; the dilution possible with turpentine) led to other, opposite surfaces and methods.

These lines are the locus of another kind of stratification as well: they are where Gorky's sources most visibly pile up. The lines, considered compositionally, carry and condense many of the models behind the painting, doing triple or even quadruple duty. When dropped vertically and ended with a solid black circle, they recall Picasso; when run horizontally or vertically with no end stop, they recall Mondrian; and when the end stop is an open circle, they recall Picabia (several of the lines in *De Zayas! De Zayas!* terminate or connect in small circles). Above all, perhaps, they recall the sketches of Stuart Davis, whose diagrams of pictorial structure and "angle theory" from 1932 used just such elements: angled lines linked by circles open and closed (fig. 48). Compared to Picabia's, Davis's sketches constitute another kind of diagram, a mechanics of vision and composition. No doubt he would have tried them out on Gorky, if only on napkins or scraps of paper. In adopting their vocabulary, Gorky was paying tribute to a fellow artist who had also attempted to conjoin structure and free association, work and play, in the unlikely meeting of an eggbeater, an electric fan, and a rubber glove. But that is another story.

FIG. 49
Detail of *Organization* (plate 66), center, top

FIG. 50
Detail of *Organization* (plate 66), center, left

Chorus (Circles)

There are many circles in Gorky's painting. More than any other element, they organize our scan of the surface of the canvas, punctuating our visual tour, advancing and receding, expanding and contracting, popping and winking. They insist on being noticed. One of them, the one within the beaked, birdlike form at left, must represent a blank eye. Three of them are circles within circles, and thus targets, termini of vision. If we push this thematics of vision just a little further, they are all eyes. In Davis's inscription on his sketch, the open circles represent the "two sources of observation" necessary to "good drawing." What kind of drawing is produced by eight such sources or circles? These eye holes are the *disjecta membra* of earlier states in which the painter gazed across the easel at his canvas. Just as the figure at left has been dissected and displaced or spread (the pinkish shapes, suggesting flesh, float free of the body, as does the black biomorph), so have its organs of vision. The painting is an image of vision set loose—of scopophilia, the drive and desire to look that in psychoanalytic theory both precedes and ultimately triggers genital organization. Vision as desire. The organic eye.

Turn vision the other way and the circles become windows. They have been there for a long time. The three within the central white rectangle are visible in the first photograph, the painting's first state (see fig. 32). Accordingly, they are recessed in the topography of the surface, testifying to their priority. In the final composition, one small circle is divided in two, into white and gray areas, making its window function explicit (fig. 49); it is as if we are getting a small piece of a large compositional division that no longer exists. The same kind of division, registered more subtly, can be found in the small white circle within the yellow ovoid (fig. 50). These windows offer glimpses into the past of the painting, laying bare the labor that went into its making. The painting, no longer seeing, allows itself to be seen, if we are close and diligent observers. Vision as work. The ergonic eye.

FIG. 51
Detail of *Organization* (plate 66), upper
left edge, photographed at an angle

71

TO ORGANIZE PAINTING

But of course these oppositions do not hold. The windows make us voyeurs, delivering to us the sheer pleasure of a crisp, ancient brushstroke. The eyes organize themselves, connecting to one another via rods and pistons in a propulsive, misguided machine.[53] Arp reminds us that the circles are not eyes, or not just eyes—they are navels. This suggests a childish sexual interest, a pregenital pseudo-orifice, and behind that a creation myth, a prenatal tie. But these are not the only associations that psychoanalysis has to offer:

> There is often a passage in even the most thoroughly interpreted dream which has to be left obscure; this is because we become aware during the work of interpretation that at that point there is a tangle of dream-thoughts which cannot be unravelled and which moreover adds nothing to our knowledge of the content of the dream. This is the dream's navel, the spot where it reaches down into the unknown.[54]

Here is another kind of organization, one predicated on impossibility, a tangle that hangs together because it cannot be undone. The circles of *Organization* offer a teasing transparency that does not really open up; the layers of the painting are too thick to be unteased, just as its sources are too contradictory to be unpacked. These impossibilities may be suggested by the navels of the painting, but they become thematized just where vision is most explicitly rendered, in the black eye mask at upper left, oddly divided or broken in two and showing just enough through its slits to interest us in what lies behind (fig. 51). Like the smile of the disappearing Cheshire Cat, this mask is all that remains of the insect-eyed head that dominated earlier studies and states—the vicissitudes of the figure come to rest. Its bravura black strokes, which sit up on the surface and whip around the forms, were Gorky's final touch to the canvas, or such at least is my fantasy. In their jaunty disarray (but not disorganization), they are the index of a hand that moved with pleasure, an eye that narrowed, and a body that all but disappeared.

I thank Sarah Boxer and Yve-Alain Bois for their comments on the manuscript of this essay; John Delaney and Jay Kreuger for helping me understand the structure of the painting; and the New York Studio School for inviting me to present an earlier draft as a lecture.

1. Selden Rodman, *Conversations with Artists* (New York: Devin-Adair, 1957), p. 109; quoted in *Franz Kline: Black and White, 1950–1961* (Houston: Houston Fine Art Press, 1994), p. 9.

2. Matthew Spender, *From a High Place: A Life of Arshile Gorky* (New York: Alfred A. Knopf, 1999), pp. 139, 141.

3. Gorky considered several possible names; see Hayden Herrera, *Arshile Gorky: His Life and Work* (New York: Farrar, Straus, and Giroux, 2003), pp. 118–19. He also experimented with the spelling of Arshile.

4. The title is not inscribed on the painting, but in the absence of evidence to the contrary, we can assume that it was his.

5. Mondrian also availed himself, less frequently, of *Tableau, Compositie, Painting,* and *Gemälde,* depending on where the work was to be exhibited.

6. Gorky told the dealer Julien Levy in the winter of 1932–33: "I was *with* Cézanne for a long time, and now naturally I am *with* Picasso"; Levy, foreword to William C. Seitz, *Arshile Gorky: Paintings, Drawings, Studies,* exh. cat. (New York: The Museum of Modern Art, 1962), p. 7.

7. The American abstract painter Lorser Feitelson (1898–1978) titled a 1959 painting *Dichotomic Organization* (private collection), and František Kupka titled a 1912–13 painting *Localisation de mobiles graphique II* (National Gallery of Art, Washington, D.C.), which for many years has been poorly translated as "Organization of Graphic Motifs II." No doubt there are other scattered instances of titles that make reference to the concept of organization. In 1939 Peter Busa exhibited a painting titled *Organization* at the New York World's Fair. For a reproduction, see *American Art Today: New York World's Fair* (New York: National Art Society, 1939), p. 52, fig. 70. The painting is an abstracted still life resembling contemporaneous paintings by Gorky and David Smith. In an interview with Dorothy Seckler on September 5, 1965, Busa related the title to his opposition to a Marxist separation of form and content in art, citing Gorky and Davis (with whom he was close) as standing up for the same idea. Given this, it seems likely that Busa was inspired by Gorky's use of the same title. See the Web site for the Smithsonian's Archives of American Art, http://www.aaa.si.edu/collections/oralhistories/transcripts/busa65.htm (accessed April 6, 2009). My thanks to Kathleen Krattenmaker for this discovery.

8. In his important essay for the catalogue raisonné of Gorky's paintings, Jim Jordan often attends to Gorky's titles but fails to note the willful oddity of *organization.* Quite the contrary: "Such titles as 'Organization' and 'Composition,' and sometimes numbers, seem to have been used informally, probably inconsistently by Gorky at this time…. Perhaps Gorky still hesitated to search for titles of poetic expression, being unsure just how personal and provocative titles should be. He still had as a model not only the poetic Surrealists and Graham, but Picasso, who apparently was indifferent to titles. Titles

resembling 'Composition' and 'Organization' had been used not only by Mondrian but by the Expressionist Kandinsky." Jim M. Jordan, "The Paintings of Arshile Gorky: New Discoveries, New Sources, and Chronology," in Jordan and Robert Goldwater, *The Paintings of Arshile Gorky: A Critical Catalogue* (New York: New York University Press, 1982), p. 47; also p. 72.

9. Arshile [spelled Arshele] Gorky, "Stuart Davis," *Creative Art* 9, no. 3 (September 1931), p. 213; quoted in Herrera, *Arshile Gorky: His Life and Work,* p. 217.

10. Typescript created from conversations with Gorky and an unknown interviewer about his proposed mural for the Newark Airport, Newark Museum Library; reproduced in Herrera, *Arshile Gorky: His Life and Work,* pp. 679–80.

11. Arshile Gorky, "My Murals for the Newark Airport: An Interpretation" (1936), in *Art for the Millions: Essays from the 1930s by Artists and Administrators of the WPA Federal Art Project,* ed. Francis V. O'Connor (Greenwich, Conn.: New York Graphic Society, [1973]), p. 73. Gorky's text is also reproduced in Ruth Bowman, *Murals without Walls: Arshile Gorky's Aviation Murals Rediscovered,* exh. cat. (Newark, N.J.: Newark Museum, 1978), pp. 13–16.

12. In addition to the painting under consideration here, there is a *Nighttime, Enigma, and Nostalgia* painting also called *Organization* (c. 1933–34; plate 54), and another painting, from a small 1936–37 series, called *Organization No. 2* (private collection). The title *Organization No. 4* (1931) appears in the checklist of the First Municipal Art Exhibition, Rockefeller Center, New York, in 1934, but it is not clear which painting this is. See Jordan and Goldwater, *The Paintings of Arshile Gorky,* pp. 250, 320, 549.

13. My thanks to Kristin Romberg for alerting me to this usage.

14. In one of his few statements about Freud, Gorky evinced resistance to (as well as acknowledgment of) a principal tenet of his theory, the universality of the Oedipus complex. "Since I, as a son, cannot kill my father—that is, my past, the past of art—then I have to die because I am born to art and cannot deny my father and cannot murder him." Milton Resnik quoting Gorky in an interview with Karlen Mooradian, New York, July 21, 1966, cited in Mooradian, *The Many Worlds of Arshile Gorky* (Chicago: Gilgamesh, 1980), pp. 192–93.

15. A good, brief discussion can be found in Jean Laplanche and J.-B. Pontalis, *The Language of Psycho-analysis,* trans. Donald Nicholson-Smith (W. W. Norton., 1974), p. 289 ("Organisation of the Libido"); originally published as *Vocabulaire de la psychanalyse,* 4th ed. rev. (Paris: Presses Universitaires de France, 1973).

16. Spender suggests that Gorky's "intensely physical" painting process was partly a response to accusations by his father and half-brother that painting, compared to "a day spent in the factory or plowing a field," was "nonwork"; Spender, *From a High Place,* p. 76.

17. Gorky's second wife, Agnes Magruder (Mougouch), observed in a letter to Hayden Herrera on December 9, 1972: "I can find the source of almost *all* of Gorky's erratic dictums in Graham." See Herrera, *Arshile Gorky: His Life and Work,* pp. 178, 662.

18. Marcia Epstein Allentuck, ed., *John Graham's System and Dialectics of Art* (Baltimore and London: Johns Hopkins Press, 1971), p. 96.

19. Ibid., p. 97 (the italics are Graham's).

20. Ibid., pp. 194–95.

21. Quoted in Frank O'Hara, introduction to *David Smith,* exh. cat. (London: Tate, 1966), p. 7; also Allentuck, introduction to *John Graham's System and Dialectics of Art,* ed. Allentuck, p. 17.

22. On the weight of Gorky's paintings, see Spender, *From a High Place,* pp. 172–73.

23. See Lawrence Gowing, "The Logic of Organized Sensations," in *Cézanne: The Late Work,* ed. William Rubin, exh. cat. (New York: The Museum of Modern Art, 1977), pp. 55–71, esp. p. 62.

24. Spender, *From a High Place,* pp. 153, 161. Mougouch described Gorky as "a Stalinist to the end…. Stalin was for him a father figure, inviolable. Gorky's Stalinism was very primitive and childlike." Gorky gave Mercedes Carles books on Marx and Lenin, and his library included Mikhail Lifshits, *The Philosophy of Art of Karl Marx* (New York: Critics Group, 1938). See Herrera, *Arshile Gorky: His Life and Work,* pp. 256, 258.

25. After writing this, I was happy to find a similar view espoused by Matthew Spender: "The word 'organization' was in the air. The American Communist Party was urging all workers to 'get organized,' join trade unions and bargain collectively with the capitalist bosses. In taking the word for a title, perhaps Gorky meant that the only organization he himself was interested in was shapes and colors on canvas." See his catalogue entry for *Organization No. 2,* in David Sylvester et al., *Arshile Gorky: Paintings and Drawings, 1929–1942,* exh. cat. (New York: Gagosian Gallery, 1998), p. 32.

26. Gorky went to see *Cubism and Abstract Art* and was particularly impressed by Picasso's *Seated Woman* (1927) and *The Three Musicians* (1921). See Herrera, *Arshile Gorky: His Life and Work,* p. 181.

27. Ibid., p. 218.

28. Diane Waldman, "Arshile Gorky: Poet in Paint," in *Arshile Gorky, 1904–1948: A Retrospective,* exh. cat. (New York: Harry N. Abrams in collaboration with the Solomon R. Guggenheim Museum, 1981), p. 42. Waldman's brief analysis of the painting, to which we will return, is more nuanced than her conclusion would suggest.

29. Allentuck, *John Graham's System and Dialectics of Art,* p. 17.

30. Gilles Deleuze, *Francis Bacon: The Logic of Sensation,* trans. Daniel W. Smith (Minneapolis: University of Minnesota Press, 2004), chap. 11 ("The Painting before the Painting"), p. 71; originally published as *Francis Bacon: logique de la sensation* (Paris: Éditions de la Différence, 1981).

31. Balcomb Greene reported that in response to the protests of his friends, Gorky "denied" that his "masses of pigment" would one day crack; see Waldman, "Arshile Gorky: Poet in Paint," p. 41.

32. The former had been acquired by the Museum of Modern Art from the Valentine Gallery in 1935, and the latter, which would also end up at MoMA, was in the home of Harriet and Sidney Janis, a gathering spot for New York artists.

33. The A. E. Gallatin Collection, then in the recently opened Gallery of Living Art at New York University, an easy walk from Gorky's studio, also held paintings by Mondrian, but not one of this type.

34. The exercise works particularly well if one also crops several inches off the left side of the picture, so that the small gray quadrilateral at lower left anchors the corner. In addition, many of the horizontals and verticals in the painting are not true.

35. "References to the concrete object consist of a rubber horn, wheels, discs, and of many rigid bars spanning gaps and linking elements of the structure together. In some of the studies the bicycle chain loops freely and eccentrically through the center of the composition; the horn and handlebars are also disposed in no actual structural relationship to the other parts." See Eliza Rathbone, unpublished paper on *Organization*, January 1985, in the files of the Department of Modern and Contemporary Art, National Gallery of Art, Washington, D.C. Rathbone also suggests that the masklike head may relate to Stuart Davis's painting *Salt Shaker* of 1931 (The Museum of Modern Art, New York).

36. Compare David Smith's sculpture *Interior* of 1937 (Weatherspoon Art Museum, University of North Carolina at Greensboro), which represents a photographer taking a picture of a sculpture on a studio table. Karen Wilkin, *David Smith: Two into Three Dimensions*, exh. cat. (Miami Beach: Grassfield Press, 2000), p. 33. Even closer to *Organization*, and perhaps inspired by it, is Smith's *Interior for Exterior* of 1939 (private collection on loan to the Carnegie Museum of Art, Pittsburgh). These examples, together with earlier linear sculptures by Picasso and Giacometti, bring out the sculptural aspects of *Organization*, albeit sculpture of the drawing-in-space variety.

37. In the large study for *Organization* (plate 64), what would later become the central black biomorph took the form of a simply outlined bird, facing left and appearing to peck in the direction of the figure with the mask head and circuit breasts. By the time of the second photograph of the painting in progress (see fig. 33), the bird had migrated into the figure itself, whose torso is composed of two interlocking bird forms, both again facing left. In the final state, the removal of one of the ball-stopped lines under this figurative compound leaves us with the even more birdlike suggestion of a creature standing on one leg. The inspiration for these forms seems to have been Max Ernst, in particular his painting *Monument aux Oiseaux* of 1927 (Musée Cantini de Marseille, France), which has also been proposed as a source for the right-hand group in Gorky's *Column with Objects* series of drawings of 1932–34; see Matthew Spender and Barbara Rose, *Arshile Gorky and the Genesis of Abstraction: Drawings from the Early 1930s*, exh. cat. (New York: Stephen Mazoh, 1994), p. 14. No doubt Gorky also studied the interlocking, single-eyed, macabre forms of Picasso's 1915 painting *Harlequin* (Museum of Modern Art, New York).

38. Adolph Gottlieb, preface to *Arshile Gorky*, exh. cat. (New York: Kootz Gallery, 1962); quoted in Seitz, *Arshile Gorky: Paintings, Drawings, Studies*, p. 20.

39. See Levy, foreword to Seitz, *Arshile Gorky: Paintings, Drawings, Studies*, p. 7.

40. Deleuze, *Francis Bacon*, chap. 11 ("The Painting before the Painting"), p. 79.

41. Ibid., chap. 7 ("Hysteria"), p. 39.

42. Ibid., chap. 4 ("Body, Meat, and Spirit: Becoming-Animal"), p. 19.

43. Ibid., chap. 12 ("The Diagram"), p. 84.

44. Yve-Alain Bois et al., *Piet Mondrian, 1872–1944*, exh. cat. (Boston: Bulfinch, 1994).

45. Deleuze, *Francis Bacon*, chap. 11 ("The Painting before the Painting"), pp. 79–80.

46. Ibid., chap. 1 ("The Round Area, the Ring"), p. 8.

47. See Jacob Kainen, "Memories of Arshile Gorky," in "Arshile Gorky," special issue, *Arts Magazine* 50, no. 7 (March 1976), p. 96. "Glahss" is Kainen's attempt to render Gorky's accent.

48. Deleuze, *Francis Bacon*, chap. 11 ("The Painting before the Painting"), p. 79 (Deleuze italicized this sentence).

49. Ibid., chap. 12 ("The Diagram"), p. 83.

50. Waldman, "Arshile Gorky: Poet in Paint," p. 42.

51. Deleuze, *Francis Bacon*, chap. 12 ("The Diagram"), p. 83.

52. Ibid., chap. 17 ("The Eye and the Hand"), p. 129.

53. In a recent appreciation in *The New Yorker*, Adam Gopnik referred to John Updike's "will to treat the organic mechanically." The same (and vice versa) could be said of Gorky. See http://www.newyorker.com/talk/2009/02/09/090209ta_talk_gopnik (accessed February 3, 2009).

54. Sigmund Freud, *The Standard Edition of the Complete Psychological Works of Sigmund Freud*, vol. 5, *The Interpretation of Dreams*, ed. James Strachey et al. (London: Hogarth and the Institute of Psycho-Analysis, 1953–74), p. 525.

"Flight from Reality"? A Reconsideration of Gorky's Politics and Approach to Public Murals in the 1930s

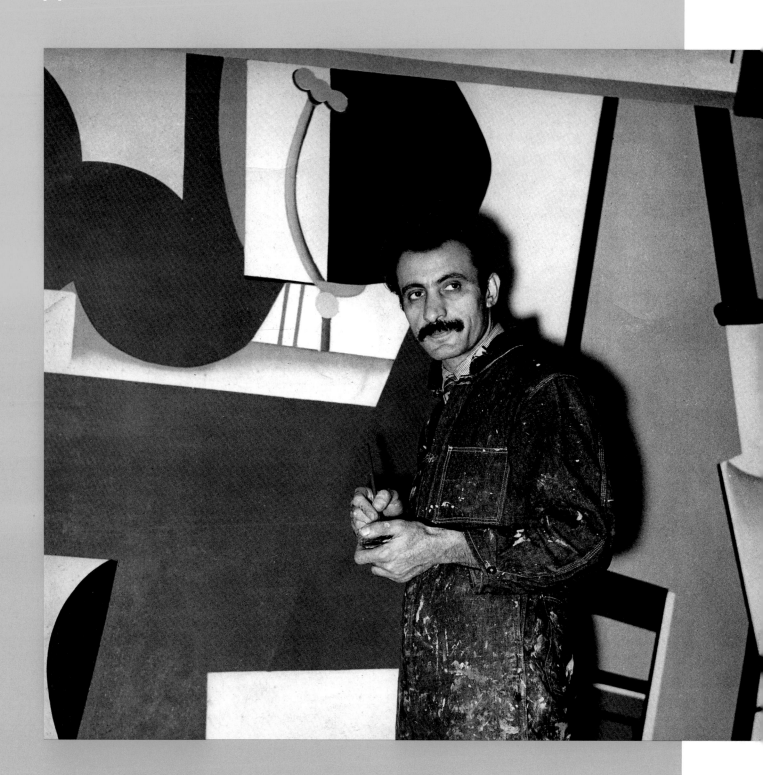

Among the first modernist murals created and installed under the aegis of the Works Progress Administration's Federal Art Project (WPA/FAP), a New Deal relief effort in the years 1935–43 aimed at easing the plight of unemployed artists, were those painted by Arshile Gorky between 1935 and 1937 for the Newark Airport Administration Building.[1] These murals have been discussed in the literature on the artist far less than they merit, probably for three primary reasons, most important among them the fact that histories of American modernism have consistently apportioned comparatively little space for analysis of the art of the 1930s. Another, related, factor is that when the cultural production of this period is mentioned, the use of modernist form is rarely accorded any sustained discussion and is eclipsed by a focus on more figurative tendencies, namely, those of American Scene, Regionalist, and Social Realist painting. And finally, as early as the 1940s the Newark murals were lost or destroyed, and the two remaining panels were not rediscovered until 1973.[2]

Gorky's murals, like his output of the 1930s in general, occupy a unique position within his oeuvre as a source of insight into the development of one of the quintessential American modernists. However, the extensive writing on the artist has been characterized by an overwhelming focus on the late paintings executed between 1943 and 1948, a period almost universally described as one in which he achieved maturity as an artist.[3] As Michael Auping noted in the catalogue accompanying an exhibition focusing on the works of the 1940s, symptomatically titled *Arshile Gorky: The Breakthrough Years*, "critics and historians have always acknowledged the importance of Gorky's works of the 1940s, generally downplaying his earlier imagery of the late 1920s and 1930s."[4] The reason for this, as he describes it, is that "important as the 1930s were to Gorky's eventual maturity as an image maker, they also constituted a low point in his…artistic struggles."[5] It was only after Gorky's tenure on the FAP that the assimilation of certain aspects of Surrealism already present in his works of the 1930s came to dominate his aesthetic, gaining him critical acclaim. Within the broader history of American modernism, it was these paintings of the 1940s, with their predominantly expressionist and lyrical style, that pointed toward Abstract Expressionism and so made it possible, not to mention desirable, to position the artist as an "umbilical cord between European Surrealism

and the development of Abstract Expressionism" and, accordingly, as a "cornerstone of the postwar achievement in modern art."[6]

My point here is not to refute such claims but merely to show how they demonstrate the widespread biases that have informed the history of American modernism as written. Critical assessments of Gorky's mural practice generally conclude, to use Harold Rosenberg's words, that "all through the thirties Gorky was a parodist and 'quoter'" and that, by extension, his murals were simply stepping stones on a developmental path culminating in his role as a "leading member of the New York School."[7] I would like to return to the Newark panels, however, in order to address the ways that Gorky responded, both formally and politically, to an era in which the cultural and ideological priorities informing artistic production were decidedly different from those that took precedence in the 1940s. Although he has consistently been characterized as having remained "detached from left-wing activities" during the politicized 1930s, there are signs to the contrary.[8] A reconsideration of Gorky's political perspective is in order for the light it may shed on his mural practice, a public art form that underwent something of a renaissance during the New Deal years and that was eagerly embraced by American leftists.

Gorky's tendency to obfuscate aspects of his personal life and subject details of his biography to an intricate process of embroidery means that determining his politics, or anything else about him, is not a straightforward process.[9] Yet while he remained something of an opaque character within the milieu of the New York art world, there is evidence that suggests he was far more interested in leftist political matters than previous scholarship would indicate. I believe that Gorky's Newark murals can be interpreted as achieving a sophisticated synthesis of modernism and realism, a synthesis that had political resonance at the time and was not unlike that practiced and theorized contemporaneously by his friend and fellow artist Stuart Davis.[10] While these may seem old issues, they have yet to be fully worked out, and in reassessing Gorky's political position and approach to public murals during the 1930s, I would like to offer an alternative to the still widespread scholarly tendency to polarize modernism and realism as antipodes on the aesthetic spectrum. Tellingly, this interpretive habit has been deployed within the context of a postwar art history that seeks to

FIG. 52

Gorky at work on the left panel of *Activities on the Field*, his mural for the Administration Building, Newark Airport, 1936. Courtesy of the Frances Mulhall Achilles Library, Whitney Museum of American Art, New York

FIG. 53
Arshile Gorky, *1934*, c. 1931–32. Pen and ink
on paper, 9½ x 29 inches (24.1 x 73.7 cm).
Private collection. courtesy of Christie's,
New York

establish a distance from the realist art of the 1930s and its overriding connections to Stalinist culture and politics. However, as the art historian Janet Wolff has recognized, "the opposition modernism/realism does not necessarily hold up in particular cases, nor is it always helpful as a general (or historical) framework for analysis."[11] Such a simplistic binary is misconceived, at least in the case of artists such as Gorky and Davis.

Like most artists during the 1930s, Gorky was deeply affected by the Great Depression and was quick to enroll in the short-lived Public Works of Art Project (PWAP; 1933–34), a New Deal relief initiative preceding the establishment of the FAP. During his brief time on the PWAP, he worked on studies for a mural project (unexecuted) that he suggested would be well suited for the "Port of New York Authority," the "Entrance to Museum of Peaceful Arts," or a "News Building... in mashinery [*sic*] dept."[12] Each laconically titled *1934* in the PWAP records (fig. 53; plate 44), the pen-and-ink sketches for this project fuse elements from his *Nighttime, Enigma, and Nostalgia* drawings and paintings (plates 42–49, 51–55), a series in which he had been engaged for several years and which owes clear formal debts to Hans Arp, Joan Miró, and André Masson.[13] The studies are characterized by a compartmentalized spatial structure and demonstrate Gorky's ability to combine an array of abstract, surrealist, and figurative motifs culled from across the history of Western art and from artists as diverse as Paolo Uccello, Pablo Picasso, and Giorgio de Chirico.

In a project card written two days after applying to the PWAP in December 1933, Gorky described his mural as follows:

My subject matter is directional. American plains are horizontal. New York City which I live in is vertical. In the middle of my picture stands a column which symbolizes the determination of the American nation. Various abstract scenes take place in the back of this column.

My intention is to create objectivity of the articles which I have detached from their habitual surroundings to be able to give them the highest realism.[14]

Gorky's reference here to "the determination of the American nation" should perhaps be understood as an attempt to link his work to the continuing economic crisis and as a means of appeasing project officials, who tended to prefer material that dealt with some aspect of the American Scene. Given that he was submitting a decidedly modernist work, his invocation of "realism" may have been framed by similar concerns, but the positioning of modernism *as* realism, a stance similarly espoused by Davis, was one that Gorky would subscribe to throughout the decade and one that, beyond merely enabling links with the dominant realist aesthetic and perhaps posing a challenge to the aesthetic prejudices of project administrators, had broader formal and political import for both artists.

Following his dismissal from the PWAP rolls, after only eighteen weeks of pay, when the program was halted in April 1934, Gorky "threw himself into organising against cuts and demonstrating for greater numbers to be hired."[15] Although he is never discussed as a leftist sympathizer, his personal library included a copy of André Salmon's *Art russe moderne* (1928), a well-illustrated overview of the variety of

FIG. 54 *top*
Workers' Cultural Festival handout with
Gorky's sketches on the verso, c. 1934.
Private collection

FIG. 55 *center*
Gorky at a protest march for the
Artists' Union, New York, October 1934.
Courtesy of Maro Gorky and Matthew
Spender

developments in twentieth-century Soviet art, and Mikhail Lifshits's *The Philosophy of Art of Karl Marx* (1938), published by the Marxist Critics Group in New York.[16] The latter text is of considerable importance in that it was a groundbreaking attempt to identify the philosophical premises of a Marxist aesthetics and "marked a turning point in Soviet thinking about art and culture," as Stanley Mitchell has noted.[17] What was perhaps particularly germane to Gorky's perspective on mural painting was Lifshits's contention that significant art was always *realistic*. In the words of Mitchell, without Lifshits "there would have been no Marxism that could counter the stereotyped naturalism that went under the name of Socialist Realism."[18]

Gorky's interest in leftist political activities is also suggested by some sketches he made on the back of a handout from the Workers' Cultural Festival (fig. 54), a gathering in Irving Plaza on December 21, 1934, jointly sponsored by the Communist John Reed Club and the Trade Union Unity Council. He also participated in leftist initiatives such as the Artists' Committee of Action and the Artists' Union. As fellow artists who formed Gorky's circle of acquaintances in the 1930s confirm, he "was in these things from the beginning."[19] Not only did he lecture on the topic of abstract and modern art at the Artists' Union and make his studio available for its meetings, but he participated in a protest march to City Hall in October 1934 in order to "dramatize what the Artists Union was," creating an "abstract tower so large—it was made of painted cardboard, had a wooden skeleton and wires—that six people had to carry it" (fig. 56).[20] A photograph shows Gorky at the march standing next to his construction and wearing a favorite sweater with a similar diamond pattern (fig. 55).

An enigmatic drawing that appears in one of Gorky's sketchbooks also indicates a concern with leftist politics (fig. 57).[21] The image shows what appear to be banners relating to a political demonstration that read: "Scrap this policy American imperialism," "Scrap metal petroleum products," and "450,000,000 people figting [*sic*] aggression." It is unclear whether these are Gorky's designs for banners to be carried in a political event or his recording of banners he observed, either by participating himself or by simply looking out his studio window at 36 Union Square. As the Federal Writers' Project, another branch of the

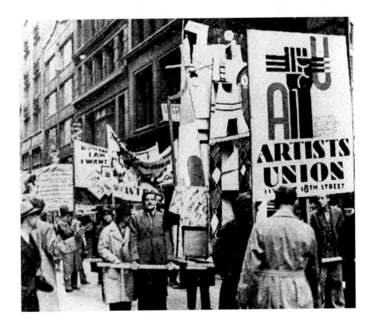

FIG. 56
Protest march for the Artists' Union, New York, October 1934. At center is Gorky's construction, an abstract tower made of painted cardboard over a wooden skeleton and wires. Courtesy of the Archives of American Art, Smithsonian Institution, Washington, D.C.

FIG. 57
Arshile Gorky, sketchbook page with image
of banners, c. 1937. Pencil and pen and ink,
12⅛ x 9⅞ inches (31.8 x 25.1 cm). The
Metropolitan Museum of Art, New York.
Bequest of William S. Lieberman, 2005

WAP, noted in its *New York City Guide* in 1939, during the Great Depression Union Square was "the heart of the city's radical activities" and was often the site of rallies and protests.[22] While it is impossible to know in what context Gorky drew the banners, they seem to reference the increasingly urgent political issues then arising in East Asia and are consonant with Communist perspectives on these matters.[23] I can only speculate on the meaning of such telegraphic phrases, but I would suggest that the first almost certainly refers to Comintern (Communist International) criticism of "American imperialism" in China, that is, attempts by the United States to maintain China's semicolonial status in order to ensure business and trade privileges in the increasingly unstable Pacific region.[24] During the early 1930s Japan had taken military control of much of northern China, and the United States was intent on thwarting the interests of a potential competitor for the world's most populous market. Interestingly, the population of China during the interwar years was estimated to be in the neighborhood of Gorky's "450,000,000," and this might account for those described as "figting aggression."[25]

In addition to the mounting rivalry between the United States and Japan, the period was marked by the rise of Communism in East Asia,

and the Comintern was naturally interested in strengthening its own position in the region. Further complicating matters, Japan signed the Anti-Comintern Pact with Germany in November 1936, raising the specter of a two-front war against the Soviet Union. The subject's topicality among New York leftists is attested to by Vanguard Press's publication in 1938 of Agnes Smedley's *China Fights Back: An American Woman with the Eighth Route Army*. Considered "the John Reed of the Chinese revolution for her tireless advocacy of the Chinese Communist cause," Smedley was a journalist who in 1937–38 accompanied the Chinese Red Army to the northwestern front, where the Japanese were attempting to drive a wedge between China and Soviet Russia.[26] *China Fights Back* was based on Smedley's diaries and letters, and the text offered readers a firsthand account of developments in the Chinese Soviet districts. Moreover, in December 1937 the American Artists' Congress, which subtitled itself "Against War and Fascism," mounted *An Exhibition in Defense of World Democracy, Dedicated to the Peoples of Spain and China*, and the following year participated in an exchange exhibition with Chinese artists "dedicated to the defense of their country against the Japanese invasion."[27]

All of this leads me to believe that the reference to "Scrap metal petroleum products" on Gorky's sketchbook banner refers to American exports to Japan. While the United States was hostile to Japanese military activities in China, the continuing depression meant that it needed the revenue from goods exported to Japan, whose rapidly expanding industrial economy was dependent on vast imports of raw materials from the United States, namely, scrap metal and petroleum products.[28] Thus, beyond their interest in China and their criticism of American foreign policy as predicated upon imperialist practices, Communists denounced the U.S. government for continuing to supply Japan with the raw materials it required to build its war machine. There was no question in their minds that Japan, like its German and Italian allies, posed a serious threat. The U.S. Communist party was thus demanding an "embargo [of] all shipments to Germany and Japan for the defeat of fascist aggression."[29]

While the surviving material evidence suggests that Gorky was indeed interested in leftist political matters, any attempt to make

conclusive statements about his perspective during the 1930s, or to establish a consensus around his thinking, is stymied by several factors, each of which contributes to the indeterminacy of what can only amount to conjectures about his life and work. Little in the way of archival documentation exists to shed light on his political views, and the matter has been further complicated by the fact that extracts from purportedly personal letters published by his nephew in three frequently quoted sources have now convincingly been shown to be forgeries.[30] As for Gorky's connections to Stalinist politics, it is known that his cousin Ado Adoian had risen high in the Soviet Communist party, and it can be surmised that the premature death of his mother in 1919 from starvation as a result of Turkish policies might well have made him sympathetic to the counterattacks of the Red Army.[31] However, even this supposition is called into question by the experiences of his sister Vartoosh, who repatriated to Soviet Armenia in 1932. There she witnessed firsthand how poorly Armenians were treated by the Soviet state under Stalin. Although she had urged Gorky to return with her to their homeland and "take his rightful place among the artists of the Revolution," he soon began receiving censored letters from her in which she hinted at hardship and repression and "begged him to 'make the best' of his life in New York."[32] Remarkably, although she hastily returned to the United States, she seems to have maintained her faith in the party, holding meetings of the pro-Soviet HOK (Hayasdan Oknoutian Komite, or Committee for Assisting Armenia) Progressive Party in Gorky's studio and leaving papers and books behind for him to read.[33] He seems not to have shared his sister's idealism about Soviet Communism, however, and was particularly disappointed that art under Stalin was "so backward."[34] His oft-quoted refusal to paint "poor art for poor people" should perhaps be rethought in this context as both a repudiation of the American trend toward what Davis dismissively called "domestic naturalism" and a rejection of the reactionary aesthetic orthodoxy enforced in the Soviet Union.[35]

Gorky's own rhetoric has been a major factor contributing to the belief in his putative apolitical stance of the 1930s. What has perhaps given him the veneer of seeming uninterested in political struggles is that he ardently refused to instrumentalize his art in the interests of propaganda, leftist or otherwise. As Jacob Kainen, a leftist art critic and expressionist painter who was a member of The Ten, one of the more progressive art organizations of the time, later observed: "The Depression had driven us to think of social change [and] in such an atmosphere a more than passing concern with aesthetics was tantamount to frivolity."[36] But while Gorky "attended Union meetings, served on committees, and spoke with much feeling on many issues," as his fellow modernist Balcomb Greene recalled, he maintained a deep respect for artistic autonomy and the importance of aesthetics and believed that social change should entail greater freedom of expression for artists, not less.[37] Greene, a leftist sympathizer, emphasized that the issue was partly one of autonomy, but unlike Gorky and Davis he understood the development of modernist form in terms of a strictly *internal* logic. This further confuses matters, because Greene's model of the artist's role, which he attributed to Gorky as well, was more elitist than either Gorky's or Davis's.[38]

While I would in no way make the kind of claims for Gorky's political commitment that I do elsewhere for Davis's—primarily because there is no evidence of Gorky engaging with Marxist theory as Davis did—I would maintain that he shared Davis's conviction that murals need not embrace reactionary formal conventions in order to participate in the broader social and cultural milieu.[39] Gorky certainly did not recognize leftist orthodoxy in the field of aesthetics, and, like Davis, he adamantly did not want his painting to serve as a form of illustration. In the case of mural practice, as in that of easel painting, he believed that artists should embrace the most sophisticated tools at their disposal, namely, those developed within the context of European modernism. As he wrote in a tribute to Davis published in the journal *Creative Art* in 1931, while there were "large numbers of critics, artists, and public suspended like vultures...[waiting to] hear of the sudden death of Cubism, abstraction, and so-called modern art," they were "doomed to disappointment."[40] Invoking discoveries in science, mathematics, and physics, Gorky argued that modernist form was "the new art of a new age."[41]

For Gorky, as for Davis, progress in artistic matters did not come from toeing the party line. As Kainen recalled, "Gorky had a deep feeling of responsibility to all vanguard art in the rough going of the

mid-thirties" and "believed in defending any advanced tendency, on principle."[42] Gorky's take on the relationship between politics and art was made explicitly clear in one of his notorious outbursts, in this instance directed at Charmion von Wiegand, a painter, fellow traveler, and art critic for the Communist journal *New Masses* and for *Art Front*, the organ of the Artists' Union.[43] After encountering Gorky in July 1937, von Wiegand reported to her husband, Joseph Freeman, himself a Communist writer, that "whe[n] he saw me, he let out a roar like a lion." She continued: "'Eh,' says he, 'so *now* Picasso is a great painter because he is for the Popular Front—you people make me sick. You are vulgarians. I will not speak of that idiot in the D[aily] W[orker]—it is a waste of time to talk with you. You praise that cheap little stealer [the Social Realist painter William] Gropper ahead of men who make history.'"[44]

While both von Wiegand and Kainen (the latter surely the "idiot" at the *Daily Worker*, New York's Communist newspaper) were decidedly pro-modernist in their artistic outlook, Gorky was enraged by their apparent about-face with respect to Picasso. To take Kainen first, he recalled that Gorky was "furious" about his rather patronizing review of James Thrall Soby's book *After Picasso* in the November 1935 issue of *New Masses*, in which he claimed that Paris was "barren" and that all that remained there was a "tradition of aesthetic nihilism."[45] After this, despite their friendship earlier in the decade, they saw increasingly less of each other. For Gorky, such narrow-minded judgments as Kainen's "had nothing to do with art" and merely "reflected the insensitivity of mass-minded social groups."[46] On July 9, 1937 (the

day before Gorky's outburst to von Wiegand), however, following the unveiling of *Guernica* at the Paris International Exposition—which placed modernist form in the service of the Popular Front, an international alliance of democratic and left-wing movements that came together in 1936 to fight fascism—Kainen opined in the *Daily Worker* that whereas Picasso's Cubism had only been "social protest by implication," he was now "returning to the masses" and was responsible for "the greatest contribution of modern times to the vocabulary of art."[47]

Von Wiegand, who despite her disdain for the FAP praised Gorky as "the only man who has done a fairly decent WPA mural so far," seemed to subscribe to an evaluation of Picasso that was in line with that promulgated by Kainen.[48] As she contended in *New Masses* on July 13 (again in the wake of *Guernica* and in the same week as her encounter with Gorky), while "the split between form and content in Picasso's work . . . makes his pictures so incomprehensible to the man in the street," his espousal of the Loyalist cause in Spain (which received support from Soviet Russia) "should awaken a new interest in his art."[49] The problem for Gorky was that while von Wiegand and Kainen readily acknowledged the importance of European technical advances in art, they did not accord modernist form any progressive significance in itself, requiring that it be infused with social and political content.

The issue of Picasso was a loaded one. Not only was he one of the artists whom Gorky, like Davis, held in particularly high esteem, but the centrality of Cubism to the painting of both men established a critical distance between their art and that of other modernists on the left

FIG. 58
Arshile Gorky and Wyatt Davis, *Mechanical Aspects of Airplane Construction*, 1936. Collage study for an unrealized mural for Floyd Bennett Field in Brooklyn. Location unknown

pursuing a more expressionist approach to form, the latter a stylistic tendency that characterized the paintings of Kainen and fellow members of The Ten and that was championed by von Wiegand.[50] The questions remain, then, How did the Cubist challenge to form and composition manifest itself in Gorky's murals, and, by extension, How did this constitute a form of realism, one with social and political import, no less?

Gorky's major commission for the FAP—the only one to be realized—was for a series of murals on the theme of aviation originally intended for the Administration Building at the new Floyd Bennett Field but later repurposed for the Newark Airport.[51] Opened in 1931, the now defunct Bennett airfield was located at the southeastern end of Brooklyn and was New York City's first municipal airport.[52] Named after the aviator who flew Admiral Richard E. Byrd across the North Pole in 1926, the airfield gained much public notoriety for the record-breaking flights that originated there. With frequent visits by famous pilots, such as Wiley Post, Howard Hughes, and Amelia Earhart, it became one of the most important airfields of its time, making Gorky's mural commission a particularly prestigious not to mention visible one.

Although the Bennett Field commission was to have been a single panel measuring 720 square feet, whereas the Newark project comprised ten panels covering some 1,500 square feet, Gorky's preparatory work for the earlier, unrealized commission served as the foundation for the panels he executed in Newark. These studies demonstrate his early efforts to synthesize aspects of realism within a Cubist idiom (fig. 58). The Bennett Field murals were to incorporate enlargements of photographs of airplanes and flight paraphernalia taken by Wyatt Davis (Stuart's brother) and Leo Seltzer with paintings designed by Gorky. This was the first time such a combination of elements had been suggested for a mural design, and the inspiration for collaging a variety of abstracted yet recognizable forms against a flat, undifferentiated ground may well have come from Stuart Davis's early mural efforts, such as *New York Mural* of 1932 (fig. 59), a painting that, one assumes, both Gorky and Wyatt Davis would have seen firsthand in the exhibition *Murals by American Painters and Photographers* at the Museum of Modern Art (MoMA) in New York that year. Additionally, the relationship between mechanical themes and modernist art practices was the subject of the

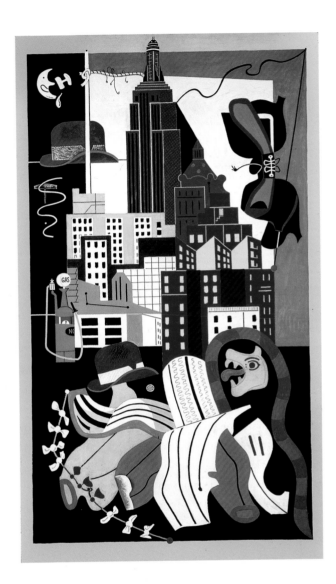

FIG. 59
Stuart Davis (American, 1892–1964). *New York Mural (Abstract Vision of New York: A Building, a Derby Hat, a Tiger's Head, and Other Symbols)*, 1932. Oil on canvas, 84 x 48 inches (213.4 x 121.9 cm). Norton Museum of Art, West Palm Beach, Florida. Purchase, the R. H. Norton Trust

FIG. 60
—
Arshile Gorky and Mayor Fiorello La Guardia at
the opening of the Federal Art Project Gallery,
New York, December 27, 1935. Courtesy of the
Frances Mulhall Achilles Library, Whitney
Museum of American Art, New York

Machine Art exhibition mounted at MoMA in the spring of 1934. Curated by the architect Philip Johnson and opened by Earhart, this show celebrated the kind of machine aesthetic championed by Fernand Léger, who singled out airplane propellers—one of which was featured in the exhibition—as modern forms that "strike everyone as being objects of beauty."[53] Léger, who was well known for his identification with the proletariat, paid several visits to New York during the 1930s, and his espousal of a "New Realism" grounded in modernist forms would prove particularly influential for Gorky and Davis throughout the decade.[54]

In December 1935, Gorky's design, along with a second by Eugene Chodorow for the same space, was submitted by the New York director of the FAP, Audrey McMahon, to MoMA director Alfred H. Barr, Jr., for his opinion.[55] Barr selected Gorky's modernist design over Chodorow's strictly figurative one, writing to McMahon that Gorky's plans were preferable "from almost any point of view except a purely conventional or academic [one]."[56] Yet despite Barr's approval, not to mention the support of Holger Cahill, the national director of the FAP, Gorky's murals were not destined for the walls at Bennett Field.[57] They

received approval all along the line, but the airfield was Mayor Fiorello La Guardia's "baby," and he did not particularly like Gorky's plans. Following Barr's letter to McMahon on December 3, one of Gorky's preparatory gouaches was shown at the opening of the Federal Art Gallery in New York at the end of the month. The mayor attended the opening and was decidedly unimpressed with what he saw (fig. 60). Although Gorky was enlisted to mollify him and offer something by way of an explanation and defense of modernism, the Bennett Field project was given to Chodorow, whose proposal, including a muscular image of Icarus, seemed to please La Guardia's more conservative tastes.[58]

Gorky's design was ultimately transferred to the second-floor foyer of the new Administration Building of the Newark Airport, an ultramodern complex equipped with the most advanced aeronautical technology. Designed to serve as a major passenger facility at what was ranked as the busiest commercial airport in the world by the end of the decade, the building was completed in 1935 under the Civil Works Administration, a short-lived work-relief program administered by the federal government.[59] The new structure was deemed an ideal site for murals, and by September 1936 preliminary approval was granted for Gorky to execute a ten-panel cycle titled *Aviation: Evolution of Forms under Aerodynamic Limitations*. However, following the showcasing of a completed panel, several gouaches, and a model at the Newark Museum, "the locals were," as Gorky's biographer Matthew Spender has described it, "hostile."[60] *The Newark Ledger*, for example, reproduced Gorky's panel with the headline "Goodness Gracious! Is Aviation Really Coming to This?"[61] Sarcastically referring to the panel as "this little gem," the writer sided with the baffled public: "If you look closely, you can distinguish what appears to be an airship tail at the left, but the rest of it has us stumped, too."[62] A rebuttal on Gorky's behalf was swiftly issued in the December 1936 issue of *Art Front* by the prominent modernist architect and theater designer Frederick Kiesler, who had befriended Gorky soon after his arrival in New York in the mid-1920s. The riposte, issued in the

form of mocking agreement with Gorky's detractors, drew attention to the distinction between naturalism and modernist form *as* realism: "Well, no abstraction, boys! Better go home and learn how to design wrinkles, and never mind wrinkles in an abstract way, but these must stick to nose and mouth and eyes and even ears."[63]

Despite the less than warm welcome Gorky received in Newark, he was permitted to proceed with the murals, completing the remainder of the *Aviation* panels by the summer of 1937. Like the majority of project murals, they were not made in situ but were instead painted in a studio provided by the FAP. As the New Deal scholar Francis V. O'Connor has observed, this way of working meant that "the formal relationship . . . between the architectural setting of a New Deal mural and the design of the painting intended for it, broke sharply with traditional—and especially 'academic'—mural practice."[64] This suited Gorky particularly well, as he opposed the view that murals were mere architectural embellishment and was adamant that "mural painting should not become architecture."[65] Not only did he rebuff "the interior decorator's taste in mural painting," where "everything must 'match,'" but he rejected the standard devaluing of the mural as a decorative adjunct and insisted on its pictorial autonomy.[66] Invoking the antinomy between the "decorative" and the "pictorial" that has been a mainstay of the modernist narrative, Gorky contended that "mural painting should not become part of the wall, as the moment this occurs the wall is lost and the painting loses its identity."[67] In adopting this stance, his views were entirely consonant with those of the French Cubist painters Albert Gleizes and Jean Metzinger, who argued that in order for painting to differentiate itself from decoration it needed to carry its raison d'être within itself—it must be "essentially independent" and "necessarily complete."[68]

But if Gorky raised the concept of pictorial autonomy to ward off the threat of "decoration," it proved more challenging to maintain a distinction between murals and easel paintings, given that his panels were, like 60 percent of the murals painted in New York under the FAP, executed in oil on canvas on a stretcher.[69] This "muralizing" of easel paintings was, according to Kiesler, caused by several key factors, including "the lack of material, the lack of proper wall preparation, the shortness of time, [and] the necessity for a 'mobile' mural painting due to short-lived building structures as a whole."[70] As a result, portable paintings that fused easel and mural techniques were created for the project, serving as a harbinger of the "large moveable pictures" of the postwar New York School that would, as Jackson Pollock put it in 1947, "function between the easel and the mural."[71]

The overall theme for Gorky's Newark murals was determined by project officials, whose brief called for panels on early developments in flight, modern aviation, the mechanics of flying, and activities in the field.[72] The formal approach to the iconographic program, however, was decidedly his own. And while he would have been all too aware of prescriptions for federal art that called for an "accessible" aesthetic employing some aspect of the American Scene—especially given Mayor La Guardia's earlier denunciation of abstraction as incomprehensible— he did not abandon the formal lessons of modernism, instead linking them to the more generally sanctioned concerns of realism. As Burgoyne Diller, the head of the New York Mural Division, noted at the time, Gorky's plan for the Newark murals "certainly had a good deal of [modernist] formal value, but at the same time it had enough of the objects—particularly, you know, recognizable, discussible by people concerned with aviation and so on."[73] As Diller observed, Gorky "never was completely a nonobjective painter."[74] It is to his formal repertoire that I now turn.

While Gorky's desire to abstract elements from nature and then subject them to processes of formal manipulation is usually discussed in relation to certain Surrealist precepts involving the dislocation and dissociation of discrete objects, his aesthetic strategy may also be understood to correspond with the theory of realism practiced by Davis, in which modernist strategies were deemed to be the only ones appropriate to a realist engagement with the contemporary world. Although Gorky's use of biomorphic forms in his paintings of the 1930s established clear links with the vocabulary of Arp and Miró, as Spender has provocatively observed, "No one has asked why [he] abandoned the dream imagery, ambiguous space, automatic drawing, and phantasmagorical erotic content of Surrealism for the mundane objectivity, flat space, and industrial iconography of the Newark Airport murals."[75] Indeed,

FIG. 61
Detail of *Study for "Activities on the Field,"* for
*"Aviation: Evolution of Forms under Aerodynamic
Limitations" (Newark Airport Mural)*, 1935–36
(plate 78)

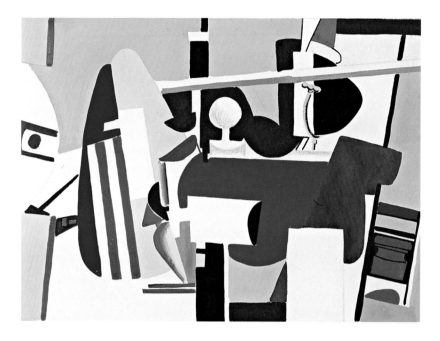

Gorky's easel paintings of the 1930s manifest a greater preoccupation with Surrealist techniques than do his murals, which leads me to wonder if he was making a critical distinction between the types of painting best suited to the interests of different audiences. For while he embraced what Spender describes as "a more down-to-earth" Cubist vocabulary in his murals, he would have been aware that Surrealism was being enthusiastically promoted within the gallery and museum worlds.[76] If Surrealism was frequently attacked by artists and critics on the left for its escapism, there were important dealers such as Julien Levy devoting major exhibitions to it, and it was given the official stamp of approval with the opening of MoMA's exhibition *Fantastic Art, Dada, Surrealism* in December 1936. As Kainen observed with more than a modicum of cynicism, although the Surrealists ostensibly championed an approach to painting "cellophaned from the infection of everyday existence," for artists living in a "dream world" they certainly managed "to keep a sharp eye cocked for business."[77] Thus, while Gorky astutely may have recognized that Surrealism served the predilections of the bourgeois art market, his murals manifest a different set of formal preoccupations. Bearing this distinction in mind, I would like to suggest that when it came to public art, his commitment to realism, albeit grounded in the lessons of the European avant-garde, took precedence over his interest in *sur*realism, both in terms of his formal concerns and with respect to his belief that murals constituted a social art that must appeal to a broad audience.

In a statement written for the PWAP in 1933, Gorky insisted that his use of modernist forms enabled him to engage directly with the contemporary world through the "highest realism."[78] While this stance would have helped allay charges of elitism and "un-Americanness" frequently mounted against modernist practices, I would argue that his insistence on the realism of his practice was not merely expedient but had broad sociopolitical resonance. Jim Jordan has noted Gorky's repeated use of the term *realism* to describe his murals, interpreting it as a reference to "Cubist literature of the Platonic tradition, [whereby] an analyzed object was thought to be more real than its 'accidental'

prototype in the visual world."[79] In contradistinction to Jordan's assertion that Gorky's was thus an essentializing "intellectual realism," I would suggest that his interest in positioning modernism *as* realism was in fact more materialist than idealist in its emphases.

Gorky's claim to be producing a realist art does require some explanation, given that his paintings, like Davis's, do not embrace the conventions of realism in the more traditional naturalistic sense. That being said, his panels for the Newark Airport, despite their dependence upon modernist artistic strategies, hardly constitute the "flight from reality" that some critics attributed to modernism.[80] Gorky's rejection of linear perspective, for example, with its "measurable space" and "clear definite shape[s]," in favor of a two-dimensional Cubist spatial framework and the aesthetics of collage, was a means of capturing the "new reality" of the contemporary urban environment, with its "intensity," "activity," and "nervous energy."[81] Rejecting the limitations of perspectival space and the mimetic artistic language of the past, he reproached the "weakness of the Old Masters," who believed that "their painting was complete when the outline of the object was correct."[82] He insisted that "the

FIG. 62
Fernand Léger (French, 1881–1955).
The City, 1919. Oil on canvas, 91 x 117½
inches (231.1 x 298.4 cm). Philadelphia
Museum of Art. A. E. Gallatin
Collection, 1952

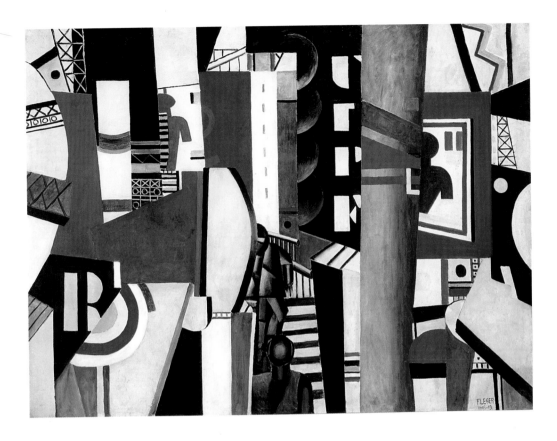

realism of Modern Painting is diametrically opposed to this concept, since the painter of today operates on the given space of the canvas, breaking up the surface until he arrives at the realization of the entirety."[83] While each element in the Newark murals was abstracted from photographs and thus culled from the "real" world, Gorky was not at all interested in merely mirroring nature and claimed to "oppose the photographic image."[84] In an effort to present "the real" in a visual language that reduced the structure of each element to a series of planar relationships, he insisted that "a plastic operation is imperative."[85] As he explained in relation to the Newark murals: "I dissected an airplane into its constituent parts. An airplane is composed of a variety of shapes and forms and I have used such elemental forms as a rudder, a wing, a wheel and a searchlight to . . . invent within a given wall space plastic symbols of aviation."[86] Presented in a flattened, schematic fashion that decontextualizes and denaturalizes them, these elements become isolated "plastic symbols" that function as pictorial equivalents for real objects such that the realm of the painting is rendered analogous to the exterior world.

While Gorky's formal vocabulary betrays the influences of Synthetic Cubism and Purist still-life painting, his use of bold, saturated colors contrasted with black and white, combined with the mechanical precision of his iconography, reveals significant debts to Léger, whom he met during the 1930s.[87] As others have discussed, *Activities on the Field* (plate 78; fig. 61), the most Légeresque of the Newark panels, is strikingly akin to Léger's cityscapes, particularly *The City* (1919; fig. 62), with its collage of predominantly flat shapes set within a shallow space and punctuated by modeled forms.[88] Both Gorky's painting and Leger's are compositionally complex and are characterized by juxtapositions of crisp verticals and diagonals, abrupt collisions of overlapping hard-edged planes, and sharp cuts from element to element. With respect to Léger's treatment of subject matter in *The City*, the art historian Christopher Green has observed that during this period the artist was interested in "no more than a generalized 'equivalence', not a specific 'likeness,'" which, I would assert, was exactly what Gorky was trying to achieve in his Newark murals.[89]

Jordan has offered a concise comparison of the two paintings,

FIG. 63
Stuart Davis (American, 1892–1964). *Egg Beater No. 4,* 1928. Oil on canvas, 27 x 38¼ inches (68.6 x 97.2 cm). The Phillips Collection, Washington, D.C. Acquired 1939

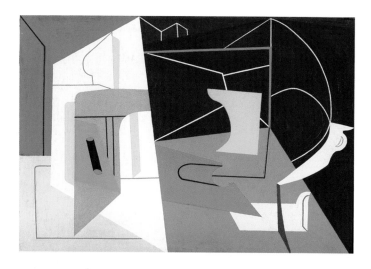

noting that, among other similarities, Gorky's expansive curves and decorative stripes in *Activities on the Field* match analogous forms in Leger's painting.[90] Gorky's stylized mechanic, for example, resembles the robotic figures descending the staircase in the center of *The City,* which even includes a flat, yellow propeller blade in its lower right corner. As Jordan points out, *The City* entered the collection of Albert Eugene Gallatin's Gallery of Living Art at New York University in early 1937, some five months after the final designs for the Newark murals were complete, thus making it unlikely that the painting itself was a direct, firsthand influence, although it is entirely possible that Gorky saw it when Léger first arrived in New York on the occasion of his exhibition mounted at the Anderson Galleries by the Société Anonyme in 1925.

Regardless, *The City* was one of Léger's best-known paintings and had been widely reproduced. Gorky was an avid reader of art publications, and a full-page color illustration of *The City* was found in his studio, replete with paint-stained fingerprints all around the margins.[91] We can thus be confident that he was looking at *The City* at some point while he was working. It is also well known that, as Harold Rosenberg phrased it, Gorky "memorized the shapes in reproductions as one might lines of poetry."[92] Given that he was such a "fervent scrutinizer" of paintings, he may well have studied Leger's enormous painting while working out his mural.[93] While *The City* is not technically a mural, it

measures more than seven by nine feet and thus would have suggested formal and compositional strategies for dealing with the grand scale of the Newark panels, the largest paintings Gorky had yet executed (the tallest panel measures approximately nine feet).

Although the visual evidence suggests that Gorky took direct inspiration from *The City,* his relationship to his sources is complex. As the original gouache and photomontage studies made for the Bennett Field mural in 1935 indicate, many of the compositional elements for *Activities on the Field* were based on Wyatt Davis's photographs, and the iconography is largely abstracted directly from the studies for this earlier collage. It could also convincingly be argued that Gorky's approach to the Newark panels was influenced by Davis's *Egg Beater* series (1927–28), paintings that Davis showed to Léger while he was in Paris and that the French artist apparently liked "very much."[94] As Diane Waldman has observed, "the urban, technological theme of the [Aviation] murals moved Gorky to search for appropriate new models," and she cites Davis among them.[95] Gorky was certainly aware of Davis's series. In his 1931 text on Davis in *Creative Art* he singled out the *Egg Beater* paintings as exemplary, and as offering "a new position upon the visible world."[96] I believe Davis's approach to modernist practices in the *Egg Beater* series, along with his paintings of the late 1920s and his early murals, would have offered Gorky formal solutions to the problem of transposing conventional elements into a modernist visual idiom for his airport mural.[97]

Both artists started their paintings with industrially produced three-dimensional objects—in Davis's case, an electric fan, a rubber glove, and an egg beater nailed to a table—and sought to deconstruct them into constellations of two-dimensional interlocking planes. For example, Gorky's *Mechanics of Flying* (1936–37; plate 84), like Davis's *Egg Beater No. 4* (1928; fig. 63), consists of flattened, fractured elements arrayed across the surface of the canvas in unmodulated, saturated colors, and both paintings have the look of collaged cut-outs set against an exceptionally shallow ground. Moreover, Gorky adhered to Davis's recommendation that in painting visual details must be eliminated in order to "strip [the] subject down to the real physical source of its stimulus."[98] Yet despite their largely abstract character, both

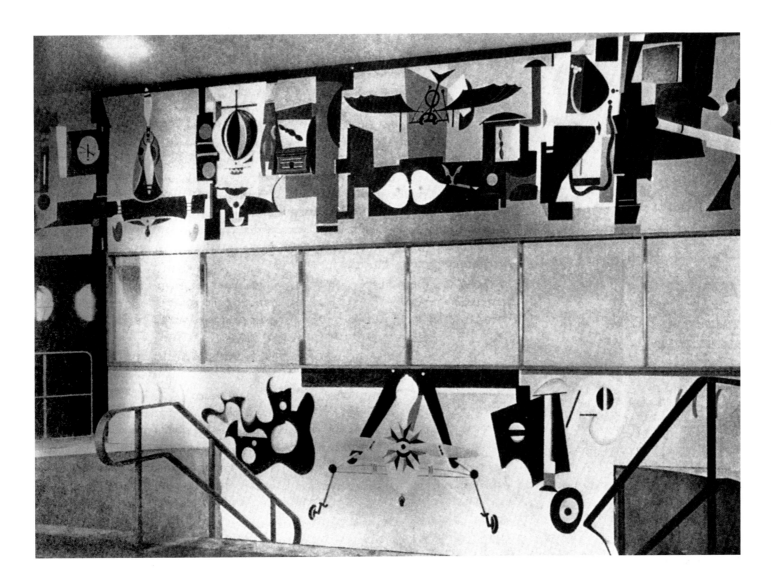

FIG. 64
Arshile Gorky, *Man's Conquest of the Air*, mural
in situ (since destroyed), Aviation Building,
New York World's Fair, 1939. Courtesy of the
Frances Mulhall Achilles Library, Whitney
Museum of American Art, New York

FIG. 65
Cover of the February 1936 issue of the
journal *Art Front* with the symbol of the
Artists' Union, a hand clenching a sheaf of
brushes, pictured over a map of the United
States. Courtesy of the Smithsonian
American Art Museum / National Portrait
Gallery Library, Washington, D.C.

FIG. 66
Announcement for the exhibition *We Like
America* published in the November 1938
issue of *New Masses* magazine. Courtesy of
the Smithsonian American Art Museum /
National Portrait Gallery Library,
Washington, D.C.

paintings maintain connections to the conventional still life in their
compositional structure, and each artist adamantly argued for the real-
ism of his approach. Davis claimed that while "the method of con-
struction was based on abstract theory, the picture itself was a concrete
visual image, capable of creating direct sensations of form and color in
exactly the same way as any accidental association of objects in nature
creates visual sensations."[99] Gorky similarly insisted that "these sym-
bols, these forms, I have used in paralyzing disproportions...impress
upon the spectator the miraculous new vision of our time."[100]

In his Newark murals, then, Gorky seems to have worked accord-
ing to the same formal procedure he outlined in his initial statement
for his unrealized PWAP mural: "My intention is to create objectivity
of the articles which I have detached from their habitual surroundings
to be able to give them the highest realism."[101] His murals therefore
merely suggest nonobjectivity, when in fact, as Kiesler affirmed, the
design is "very realistic" and basically adheres to a prescribed, repre-
sentational subject matter.[102] According to Gorky, this process of trans-
posing and translating representational subject matter into a modernist
vocabulary created a "new reality."[103] He later redeployed this strategy
in *Man's Conquest of the Air*, a mural he executed for the Aviation Build-
ing at the 1939–40 New York World's Fair.[104] This mural presumably
met the same fate as all the other mural commissions for the exposi-
tion and was destroyed along with the building it adorned when the
fair ended. It is known today only through a handful of sketches and a
surviving photographic postcard (fig. 64) that indicates two separate
friezelike panels installed over a staircase, though this is difficult to
ascertain as the photograph significantly crops the overall view.[105]
However, as even this scant visual evidence demonstrates, Gorky once
again relied on a Légeresque modernist "machine aesthetic" in a cata-
logue of imagery that closely follows that of the 1936 Newark panels.
The autogiro, for example, whose source lay in Wyatt Davis's photo-
graphs for the previous commission, assumes a central position in the
World's Fair composition, while elements such as searchlights, landing
gear, and flight paraphernalia appear in unaltered form.

What I am suggesting is that in his mural practice of the 1930s,
Gorky subscribed to the same kind of "realist" position adopted by

Davis and Léger, one that privileged the realism of the object over that of the subject. Gorky, too, sought to synthesize observation and abstraction in ways that indicate he saw art not as a tool for mirroring or illustrating nature, but as a way to register commonalities between the artistic realm and the world around him through analogy. Moreover, he shared Davis's and Léger's conviction that such "realist" mural painting had social implications and was ideally suited for a mass audience. Emphasizing the potential of murals to serve as a truly social art form, Gorky argued that mural painting could only serve in an educational capacity—rather than in a merely decorative one—if it ceased to offer to the public images painted "in a descriptive sense, portraying cinema-like the suffering or progress of humanity."[106] He argued that the masses had a right to enjoy the plastic forms of modernism: "Since many workers, schoolchildren, or patients in hospitals (as the case may be...) have little or no opportunity to visit museums, mural painting could and would open up new vistas to their neglected knowledge of a far too-little popularized Art."[107]

Regrettably, it seems that the "locals" still did not share Gorky's optimistic embrace of a new form of radical realism. As the *Aviation* murals neared completion, they were greeted with a barrage of criticism. According to the *Newark Ledger*, Gorky's "supposed conceptions" of airplanes merely "puzzled" the public, and visitors to the new Administration Building "were walking around in a daze...trying to decipher [the] series of startling murals."[108] In fact, once the murals were completed, final approval from the Newark Municipal Commission (established in November 1936) was nearly denied. As Davis recalled, "a local committee who had to approve them was hemming and hawing, and trying to find some valid excuse to reject them."[109] Davis and the New York FAP organized a delegation in defense of Gorky to "invade this benighted suburb and put the locals in their place."[110] Davis, the artist member of the delegation, later reported that "there was nothing to it after the first broadside fired by our oratorical Professors, Doctors and Experts. One of the locals quickly joined our side, and the rout was complete."[111] The delegation ensured that an official surrender on the part of the local committee was signed, and the

cavalcade "sped back victorious to the taverns of New York to celebrate."[112] This victory for Gorky's murals was short-lived, however. Of the ten panels installed at the Newark Airport, only two survive, *Mechanics of Flying* (plate 84) and *Aerial Map* (plate 85). Remodeling of the building by the Army Air Corps during World War II and subsequent alterations by the Federal Aviation Administration probably account for the loss of the eight others. The two surviving panels, from the east walls, were rediscovered in 1973 under more than a dozen layers of paint. Following their restoration, the Port Authority appointed the Newark Museum permanent custodian of the works, and they were unveiled to the public again in 1978 and remain on permanent view, recently re-restored.[113]

A further objection to Gorky's murals on the part of the Newark Municipal Commission concerned a five-pointed red star adorning the right-hand panel of *Activities on the Field*. The artist claimed the star was simply the symbol for the Texaco oil company, but it was a well-known emblem of the Soviet Union and a common symbol for communism.[114] Indeed, one has to wonder about Gorky's explanation. Spender has recently pointed out that in the *Aerial Map* panel Gorky surreptitiously included the symbol of the Artists' Union, a hand clenching a sheaf of brushes, which had been pictured over a map of the United States on the cover of *Art Front* in February 1936 (fig. 65).[115] In addition, the composition of *Aerial Map* is strikingly similar to a notice that appeared in *New Masses* in November 1938 announcing *We Like America*, its first annual art exhibition (fig. 66). While the notice appeared after Gorky had completed the mural, the choice of iconography, superimposing a palette and artists' tools over a map of the United States and adding a single pentagonal red star, seems unlikely to have been merely a coincidence and at the very least suggests that Gorky was using a visual vocabulary embraced by the left. Within a public and highly visible federal commission, he managed to execute a cycle of murals that engaged modernist forms in a sophisticated reconception of realism, while also, albeit subtly, expressing his solidarity with fellow artists on the left. These surely were not the actions and ideas of an artist whose approach to murals was totally apolitical.

I would like to thank Warren Carter and Andrew Hemingway for their insightful comments on the material discussed in this essay and for their continuing dialogue around these issues. I am also grateful to Michael Taylor and Kim Theriault for their invaluable input in the early stages of my research, and to Kathleen Krattenmaker for her editorial expertise.

1. For a history of New Deal programs initiated by President Franklin Roosevelt to foster economic recovery and provide work relief for those in need during the Great Depression, see Anthony Badger, *The New Deal: The Depression Years, 1933–1940* (New York: Palgrave, 1989). On the arts projects, see, for example, Richard D. McKinzie, *The New Deal for Artists* (Princeton, N.J.: Princeton University Press, 1973); Belisario Contreras, *Tradition and Innovation in New Deal Art* (London: Associated University Press, 1983); and Andrew Hemingway, *Artists on the Left: American Artists and the Communist Movement, 1926–1956* (New Haven and London: Yale University Press, 2002), pp. 75–100, 147–88. For a detailed study of Gorky's Newark murals that lays the groundwork for further discussion, see Ruth Bowman, *Murals without Walls: Arshile Gorky's Aviation Murals Rediscovered*, exh. cat. (Newark, N.J.: Newark Museum, 1978).

2. I am grateful to Michael Taylor and Kim Theriault for organizing the "Rethinking Arshile Gorky" session at the 2008 College Art Association conference in Dallas, which gave me an opportunity to present some of my thoughts on the *Aviation* murals and to benefit from their valuable comments.

3. The numerous monographs on Gorky explore his late works thoroughly, while conceding little space to those of the 1930s. See, for example, Ethel K. Schwabacher, ed., *Arshile Gorky Memorial Exhibition*, exh. cat. (New York: Whitney Museum of American Art, 1951); Schwabacher, *Arshile Gorky* (New York: Macmillan for the Whitney Museum of American Art, 1957); Harold Rosenberg, *Arshile Gorky: The Man, the Time, the Idea* (New York: Horizon, 1962); William C. Seitz, *Arshile Gorky: Paintings, Drawings, Studies*, exh. cat. (New York: The Museum of Modern Art, 1962); Julien Levy, *Arshile Gorky* (New York: Harry N. Abrams, 1966); and Fundación Caja de Pensiones and Whitechapel Art Gallery, *Arshile Gorky, 1904–1948*, exh. cat. (Madrid: La Caja, 1989). The murals are discussed in Harry Rand, *Arshile Gorky: The Implications of Symbols* (London: Prior, 1981), pp. 32–39, and Jim M. Jordan and Robert Goldwater, *The Paintings of Arshile Gorky: A Critical Catalogue* (New York: New York University Press, 1982), pp. 57–66.

4. Michael Auping, preface and acknowledgments to Dore Ashton, Michael Auping, and Matthew Spender, *Arshile Gorky: The Breakthrough Years*, exh. cat. (Fort Worth, Tex.: Modern Art Museum of Fort Worth in association with Rizzoli, 1996), p. 9.

5. Auping, introduction to Ashton et al., *Arshile Gorky: The Breakthrough Years*, p. 15.

6. Auping, preface and acknowledgments to Ashton et al., *Arshile Gorky: The Breakthrough Years*, p. 9; Jordan and Goldwater, *The Paintings of Arshile Gorky*, p. 7.

7. Harold Rosenberg, "Arshile Gorky: The Last Move," *Hudson Review,* Spring 1960, p. 104; Jordan and Goldwater, *The Paintings of Arshile Gorky*, p. 7.

8. Matthew Spender, "Gorky's Early Life," in Ashton et al., *Arshile Gorky: The Breakthrough Years*, n.p.

9. Gorky's brief and tragic life has spawned a number of biographies in recent years: Matthew Spender, *From a High Place: A Life of Arshile Gorky* (New York: Alfred A. Knopf, 1999); Nouritza Matossian, *Black Angel: A Life of Arshile Gorky* (London: Chatto and Windus, 1998); and Hayden Herrera, *Arshile Gorky: His Life and Work* (New York: Farrar, Straus, and Giroux).

10. I deal extensively with Davis's theory of realism and his approach to muralism in the 1930s in Jody Patterson, "Modernism for the Masses: Painters, Politics, and Public Murals in New Deal New York" (Ph.D. diss., University of London, 2008).

11. Janet Wolff, *AngloModern: Painting and Modernity in Britain and the United States* (Ithaca, N.Y.: Cornell University Press, 2003), p. 160. Other scholars have made much the same point; see, for example, David Peters Corbett and Lara Perry, eds., *English Art, 1914–1960: Modern Artists and Identity* (Manchester, U.K.: Manchester University Press, 2000), p. 2; Brendan Prendeville, *Realism in 20th-Century Painting* (London: Thames and Hudson, 2000), p. 5; Paul Wood, "Realism and Realities," in *Realism, Rationalism, Surrealism: Art Between the Wars*, ed. Briony Fer, David Batchelor, and Paul Wood (New Haven and London: Yale University Press in association with the Open University, 1993), p. 254; Esther Leslie, "Interrupted Dialogues of Realism and Modernism," in *Adventures in Realism*, ed. Matthew Beaumont (Oxford: Blackwell, 2007), pp. 125–41; Peter Wollen, "Modernities and Realities," in Nicholas Serota, Sandy Nairne, and Adam D. Weinberg, *Views from Abroad: European Perspectives on American Art*, vol. 3, *American Realities*, exh. cat. (New York: Whitney Museum of American Art, 1997), pp. 13–19; and Pam Meecham, "Realism and Modernism," in *Varieties of Modernism*, ed. Paul Wood (New Haven and London: Yale University Press in association with the Open University, 2004), p. 75.

12. Gorky suggested these locations for his mural in a progress report dated January 17, 1934. See PWAP, "Records of the Public Buildings Service" (Record Group 121, esp. 121.2.4, 121.3), box 4, entry no. 117, National Archives and Records Administration (NARA), College Park, Maryland (these records are also housed in the New York office).

13. For a formal analysis of the mural sketches, see Matthew Spender and Barbara Rose, *Arshile Gorky and the Genesis of Abstraction: Drawings from the Early 1930s*, exh. cat. (New York: Stephen Mazoh, 1994), pp. ix–xiii, xvi–xvii, and n.p. As Spender points out, works in the *Nighttime, Enigma, and Nostalgia* series were inspired by a mural executed by André Masson for Gaston David-Weill, which Gorky had seen in reproduction; Spender, *From a High Place*, p. 88.

14. Gorky, Project Card, December 22, 1933, PWAP, Record Group 121, box 4, entry no. 117, NARA; reprinted in Francis V. O'Connor, "Arshile Gorky's Newark Airport Murals: The History of Their Making," in Bowman,

Murals without Walls, p. 22. Artists hired on the project were required to fill out project cards and submit them to the regional office. In addition to asking what type of work the artist was doing, in what medium, and when work was started, these cards asked for an explanation of the subject matter chosen.

15. Matossian, *Black Angel*, p. 221.

16. A list of the contents of Gorky's library has been deposited by Matthew Spender at the Archives of American Art, Smithsonian Institution, Washington, D.C. (Research material regarding Arshile Gorky, 1957–1999, reel 4982). The Marxist Critics Group was in existence from 1936 to 1939; it also published briefer texts in the nine issues of its journal, *Dialectics*, which ran from 1937 to 1939. For more on the Marxist Critics Group, see Hemingway, *Artists on the Left*, p. 113.

17. Stanley Mitchell, "Mikhail Lifshits: A Marxist Conservative," in *Marxism and the History of Art: From William Morris to the New Left*, ed. Andrew Hemingway (London: Pluto, 2006), p. 30.

18. Ibid.

19. Stuart Davis, "Arshile Gorky in the 1930s: A Personal Recollection," *Magazine of Art* 44, no. 2 (February 1951), pp. 56–58; reprinted in *Stuart Davis*, ed. Diane Kelder (New York: Praeger, 1971), p. 182.

20. As cited in the remembrances of Willem de Kooning and Robert Jonas in Karlen Mooradian, "A Special Issue on Arshile Gorky," *Ararat* 12 (Fall 1971), p. 48. His fellow modernist Rosalind Bengelsdorf Browne recalls Gorky lecturing at the Artists' Union in 1936; Bengelsdorf, "The American Abstract Artists and WPA FAP," in *The New Deal Art Projects: An Anthology of Memoirs*, ed. Francis V. O'Connor (Washington, D.C.: Smithsonian Institution, 1972), p. 224. The protest march was organized by the Artists' Committee of Action on October 27, 1934.

21. I am grateful to Michael Taylor for bringing this fascinating drawing to my attention.

22. See Federal Writers' Project, *The WPA Guide to New York City: The Federal Writers' Project Guide to 1930s New York* (New York: Pantheon Books, 1982), p. 200. Originally published as *New York City Guide* (New York: Random House, 1939).

23. I would like to thank Andrew Hemingway and Warren Carter for helping me to puzzle through the phrases on the banners.

24. On American-Asian relations during the 1930s, see, for example, Robert Smith Thompson, *A Time For War: Franklin D. Roosevelt and the Path to Pearl Harbor* (New York: Prentice-Hall, 1991), and Akira Iriye and Warren Cohen, eds., *American, Chinese, and Japanese Perspectives on Wartime Asia, 1931–1949* (Wilmington, Del.: Scholarly Resources, 1990).

25. The currency of this figure for the population of China is attested to by the title *400 Million*, which the Dutch documentary filmmaker and devout Communist Joris Ivens gave to his pro-Chinese film in 1939. From 1936 to 1945 Ivens lived in the United States, where he made a number of anti-fascist propaganda pieces,

including a collaboration with Ernest Hemingway, *The Spanish Earth* (1937).

26. Janice R. MacKinnon and Stephen R. MacKinnon, *Agnes Smedley: The Life and Times of an American Radical* (London: Virago, 1988), p. 1. John Reed was an American Communist journalist who wrote a firsthand account of Russia's Bolshevik Revolution, *Ten Days that Shook the World* (1919).

27. Jacob Kainen, "American Art in China," *Daily Worker*, April 9, 1938.

28. For example, in 1937 the United States exported 800,000 tons of scrap iron and steel to Japan and had been supplying the country with something like 60 percent of its mineral oil requirements; see Elizabeth Boody Schumpeter, "The Policy of the United States in the Far East," *Annals of the American Academy of Political and Social Science* 210 (1940), pp. 101–2.

29. Letter to the editor, *Daily Worker*, September 6, 1939. In California, for example, Communists and fellow travelers were picketing ships carrying scrap iron to Japan; see Harvey Klehr, *The Heyday of American Communism: The Depression Decade* (New York: Basic Books, 1984), p. 272. The United States did not impose trade embargoes on Japan until 1940, when it finally halted all exports of petroleum products, including crude oil and gasoline, and all grades of iron and steel scrap.

30. The letters, which Gorky supposedly sent to his family during the period from 1937 until his death in 1948, first appeared in the journal *Ararat* and were subsequently cited in Karlen Mooradian, *Arshile Gorky Adoian* (Chicago: Gilgamesh, 1978), and Mooradian, *The Many Worlds of Arshile Gorky* (Chicago: Gilgamesh, 1980). On the forgery, see Matossian, *Black Angel*, pp. 496–98.

31. On the Turks in Armenia, see Donald Bloxham, *The Great Game of Genocide: Imperialism, Nationalism, and the Destruction of the Ottoman Armenians* (Oxford: Oxford University Press, 2005). The independent Republic of Armenia was established in May 1918 but only survived until November 1920, when it was annexed by the Soviets. In March 1922, Georgia, Armenia, and Azerbaijan were brought together as the Transcaucasian Soviet Socialist Republic, which became part of the Soviet Union, or USSR (Union of Soviet Socialist Republics). In 1936, after a reorganization, Armenia became a separate constituent republic of the USSR. Armenia declared its independence from the collapsing Soviet Union on September 23, 1991. See Thomas Streissguth, *The Transcaucasus* (San Diego: Lucent Books, 2001).

32. See Matossian, *Black Angel*, pp. 200, 205.

33. Ibid., p. 257.

34. Ibid., p. 258.

35. As Kainen noted, this was probably Gorky's best known punch line; Jacob Kainen, "Memories of Arshile Gorky," in "Arshile Gorky," special issue, *Arts Magazine* 50, no. 7 (March 1976), p. 98. Davis frequently used this phrase to denounce Regionalist painting; see, for example, Stuart Davis, "Abstract Painting Today," p. 122.

36. Kainen, "Memories of Arshile Gorky," p. 97. On Kainen, see William C. Agee and Avis Berman, *Jacob Kainen*, exh. cat. (Washington, D.C.: National Museum of American Art, Smithsonian Institution, 1993); and Hemingway, *Artists on the Left*, pp. 117–18. On Expressionism in the 1930s and The Ten, see Herbert Lawrence, "The Ten," *Art Front* 2 (February 1936), p. 12; Jacob Kainen, "Our Expressionists," *Art Front* 3 (February 1937), pp. 14–15; Lucy Embick, "The Expressionist Current in New York's Avant-Garde, 1935–1940," *Rutger's Art Review* 5 (1984), pp. 56–69; and Isabelle Dervaux, "The Ten," *Archives of American Art Journal* 31 (1991), pp. 14–20.

37. Balcomb Greene, "Memories of Arshile Gorky," in "Arshile Gorky," special issue, *Arts Magazine* 50, no. 7 (March 1976), p. 109. On Greene, see Robert Beverly Hale and Niké Hale, *The Art of Balcomb Greene* (New York: Horizon, 1977).

38. See, for example, Greene, "Society and the Modern Artist," in *Art for the Millions: Essays from the 1930s by Artists and Administrators of the WPA Federal Art Project*, ed. Francis V. O'Connor (Greenwich, Conn.: New York Graphic Society, 1973), pp. 263–65.

39. I discuss Davis's political perspective in "Modernism for the Masses" (see note 10 above).

40. Gorky, "Stuart Davis," *Creative Art* 9, no. 3 (September 1931), p. 213.

41. Ibid.

42. Kainen, "Memories of Arshile Gorky," p. 97.

43. On von Wiegand, see Susan Noyes Platt, *Art and Politics in the 1930s: Modernism, Marxism, Americanism; A History of Cultural Activism during the Depression Years* (New York: Midmarch Arts, 1999), pp. 109–21; Susan Carol Larsen, "Charmion von Wiegand: Walking on a Road with Milestones," *Arts Magazine* 60, no. 3 (November 1985), pp. 29–31; and Hemingway, *Artists on the Left*, pp. 109–12.

44. Charmion von Wiegand to Joseph Freeman, July 11, 1937, Joseph Freeman Papers, 1904–1966, Hoover Institution Archives, Stanford University, Stanford, California (emphasis in original). I am immensely indebted to Andrew Hemingway for sharing this letter with me, as it sheds precious light on Gorky's thinking during the 1930s.

45. Kainen, "Memories of Arshile Gorky," p. 98, and Kainen, "Dream-World Art," *New Masses* 17 (November 12, 1935), p. 25.

46. Gorky, as cited in Kainen, "Memories of Arshile Gorky," p. 98.

47. Jacob Kainen, "Development of a True Artist," *Daily Worker*, July 9, 1937.

48. Von Wiegand to Freeman, July 11, 1937, Joseph Freeman Papers, 1904–1966, Hoover Institution Archives, Stanford University, Stanford, California.

49. Charmion von Wiegand, "The Fine Arts," *New Masses* 24 (July 13, 1937) [page numbers removed in the version consulted].

50. See, for example, Charmion von Wiegand, "Expressionism and Social Change," *Art Front* 2 (November 1936), pp. 10–13.

51. Alongside Greene and Jean Xceron, who were awarded WPA mural commissions for Rikers Island Penitentiary, Gorky was hired to produce a stained-glass window for the prison chapel. But his design, which he described as exploiting "the geometrical and ornamental character of abstract modern shapes based on traditional medieval church symbols and dependent upon its final affect [*sic*] on the richness of the light it casts," was rejected on March 12, 1940, after receiving preliminary approval. Although he resubmitted designs a month later and again received preliminary approval, his window was never realized. Greene's mural sketch was rejected a month later, on April 9, 1940. Greene's mural was intended for the left panel of the Jewish Chapel, and although he recognized that a key part of the commission was to produce a design that "would not in any way offend the religions which use this part of the auditorium," his studies were found objectionable by the chapel's rabbi because of the inclusion of a small symbol that resembled a swastika. In June 1942, Xceron was given final approval to execute both the left and right panels in the chapel, which are titled *Abstraction in Relation to Surrounding Architecture* (see fig. 15). The panels were completed that year (their present whereabouts is unknown). On the commissions, see the records of the Art Commission of the City of New York, City Hall, which include a "thesis" statement written by each of the artists describing their intentions for the project.

52. On Floyd Bennett Field, see *The WPA Guide to New York City*, pp. 503–4.

53. Fernand Léger, "The New Realism Goes On," *Art Front* 3 (1937), pp. 7–8; reprinted in Fernand Léger, *Functions of Painting*, ed. Edward F. Fry, trans. Alexandra Anderson (New York: Viking, 1973), p. 116. This text followed a lecture entitled "The New Realism" delivered by Léger at the Museum of Modern Art, New York, on the occasion of his exhibition there, extracts of which were published in *Art Front* 1 (1935), pp. 10–11; reprinted in Léger, *Functions of Painting*, pp. 109–13.

54. On Léger and America, see Carolyn Lanchner, "Fernand Léger: American Connections," in *Fernand Léger*, exh. cat. (New York: The Museum of Modern Art, 1998), pp. 15–70 (esp. pp. 36–52, on his sojourns in the United States during the 1930s); Simon Willmoth, "Léger and America," in *Fernand Léger: The Later Years*, ed. Nicholas Serota, exh. cat. (London: Whitechapel Art Gallery, 1987), pp. 43–54; and Fondation Beyeler, Basel, *Fernand Léger: Paris–New York*, ed. Delia Ciuha, exh. cat. (Ostfildern-Ruit, Germany: Hatje Cantz, 2008).

55. Spender, *From a High Place*, p. 146.

56. Alfred H. Barr, Jr., to Audrey McMahon, December 3, 1935, Alfred H. Barr, Jr., Papers, The Museum of Modern Art Archives, New York; cited in Spender, *From a High Place*, p. 146.

57. Holger Cahill, who was decidedly pro-modernist and whose commitment to democratic pluralism was the hallmark of the FAP, had taken art lessons from Gorky in 1931 and wrote a text for his first solo exhibition in February 1934 at the Mellon Galleries in Philadelphia.

58. Somewhat amusingly, Gorky and Mayor La Guardia were photographed in front of Gorky's gouache with

someone attempting to place a copy of *Art Front* in the mayor's hands; as recounted by Burgoyne Diller in "Interview: Burgoyne Diller Talks with Harlan Phillips," *Archives of American Art Journal* 16, no. 2 (1976), p. 21.

59. On the Newark Airport, see The Federal Writers' Project of the Works Progress Administration for the State of New Jersey, *The WPA Guide to 1930s New Jersey* (1939; repr., New Brunswick, N.J.: Rutgers University Press, 1989), pp. 107, 338. For an overview of the Civil Works Administration, see Badger, *The New Deal*, pp. 197–200.

60. Spender, *From a High Place*, p. 163.

61. "American Art: WPA Show Opens at the Museum," *The Newark Ledger*, November 8, 1936; see also "Mr. Gorky's Murals the Airport They Puzzle," *Newark Ledger*, June 10, 1937.

62. "American Art: WPA Show Opens at the Museum," *Newark Ledger*, November 8, 1936.

63. Frederick T. Kiesler, "Murals without Walls: Relating to Gorky's Newark Project," *Art Front* 2 (December 1936), p. 11; reprinted in Bowman, *Murals without Walls*, p. 33. On Kiesler, see Chantal Béret, *Frederick Kiesler, artiste-architecte*, exh. cat. (Paris: Centre Georges Pompidou, 1996). Gorky must have met Kiesler shortly after his arrival in New York in 1924, because in 1926 he brought him to the Grand Central School of Art to give lectures.

64. O'Connor, "Arshile Gorky's Newark Airport Murals," p. 17.

65. Arshile Gorky, "My Murals for the Newark Airport: An Interpretation" (1936), in Bowman, *Murals without Walls*, p. 13. This text was written for *Art for the Millions*, a remarkable collection of testimonials from artists and administrators conceived by Cahill in 1936 to counter charges of "boondoggling" leveled by Congress and the conservative press since the inception of the FAP in 1935. Although ready for publication in 1939, the anthology remained unpublished until 1973 (edited by Francis V. O'Connor; Gorky's essay is on pp. 72–73). As Spender contends, Gorky was not equipped to write his text alone, but even with help he did not provide the kind of essay that was required in such a context, as is evident in the correspondence between Emanuel Benson (who was organizing the publication) and Audrey McMahon; Spender, *From a High Place*, p. 165; see also Records of the Work Projects Administration (Record Group 69), NARA. There are further issues with this text: According to Francis V. O'Connor, several versions exist, and this has led to interpretative problems. For example, the versions published in Schwabacher, *Arshile Gorky*, pp. 7–74, and Rosenberg, *Arshile Gorky: The Man, the Time, the Idea*, pp. 13–32, reveal that several alterations were made to the holograph manuscript intended for *Art for the Millions*. O'Connor suggests that such alterations were probably made to render the essay more comprehensible to the general public but were "unfortunately done at the expense of the artist's ideas and intentions"; O'Connor, "A Note on the Text's of Gorky's Essay for *Art for the Millions*," in *Murals without Walls*, p. 16. All subsequent quotations from Gorky's essay will be taken from the version published in *Murals without Walls*, pp. 13–16.

66. Gorky, "My Murals for the Newark Airport," p. 13.

67. Ibid. For a rethinking of the opposition between the "pictorial" and the "decorative," see Roger Benjamin, "The Decorative Landscape, Fauvism, and the Arabesque of Observation," *Art Bulletin* 75, no. 2 (June 1993), pp. 295–316; David Cottington, *Cubism in the Shadow of War* (New Haven and London: Yale University Press, 1998), pp. 169–95; Nancy J. Troy, *Modernism and the Decorative Arts in France* (New Haven and London: Yale University Press, 1991); and Peter Wollen, *Raiding the Icebox: Reflections on Twentieth-Century Culture* (London: Verso, 1993), p. 16.

68. Albert Gleizes and Jean Metzinger, "Cubism" (1912), in *Modern Artists on Art*, ed. and trans. Robert L. Herbert (Englewood Cliffs, N.J.: Prentice-Hall, 1964), p. 5.

69. Francis V. O'Connor, "New Deal Murals in New York," *Artforum* 7, no. 3 (1968), p. 45.

70. Kiesler, "Murals without Walls," p. 10.

71. Jackson Pollock, as cited in Francis Frascina, ed., *Pollock and After* (New York: Harper and Row, 1985), p. 101.

72. The iconographic program was first outlined by Olive Lyford, one of McMahon's project supervisors, in an FAP report dated January 31, 1936; see O'Connor, "Arshile Gorky's Newark Airport Murals," p. 21.

73. "Interview: Burgoyne Diller Talks with Harlan Phillips," p. 21; see also Francis V. O'Connor, "The Economy of Patronage: Arshile Gorky on the Art Projects," in "Arshile Gorky," special issue, *Arts Magazine* 50, no. 7 (March 1976), p. 95.

74. "Interview: Burgoyne Diller Talks with Harlan Phillips," p. 21.

75. Spender and Rose, *Arshile Gorky and the Genesis of Abstraction*, n.p.

76. On the reception of Surrealism in the 1930s, see Jeffrey Wechsler, *Surrealism and American Art, 1931–1947* (New Brunswick, N.J.: Rutgers University Press, 1976); Isabelle Dervaux, "A Tale of Two Earrings: Surrealism and Abstraction, 1930–1947," in Dervaux et al., *Surrealism USA*, exh. cat. (New York: National Academy Museum; Ostfildern-Ruit, Germany: Hatje Cantz, 2005), pp. 48–51; and Angela Miller, "With Eyes Wide Open: The American Reception of Surrealism," in *Caught by Politics: Hitler Exiles and American Visual Culture*, ed. Sabine Eckmann and Lutz Koepnick (New York: Palgrave Macmillan, 2007), pp. 61–94.

77. Kainen, "Dream-World Art," p. 25. Despite the overwhelmingly negative reception Surrealism received from those on the left, there were artists pursuing a variant called Social Surrealism; see Gerrit L. Lansing, "Surrealism as a Weapon," in Dervaux et al., *Surrealism USA*, pp. 30–35; and Ilene Susan Fort, "American Social Surrealism," *Archives of American Art Journal* 22 (1982), pp. 8–20.

78. Gorky, Project Card, December 22, 1933, PWAP, Record Group 121, box 4, entry no. 117, NARA.

79. Jim Jordan, "The Place of the Newark Murals in Gorky's Art," in Bowman, *Murals without Walls*, p. 56.

80. Stuart Davis used this phrase to condemn "mechanically-minded art critics" who saw modernism as a "flight from reality." See Davis, "Notes on the Nature of Abstract Art," Stuart Davis Papers, Archives, Harvard Art Museum, gift of Mrs. Stuart Davis, Reel 1, August 27, 1937 (all rights reserved by the President and Fellows of Harvard College).

81. Gorky, "Stuart Davis," p. 193.

82. Ibid.; also Gorky, "My Murals for the Newark Airport," p. 13.

83. Gorky, "My Murals for the Newark Airport," p. 13.

84. Ibid.

85. Ibid.

86. Ibid.

87. As Diane Waldman has noted, Amédée Ozenfant was living in New York at this time, and Gorky was known to have visited his studio; Waldman, *Arshile Gorky, 1904–1948: A Retrospective*, exh. cat. (New York: Harry N. Abrams in collaboration with the Solomon R. Guggenheim Museum, 1982), p. 38. Although it is not known when Gorky first met Léger, the introduction was almost certainly arranged by Kiesler and could have happened as early as October 1931, when Léger was in New York for an exhibition of his drawings.

88. See, for example, Jordan and Goldwater, *The Paintings of Arshile Gorky*, pp. 60–62. The frequency with which this similarity is noted is partly a result of the fact that one of the few remaining sketches for the Newark murals is a gouache of the left-hand panel of *Activities on the Field* on long-term loan to the Museum of Modern Art, New York, thereby making it the best-known portion of the murals.

89. Christopher Green, *Léger and the Avant-Garde* (New Haven and London: Yale University Press, 1976), p. 183.

90. Jordan and Goldwater, *The Paintings of Arshile Gorky*, p. 61.

91. Jordan, "The Place of the Newark Murals in Gorky's Art," p. 63 n. 23. Léger's *The City* was illustrated in a number of books and periodicals, including E. Teriade's *Fernand Léger* (Paris: Éditions Cahier d'Art, 1928), of which, as Spender's list of the contents of his library confirms, Gorky had a copy. Research material regarding Arshile Gorky, 1957–1999, Archives of American Art, Smithsonian Institution, Washington, D.C., reel 4982.

92. Harold Rosenberg, paraphrasing Ethel Schwabacher, in "Arshile Gorky: The Last Move," p. 102.

93. The description of Gorky as a "fervent scrutinizer" of paintings is Meyer Schapiro's in "Arshile Gorky" (1957), in *Modern Art: 19th and 20th Centuries* (New York: George Braziller, 1978), p. 179.

94. Davis recounted Léger's response to the paintings in a letter to his father on September 17, 1928, which is quoted in Karen Wilkin, *Stuart Davis* (New York: Abbeville, 1987), p. 120. On the *Egg Beater* paintings, see, for example, Lowery Stokes Sims, *Stuart Davis: American Painter*, exh. cat. (New York: The Metropolitan Museum of Art, 1991), pp. 184–90, and Davis, "Eggbeater Series" (1941), in *Stuart Davis*, ed. Kelder, p. 99.

95. Waldman, *Arshile Gorky, 1904–1948*, p. 38.

96. Gorky, "Stuart Davis," p. 213.

97. See, for example, Waldman, *Arshile Gorky, 1904–1948*, p. 38, and Spender, *From a High Place*, p. 88.

98. Davis, as cited in James Johnson Sweeney, *Stuart Davis*, exh. cat. (New York: The Museum of Modern Art, 1945), p. 16.

99. Ibid.

100. Gorky, "My Murals for the Newark Airport," p. 15.

101. Project Card, December 22, 1933, PWAP, Record Group 121, box 4, entry no. 117, NARA.

102. Kiesler, "Murals without Walls," p. 11.

103. Gorky, "My Murals for the Newark Airport," p. 13.

104. Gorky also executed studies for the U.S. Maritime Commission's competition for murals for the Marine Transportation Building at the New York World's Fair, but they were not accepted. I am grateful to Patricia E. Phagan for her helpful correspondence regarding the marine studies, one of which is illustrated in Phagan, *For the People: American Mural Drawings of the 1930s and 1940s*, exh. cat. (Poughkeepsie, N.Y.: Frances Lehman Loeb Art Center, 2007).

105. The postcard is in the collection of the New York Public Library, and the Whitney Museum of American Art, New York, has a copy.

106. Gorky, "My Murals for the Newark Airport," p. 15.

107. Ibid.

108. Gerard Sullivan, "Mr. Gorky's Murals the Airport They Puzzle!" *Newark Ledger,* June 10, 1937.

109. Davis, "Arshile Gorky in the 1930s," p. 183.

110. Ibid.

111. Ibid.

112. Ibid. The panels were installed sometime after July 1937.

113. See Ruth Bowman, "Arshile Gorky's *Aviation* Murals Rediscovered," in *Murals without Walls*, pp. 34–45. I am grateful to Mary Kate O'Hare for her helpful correspondence regarding these panels.

114. For more on this incident, see McKinzie, *The New Deal for Artists*, pp. 165–66. Burgoyne Diller also recalls objections to Gorky's murals; "Interview: Burgoyne Diller Talks with Harlan Phillips," p. 18.

115. Spender, *From a High Place*, p. 152.

Gorky and Surrealism

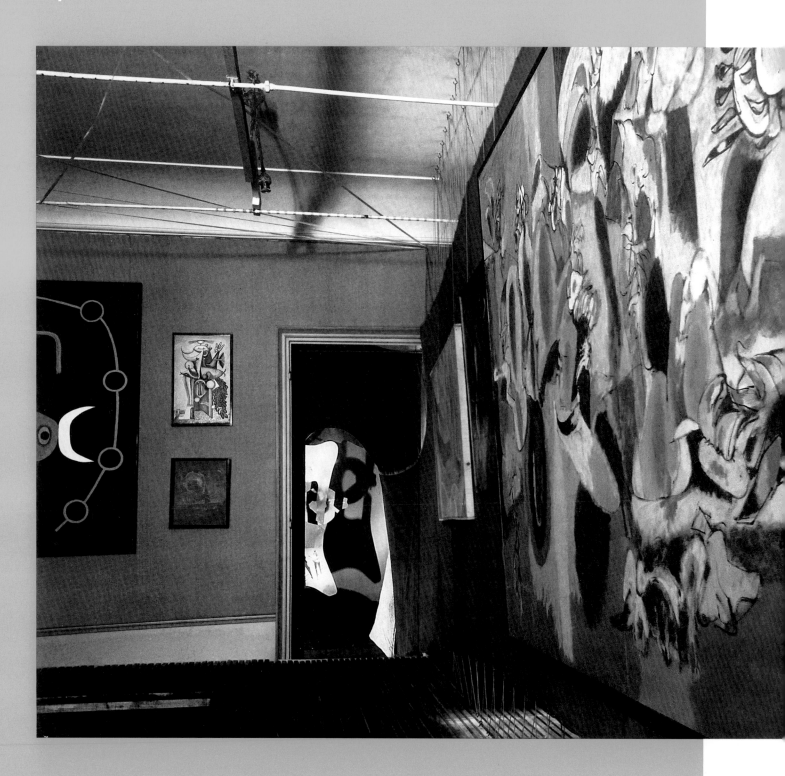

Shipwrecked Surrealism

In the early 1940s, Arshile Gorky's prominent position in the New York art scene brought him into regular contact with several members of the exiled Surrealist group, including André Breton, Max Ernst, Wifredo Lam, André Masson, Roberto Matta, and Yves Tanguy, whose art and ideas, especially regarding automatist techniques, would have a decisive impact on the direction of his work.[1] Gorky was uniquely prepared for his encounter with what Dorothea Tanning memorably dubbed "Shipwrecked Surrealism,"[2] as a result of his self-imposed apprenticeship, lasting from the mid-1920s to the early 1940s, to a long list of European-based modern artists. He had devoured the work of Pablo Picasso, Giorgio de Chirico, and Joan Miró in New York's museums and art galleries, as well as through reproductions in art magazines and exhibition catalogues that he read in bookstores or borrowed from friends like the artist John Graham and the gallery owner Julien Levy. Gorky's palpable excitement in reading such Surrealist magazines as *Documents* and *Minotaure* can be gauged by the fact that he often covered these publications with ink or pencil drawings, such as the Miró-inspired creature that he drew in blue ink on the inside cover of the spring 1938 issue of *Minotaure* (fig. 68), which had a cover illustration by Ernst. The iconography of this signed sketch is consistent with Gorky's work in or around 1943, when he began to incorporate natural and organic forms in his drawings, imbuing them with an explosive, erotic energy.

Gorky's prior engagement with Surrealism allowed him to meet the exiled Surrealists as an equal, at least in his own mind. Unlike many of his contemporaries in New York, his interest in the movement can be traced back to more than a decade before the arrival of the Paris Surrealists on American shores. In January 1932, for example, Gorky's work was included in the Surrealist section of a large exhibition of modern Russian art held at the Wilmington Society of the Fine Arts (now the Delaware Art Museum). Organized by the prominent art critic Christian Brinton, this exhibition also included works by several of Gorky's Russian-born friends and colleagues, including David Burliuk, Nicolai Cikovsky, Nikolay Feshin, Boris Grigoriev, John Graham, Chaim Gross, Nicholas Roerich, and Nicholas Vasilieff, the latter of

whom worked in the studio next to Gorky's at 36 Union Square. According to Brinton, the work of these artists "seldom disassociates itself from nature and from life," which they sought to "intensify" and "magnify" through their dreamlike paintings.[3]

The brightly colored, folkloric paintings of these Russian exiles, many of whom remained close friends and supporters of Gorky for the rest of his life, must have prepared him for his eventual engagement with Surrealism, although far more research needs to be done on his interactions with this group of expatriate artists. Claiming to be the cousin of the Russian writer Maxim Gorky, Gorky lent two paintings to the Wilmington exhibition, which were listed in the catalogue under the generic titles "Composition" and "Portrait."[4] Since neither was illustrated, they cannot be securely identified, but the Surrealist theme of the exhibition would suggest the inclusion of a recently completed painting, such as the totemic *The Barber (Composition No. 5)* of about

FIG. 67
Gorky's painting *The Liver Is the Cock's Comb* in the Salle de la Pluie (Rain Room) of the *Exposition Internationale du Surréalisme*, Galerie Maeght, Paris, 1947. Photograph by Rémy Duval. Courtesy of the Austrian Frederick and Lillian Kiesler Private Foundation, Vienna

FIG. 68
Arshile Gorky. Surrealist Drawing, c. 1943. Ink on paper (inside cover of *Minotaure* 11 [1938]), 12½ x 9¼ inches (31.8 x 23.5 cm). Private collection

FIG. 69
Arshile Gorky, *The Barber (Composition No. 5)*,
c. 1931–32. Oil on paperboard mounted to rag-
board mounted to aluminum hexcel panel, 17½
x 8½ inches inches (44.4 x 21.6 cm). Hirshhorn
Museum and Sculpture Garden, Washington,
D.C. Gift of Joseph H. Hirshhorn, 1966

1931–32 (fig. 69). The standing figure in Gorky's painting owes a strong debt to Picasso's Surrealist-inspired Dinard Bathers, most notably *Nude Standing by the Sea* of 1929 (fig. 70), which had been exhibited at the Valentine Gallery, New York, in January 1931. Gorky described his two paintings in the Wilmington show as Surrealist in his correspondence with the exhibition organizers, thus marking his first public identification with the international movement.

In the same month that Gorky was exhibiting in Wilmington, Julien Levy presented the exhibition *Surréalisme* at his gallery in New York, showing works by Ernst, Salvador Dalí, Man Ray, and Pierre Roy. This landmark exhibition encouraged Gorky to increasingly incorporate Surrealist-inspired imagery in his own work, such as Ernst-inspired bird motifs and de Chirico's iconography of gladiators and horses (plate 63). As we saw in the introduction to this catalogue, Gorky's extended *Nighttime, Enigma*, and *Nostalgia* series (c. 1931–34; plates 42–55) took de Chirico's 1914 painting *The Fatal Temple* (see fig. 16) as its point of departure, underlining the seminal importance of the Italian artist's Metaphysical paintings for Gorky, as well as for the Surrealists, who regarded these works as powerful forerunners of their own artistic vision.

Another, previously unacknowledged source for Gorky's paintings and drawings of the mid-1930s is the French Symbolist artist Odilon Redon, whose delirious and often macabre visual fantasies were acclaimed by the Surrealists as important precursors of their efforts to liberate the imagination and access the unconscious. In 1936 Redon's graphic work was included in two important survey exhibitions at the Museum of Modern Art (MoMA), New York—*Cubism and Abstract Art* and *Fantastic Art, Dada, Surrealism*—which attests to the importance and diversity of his creative output.[5] At a time when Gorky was attempting to blend his previous interest in the spatial ambiguities of Cubist painting with his new passion for the dreamlike fantasies of Surrealism, Redon provided him with a perfect role model for how realism and abstraction could be combined to form a highly imaginative and individual artistic vision. Writing in the catalogue for *Cubism and Abstract Art*, the exhibition's curator, Alfred H. Barr, Jr., claimed that Redon "contributed not only an iridescent amorphous shimmer of color which was to affect Matisse and Kandinsky, but also an intro-

FIG. 70
Pablo Picasso (Spanish, 1881–1973). *Nude Standing by the Sea*, 1929. Oil on canvas, 51⅛ x 38⅛ inches (129.9 x 96.8 cm). The Metropolitan Museum of Art, New York. Bequest of Florene M. Schoenborn, 1995

FIG. 71
Odilon Redon (French, 1840–1916), *Les Bêtes de la mer rondes comme des outres* (*The Beasts of the Sea, Round Like Leather Bottles*), 1896. Lithograph from the portfolio *La Tentation de Saint Antoine*, written by Gustave Flaubert (French, 1821–1880), printed by Blanchard, Paris, published by Ambroise Vollard, Paris (1938). Philadelphia Museum of Art. Gift of Lessing J. Rosenwald, 1956

97

GORKY AND SURREALISM

spective, visionary, subjective attitude which anticipated both Kandinsky and the Surrealists."[6]

Around 1934, Gorky found inspiration in Redon's hallucinatory prints based on Gustave Flaubert's 1874 prose poem *The Temptation of Saint Anthony*, whose strange dream world had an enormous impact on modern painters in the nineteenth and twentieth centuries.[7] One lithograph in particular from Redon's series, *Les Bêtes de la mer rondes comme des outres* (*The Beasts of the Sea, Round Like Leather Bottles*) (1896; fig. 71), provided a source for the sequence of drawings and paintings that Gorky titled *Image in Khorkom* (c. 1934–36; plates 56–61), which immediately followed the *Nighttime, Enigma, and Nostalgia* series. Redon's composition featured a floating underwater creature with linear tentacles and curvilinear folds of skin whose form is defined by deep, black shadows. This print, from a portfolio of twenty-four lithographs published by Ambroise Vollard in Paris in 1896, was prominently illustrated in *Cahiers d'art* in 1930, opposite several recent paintings by Vasily Kandinsky. Gorky may have discovered this startling image in the French magazine, to which he subscribed and whose reproductions of modern art often inspired his early work.

Over the next two years, Gorky would combine this subterranean imagery with the forms he had derived from de Chirico's *The Fatal Temple* and with the interlocking, geometric shapes of the *Nighttime, Enigma, and Nostalgia* drawings to produce his Khorkom series. The origins of this long sequence of highly imaginative and richly textured drawings in the undulating organic and aqueous forms of Redon's Flaubert-inspired lithographs have until now been obscured by the titles' reference to Gorky's cherished hometown on the shores of Lake Van. When these drawings were transformed into finished paintings, sometimes several years later (plates 60, 61), Gorky omitted the swaying filaments that relate to the tentacles of Redon's sea creature, possibly to obscure the source of his imagery, but perhaps more mundanely because he had not yet discovered a means of translating such fine lines into oil paint.

Gorky's interest in Surrealism continued throughout the 1930s, as is evidenced by an anecdote supplied by Levy, who remembered that when his important book *Surrealism* was published in 1936, the artist immediately read the entire volume in the back room of the gallery and

FIG. 72
André Masson (French, 1896–1987). *Cockfight*, 1930. Oil on canvas, 8⁹⁄₁₆ x 10⁵⁄₈ inches (21.7 x 27 cm). Philadelphia Museum of Art. A. E. Gallatin Collection, 1952

soon borrowed it to take back to his studio, where he swiftly responded to its black-and-white reproductions in his own work.[8] Levy's book appears to have encouraged Gorky to move away from his interest in the spatial effects of Cubism, which had culminated in the recently completed painting *Organization* (1933–36; plate 66), toward a new form of abstraction that incorporated biomorphic shapes derived from Redon, Miró, and Hans (Jean) Arp, while also bearing his own, unique imprint.

The playful, interlocking forms found in the Khorkom series and works such as *Painting* (plate 71), the latter completed in 1937, reveal Gorky's interest at this time in developing a new pictorial language informed by André Masson's violent abstract compositions of the 1930s, which featured slaughterhouses, cock fights, and animals caught in traps or devouring each other. Masson had temporarily broken with Breton's orthodox Surrealist group in 1929 and was instead closely aligned with the dissident Surrealist group that had formed around the French philosopher Georges Bataille. Gorky was an avid peruser of Bataille's journal *Documents*, which prominently featured Masson's abattoir paintings, and he would have known Masson's 1930 painting *Cockfight* (fig. 72), for it had been acquired by Albert Eugene Gallatin the year after it was made and was prominently installed at the Gallery of Living Art at New York University. The frenetic imagery of fighting birds found in this small, dynamic painting helps to explain the presence of similar bird motifs, especially schematically rendered heads and necks, in Gorky's biomorphic paintings of the mid- to late 1930s, which, despite their seemingly abstract appearance, often suggest combat or struggle (plates 71, 74).

Gorky's interest in Levy's book extended beyond its reproductions of Surrealist works of art, as is evidenced by the letters he sent to Corinne Michael West, his student and girlfriend, in August 1936. These love letters incorporated long quotations from the section of *Surrealism* devoted to the lyric poetry of the French Surrealist writer Paul Éluard, the pseudonym of Eugène Grindel. In a letter of August 11, 1936, Gorky lifted a long paragraph from Éluard's "Simulation of General Paralysis Essayed," a poem that had first appeared in 1930 in Éluard's collection *L'Immaculée Conception* (*The Immaculate Conception*) and had been translated for Levy's book by the Irish playwright Samuel Beckett:[9]

My heart bleeds on thy mouth and closes on thy mouth on all red chestnut-trees of the avenue of thy mouth where we are on our way through thy shining dust to lie us down amidst the meteors of the beauty that I adore my great one who art so beautiful…my original woman my scaffolding of rose-wood thou are the fault of my fault of my very great fault as Jesus Christ is the woman of my cross—twelve times twelve thousand one hundred and forty-nine times I have loved thee with passion on the way and I am crucified to north east west and north for thy kiss of radium and I want thee and in my mirror of pearls thou are the breath of him who shall not rise again to the surface and who loves thee in adoration my woman lying upright when thou art seated combing thyself.[10]

That Gorky chose this stream-of-consciousness passage to send to West indicates that he felt an intense admiration for Éluard's poetry, which he had known since the early 1930s. The American playwright Lionel Abel remembered "Gorky in about 1931, at a bar, with a copy of the poems of Paul Éluard. I'm not sure how much he can have made of them, as he did not speak French, but I was impressed all the same."[11] Gorky no doubt passed off Éluard's poetry as his own in his 1936 love letters with the intention of impressing his young girlfriend with his passionate feelings for her, as well as with the daring originality of his romantic poetry. Éluard's automatic text resonated with Gorky's own highly personal stream-of-consciousness writing style, in which sentences ran into each other, and periods, capital letters, and other forms of punctuation were generally avoided.[12]

A second letter to West, dated August 24, 1936, again contained a poem by Éluard, titled "Lady Love," that was also lifted wholesale from Levy's book.[13] First published in 1924 as "L'amoureuse" in the collection *Mourir de ne pas mourir* (*To Die of Not Dying*), this poem also speaks to Gorky's ambition to present himself as a sophisticated, multitalented artist and poet of great promise, as well as a sensitive yet ardent lover, as seen in the first stanza: "She is standing on my lids / And her hair is in my hair / She has the colour of my eye / She has the body of my hand / In my shade she is engulfed / As a stone against the sky."[14] The poem's cadence and metaphors anticipate the future direction of Gorky's work, which in the early 1940s would incorporate chance procedures and

FIG. 73

Joan Miró (Spanish, 1893–1983). *Still Life with Old Shoe*, 1937. Oil on canvas, 32 x 46 inches (81.3 x 116.8 cm). The Museum of Modern Art, New York. Gift of James Thrall Soby, 1969

imagery derived from Surrealism and from the natural world, as filtered through his unique imagination and gift of poetic suggestion.[15]

In the fall of 1939, Gorky completed *Hitler Invades Poland* (plate 88), a collaborative drawing made with his friend the sculptor Isamu Noguchi and the artist De Hirsh Margules. This drawing has much in common with the Surrealist *cadavre exquis* (exquisite corpse), which was based on an old parlor game. Breton defined it in the *Dictionnaire abrégé du Surréalisme* (Abridged Dictionary of Surrealism) as a "game of folded paper that consists in having a sentence or a drawing composed by several persons, each ignorant of the preceding collaboration. The classic example, which gave its name to the game, is the first sentence obtained by those means: 'The exquisite corpse / will drink / the new / wine.'"[16] In this collective activity, the first participant writes down a few words or makes a drawing, and then folds over the sheet of paper before passing it to the next person, who does the same without peeking at the first phrase or sketch, thus ensuring that the finished work departs from accepted notions of reality. The resulting hybrid images and sentences answered the Surrealists' interest in utilizing chance procedures to unlock the secrets of the unconscious, since the revelatory power of these works comes from juxtapositions that produce unforeseen and unplanned similarities and metaphors. As Breton later explained, "with the *exquisite corpse* we had at our disposal—at last—an infallible means of sending the mind's critical mechanism away on vacation and fully releasing its metaphorical potentialities."[17]

According to Noguchi, *Hitler Invades Poland* was made in his Tenth Street studio on September 1, 1939, immediately after he, Gorky, and Margules heard on the radio that Nazi Germany had invaded Poland.[18] Using one of Noguchi's preexisting linear drawings, they began to improvise with colored crayons and a stamp that left repeated impressions with sealing wax. Gorky completed the freely conceived abstract composition "by pressing his fingers into the red paste used for seals in the Orient. His finger marks attest to their origin. The black

crayon marks are also his signature overlaid on to my more geometric base."[19] The staring eyes that emerge from the resulting black shapes and Gorky's red handprints, ominously redolent of blood, add a human presence to the work, which records the artists' fear and anxiety at the beginning of World War II. Gorky's response to the impending global conflict, a variation on the exquisite corpse game, speaks to his strong interest by this time in Surrealist painting, poetry, and automatic writing. Two years later, in an interview in the *New York Sun*, he stated that his work could be termed "surrealistic," thus publicly aligning himself with the international movement at a time when many of its members had recently arrived in New York.[20]

During these years Gorky was experimenting with free-floating, brightly colored imagery derived from Miró's nature-based abstractions. This body of work would culminate in a series of paintings and gouache studies titled *Garden in Sochi* (1940–43; plates 93–97), in which he memorialized his father's garden in the village of Khorkom near Lake Van, although the deliberately obfuscating title confusingly references the Russian Black Sea resort of Sochi, in line with Gorky's efforts to camouflage his background. The dominant motif of the series

FIG. 74
Roberto Matta (Chilean, 1911–2002). *Invasion of the Night*, 1941. Oil on canvas, 38 x 60⅛ inches (96.5 cm x 152.7 cm). San Francisco Museum of Modern Art. Bequest of Jacqueline Marie Onslow Ford

is a large boot-shaped form, thought to represent an old-fashioned butter churn used by his mother,[21] or a Turkish slipper,[22] but which could just as easily relate to the shoe in Miró's *Still Life with Old Shoe* (1937; fig. 73), a painting Gorky is known to have admired.[23] Gorky would later describe his father's small garden as filled with poplars and apple trees, as well as "incalculable amounts of wild carrots,"[24] and he based his *Garden in Sochi* series on his childhood memories of this idyllic place as filtered through Miró's lexicon of abbreviated and often fanciful natural forms. He had recently seen the Catalan artist's 1941 retrospective at MoMA, which included *The Farm* of 1921–22 (National Gallery of Art, Washington, D.C.), whose joyous fantasy world shared the exuberant impulse and subject matter of Gorky's *Garden in Sochi* series.

The Automatic Message

Between January and March 1941, Gorky attended Gordon Onslow Ford's important series of four lectures on Surrealism at the New School for Social Research in New York, after which he made numerous visits, for a while on a daily basis, to the expatriate British artist's Manhattan apartment, a seventh-floor walk-up on Eighth Street, where he could ask questions about Surrealism in a private setting.[25] Onslow Ford's final lecture, delivered on March 8, included an in-depth analysis of Roberto Matta's recently completed painting *Invasion of the Night* (fig. 74), an intensely colored landscape whose glowing mountains and liquescent atmosphere Onslow Ford compared to volcanic eruptions. He ended the lecture by characterizing Matta's painting as "a glimpse of that marvelous world that is perhaps buried in each of us; once we

can become aware of it, it can lead to a fuller life."[26] These words were intended to have a liberating effect on the American artists who heard them, and Onslow Ford's "incitement to revolution" did indeed ignite Gorky's interest in Surrealist automatism.[27]

It was almost certainly at one of these 1941 lectures that Gorky first met the Chilean-born Matta, who would soon become his friend and guide on the path to Surrealist automatism. Jimmy Ernst, the son of Max Ernst and a painter in his own right, recalled Matta and Gorky having an animated discussion at the Jumble Shop, a favorite hangout at the corner of West Eighth and MacDougal Streets in Greenwich Village, after one of Onslow Ford's lectures, possibly the final one, which included a lengthy interpretation of Matta's work.[28] During their conversation, Matta referred to a prior visit to Gorky's studio on Union Square, which suggests that the two men had met slightly earlier, probably at one of Onslow Ford's lectures in either January or February. Shortly thereafter, Gorky began to frequent Matta's studio at 15 Gay Street, between Eighth Street and Sixth Avenue, where they would discuss the history of Surrealism and the role of automatism in accessing a mysterious world beyond the realm of external reality.

In the fall of 1942, the charismatic Matta invited a group of young American artists, including William Baziotes, Peter Busa, Gerome Kamrowski, Robert Motherwell, and Jackson Pollock, to his new studio on Ninth Street, in the hope of beginning a splinter group that would create and explore new automatist methods and techniques as an alternative to the reigning Surrealist orthodoxy. Unfortunately, these collective plans were never realized, in part because of the strong

and often volatile personalities of those involved. Pollock, for example, resented the idea of joining a group formed around Matta's ideas of automatism and psychological morphology, while Motherwell and Matta disagreed on aesthetic issues.[29] The fiercely independent Gorky did not attend these Saturday afternoon sessions, which began in October 1942 and lasted for at least a month and a half,[30] but as his friendship with Matta deepened over the next seven years, it became clear that they shared an interest in discovering and inventing new forms with automatic means that went beyond the traditional Surrealist methods of automatic writing and the exquisite corpse game.

In his 1922 essay "Entrée des médiums" (The Mediums Enter), André Breton identified the Surrealist technique of automatic writing as a kind of "magical dictation" of the unconscious mind, akin to the hypnotic trances exploited by both modern psychiatry and spiritualism in the late nineteenth and early twentieth centuries.[31] "Psychic automatism in its pure state," as this form of unconscious mediumistic activity was defined two years later in the first Manifesto of Surrealism,[32] would have a profound impact on the visual arts, as seen, for example, in Arp's, Masson's, and Miró's experiments with automatic drawing, in which they similarly relinquished control of their conscious faculties. In Masson's case, he would let his pen travel across the paper with great speed and no previously conceived subject matter or composition in mind, and then discover within the resulting complex web of modulating lines subtle, anthropomorphic fragments suggestive of eroticized bodies, animals, and birds, which he then elaborated upon in subsequent drawings and paintings to clarify the imagery. Masson's *Birth of Birds* (fig. 75), an automatic drawing reproduced in *La Révolution surréaliste* in October 1925, reads as a seated female nude, complete with eyes and fragments of other body parts, including hands, a star-shaped nipple, and a vulva from which two soaring birds emerge.

Whereas Masson believed that his automatic drawings were the result of a free and uninhibited, unconscious process that bypassed the reasoning mind, Matta—in his sessions with Gorky and other American artists in the 1940s—criticized the earlier efforts of his Surrealist colleagues to produce automatic writing and drawing, arguing that despite their ludic origins these Surrealist works of art always betrayed

"a dose of control" and "pretended to be a language," rather than truly reflecting the unconscious functioning of the mind.[33] Salvador Dalí, in presenting his paranoiac-critical method, had expressed similar reservations in the 1930s about the supposedly unpremeditated nature of Surrealist automatism, especially when artists like Masson and Miró attempted to replicate the immediacy of automatic writing and drawing in their paintings.[34] The oil medium was too slow and cumbersome to maintain the rapid and continuous movement that was the essence of automatism, and in the 1930s automatic writing and drawing were largely abandoned in favor of illusionistic paintings that explored the irrational world of dreams and the subconscious, as exemplified by the hyperrealistic styles of Dalí and René Magritte.

In 1939, Breton advocated for a "return to automatism" in Surrealist painting, based on the "precious unpremeditated discoveries" of artists such as Onslow Ford, Matta, Oscar Domínguez, Wolfgang Paalen, Kurt Seligmann, and Raoul Ubac.[35] Breton was undoubtedly excited by the new forms of automatism developed by these artists, including decalcomania (Domínguez), fumage (Paalen), lithochronism (Seligmann), and brûlage (Ubac), and he suggested that the Surrealist group return to its earlier emphasis on chance and automatism, as updated through these new techniques. His proposal coincided with the expulsion of Dalí from the Surrealist group, effectively bringing an end to the movement's interest in his paranoiac-critical method. Like Breton, Matta believed that automatism remained Surrealism's most

MICHAEL R. TAYLOR

FIG. 76
Arshile Gorky, *Carnival*, 1943. Crayon with graphite
and scraping on off-white wove paper, 22¾ x 28⅞
inches (57.8 x 73.2 cm). The Art Institute of Chicago.
Gift of Lindy Bergman (The Lindy and Edwin
Bergman Collection), 1999

liberating innovation and would open up new possibilities for abstract painting that would express the artist's innermost self while remaining independent of any preconceived intention or artifice. Matta's solution to the problem of applying automatic procedures to painting was to thin his oil paint with turpentine to allow for a freer, more spontaneous manipulation of the medium, as well as to develop fluid, amorphous forms out of the stains, drips, and other accidents that occurred when applying the diluted paint. This technique, which looks back to the abstract liquefaction of Miró's paintings of the mid-1920s, such as *The Birth of the World* (MoMA) and *Painting* (Peggy Guggenheim Collection, Venice), was adopted by Gorky around 1943–44, quickly giving his paintings a pulsating feeling akin to living nature.

Gorky's fortuitous encounter with Matta in the early months of 1941, and their subsequent discussions in his downtown studio about the role of chance and automatism in Surrealist painting, played a crucial role in Gorky's break from his previous working methods, whereby his strong personal identification with particular artists, living or dead, had led him to emulate their work to the point of obsession. Although the abstract visual language of Miró, the last of these artistic father figures, would remain a powerful presence in his work, Gorky developed his own means in the early 1940s of investigating and revealing the world, based on the chance procedures introduced to him by Matta. Although younger than Gorky, Matta was a spell-binding proselytizer who taught his friend to cultivate an intuitive awareness and understanding of his internal, unconscious control, liberated through automatic techniques. These new working methods provided Gorky with a seemingly endless source of creative inspiration, especially during and after the summer of 1943, when he spent four months making detailed drawings of natural forms that he discovered in the fields of rural Virginia (plates 108–12). The teeming bacchanalia of plants, birds, and animal life in these brightly colored drawings fused with other forms and motifs, such as body parts and genitalia, derived from Gorky's memories, daydreams, and sexual fantasies, resulting in a polymorphous, psychosexual pageant. It is no coincidence that several of his works on paper from this time bear the name *Carnival* (fig. 76), a title that Gorky borrowed from a 1914 painting by Kandinsky.

The Great Transparents

Gorky's paintings and drawings of the early 1940s were often populated by fantastical beings, wrought via automatism from the depths of his subconscious. These creatures are impossible to imagine without the precedent of Surrealism, especially Breton's clarion call for a new myth centered around transparent entities called "Les Grands Transparents." After failing to adequately oppose and defeat fascism in Europe, the transplanted Surrealists hoped to reinvent themselves in the New World. One of their strategies was to create new belief systems on which a future society could be based, displacing the outmoded economic model of capitalism and the failed utopia of communism. It was in his "Prolegomena to a Third Manifesto of Surrealism or Else," published in the June 1942 issue of the Surrealist magazine *VVV*, that Breton first proposed the myth of "Les Grands Transparents" (translated in *VVV* as "The Great Invisibles"). He derived the concept from a wide range of sources, including the writings of the American psychologist and philosopher William James, the German Romantic poet Novalis, and a former director of the Institut Pasteur in Paris, Émile Duclaux.[36]

Breton's article proposed that human beings were surrounded by invisible entities undetectable by the five senses. "Man is perhaps not the center, the *focus* of the universe," he wrote:

FIG. 77
Roberto Matta. *Los Grandes Transparentes*
(*The Great Transparents*), drawing repro-
duced in *VVV*, June 1942, p. 25. Courtesy
of the Philadelphia Museum of Art Library

FIG. 78
Roberto Matta. *Joan of Arc*, 1942. Crayon and
pencil on paper, 23⅜ x 29⅛ inches (59.1 x
73.9 cm). The Museum of Modern Art, New
York. James Thrall Soby Bequest, 1980

One may go so far as to believe that there exist above him, on the animal level, beings whose behavior is as alien to him as his own must be to the day-fly or the whale. There is nothing that would necessarily prevent such beings from completely escaping his sensory frame of reference, since these beings might avail themselves of a type of camouflage, which no matter how you imagine it, becomes plausible when you consider the *theory of form* and what has been discovered about mimetic animals.[37]

Breton's article was illustrated with a drawing by Matta titled *Los Grandes Transparentes* (fig. 77)—in which phantasmatic beings and mysterious shapes hover in space—thus underscoring the important role the artist's work played in the formation of this idea. According to Matta, Breton derived his concept of the Great Transparents from contemporaneous depictions of totemic glass creatures whose actions are controlled by invisible psychic forces, as seen in works such as *Joan of Arc* (1942; fig. 78).[38] Beginning around 1944, Matta would explore this idea further in a series of drawings and paintings of diaphanous mythical beings that he titled "les vitreurs," which translates as "the glazers" or, more precisely, "men made of glass."[39] The transparent beings depicted in these works, which inhabit our own irrational and self-destructive world, as well as a universe beyond our perception,

function as the pictorial embodiment of Breton's myth of the Great Transparents.

The transcendental escapism of this collective social myth also appealed to many other artists, including Enrico Donati, David Hare, Jacques Hérold, Gerome Kamrowski, Lee Mullican, and Kurt Seligmann. In his celebrated 1943 painting *Melusiné and the Great Transparents* (fig. 79), for example, Seligmann conflated the myth of Melusiné, the beautiful half-woman, half-serpent of fifteenth-century French folklore, with Breton's new myth of the Great Transparents, who appear in the painting as cyclonic forms wrapped in ribbonlike drapery that whirl about the canvas like spinning tops. These gyrating, chimerical figures convey the powerful attraction of the new myth for artists, as well as its malleability. Having no iconographic precedents, the erudite Seligmannn simply conflated Breton's notion with his own earlier interest in the heraldic symbolism of his native Switzerland, which frequently featured the mermaid-like figure of Melusiné.

Two years later, in his collection of new poems and essays, *Arcane 17*, Breton similarly invoked the medieval myth of the serpent-tailed Melusiné as a symbol of French resistance and renewal, writing that "she's the only one I can see who could redeem this savage epoch."[40] Breton heard of the liberation of Paris while writing the analogical

prose of *Arcane 17*, and he envisioned the mythological redemptress not only standing guard over France but also serving as a warning that liberation does not necessarily mean true freedom, which he believed would require that the French people renew their faith in the transformative power of myth. As the literary historian Anna Balakian has pointed out, Melusiné was "the unjustly cursed mortal, the uprooted, homeless, anguished protector of her breed."[41] This reading can also be applied to Seligmann's painting, and by extension to the myth of the Great Transparents as a whole, which can be understood as a political allegory wherein these invisible beings function as a reminder that modern dictators do not control everything that surrounds them, and thus are not invincible, despite the "trails of spilled blood" they had scattered across war-torn Europe.[42]

Gorky seems to have been aware of the Great Transparents as early as 1942, either through Breton's article in *VVV* or through the catalogue that accompanied the *First Papers of Surrealism* exhibition, which was held in October 1942 on the second floor of the old Whitelaw Reid Mansion, an ornate, block-long brownstone located at 451 Madison Avenue in New York. Organized by the Coordinating Council of French Relief Societies for the benefit of war prisoners, *First Papers of Surrealism* included paintings and works on paper by some fifty artists, installed by Marcel Duchamp amid crisscrossing lines of taut white string that he hung from the gilded moldings, crystal chandeliers, and Italianate painted ceiling to produce what amounted to a giant cobweb (see fig. 84).

The exhibition's catalogue contained a page dedicated to the theme of "Les Grands Transparents," illustrated with an enigmatic photograph by the American sculptor David Hare titled *Hidden Fundamental* (fig. 80). Hare created this work by applying heat from a match or alcohol flame to the negative emulsion to fundamentally alter its appearance,[43] thereby transforming the naked torso in the original image into a fiery walking inferno akin to the man depicted in the unidentified print at the top of the page, who spews flames and smoke from his head and arms. The forward motion of the nude and the trail of featherlike flames that she leaves in her wake also bring to mind the famous ancient Greek sculpture of the *Victory of Samothrace*. This visual correspondence speaks to

FIG. 80
"Les Grands Transparents" in the exhibition
catalogue for *First Papers of Surrealism*,
1942. Courtesy of the Philadelphia Museum
of Art Library

105

GORKY AND SURREALISM

the control Hare had over his inventive heat-altered photographs, which have been largely overlooked in accounts of the automatist practices of the American avant-garde during the 1940s, despite the fact that their melting, amorphous forms provide a photographic equivalence to the contemporaneous abstract paintings of Gorky and Matta, which similarly present forms in a state of metamorphosis and liquefaction.

Gorky may have been drawn to Breton's notion of the Great Transparents through his longstanding interest in camouflage. In May 1937, Gorky gave a lecture on the subject at the American Federation of Arts in Washington, D.C., and in the fall of 1940, following the outbreak of World War II, he proposed the idea of teaching a course on camouflage at the Grand Central School of Art. At the end of the next year Edmund Greacen, the school's director, approved the class on the history and application of camouflage, which was intended to make an important contribution to civilian and military defense, according to the course description: "An epidemic of destruction sweeps the world today. The mind of civilized man is set to stop it. What the enemy would destroy, however, he must first see. To confuse and paralyze this vision is the role of camouflage. Here the artist and more particularly the modern artist can fulfill a vital function for opposed to this vision of destruction is the vision of creation."[44] The three-page course outline reveals that Gorky planned to teach a studio workshop in which students would produce scale models and abstract constructions, drawing on "data on protective coloring in zoology, optical illusion in the physics of light, and visual reactions to movement in Gestalt psychology."[45]

Breton's suggestion in *VVV* that the Great Transparents might "avail themselves of a type of camouflage,"[46] based on the theory of form and the mimetic study of animals that had obsessed the Surrealists (especially Dalí and Roger Caillois) since the early 1930s, must have piqued Gorky's interest around 1942, given that he was then teaching his class on camouflage. Caillois's theory, expressed in his article "Mimétisme et psychasthénie légendaire" (Mimicry and Legendary Psychasthenia) in the June 1935 issue of *Minotaure*, resonates with Gorky's fascination with camouflage as a means to render creatures and objects indiscernible from their environment.[47] According to Caillois, those birds, insects, reptiles, and fish that mimic their surroundings do not do so as

a defensive strategy against predators, as was commonly thought at the time, but rather because they are suffering from depression. Because of their pathological loss of *élan vital*, they fail to differentiate themselves from their surroundings and elect instead to blend in with their environment. "To these dispossessed souls," wrote Caillois, "space seems to be a devouring force. Space pursues them, encircles them, digests them in a gigantic phagocytosis. It ends by replacing them."[48] It is hard not to apply this theory to Gorky's own psychic state as the traumatized survivor of an unrecognized genocide, whose salvation was his vocation as an artist.[49]

Gorky's recent work had begun to shift away from Miró-inspired abstractions toward a new engagement with the natural environment following his visit to the artist Saul Schary's bungalow in New Milford, Connecticut, where he worked outdoors for three weeks in the summer of 1942. In the paintings and studies that he made in the fields and

Julien Levy, Gorky's friend and dealer from 1945 until his death three years later, claimed that the artist based these works on a mongrel called "Old Pirate" that frequented the backyard of Schary's house in Connecticut.[50] The seated animal's nose, whiskers, and paws are clearly discernible in both paintings, although Levy is surely mistaken about the order in which they were made. The green-, blue-, and lavender-hued painting that Levy called *The Pirate I*, because Gorky dated it to 1942, must have been completed at a later time, given its Matta-like surface of dripping, thinned-out paint. The vigorous brushwork of what has commonly been referred to as *The Pirate II*, on the other hand, which Gorky signed and dated to 1943, is consistent in form and color with the Kandinsky-inspired works made in that year. *The Pirate I* has thus become *The Pirate II* for this catalogue and has been redated to circa 1943–44, despite Gorky's 1942 date, which perhaps recorded the year of his Connecticut vacation, rather than the time of its making.

Levy described these paintings as "abstracted out of and not without nature. His next step is to camouflage."[51] Although he did not elaborate, the implication is that Gorky's 1941 class on camouflage had a direct impact on his work, as seen in the two versions of *The Pirate*, in which the dog almost disappears into its surroundings. Gorky's interest in camouflage and the study of mimicry in animals, which I would argue was also informed by Breton's notion of the Great Transparents, would lead him to invent hybrid creatures in the paintings and works on paper that followed, such as the Virginia landscape drawings of 1943 (plates 107–12), in which the shape-shifting bugs and other insects and animals that comprise his Surrealist virtual bestiary appear in a constant state of transition or flux that veils their appearance. The artist's widow wrote that Gorky "saw fantastic animals and menacing heads in the shapes of trees" and felt the earth "as a swell, a bosom, an expansion like a sigh."[52]

The fulgurating, polymorphous creatures that reveal themselves in these 1943 colored drawings are first cousins of the camouflaged, hypothetical beings of Matta's *Los Grandes Transparentes* drawing of the previous year, which Gorky would have known from its reproduction in *VVV*. The intricate circular patterns of dots that appear in Gorky's works on paper of this time probably derive from Matta's 1942 drawing, although Gorky may also have recognized its original source in the

apple orchard surrounding Schary's country home (plate 100), as well as at an abandoned silica mill on the Housatonic River just south of New Milford (plate 105), he rediscovered the pleasure of working from nature that he had first experienced as a student in Boston. In the following year, Gorky would develop these drawings into several vibrantly colored paintings, including *Waterfall* (plate 104), a joyous work based on a small waterfall in a Connecticut wood. This painting was inspired in large part by the warm palette and scumbled, iridescent surfaces of Kandinsky's early work, such as the *Improvisations* series that he made between 1909 and 1914. In these paintings, Kandinsky divided the canvases into episodic compositions featuring black linear elements and thinly applied areas of brilliant color (fig. 81), similar to the greens and browns of Gorky's painting, where they are suggestive of overhanging trees and dense foliage. Kandinsky's lyrical abstractions, which Gorky would have seen firsthand at the recently opened Museum of Non-Objective Painting (now the Solomon R. Guggenheim Museum) in New York, provided an important link between his earlier interest in painterly abstraction and his future experimentation with Surrealist automatism, a transition that can be charted in the two versions of *The Pirate* (plates 98, 99).

FIG. 82
Arshile Gorky. *Crooked Run*, 1944. Oil on canvas,
19 x 28 inches (48.3 x 71.1 cm). Private collection

FIG. 82
Arshile Gorky. *Crooked Run*, 1944. Oil on canvas,
19 x 28 inches (48.3 x 71.1 cm). Private collection

Mary Burliuk, the Ukranian painter David Burliuk's wife, in 1933, "close my eyes and feel how clouds move in the sky."[54]

These sketches often began with recognizable imagery from the natural world, such as flowers, plants, birds, and insects, which Gorky then developed into an abstract visual language in his subsequent drawings and paintings. Although initially indebted to the gestural spontaneity of Matta and Miró, both of whom used the natural environment as a touchstone for their own artistic practice, Gorky's mature work eventually developed into an independent and highly original form of Surrealist automatism through which he embraced and attempted to harness the uncontrollable forces of nature. Encouraged by the catalytic Matta, he began to experiment and improvise with thinned-out washes of liquid oil paint to create transparent veils of evanescent color in paintings such as *Water of the Flowery Mill* (1944; plate 118). He quickly mastered this radically new application of the paint medium, allowing the pigment to run and pool in certain areas to suggest spontaneity, while always remaining in control of the "accidents" that took place. This can be seen in two very similar paintings from 1944—*Crooked Run* (fig. 82) and *Scent of Apricots on the Fields* (plate 122)—in which the effects of dripping, pooling, bleeding, and pouring the fluid oil paint are almost mirrored, thus confirming the immense control Gorky maintained over his medium.

Since arriving in the United States in 1939, Matta, the youngest of the Surrealists to emigrate from Paris during the war, had played an instrumental role in introducing the experimental techniques and theoretical principles of European Surrealism to a group of young American painters, including Gorky, Motherwell, Pollock, Adolph Gottlieb, and Mark Rothko, who were seeking valid alternatives to the cold formalism of geometric abstract art. These American artists learned from Matta's use of heroic scale, apocalyptic imagery, and innovative painting techniques, especially automatism, as they searched for a new language of

dotted lines and circles of colored dots in the work of Miró, which he had studied intently since the mid- to late 1930s and had a chance to view up close in Miró's 1941 exhibition at MoMA.

Gorky spent the summer and early fall of 1943 near Lincoln, Virginia, at Crooked Run Farm, recently purchased by his new wife's parents. He had met Agnes Magruder, whom he affectionately nicknamed Mougouch (an Armenian term of endearment), through Elaine Fried (later de Kooning) early in 1941, and they were married that September. The time that Gorky spent at his in-laws country house in 1943 would have a direct bearing on his newfound interest in the natural environment after more than a decade of Cubist experimentation. In the "breakthrough" drawings that he produced from July to November of that year, his working method consisted of making quick sketches in the fields, which he would expand upon in highly finished drawings and paintings completed back in his New York studio during the winter months. Gorky's decision to "look into the grass,"[53] as he described his recent process to MoMA curator James Johnson Sweeney, fulfilled a decade-long desire to return to nature. "I would like to lie in the grass," he told

FIG. 83
Roberto Matta. *To Escape the Absolute*, 1944. Oil on
canvas, 37¾ x 49¾ inches (95.9 x 126.4 cm). Philadelphia
Museum of Art. Gift of Sylvia and Joseph Slifka, 2004

FIG. 84
John D. Schiff (American, born Germany, 1907–1976). Installation
view of *First Papers of Surrealism* showing the "Sixteen Miles of
String" installation by Marcel Duchamp (American, born France,
1887–1968), New York, 1942. Gelatin silver print. Philadelphia
Museum of Art. Gift of Jacqueline, Paul, and Peter Matisse in
memory of their mother, Alexina Duchamp, 1998

myths and archetypal symbols. In turn, Matta matured as an artist during his stay in the United States, which lasted until 1948, learning a great deal from his discussions with Gorky, whose knowledge of the history of painting far surpassed his own.

Matta's paintings of the early 1940s suggest primordial mayhem, in strange, mineral landscapes filled with peculiar biomorphic shapes, gemlike clusters of pigment, and burning fires rendered with iridescent colors. Matta called these works "Inscapes" or "Psychological Morphologies," by which he meant the kind of fantastic landscapes and turbulent galaxies to be discovered within the inner self.[55] Morphology, a science dealing with the structure, growth, and metamorphosis of forms in animals, plants, and even language, established the atmosphere of continuous transformation that characterized Matta's paintings of this time, in which molten shapes and jets of fire symbolize the turmoil of the mind and the chaos of nature's creative and destructive forces. This important body of work was included in the artist's first exhibition in New York, held at the Julien Levy Gallery in April–May 1940, and followed two years later by a second major New York exhibition at the Pierre Matisse Gallery, which presented Matta's work on

an annual basis after 1942. These early exhibitions helped to establish Matta as a leading exponent of Surrealist painting and encouraged him to continue to expand his exploration of "the subconscious in its burning, liquid state; a conscious daytime substitution of the phenomenon of dreams."[56]

In subsequent paintings, such as *To Escape the Absolute* (1944; fig. 83), Matta used a palette of dark crimson-brown punctuated with bursts of scarlet and an eerie yellowish green to depict a nebulous spatial realm filled with linear whirlpools and electromagnetic force fields. The geometric webs of straight and curved lines in *To Escape the Absolute* are reminiscent of geodesic lines and waves, as well as the maze of string that Duchamp had created for *First Papers of Surrealism* in 1942 (fig. 84), when he had strung the main gallery of the Reid mansion with a labyrinthine arrangement of white cord that ensured that the paintings on view were seen through changeable perspectives. As the curator and collector James Thrall Soby has argued, this installation may have inspired Matta to use intricate linear patterns to suggest multiperspectival spatial systems, which would in turn have an enormous impact on Gorky's own surface calligraphy of the mid-1940s.[57]

FIG. 85

Georges Braque (French, 1882–1963). *The Table*, 1918. Oil on canvas, 52 5/16 x 29 3/4 inches (132.9 x 75.6 cm). Philadelphia Museum of Art. The Louise and Walter Arensberg Collection, 1950

The sense of cosmic violence and destruction in Matta's work is enhanced through the use of vaporous washes of paint in varying degrees of weight and transparency that are spilled, wiped, and brushed across the canvas.

Although Gorky was no doubt inspired by his young friend's restless experimentation and energetic temperament, he nonetheless remained a consummate craftsman attached to the history and techniques of oil painting. While Matta disdained the romantic associations of the oil paint medium, Gorky delighted in its history as well as its endless possibilities. This explains why his work ultimately surpassed that of his friend and mentor around 1944, as he continued to explore new techniques and subject matter inspired by his increasing engagement with Surrealist art and literature, which he reconciled with his previous interest in the art of the past.

Gorky's work of the 1940s, especially the paintings he made in 1944—perhaps the most productive and singularly inventive year of his career—shares many affinities with the color and linear components of Matta's "Inscapes." But whereas Matta used his thinned-out, semi-transparent washes of oil paint to suggest the deep reaches of the psyche—an invented galaxy replete with electrical storms and whirlpools—Gorky, in paintings such as *Scent of Apricots on the Fields* (plate 122) and *Good Afternoon, Mrs. Lincoln* (plate 119), kept his focus firmly on the ground, perhaps because of his earlier interest in the visual syntax of Paul Cézanne and the Cubist still life, which had given him a deep regard for formal structure. In contrast with the convulsive forms, synthetic and often phosphorescent colors, and vast spatial expanses of Matta's paintings (Gorky called them "airplane vistas"),[58] his own paintings of the mid-1940s retain Cubism's compressed, shallow space, as well as its preservation of the picture plane. This can be seen again in his 1945 painting *Landscape Table* (plate 136), with its strong trace memory of Georges Braque's *guéridons* (fig. 85), in which still-life elements are arranged on the surface of a distinctive wooden table whose two front legs have been elongated and flattened to the point where they lie parallel to the picture plane.

The differences in the two artists' approaches to painting, and its history, helps to explain why the fragile web of lines and opaque black shapes that float about in Matta's canvases like kites in the night sky were flattened out when they began appearing in Gorky's work in 1944 (plates 123, 124). The fine black threads that animate Gorky's paintings and drawings of this time give clarity to his isolated forms and patches of color, connecting them without suggesting depth or illusion. In Matta's paintings, these lines become a filigree thread that weaves together the convulsive patterns of the whirlpools or electromagnetic fields of his imagination,[59] while Gorky's paintings and drawings remain firmly rooted in the natural world, despite their seemingly abstract appearance.

The Eye-Spring

Gorky's nature-based abstractions of the early 1940s can be understood within the context of Surrealism's longstanding engagement with the natural world. Breton, in his 1945 essay on the artist, "The Eye-Spring: Arshile Gorky," characterized nature as an abstract or symbolic language.[60] As the Surrealist leader was no doubt aware, the lush vegetation of the Virginia countryside reminded Gorky of his rural Armenian homeland. Indeed, the freely improvised drawings in pencil or ink and wax crayon that Gorky produced in the fields surrounding Crooked Run Farm during the summer and fall of 1943—and again in the spring, summer, and fall of 1944, when he spent nine months in Virginia drawing outdoors and painting furiously—combined childhood memories of the gardens, orchards, and wheat fields of Turkish Armenia with direct observations from nature to create imaginary landscapes that are remarkable for their evocative power and fecundity of organic forms (plates 107–12, 117–22). The swelling, rounded shapes and contours found in these drawings are suggestive of flower petals, stems, stamens, and tendrils, as well as leaves, weeds, and blades of grass, but also insects, feathers, and body parts, especially human sexual organs. These images welled up from Gorky's subconscious fantasies and daydreams as he worked outdoors and explored what Breton called the "free unlimited play of *analogies.*"[61]

Gorky's remarkable drawings provided the point of departure for a series of important paintings that he produced upon returning to his New York studio in the winter and spring of 1943–44. In works such as *One Year the Milkweed* (plate 120) and *Cornfield of Health* (plate 117), the thinned-out oil paint pools, drips, and stains the bare canvas in emulation of elemental natural forces, while the palette of greens and yellow ocher evokes the colors and textures of the natural world, denoting forest glades and fields of grass or grain, as well as the sun-baked earth. *One Year the Milkweed* is emblematic of the shift away from the botanical precision of Gorky's drawings, which is replaced in these paintings by automatist gestures that allow the colors to bleed and run into and over each other. These lyrical abstractions, which bear almost no relation to the direct observation of plants, insects, and birds found in the earlier drawings, are justifiably recognized as among Gorky's finest paintings.

However, the best known among them, *The Liver Is the Cock's Comb* (plate 114), stands out from the rest of the paintings he made after returning to New York from his first trip to Virginia.[62]

Whereas *One Year the Milkweed* celebrated the lyrical beauty of the streams and pools filled with floating lily pads, plants, and weeds that Gorky discovered in rural Virginia, the monumental *The Liver Is the Cock's Comb* offers a menacing vision of nature's destructive power, replete with claws, talons, and other spiky, visceral forms, as well as feathers, leaves, flower petals, and swollen, overripe genitalia. In 1945, the year after the painting was completed, the American poet and film critic Parker Tyler described the destructive qualities of *The Liver Is the Cock's Comb* as "the successfully deceptive dismemberment of a rooster" before commenting on its scale, which was so large "that the butchery seems to have taken place in Grand Central Station."[63] Although intended to be humorous, Tyler's interpretation of the painting as depicting the violent sacrifice of a red-plumed bird nonetheless signals the abrupt shift in Gorky's vision away from the harmonious view of nature's fecundity seen in the 1943 drawings, to the dark, threatening forms of *The Liver Is the Cock's Comb* and such subsequent paintings as *Agony* (1947; plate 165) and the several versions of *The Betrothal* (1947; plates 172–74).

Gorky's increasingly bleak and nightmarish vision has commonly been explained in relation to the tragic events of the final years of his life, beginning in January 1946 with a catastrophic fire in his Connecticut studio that destroyed a large number of recent paintings and drawings as well as cherished art books, including a rare French publication on Jean-Auguste-Dominique Ingres. This disastrous event was closely followed by a painful operation for rectal cancer—misdiagnosed as hemorrhoids the previous year—that was performed at New York's Mount Sinai Hospital on March 5. In mid-June of 1948 Gorky's increasingly black moods led his wife to pursue a brief affair with his friend Matta. Then, on June 26, 1948, he was involved in a serious car accident that left him with a broken collarbone and two broken vertebrae that temporarily paralyzed his painting arm, leading him to fall into a deep depression from which he never recovered. Unable to cope with her husband's brooding melancholy and violent outbursts, his young wife left him shortly afterward, taking their two daughters with her.

FIG. 86
André Masson. *Meditation on an Oak Leaf*, 1942.
Tempera, pastel, and sand on canvas, 40 x 33
inches (101.6 x 83.8 cm). The Museum of Modern
Art, New York. Given anonymously, 1950

In physical and emotional torment, Gorky took his life in Sherman, Connecticut, on July 21, 1948.

While *Agony* and *The Betrothal* series can be firmly placed within this traumatic sequence of events, *The Liver Is the Cock's Comb* was completed in 1944, during a time of domestic and marital bliss following the birth of the couple's first daughter, Maro, on April 5, 1943, which led to a tremendous increase in Gorky's productivity. The astonishing creative outpouring that he experienced in the summer of 1943 can be partially explained through this event, which no doubt inspired the themes of copulation, fertilization, and birth that dominate the Virginia landscape drawings (plates 107–12). Gorky even painted a bull's head on the barn door of his studio around this time, likely intending it as a symbol of his feelings of virility, confidence, and power, which rivaled those of Picasso.[64] As a new father and the husband of an attractive young wife who supported his creative work, Gorky assumed the identity of a "bull in the sun" in the bright Virginia fields.[65] Given that the mood and subject matter of his harsher, more genuinely Surrealist works from this time, such as *The Liver Is the Cock's Comb*, are altogether darker and more violent, their inspiration must lie elsewhere.

In late 1943 or early 1944, Isamu Noguchi, at the suggestion of their mutual friend and fellow artist Jeanne Reynal, introduced Gorky and his wife to André Breton over dinner at the Lafayette Hotel in New York.[66] According to Mougouch, Breton visited Gorky's studio the next day and was immediately impressed by the dizzying range of paintings and drawings he saw there.[67] Gorky entered the orbit of the Surrealist leader at a time when Breton was looking for friendship and support in a strange country, whose language he pointedly refused to learn, believing that it would diminish the cadence of his poetry and dilute his perfect mastery of the French language. The lion-maned poet was head of a fractious, now geopolitically displaced group that had grown increasingly weary of his overbearing ways and had used the freedom of a new country and a fresh influx of members to challenge his rigid control of the Surrealist movement. Breton was thus at his most vulnerable, besieged by a series of crises, defections, insults, and disappointments, and his friendship with Gorky, which lasted until the artist's death four years later, was one of the few highlights of his years in exile in the United States.

Breton had hoped to replicate in New York the stimulating intellectual atmosphere of Paris between the wars, when the Surrealists met regularly at their favorite cafés and restaurants. However, it soon became apparent that the New York sites where the Surrealists met, such as Larré on West Fifty-sixth Street or Mont d'Or on East Forty-eighth Street, could not take the place of Les Deux Magots in Paris. Without effective leadership, the displaced Surrealist artists and writers, including Ernst, Masson, Seligmann, and Tanguy, initially maintained a solitary existence, keeping to themselves, speaking French, and making little or no contact with the fledgling American avant-garde. Ernst later recalled the negative effect that New York's lack of a café culture had on the possibility of Surrealist meetings: "It was hard to see one another in New York. The café life was lacking. In Paris at 6 o'clock on any evening you knew on what café terraces you could find Giacometti or Éluard. Here you would have to phone and make an appointment in advance.... Such a communal life as that of the Paris café is difficult if not impossible here."[68]

Like many of his colleagues in the exiled Surrealist camp, Breton frequently left New York for excursions into the surrounding country-side, especially to the Surrealist enclave that Gorky, along with Peter Blume, Alexander Calder, Malcolm Cowley, Masson, and Tanguy and his wife Kay Sage, had formed in rural Connecticut, which served as a safe haven for the displaced artists and writers. Many of them found inspiration in the animal and plant life they found in the country, especially Masson, whose dense, brightly colored paintings of this time, such as *Leonardo da Vinci and Isabella d'Este* (MoMA) and *Meditation on an Oak Leaf* (fig. 86), both of 1942, were well known to Gorky. The latter work visually captures a remark Masson made to Gorky during their time together in Roxbury, Connecticut—"I do not paint in front of, but from within nature"—a comment that could just as easily have been applied to Gorky, who was equally immersed in the natural environment in the 1940s.[69]

Masson showed Breton the plants, flowers, and birds in the woods around his rustic converted barn in New Preston, Connecticut, including the "timorous" and "ambiguous" Indian Pipe and the Scarlet Tanager, which they both admired.[70] The pastoral Connecticut landscape, with its "truly surrealist flora,"[71] would become subject matter for the richly colored paintings that Masson created during his four-year stay in the United States, which, like Gorky's work of the same period, often dealt with the metamorphic processes of fertilization, germination,

blossoming, and growth, and featured vegetable and animal motifs, such as leaves, worms, caterpillars, seeds, and flowers. These "telluric" paintings, as Masson called them, are usually noted for their brilliant chromatic effects, which register the artist's emotional response to the warm browns, reds, and other autumnal colors of the New England fall, when, he claimed, it was "as if the sky had dumped pots of paint on the trees."[72] As with Gorky, however, the American landscape was also capable of inducing visions of aggression, violence, and destruction, as Masson explained to James Johnson Sweeney on the eve of his departure for Europe, citing "the might of nature—the savagery of nature—the feeling that nature may one day recover its strength and turn all back to chaos."[73] It was this combination of the positive, vitalistic forces of nature, especially germination and growth, with the opposite forces of death and destruction that lay behind Masson's concept of the telluric.

As the film historian Paul Hammond has noted, during the years Breton spent in exile in the United States, he "rejected the skyscrapers of Manhattan and went botanizing, à la Rousseau in his *Reveries of the Solitary Walker*, in the meadows of New England and on the shores of the St. Lawrence River. What had begun [in Paris in the early 1920s] as an ironical disavowal of nature in favor of the enchantments of the urban life-world was reversed . . . in favor of the Arcadian potential of the embattled natural world."[74] A photograph taken by Breton's wife, Elisa, in April 1945 confirms the Surrealist leader's newfound embrace of the splendors of nature (fig. 87). In the picture, taken in a field near David Hare's house at 148 Good Hill Road in Roxbury, Breton holds a pitchfork while standing next to a rustically attired Gorky, his daughter Maro on his shoulders and a cigarette hanging from his mouth (the large bag he holds is presumably filled with apples). Like Breton, Gorky similarly leans on a farm implement, but he appears more comfortable in this rural environment than Breton in his corduroy smoking jacket.

The shift of the Surrealist movement from an urban, café-based milieu to a nature-oriented group may explain Breton's immediate attraction to Gorky's landscape-based paintings and drawings, which combine elements of the natural world with those from his memories or imagination. It also explains his ability to write so eloquently and enthusiastically about Gorky's recent paintings and drawings, which he

FIG. 87
Arshile Gorky, with Maro Gorky on his shoulders, and André Breton, Roxbury, Connecticut, April 1945. Photograph by Elisa Breton. Courtesy of the Austrian Frederick and Lillian Kiesler Private Foundation, Vienna

FIG. 88
Salvador Dalí (Spanish, 1904–1989).
The Persistence of Memory, 1931. Oil
on canvas, 9½ x 13 inches (24.1 x 33
cm). The Museum of Modern Art,
New York. Given anonymously, 1934

FIG. 89
Arshile Gorky, *The Eye-Spring*, 1945. Ink on paper,
11⅜ x 14½ inches (28.9 x
36.8 cm). Private collection

113

GORKY AND SURREALISM

had seen repeatedly since their first encounter. In 1944, Breton published *Arcane 17*, in which he described Maro as "the eleven-month old of my friends Arshile and Agnès Gorky, so purely magical, turning her shoulder away and looking very offended when I made as if to take her hand and bring her back, her eyes ever brighter, begging with all the power of playfulness and grace for what she was fleeing."[75] In the same year, he praised Gorky's work in a footnote to an essay on Matta that paved the way for his famous "Eye-Spring" essay of the following year:

> Gorky, in his marvellous recent paintings, seems to have gone to draw this "exalted water" from the centre of flowers, especially the pansy, through the grace of a graph which is so unique and so absolutely sure that one must believe that it is wedded exactly to the desire of the butterfly and the bee. Although Gorky's work is developing according to an entirely different rhythm to that of Matta's, it is surely destined to excite the widest possible attention in the near future.[76]

Breton wrote his "Eye-Spring" essay as the preface to the catalogue of Gorky's solo exhibition at the Julien Levy Gallery in March 1945. In it he places special emphasis on the painter's eye: "I say that the eye is not *open* when it is limited to the passive role of a mirror . . . that eye impresses me as no less dead than the eye of a slaughtered steer if it has only the capacity to *reflect*—what if it reflects the object in one or in many aspects, in repose or in motion, in waking or in dream? *The treasure of the eye is elsewhere!*"[77] Nonetheless, Breton claimed that most artists—and he almost certainly had in mind Dalí's *The Persistence of Memory* (1931; fig. 88), with its famous iconography of melting watches in a barren landscape, when he wrote these words—were still at the stage of examining the watch case from every possible angle, without having the faintest idea that there was a spring hidden inside its opaque covering. Gorky's achievement, as Breton perceived it, was that of being the first painter to unveil, completely, "the eye-spring."[78]

As the Surrealist scholar J. H. Matthews has noted, Breton's perspective in this essay is highly illuminating, since he completely rejects

> the view that the painter's eye serves to "inventorize like a bailiff's." More important still, it sets Arshile Gorky apart from the madman, whose eye "takes pleasure in illusions of false reconnaissance," as Breton put it. With uncompromising dismissal of artists whose aim is confined to recording the visible goes also unqualified disapproval of those whose work bears witness to their total withdrawal from reality. And so Breton located Gorky's place, as a Surrealist, somewhere between the two groups. Here Gorky's painting demonstrates the possibility of *using* the real, without paying the unacceptable price of falling victim to it.[79]

Gorky was clearly moved and inspired by Breton's eye-spring metaphor, for he illustrated the idea in several drawings made that year, including a double-sided work in which an eye is visible within a series of spiraling lines that suggest a coiled spring (fig. 89).

Breton goes on in the essay to connect Gorky's nature-based abstractions with the revolutionary writings of Charles Fourier, the

nineteenth-century French social theorist who envisioned a non-repressive social order in which carnal desires would be given free reign, but only after cures had been found for all known sexual diseases. As Surrealism recast itself in New York during the upheaval of World War II, its earlier faith in Marxist revolution was replaced with utopian humanist ideals inspired by Breton's rediscovery of Fourier, whose advocacy of free love encouraged the Surrealists to redefine their notions of eroticism and the sexual act.[80] Breton connected Gorky's often erotic renderings of the natural world, in which the flora and fauna of the Virginia countryside were translated into an abstract visual language, with Fourier's theory of universal analogy. Rereading Fourier's writings led Breton to consider Gorky's *The Liver Is the Cock's Comb* as the "great open door to the analogy world," in which the hybrid forms of nature are "treated as a cryptogram."[81]

Breton's renewed interest in Fourier's sexualized utopia in the 1940s speaks to the changing conditions of Surrealism both during and after World War II, when core members of the exiled group in New York, as well as such new recruits as Gorky, Enrico Donati, David Hare, and Kay Sage, embraced Tarot cards, black magic, pagan rituals, hermetic philosophy, and alchemical, cabalistic, and other forms of arcane imagery, as well as modern physics and, above all, a new conception of Eros, as the art historian Alyce Mahon has persuasively argued.[82] In an interview with Nicolas Calas that appeared in the October–November 1941 issue of the American Surrealist magazine *View*, shortly after Breton had arrived in New York, the Surrealist leader declared that the appropriate response to the human suffering caused by World War II was to "learn to read with and look with and through the eyes of Eros— Eros who will be called upon, in the days to come, to restore the balance that has tipped in death's favor."[83] This statement provides important insights into Breton's newfound admiration for Fourier's concept of a utopian society based on free love, rather than greed and aggression. However, Gorky's introduction to Fourier's utopian writings through Breton's "Eye-Spring" panegyric did not occur until 1945. He made the first studies for *The Liver Is the Cock's Comb* in 1943 and had completed the painting in 1944; again, we must look for its source of inspiration elsewhere.

Les Chants de Maldoror

I would like to propose as the source for *The Liver Is the Cock's Comb* the macabre prose poem *Les Chants de Maldoror* that the Uruguayan-born poet Isidore Ducasse published in 1869 under the pseudonym of Le Comte de Lautréamont. Mougouch recalls that Gorky liked to paint while she read to him, and that their exposure to the exiled Surrealist group in New York in the early 1940s led them to tackle several of the movement's most venerated texts, including Alfred Jarry's *Ubu roi*, the erotic novels of the Marquis de Sade, and Stéphane Mallarmé's *Un coup de des jamais n'abolira le hasard* (*A Throw of the Dice Will Never Abolish Chance*), which must have been of great interest to Gorky when he was beginning to experiment with the ludic aspects of the creative act. Mougouch remembers that she and Gorky read and discussed Lautréamont's book-length poem during the fall and winter of 1943–44, a period that coincides with his work on *The Liver Is the Cock's Comb*.[84] Although Gorky had previously read two excerpts from *Les Chants de Maldoror* in Levy's 1936 book on Surrealism, it was through the new English-language edition published in New York in 1943 that he fully grasped the importance of Lautréamont's masterpiece of black humor, passages of which he memorized and liked to recite to friends and acquaintances.[85]

Gorky and Mougouch received a limited-edition copy of this book as a present from their close friend Jeanne Reynal shortly after it was published.[86] Mougouch remembers that Gorky was mesmerized by Lautréamont's poetry and believed it to be far superior to Breton's in his 1932 collection *Les Vases communicants* (*The Communicating Vessels*), a book he had just finished reading—along with Breton's 1928 novel *Nadja*, which apparently also disappointed him.[87] While Breton's poetry struck Gorky as boring and traditional, in stark contrast with the rebellious nonconformist who wrote it, Lautréamont's delirious masterpiece was "a debauch of the imagination" that carried the extraordinary, the horrible, the grotesque, and the absurd to extremes that had never been reached before and seldom since.[88]

In his brash, idiosyncratic, utterly unreliable translation for the 1943 edition of *Les Chants de Maldoror*, Guy Wernham took great delight in finding equivalent English words or phrases for Lautréamont's

hallucinatory poetry of revolt, which meant straying so far from the original French text that his translation is today widely regarded as a travesty.[89] By doing so, however, Wernham updated Lautréamont's uncompromising assault on the values of Western civilization through a translation that captured and regenerated the dynamism of the prose poem. This may explain why Gorky was so mesmerized by *Les Chants de Maldoror*'s violent imagery and absolute dismantling of language, while he failed to develop an interest in the subversive writings of the Marquis de Sade, which were available only in insensitive and often heavily censored English translations that robbed the original texts of their searing defiance and erotic charge.

Gorky's enthusiasm on discovering the poetic bestiary of Lautréamont's *Maldoror* must be seen within the context of the work he carried out during the summer of 1943 at Crooked Run Farm during a time of great personal happiness. The drawings he made that summer while sitting or lying in the fields and scrutinizing nature up close have an orgiastic sense of fecundity, seen in the numerous images of opening or bursting seeds that explode like clusters of vibrantly colored fireworks (plates 109, 112), reflecting his happiness as a new father and the proud husband of a beautiful young wife. As we have seen, however, the Virginia landscape also reminded Gorky of his fertile homeland, which he had been forced to leave behind during the Armenian Genocide that took place under cover of World War I. This tragic loss was not reflected in the vitality and joy of the vast majority of the 1943 Virginia landscape drawings, but it returned to haunt his subsequent paintings, especially *The Liver Is the Cock's Comb*, which, as Elaine de Kooning aptly pointed out in 1951, contains "a cruel and opulent sexual imagery. Accents of bright color suddenly lose their meaning as flowers and become crevices, imparting a strange, voluptuous meaning to the surrounding pale, thinly washed surfaces; or plant forms change into human organs and a riotous pageant is transformed into a desolate landscape strewn with viscera."[90]

This insightful description of Gorky's painting also resonates with the relentless cruelty of Maldoror, Lautréamont's animal-vampire-hero. The frequent references to gangrene and putrefaction suggest that Maldoror functions like a plague or pestilence on the human race, as indi-

cated by his name, a pun on *mal d'aurore* (dawn sickness). Maldoror is portrayed as the blasphemous, remorseless opponent of God and man—in him there is no hope of repentance, no trace of redemption. He offers what Breton described as an "unadulterated challenge to all that on earth is stupid, base, and sickening."[91] The aggressive violence expressed in *The Liver Is the Cock's Comb* resonates with Lautréamont's descriptions of Maldoror as a predatory beast with claws and talons that tear his victims apart. Like Lautréamont's eponymous antihero, Gorky was treated cruelly by the so-called civilized world during his youth, culminating in 1919 with the death of his mother from starvation as a result of the genocide. The shattering effect of this personal tragedy on the young Gorky cannot be overestimated and may explain this self-styled Black Angel's attraction to the violence of Maldoror's cruel acts of revenge,[92] which encouraged the artist to give free reign to his imagination, including the morbid fantasies and haunted inner life that had been repressed in his earlier drawings.

Lautréamont's virulent assault on rational thinking and the hypocrisy of bourgeois society in *Les Chants de Maldoror* served as ample fodder for Gorky's attempts to reconcile the terror and pain of his Armenian childhood with the idyllic Virginia landscape that he had represented so lyrically in his 1943 drawings. His use of Lautréamont's startling imagery of razor-sharp claws, beaks, and talons suggests a strong personal identification with the author's sinister antihero, whose hatred, anger, and aggression date from an early moment in his development, when he witnessed God torturing and devouring human beings while seated on a throne built of gold and excrement.[93]

The Liver Is the Cock's Comb was not Gorky's first foray into brutal, animalistic imagery. As we have seen, he had incorporated elements of Masson's abattoir paintings, with their slaughtered birds and animal entrails, in his own paintings of the 1930s. These works must have prepared Gorky for his future engagement with the beauty and cruelty of the natural world, which he conveyed so eloquently in his later paintings and drawings through the twin forces of metamorphosis and mutability. Throughout Lautréamont's poem, Maldoror exists in a state of transformation and flux—and, like Gorky, assumes many disguises and plays many roles, including narrator, creator, actor, reader, and

lover. (In one memorable passage, Maldoror copulates with a female shark after becoming sexually aroused by the spectacle of her ferocious acts of wild carnage.)[94] Gorky's own metamorphosis from the immigrant Vosdanig Adoian to the artist Arshile Gorky ensured that his true identity, and even ethnic background, remained shrouded in mystery during his lifetime, even to his closest friends and loved ones.[95]

Gorky may have felt a personal bond with Isidore Ducasse, who wrote under an assumed name and rejected the stigma of plagiarism by unashamedly adopting the work of other writers as his own. In his *Poésies*, Lautréamont/Ducasse expressed his contempt for Western culture's obsession with originality, writing that "plagiarism is necessary, progress implies it,"[96] a statement he backed up by borrowing the vast majority of the 435 references to animal life that Gaston Bachelard counted in *Les Chants de Maldoror* from Jean Charles Chenu's *Encyclopédie d'histoire naturelle* (*Encyclopedia of Natural History*).[97] The fact that one of the birds described in the poem was "the great horned owl of Virginia" surely would not have escaped Gorky's attention, especially since Lautréamont described its plumage as being "beautiful as the memory of a curve described by a dog running after its master."[98]

An unrepentant autodidact, Gorky similarly rejected modernism's cult of innovation and originality through his steadfast allegiance to the vision and style of other artists as a means of self-creation.[99] His cannibalistic efforts to consume and regurgitate the work of earlier modern artists such as Cézanne and Picasso, whose painting styles he so masterfully absorbed, shares with Lautréamont the desire—as a dislocated, decentered subject—to create his own personality through others' work. Just as Lautréamont evolved a novel kind of writing by transforming his lifted material into a collage of new aphorisms with an unorthodox logic of its own, so Gorky's own artistic borrowings were used to forge a new visual language of metaphoric analogies in paintings that would astound his Surrealist colleagues when they were first shown at the Julien Levy Gallery in March 1945.

In 1939, Bachelard had discussed the similarities between cruelty in humans and in animals in his critical study of Lautréamont, observing that humans are just as eager to strike out blindly and maim or kill as are animals in the jungle, ignoring all prior relationships and invalidat-

ing any previous feelings.[100] Human cruelty, he suggests, returns us to an instinctive animal state. The relentless, unmitigated violence that permeates Lautréamont's oceanic text resurfaces in the brutality of Gorky's *The Liver Is the Cock's Comb*, which depicts the primordial cruelty inherent in the laws of nature but repressed by so-called civilized society—except in times of warfare and genocide, when the mask slips and base animal instincts return. It is surely no coincidence that Gorky created *The Liver Is the Cock's Comb* during World War II, whose "epidemic of destruction" had continued to engulf Europe and other parts of the globe in the two years since he had taught his class on camouflage at the Grand Central School of Art.[101]

The French historian of Surrealism Marcel Jean took *The Liver Is the Cock's Comb*—poetically described by the artist as "the song of a cardinal, liver, mirrors that have not caught reflection, the aggressively heraldic branches, the saliva of the hungry man whose face is painted with white chalk"[102]—to represent "the vision of a *shipwreck*, the chaos prevailing in the tilting saloons of a sinking ship that is being inexorably drawn down to the nothingness of the ocean's bed."[103] This comparison again connects Gorky's work with Lautréamont's strange epic, which includes a description of the sinking of a ship in a raging storm, during which Maldoror gleefully observes the drowning people, including one poor soul whom he shoots dead in order to prevent him from reaching the safety of the shore. Jean perceived Gorky's work as representing a similar headlong tumble into catastrophe, yet the artist could not have known when he completed this Surrealist masterwork that he was about to feel the pain of Maldoror's ferocious claws again, and that within four years he would hang himself from the rafters of a shed in rural Connecticut.

Young Cherry Trees Secured against Hares

In April 1945, Breton's "Eye-Spring" essay was republished by Brentano's in its original French in a revised and updated edition of his 1928 anthology *Le Surréalisme et la peinture* (*Surrealism and Painting*). This new volume included a black-and-white illustration of Gorky's 1944 painting *Good Afternoon, Mrs. Lincoln* (plate 119), which—in its arrangement of swelling, rounded forms suggestive of both male and female

FIG. 90

Marcel Duchamp (American, born France, 1887–1968). Cover of André Breton's *Young Cherry Trees Secured against Hares*, 1946. Published by *View*, New York. Hardbound book with paper cover, 9 3/8 x 6 3/8 inches (23.8 x 16.2 cm). Philadelphia Museum of Art. Gift of an anonymous donor, 1988

117

GORKY AND SURREALISM

genitalia and human figures in a landscape—perfectly illustrated Breton's argument about Gorky's gift for poetic analogy. The fact that Breton devoted the concluding section of the new edition to a sensitive exegesis of Gorky's work reveals the high esteem in which he held the artist. (In October 1945, the *View* editor John Bernard Myers wrote in a diary entry that Breton was "ecstatic about the pictures of Arshile Gorky.")[104] The Surrealist leader's enthusiastic appreciation of Gorky's work explains why he chose him to supply illustrations for his bilingual anthology of recent poems, titled *Young Cherry Trees Secured against Hares (Jeunes cérisiers garantis contre les lièvres)* and published by View Editions in 1946 with a distinctive cover and dust jacket design by Marcel Duchamp (fig. 90). As Gorky was no doubt aware, the title, which Breton had stumbled upon by chance in a book, is an allusion to David Hare's treacherous affair with Breton's former wife, Jacqueline Lamba, who ultimately became Hare's second wife. Of greater interest to this discussion, however, is the fact that Breton found the title in a volume on horticulture, once again highlighting the importance of the natural world for the exiled Surrealists during their years in the United States.

Duchamp's cover design for *Young Cherry Trees* is a montage featuring an image of the Statue of Liberty, the famous emblem of Franco-American exchange, reproduced in a heavily screened photograph on the book's dust jacket, while a photograph of Breton graces the front cover. A hole cut through the face of the statue on the dust jacket allows Breton's features to show through. The effect is much like the placard that once stood outside the entrance to what is now the Ellis Island Immigration Museum, which bore a painted image of the Statue of Liberty with a cut-out face through which newly arrived immigrants or refugees, like Breton and Duchamp during World War II and Gorky in 1920, could poke their heads and be photographed.[105]

Duchamp's open-ended work sends an ambiguous message that can be read on many levels—in the broadest terms, as a tribute to Breton's defense of French culture and liberty during the war years. Alternatively, Duchamp's earlier creation of his lascivious alter ego Rrose Sélavy suggests that he meant the image to lampoon Breton's infamous homophobia by presenting him as a cross-dressing drag queen, perhaps as a private joke with Charles Henri Ford, the editor of *View* and publisher of *Young Cherry Trees*, who was openly gay and had earlier mocked the imperious Breton as "Miss Breton," imagining him with long hair and wearing "velvet knee pants and silk stockings."[106] That Duchamp may have satirized his friend in this way is supported by the fact that Breton's overbearing, authoritarian personality often tested his patience to its limit. In a letter to his longtime lover, the Brazilian sculptor Maria Martins, in May 1949, Duchamp wrote, "André can be really very vulgar at times and his Hitlerite attitude is often synonymous with imbecility."[107]

Despite objections from some of his friends, who recognized its strong undercurrent of transvestitism,[108] Breton used Duchamp's look-through design for his book's cover, identifying the depiction as an allegorical symbol of "liberty enlightening the world" (in the words of Frédéric-Auguste Bartholdi's original title for the sculpture). It is also possible that the image references Breton's "Lighthouse of the Bride" essay, recently translated and reprinted in the 1945 issue of *View* dedicated to Duchamp, in which Breton celebrated the artist's *The Bride Stripped Bare by Her Bachelors, Even (The Large Glass)* (1915–23; Philadelphia Museum of Art) as a beacon of salvation for a drowning modern civilization. Duchamp's cover design could thus be read as suggesting that the "luminously erect" Breton would assume the role designated in his essay for the *Large Glass* and guide "future ships on a civilization which is

FIG. 91
Arshile Gorky, untitled drawing reproduced
in *Young Cherry Trees Secured against Hares*,
1946 (fig. 90)

ending."[109] This is almost certainly how Gorky would have understood the design, given his status as an immigrant and his tremendous admiration for Breton's strong leadership qualities and generosity of spirit.

While Duchamp's mischievous cover design has received a great deal of critical attention in recent years, Gorky's line drawings and Breton's poetry, the latter sensitively translated into English by Edouard Roditi, have been overlooked in comparison. *Young Cherry Trees Secured against Hares* was printed by Van Vechten Press in Metuchen, New Jersey, in an edition of one thousand, of which twenty-five copies, numbered I to XXV, contained two original color drawings by Gorky in addition to the black-and-white linecut reproductions for the front and back pages of the regular edition. This meant that Gorky created at least fifty-two drawings for the project in a relatively short amount of time, a reflection of his excitement about the commission, which he considered a great honor as well as an important showcase for his virtuoso talent as a draftsman.[110]

The two drawings that Gorky made for reproduction in the regular edition are now lost and presumed destroyed. John Bernard Myers, *View*'s managing editor, recalled that his office manager, Betty Cage, asked him: "What shall we do with these drawings by Gorky that were reproduced in Breton's *Young Cherry Trees*? I've sent notes to several people asking they be picked up for months now, but no one has responded." "In that case," Myers responded, "let's throw them in the trash can. After all, they were reproduced in the book and are of no value to anyone."[111] This chilling remark was recorded in a diary entry in May 1947, shortly after Charles Henri Ford had announced that he was closing the magazine, which was "hopelessly in debt."[112] The bleak state of the magazine's affairs may explain Myers's callous indifference to the fate of Gorky's original black-and-white drawings, which survive today only as illustrations in the book (figs. 91, 92).

These reproductions reveal that both of Gorky's drawings took inspiration from works by his Surrealist precursors, including Ernst, Matta, and Tanguy. The frontispiece (fig. 91) consists of a contour drawing of a sexualized female nude, whose torso has been constructed from interlocking bonelike forms that ultimately derive from the jumbled piles of smoothly worn rocks and bone fragments found in the petro-

FIG. 92
Arshile Gorky, untitled drawing reproduced
in *Young Cherry Trees Secured against Hares*,
1946 (fig. 90)

FIG. 93
Yves Tanguy (French, 1900–1955). *The Great Mutation*, 1942. Cut-and-pasted painted paper, gouache, and pencil on paper, 11³⁄₈ x 8⁵⁄₈ (29.1 x 21.9 cm). The Museum of Modern Art, New York. Kay Sage Tanguy Bequest, 1963

FIG. 94
Leonardo da Vinci (Italian, 1452–1519). Botanical studies reproduced in Ludwig Goldscheider's monograph *Leonardo da Vinci* (London: Phaidon, 1943)

119

GORKY AND SURREALISM

glyphic fantasies of Tanguy, such as his 1942 drawing *The Great Mutation* (fig. 93), in which inanimate shapes similarly coalesce into anthropomorphic forms suggestive of pelvic bones and vertebrae. In the mid- to late 1940s, Gorky was a frequent visitor to Tanguy's nineteenth-century farmhouse in Woodbury, Connecticut, and the two artists had a great deal in common. Both were meticulous craftsmen, working in studios that they kept impeccably clean, and both shared a passion for the natural world, which undoubtedly informed their paintings and works on paper, despite their adherence to an abstract visual language steeped in automatism and the world of dreams and the imagination. When Gorky's painting *The Artist and His Mother* (1926–36; plate 32) was included in the exhibition *Fourteen Americans* at MoMA in the fall of 1946, Tanguy wrote a letter to him commending the work.[113] His praise must have elated Gorky, given his evident admiration for the French Surrealist's work, whose influence is seen in the 1945 drawings and later paintings such as *Nude* (1946; plate 133) and *Agony* (1947; plate 165).

Another important source for the frontispiece and other, related drawings was his copy of Ludwig Goldscheider's lavishly illustrated 1943 monograph on Leonardo da Vinci, whose frontispiece and end-

papers Gorky filled with sketches connected with the *Young Cherry Trees* book project.[114] He was clearly drawn to Leonardo's botanical and anatomical studies, as well as to his imaginative exercises, all of which were reproduced in their original size in Goldscheider's volume (fig. 94). In addition, Matta had made Gorky aware of the important role Leonardo had played in the Surrealist theory of automatism.[115] Dalí had earlier invoked Leonardo's statement in the catalogue essay for his 1939 exhibition at the Julien Levy Gallery: "Leonardo da Vinci proved an authentic innovator of paranoiac painting by recommending to his pupils that, for inspiration, in a certain frame of mind they regard the indefinite shapes of the spots of dampness and the cracks on the wall, that they might see immediately rise into view, out of the confused and the amorphous, the precise contours of the visceral tumult of an imaginary equestrian battle."[116] It is no coincidence that Gorky was examining Leonardo's sketches of trees, plants, and flowers while seeking his own inspiration from the flora and fauna that surrounded him in the pastoral landscape of rural Virginia.

Gorky's interest in nature and metamorphosis can be seen again in the drawing reproduced on the final page of *Young Cherry Trees* (fig. 92),

MICHAEL R. TAYLOR

1944 No. 4

FIG. 95
Roberto Matta's design for the front cover of *VVV* 4
(1944). Paperbound periodical, 11 x 8⁷/₁₆ inches
(27.9 x 21.4 cm). Philadelphia Museum of Art. Gift
of Jacqueline, Paul, and Peter Matisse in memory
of their mother, Alexina Duchamp, 1998

which bears a certain similarity to the book illustrations of Max Ernst, including his cover design for David Gascoyne's *A Short Survey of Surrealism* (1935). Gorky owned a copy of this book and would naturally have turned to other Surrealist publications when making his own illustrations for Breton's volume of poetry. Ernst's striking cover design for Gascoyne's seminal text consists of an abstract line drawing reproduced in gold on a green background. Gorky's drawing shares the thin, energetic lines of Ernst's cover illustration but departs from its spare and graceful abstract design. His depiction of a monstrous form threatens castration and mutilation through its sharp-fanged orifices, one of which is shaped like an open vagina while the other hovers at the end of a phallic appendage.

The rows of razor-sharp teeth in Gorky's drawing recall Matta's cover for the fourth and final issue of *VVV* (fig. 95), which depicts an open mouth fringed with black hair to denote a *vagina dentata*, a beloved theme of the Surrealists and one that clearly fascinated Gorky around the time of the *Young Cherry Trees* project. Gorky's fierce creature, with its double orifices (see fig. 92), initiated the demonology of phallic and vaginal imagery that would follow in his fifty drawings for the deluxe edition of the book, which often contain a cruel and aggressive sexuality that replaced the poetic eroticism of his earlier paintings and works on paper. Made in an intense burst of creativity over a period of just

two weeks in April 1945 (following Breton's visit to Roxbury), these drawings were produced in a variety of mediums, including India ink, gouache, pen, and colored crayons, and on paper of various sizes, color, and quality. As Mougouch humorously recounted, the word *shit* would echo across the fields around their Connecticut home, as Gorky went through $100 worth of paper (a small fortune at the time) before completing the assignment to his satisfaction.[117]

The stimulus for this important cache of drawings appears to have been provided by one of Gorky's paintings of that year, *The Unattainable* (plate 134). He used a thin sign-painter's brush to demarcate the allover composition of this work with long, thin, uninterrupted black lines, highlighting the resulting zones here and there with flashes of bright color, including red, yellow, blue, and green. According to the art critic Harold Rosenberg, this long-haired brush, known as a "liner," was introduced to Gorky in the 1930s by Willem de Kooning,[118] but he did not use it with any frequency until the following decade, when he began to translate the fluid lines of his drawings into large-scale paintings, such as *The Unattainable* and *Nude* (plate 133). These were shown to great acclaim in the exhibition *Paintings by Arshile Gorky*, which opened at the Julien Levy Gallery on April 9, 1946. As the curator William C. Seitz has argued, they can be understood as enlargements of Gorky's earlier nature studies made in pencil and wax crayon: "Some of them, painted in transparent wiped washes on otherwise bare white canvas, are in fact large drawings. The lines streak across their surfaces like the blades of an ice skater, fluently delineating configurations Gorky had originated previously in drawings."[119]

The manual dexterity found in Gorky's paintings of 1945, in which he perfected his use of the liner brush, would in turn provide him with new possibilities for his wonderful line drawings of plant petals and bonelike forms,[120] which he would expand upon in the fifty drawings made for insertion in *Young Cherry Trees* (plates 127–30). The importance of these drawings for the publisher can be gauged by the price difference between the regular edition ($3.75) and the deluxe edition ($30.00) of the book. As for Gorky, he would continue to explore the ramifications and possibilities of these works on paper for the next year or so, most notably in his *Charred Beloved* series (plates 166–68).

Gorky's drawings for the deluxe edition of Breton's book of poems coincided with his third sustained campaign of drawing outdoors in the Virginia landscape, which took place at Crooked Run Farm in the summer and fall of 1946. As he convalesced following his operation for rectal cancer, he once again drew in the fields during the day and before the fireplace in the living room at night. Perhaps unsurprisingly, given his mental state during this time of deep emotional and physical crisis, many of the nocturnal drawings made in the fire-lit living room invoke Matta's recent depictions of torture chambers and terrifying, man-eating monsters. The devastating fire that had destroyed Gorky's Connecticut studio in January 1946, combined with the painful colostomy surgery he had undergone in March, may explain his attraction to Matta's increasingly dark and sardonic view of the human condition during what the Chilean artist termed the "horrible crisis in society" of the 1940s.[121]

Matta's paintings and drawings of the mid- to late 1940s depict monstrous half-human, half-machine forms that perpetrate acts of cruelty and violence on each other, in line with Breton's statement that "man is powerless to be anything but victim or witness" in the face of a cyclone or during war.[122] Matta's torture chambers, where these anthropomorphic figures are subject to unspeakable acts of cruelty, including being flayed alive or crucified, suggest that his early training as a draftsman in the office of the modernist architect Le Corbusier had returned to him, to be deployed in nightmarish form following recent events, especially the horrors of World War II and the Holocaust.

Gorky's interiors, as seen in works such as *Agony* (1947; plate 165) and *From a High Place II* (1946; plate 175), are no less dark and ominous, but their architecture is less defined and at times barely perceptible, having been integrated into his paintings' formal structures. Many of the nearly three hundred drawings[123] that Gorky made in the Virginia countryside during the summer of 1946 again share Matta's spidery lines, swirling eddies, and fiery flashes of smudged and scumbled color, but Gorky's imagery, despite its depiction of apparent cruelty, ultimately remained nature-based, unlike the night-

marish, apocalyptic visions of his friend and mentor. Although they drew their imagery from different sources, both artists clearly sought to capture the forces of nature and an existence that lies beyond our perception. Matta and Gorky can thus be seen as the main proponents and interpreters of Breton's myth of the Great Transparents in the 1940s.

Bloodflames

Gorky's continued interest in Surrealism in the late 1940s led to his participation in two prominent Surrealist exhibitions in 1947, *Bloodflames*, held at Alexander Iolas's Hugo Gallery at 26 East Fifty-fifth Street, New York, in February of that year, and *Exposition Internationale du Surréalisme*, which opened at the Galerie Maeght at 13, rue de Téhéran, Paris, on July 7.[124] The former, organized by the Greek-born poet and art critic Nicolaos Calamaris, who wrote under the name of Nicolas Calas, included "only those Surrealists who shunned the realistic image."[125] *Bloodflames* presented the work of eight artists—Gorky, Matta, David Hare, Gerome Kamrowski, Wifredo Lam, Isamu Noguchi, Helen Phillips, and Jeanne Reynal—in a dynamic environment designed by the visionary architect and theorist Frederick Kiesler, in which the walls, ceiling, and floor of the Hugo Gallery were covered in a bold design of meandering bands of colored paint that emphasized what Calas described as "the magic character of unexpected associations" (fig. 96).[126] The

FIG. 96
Frederick Kiesler's installation design for the exhibition *Bloodflames*, Hugo Gallery, New York, 1947. Courtesy of the Austrian Frederick and Lillian Kiesler Private Foundation, Vienna

FIG. 97
Installation view of *Bloodflames*, with artists' names on the door, Hugo Gallery, New York, 1947. Courtesy of the Austrian Frederick and Lillian Kiesler Private Foundation, Vienna

FIG. 98
Max Ernst regarding Wifredo Lam's painting *The Eternal Present* at the *Bloodflames* exhibition, Hugo Gallery, New York, 1947. Courtesy of the Austrian Frederick and Lillian Kiesler Private Foundation, Vienna

FIG. 99
Wifredo Lam (Cuban, 1902–1982). *Le présent éternel* (*The Eternal Present*), 1944. Mixed media on jute, 85 x 77 1/2 inches (216 x 197 cm). Museum of Art, Rhode Island School of Design, Providence. Nancy Sayles Day Collection of Modern Latin American Art

FIG. 100
Helen Phillips with her bronze sculpture *Dualism* at
the *Bloodflames* exhibition, with Gorky's painting
Nude (plate 133) hanging behind her, Hugo Gallery,
New York, 1947. Courtesy of the Austrian Frederick
and Lillian Kiesler Private Foundation, Vienna

continuous ribbon of solid color that wound its way around the gallery both framed and encapsulated the works on display, while providing Calas with a blackboard-like surface on which to write his statement from the exhibition catalogue about the objectivism and individualism of the artist: "He will be heroic: he will aim towards freedom and achieve magic when he reaches the extreme limits of both objectivism and individualism—then only will the fantastic and the real, the unknown and the known produce that alchemy of form and colors which transform an artificial object into an eye emanating light."[127] This inscription was appropriately located beside a door on which were written the names of the participating artists (fig. 97), with Kiesler's statement reproduced on the other side of the entrance: "We, the inheritors of chaos, must be the architects of a new unity."[128]

As the title *Bloodflames* suggests, Calas employed Kiesler to create a disorienting environment that would exacerbate the inward-looking or otherworldly qualities of the works of art he had selected for the exhibition, which included Gorky's *Nude* (plate 133). Kiesler's challenge, as suggested in his exhibition statement, was to integrate the paintings and sculpture in a unified design, which he achieved by hanging or placing the works of art at varying angles on the walls and floor, with Matta's painting *Grave Situation* being shown at an especially acute angle. Some paintings simply leaned against walls, resulting in a "unique imaginative experiment" that offered new ways of seeing and understanding Surrealist art.[129] The highlight of the exhibition was a net curtain that surrounded Wifredo Lam's ambitious and highly erotic painting *The Eternal Present* (1944; fig. 99), which was mounted on the ceiling. Visitors had to pass behind the diaphanous curtain to enter the intimate, cocoonlike space, where they sat in one of Kiesler's Correalist chairs to view the monumental painting, whose placement on the ceiling challenged traditional, wall-bound methods of displaying art by forcing viewers to contemplate it while gazing upward (fig. 98). Kiesler's original plan to include running water within this space (the transparent drapes would have functioned as shower curtains) was not carried out, perhaps because of fear of damaging the art on display. However, the idea would be resuscitated later that year in Kiesler and Duchamp's Salle de la Pluie (Rain Room) installation in the Surrealist exhibition in Paris.

Gorky's *Nude*, displayed at the Hugo Gallery alongside a bronze sculpture by Phillips and opposite Reynal's gemlike mosaics in their boomerang frames specially designed by Kiesler for the exhibition (fig. 100), had its origins in the suite of Tanguy-inspired ink drawings of sinuous female figures that he made to illustrate Breton's *Young Cherry Trees*. In selecting the large, austere *Nude* for the exhibition, Calas correctly intuited the important role that automatism had played in its creation, for Gorky had used the rapidly executed line drawings as the basis for a series of working studies for the painting (plates 131, 132), which he completed shortly after the fire in his Connecticut studio in January

1946. It is not known whether an earlier version of the painting was among the works lost in this blaze, but in its final form *Nude* relates closely to an important series of grisaille paintings titled *Charred Beloved* that Gorky completed afterward, while working in an improvised studio in a ballroom at 101st Street and Fifth Avenue in New York (plates 166–68). *Nude* shares the brooding atmosphere of these paintings and their smoky depths of smudged black and gray, replete with flashes of orange or red that surely allude to the traumatic incident of the studio fire.[130] For the purposes of *Bloodflames*, however, it was no doubt the work's overt sexuality that caught Calas's eye, rather than its tragic undercurrent of loss and destruction, since its sexual charge resonated with other works in the exhibition. These included *The Eternal Present* by Lam (see fig. 99), whose paintings have been compared to Gorky's own works in their use of "strong linear elements in a coequal yet distinct relationship with color."[131]

ARSHILLE GORK : **Comment le tablier brodé de ma mère se déplie dans ma vie**

MATTA : **Rêve ou morte**

FIG. 101
Gorky's painting *How My Mother's Embroidered Apron Unfolds in My Life* (plate 115) reproduced in *Le Surréalisme en 1947* (Paris: Maeght, 1947). Book with cover made of collage of foam rubber and velvet on cardboard, 9¼ x 8¹/₁₆ inches (23.5 x 20.5 cm). Philadelphia Museum of Art. Purchased with the Gertrud A. White Memorial Fund, 1995

Co-organized by Duchamp and Breton, the *Exposition Internationale du Surréalisme* and its accompanying catalogue, *Le Surréalisme en 1947*, were dedicated to the theme of modern myths. This was a familiar subject for the Surrealists both during and after World War II, particularly as they sought to reinvent and reinvigorate their activities in the changing cultural landscape of the 1940s, when they were increasingly isolated and often associated exclusively with the avant-garde of the 1920s and 1930s. The 1947 *Exposition Internationale du Surréalisme* was an attempt to cement the collective efforts of the Surrealist artists and writers, led by Duchamp and Breton, and to discover new myths, rather than to perpetuate what were perceived as outmoded ideologies.[132]

Gorky was one of only a handful of American artists, including Donati, Hare, Kamrowski, and Sage, who were invited to participate in the Paris exhibition, which was a far larger and more ambitious presentation than the 1942 *First Papers of Surrealism* show in New York.[133] The exhibition and its accompanying catalogue presented Gorky's work on an international stage for the first time since the summer of 1938, when *Painting* (1936–37; plate 71) had been shown in *Trois siècles d'art aux États-Unis* at the Musée du Jeu de Paume, Paris.[134] Two of Gorky's greatest paintings from 1944 were included in the 1947 exhibition: the monumental *The Liver Is the Cock's Comb* (plate 114) and another large painting, *How My Mother's Embroidered Apron Unfolds in My Life* (plate 115), which was also illustrated in the catalogue, along with a French translation of the title, "Comment le tablier brodé de ma mère se déplie dans ma vie" (fig. 101).[135]

Gorky's paintings in this exhibition appear to have been chosen carefully, since their imagery and titles fitted perfectly with Breton's notion of new myths to replace older ones, including the legends of Prometheus, Pygmalion, and the Minotaur and the Labyrinth, whose visual evocation often included related figures—such as Pasiphaë, Theseus, and Ariadne—that had obsessed Surrealist artists like Ernst and Masson (as well as fellow travelers like Picasso) throughout the 1930s.[136] It is not known whether Breton personally chose Gorky's two paintings for the exhibition, both of which he had seen in New York shortly after their completion, or if the artist himself had a hand in their

from the "Rain Room," perhaps because of fears that the falling water might damage the work, since photographs taken after the opening indicate that *The Liver Is the Cock's Comb* had been relocated to the entrance of the exhibition, where it was hung alongside works by Noguchi and Calder (fig. 102).

Gorky could of course have entered *Nude* (plate 133), which had been shown to great acclaim in the *Bloodflames* exhibition, or any number of works from the recent *Plow and the Song* series, rather than two paintings that he had completed three years earlier and that bore little relation to his current artistic production. His most recent paintings revealed an anguished state of mind as he continued to battle cancer and depression. These works included *Agony* (plate 165), the tragic masterpiece that Alfred H. Barr, Jr., the director of MoMA, once described as "a painting of pulsating ominous beauty."[139] The smoldering reds and deep blacks of *Agony* combine to produce a hypnotic psychological drama in which Gorky's traumatic life story takes on epic proportions. Even without prior knowledge of the painting's title, viewers no doubt sense the intensely sad and haunting atmosphere of the work, in which "colors throb and pulsate like psychic wounds."[140] According to his widow, Gorky was too sick to travel to Paris to see the exhibition and may therefore have wanted to include paintings that were made before his illness and during the time when Breton had first championed his work.[141]

Not all of Gorky's paintings from 1947 share the suffering and nervous tension of *Agony* or the *Betrothal* series (plates 171–74), with its dramatis personae of heraldic exoskeletal figures derived from Duchamp and Paolo Uccello.[142] The grave atmosphere of these works is countered, for example, by the lyric beauty and optimism of his contemporaneous series *The Plow and the Song* (plates 144–49), in which the Virginia landscape, which he had revisited in 1947, converges with his own, surely idealized, childhood memories of communal farming in the wheat fields of rural Armenia. In these paintings, Gorky evokes the sun-warmed fertility of the plow-turned earth and his memories of farmers singing songs to pass the time as they worked, combining these themes with his studies of a toppled haystack he had seen in Virginia, which supplied the elongated central form of the compositions. Gorky

selection. *How My Mother's Embroidered Apron Unfolds in My Life* was first exhibited in March 1945 in Gorky's first solo exhibition at the Julien Levy Gallery, for which Breton had written his essay "The Eye-Spring," and it was also selected for inclusion in *Painting in the United States,* an exhibition that opened at the Carnegie Institute in Pittsburgh in October 1945, suggesting that Gorky considered it to be among his best works.[137]

The Liver Is the Cock's Comb, prominently displayed by Kiesler in the Salle de la Pluie (see fig. 67) alongside works by Noguchi, Victor Brauner, and Maria Martins, had been the central focus of Breton's "Eye-Spring" essay. Breton later told the art dealer Sidney Janis that he considered the work to be "the most important picture done in America at that time,"[138] which probably explains why this enormous painting made the trip across the Atlantic. At some point it was removed

FIG. 103
Salle de Superstitions (Room of Superstitions)
of the *Exposition Internationale du Surréalisme*,
Galerie Maeght, Paris, 1947. Photograph by Willy
Maywald. Courtesy of the Austrian Frederick and
Lillian Kiesler Private Foundation, Vienna

realized that the horse-drawn wooden plow was fast becoming obso-
lete in the age of modern, mechanical farming methods. As he remi-
nisced to the journalist Talcott B. Clapp: "What I miss most are the
songs in the fields. No one sings them any more…and there are no
more plows. I love a plow more than anything else on a farm."[143] The
artist could have sent one of these joyous paintings to the 1947 Surre-
alist exhibition, especially since their deeply personal subject matter
fit the mythical theme of the show. The fact that he preferred to in-
clude two earlier paintings would seem to confirm the notion that he
associated their making with a happier time in his life.

Breton, who had returned to Paris in 1946, could just as easily
have included in the 1947 Paris exhibition the two untitled landscape
paintings that Gorky gave him in the spring of 1945 (plates 137, 138), a
move that would have saved packing and transportation costs. When
seen in conjunction with Breton's call for new myths, Gorky's choice of
The Liver Is the Cock's Comb and *How My Mother's Embroidered Apron
Unfolds in My Life*, the latter with its reference to the artist's boyhood in
Armenia, no longer appears random, but rather appears to be a delib-
erate expression of his own personal mythology, centered around
memories of his beloved mother and former homeland.[144] Such dream-
like reminiscences surely replaced other, more painful, and hence
likely repressed memories of his mother, who died of starvation in

March 1919 while living with Gorky and his sister as refugees in an
abandoned and only partially roofed hovel in Yerevan, following a har-
rowing forced march across eastern Turkey.

How My Mother's Embroidered Apron Unfolds in My Life depicts the
embroidered apron worn by Gorky's mother in a 1912 photograph (see
figs. 18, 19) she sent to his father, Setrag Adoian (who had recently
immigrated to the United States), in a desperate and ultimately failed
attempt to persuade him to send money to his family in Armenia,
including his handsome young son. Gorky no doubt embellished his
childhood memories of the embroidered apron, which appears in the
painting through a sequence of interlocking shapes and trails of evanes-
cent color that coalesce into blurred, indistinct shapes reminiscent of
the apron's distinctive floral motifs. The diluted washes of thinned-out
pigment function like hazy yet palpable childhood memories of a hap-
pier time, when Gorky would place his head in his mother's lap and feel
the warmth of her body offering both protection and unconditional
love. Gorky thus presented at the Paris Surrealist exhibition a new myth
forged in his childhood in the Lake Van region of Turkish Armenia and
tinged with the tragic events that would follow shortly thereafter.

The installation of *Exposition Internationale du Surréalisme* was
again created by Kiesler, who this time based his design on Duchamp's
preliminary ideas.[145] One of the key concepts of Kiesler and Duchamp's
installation was that progress through the successive spaces would cor-
respond with what Breton described in the catalogue as "initiatory" set-
tings.[146] The seekers of knowledge, in this case visitors to the exhibition,
would be presented with a series of tasks or ordeals to overcome, induc-
ing them to "dwell on the disturbing and extraordinary aspects through-
out the ages of certain individual and collective types of behavior."[147]

Duchamp left behind some initial concepts for the installation
before returning to the United States, including his idea for a Salle de
Superstitions (Room of Superstitions) as well as the Salle de la Pluie,
in accordance with the notion of an exhibition environment that would
unfold as a cycle of tasks and initiations into the mysteries of Surreal-
ism. As the Surrealist artist and historian Marcel Jean recollected,
Duchamp "imagined the hall of Superstitions as a white grotto and pro-
posed that the effect should be produced by stretching an immaculate

fabric on some suitable framework; he also drew up plans for the Labyrinth, and for the Rain hall, in which he recommended that a billiard table should be installed—one of the rare notes of deliberate humour in the exhibition."[148]

Kiesler, a polymath artist-architect whose work sought to redefine the relationship between art and the viewer through creative installation techniques, was well qualified to expand on Duchamp's ideas for a fluid, unnerving, disorienting architectural environment in which to display the entries by the eighty-seven participating artists, who represented twenty-four countries.[149] The initial plan, left unrealized, began the exhibition with a room devoted to "surrealists despite themselves," which was to have included works by such early precursors as Giuseppe Arcimboldo, Hieronymous Bosch, William Blake, and Lewis Carroll, as well as more recent artists "who had ceased to gravitate in the movement's orbit," such as Dalí, de Chirico, Magritte, and Picasso.[150] In Kiesler's final design, visitors entered the exhibition by ascending a red staircase of twenty-one steps, signifying all but one of the Major Arcana of Tarot cards, which are numbered from zero to twenty-one. The steps were designed after the spines of occult and mystical books, such as Emanuel Swedenborg's *Memorabilia* and Sir James George Frazer's *The Golden Bough*, which together indicated the "degrees of ideal knowledge."[151]

Having reached the top of the stairs, viewers donned white hoods designed by Miró and entered the Salle de Superstitions, a dramatic,

multipart environment in the shape of an egg, which Kiesler believed would "cure man of his anguish" by unleashing and satisfying his psychic need for ritual and superstition.[152] It was in this central exhibition space that Gorky's painting *How My Mother's Embroidered Apron Unfolds in My Life* hung alongside recent works by Julio De Diego, Donati, Ernst, Hare, Matta, Miró, and Tanguy, which Kiesler installed on the floors, ceilings, and curtained walls of the Galerie Maeght's oval-shaped entranceway. Miró's long, scroll-like painting *Waterfall of Superstitions*, described by Kiesler in the exhibition catalogue as "the frozen cascade of superstition,"[153] was mounted vertically on a curved wall, where it flowed like a waterfall of hieroglyphic signs from the ceiling to the floor (fig. 103). There it met Ernst's *Black Lake*, painted on the floor, which Kiesler viewed as "a feeding source of fear," according to an inscription on one of his preparatory installation drawings.[154] The snakelike form of Miró's friezelike painting formed the centerpiece of this unconventional spatial configuration, and the different displays were unified through the green canvas walls of Kiesler's installation, which formed a room within the circular entrance. Gorky's painting was placed in the midst of this discombobulating installation, designed to help visitors, and by extension the artists themselves, overcome their deep-seated fears and superstitions, thus supplying another layer of personal meaning to the painting's inclusion in the exhibition.

The 1947 *Exposition Internationale du Surréalisme* would be the last occasion during Gorky's short lifetime that he would exhibit his work

FIG. 104
Marcel Duchamp. *Boîte alerte* (*Emergency Box*), 1959. Deluxe edition of the catalogue for the *Exposition inteRnatiOnale du Surréalisme*. Cardboard box containing paper-bound catalogue and ephemera, postcards, notes, envelopes, portfolio of artists' prints, printed nylon stocking, and 45 rpm record, 11¼ x 7⅛ x 2½ inches (28.6 x 18.1 x 6.4 cm). Philadelphia Museum of Art. Gift of Jacqueline, Paul, and Peter Matisse in memory of their mother, Alexina Duchamp, 1998

FIG. 105
Gorky's painting *The Orators* (1947) reproduced as a postcard included in Duchamp's *Boîte alerte*, 1959

alongside his Surrealist colleagues in a group show. Following his suicide on July 21, 1948, however, his work was frequently included in Surrealist exhibitions. Eleven years after his death, Duchamp included Gorky's work in the *Exposition inteRnatiOnale du Surréalisme*, which was dedicated to Eros, as indicated by the uppercase letters of the title. The show opened in December 1959 at the Galerie Daniel Cordier on the rue de Miromesnil, Paris, and Duchamp once again played a central role in both the layout of the exhibition and the design of the catalogue, titled *Boîte alerte* (*Emergency Box*; fig. 104). Made in collaboration with the Canadian artist Mimi Parent, the deluxe edition of the catalogue was housed in a green cardboard box designed to resemble a mailbox filled with *missives lassives* (lascivious missives). The letterbox contained several erotic objects, including a woman's black silk stocking and a hand-tinted postcard by Hans Bellmer of his 1937 photograph of a flushed, tumescent female doll. Among the other items that Duchamp personally selected for inclusion in *Boîte alerte* was a color postcard of Gorky's painting *The Orators* (1947; fig. 105), which he clearly understood to have erotic overtones, despite the funereal associations of its title.[155] Duchamp's admiration for Gorky's work, and his recognition of its connection to the Surrealist movement, was reflected again in the following year when he reproduced one of the artist's *Young Cherry Trees* drawings on the announcement card for the 1960 international Surrealist exhibition at the D'Arcy Galleries in New York.[156] The exhibition, which Duchamp titled *Surrealist Intrusion in the Enchanter's Domain*, included Gorky's *Good Hope Road II (Hugging)* (1945; plate 135), alongside works by Ernst, Magritte, and Man Ray.

The Limit

In spite of Gorky's keen interest and active participation in the Surrealist movement during the 1930s and 1940s, the literature on the artist remains remarkably ambivalent about his allegiance to the group. This slippage in the critical reception can partially be explained through the cultural nationalism of the American critics associated with Abstract Expressionism, most notably Clement Greenberg, Harold Rosenberg, and Thomas B. Hess, who in the 1950s began to champion Gorky's work as an authentically American form of abstraction. In his influential 1951 study of the development of abstraction in Western art, *Abstract Painting: Background and American Phase*, Hess published the first extensive account of the new movement, and positioned Gorky as a precursor to Abstract Expressionism while omitting any reference to his ties to Surrealism. Greenberg, who had been openly hostile to Gorky's work in the mid-1940s, which he rightly associated with Matta, Miró, and Surrealism, changed his mind, and by the end of the 1940s, and especially after Gorky's death in 1948, he began to incorporate the artist's work into his formulation of Abstract Expressionism, deliberately downplaying Gorky's debt to Surrealism in favor of other elements of his work, such as scale, color, flatness, improvisation, and brushwork.[157]

The fact that most of Gorky's friends in the international Surrealist movement, including Breton, Lam, Matta, and Tanguy, had returned to Europe by the time of his death also helped to ensure that his story would not be told from a Surrealist perspective. Following his return to Paris in May 1946, Breton in particular had remained Gorky's devoted friend and indefatigable champion. In an interview with Jean Duché, published in *Le Littéraire* on October 5, 1946, he declared that it was "on the American continent that painting seems belatedly to have given off its finest shower of light." He then outlined his plans to "bring together and confront" the work of Gorky, along with that of Donati, Matta, and a handful of other New York–based artists, in the forthcoming *Exposition Internationale du Surréalisme*.[158]

While Breton's 1945 "Eye-Spring" essay is rightly regarded as the most important critical text on Gorky to be published during his lifetime, the Surrealist leader's heartfelt eulogy to his late friend, "Farewell to Arshile Gorky," has received far less attention. Published in November 1948 in the fourth issue of *Nêon*, the large-format Surrealist newspaper, Breton's poem reveals that he experienced his friend's death as both a great personal loss and an irreparable blow for Surrealist painting.[159] The poem is filled with references to nature, as when Breton compares Gorky's voice to an eagle's nest, or imagines seeing him again "among the stars and the flowering trees," thus extending his previous interpretation of the artist's work as a cryptogram of the natural environment.[160] Breton's emotional eulogy ends with the distressing image of Gorky, hanging high in the air, experiencing "the magical death of

FIG. 106
Jean-Auguste-Dominique Ingres (French,
1780–1867). *Henri Labrouste*, 1852. Graphite
on wove paper, 12¼ x 9¼ inches (31 x 23.5 cm).
National Gallery of Art, Washington, D.C.
Collection of Mr. and Mrs. Paul Mellon, 1995

FIG. 107
Kay Sage, Marcel Duchamp, Maria Martins, Arshile
Gorky, and Frederick Kiesler at Yves Tanguy's house,
Woodbury, Connecticut, May 1948. Gelatin silver
print. Philadelphia Museum of Art, Archives, Alexina
and Marcel Duchamp Papers. Gift of Jacqueline,
Paul, and Peter Matisse in memory of their mother,
Alexina Duchamp, 1998

Gerard de Nerval,"[161] while leaving the Surrealist leader to weather "the great storms of my heart."[162]

Gorky's death split the Surrealist group and resulted in the expulsion of Matta from the international movement on October 25, 1948, on the ground of "intellectual disqualification and moral turpitude" for his affair with Mougouch, a sin that Matta always referred to as "moral turpentine."[163] On November 8, 1948, the Romanian-born painter Victor Brauner was also excommunicated from the group for refusing to sign their statement excluding Matta because he believed that the accusations against the Chilean Surrealist "were the product of bourgeois morality."[164] The result was the removal of three of the movement's brightest stars—Gorky, Matta, and Brauner—from the Surrealist firmament within a matter of weeks. This catastrophic sequence of events, which began with Gorky's suicide, was set in motion by Kiesler, who, deeply upset about his friend's death, in a moment of weakness wrote a letter to Breton unfairly suggesting that Matta was responsible for Gorky's death—without taking into account the artist's long history of depression and suicidal thoughts, as well as his struggle with cancer, the studio fire, and the injuries from his recent automobile accident. In reference to Matta, Kiesler asked Breton, "Qu'est ce qu'on doit faire avec ce garçon?" (What should be done about this boy?).[165] Breton took

Kiesler's letter, dated October 17, 1948, as a call to action and expelled Matta from the group—and Brauner, too, for leaping to his defense—during one of the most painful chapters in Surrealism's history.

In his defense, Kiesler had known Gorky since the 1920s and greatly admired his work, as is clear in his essay on the artist's Newark Airport murals (see plates 76–85).[166] Gorky had also liked Kiesler enough to make two portrait drawings of him: an early sketch made in 1932 (Austrian Frederick and Lillian Kiesler Private Foundation, Vienna), and a second, more polished pencil drawing made sometime around 1938 (plate 36). The latter was based on Ingres's 1852 drawing of the French architect Henri Labrouste (fig. 106), which provided a suitable prototype for Gorky's delicately shaded rendering of his architect friend. This exquisite portrait was made before Kiesler and Gorky's deep involvement with the exiled Surrealist group, but well into their own friendship, and Kiesler's relaxed countenance speaks to the comfortable atmosphere of the sitting, despite the formality of the pose that Gorky borrowed from the Ingres drawing. Gorky and Kiesler's close friendship between 1926 and 1948 helps to explain the architect's raw emotions at the time that he wrote his account of Gorky's death in his letter to Breton, which also effectively ended his own relationship with the Surrealists (fig. 107). As his second wife, Lillian, later recalled:

"Kiesler was terribly upset at Gorky's suicide in 1948—and decided not to belong to the group of Surrealists because they seemed hard and inhuman compared with Gorky's sweetness."[167]

The fact that Breton's 1948 tribute to Gorky was overlooked in the earliest memoirs and critical appraisals of the artist's life and work is not surprising, since these accounts were for the most part written by American artists and writers who knew him in the 1930s, including his student Ethel K. Schwabacher, his friend Willem de Kooning, and his onetime ally Stuart Davis. These artists had little or no interest in Surrealism and were thus not part of Gorky's circle of friends and supporters in the 1940s, having been supplanted by new friends and colleagues, such as Breton, Hare, Kiesler, Lam, Matta, Sage, and Tanguy. In fact, de Kooning and Davis were openly hostile to Breton's exiled group and sought to diminish Gorky's role in the Surrealist movement. Their accounts of the artist instead focused on his noble and often larger-than-life persona during the tough years of the Great Depression, when he first revealed himself to be an eclectic, virtuoso painter in both figurative and abstract modes. It was during this period of self-abnegation that Gorky had inspired others through a steadfast commitment to his craft, despite his impoverished circumstances, and came to embody the idea of the flamboyant, but ultimately mythical, bohemian avant-garde artist.

In 1956 his widow recalled that Gorky's own memories of the bitter struggle and isolation of the poverty-stricken Depression years were not as rosy as those of his friends:

> He did not live long enough to look back on those days with any sentimental softness. Certainly there were a lot of political beliefs and bickerings that sound sheer poetry now. But Gorky described it as the bleakest, most spirit-crushing period of his life and spoke with bitterness of the futility of such paralyzing poverty for the artist.... He often said that, if a human being managed to emerge from such a period, it could not be as a whole man and that there was no recovery from the blows and wounds of such a struggle to survive.... You will see much of this obsessive agony in some of the paintings.... I think I can say that SURVIVAL was the meaning and the flavor of those days to him.[168]

Mougouch's recollections are supported by a letter Gorky wrote in 1941 to MoMA, which had recently acquired one of his *Nighttime, Enigma,*

and Nostalgia drawings for its permanent collection. When asked by the museum to complete a questionnaire on the work, Gorky responded to a query about whether the subject of the drawing had any personal, topical, or symbolic significance with the comment: "Wounded birds, poverty, and one whole week of rain."[169]

Gorky's involvement with the Surrealists in the 1940s had no place in the idealized version of events presented by Davis, de Kooning, and Rosenberg, since his later group activity would undercut the romantic notion of the artist as a heroic bohemian outsider and solitary artistic genius. "Some years later," Davis recalled in his 1957 review of Schwabacher's book, "*long after I had ceased to have contact with him* [my emphasis], he got mixed up with a swarm of migrant Surrealists who fixed him up good in more ways than one. After being buzzed, wafted, fluttered, be-limed, and moths sifted into his prayer-type rug— he was taken into the cult and given the name of 'The Eye Spring' by a high priest."[170] Davis's virulent hatred of Surrealism, which he dismissed in the same essay as a "cut-rate novelty import,"[171] was shared by de Kooning, whose accounts of his friendship with Gorky are marred by the same form of anti-intellectualism and xenophobia, no doubt tinged with more than a small amount of petty jealousy. De Kooning later told Gorky's daughter Maro that he did not see much of her father during the 1940s, after he had been taken up by "those Connecticut Puerto Ricans,"[172] an offensive, racist remark aimed at the Cuban Surrealist painter Wifredo Lam, who had befriended Gorky in 1946.[173]

The initial anti-Surrealist reception of Gorky's life and work that followed his death in 1948 paved the way for his gradual assimilation into the canon of Abstract Expressionism as it was formed in the 1950s by critics, art historians, and curators such as Greenberg, Rosenberg, Hess, Dore Ashton, Sam Hunter, and William Seitz. Gorky's work was universally acclaimed as an important precursor to the large-scale abstract paintings of friends and colleagues such as William Baziotes, Willem de Kooning, Jackson Pollock, and Mark Rothko, despite his longstanding allegiance to Surrealism. "At all times," argued Rosenberg, "Gorky belongs to America's new abstract art, pre-figured by Kandinsky, rather than to a latter-day Surrealism."[174]

This trend began in 1950, when Barr included Gorky's work along-

FIG. 108
Arshile Gorky, *Year after Year*, 1947. Oil on
canvas, 34⅝ x 40⅞ inches (87.9 x 104 cm).
Private collection

Gorky's friends David Hare and Isamu Noguchi. During his lifetime, Gorky chose to show his paintings (many of whose titles had been supplied by Breton and Ernst)[176] alongside those of his Surrealist colleagues, and he maintained an unswerving loyalty to Surrealism's fundamental aims, principles, and techniques to the end of his life. It seems highly doubtful that his allegiance would have changed, even if he had lived to see the critical and commercial ascendancy of Abstract Expressionism by the end of the 1950s.

Unfortunately, the vast majority of critics, curators, and art historians who have addressed Gorky's work since the 1950s have continued to view him as a transitional figure in the burgeoning Abstract Expressionist movement, while denying his Surrealist lineage. Gail Levin, for example, claimed in 1978 that Gorky "was never a Surrealist, although he certainly felt the influence of the Surrealists' biomorphic shapes and automatism. Gorky's sources were more diverse, from Kandinsky's lyrical abstract improvisations to the classicism of Ingres, Uccello, and Picasso. Unlike the work of the other Abstract Expressionist painters, we must consider Gorky's work of his last years as formative in the sense of forging a new style."[177] The artist's paintings of the late 1940s—especially monumental, allover compositions such as *The Limit* (1947; plate 183), with its vast expanse of empty greenish gray space, and the freely brushed *Year after Year* (1947; fig. 108)—do indeed share some of the characteristics generally associated with Abstract Expressionism, such as expansive scale, nonillusionistic flatness, the priority of formal concerns and technical innovation, and the lack or problem of finish, which Gorky had addressed in an interview with a Connecticut magazine reporter in 1948: "I don't like that word finish. When something is finished, that means it's dead, doesn't it? I believe in everlastingness. I never finish a painting—I just stop working on it for a while."[178] An important distinction needs to be drawn between Gorky's paintings and the gestural abstraction of his American contemporaries, however, for every major painting he made after 1943 was informed by at least one fully developed study that determined its composition. The apparent spontaneity

side that of Pollock, de Kooning, Hyman Bloom, Lee Gatch, and Rico Lebrun at the Venice Biennale. Thereafter, it became commonplace to show Gorky with his Abstract Expressionist "colleagues" in museum and gallery exhibitions, despite the fact that he had never used the term to describe his own work, preferring instead to align himself with Breton and the Surrealists, whose temperament, techniques, and philosophy he shared. In March 1958, almost a decade after the artist's suicide, Barr stamped the imprimatur of the Museum of Modern Art on this apocryphal reading of his work in his introduction to *The New American Painting*, the catalogue of an exhibition that traveled to eight European countries in 1958 and 1959, in which he declared Gorky to be "the most important early master" of the Abstract Expressionist movement.[175] It should be pointed out, however, that Gorky did not exhibit with this diverse coterie of largely New York–based abstract painters during his lifetime, except in large-scale group shows like Dorothy C. Miller's eclectic *Fourteen Americans* exhibition at MoMA in 1946, which included abstract artists such as Robert Motherwell and Mark Tobey, but also

of his mature work thus masks a carefully thought out working process in which initial sketches led to preparatory studies that were drawn up for transfer to the canvas through a grid system, allowing Gorky to map the entire composition before beginning work on a new painting (see plates 121, 178, 181).

Gorky cannot therefore be considered an "action painter" in the uncompromising terms conceived by Rosenberg in his important and widely read essay published in *ARTnews* in December 1952, in which he stressed the artist's freedom as a creator and risk-taker.[179] According to Rosenberg's epigrammatic description, the American artist in the post–World War II era had been transformed into an existentialist hero whose abstract paintings were the result of a complex series of decisions, changes, risks, and accidents that took place during the creative process, which began with a blank canvas, rather than with preparatory sketches. For Gorky, however, the blank canvas was not an arena in which to theatrically express his personal anguish through uncalculated painterly gestures, as suggested by Rosenberg's theory, but rather a place where preconceived ideas, memories, daydreams, and fantasies could be memorialized in paint.

Having been incorporated into Gorky's sketches and finished drawings, chance and accident played only minor roles in his paintings, unlike the unpremeditated and thus unpredictable and surprising results found in the work of artists such as Pollock and de Kooning. Taking Rosenberg's argument to its logical conclusion, the American art critic and curator Sam Hunter claimed that for "these two artists the revelation on canvas of the dynamics of the painting process assumes the character of a significant and *vital* action."[180] Rosenberg, who chided artists who valued the past, claimed that American action painters eschewed old-fashioned working methods, dispensing with formal values and tradition in the process of painting as they embarked on a voyage of self-discovery and self-transformation. Yet, in the carefully worked out preparatory studies for *Scent of Apricots on the Fields* (1944; plate 122), *The Orators* (1947; see fig. 105), and *Dark Green Painting* (c. 1948; plate 182), for example, Gorky utilized the centuries-old technique in which preparatory drawings are squared with an evenly spaced, pencil-drawn grid for transfer of the image to canvas. His paintings

therefore have far more in common with the carefully plotted painted poetry of Miró, who used gridded transfer drawings throughout his career (as seen, for example, in his *Dutch Interior* series),[181] than with the improvisatory, animated painterly abstraction of his American counterparts. Like Miró, Gorky was concerned with illustrating, in his own unique style, the state of his psyche and his personal world of memories, desires, and dreams.

The subsequent literature on the artist's life and work persistently focused on the political and artistic debates and practices of the New York art scene in the 1930s, rather than on the exciting Surrealist milieu that Gorky helped to shape in the following decade. In his 1962 study of the artist's life and work, Rosenberg upheld the romantic image of Gorky as related to him by friends such as de Kooning, while he perceived the role that Surrealism played in his work in negative terms. The obscuring of Gorky's debt to Surrealism, thanks to the critical and biographical studies that appeared not long after his death, shored up his reputation as a vital precursor to Abstract Expressionism. Sadly, this flawed argument was bolstered in the fall of 1971 by the appearance of his nephew Karlen Mooradian's forged letters, published as Gorky's own missives to his youngest sister, Vartoosh, and misleadingly presenting him as an Armenian nationalist who made vitriolic outbursts against Surrealism. The anti-Surrealist rhetoric of these twenty-nine forgeries can be seen in the following passage, which Karlen wrote in Armenian (of which he had only a rudimentary grasp) and then translated into English for publication in the magazine *Ararat*:

> Surrealism is academic art under disguise and anti-aesthetic and suspicious of excellence and largely in opposition to modern art. Its claim of liberation is really restrictive because of its narrow rigidity. To its adherents the tradition of art and its quality mean little. They are drunk with psychiatric spontaneity and inexplicable dreams. These Surrealists. These people are interesting to a limited extent. We do not think alike because their views on life differ so much from mine and we are naturally of opposite background. Their ideas are quite strange and somewhat flippant, almost playful. Really they are not as earnest about painting as I should like artists to be. Art must always remain earnest. Perhaps it is because I am an Armenian and they are not. Art must be serious, no sarcasm, comedy.[182]

Mooradian's hostility to Surrealism in these counterfeit letters can be explained by the fact that the movement's interest in dreams and the imagination offered a powerful alternative to his own misguided interpretation of his uncle's work, which he saw as exclusively Armenian in content and expression. No doubt emboldened by Gorky's own plagiarism of the writings of Paul Éluard and the modernist sculptor Henri Gaudier-Brzeska,[183] to say nothing of his imaginative interpretations of the work of Cézanne, Picasso, and Miró, among others, Mooradian invented for posterity a fictitious Gorky whose political and artistic views were closely aligned with his own Armenian nationalist agenda, and with the left-wing beliefs he inherited from his mother (who named her son Karlen after her heroes Karl Marx and Vladimir Lenin). In his subsequent monograph, published in 1978 under the title *Arshile Gorky Adoian*, Mooradian went even further in his assault on the Surrealists, "whose ultra anarchical art popularizations," he expounded, "spin round so-called subconscious upbeat dream-slices, in a do-anything-is-the-true-artistic-fling view."[184] Clearly, he could not conceive that his uncle would be interested let alone participate in what he described as Surrealism's "Freudian orgasmic fascination" and "spontaneous sensationalism," despite overwhelming evidence to the contrary.[185]

It goes without saying that Mooradian's view of his uncle as an earnest and rather humorless artist with little or no interest in Surrealism's "psychiatric spontaneity and inexplicable dreams" does not match the historical evidence. The letter quoted above, for example, was allegedly written in New York on January 17, 1947, shortly after Breton had published *Young Cherry Trees Secured against Hares*, with its Surrealist drawings and illustrations by Gorky, and just one month before the exhibition *Arshile Gorky: Colored Drawings* opened at the Julien Levy Gallery, featuring a selection of almost three hundred works on paper that he had made the previous summer. On February 15, 1947, Gorky's 1946 painting *Nude* was included in the Surrealist exhibition *Bloodflames* at the Hugo Gallery, New York. That same month, Gorky and Mougouch hosted a lively dinner party for Miró at the Union Square studio when the Catalan artist arrived in New York to work on a mural commissioned for the Terrace Plaza Hotel in Cincinnati, Ohio.

This historical context reveals Gorky's central position in the Surrealist group in New York, providing a far different scenario from the imaginative one of Mooradian's forged letters, with their repeated invective against Breton and the Surrealists, whom he clearly blamed for his uncle's death. In fact, in one of the few authentic letters that Gorky wrote to his sister, dated November 17, 1946, he lauds Breton and reveals that he and Mougouch are contemplating a trip to Paris in the spring of 1947: "Our friend the great poet Andre Breton, who wrote such good things about me, wants us to go there."[186] Regrettably, the twenty-nine forged letters published by Mooradian were frequently cited in the literature on the artist, until 1998, when the Armenian writer Nouritza Matossian revealed them to be a sham in her biography of Gorky.[187] By then, however, an entire generation of critics and art historians had been misled about Gorky's profound interest and participation in the international movement.

As I hope to have demonstrated, Gorky found himself at the epicenter of an exciting cultural milieu in the 1940s, and the paintings, drawings, and sculpture that he made in that decade reflect his deep immersion in the art and ideas of the exiled Surrealist group, which he eagerly embraced. Indeed, his mature style, though quite personal and highly individualistic, is unthinkable without the precedent of Surrealist painting, especially the exuberant automatism of Masson, the anthropomorphic rock formations of Tanguy, the melting mineral dreamscapes of Matta, and the whimsical associative form-language of Miró. These artists helped Gorky to unleash images from the depths of his fecund imagination and tragic personal history, leading to the creation of some of the most hauntingly beautiful and intensely moving works of art of his time, or any other. Breton considered Gorky to be the greatest of the new adherents to Surrealism during its period of exile in the United States during World War II. There can be no doubt that Gorky reinvigorated Surrealism during the most tumultuous and least understood decade of its existence.

1. For more on the encounter between the American avant-garde and the exiled Surrealist group, see William S. Rubin, "Arshile Gorky, Surrealism, and the New American Painting," *Art International* 7, no. 2 (February 25, 1963), pp. 27–38; Martica Sawin, *Surrealism in Exile and the Beginning of the New York School* (Cambridge, Mass.: MIT Press, 1995); Dickran Tashjian, *A Boatload of Madmen: Surrealism and the American Avant-garde, 1920–1950* (New York: Thames and Hudson, 1995); and Isabelle Dervaux, ed., *Surrealism USA*, exh. cat. (New York: National Academy Museum, 2005).

2. Dorothea Tanning, *Birthday* (Santa Monica, Calif.: Lapis, 1986), p. 19.

3. Christian Brinton, ed., *Exhibition of Russian Painting and Sculpture: Realism to Surrealism*, exh. cat. (Wilmington, Del.: Wilmington Society of the Fine Arts, 1932), n.p.

4. Ibid.

5. We know that Gorky saw the *Fantastic Art, Dada, Surrealism* exhibition, or at least read the catalogue, as he made reference to one of the key works in the show, William Hogarth's engraving *The Analysis of Beauty* (1753), in a 1936 interview. See Hayden Herrera, *Arshile Gorky: His Life and Work* (New York: Farrar, Straus, and Giroux, 2003), pp. 267, 681.

6. Alfred H. Barr, Jr., *Cubism and Abstract Art*, exh. cat. (New York: The Museum of Modern Art, 1936), p. 24.

7. First published in 1874 under the French title *La Tentation de Saint Antoine*, this novel influenced many modern artists, despite receiving a mixed response from literary critics. As Theodore Reff has argued, artists like Paul Cézanne, Fernand Khnopff, James Ensor, and Odilon Redon were enthralled by Flaubert's whirling series of visual hallucinations, all of which were conveyed in a brilliantly pictorial writing style; Reff, "Images of Flaubert's Queen of Sheba in Later Nineteenth-Century Art," in *The Artist and the Writer in France: Essays in Honor of Jean Seznec*, ed. Francis Haskell, Anthony Levi, and Robert Shackleton (Oxford: Clarendon, 1974), pp. 126–33.

8. Julien Levy, foreword to William C. Seitz, *Arshile Gorky: Paintings, Drawings, Studies*, exh. cat. (New York: The Museum of Modern Art, 1962), p. 8.

9. Paul Éluard, "Simulation of General Paralysis Essayed," trans. Samuel Beckett, in Julien Levy, *Surrealism* (New York: Black Sun, 1936), p. 120.

10. Arshile Gorky to Corinne Michael West, August 11, 1936, NY School Art Gallery, Yorktown Heights; reproduced in Ethel K. Schwabacher, *Arshile Gorky* (New York: Macmillan for the Whitney Museum of American Art, 1957), p. 62. Gorky included the first paragraph of Éluard's prose poem in his next letter to West, which he sent from Long Island; ibid., pp. 62–63.

11. Lionel Abel in conversation with Matthew Spender, New York, November 5, 1993, Matthew Spender Papers, Archives of American Art, Smithsonian Institution, Washington, D.C.

12. Gorky's idiosyncratic use of grammar and syntax can be seen in his earliest letters to his sister Vartoosh, who moved with her family to Chicago in November 1936. See Herrera, *Arshile Gorky: His Life and Work*, pp. 281–86.

13. Paul Éluard, "Lady Love," trans. Samuel Beckett, in Levy, *Surrealism*, p. 114.

14. Arshile Gorky to Corinne Michael West, August 24, 1936; reproduced in Schwabacher, *Arshile Gorky*, p. 63.

15. Gorky's continued interest in Éluard's poetry in the following decade is apparent in the title of his 1947 painting *Days, Etc.* (private collection). Gorky told Julien Levy: "There is that poem by Paul Eluard—'Days, like fingers, twist their battalions'—but I think that is too long . . ." The title was thus shortened to *Days, Etc.* See Levy, *Arshile Gorky* (New York: Harry N. Abrams, 1966), p. 35.

16. André Breton, *Dictionnaire abrégé du Surréalisme* (1938; Rennes: José Corti, 1969), p. 6 (my translation). The first Surrealist exquisite corpse is thought to have been made at the end of 1925 in the house of Marcel Duhamel at 54, rue de Château, Paris, where Duhamel played the game with the poet Jacques Prévert and the painter Yves Tanguy. The name was born when the first sufficiently striking sentence to emerge read "Le cadavre exquis boira le vin nouveau" (the exquisite corpse will drink the new wine). See André Breton, "The Exquisite Corpse, Its Exaltation" (1948), in Breton, *Surrealism and Painting*, trans. Simon Watson Taylor (New York: Harper and Row, 1972), p. 288.

17. Breton, *Surrealism and Painting*, p. 290.

18. Cynthia Jaffee McCabe, "Artistic Collaboration in the Twentieth Century: The Period between Two Wars," in *Artistic Collaboration in the Twentieth Century*, ed. McCabe, exh. cat. (Washington, D.C.: Smithsonian Institution Press, 1984), p. 33.

19. Isamu Noguchi, "Regarding the Collaborative Drawing by Isamu Noguchi and Arshile Gorky," July 22, 1983, typescript, Hirshhorn Museum and Sculpture Garden Library, Washington, D.C.; as cited in McCabe, *Artistic Collaboration in the Twentieth Century*, p. 33.

20. Malcolm Johnson, "Café Life in New York: The New Murals at Ben Marden's Riviera as the Artist Sees Them," *New York Sun*, August 22, 1941.

21. Ethel K. Schwabacher, "Arshile Gorky," in *Arshile Gorky Memorial Exhibition*, ed. Schwabacher, exh. cat. (New York: Whitney Museum of American Art, 1951), p. 23. Matthew Spender concurs with Schwabacher that the subject of the series was a scene Gorky remembered from his childhood, namely, his mother making butter in the Adoian house in Khorkom. According to Spender, the butter churn was made of goatskin and hung above the hearth when not in use. Spender, *From a High Place: A Life of Arshile Gorky* (New York: Alfred A. Knopf, 1999), p. 186.

22. Levy, *Arshile Gorky*, p. 13.

23. See Herrera, *Arshile Gorky: His Life and Work*, p. 362.

24. Schwabacher, *Arshile Gorky*, p. 66.

25. Gordon Onslow Ford to Jeffrey Wechsler, July 4, 1976, in Wechsler, *Surrealism and American Art, 1931–1947*, exh. cat. (New Brunswick, N.J.: Rutgers University, 1977), p. 51.

26. Gordon Onslow Ford, quoted in Sawin, *Surrealism in Exile*, p. 162.

27. Ibid.

28. Sawin, *Surrealism in Exile*, p. 167.

29. Sidney Simon, "Concerning the Beginnings of the New York School, 1939–1943: An Interview with Peter Busa and Matta Conducted by Sidney Simon in Minneapolis in December 1966," *Art International* 11, no. 6 (Summer 1967), p. 18.

30. Max Kozloff, "An Interview with Matta: 'These Things Were Like Rain Catching Up with a Man Who Is Running,'" *Artforum* 4, no. 1 (September 1965), p. 25.

31. André Breton, "Entrée des médiums," *Littérature* (Paris) 6 (November 1, 1922), p. 2 (my translation).

32. André Breton, "First Manifesto of Surrealism" (1924); reproduced in Breton, *Manifestoes of Surrealism*, trans. Richard Seaver and Helen R. Lane (Ann Arbor: University of Michigan Press, 1969), p. 26.

33. Kozloff, "An Interview with Matta," p. 23.

34. For more on Dalí's successful efforts to change the course of Surrealism in the 1930s through his paranoiac-critical method, see Laurent Jenny, "From Breton to Dalí: The Adventures of Automatism," trans. Thomas Trezise, *October* 51 (Winter 1989), pp. 105–14.

35. André Breton, "The Most Recent Tendencies in Surrealist Painting" (1939), in Breton, *Surrealism and Painting*, p. 145.

36. André Breton, "Prolégomènes a un troisième manifeste du Surréalisme ou non / Prolegomena to a Third Manifesto of Surrealism or Else," trans. N. G., *VVV* 1 (June 1942), p. 25. For more on the history and application of the Great Transparents myth, see Didier Ottinger, "Les Grands Transparents," in Ottinger, *Surréalisme et mythologie moderne: Les voies du labyrinthe d'Ariane à Fantômas* (Paris: Gallimard, 2002), pp. 85–93; and Romy Golan, "Mise en suspens de l'incrédulité: Breton et le mythe des Grands Transparents," trans. Jeanne Bouniort, in *André Breton: La beauté convulsive*, exh. cat. (Paris: Musée national d'art moderne, Centre Georges Pompidou, 1991), pp. 353–54.

37. Breton, "Prolegomena to a Third Manifesto of Surrealism or Else," pp. 25–26 (emphasis in original).

38. Nancy Miller, "Interview with Matta," in *Matta: The First Decade*, exh. cat. (Waltham, Mass.: Rose Art Museum, Brandeis University, 1982), p. 16.

39. Nancy Miller, "Matta: The First Decade," in ibid., p. 33.

40. André Breton, *Arcane 17* (New York: Brentano's, 1944); reproduced in Breton, *Arcanum 17*, trans. Zack Rogow (Los Angeles: Sun and Moon, 1994), p. 63.

41. Anna Balakian, *André Breton: Magus of Surrealism* (New York: Oxford University Press, 1971), p. 204.

42. Breton, *Arcanum 17*, p. 29.

43. This thermographic photographic technique, known as *brûlage*, or "heated photographs," was first utilized by the Belgian-born Surrealist Raoul Ubac.

44. Arshile Gorky, "Camouflage" (c. 1941); reproduced in Harold Rosenberg, *Arshile Gorky: The Man, the Time, the Idea* (New York: Horizon, 1962), p. 133. In an interview with Harry Rand in April 1977, the artist Robert Jonas claimed that he, not Gorky, was the author

of this piece; Rand, *Arshile Gorky: The Implications of Symbols* (London: Prior, 1981), p. 200 n. 9.

45. Ibid., p. 134.

46. Breton, "Prolegomena to a Third Manifesto of Surrealism or Else," p. 25.

47. Roger Caillois, "Mimétisme et psychasthénie légendaire," *Minotaure* 7 (June 1935), pp. 5–10; reproduced in Caillois, "Mimicry and Legendary Psychasthenia," trans. John Shepley, *October* 31 (Winter 1984), p. 30.

48. Ibid.

49. This notion corresponds with Levy's description of Gorky as "a very camouflaged man"; Levy, foreword to Seitz, *Arshile Gorky: Paintings, Drawings, Studies*, p. 7.

50. Levy, *Arshile Gorky*, p. 26.

51. Ibid.

52. Agnes Gorky to Ethel Schwabacher, December 28, 1949; quoted in Herrera, *Arshile Gorky: His Life and Work*, p. 422.

53. Gorky, quoted in James Johnson Sweeney, "Five American Painters," *Harper's Bazaar*, April 1944, p. 122.

54. Gorky, quoted in Mary Burliuk, diary entry for 1933. I am very grateful to the late Melvin P. Lader for supplying me with this reference.

55. Matta, "Morphologie psychologique," in *Matta*, exh. cat. (Paris: Musée national d'art moderne, Centre Georges Pompidou, 1985), pp. 30–31.

56. Roberto Matta, quoted in Michael Kimmelman, "Matta, Chilean Artist Who Was Prominent in the Surrealist Movement, Is Dead," *New York Times*, November 25, 2002.

57. James Thrall Soby, *Contemporary Painters* (New York: The Museum of Modern Art, 1948), p. 65.

58. Gorky made this remark to Jeanne Reynal; see Robert Frank Reiff, "A Stylistic Analysis of Arshile Gorky's Art from 1943–1948" (Ph.D. diss., Columbia University, New York, 1961), p. 234.

59. In 1946 Marcel Duchamp described Matta as "the most profound painter of his generation" and credited him with "the discovery of regions of space hitherto unexplored in the realm of art"; Duchamp, "Matta" (1946), in *Salt Seller: The Writings of Marcel Duchamp (Marchand du sel)*, ed. Michel Sanouillet and Elmer Peterson (New York: Oxford University Press, 1973), p. 154. As the art historian Gavin Parkinson has astutely observed, Duchamp's choice of the word *profound* can be understood as a punning compliment to his friend, since it plays on the French word *profondeur* (depth) to distinguish Matta's use of a deep, non-Euclidean space from the modernist credo of flatness then being championed by the American art critic Clement Greenberg; Parkinson, *Surrealism, Art, and Modern Science: Relativity, Quantum Mechanics, Epistemology* (New Haven, Conn.: Yale University Press, 2008), p. 154.

60. André Breton, "The Eye-Spring: Arshile Gorky," trans. Julien Levy, in *Arshile Gorky*, exh. cat. (New York: Julien Levy Gallery, 1945), n.p.

61. Ibid.

62. For more on the history and reception of *The Liver Is the Cock's Comb*, see Michael Auping, "An Erotic Garden," in *Arshile Gorky: The Breakthrough Years*, ed. Auping, exh. cat. (Fort Worth, Tex.: Modern Art Museum of Fort Worth in association with Rizzoli, 1995), pp. 63–77.

63. Parker Tyler, "The Limit of the Probable in Modern Painting," *View*, ser. 5, no. 1 (March 1945), p. 39.

64. See Rand, *Arshile Gorky: The Implications of Symbols*, pp. 113–14.

65. Gorky designed a rug with the title *Bull in the Sun* for the exhibition *New Rugs by American Artists*, which opened at MoMA in June 1942. Woven by the rug manufacturer V'soske, *Bull in the Sun* represented the skin of a bull stretched out to dry in a sunny wheat field. See Herrera, *Arshile Gorky: His Life and Work*, pp. 390–91.

66. Mark Polizzotti, *Revolution of the Mind: The Life of André Breton* (New York: Farrar, Straus and Giroux, 1995), p. 519.

67. Author's interview with Agnes Gorky Fielding, London, June 5, 2008.

68. Max Ernst, in George Melly, *Paris and the Surrealists* (New York: Thames and Hudson, 1991), p. 70.

69. André Masson, in Levy, *Arshile Gorky*, p. 30.

70. Nicolas Calas, "Interview with André Breton," *View* 1, nos. 7–8 (October–November 1941), p. 1.

71. Ibid.

72. Jean-Paul Clébert, *Mythologie d'André Masson* (Geneva: Pierre Cailler, 1971), p. 69 (my translation).

73. André Masson, statement in James Johnson Sweeney, "Eleven Europeans in America," *The Museum of Modern Art Bulletin* 13, nos. 4–5 (1946), p. 3.

74. Paul Hammond, *The Shadow and Its Shadow: Surrealist Writings on the Cinema* (London: British Film Institute, 1978), p. 3.

75. Breton, *Arcanum 17*, p. 26.

76. André Breton, "Matta" (1944), in Breton, *Surrealism and Painting*, p. 184 n. 2.

77. Breton, "The Eye-Spring," n.p. (emphasis in original).

78. Ibid.

79. J. H. Matthews, "André Breton and Painting: The Case of Arshile Gorky," *Dada/Surrealism* (Iowa City) 17 (1988), p. 39 (emphasis in original).

80. For an excellent discussion of Breton's interest in Fourier, whom he correctly identified as an enemy of rationalism whose Romantic Socialism could play an important role in the redirection of Surrealist theory and activity both during and after World War II, see Donald LaCoss, "Attacks of the Fantastic," in *Surrealism, Politics, and Culture*, ed. Raymond Spiteri and LaCoss (Aldershot, Hampshire, U.K.: Ashgate, 2003), pp. 267–99.

81. Breton, "The Eye-Spring," n.p.

82. Alyce Mahon, *Surrealism and the Politics of Eros, 1938–1968* (London: Thames and Hudson, 2005).

83. Calas, "Interview with André Breton," p. 1.

84. Author's interview with Agnes Gorky Fielding, London, June 5, 2008. I am greatly indebted to Arshile Gorky's widow for providing me with information regarding the novels, poetry, and plays that they read during the early years of their marriage. Gorky's interest in the writings of Stéphane Mallarmé was first noted by Harry Rand, who correctly connected the title of the artist's 1936 painting *Child of an Idumean Night* with the French writer's 1865 poem "Don du poème"; Rand, *Arshile Gorky: The Implications of Symbols*, pp. 90–93.

85. Lautréamont, *Maldoror (Les Chants de Maldoror)*, trans. Guy Wernham (New York: New Directions, 1943). According to Hayden Herrera, Gorky once shocked his Quaker neighbors in Lincoln, Virginia, by recounting Lautréamont's famous episode in which God visits a brothel and accidentally leaves behind a pubic hair, thus inadvertently providing physical evidence of his existence; Herrera, *Arshile Gorky: His Life and Work*, p. 419. The Armenian-born sculptor Raoul Hague, in an unpublished interview with Karlen Mooradian in Woodstock, New York, on July 22, 1966, reported that Gorky quoted the same *Maldoror* passage to him.

86. This book, which remains in the possession of the artist's widow, is number 49 of the first edition, which was limited to 1,000 copies.

87. Author's interview with Agnes Gorky Fielding, London, June 5, 2008.

88. David Gascoyne, *A Short Survey of Surrealism* (London: Shenval / R. Cobden-Sanderson, 1935), p. 10.

89. According to Alexis Lykiard, whose 1970 translation remains the best English-language version of *Maldoror*, Wernham's 1943 translation amounted to a "guerilla war on the text. . . . Mr. Wernham is guilty of the crassest mistakes on every page"; Lykiard, "Note on the Text and Translation," in *Maldoror and the Complete Works of the Comte de Lautréamont*, trans. Alexis Lykiard (Cambridge, Mass.: Exact Change, 1994), p. 21.

90. Elaine de Kooning, "Gorky: Painter of His Own Legend," *ARTnews* 49, no. 9 (January 1951), p. 65.

91. André Breton, quoted in Henri Peyre, "The Significance of Surrealism," *Yale French Studies* 31 (1964), p. 25.

92. For Gorky's use of this term to describe himself, see Nouritza Matossian, *Black Angel: The Life of Arshile Gorky* (London: Chatto and Windus, 1998), pp. 338–39.

93. Lautréamont, *Maldoror*, p. 76.

94. Ibid., pp. 111–13.

95. According to her son-in-law Matthew Spender, Mougouch was "deeply hurt," after Gorky's death, to discover just how little he had told her about himself, "how reluctant he had been to bare his soul to true intimacy"; Spender, *From a High Place*, p. 374.

96. Lautréamont, *Poésies*, in *Maldoror and the Complete Works*, trans. Lykiard, p. 240.

97. Gaston Bachelard, *Lautréamont* (Paris: Librairie José Corti, 1939), p. 12. It was Maurice Viroux who, in a celebrated 1952 article, traced many of Lautréamont's astounding prose descriptions of birds and animals back

to Dr. Chenu's *Encyclopédie d'histoire naturelle*; Viroux, "Lautréamont et le Dr. Chenu," *Mercure de France* (Paris) 1070 (December 1952), p. 639.

98. Lautréamont, *Maldoror*, p. 220.

99. See Michael R. Taylor, "Learning from 'Papa Cézanne': Arshile Gorky and the (Self-)Invention of the Modern Artist," in *Cézanne and Beyond*, ed. Joseph J. Rishel and Katherine Sachs, exh. cat. (Philadelphia: Philadelphia Museum of Art in association with Yale University Press, 2009), pp. 407–31.

100. Bachelard, *Lautréamont*, pp. 7–25.

101. Gorky, "Camouflage," in Rosenberg, *Arshile Gorky: The Man, the Time, the Idea*, p. 134.

102. In 1944, when the New York art dealer Sidney Janis reproduced *The Liver Is the Cock's Comb* in his book on abstract and Surrealist art in the United States, he invited the artists whose work he illustrated, including Gorky, to provide captions as accompanying explications for their paintings. See Janis, *Abstract and Surrealist Art in America* (New York: Reynal and Hitchcock, 1944), p. 120.

103. Marcel Jean, *The History of Surrealist Painting*, trans. Simon Watson Taylor (New York: Grove, 1959), p. 329 (emphasis in original).

104. John Bernard Myers, "Interactions: A View of 'View,'" *Art in America* 69, no. 6 (Summer 1981), p. 86; reproduced in Myers, *Tracking the Marvelous: A Life in the New York Art World* (New York: Random House, 1983), p. 42.

105. David Hopkins, *Dada's Boys: Masculinity after Duchamp* (New Haven: Yale University Press, 2007), p. 102.

106. Charles Henri Ford to Parker Tyler, undated [April 20, 1939?], Harry Ransom Humanities Center, University of Texas at Austin, Charles Henri Ford Papers; quoted in Tashjian, *A Boatload of Madmen*, pp. 170–71.

107. Marcel Duchamp to Maria Martins, May 24 [1949], in *Marcel Duchamp: Étant donnés*, ed. Michael R. Taylor, exh. cat. (Philadelphia: Philadelphia Museum of Art in association with Yale University Press, 2009), p. 411.

108. Mark Polizzotti has noted that, despite Breton's enthusiasm for Duchamp's witty cover design, Charles Duits—one of the French writer's young protégés in the Surrealist group in New York at that time—felt that "they were making fun of my great man"; Polizzotti, *Revolution of the Mind*, pp. 518–19.

109. André Breton, "Lighthouse of the Bride," *View*, ser. 5, no. 1 (March 1945), p. 13.

110. Author's interview with Agnes Gorky Fielding, London, June 5, 2008.

111. Myers, "Interactions: A View of 'View'"; reproduced in Myers, *Tracking the Marvelous*, p. 87.

112. Ibid., p. 86.

113. See Reiff, "A Stylistic Analysis of Arshile Gorky's Art," p. 240 n. 1.

114. According to Nouritza Matossian, Mougouch gave Ludwig Goldscheider's book on Leonardo da Vinci to Gorky for his birthday; Matossian, *Black Angel*, p. 472.

115. Julien Levy recalled that Matta encouraged Gorky "to use the accidental splotches [of liquid oil paint] as suggestive forms for further elaboration, as Leonardo da Vinci used the stains on the wall plaster of his room"; Levy, *Arshile Gorky*, p. 24.

116. Salvador Dalí, "Dali, Dali!" in the catalogue of the Dalí exhibition held at the Julien Levy Gallery, New York, March 21–April 17, 1939, n.p., Julien Levy Papers, Philadelphia Museum of Art, Archives.

117. Agnes Gorky to Jeanne Reynal, [c. May 1945]; quoted in Herrera, *Arshile Gorky: His Life and Work*, p. 481.

118. Rosenberg, *Arshile Gorky: The Man, the Time, the Idea*, p. 68. Martica Sawin has disputed Rosenberg's claim that de Kooning introduced Gorky to the liner brush, proposing instead that it was the graphic artist Gabor Peterdi who suggested to Gorky that he use a lettering brush because its long bristles could hold enough paint to make a continuous, unbroken line of considerable length; Sawin, *Surrealism in Exile*, p. 331.

119. Seitz, *Arshile Gorky: Paintings, Drawings, Studies*, p. 34.

120. During his visits to Crooked Run Farm and, later, in Roxbury, Connecticut, Gorky liked to collect horse, sheep, and cow bones in the surrounding fields. Author's interview with Agnes Gorky Fielding, London, June 4, 2008.

121. William Rubin, "Matta," *The Museum of Modern Art Bulletin* 25, no. 1 (1957), p. 9.

122. Breton, "Prolegomena to a Third Manifesto of Surrealism or Else," p. 26.

123. In a letter to Vartoosh on November 17, 1946, the day before leaving Virginia, Gorky reported, "This summer I made many drawings, 293 of them, I notice, I have never been able to draw so much and they are very beautiful"; as cited in Spender, *From a High Place*, p. 319.

124. Gorky's work was also selected by the art critic Katherine Kuh for inclusion in the exhibition *Abstract and Surrealist American Art* held at the Art Institute of Chicago from November 6, 1947, to January 11, 1948. However, it is not clear from the catalogue whether Kuh considered Gorky's entry, the 1944 painting *The Sun, the Dervish in the Tree*, to be abstract or Surrealist in its imagery and technical execution.

125. Nicolas Calas, letter to the editor, *Arts Magazine* 50, no. 10 (June 1976), p. 110.

126. Nicolas Calas, introduction to *Calas Presenting Bloodflames 1947: Hare, Gorky, Kamrowski, Lam, Matta, Noguchi, Phillips, Raynal* [sic], exh. cat.(New York: Hugo Gallery, 1947), p. 6.

127. Ibid., p. 7.

128. Frederick Kiesler, in ibid., n.p.

129. Ad Reinhardt, "Neo Surrealists Take Over a Gallery," *PM* (New York), March 11, 1947, p. 11.

130. *Nude* was included in Gorky's second solo exhibition at the Julien Levy Gallery, which opened on March 1, 1946, so it can be securely dated to February 1946. In his catalogue entry on Gorky, Nicolas Calas sensitively described the artist's "incessant pursuit . . . of that line or color which will become isolated by achieving independence. A blue detached from the night, a red withdrawn from the flesh, a curve formed out of the resistance of the branch to the gale, the bitterness that ossifies the lip after the smile has faded away, the weight of the bones felt after the embrace has been unlocked— that which remains and is worthy of lasting, is recalled and lauded. Yet, this is not a painting of memorized images and feelings, for the forms which have been extracted from life and nature with such sensitivity are

treated like precious elements and combined to form a whole whose presence was sensed on a still empty canvas and was realized through insight and labor"; Calas, "Arshile Gorky," in *Calas Presenting Bloodflames 1947*, p. 8.

131. Lowery Stokes Sims, "Wifredo Lam and Roberto Matta: Surrealism in the New World," in *In the Mind's Eye: Dada and Surrealism*, ed. Terry Ann R. Neff, exh. cat. (Chicago: Museum of Contemporary Art, Chicago, 1984), p. 94.

132. The Surrealist movement's increasing preoccupation with the esoteric and the occult rather than leftwing politics came under fire at this time from, among many others, the poet and artist Christian Dotremont, who recently had founded the dissident group Surréalisme Révolutionnaire in Belgium. See Mary Ann Caws, *Surrealism* (London: Phaidon, 2004), p. 41. In his article on the "Situation of the Writer in 1947," Jean-Paul Sartre also publicly abraded the Surrealists, and André Breton in particular, for spending World War II in exile in the United States, rather than remaining in France and taking part in the Resistance. See Sartre, "Situation of the Writer in 1947," in *"What Is Literature?" and Other Essays*, trans. Steven Ungar (Cambridge, Mass.: Harvard University Press, 1988), p. 164.

133. These artists were officially invited to participate in the 1947 Surrealist exhibition by André Breton, who wrote on January 12, 1947, outlining the themes and aspirations of the exhibition and meticulously detailing the installation plans. For Donati's copy of this letter, see Enrico Donati Papers, André Breton Letters, folder 2, Getty Research Institute for the History of Art and the Humanities, Los Angeles.

134. *Trois siècles d'art aux États-Unis*, exh. cat. (Paris: Éditions des musées nationaux, [1938]), p. 39, fig. 53.

135. *Le Surréalisme en 1947*, exh. cat. (Paris: Maeght, 1947), plate 10. Next to the illustration of *How My Mother's Embroidered Apron Unfolds in My Life*, Gorky's name was misspelled as "Arshille Gork," though it appeared correctly in the list of contributing artists at the beginning of the book.

136. For an excellent overview of the Surrealist artists' engagements with these myths, see Ottinger, *Surréalisme et mythologie moderne*.

137. *Painting in the United States, 1945*, exh. cat. (Pittsburgh: Carnegie Institute, 1945), cat. 117.

138. André Breton, in Matossian, *Black Angel*, p. 353.

139. Alfred H. Barr, Jr., *Masters of Modern Art* (New York: The Museum of Modern Art, 1958), p. 175.

140. Robert Rosenblum, "Arshile Gorky," *Arts* (New York) 32, no. 4 (January 1958), p. 32.

141. Author's interview with Agnes Gorky Fielding, London, June 5, 2008.

142. Paul Schimmel, "Arshile Gorky's Unresolvable Struggle for an Ambiguous Pictorial Language," in *Gorky's Betrothals*, exh. cat. (New York: Whitney Museum of American Art, 1993), n.p.

143. Gorky, quoted in Talcott B. Clapp, "A Painter in a Glass House," *Sunday Republican Magazine* (Waterbury, Conn.), February 9, 1948, p. 6.

144. Dickran Tashjian has related *How My Mother's Embroidered Apron Unfolds in My Life* to Gorky's memories of the American stories his mother told him during

his childhood: "Understandably, given his vocation as a painter, Gorky translated to his canvases the oral repetition necessary to stave off oblivion"; Tashjian, "Arshile Gorky's American Script: Ethnicity and Modernism in the Diaspora," in *Perspective: Art, Literature, Participation*, ed. Mark Neuman and Michael Payne (Lewisburg, Pa.: Bucknell University Press, 1986), p. 148.

145. The installation design of the 1947 Surrealist exhibition has been discussed at length by Marcel Jean in his *History of Surrealist Painting*, pp. 341–44. See also José Pierre, "Le Surréalisme en 1947," in *La Planète affolée: Surréalisme, dispersion et influences, 1938–1947*, exh. cat. (Marseille: Centre de la Vieille Charité; Paris: Flammarion, 1986), pp. 282–319; and Mahon, *Surrealism and the Politics of Eros*, pp. 107–40.

146. André Breton, "Devant le rideau," in *Le Surréalisme en 1947*, p. 18 (my translation).

147. Ibid.

148. Jean, *The History of Surrealist Painting*, p. 342.

149. Duchamp later admitted to the French art critic Pierre Cabanne that "as an architect, [Kiesler] was far more qualified than I to organize a Surrealist exhibition"; Cabanne, *Dialogues with Marcel Duchamp*, trans. Ron Padgett (New York: Viking, 1971), p. 86.

150. Jean, *The History of Surrealist Painting*, p. 342.

151. Ibid., p. 341.

152. Frederick Kiesler in Jean Arp, "L'Oeuf de Kiesler et la Salle des superstitions," *Cahiers d'art* 22 (1947), p. 281 (my translation).

153. Frederick Kiesler, "L'Architecture magique de la Salle de superstition," in *Le Surréalisme en 1947*, p. 134 (my translation).

154. This drawing is reproduced in Cynthia Goodman, "The Art of Revolutionary Display Techniques," in *Frederick Kiesler*, ed. Lisa Phillips, exh. cat. (New York: Whitney Museum of American Art in association with W. W. Norton, 1989), p. 72.

155. Julien Levy quoted Gorky as saying, in connection with the title of this painting, "My father's death, and everybody making big orations while a candle gutters out like a life. I didn't love my father very much, but I know about Armenian funerals"; Levy, *Arshile Gorky*, p. 35. Matthew Spender doubted Levy's recollections and suggested instead that *The Orators* was inspired by preachers on soapboxes in Union Square; Spender, *From a High Place*, p. 339.

156. For a reproduction of the announcement card, see Marcel and David Fleiss, *Arshile Gorky*, exh. cat. (Paris: Galerie 1900–2000, 2002), p. 21.

157. In March 1945, Clement Greenberg suggested that Gorky's embrace of the "prismatic, iridescent color, and open forms of abstract, 'biomorphic' surrealist painting" made his work "less serious and less powerful and emphasizes the dependent nature of his inspiration"; Greenberg, "Art," *The Nation* 160 (March 24, 1945), p. 343. Three years later, Greenberg had made a complete about-face, as can be seen in his effusive praise of Gorky as "one of the best brush-handlers alive." According to Greenberg, Gorky's strongest paintings, such as *Agony* (1947; plate 165) and *Soft Night* (1947; plate 180) showed him to be "the equal of any painter of his own generation anywhere"; Greenberg, "Art," *The Nation* 166 (March 20, 1948), p. 332.

158. Jean Duché, "André Breton, nous parle…," *Le Littéraire* (Paris), October 5, 1946, p. 1; reproduced in Breton, *Conversations: The Autobiography of Surrealism*, trans. Mark Polizzotti (New York: Marlowe, 1993), p. 200.

159. Gorky was included on the editorial board for the first issue of *Néon*, whose initials stood for "N'Être rien, Être tout, Ouvrir l'être," which appeared in January 1948, although the exact nature of his contribution, if any, remains unknown.

160. André Breton, "Farewell to Arshile Gorky" (1948), trans. Denise Hare; reproduced in Rosenberg, *Arshile Gorky: The Man, the Time, the Idea*, p. 136.

161. Gérard de Nerval (1808–1855) was a French Romantic poet and essayist who hung himself after suffering a number of nervous breakdowns.

162. Ibid., p. 137.

163. See Calvin Tomkins, *Duchamp: A Biography* (New York: Henry Holt, 1996), p. 364.

164. Polizzotti, *Revolution of the Mind*, p. 557. Duchamp shared Brauner's view that Kiesler and Breton had no right to expel Matta for pursuing an affair with a married woman, given their own past sexual conduct; he ended his longstanding friendship with Kiesler, with whom he had frequently collaborated, in late 1948, and they seem to have had little contact with one another after that time.

165. Frederick Kiesler to André Breton, October 17, 1948. I am grateful to the Austrian Frederick Lillian Kiesler Private Foundation, Vienna, for sharing this letter with me.

166. Frederick Kiesler, "Murals without Walls: Relating to Gorky's Newark Project," *Art Front* 2 (December 1936); as reproduced in Ruth Bowman, *Murals without Walls: Arshile Gorky's Aviation Murals Rediscovered*, exh cat. (Newark, N.J.: Newark Museum, 1978), pp. 33–33.

167. Lillian Kiesler, in Maria Bottero, "Kiesler Observed by Lillian Kiesler," in *Frederick Kiesler: Arte, Architettura, Ambiente*, ed. Bottero, exh. cat. (Milan: Electa, 1995), p. 209.

168. Mougouch Phillips (Agnes Gorky Phillips) to Patricia Passlof, December 29, 1956, Pat Passlof Papers, 1957–1969, N69-45, Archives of American Art, Smithsonian Institution, Washington, D.C. (emphasis in original).

169. Arshile Gorky, statement on a questionnaire, curatorial files, Department of Painting and Sculpture, The Museum of Modern Art, New York; quoted in *Arshile Gorky: Paintings and Drawings, 1929–1942*, exh. cat. (New York: Gagosian Gallery, 1998), p. 60.

170. Stuart Davis, "Handmaiden of Misery," *Saturday Review*, December 28, 1957, p. 17.

171. Ibid.

172. De Kooning, quoted in Spender, *From a High Place*, p. 341. It is also possible that de Kooning was referring here to Matta. Harold Rosenberg's critical study of Gorky, which was largely based on de Kooning's recollections of his former friend and mentor, contains similarly offensive remarks about the Chilean artist, whom he described as a "short, rubicund Latin American" with "bright black eyes" and a "darting mind that revered cruel thoughts in the Surrealist canon of the Marquis de Sade"; Rosenberg, *Arshile Gorky: The Man, the Time, the Idea*, pp. 108–9. According to Rosenberg, Matta was "committed to moral provocations and ruses of destruction" and "did not hesitate to break his ego to

pieces by willfully emerging into the desolation of Gorky's illness as the focus of his violent jealousy"; ibid., pp. 109–10. This defamatory account was written with the benefit of malicious hindsight, since Matta had no intentions of ruining Gorky's life and bringing about his tragic early death when they first met in 1941.

173. For more on Gorky's friendship with Lam, see Matossian, *Black Angel*, pp. 414–15.

174. Rosenberg, *Arshile Gorky: The Man, the Time, the Idea*, p. 113.

175. Alfred H. Barr, Jr., introduction to *The New American Painting*, exh. cat. (New York: The Museum of Modern Art, 1959), p. 18.

176. On New Year's Eve 1944, Breton went to Gorky's studio at 36 Union Square to help the artist title his works for his forthcoming solo exhibition at the Julien Levy Gallery. Titles such as *One Year the Milkweed* (1944; plate 120), *Water of the Flowery Mill* (1944; plate 118), and *Love of the New Gun* (1944; plate 116) give an idea of the distinctive names that came out of this session; see Herrera, *Arshile Gorky: His Life and Work*, p. 465. In 1945, Max Ernst supplied the title of *Diary of a Seducer* (plate 126), which he took from the title of a chapter in the Danish philosopher Sören Kierkegaard's 1843 masterpiece *Either/Or*; see Schwabacher, *Arshile Gorky*, p. 104.

177. Gail Levin, "Arshile Gorky (1904–1948)," in *Abstract Expressionism: The Formative Years*, ed. Robert Carleton Hobbs and Levin, exh. cat. (Ithaca, N.Y.: Herbert F. Johnson Museum of Art, Cornell University; New York: Whitney Museum of American Art, 1978), p. 72.

178. Gorky, in Clapp, "A Painter in a Glass House," p. 6.

179. Harold Rosenberg, "The American Action Painters," *ARTnews* 51, no. 8 (December 1952), pp. 22–23, 48–50.

180. Sam Hunter, *Modern American Painting and Sculpture* (New York: Dell, 1959), p. 151 (emphasis in original).

181. Jim Coddington, "The Language of Materials," in *Joan Miró: Painting and Anti-Painting, 1927–1937*, ed. Anne Umland, exh. cat. (New York: The Museum of Modern Art, 2008), p. 22.

182. Karlen Mooradian, "The Letters of Arshile Gorky," in "A Special Issue on Arshile Gorky," *Ararat* 12 (Fall 1971), p. 39. Mooradian clearly based this aspect of the forged letter on his October 6, 1965, interview with Jeanne Reynal, who told him that during Surrealist parties Gorky would often try to steer the conversation toward serious art, only to be rebuffed. See Mooradian, *Arshile Gorky Adoian* (Chicago: Gilgamesh, 1978), p. 43. Unfortunately, Mooradian did not publish this interview in its entirety, so we do not know the exact context in which Reynal made the remark.

183. For Gorky's use of Gaudier-Brzeska's writings in his own letters, see Nick Dante Vaccaro, "Gorky's Debt to Gaudier-Brzeska," *Art Journal* 23, no. 1 (Autumn 1963), pp. 33–34.

184. Mooradian, *Arshile Gorky Adoian*, p. 25.

185. Ibid.

186. Gorky to Vartoosh Mooradian, November 17, 1946; quoted in Spender, *From a High Place*, p. 319.

187. Matossian, *Black Angel*, pp. 496–98.

If you study the walls of artists' studios carefully you can sometimes read their minds. It is not necessarily the work on view, whether complete or in progress, that gives the most direct insight into their thoughts. Rather, it may be the carefully chosen and preserved talismans of that artist's unfolding aesthetic identity—items propped or pinned up near the area where he or she actually makes things—that tell the tale. These may include work by other artists, suggestive curios, found objects, cherished souvenirs, and all manner of printed materials. In the latter category, for example, there may be clipped and posted obituaries of friends and rivals, personal heroes and bêtes noires. Igor Stravinsky folded such gleanings from the press into his composition books (among them the death notice of Alberto Giacometti, who had drawn Stravinsky's portrait, thereby creating his own icon of the musical iconoclast). In the same vein, exhibition cards, museum brochures, invitations, private letters, public commendations, and fading snapshots litter the interiors where other artists go to work or go to ground. One wall of Louise Bourgeois's warrenlike, all-purpose living room–dining room–studio is covered with scraps that in the aggregate constitute a mental map of her preoccupations while simultaneously serving as a collaged autobiography.

Yet more revealing, in some ways, are the images chosen by young artists as they begin their courses of self-discovery and self-invention. Who their patron saints are says a good deal about what they aim to become. And, not infrequently, in situations where such accumulations go unedited for long periods, they offer surprising reminders of whom they ultimately rebelled against. Before photocopying and Internet-downloading became everyday conveniences, collecting pictures of or by revered historical figures and near contemporaries represented a significant investment in time and money on the part of aspirants in the arts, with the result that the images they possessed, no matter how dog-eared or poor in quality, were enveloped in an aura of precious scarcity. Indeed, in the dilapidated studios that have been typical of talent on its way up, such tokens of admiration glow with an extra intensity when they are most rare and most meager.

For several generations of young avant-gardists, images by Arshile Gorky were ubiquitous in such circumstances. Often, they were images of the painter himself appearing as a boy in the two versions of *The Artist and His Mother* (plates 32, 33). In such cases, not the least of the ironies was the way in which artistic rebels in search of a father figure chose the likeness of a predecessor who clung to the remembered apron of his long-lost mother, even as he sought to replace his largely inaccessible and inadequate father with magisterial and empowering surrogates. Christened Vosdanig Adoian, he started his metamorphosis by adopting a pseudonym that incorporated the name of the likewise pseudonymous Russian revolutionary writer Maxim Gorky. In light of such Oedipal dynamics, it is easy to see why young artists should, in turn, have taken after Gorky—at least so long as the headwaters of new painting still pooled in the French capital and seasonally flooded the main channels, myriad tributaries, and wide deltas of modern art.

For was Gorky himself not the most adoring, assiduous, and acute of students, his chosen mentors being Paul Cézanne, Pablo Picasso, and Joan Miró? Did he not cut a path to modernism for those trapped, as he had been, in the thickets of aesthetic provincialism? And, more specifically, did he not show many innovative ways to make a picture to those lacking, as he once had, the technical mastery that would give them courage to abandon the formulas of the old academy for the conventions-in-formation of the "Tradition of the New"? That was the teasing label Harold Rosenberg applied to the emerging academy of post-Cubist, post-Surrealist art that provided the basis for Abstract Expressionism, although Rosenberg, among Gorky's staunchest critical advocates, preferred to call the new tendency "Action Painting," taking his inspiration from Marxist and existentialist ideas often marginal to the thinking of the artists he championed.[1]

Looking back from the present to the early and middle decades of the twentieth century, specifically to the period beginning just after World War I and continuing through the end of the war in Vietnam, Gorky seems more than ever the emblematic figure of a bygone age, a martyr to the ideological mystifications and genuine mysteries of a concept of modern art that few but the most ardent of fundamentalists would be willing to bet their lives on now, and that none is equipped to bring back to life through such sacrifices as Gorky made. Yet with twenty-first-century hindsight he also appears to have been the herald

FIG. 109
Gorky doing an Armenian dance at the wedding of V. V. Richard and John Magruder, New York, 1944. Courtesy of the Young-Mallin Archive, New York

of attitudes and practices that were nameless during an era fixated on "the future" but incapable of imagining its own aftermath—attitudes and practices that have become closely associated with an evolving postmodernism inconceivable to Gorky despite the many ways in which he vividly foreshadowed it.

Since his death in 1948 Gorky has been a pivotal figure in virtually all histories of pre- and postwar American art, as a result of having been among the very first of his cohort to seize upon and convincingly recast French modernism in the image of an apparently more improvisational and supposedly American idiom. Borrowing from Surrealism's mystical lexicon without subscribing to the esoteric notions such terminology sometimes evokes, one might call him a "communicating vessel" between Paris and New York.[2] Yet by virtue of the extreme compression of his career and the complexity of his persona, Gorky is less a monument on the road to the "New American Painting"—that having been the title of the traveling exhibition of Abstract Expressionism that

the Museum of Modern Art, New York (MoMA), exported to Europe in 1958–59, in which Gorky was posthumously featured—than a male Matryoshka doll of paradoxes regarding aesthetic and cultural identity and the formal strategies and teleologies of the avant-garde.

That Gorky was recognized early on as *primus inter pares* by members of his generation is indisputable. No less a witness than Willem de Kooning wrote in protest to an item that appeared in 1949 in *ARTnews*—the house organ of the New York School—reporting on Gorky's exhibition at the Julien Levy Gallery in December of the previous year:

> In a piece on Arshile Gorky's memorial show—and it was a very little piece indeed—it was mentioned that I was one of his influences. Now that is plain silly. When, about fifteen years ago, I walked into Arshile's studio for the first time, the atmosphere was so beautiful that I got a little dizzy and when I came to, I was bright enough to take the hint immediately. If the bookkeepers think it necessary continuously to make sure of where things and people come from, well then, I come from 36 Union Square.... I am glad that it is about impossible to get away from his powerful influence. As long as I keep it with myself I'll be doing all right.[3]

What de Kooning and others found at 36 Union Square was a studio stocked with an almost unimaginable cache of paint, brushes, and other art supplies—the only riches Depression-era painters dared dream of—and an ambiance saturated with the aura of the obsessive craftsman into whom Gorky had transformed himself by dint of intense scrutiny of masterworks old and new, and, uniquely, by uncanny impersonations of their authors.

Assuming that a considerable body of juvenilia has disappeared, it is telling that the second painting in Gorky's catalogue raisonné, following a bravura 1923–24 self-portrait in the manner of the young Picasso, is a convincing ringer for a middle-period Cézanne.[4] Both were painted when Gorky was about twenty; both pulse with a Promethean authority that was pirated rather than leased, reminding one of Picasso's own dictum, "minor artists borrow, great artists steal."[5] For the next five years Picasso vied with Cézanne for the upper hand in Gorky's work, and by 1929 he had claimed it. As Gorky himself told the dealer Julian Levy, "I was *with* Cézanne for a long time, and now naturally I am *with*

Picasso."[6] During the 1930s Gorky would, here and there, be "with" Fernand Léger (fig. 110)—notably in his WPA mural project for the Newark Airport Administration Building (plates 76–85)—then, through the remainder of the decade and into the 1940s, "with" Miró and finally Miró's young Surrealist acolyte, Roberto Matta.

What set Gorky's pastiches apart from the average or even above-average imitations of his day was their almost totally self-effacing admiration coupled with an extraordinarily competitive virtuosity.[7] In this regard he showed no deference whatsoever. Gorky's way of approaching his unreachably remote teachers through their marginally more accessible works resembled the attitude of a gifted pianist who habitually forgets in the middle of performing a canonical sonata that he has not composed it himself. The skill that was the predicate of this psycho-aesthetic displacement was born of an assiduous pursuit of technical perfection that was, owing to the secondhand nature of so many of Gorky's sources, closely akin to what a musician does when interpreting an unreliable transcription or otherwise incomplete score. Recalling the years before World War II propelled much of the Parisian avant-garde across the ocean and into the midst of the close-knit enclave of Gorky and his peers, David Smith described how the Americans learned long distance from the example of their European gods: "Being far away, depending upon *Cahiers d'art* and the return of patriots, often left us trying for the details instead of the whole. I remember watching a painter, Gorky, work over an area edge probably a hundred times to reach an infinite without changing the rest of the picture, based on [John] Graham's recount [*sic*] of the import put in Paris on the 'edge of paint.'"[8]

In short, looking at reproductions and listening to descriptions of the Parisian modernists at work became the basis for paraphrasing the images and reinventing the processes that engendered them. Nobody in New York excelled at this better than the culturally hybrid autodidact at 36 Union Square. That this supreme command of French modernism had been achieved by someone who, unlike the worldly, cosmopolitan Graham, had never set foot in France nor met the artists he mimicked until after his own identity had gelled, added rather than detracted from his aura, as if, in his apparent capacity as a medium to the medium of painting, Gorky had actually "channeled" the spirits everyone else in his circle sought contact with as well.

Seconded by Smith, Stuart Davis, and Raphael Soyer, to cite only a handful of the artists who knew Gorky intimately, de Kooning was just one of many to have recognized this exceptional ability. "I had some training in Holland, quite a training, the Academy," de Kooning wrote. "Gorky didn't have that at all. . . . And for some mysterious reason, he knew lots more about painting and art—he just knew it by nature."[9] In practice, Gorky was less an adulator than a visual anatomist of the masterpieces he found at the Metropolitan Museum of Art, which he haunted more than anyone in his circle except the art historian Meyer Schapiro. Himself no mean draftsman, Schapiro observed Gorky's loving dissections and wrote, "As some poets are great readers, Gorky—especially among painters—was a fervent scrutinizer of paintings."[10] Graham, author of the strange but influential 1937 treatise *System and Dialectics of Art*—as well as a direct conduit to the studio of Picasso who intimated to Gorky the secrets of their common idol's genius (fig. 111)—spent much of his time playing catch-up with the prodigy he had inspired.

Indeed, Gorky's pictorial impersonations outstripped similar efforts by his contemporaries, none of which were as all-consuming or as compelling as his. After those of Graham, Byron Browne's came closest, though he never got beyond journeyman glosses, while de Kooning was never really an imitator, despite the readily acknowledged debt he owed to Gorky and, through Gorky, Miró and Picasso, and, through Picasso, the finely wrought Neoclassicism of Jean-Auguste-Dominique Ingres. In fact, it is the hybrid paintings and drawings of Picasso and his followers' "return to order" of the late 1910s to mid-1920s that more than anything linked de Kooning and Graham to Gorky—and all three to that transitional and, in part, antimodernist phase of modern art in which New Yorkers' work began to rival that of their Parisian colleagues for the first time. Likewise, these revivalist adaptations chart the formal intersection of influences where Gorky's actual methods took precedence over his ostensible style and, in so doing, significantly and usefully complicated his legacy in relation to the historical tendency with which he is associated—Abstract Expressionism—and all

the various derivatives of that tendency with which he has been or
might be associated.

The standard account of the fundamentals of Abstract Expres-
sionism is a dramatic fiction. Penned by Rosenberg long after the move-
ment whose mythic birth he described had become the basis of a new
studio orthodoxy, it was effectively memorized by thousands of artists
and critics who could more or less faithfully repeat the crucial lines,
even as their various acts of emulation and creative misprision altered
the import of the words or prompted rebellion against them. Such was
the case with Allan Kaprow, who, largely thanks to Rosenberg's rhetor-
ical gambit, sketched Abstract Expressionism's postpainterly aftermath
of environments and happenings in his seminal *ARTnews* article, "The
Legacy of Jackson Pollock."[11] Kaprow's manifesto appeared the year
before the 1959 republication of Rosenberg's essay "The American Action
Painters," of which the pertinent passage is:

At a certain moment the canvas began to appear to one American
painter after another as an arena in which to act—rather than as a
space in which to reproduce, re-design, analyze or "express" an object,
actual or imagined. What was to go on the canvas was not a picture but
an event.

The painter no longer approached his easel with an image in his
mind; he went up to it with material in his hand to do something to
that other piece of material in front of him. The image would be the
result of this encounter.[12]

That said, Rosenberg's vivid memory of what he called Gorky's
"fakery" and "play acting" runs directly counter to his celebration of
unfettered spontaneity in the face of the confrontational materiality of
painting as medium and support.[13] Thus, in his 1962 book, *Arshile
Gorky: The Man, the Time, the Idea*, Rosenberg speaks of how the painter
he admired would imitate to the point of self-denial the great Spaniard
they both admired. A fellow artist, mocking what he deemed Gorky's
abject slavishness, wise-cracked, "Just when you've gotten Picasso's
clean edge, he starts to run over"; to which the object of his mockery
replied, "If he drips, I drip."[14] This was said long before Robert Rauschen-
berg challenged the improvisational authenticity of the drip in *Factum I*
and *Factum II* (1957; The Museum of Contemporary Art, Los Angeles,
and MoMA, respectively), but the revealing irony of the situation is
that Gorky himself never prized the *sui generis* work of art as much as
the Surrealists had before him, or as Rosenberg did once "Action Paint-
ing" had hit its stride.

The truth is that the unquestionable and unprecedented poetry of
Gorky's work is frankly secondhand and essentially synthetic. Long
before postmodernist theoreticians began to challenge the concept of
absolute originality—not to mention pick apart individual artists' pre-
tensions to being totally "original"—Gorky spoke openly against such
an ideal. And he did so as a modernist. "I am in entire sympathy with
the modern European movement," he declared, only to qualify this
sweeping statement by adding, "to the exclusion always of those mod-
erns who belong to the other class, those who invent things instead of
translating them."[15] This paradoxically modernist—or prematurely post-
modernist—skepticism about originality was confirmed by de Kooning,

FIG. 112
Pablo Picasso (Spanish, 1881–1973). *Seated
Woman in a Chemise*, 1923. Oil on canvas, 36¼ x
28¾ inches (92.1 x 73 cm). Tate Modern, London.
Bequeathed by C. Frank Stoop

who remembered that Gorky, having completed an inspection of some
of de Kooning's drawings during his first visit to his studio, remarked,
"Aha, so you have ideas of your own." Assessing those words, de Kooning
concluded, "Somehow, that didn't seem so good."[16]

Thus, as Rosenberg was the first to argue, Gorky's genius was com-
posed in large part of his spellbinding ability to imaginatively displace
the displaced person that history—specifically the Turkish persecution
of the Armenians—had made him. In unprecedented and, ever since,
unparalleled ways, Gorky demonstrated the power to assume and meld
a suite of identities rather than forge one unalloyed identity out of the
raw material of his origins and direct experience, and, at the same time,
the power that issues from such a capacity to project complex, pro-
found, and wholly genuine emotional force and nuance into each and
every one of his personae while making all of them distinctly his own.

The other half of Gorky's genius consisted of a thoroughgoing,
deeply traditional self-schooling that provided him with everything he
needed to push the formal and technical advances of his role models
beyond anything they had achieved. Moreover, in the service of that
education, Gorky's hoarding of materials and his fetishization of tools
went farther than anything found in students of the Academy prepar-
ing to draw a plaster cast or copy a Renaissance painting. Nevertheless,
it was academic practice that Gorky emulated before exceeding it, and
it was that same traditional practice to which he returned after each leap
forward. In keeping with such methods, he habitually carved his pencils
and sanded the exposed lead to a needlelike length and sharpness that
allowed for the finest contouring or subtlest hatching. Likewise, his
paint application—*brushwork* is too limited a term—followed long-
established conventions. And when surpassing or deviating from those
conventions, as he did when resorting to Picasso's heavy encrustations
or Matta's extreme dilutions of pigment, he honed these newly acquired
techniques with the know-how of a "compleat" craftsman—for instance,
when draining oil from tube color by letting it sit and soak overnight
on newsprint, or putting the same tube color in solvent baths to strip
away the binder. As important as was his manipulation of the density
and consistency of pigments were the ways he prepared his grounds
and subsequently worked back into them by repeatedly scraping down

accumulated oil color and dry-sanding or wet-sanding his canvases
before reapplying paint. (Wet-sanding he seems to have learned from
de Kooning, who had learned it from house painters.) To these freely
employed yet anything but improvised tricks of the trade are owed the
alternately robust and exquisite felicities of light and surface that in
their beautifully calculated variations distinguish Gorky's work from
that of all his contemporaries, including his mentors.

As noted, the archconservative nineteenth-century Neoclassicist
Ingres had in his work established the lingua franca of the post–World
War I "return to order" that Picasso presaged in 1914.[17] As a latter-day
disciple, Gorky effectively pastiched Picasso in the same way that
Picasso pastiched this paragon of academic standards and style that he
had so perversely but—given the parade of followers who lined up
behind him during World War I—presciently latched onto. However,
when looking backward through Picasso's telescope, you see one artist
(fig. 112), but when looking back through Gorky's, you see two—Ingres
and Picasso. And possibly more, since the phalanx around Picasso

incorporated the host of artists he had already influenced by the time Gorky became one of them.

From the mid-1920s through the mid-1930s there is another crucial if obvious distinction to be made between Picasso's work and Gorky's. For it was during this interval that Gorky simultaneously mimed Picasso's Ingresque manner and his Synthetic Cubist manner, filtering his paired impersonations or doubled doublings through Picasso's impersonation, on the one hand, and through Picasso's invention, on the other, thereby applying the principles of premeditation and rehearsed execution to both ways of working at once. So it was that Gorky used the same basic means to painstakingly realize the two versions of *The Artist and His Mother* (plates 32, 33) that he used to develop the many variations of his Picasso- and Miró-derived composition *Garden in Sochi* (plates 93– 97): pencil and pen-and-wash studies drawn and redrawn, studies squared up and transferred to canvas, multiple revisions of each canvas, and multiple canvases all focused on the same group of elements.

Nudging the performance analogies away from music and into the theater, one might say that Gorky was both a classical and a Method actor, both Laurence Olivier and Marlon Brando. Or that, to follow up on the literary analogy suggested by his own words, like any great "translator" he altered and enhanced the meaning of the text that was his starting point, creating a new text out of the primary one—even when that new text is a clone for the original, as was first hypothesized by Jorge Luis Borges in his story "Pierre Menard, Author of the Quixote," written in 1939 when Gorky was deeply enmeshed in his corresponding struggle with greatness.

Meanwhile, the earnestness of the Method is a helpful reference point when returning to pictorial modes, in that Rosenberg tended to conflate Gorky's impersonations of Picasso and others with parody. However, insofar as parody almost invariably contains an element of ridicule—just as Picasso's riffs on Ingres were both satirical salutes to the old master and annihilating send-ups of the legion of hacks who came after him—what is striking about Gorky's pastiches is the absence of animus toward their sources.

Gorky never tried to kill his artistic fathers. Picasso's Oedipal ambivalence was more all-embracing and more ruthless. At the same time

as Picasso was running changes on Ingres, he was also raiding the territory of Georges Seurat and the Le Nain brothers. The visual dissonance and cognitive clashes produced by his allusions and appropriations constitute an unnervingly dexterous travesty of tradition as a whole. Gorky never indulged in such tactics, no matter how blatantly he drew upon other artists. The fault line between radicalism and conservatism fell on a different axis in Gorky than it did in Picasso. Like the Method men Brando, Montgomery Clift, and James Dean, Gorky was a believer who wished no harm to the part he was playing even when aspects of his interpretation bordered on self-parody, as aspects of theirs frequently did.

Setting aside both abject subservience to an idol and more or less sly subversion of its powers, what then might we call such baffling projections? The word that most strongly suggests itself is *masquerade*, and with it the tables are definitively turned not only on originality but also on any notion of intrinsic authenticity. For masquerade dissolves the truth of given traits presumed to speak of an innate integrity of being into the truths of affected characteristics that articulate the unknowns of becoming. Ultimately, the drama of Gorky's life and the pathos of his art lie in the utter focus he brought to bear on becoming the contents of his imagination rather than on affirming any version of his "essential" nature through art.

Having said at the outset that during the postwar era few artists were as revered as Gorky, the meditation on his compulsion to be Other in order to be himself that followed that assertion is critical for properly gauging the exact characteristics and ultimate extent of his influence. Under the circumstances, one could reasonably assume that the list of those seeking to be associated with Gorky would be long, and that the list of artists who might, because of certain qualities in their work, be claimed for his legacy would be longer still. I began by citing de Kooning's forthright homage to Gorky and along the way have tried to assess the type and degree of his indebtedness. In addition, I mentioned the able but uninspired Byron Browne as a lesser artist close to Gorky whose work bears the indelible stamp of his. Hans Burkhardt, for nine years Gorky's pupil and studio mate, and Ethel Schwabacher, another student and the author of his first biography, are two others.[18]

There were more like them in Gorky's milieu, although given the eclecticism and unevenness of the paintings that suggest such links, there comes a point at which it is hard to say for sure whether the artists were following his example or simply trying to effect the same alchemical transformations he did without equivalent ability or motivation of their own. Taking off from the title of one of the greatest of his wartime paintings, one could say that Gorky's unwritten "Diary of a Seducer" would include the names not only of his lovers but of all those whom he tempted to try their hand at the daunting painterly feats only his hands could convincingly pull off.

Less directly, one can detect the ambient pressure of Gorky's example in the mid-1940s work of two of his peers. On the one hand, his erotically charged biomorphic landscapes partially inform Mark Rothko's similarly constructed and articulated paintings and watercolors of the same period. Although elements of their shared interest in Miró and Max Ernst are instantly apparent, the fluid, floating atmospherics of Gorky's work provided the open, space-engendering parameters toward which Rothko made appeal in paintings such as *Slow Swirl at*

the Edge of the Sea (1944; fig. 113)—even the lyric title is Gorkyesque!— and gouaches like *Archaic Idol* (1945; MoMA). Without the precedent of Gorky's *Waterfall* (1943; plate 104), *The Pirate I* (c. 1942–43; plate 98), and drawings such as *Anatomical Blackboard* and *Study for "The Liver Is the Cock's Comb"* (both 1943; plates 107, 113), Rothko's works would have been nearly unthinkable, although his reconstitution of Gorky's elastic holism breaks down into diffuse backgrounds and brittle, oddly de-eroticized foreground totems. Having started out searching for transcendental symbols—ancient gods and their modern surrogates— Rothko ended up painting the cosmos as if it were inhabited by a solitary viewer, like a figment out of Caspar David Friedrich's Romantic landscapes but released from gravity and lifted from his promontory. For Gorky, transcendence was always a promise of total physical immersion in the sensual world for which sexual longing and painterly consummation were the touchstones; for him, the spectator was not a spectator so much as another hungry body seeking to lose itself in the universal body of Mother/Lover Earth.

Filial piety was not a part of de Kooning's make-up as it was of Gorky's. *Woman I* (1950–52; MoMA) and her furious sorority are icons of motherliness as much as they can be said to represent any actual incarnation of *l'eternel feminin* in the Dutchman's life. Indeed, de Kooning's "women" of the 1950s resemble photographs of his mother, Cornelia de Kooning, as she appeared during her visit to the United States in the early 1950s. As such, they are emblems of what might, with punning deference to Friedrich Nietzsche, be called the "maternal return," though clearly it is not the return of the Good Mother, as it is in Gorky's various portraits of his lost matriarch, but of the grog-shop Gorgon and Terrible Mother that de Kooning could never shake off. Nevertheless, Gorky's protégé shared his Panlike sensuality, and those qualities are in some respects most startling in de Kooning's late paintings of the 1980s, in which fragments of bodies waft in open Mondrianesque armatures of red, white, blue, and black. *Untitled III* (1982; MoMA) and *Untitled VII* (1985; fig. 115) are just two examples. But every time a double-jointed abstract knee or hip bends, or an arm or shoulder shifts or torques, we catch a glimpse not only of de Kooning's fleshy abstractions of the mid- to late 1940s—*Pink Angels* (c. 1945; Frederick R. Weisman

FIG. 114
Willem de Kooning (American, born the
Netherlands, 1904–1997). *Fire Island*,
c. 1946. Oil on paper, 19 x 26 1/2 inches
(48.3 x 67.3 cm). The Margulies Collection
at the Warehouse, Miami

FIG. 115
Willem de Kooning. *Untitled VII*, 1985.
Oil on canvas, 70 x 80 inches (177.8 x 203.2 cm).
The Museum of Modern Art, New York. Purchase
and gift of Milly and Arnold Glimcher, 1991

Art Foundation, Los Angeles), *Fire Island* (c. 1946; fig. 114), *Mailbox* (1948; private collection), and *Ashville* (1949; The Phillips Collection, Washington, D.C.) being among the key pictures of this type—but also of the luxuriously profane animism of Gorky's bodyscapes that were their impetus, and of a libidinous throb that continued to course through de Kooning's work until the very end of his painting life.

Looking elsewhere in Abstract Expressionism's neighborhood—not forgetting that the tendency literally occupied a section of lower Manhattan in much the way that garment makers and florists once occupied the multiblock area between the twenties and forties of the West Side, and that artists living in the Tenth Street zone were constantly in and out of each other's studios and regularly working in intimate, osmotic proximity to one another—the syntax of many of Robert Motherwell's paintings and drawings of the war years and just after reveal his preoccupation with Gorky's facture behind the facade of his allusions to Picasso's Dinard-period works of the late 1920s. This is particularly true of his pen-and-wash studies, such as *Three Figures Shot* (1944; fig. 116) and the lost gouache *The Room* (1944),[19] whose iconography is a fairly obvious adaptation of motifs and graphic effects gleaned from Gorky's contemporaneous work but minus his grace and panache. Like Browne, Motherwell was basically a journeyman, but a socially privileged and politically astute one who made the immodest most of his modest talents.

Continuing this essentially formalist approach to tracing Gorky's impact after 1948 leads into but not out of or away from the "mainstream" of "American-type" painting—the words in quotation marks are Clement Greenberg's preferred nomenclature—in short, to an all-star cast of Abstract Expressionists and their epigones during the period of their hegemony, and, uniquely, in the case of late de Kooning, beyond their moment of dominance but not their glory. Consider Helen Frankenthaler, a Bennington student who fell under the spell of Greenberg, with whom she had a liaison for a number of crucial years and through whom she gained privileged access to the upper reaches of the art world (later forming a similar relationship with Robert Motherwell, whom she married). A quick study, Frankenthaler soon became the most precocious and, to some degree, most influential adapter of

forms, ideas, and procedures distilled from first-generation Abstract Expressionist painting. Motherwell and William Baziotes are visible in the graphic shapes of her *Abstract Landscape* (1951; private collection), for example, and the blooming organic shapes in her early stain paintings, such as *Mountains and Sea* (1952; fig. 117), are palpably indebted to Gorky, in whom she has confessed her interest. But not palpably enough.

In the event, Greenberg's recipes for going "further" than Pollock in fusing the painted surface with its material support, and Frankenthaler's interpretation of that mandate, leached the physicality of paint from painting in ways that severely limited the possibilities of stating and developing forms and reduced the slow, cumulative processes Gorky had demonstrated to a matter of more or less sprightly initial impulses and secondary embellishments. The much-vaunted "pure opticality" that Greenberg celebrated at the expense of impure tactility when promoting the Color Field School worked best for artists such as Morris Louis and Kenneth Noland, whose graphic compositions did without painterly physicality at little or no cost to the forms within. However, the suggested depths and densities of Frankenthaler's vast compositions are betrayed by her materially insubstantial staining, not least when the stains are compared with the diffuse auras of Mark

Rothko. In more adroit hands such techniques can produce marvels, as they do in watercolors, but they leave few options for building or elaborating formal complexities or correcting facile or insipid effects. Moreover, on a grand scale flaws inherent in glib lyricism are writ large and are all the more embarrassing for it, with the result that though Gorky's example explains some of Frankenthaler's beginner's luck, her failure to follow up on what he had to offer also explains the number of weak, decorative canvases she eventually produced.

Richard Diebenkorn's affinity for Gorky served him better and honored Gorky more. In Diebenkorn's work Surrealist biomorphism was deflated, and its alternately appealing and repulsive volumes were flattened into panes of tone and color separated by pliant, generally black mullions. Nevertheless, in his nominally abstract pictures—and virtually everything he ever did was in some way a picture or evocation of a place—Diebenkorn's use of intervals, his allusions to landscape, his hints of figuration, and his shallow folding of space implicitly if not explicitly recall Gorky as much as they do de Kooning, at least to the extent that 1940s de Koonings nearly always recall Gorky in some measure. Thus, if an oil such as *Miller 22* (1951; fig. 118) reminds one of the lilt of Gorky's ink sketches, or if the painting *Albuquerque*

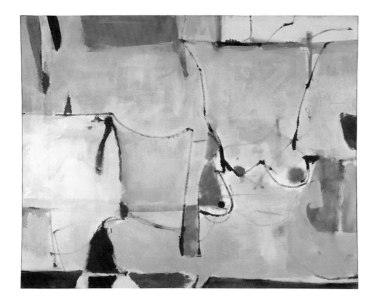

No. 20 (1952; fig. 119) echoes the brooding timbre of such crepuscular masterpieces as *Diary of a Seducer* (1945; plate 126), it is no accident.

If these paintings of Diebenkorn's pale in direct comparison with their partial inspiration, it is no more so than the degree to which his syntheses of Edward Hopper and Henri Matisse pale next to original works of either. Like Frankenthaler, Diebenkorn was quick to identify who, in the daunting array of postwar painters, offered the most to younger artists, but unlike her, he patiently dedicated himself to a comprehensive apprenticeship with his geographically distant tutors. Indeed, he learned the idioms and took on the accents of his adopted father figures so thoroughly and apparently so effortlessly (although like his Armenian elder he was at pains to hide the actual rigor of his self-education) that much of what Gorky said of himself could be adapted to his California cousin, namely, that Diebenkorn was *with* Gorky and de Kooning, and then naturally he was *with* Hopper and Matisse. Diebenkorn's fellow traveling never approached the superficially abject mimicry of Gorky's, but it did produce some very fine canvases, and it prepared him for the sustained achievement of the Ocean

Park series, upon which his reputation will, in all likelihood, rest.[20] Furthermore, his thoughtful as well as skillful assimilation of painting tradition up to that point remains of enormous value to artists just starting out, which is why from the mid-1960s on his images have been almost as ubiquitous on the walls of student painters as those of Gorky long had been. Even now, postcards of work by these two men can be found cheek by jowl in many studios alongside representations of the work of more recent favorites among tradition-minded modernists, such as Brice Marden and Terry Winters.

Four contemporary painters bring Gorky to mind in other ways. Ron Gorchov, the oldest at seventy-nine, is among the last living links to the New York School in which Gorky loomed so large, if only by virtue of his youthful acquaintance with Gorky's friend and sometime guide, sometime follower, John Graham. By Gorchov's own admission, Gorky was important to his formation both as an opener of doors and as someone to push off from. There is no need to take his word for it, for one can readily detect the affinity in his painting, inasmuch as Gorchov's slow reworkings of the paired asymmetrical forms around which his

FIG. 120
Ron Gorchov (American, b. 1930). *Chevalie
D'Eon*, 2008. Oil on canvas, 21 x 22³/₄ x 7¹/₄
inches (53.4 x 57.8 x 18.4 cm). Courtesy of the
Nicholas Robinson Gallery, New York

149

THE PAINTER'S PAINTER

compositions center, and his preparation and subtle adjustments of the
ground on which these forms figure, testify to an instinct, closely akin
to Gorky's, for honing contours and eking textural vibrations out
of every surface on which light falls within the canvas (fig. 120). That
Gorchov's canvases are concave rather than flat and his execution
looser by far than Gorky's at its loosest—although prepared with layer
after layer after scrapped-back layer of pigment—simply attests to the
fact that he is not painting "in the manner of" Gorky but by procedurally
equivalent steps, so as to achieve a vibrancy in his shapes and a hedo-
nism in his color that are pictorially equivalent to the same qualities in
Gorky's work.

Comparable things could be said of Thomas Nozkowski, an ab-
stract painter almost a decade and a half younger than Gorchov who,
although not of the same generation, nonetheless belongs to the same
aesthetic milieu as Gorchov (fig. 121). Moreover, they face comparable
dilemmas in that both have conjured with the competing pressures of
biomorphic abstraction and minimal art to arrive at distinctive hybrids
encompassing *a la prima* invention of imagery within the field of the
painting—in other words, "Action Painting," though often of the slow-
est, most deliberately discursive variety—as well as richly endowed
underpainting and repainting of that field. In Nozkowski's work, over-
all patterning—which is to say, quirky variants on the minimal grid—
plays a major role. In Gorchov, by contrast, the field is basically
monochrome and inflected by the irregularities of paint that has run
down it like rain on a windshield or been pulled across the taut, bowed
canvas with a palette knife (like the sweep of a windshield wiper).
Woven into Nozkowski's patterns, applied to them like appliqué
patches or cut out of them as if by shears, usually in ways that highlight
both their ludic qualities and their mildly disconcerting strangeness,
are the generally curvilinear protagonists of his abstractly choreo-
graphic mise-en-scènes. Gorky enters in not as a guru or a disciplinar-
ian, but rather as an approving if otherworldly devotee of a common
cult whose rituals consist of summoning fanciful but deeply felt formal
intuitions and bodying them forth with the lick of a brush—and then
another, and then another, until oil paint and the act of applying it give
definitive, tangible substance to whimsical specters.

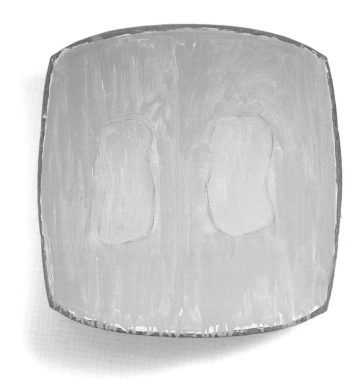

FIG. 121
Thomas Nozkowski (American, b. 1944). *Untitled (8-81)*,
2006. Oil on linen on panel, 22 x 28 inches (55.9 x 71.1
cm). Courtesy of PaceWildenstein, New York

FIG. 122
Elizabeth Murray (American, 1940–2007).
Untitled, 1962. Oil on canvas, 50⅝ x 60⅝
inches (128.6 x 154 cm). Collection of Jim Nutt

Taking off from Gorchov's modular support and the saddle-curved pictorial surface it created, Elizabeth Murray gave such specters physical bulk and relief by building complex wooden skeletons for her canvases and stretching them so as to maximize the bulges and cavities these structures articulated. In so doing, she literalized biomorphism's illusionistic dimensions and popped Surrealism into the real space of the viewer, as if the planar walls of art galleries and museums and the picture plane of formalist abstraction had simultaneously herniated under stress from churning forms they could no longer contain.

Gorky played a significant part in Murray's awakening to what painting could do, triggered by her discovery of his work at the Art Institute of Chicago, where she was schooled in the 1960s. (Cézanne, de Kooning, Miró, Salvador Dalí, and Juan Gris also had their places in her modernist Hall of Fame.) Murray's methods paralleled Gorky's process of premeditation and repetition in the drawing and redrawing of basic forms and the painting and repainting of figure and ground, although she wholly lacked—or rather, had no use for and hence did not cultivate—his academic finesse. In effect, she lent to Gorky's fastidious acquisition of traditional techniques the raw energy of Pollock's forthright indifference to them, claiming unclaimed space for painting as he had done while at the same time keeping the flame of Surrealism alive by fuel-injecting it with American popular culture—in particular Walt Disney's parallel exploration and/or outright commercialization of Surrealist tropes—in ways that the Francophile Gorky could never have imagined. "I see [Gorky] as a link between what I got out of de Kooning and what I got out of Walt Disney," Murray told *New York Times* critic Michael Kimmelman in 1994.[21] Indeed, if one looks at the earliest of Murray's surviving paintings, for example, *Untitled* (1962; fig. 122), one can clearly see the influences of Gorky and Disney commingling. Those admixtures identify the works as genuine, patently adulterated products of American culture. Of course, Gorky, the faux Parisian whom Stuart Davis described as sporting a "black velour hat pulled low over his eyes, and a black overcoat buttoned under his chin and extending to the ankles," and as prone to theatrical gestures that, enhanced by his costume, made him the epitome of the "artist type," was also an unapologetically impure product of the "melting pot."[22]

FIG. 123
Elizabeth Murray. *Wishing for the Farm*,
1991. Oil on canvas, 107 x 114 x 13 inches
(271.8 x 289.6 x 33 cm). Courtesy of
PaceWildenstein, New York

FIG. 124
Jim Nutt (American, b. 1938). *Daft*, 1991. Acrylic
on canvas, stained wood frame, 29 x 28 inches
(73.7 x 71.1 cm). Private collection, courtesy of
the artist

Yet, while he affected an exaggerated Bohemian personal style, his Ingresque aesthetic was aristocratic by comparison with Murray's frankly vernacular and avowedly democratic reconfiguration of their common heritage (fig. 123). But that is the history—arguably the "her-story," given the gendered stereotypes she had to confront in her individual rebellion against "average" Americanism—of how various are the alloys that pour from that pot at different moments or in different eras.

The Murray canvas just referred to belongs to Jim Nutt, her contemporary at the Art Institute of Chicago and another painter worthy of consideration in this context. His digressions from classic Surrealism match the finesse of Gorky's, although his usual medium, acrylic, approximates the range of effects found in tempera painting of the Renaissance rather than the French modernist and premodernist tradition in oils. Granted, the early phases of Nutt's career were given over to smoothly limned but iconographically abrasive grotesques of "The Good Life" in middle America in which the only traces of Gorky are the tensile strength of Nutt's spring-loaded line, a strength tempered by the kind of steady, quasisurgical draftsmanship with pencil and brush that Gorky had perfected in his fashion and that Nutt redeployed in his. Over the past twenty years, Nutt has tamed his once burlesque, frequently sinister subject matter in favor of formal portraits of women that have arisen from his forehead even as their foreheads, hairdos, eyes, noses, cheeks, and chins are distorted by metamorphic spasms and shot through with inky shadows that pool and drip over their convoluted features (fig. 124). Anyone familiar with Graham's comparably formal, comparably hallucinatory portraits will recognize Nutt's portraits as belonging to the same weird family tree as that disciple of Picasso's crossed-eyed beauties. Which means that they are a branch of the tree on which one also finds Gorky's *Portrait of Myself and My Imaginary Wife* (1933–34; plate 24)—and, not long thereafter, following suit, de Kooning's Ingresque *Self-Portrait with Imaginary Brother* (c. 1938; fig. 125)—as well as, in more fully articulated arabesques, his undated *Self-Portrait* (plate 6) and *Portrait of Vartoosh* (plate 25), along with the related pencil studies of Vartoosh and himself and the likewise undated *Portrait of Ahko* (plate 41). This is not to mention his *Portrait of Akabi* (c. 1936–37) in the collection of the Hirshhorn Museum and Sculpture Garden,

FIG. 125
Willem de Kooning. *Self-Portrait with Imaginary Brother*, c. 1938. Pencil on paper, 13 1/8 x 10 5/16 inches (33.3 x 26.2 cm). Private collection, courtesy of the Willem De Kooning Foundation

FIG. 126
Carroll Dunham (American, b. 1949). *Integrated
Painting Five*, 1992. Mixed media on linen, 65 x 100
inches (165.1 x 254 cm). Private collection, courtesy
of the Gladstone Gallery, New York

Washington, D.C., and both versions of *The Artist and His Mother* (plates 32, 33), with the studies for each (plates 26–31). I do not at all mean to suggest that Nutt has merely given Gorky a contemporary make-over, but rather that, enabled by Gorky and Graham, he has been free to operate as Pygmalion and model his own muses, in the process breathing life back into the perversely neoclassical style of rendering that they had modernized and that he has, in essence, postmodernized.

A still wider scan of the horizon would draw attention to yet more artists who have, in differing measure, tapped into Gorky's legacy and the modernist legacies he consolidated in his work. An argument might be made that the sculptor Joel Shapiro, who owns several prime Gorky drawings, belongs tangentially to this company, or that Carroll Dunham (fig. 126) and Sue Williams (fig. 127), who for very different reasons have found ways of parodying Gorky's parodies of Picasso and Miró, have added new dimensions to the bizarre plastic universe of Gorky's art. But at this stage of modernism's long, convoluted unfolding—and as countless examples of the stressful but unbroken continuity of modernism and postmodernism have proved over the last three decades, predictions of modernism's death and of a definitive rupture with its

past have been desperately if not hysterically premature—the aspect of Gorky's contribution that has gradually emerged as the most timely and best suited to the reality of an artistic tradition at war with its own traditionalism is not his particular reinterpretations of the precedents he paraphrased and embroidered but the primacy in his work of reinterpretation, paraphrase, and embroidery themselves.

For it would seem that modernism in its postmodern guise has reached a crisis and a turning point. Restless under the ever-accumulating burden of history, recent phases of postmodernism have attempted with varying success to sort through their hybrid inheritance and relive artistic revolutions of the past as extended exercises in commentary upon them. Sometimes self-consciously, at other times not, these neo–avant-garde reenactors remind one of the truth of Karl Marx's acerbic observation that when history repeats itself, the first time something happens is tragedy, the second time is farce.[23] Indeed, for the most self-conscious among those for whom the past is not so much a prologue as a pasture, the license to graze is paid for in explicit if not painfully obvious irony that signals to the viewer that the artist does not mean what he or she is doing but rather something else, for

which the sustenance they consume is not fuel but foil. By contrast, the least self-conscious postmodernists lack the saving grace of this irony while too often adding the intrinsically conservative vice of earnestness even as they feast indiscriminately on whatever falls within their reach. They are postmodernism's kitschmeisters, whereas the former are its major and minor stylists.

Common to the work of all is a palpable discrepancy between artifact and affect, appearance and intent, the manifest identity of the object and the elusive identity of the author. The gaps that postmodernist theory and practice have opened up between the artist and the work, and between the work and the reader or viewer, are its principle contribution to culture and a great boon to art. But postmodernism did not create these gaps or even discover them; it has merely drawn attention to those that have been overlooked or forgotten and widened them to the point that this will never happen again. Paradoxically, modern art is the chief beneficiary of what was thought by many to have been a final refutation of modernism's ostensible premises. Thus, the devil's advocacy of Roland Barthes and Jean Baudrillard brings back and updates that of Oscar Wilde, who in his 1888 essay "The Critic as Artist"

anticipated most of the dialectical inversions we have come to think of as typical of the 1980s. (Was it not Wilde, in that diabolical brief against conventional aesthetic wisdom, who wrote, "Man is least himself when he talks in his own person. Give him a mask, and he will tell you the truth"?)[24] Thus, the vulgarities and plagiarisms of Francis Picabia that caused his later work to be consigned to the lowest ranks of modernism have returned to the fore, thanks to the work of Sigmar Polke, Martin Kippenberger, David Salle, and others, while the subtle counterfeiting of Marcel Duchamp that made him the scourge of his own modernist generation is perpetually rejuvenated by the unceasing counterfeiting of his artistic heirs.

Against this background Gorky represents a special, arguably a unique, case. For here was a man who performed the role of Bohemian with carnivalesque abandon, who plagiarized the Surrealist poems of Paul Éluard in his love letters, who found himself by losing himself in the fiction of the Romantic artist, yet who earned the respect of his fellow artists despite the tragicomic excesses of his masquerade. And here was an artist who found himself and his métier by losing himself in the art of others, a mimic who never broke character, who never disowned his fabrications with a wink, nor ever begged for total suspension of disbelief on the part of his audience with the theatrical overstatement that imbued his public persona. Moreover, here was a painter who took it upon himself to embody nearly the whole of the modernist tradition as he found it, and to do so on the highest formal and poetic levels by dint of unrivaled command of its conventions—as conventions!—rather than by strategically tinkering with them or by making any pretense of sweeping them aside altogether. The realization of that ambition spanned twenty-five years during which modern art spiraled out in myriad directions in ways that made and still make Gorky seem less like one of its offshoots than its gyroscopic center at the midpoint of the twentieth century.

Oddly, the modernist who best understood the structure of modernism in ways that accord with Gorky's place in it was Ezra Pound, the writer whose first command was "Make it new!" In his contentious literary primer *ABC of Reading* (1934), Pound set forth a six-tiered hierarchy of writers. The top three are:

1. Inventors. Men who found a new process, or whose extant work gives us the first known example of a process.

2. The masters. Men who combined a number of such processes, and who used them as well as or better than the inventors.

3. The diluters. Men who came after the first two kinds of writer, and couldn't do the job quite as well.[25]

Thereafter comes the fourth category, "Good writers without salient qualities"; the fifth, "writers of belles-lettres"; and the sixth, "starters of crazes."[26]

Let me gently correct Pound's sexism by matching Frankenthaler and Diebenkorn with the "diluters," even as I give Diebenkorn the edge and place Murray among the inventors by virtue of her having been the first to make biomorphic painting fully dimensional, and also suggest that most of the artists we call either modernist or postmodernist fall within categories three, four, five, and six, these last being the biggest catch basins of intermediate talent. Then let me state unequivocally that Gorky was a great talent, while conceding that he was in no sense an inventor. In this context the usefulness of Pound's schema becomes readily apparent in that it separates the two, thereby undoing the myth of genius according to which ultimate greatness is conditioned on their coincidence. In fact, a lack of invention can be nearly total and yet under certain circumstances free an artist's imagination as fully if not more so than classic forms of modernist rebellion or the now widely accepted concept of Oedipally driven creative misprision that has been proposed by Harold Bloom in *The Anxiety of Influence* (1973). While we will never reach a point where it is wise or even safe to forego irony, as many swept along by the backlash against postmodernism or traumatized by the dangers of the contemporary world have recommended, there are ways in which critical irony and the countervailing quest for absolute authenticity can be suspended. Gorky personifies that dual suspension, and his work bespeaks the transcendent understanding and beauty such selfless immersion in multifaceted otherness can make possible. Vosdanig Adoian, also known as Arshile Gorky, was an artist of many painterly aliases as well, but he was *the* painter's painter of his time, and above all he was a master.

1. See Harold Rosenberg, "The American Action Painters," *ARTnews* 51, no. 8 (December 1952), pp. 22–23, 48–50, and Rosenberg, *The Tradition of the New* (New York: Horizon, 1959).

2. The phrase is André Breton's, in his book *Les Vases communicants* (Paris: Gallimard, 1955).

3. Willem de Kooning, letter to the editor, *ARTnews* 47, no. 9 (January 1949), p. 6.

4. Jim M. Jordan and Robert Goldwater, *The Paintings of Arshile Gorky: A Critical Catalogue* (New York: New York University Press, 1982), pp. 125–27.

5. Both Picasso and Igor Stravinsky are widely credited with various versions of this maxim.

6. Gorky, quoted in Julien Levy, *Memoir of an Art Gallery* (New York: G. P. Putnam's Sons, 1977), p. 283 (emphasis in original).

7. In considering the generally labile nature of identity, it is important to underscore the particular stresses and metamorphic possibilities that attend sudden and dramatic dislocation. Adaptation to new circumstances means both conscious and unconscious self-transformation or reinvention for the sake of survival. Harold Rosenberg places particular emphasis on the predicament of the immigrant artist in America, acutely aware that among the leading Abstract Expressionists only Robert Motherwell, Jackson Pollock, and Clyfford Still came from deeply rooted American families, while de Kooning, Gorky, Philip Guston, Mark Rothko, and many others were first- or second-generation Americans. The irony in Gorky's case is that, after largely shedding his inherent identity, he was the antithesis of a chameleon to the extent that, rather that assuming a local coloration, he cloaked himself in borrowed foreignness to become the most Parisian of New York painters.

8. David Smith, quoted in Frank O'Hara, introduction to *David Smith*, exh. cat. (London: Tate, 1966), p. 7.

9. Willem de Kooning quoted in "Content is a Glimpse," *Location* 1, no. 1 (Spring 1963), p. 46 (artist's statement composed of excerpts from a 1960 interview of de Kooning by David Sylvester for the B.B.C.).

10. Meyer Schapiro, *Modern Art: 19th and 20th Centuries* (New York: George Braziller, 1978), p. 179.

11. Allan Kaprow, "The Legacy of Jackson Pollock," *ARTnews* 57, no. 6 (October 1958), pp. 24–26, 55–57.

12. Rosenberg, *The Tradition of the New*, p. 25.

13. Harold Rosenberg, *Arshile Gorky: The Man, the Time, the Idea* (New York: Horizon, 1962), p. 42.

14. Ibid., p. 66.

15. Arshile Gorky to Agnes Gorky, May 31, 1941; as cited in Ethel K. Schwabacher, *Arshile Gorky* (New York: Macmillan for the Whitney Museum of American Art, 1957), p. 110.

16. Willem de Kooning, quoted in Rosenberg, *Arshile Gorky: The Man, the Time, the Idea*, p. 66.

17. See Robert Storr, *Modern Art Despite Modernism* (New York: The Museum of Modern Art, 2000), pp. 43–81.

18. Burkhardt was Gorky's pupil in the years 1928–37, and Schwabacher studied with him for about two years, in 1934 and 1935.

19. An illustration of this lost work can be found in William C. Seitz, *Abstract Expressionist Painting in America* (Cambridge, Mass.: Harvard University Press for the National Gallery of Art, 1983), pl. 158.

20. Examples of Diebenkorn's extensive *Ocean Park* series can be found in Jane Livingston, *The Art of Richard Diebenkorn* (New York: Whitney Museum of American Art, 1997), pp. 252–55.

21. Michael Kimmelman, "Looking for the Magic in Painting," *New York Times*, October 21, 1994, sec. C.

22. Stuart Davis, quoted in Beth Venn and Adam D. Weinberg, *Frames of Reference: Looking at American Art, 1900–1950*, exh. cat. (New York: Whitney Museum of American Art, 1999), p. 77.

23. Karl Marx, *The Eighteenth Brumaire of Louis Bonaparte* (1852; New York: International Publishers, 1963), p. 15. The actual words are: "Hegel remarks somewhere that all facts and personages of great importance in world history occur, as it were, twice. He forgot to add: the first time as tragedy, the second as farce."

24. Oscar Wilde, *The Critic as Artist*, Green Integer Series No. 3 (Los Angeles: Green Integer Books, 1997), p. 118.

25. Ezra Pound, *ABC of Reading* (New York: New Directions Paperbook, 1960), p. 39.

26. Ibid., pp. 39–40.

NOTE TO THE READER

Works of art illustrated in the plate section that are followed
by an asterisk (*) were not included in the exhibition.

PLATES

1920s

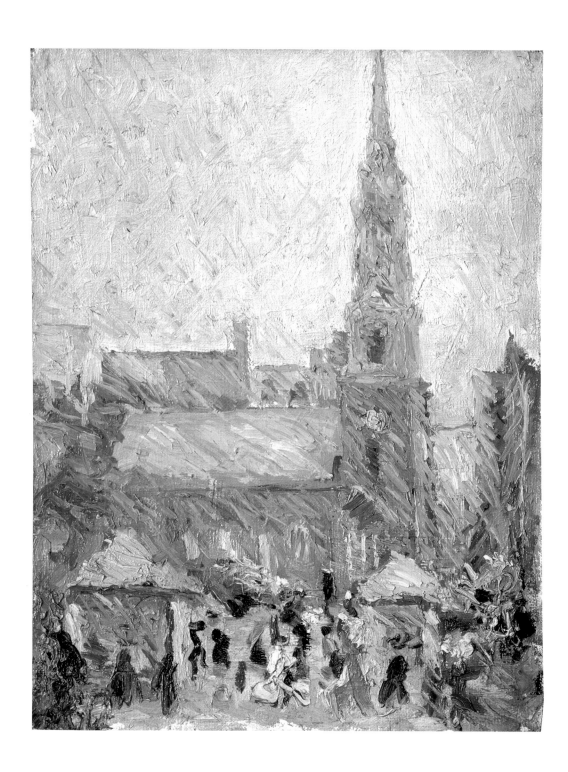

1 *Park Street Church, Boston*, 1924
Oil on canvas mounted on board
16 x 12 inches (40.6 x 30.5 cm)
The Whistler House Museum of Art. Lowell Art Association, Inc. (est.
1878), Lowell, Massachusetts. Gift of Katherine O'Donnell Murphy

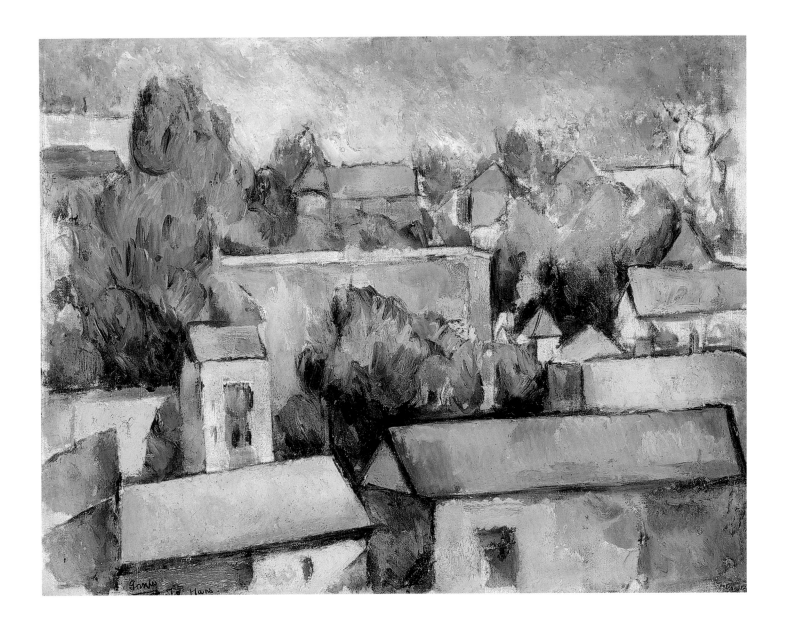

2 *Staten Island*, 1927
Oil on canvas
16 ¼ x 20 ¼ inches (41.3 x 51.4 cm)
Collection of Vartkess and Rita Balian

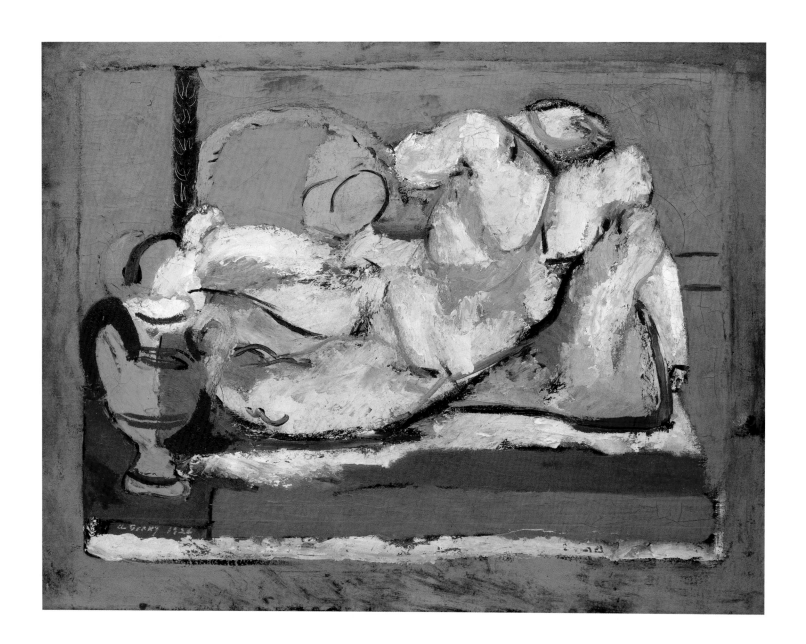

3 *The Antique Cast*, 1926
 Oil on canvas
 36¼ x 46⅜ inches (92.1 cm x 117.8 cm)
 San Francisco Museum of Modern Art.
 Gift of Mr. and Mrs. David McCulloch

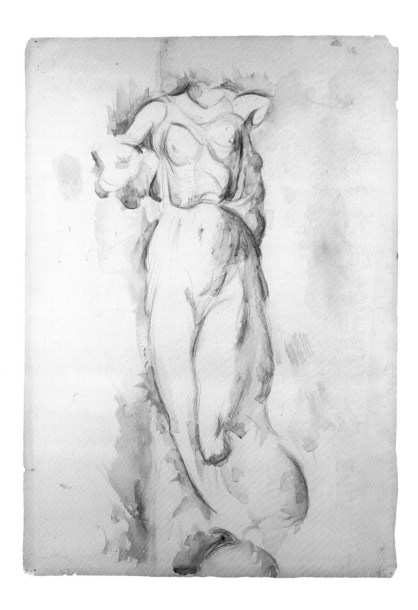

4 *Study after an Antique Sculpture*, c. 1926–29
Charcoal and watercolor on paper
22 x 15¼ inches (55.9 x 38.7 cm)
The Metropolitan Museum of Art, New York.
Purchase, gift of Sam A. Lewisohn, by exchange, 2005

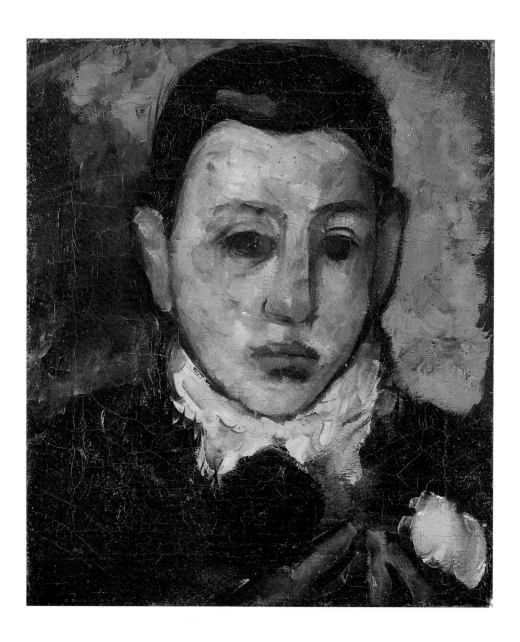

5 *Self-Portrait at the Age of Nine*, 1928
Oil on canvas
12¼ x 10¼ inches (31.1 x 26 cm)
The Metropolitan Museum of Art, New York.
Gift of Leon Constantiner, 2002

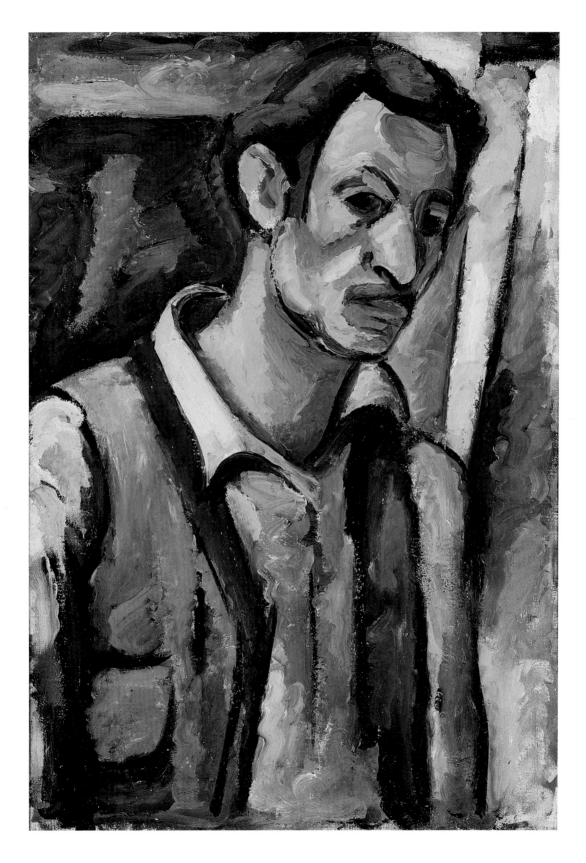

6 **Self-Portrait**, c. 1928
Oil on canvas
24 x 16 inches (61 x 40.6 cm)
Los Angeles County Museum of Art.
Gift of Mr. and Mrs. Hans Burkhardt

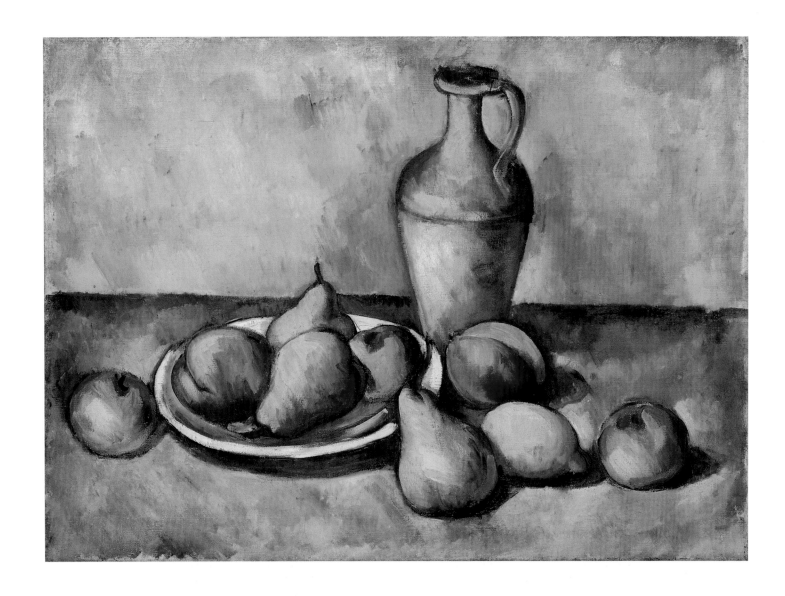

7 *Pears, Peaches, and Pitcher*, c. 1928
Oil on canvas
17 3/8 x 23 3/8 inches (44 x 59.5 cm)
Private collection

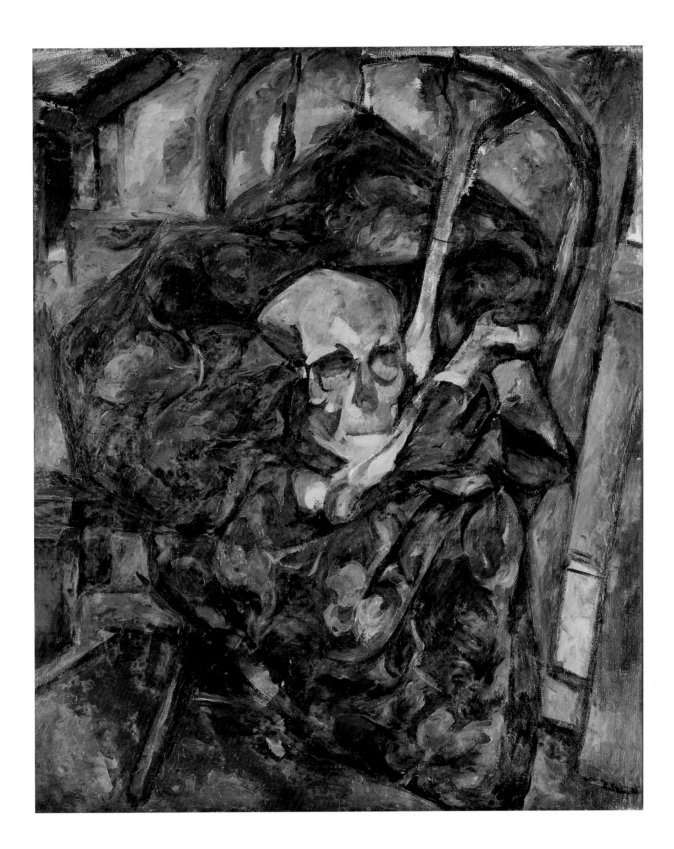

8 *Still Life with Skull*, c. 1927–28
Oil on canvas
33½ x 26¾ inches (85 x 68 cm)
Private collection

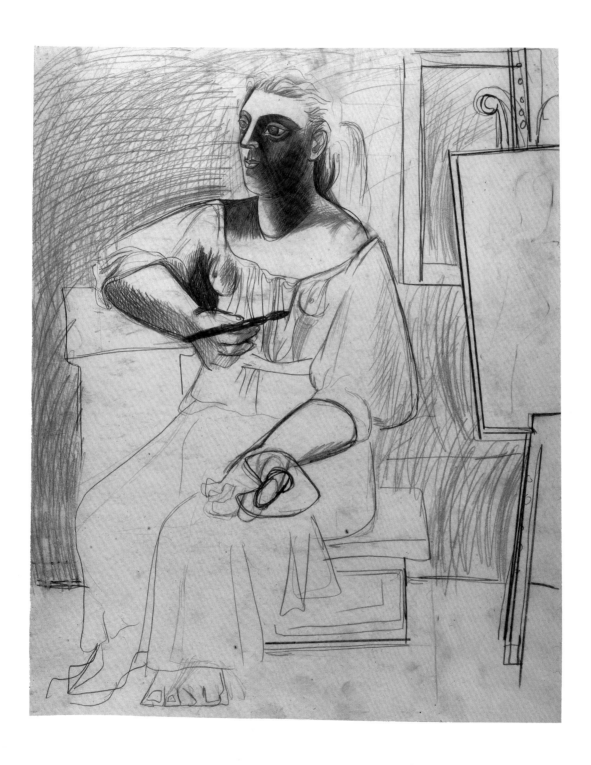

9 *Untitled (Study for "Woman with a Palette")*, c. 1927
Graphite on paper
28³⁄₄ x 19¹⁄₄ inches (73 x 48.9 cm)
Collection of Stephen Mazoh

10 *Woman with a Palette*, 1927
Oil on canvas
53¹⁄₂ x 37¹⁄₂ inches (135.9 x 95.3 cm)
Philadelphia Museum of Art. Purchased with funds (by exchange)
from the bequest of Henrietta Myers Miller and with proceeds from
the sale of other deaccessioned works of art, 2004

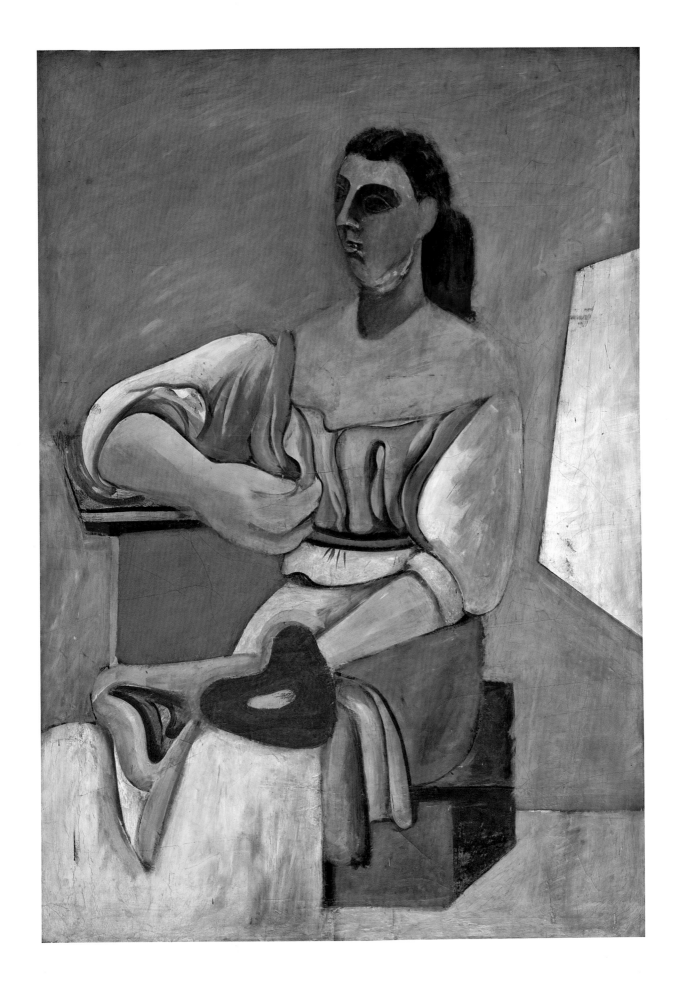

11 *Untitled (Study after "Woman with a Palette")*, c. 1930–35 *
Graphite on paper
2³/₈ x 1¹/₂ inches (6 x 3.8 cm)
The Museum of Modern Art, New York.
Gift of Mr. and Mrs. Abraham L. Chanin, 1963

12 **Untitled**, c. 1930–35 *
Graphite on paper
2$\frac{1}{2}$ x 1$\frac{5}{8}$ inches (6.5 x 4.3 cm)
The Museum of Modern Art, New York.
Gift of Mr. and Mrs. Abraham L. Chanin, 1963

13 **Untitled**, c. 1930–35 *
Graphite on paper
2$\frac{1}{2}$ x 1$\frac{3}{4}$ inches (6.5 x 4.5 cm)
The Museum of Modern Art, New York.
Gift of Mr. and Mrs. Abraham L. Chanin, 1963

14 *Still Life (Composition with Vegetables)*, c. 1928
Oil on canvas
28^{1}/$_{16}$ x 36^{1}/$_{16}$ inches (71.2 x 91.6 cm)
Blanton Museum of Art, The University of Texas at Austin. Gift of
Albert Erskine to the Mari and James A. Michener Collection, 1974

15 *Enigma (Composition of Forms on Table)*, 1928–29

Oil on canvas

33 x 44 inches (83.8 x 111.8 cm)

Collection of the Honorable and Mrs. Joseph P. Carroll

1930s

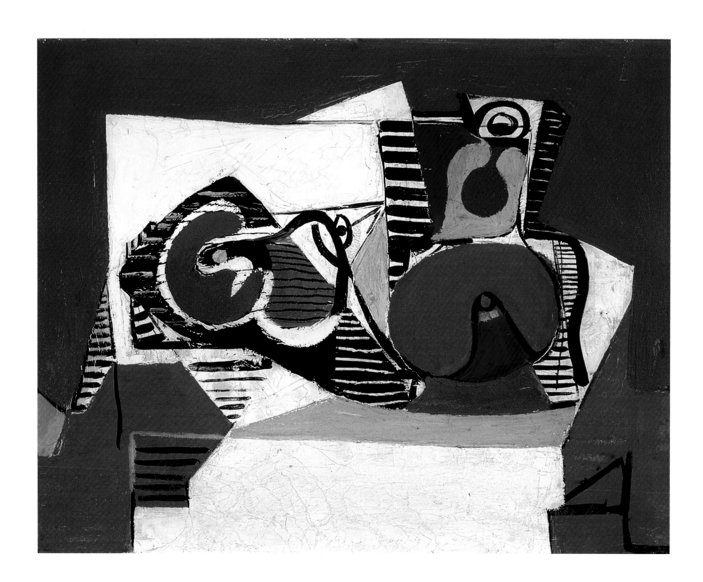

16 *Harmony*, 1931 *
Oil on canvas
22 x 27 inches (55.9 x 68.6 cm)
Diocese of the Armenian Church of America (Eastern) on deposit
at the Calouste Gulbenkian Foundation, Lisbon

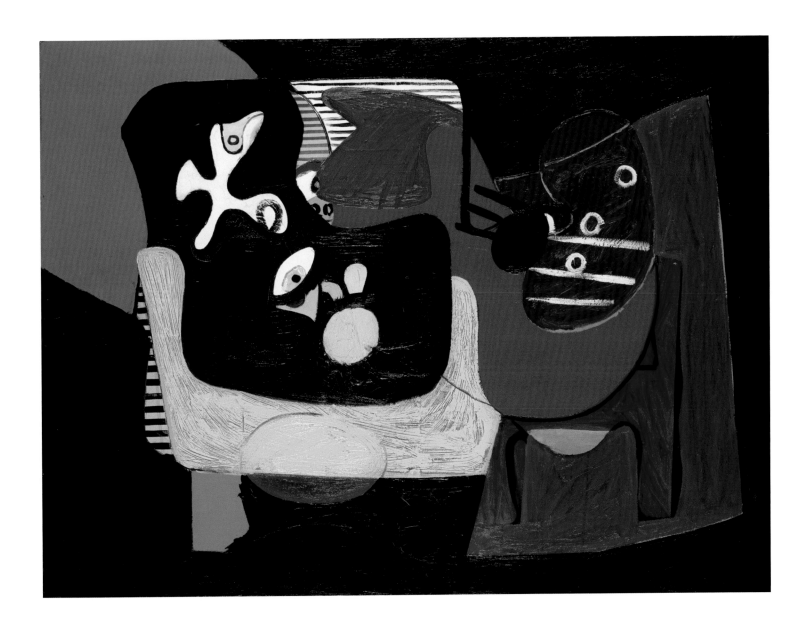

17 *Still Life*, c. 1930–31
 Oil on canvas
 38½ x 50⅜ inches (97.8 x 128 cm)
 Chrysler Museum of Art, Norfolk, Virginia.
 Bequest of Walter P. Chrysler, Jr.

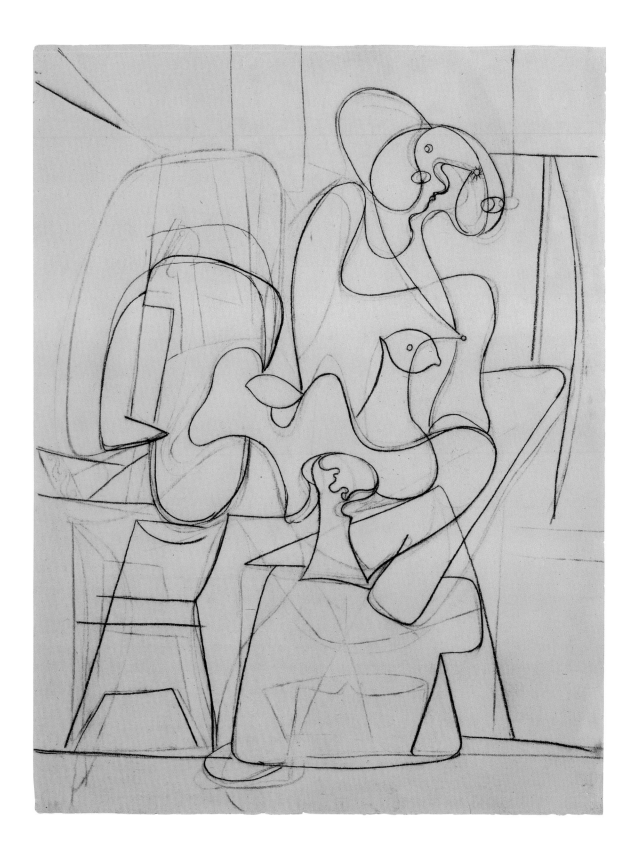

18 *Study for "Blue Figure in a Chair,"* 1931
Charcoal on paper
23 x 17 inches (58.4 x 43.2 cm)
Private collection

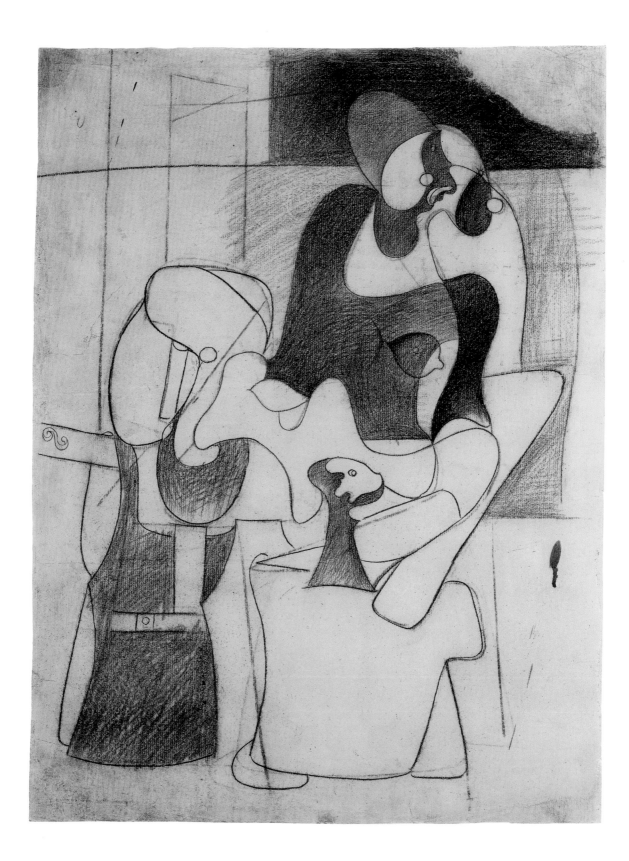

19 *Study for "Blue Figure in a Chair,"* 1931
Charcoal on paper
23 x 17⅛ inches (58.4 x 43.5 cm)
Private collection

180

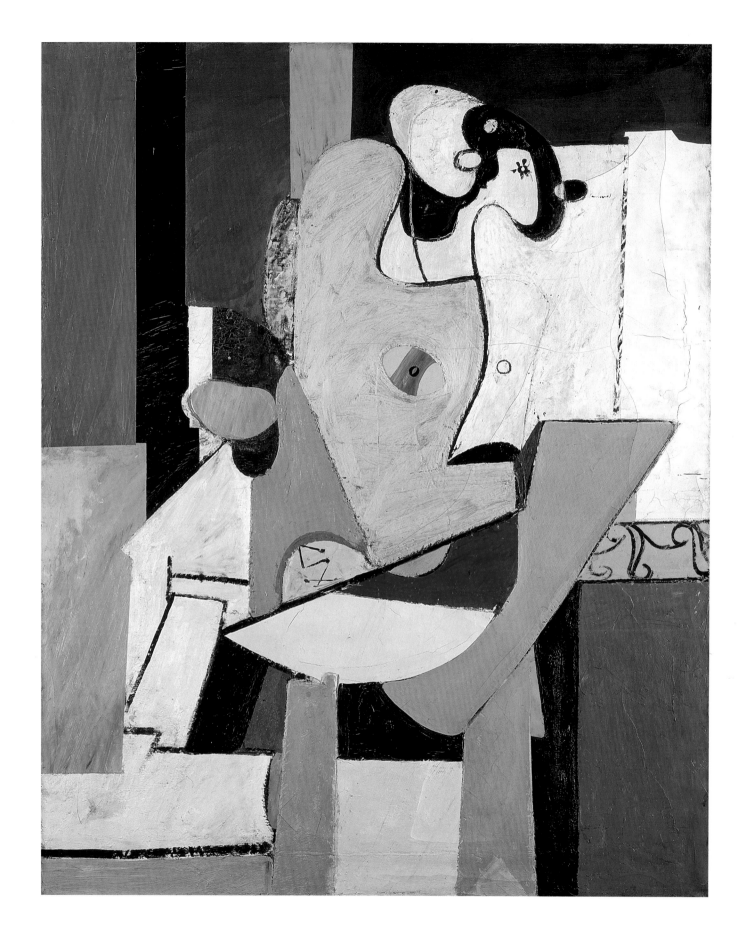

20 *Blue Figure in a Chair*, c. 1931

Oil on canvas

48 x 38 inches (121.9 x 96.5 cm)

Private collection, on long-term loan to the National Gallery of Art,

Washington, D.C.

21 *Abstraction with a Palette*, c. 1930–31
Oil on canvas
48 x 35¹⁵/₁₆ inches (121.9 x 91.3 cm)
Philadelphia Museum of Art. Gift of Bernard Davis, 1942

22 *Mannikin*, 1931
Lithograph, printed in black, on cream wove paper
14 11/16 x 11 1/4 inches (37.3 x 28.7 cm)
Whitney Museum of American Art, New York. Purchase

19/65 *Arshile Gorky*

#2 *Mannikin* 12

23 *Painter and Model (The Creation Chamber)*, 1931
Lithograph, printed in black, on cream wove paper
11¼ x 9⅞ inches (28.6 x 25.1 cm)
Brooklyn Museum, New York. Dick S. Ramsay Fund

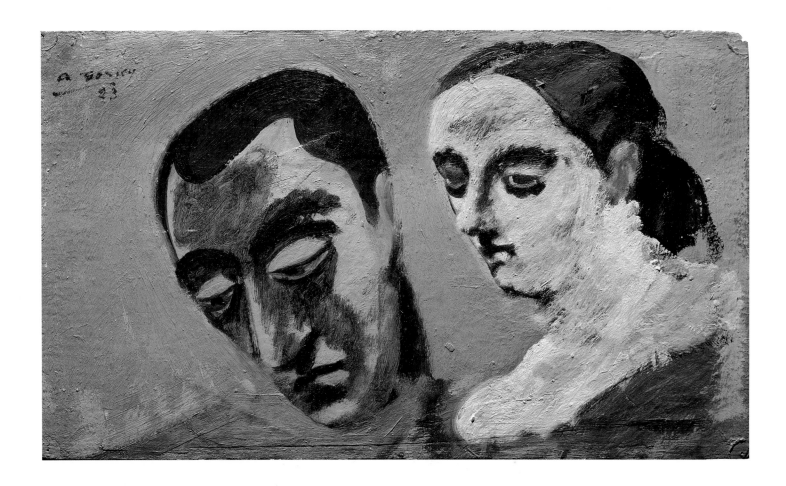

24 *Portrait of Myself and My Imaginary Wife*, 1933–34
Oil on paperboard
8 5/8 x 14 1/4 inches (21.9 x 36.2 cm)
Hirshhorn Museum and Sculpture Garden, Smithsonian Institution,
Washington, D.C. Gift of the Joseph H. Hirshhorn Foundation, 1966

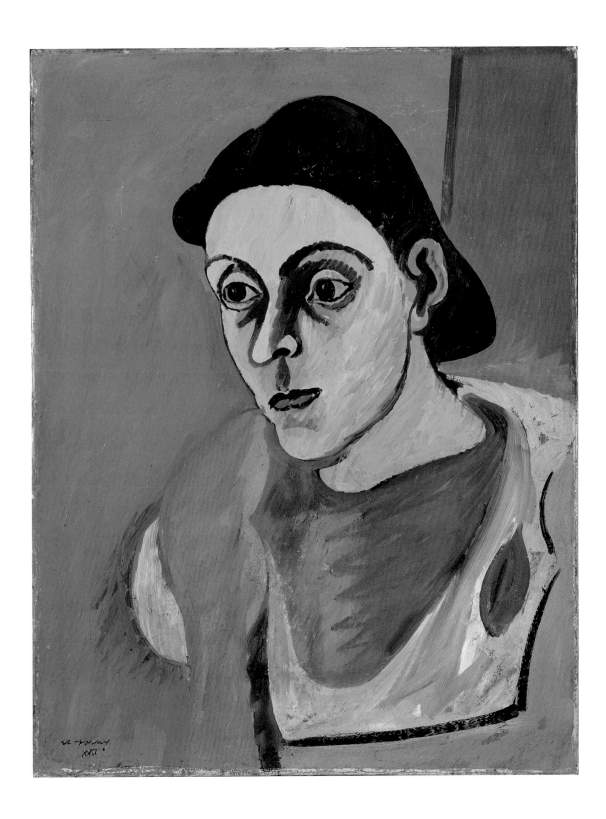

25 *Portrait of Vartoosh*, 1933–34

Oil on canvas

20¼ x 15⅛ inches (51.4 x 38.4 cm)

Hirshhorn Museum and Sculpture Garden, Smithsonian Institution,

Washington D.C. Gift of the Joseph H. Hirshhorn Foundation, 1966

26 *Study for "The Artist and His Mother,"*
c. 1926–34 *(top left)*
Graphite on paper
11 x 8¹/₂ inches (27.9 x 21.6 cm)
Private collection

27 *Study for "The Artist and His Mother,"*
c. 1936 *(top right)*
Graphite on paper
8³/₈ x 6³/₄ inches (21.3 x 17.1 cm)
Whitney Museum of American Art, New York.
Purchase, with funds from The Lauder Foundation,
Evelyn and Leonard Lauder Fund, and the Drawing
Committee

28 *Two Studies for "The Artist and His Mother,"*
c. 1926–34 *(bottom)*
Ink on brown paper
8¹/₈ x 11 inches (20.5 x 27.9 cm)
Private collection

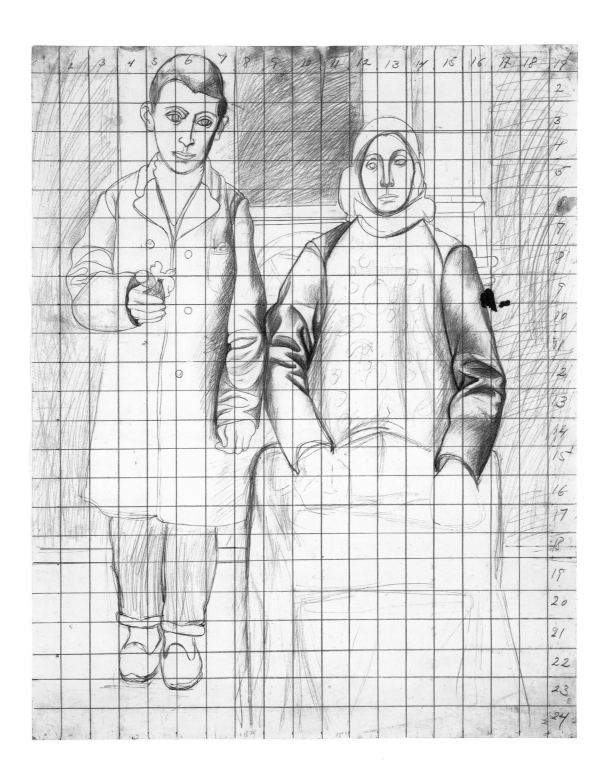

29 ***Study for "The Artist and His Mother,"*** c. 1926
Graphite on squared paper
24 x 19 inches (61 x 48.3 cm)
National Gallery of Art, Washington, D.C. Ailsa Mellon
Bruce Fund, 1979

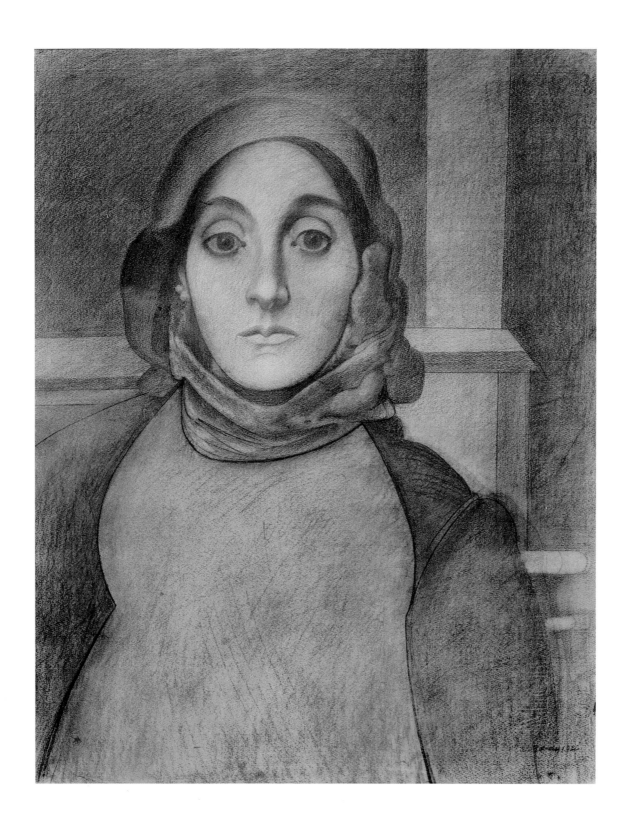

30 *The Artist's Mother*, c. 1926–36
Charcoal on ivory laid paper
24⁷/₈ x 19³/₁₆ inches (63 x 48.5 cm)
The Art Institute of Chicago. The Worcester Sketch Fund, 1965

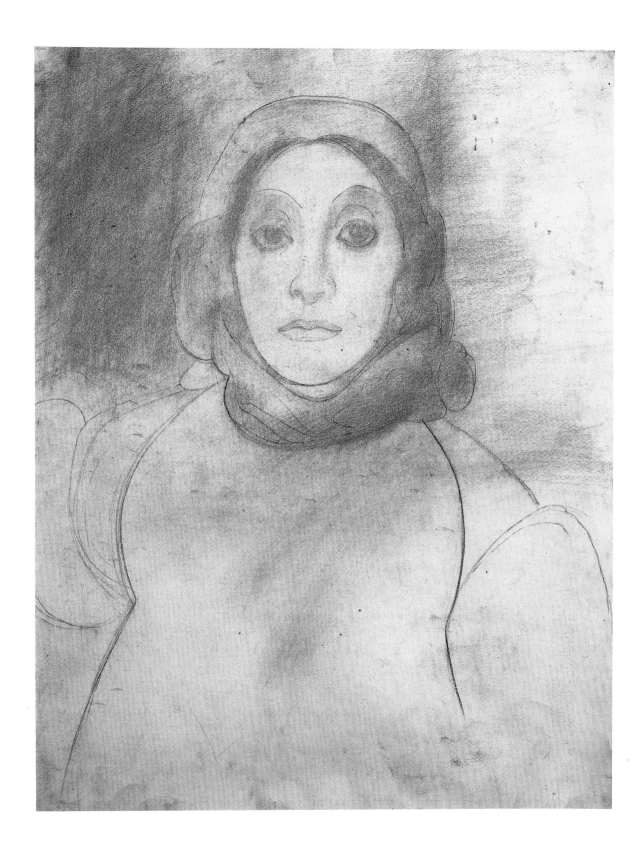

31 *The Artist's Mother*, c. 1926–34
Graphite on paper
32³⁄₄ x 25¹⁄₂ inches (83.2 x 64.8 cm)
Private collection

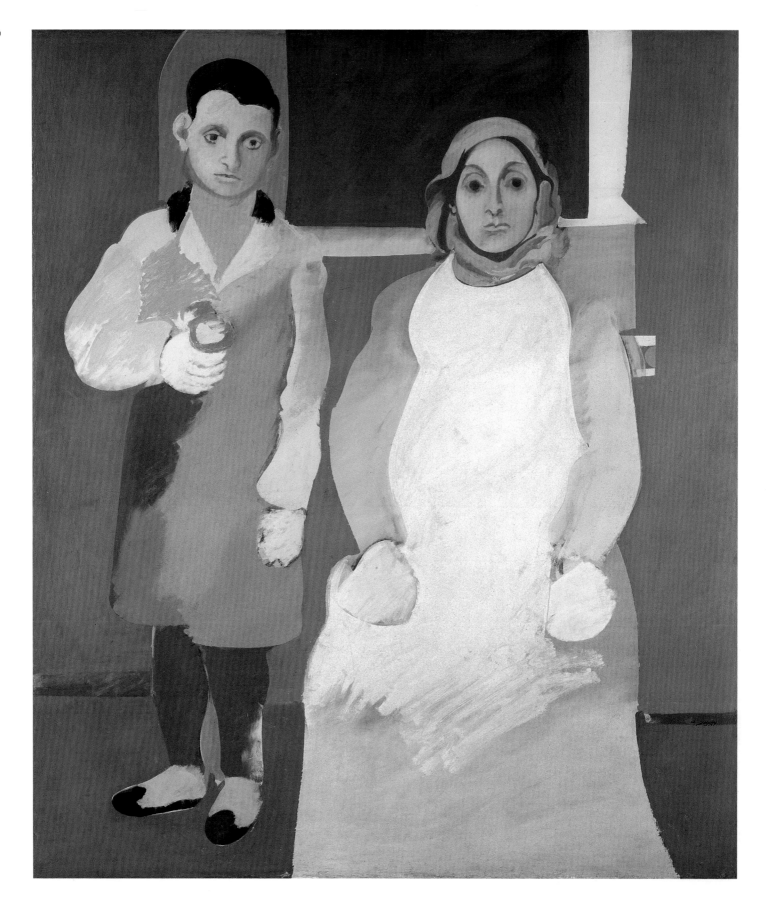

32 *The Artist and His Mother*, 1926–36
Oil on canvas
60 x 50 inches (152.4 x 127 cm)
Whitney Museum of American Art, New York. Gift of Julien Levy
for Maro and Natasha Gorky in memory of their father

33 *The Artist and His Mother*, c. 1926–c. 1942
Oil on canvas
60 x 50 inches (152.4 x 127 cm)
National Gallery of Art, Washington, D.C. Ailsa Mellon
Bruce Fund, 1979

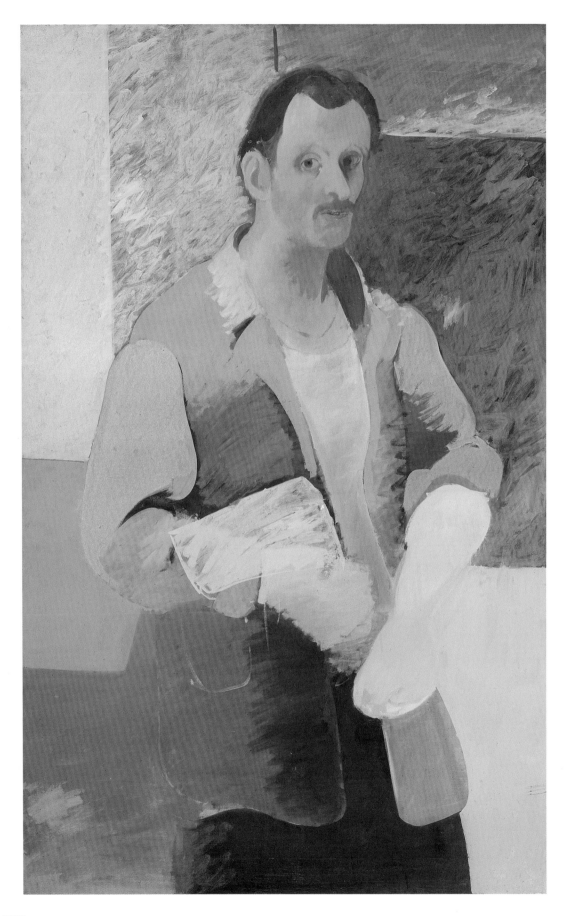

34 *Self-Portrait*, c. 1937
Oil on canvas
55½ x 34 inches (141 x 86.4 cm)
Private collection, on long-term loan to the
National Gallery of Art, Washington, D.C.

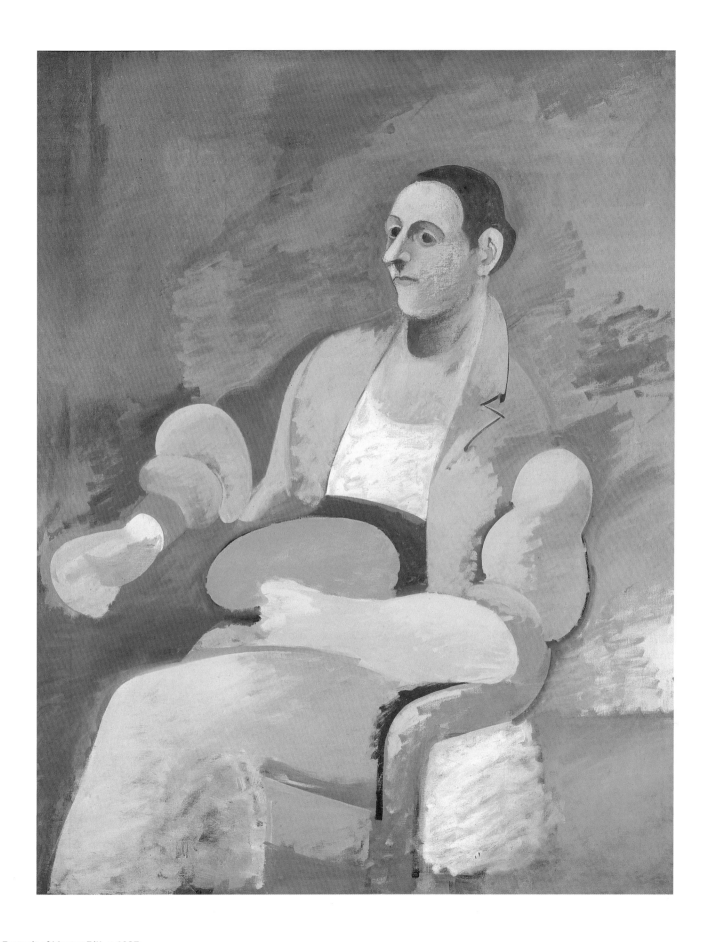

35 **Portrait of Master Bill**, c. 1937
Oil on canvas
52⅛ x 40⅛ inches (132.4 x 101.9 cm)
Private collection, on long-term loan to the
National Gallery of Art, Washington, D.C.

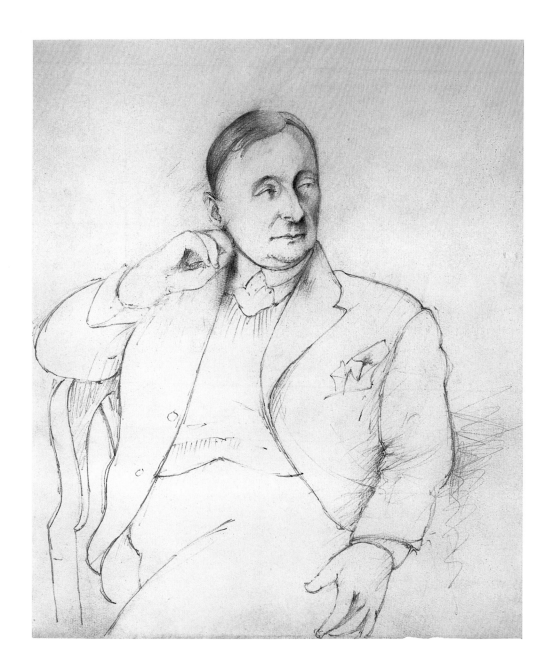

36 *Portrait of Frederick Kiesler*, c. 1938
Graphite on paper
12$\frac{1}{2}$ x 8$\frac{3}{4}$ inches (31.8 x 22.2 cm)
Private collection

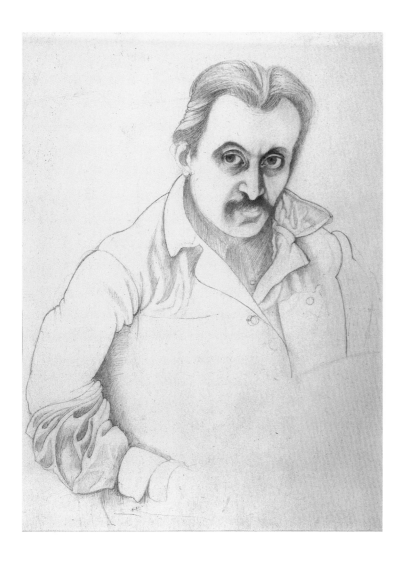

37 *Self-Portrait*, c. 1936
Graphite on paper
9⅞ x 8¼ inches (25.1 x 21 cm)
Private collection

38 *Portrait of Willem de Kooning*, 1937
Ink on paper
8½ x 5⅜ inches (21.6 x 13.7 cm)
Collection of Carroll Janis

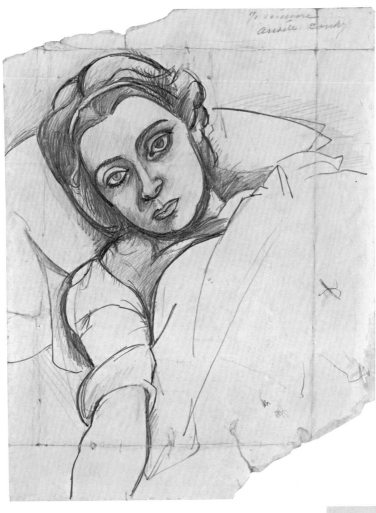

39 *Leonore Portnoff*, c. 1938–40
Graphite on paper
12¹/₂ x 9¹/₂ inches (32 x 24.3 cm)
The Museum of Modern Art, New York. Kay Sage Tanguy
Bequest (by exchange), 1975

40 *Leonore Portnoff*, c. 1938–40
Crayon on paper
13¹/₂ x 10¹/₄ inches (34.3 x 26 cm)
Collection of Ellen Phelan and Joel Shapiro

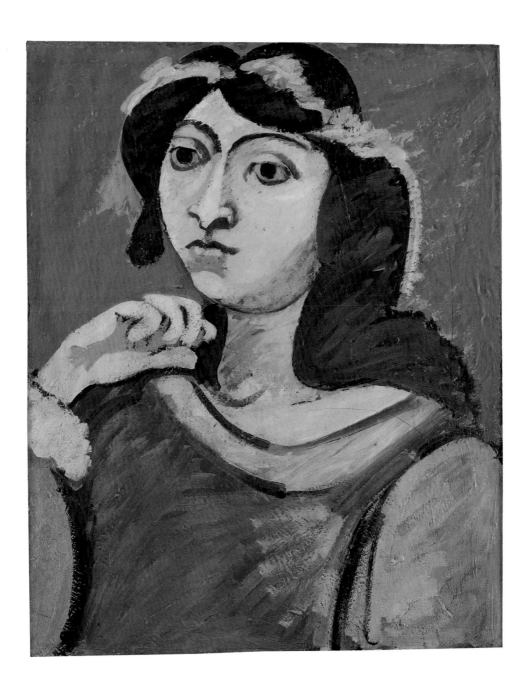

41 *Portrait of Ahko*, c. 1937
Oil on canvas
19^1/$_2$ x 15 inches (49.5 x 38.1 cm)
Private collection

42 ***Nighttime, Enigma, and Nostalgia***, c. 1931
 Graphite and ink on heavy wove paper
 21³/₈ x 30¹/₈ inches (54.4 x 76.4 cm)
 Private collection

43　*Nighttime, Enigma, and Nostalgia*, c. 1931–32

Ink on paper

24 x 31 inches (61 x 78.7 cm)

Whitney Museum of American Art, New York.

50th Anniversary Gift of Mr. and Mrs. Edwin A. Bergman

44 *Study for Mural (Nighttime, Enigma, and Nostalgia)*, c. 1931–32
Pen and black ink over graphite on wove paper
7¼ x 26 inches (18.4 x 66 cm)
The Detroit Institute of Arts. Founders Society Purchase with funds
from Mr. and Mrs. Richard A. Manoogian and K. T. Keller Fund

45 *Nighttime, Enigma, and Nostalgia,* c. 1932

Ink on paper

20⅛ x 28¾ inches (51.1 x 73 cm)

Hirshhorn Museum and Sculpture Garden, Smithsonian Institution,

Washington, D.C. Joseph H. Hirshhorn Purchase Fund, 2000

46 *Nighttime, Enigma, and Nostalgia*, 1931
Graphite on paper
19 x 25 inches (48.3 x 63.5 cm)
Collection of Aaron I. Fleischman

47 *Column with Objects (Nighttime, Enigma, and Nostalgia)*, c. 1931–32
Graphite on paper
18 3/8 x 24 1/2 inches (46.6 x 62.2 cm)
Private collection

48 *Nighttime, Enigma, and Nostalgia*, c. 1932
Ink on paper
28⅛ x 38⅛ inches (71.4 x 96.8 cm)
Private collection

49 *Nighttime, Enigma, and Nostalgia*, c. 1933–34
Pen and black and brown inks over graphite on wove paper
22 x 28 3/8 inches (55.9 x 72 cm)
National Gallery of Art, Washington, D.C. Ailsa Mellon Bruce Fund
and Andrew W. Mellon Fund, 1979

50 *Study for Murals at RIkers Island Penitentiary*, c. 1941–42 (with later additions)
Wash and India ink on paper
22 x 30 inches (55.8 x 76.2 cm)
Diocese of the Armenian Church of America (Eastern) on Deposit
at the Calouste Gulbenkian Foundation, Lisbon

51 *Column with Objects (Nighttime, Enigma, and Nostalgia)*, c. 1931–32
Graphite on off-white chain-laid paper
18⅞ x 25 inches (48 x 63.5 cm)
Private collection

52 *Nighttime, Enigma, and Nostalgia*, c. 1931–32
Graphite on off-white chain-laid paper
18¼ x 24 inches (46.5 x 61 cm)
Private collection

53 *Column with Objects (Nighttime, Enigma, and Nostalgia)*, c. 1931–32
Graphite on off-white chain-laid paper
18⁷⁄₈ x 25 inches (48 x 63.5 cm)
Private collection

54 *Organization (Nighttime, Enigma, and Nostalgia)*, c. 1933–34
Oil on board
13¹⁄₂ x 21⁵⁄₈ inches (34.3 x 54.9 cm)
The University of Arizona Museum of Art, Tucson. Gift of Edward J. Gallagher, Jr.

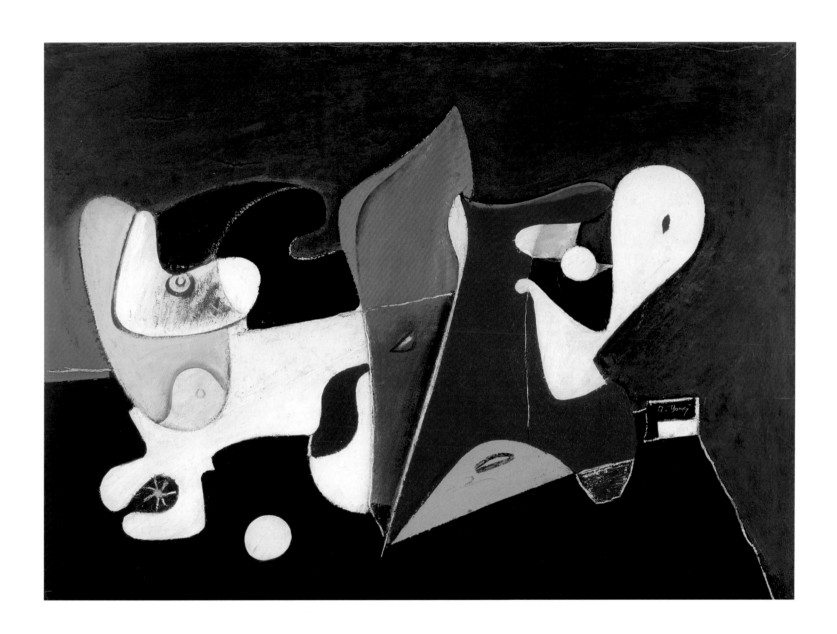

55 *Nighttime, Enigma, and Nostalgia*, c. 1933–34

Oil on canvas mounted on panel

36 x 47⅞ inches (91.4 x 121.6 cm)

The Museum of Fine Arts, Houston. Museum purchase with funds

provided by the Caroline Wiess Law Accessions Endowment Fund

56 *Study for "Image in Khorkom,"* c. 1934–36
Brush, pen and ink, and graphite on paper, with some erasing
23¾ x 28¾ inches (60.3 x 73 cm)
L & M Arts, New York

57 *Study for "Image in Khorkom*," c. 1934–36
Graphite and ink on paper
18$\frac{1}{2}$ x 24$\frac{3}{8}$ inches (47 x 61.9 cm)
Collection of Mr. and Mrs. J. Tomilson Hill

58 *Study for "Image in Khorkom*," c. 1934–36
Ink and wash on wove paper
22¾ x 30¾ inches (57.8 x 78.1 cm)
Collection of Ellen Phelan and Joel Shapiro

59 ***Study for "Image in Khorkom,"*** c. 1934–36
Graphite on paper
8$\frac{1}{2}$ x 10$\frac{1}{4}$ inches (21.6 x 26 cm)
Private collection

60 *Image in Khorkom*, c. 1934–36
Oil on canvas
33⅛ x 42½ inches (84 x 108 cm)
Private collection

61 *After Khorkom*, 1940–42
Oil on canvas
36 x 47¾ inches (91.4 x 121.3 cm)
The Art Institute of Chicago. Gift of Mr. and Mrs. Howard Wise, 1968

62 *Parthenon Horses*, c. 1934 *

Graphite on off-white wove paper

4⁷⁄₁₆ x 7³⁄₁₆ inches (11.3 x 18.2 cm)

Harvard University Art Museums, Fogg Art Museum, Cambridge, Massachusetts.

Anonymous Fund for Acquisitions, 1974

63 *Composition: Horse and Figures*, c. 1934
Oil on canvas
34¼ x 43⅜ inches (87 x 110.2 cm)
The Museum of Modern Art, New York.
Gift of Bernard Davis in memory of the artist, 1950

64 *Study for "Organization,"* c. 1935
Graphite on paper
48 3/8 x 64 3/8 inches (123 x 163.5 cm)
Private collection

65 *Study for "Organization" II*, c. 1935
Graphite on paper
11³⁄₈ x 14¹⁄₈ inches (29 x 36 cm)
Private collection

66 *Organization*, 1933–36
Oil on canvas
50 x 59¹³/₁₆ inches (127 x 152 cm)
National Gallery of Art, Washington, D.C. Ailsa Mellon Bruce Fund, 1979

67 *Portrait*, 1938
Oil on canvas
31 x 24⅝ inches (78.7 x 62.5 cm)
Private collection

68 *Head*, c. 1934–35
Oil on canvas
38¹⁄₂ x 30¹⁄₂ inches (97.8 x 77.5 cm)
Collection of Carroll Janis

69 *Composition with Head*, c. 1936–37
Oil on canvas
76¹⁄₂ x 60¹⁄₂ inches (194.3 x 153.7 cm)
Collection of Donald L. Bryant, Jr.

70 *Untitled (Study for "Painting")*, 1936–37
Gouache on paper
10¼ x 12¾ inches (26 x 32.4 cm)
Property of a gentleman

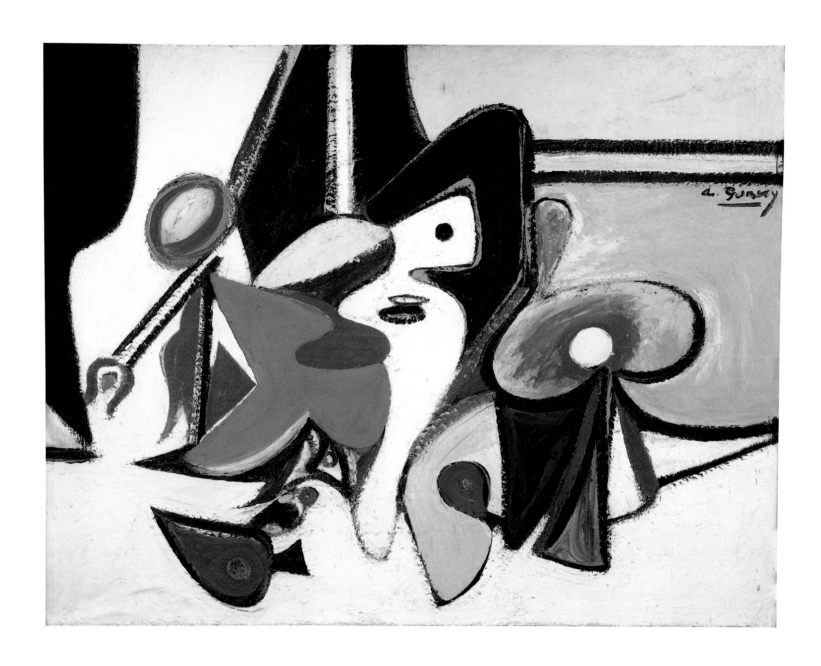

71 *Painting*, 1936–37
Oil on canvas
38 x 48 inches (96.5 x 121.9 cm)
Whitney Museum of American Art, New York. Purchase

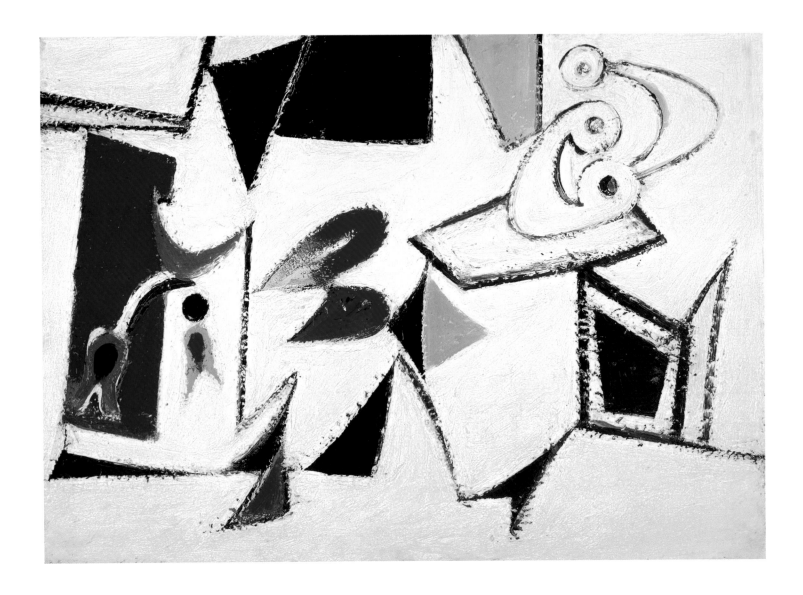

72 *Composition*, 1937
Enamel on canvas
29 1/8 x 39 7/8 inches (73.9 x 101.3 cm)
The Museum of Fine Arts, Houston. Bequest of Caroline Wiess Law

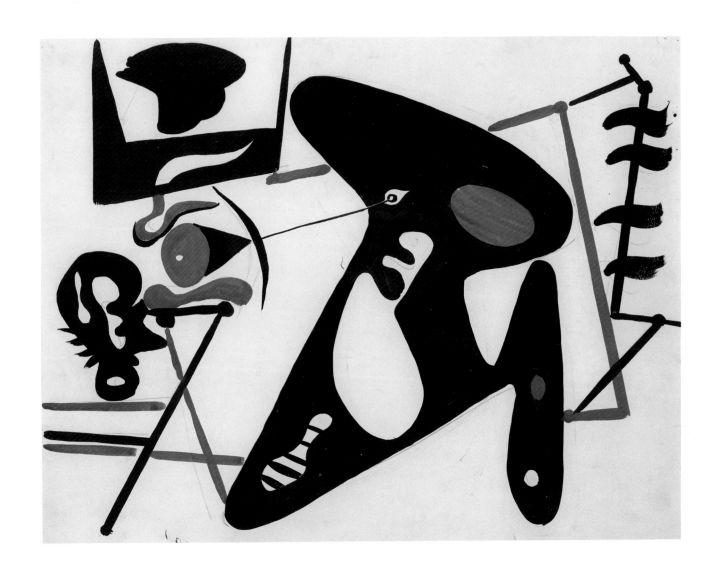

73 *Untitled (Measuring the Land)*, 1939
Graphite and gouache on paper
19 x 24 inches (48.2 x 61.1 cm)
Private collection

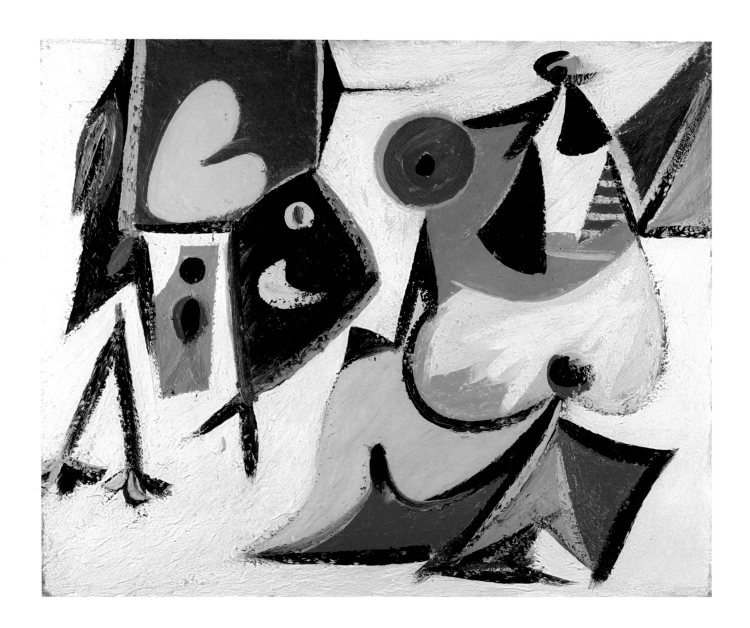

74 *Composition*, 1936–39
Oil on canvas
29¾ x 35¾ inches (75.6 x 90.8 cm)
Minneapolis Institute of Arts. The Francisca S. Winston Fund

75 *Enigmatic Combat*, 1936–37
Oil on canvas
35¾ x 48 inches (90.8 cm x 121.9 cm)
San Francisco Museum of Modern Art. Gift of Jeanne Reynal

76 *Study for "Aviation: Evolution of Forms under Aerodynamic Limitations"*
(Newark Airport Mural), c. 1935–36
Oil on canvas
30 x 35 inches (76.2 x 88.9 cm)
Grey Art Gallery, New York University Art Collection. Gift of May Walter

77 *Study for "Aviation: Evolution of Forms under Aerodynamic Limitations"*
(Newark Airport Mural), c. 1935–36
Graphite on paper
5⁷/₈ x 23 inches (14.9 x 58.4 cm)
Private collection

78 *Study for "Activities on the Field," for "Aviation: Evolution of Forms*
under Aerodynamic Limitations" (Newark Airport Mural), 1935–36
Gouache on paper
18⁵/₈ x 36³/₈ inches (47.4 x 92.6 cm)
The Museum of Modern Art, New York. Extended loan from the United States WPA Art Program.
Fine Arts Collection, Public Buildings Service, General Services Administration, 1939

79 *Study for "Aviation: Evolution of Forms under Aerodynamic Limitations" II*
(Newark Airport Mural), 1935–36
Gouache on paper
18¼ x 12 inches (46.4. x 30.4 cm)
Diocese of the Armenian Church of America (Eastern)
on Deposit at the Calouste Gulbenkian Foundation, Lisbon

80 *Study for "Aviation: Evolution of Forms under Aerodynamic Limitations" III (Newark Airport Mural)*, 1935–36
Gouache on paper
18¼ x 13½ inches (46.4 x 34.2 cm)
Diocese of the Armenian Church of America (Eastern)
on Deposit at the Calouste Gulbenkian Foundation, Lisbon

81 *Study for "Aviation: Evolution of Forms under Aerodynamic Limitations" I (Newark Airport Mural)*, 1935–36
Gouache on paper
6 x 10³/₈ inches (15.3 x 26.3 cm)
Diocese of the Armenian Church of America (Eastern) on Deposit
at the Calouste Gulbenkian Foundation, Lisbon

82 *Study for "Aviation: Evolution of Forms under Aerodynamic Limitations" IV (Newark Airport Mural)*, 1935–36
Gouache on paper
6¼ x 10 inches (16 x 25.5 cm)
Diocese of the Armenian Church of America (Eastern) on Deposit
at the Calouste Gulbenkian Foundation, Lisbon

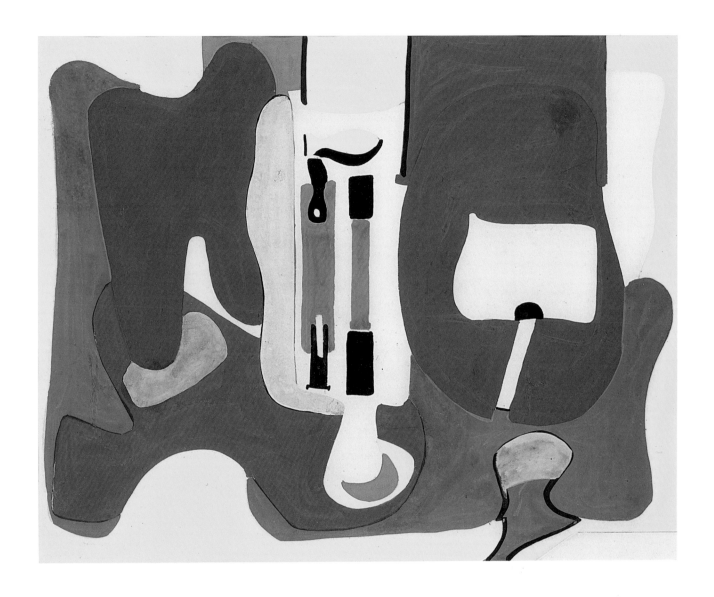

83 ***Study for "Mechanics of Flying," for "Aviation: Evolution of Forms under Aerodynamic Limitations" (Newark Airport Mural)***, c. 1936–37

Gouache on paper

13¼ x 16½ inches (33.7 x 41.9 cm)

Whitney Museum of American Art, New York. 50th Anniversary

Gift of Alan H. Temple

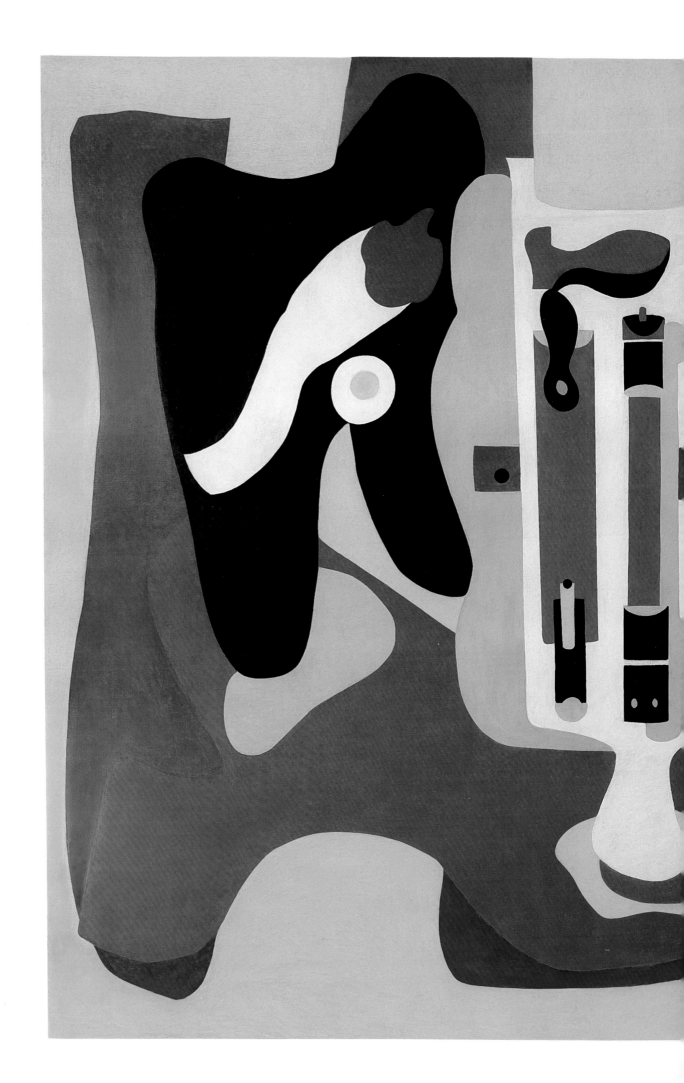

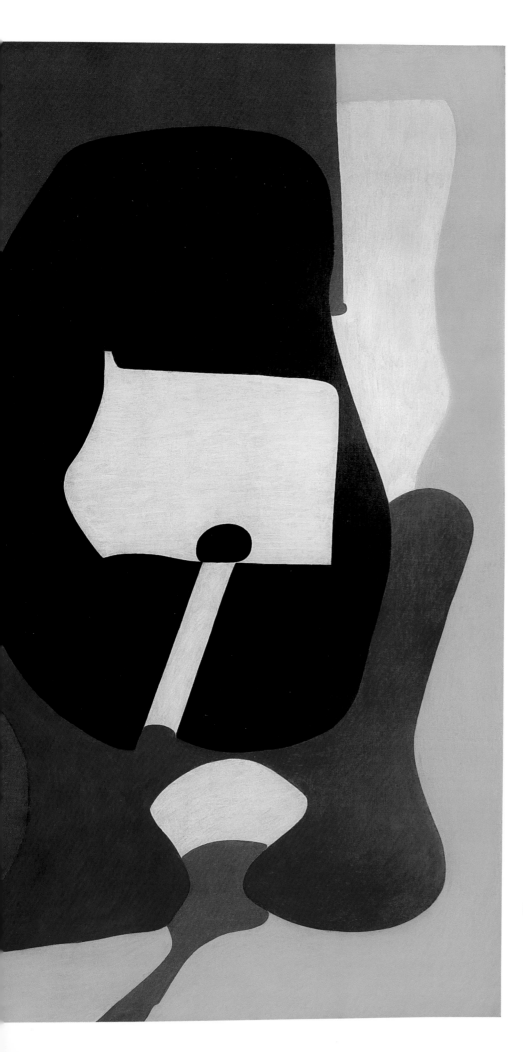

84 *Mechanics of Flying, from "Aviation: Evolution of Forms under Aerodynamic Limitations" (Newark Airport Mural)*
1936–37
Oil on canvas
111 x 136 inches (281.9 x 345.4 cm)
The Newark Museum, Newark, New Jersey, on extended loan from the collection of the Port Authority of New York and New Jersey

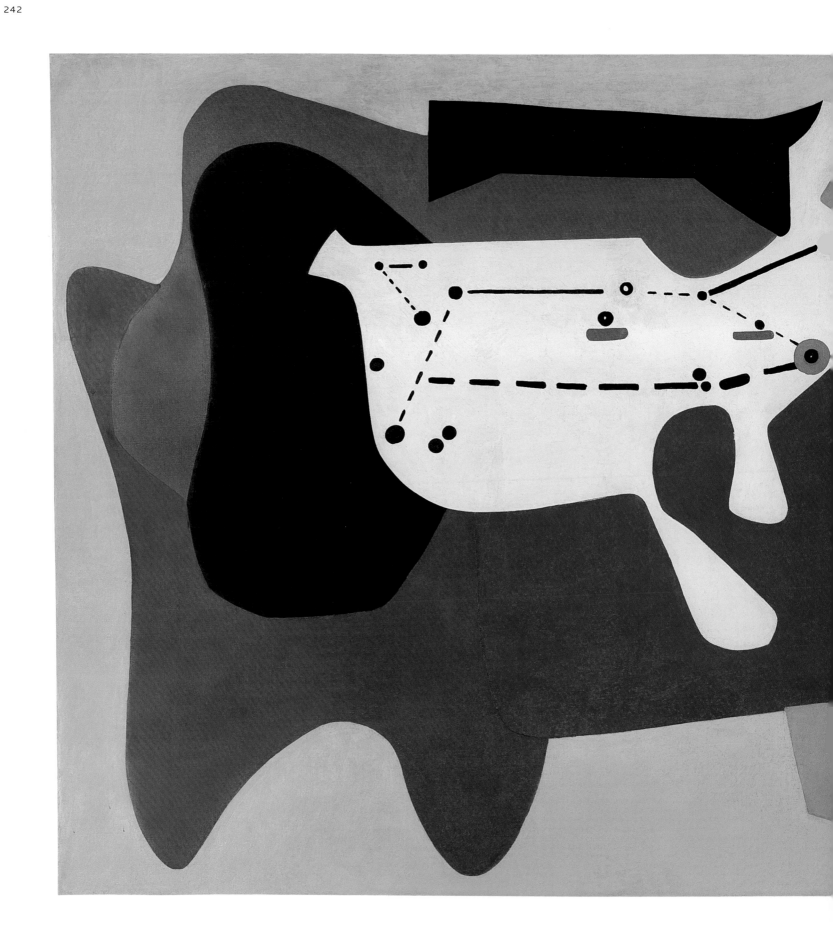

85 *Aerial Map, from "Aviation: Evolution of Forms under Aerodynamic Limitations" (Newark Airport Mural)*
1936–37
Oil on canvas
79 x 123½ inches (200.7 x 313.7 cm)
The Newark Museum, Newark, New Jersey, on extended loan from the collection of the Port Authority of New York and New Jersey

86 *Study for Marine Building Mural* (proposed for the New York World's Fair),
c. 1938–39
Gouache and mixed media on heavy paper mounted on ground wood boards
9¹⁄₈ x 40³⁄₁₆ inches (23.2 x 102 cm)
National Gallery of Art, Washington, D.C. Gift of the Avalon Foundation, 1971

87 *Study for "Transport by Air, Sea, and Rail"* (mural proposed
for the Aviation Building, New York World's Fair), c. 1938–39
Gouache on paper
28 x 22 inches (71.1 x 55.9 cm)
Private collection

88 *Hitler Invades Poland*, 1939
With Isamu Noguchi (American, 1904–1988) and De Hirsh Margules (American, 1899–1965)
Mixed media on paper
17¹⁄₂ x 22⁷⁄₈ inches (44.5 x 58.1 cm)
Private collection

1940s

89 *Untitled*, c. 1941
Gouache on paper
14 1/8 x 11 5/8 inches (35.9 x 29.5 cm)
Collection of Gerald and Kathleen Peters

90 *Untitled*, 1941–42
Gouache on paper mounted on board
17 x 22 inches (43.2 x 55.9 cm)
Frederick R. Weisman Art Foundation, Los Angeles. Lent in honor of
Anne d'Harnoncourt in recognition of her contribution to the arts community

91 *Mojave*, 1941–42
Oil on canvas
28¹³⁄₁₆ x 40¹⁄₂ inches (73 x 102.9 cm)
Los Angeles County Museum of Art. Gift of Burt Kleiner

92 *Central Park at Dusk*, 1936–42
Oil on canvas
24¹/₂ x 30¹/₂ inches (62.2 x 77.5 cm)
Curtis Galleries, Minneapolis

GARDEN IN SOCHI

plates 93–97

93 *Garden in Sochi*, 1940–41
Gouache on board
21 x 27 3/4 inches (53.3 x 70.5 cm)
High Museum of Art, Atlanta.
Purchase with bequest of Charles Donald Belcher

94 *Garden in Sochi*, 1940
Watercolor and gouache on gessoed wood panel
5 x 7 5/16 inches (12.7 x 18.5 cm)
Collection of Ms. Andrea Balian, Ms. Katherine Balian, Dr. Bruce Berberian, and
Mr. Mark Berberian, on long-term loan to the Museum of Fine Arts, Boston, 1976

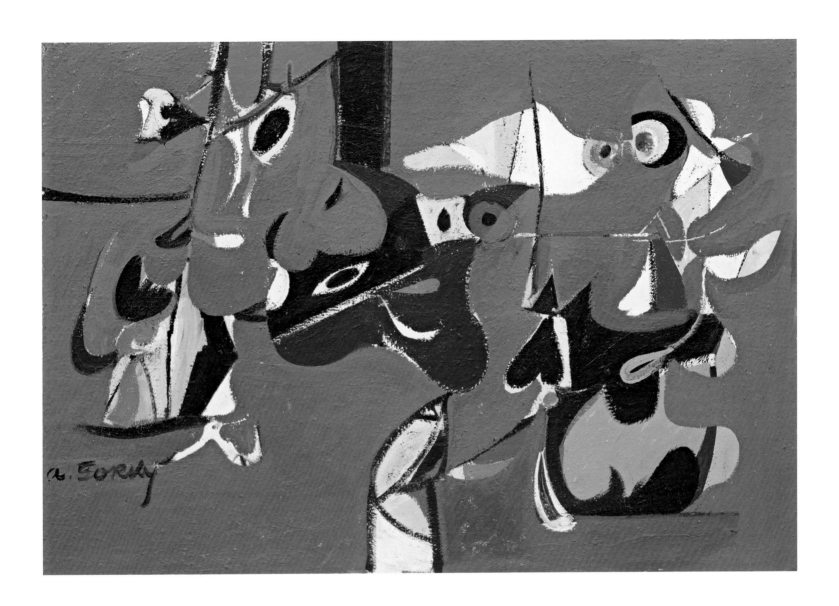

95 *Garden in Sochi*, 1941
Oil on canvas
44¼ x 62¼ inches (112.4 x 158.1 cm)
The Museum of Modern Art, New York. Purchase Fund and gift
of Mr. and Mrs. Wolfgang S. Schwabacher (by exchange), 1942

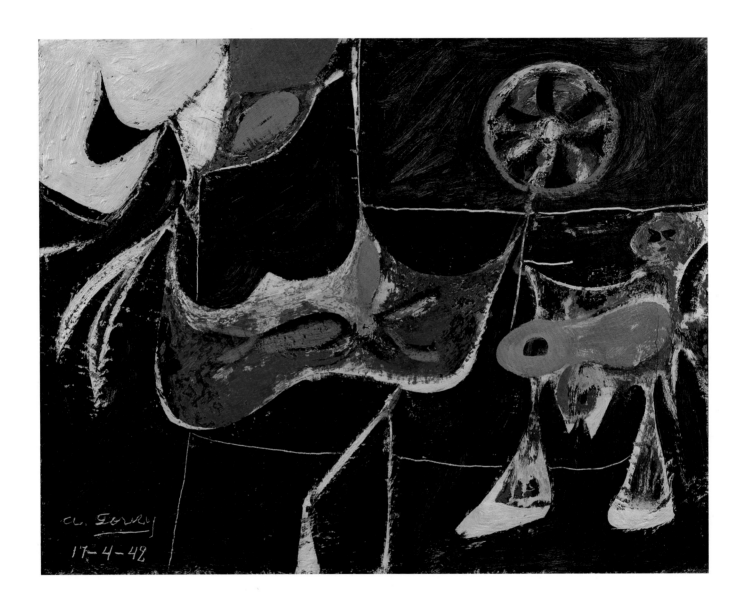

96 *Garden in Sochi Motif*, 1942
Oil on canvas
16 x 20 inches (40.6 x 50.8 cm)
Private collection

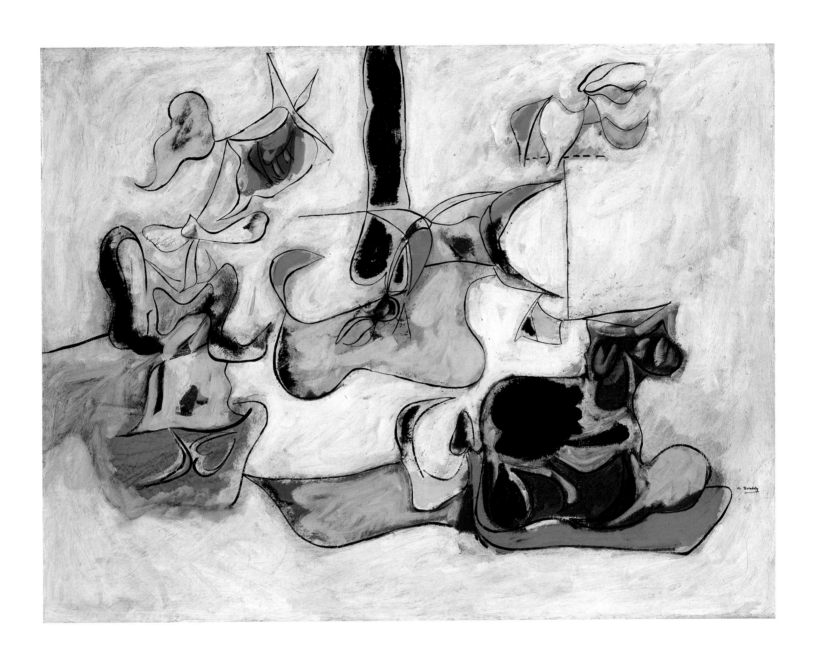

97 *Garden in Sochi*, c. 1943
Oil on canvas
31 x 39 inches (78.7 x 99 cm)
The Museum of Modern Art, New York. Acquired through
the Lillie P. Bliss Bequest, 1969

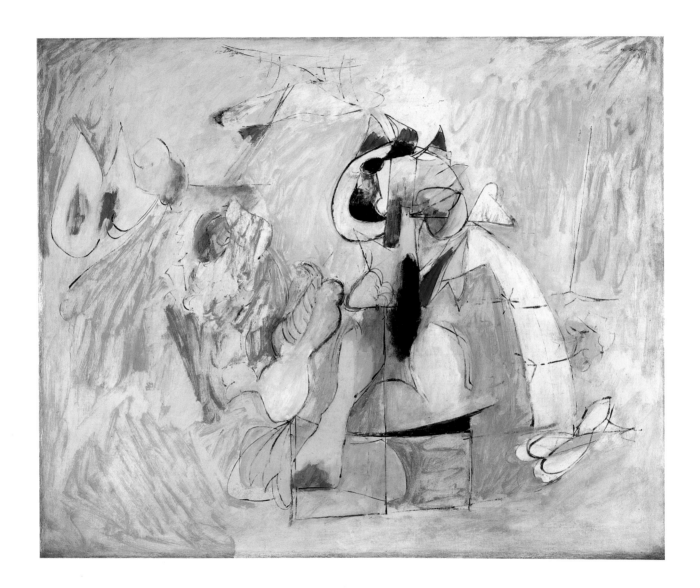

98 *The Pirate I*, c. 1942–43
Oil on canvas
30 x 36 inches (76.2 x 91.4 cm)
Collection of the Honorable and Mrs. Joseph P. Carroll

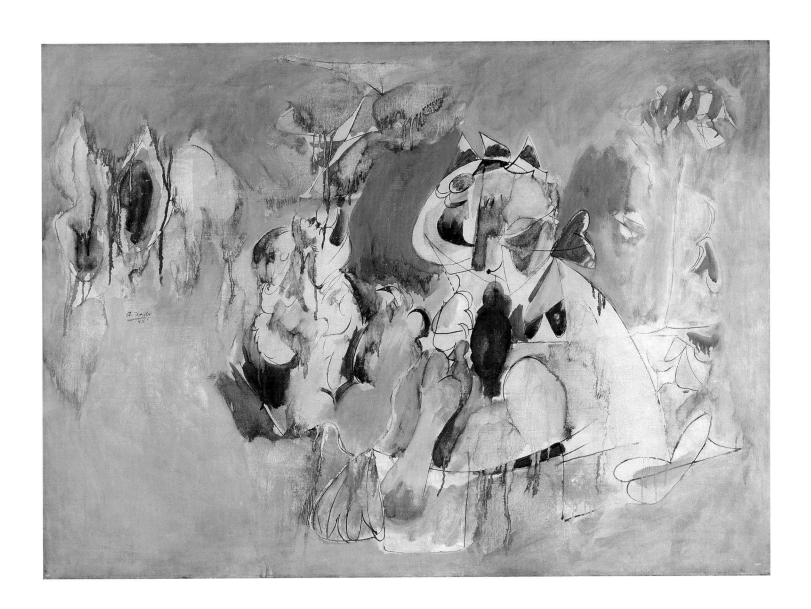

99 *The Pirate II*, c. 1943–44
Oil on canvas
29¼ x 40⅛ inches (74.3 x 101.9 cm)
Private collection, courtesy of Waqas Wajahat Ltd., New York

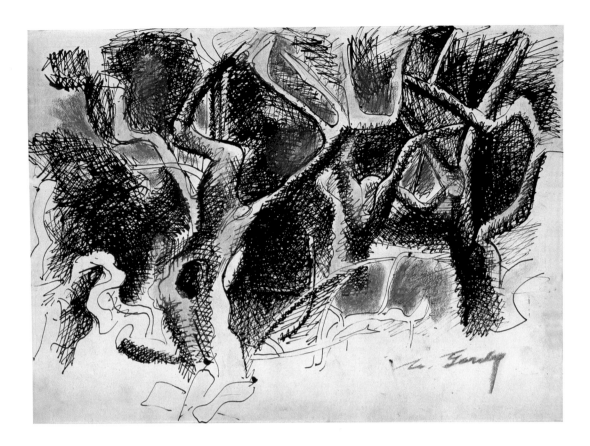

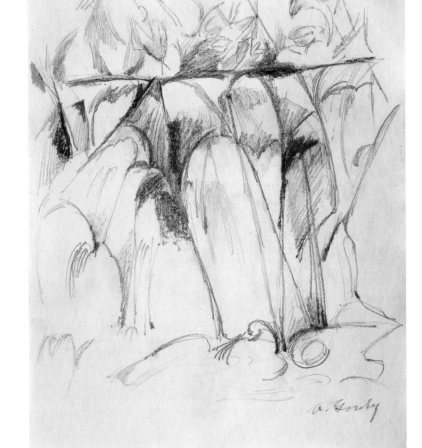

100 ***Schary's Orchard***, 1942
 Ink and crayon on paper
 11³/₄ x 15¹/₂ inches (29.8 x 39.4 cm)
 Collection of Carroll Janis

101 ***Waterfalls***, c. 1942
 Graphite and crayon on paper
 14⁹/₁₆ x 11³/₈ inches (36.9 x 28.9 cm)
 Hirshhorn Museum and Sculpture Garden, Smithsonian Institution,
 Washington, D.C. Gift of Joseph H. Hirshhorn, 1966

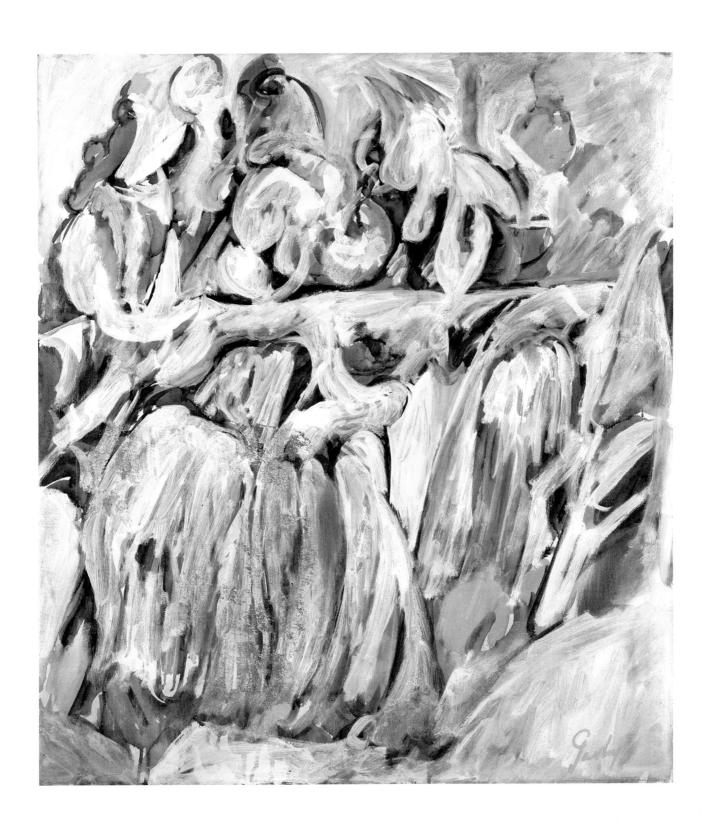

102 *Waterfall*, 1943
Oil on board
30 x 26 inches (76.2 x 66 cm)
Private collection

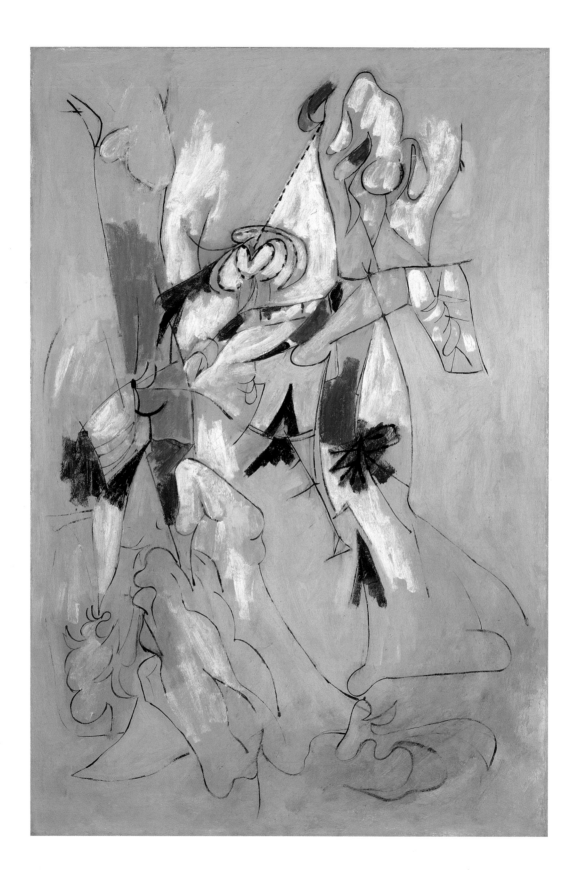

103 *Waterfall*, c. 1943
Oil on canvas
38⅛ x 25⅛ inches (96.8 x 63.8 cm)
Hirshhorn Museum and Sculpture Garden, Smithsonian Institution,
Washington, D.C. Gift of Joseph H. Hirshhorn, 1966

104 *Waterfall*, 1943
Oil on canvas
60½ x 44½ inches (153.7 x 113 cm)
Tate Modern, London. Purchased with assistance
from the Friends of the Tate Gallery

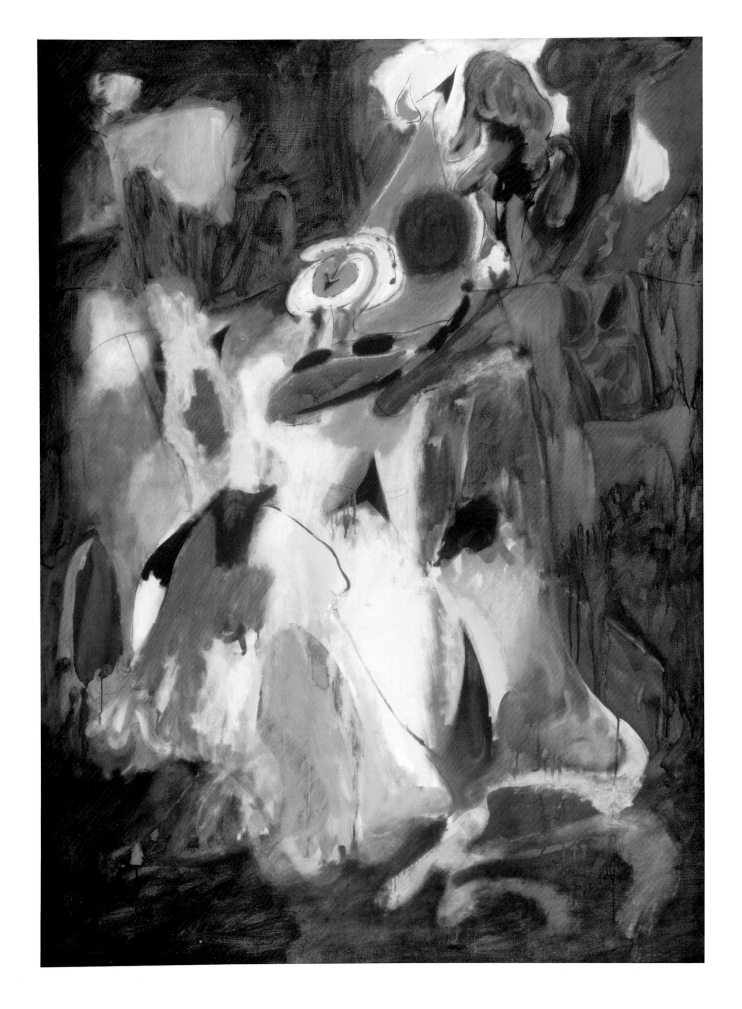

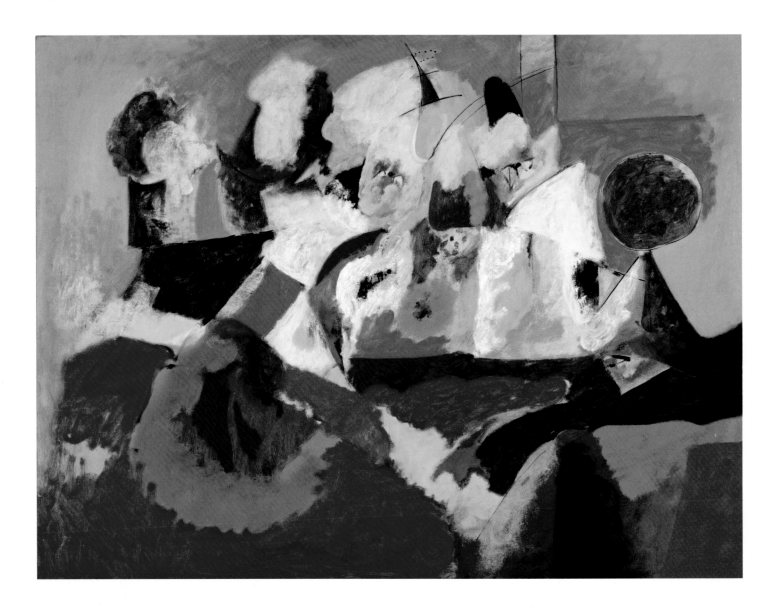

105 *Housatonic Falls*, 1943–44
Oil on canvas
34 x 44 inches (86.4 x 111.8 cm)
Private collection

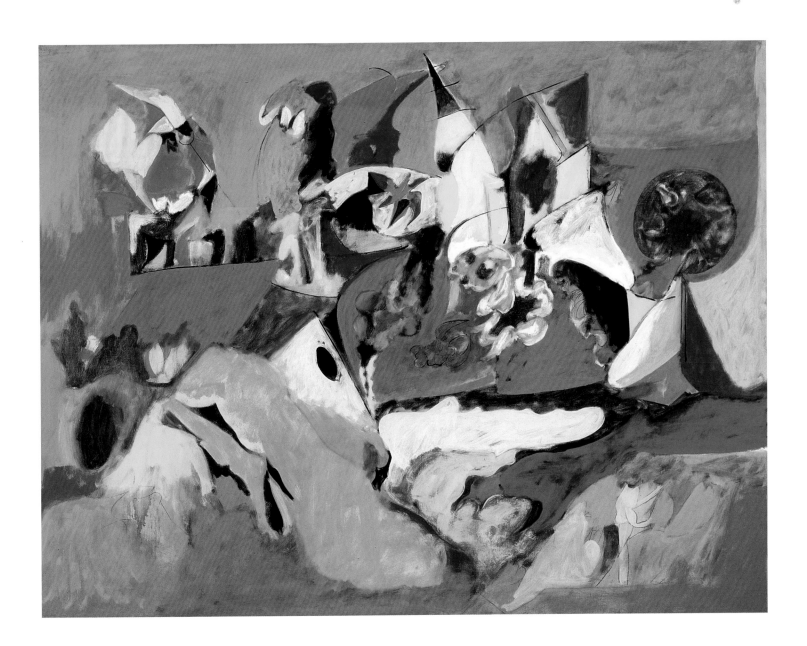

106 *Golden Brown Painting*, 1943–44
Oil on canvas
43 13/16 x 55 9/16 inches (111.2 x 141.1)
Mildred Lane Kemper Art Museum, Washington University in St. Louis.
University purchase, Bixby Fund, 1953

107 *Anatomical Blackboard*, 1943
Graphite and crayon on paper
20¼ x 27⅜ inches (51.4 x 69.5 cm)
Private collection

108 *Drawing (Virginia Landscape)*, 1943–44
Graphite and crayon on paper
17 x 23 inches (43.2 x 58.4 cm)
Private collection

109 *Untitled (Virginia Landscape)*, 1943
Graphite and wax crayon on paper
22⅞ x 29 inches (58.1 x 73.7 cm)
Glenstone

110 *Untitled (Virginia Landscape)*, 1943
Graphite and wax crayon on paper
20³/₄ x 27⁵/₈ inches (52.7 x 70.3 cm)
Collection Calouste Gulbenkian Foundation, Lisbon

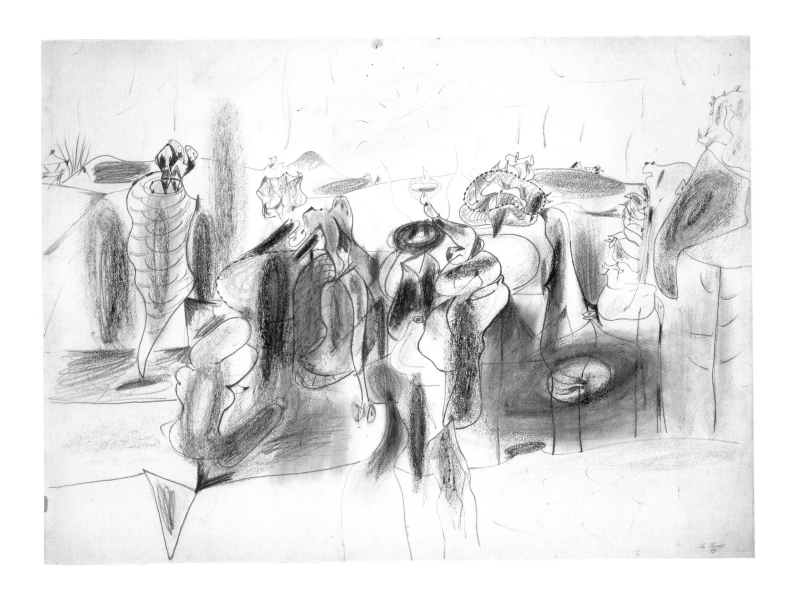

111 *Untitled (Virginia Landscape)*, 1943
Graphite and pastel on paper, mounted on board
20¹/₁₆ x 27¼ inches (51 x 69.2 cm)
Collection of Ms. Andrea Balian, Ms. Katherine Balian, Dr. Bruce Berberian, and
Mr. Mark Berberian, on long-term loan to the Museum of Fine Arts, Boston, 1976

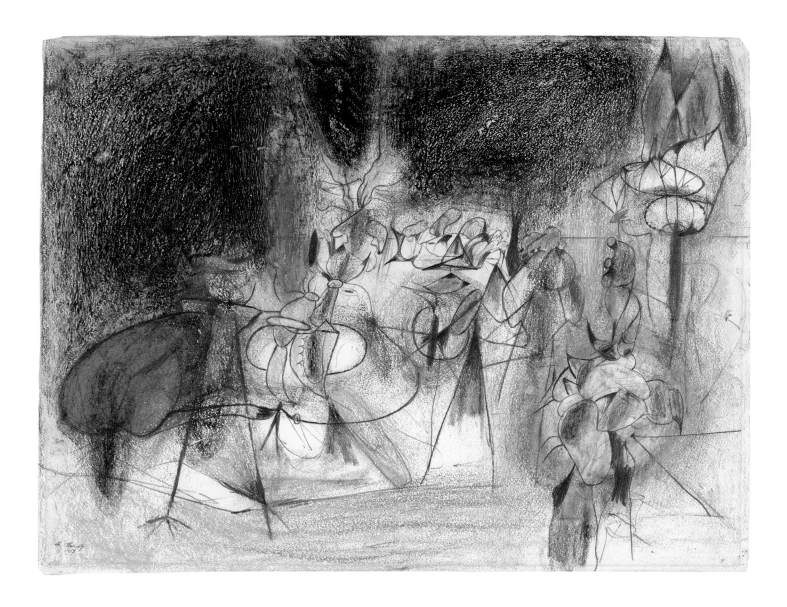

112 *Untitled (Virginia Landscape)*, 1943
Wax crayon and graphite on paper
20 x 26¾ inches (50.8 x 67.9 cm)
Solomon R. Guggenheim Museum, New York. Gift, Rook McCulloch, 1977

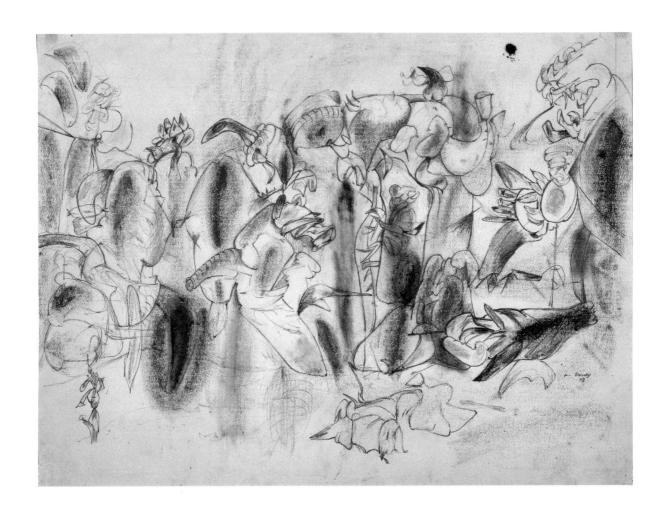

113 ***Study for "The Liver Is the Cock's Comb,"*** 1943
Graphite and crayon on paper
19 x 24³⁄₄ inches (48.3 x 62.9 cm)
The Museum of Contemporary Art, Los Angeles.
Bequest of Marcia Simon Weisman

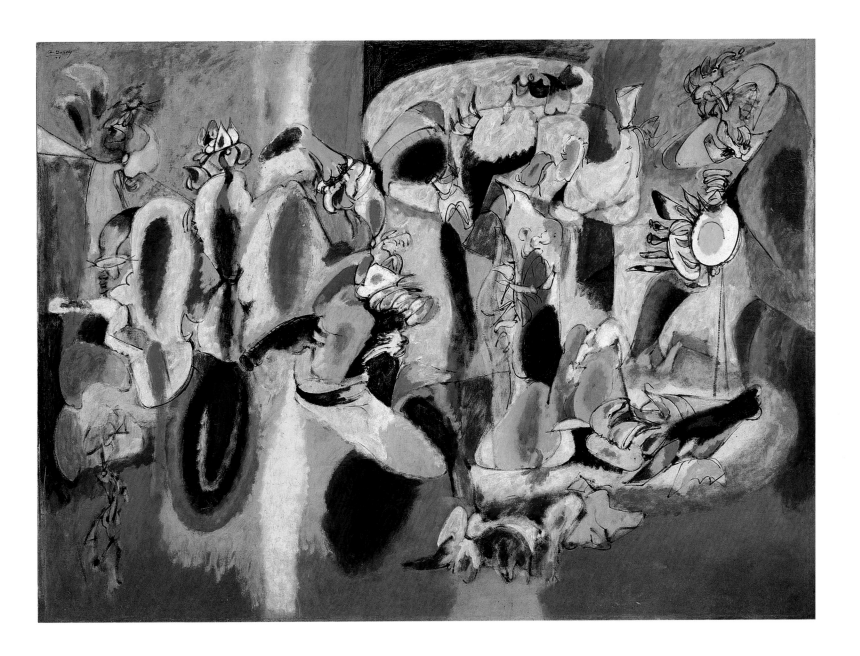

114 *The Liver Is the Cock's Comb*, 1944
Oil on canvas
73¼ x 98 inches (186.1 x 248.9 cm)
Albright-Knox Art Gallery, Buffalo, New York.
Gift of Seymour H. Knox, 1956

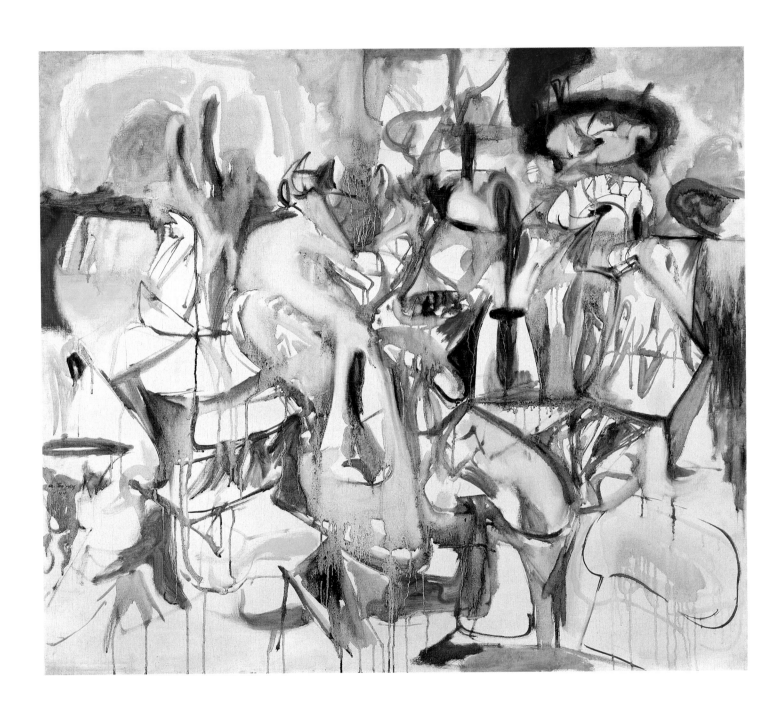

115 *How My Mother's Embroidered Apron Unfolds in My Life*, 1944
Oil on canvas
40 x 45¹/₁₆ inches (101.6 x 114.4)
Seattle Art Museum. Gift of Mr. and Mrs. Bagley Wright

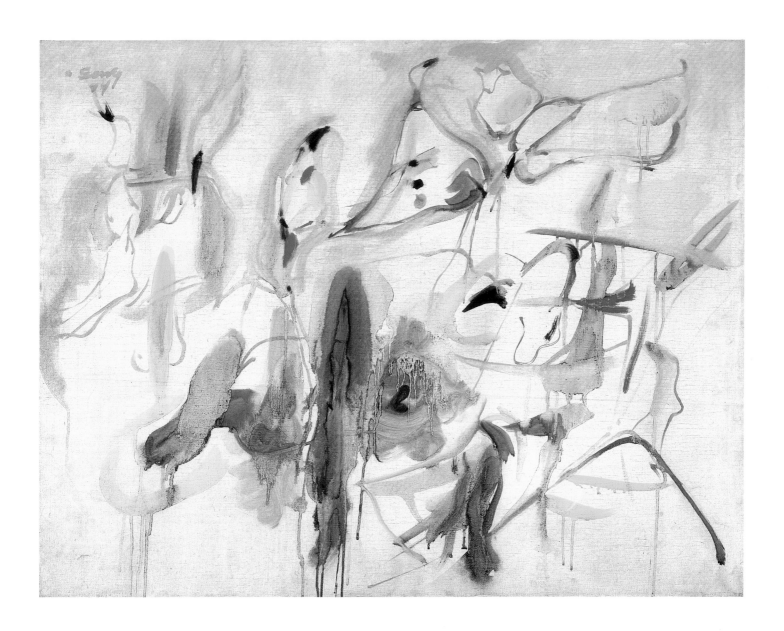

116 *Love of the New Gun*, 1944
Oil on canvas
29¾ x 37¾ inches (75.6 x 95.9 cm)
The Menil Collection, Houston

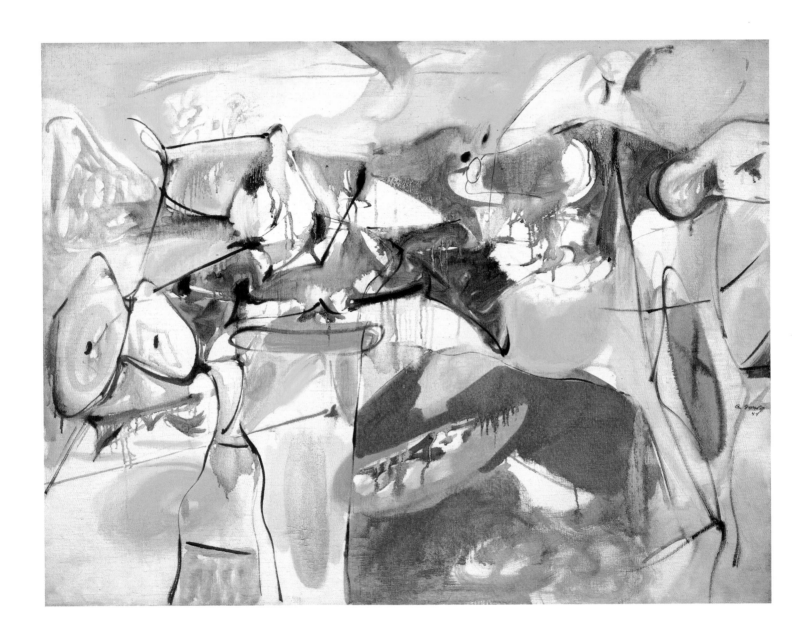

117 *Cornfield of Health*, 1944
Oil on canvas
34 x 44 inches (86.4 x 111.8 cm)
Private collection

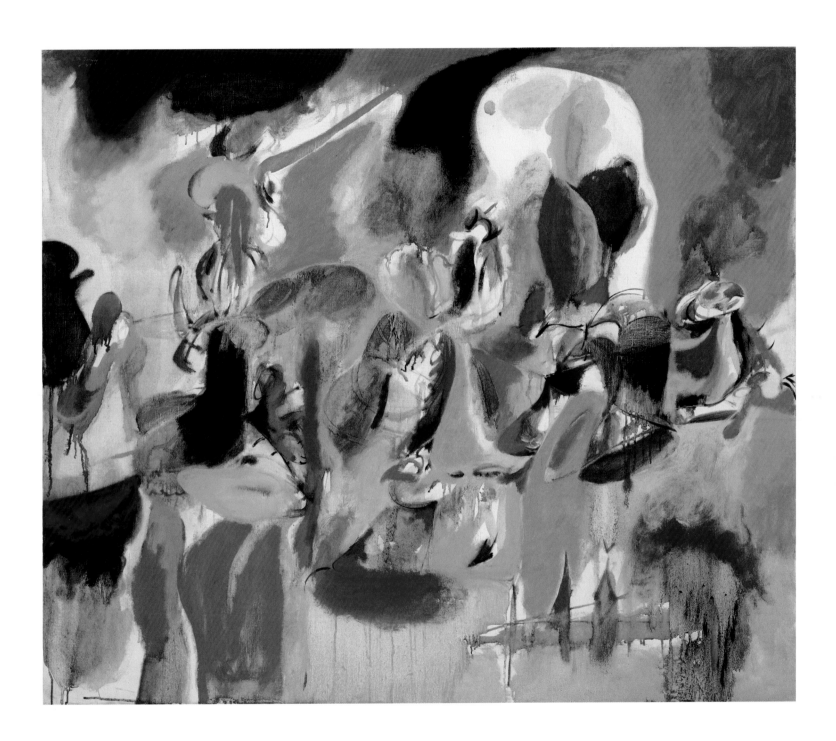

118 *Water of the Flowery Mill*, 1944
Oil on canvas
42¼ x 48¾ inches (107.3 x 123.8 cm)
The Metropolitan Museum of Art, New York. George A. Hearn Fund, 1956

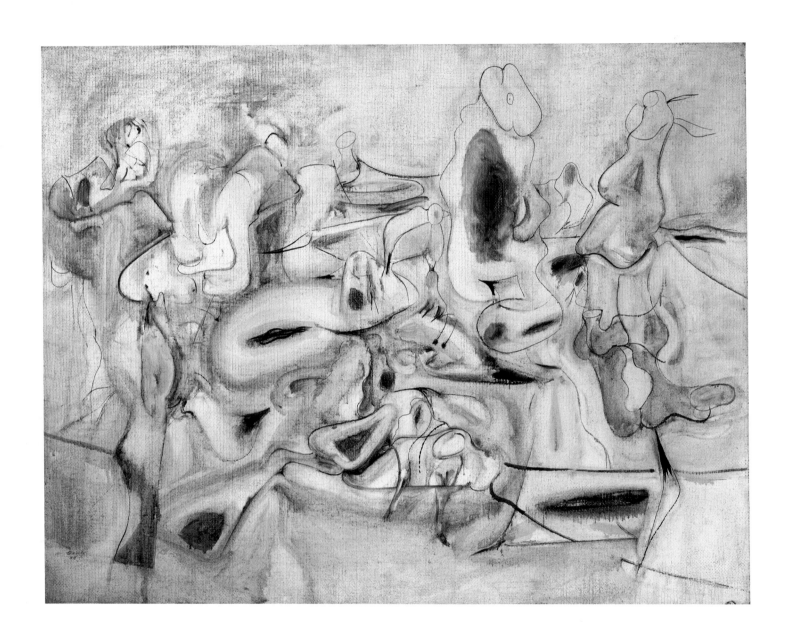

119 *Good Afternoon, Mrs. Lincoln*, 1944
Oil on canvas
30 x 38 inches (76.2 x 96.5 cm)
Collection of Barney A. Ebsworth

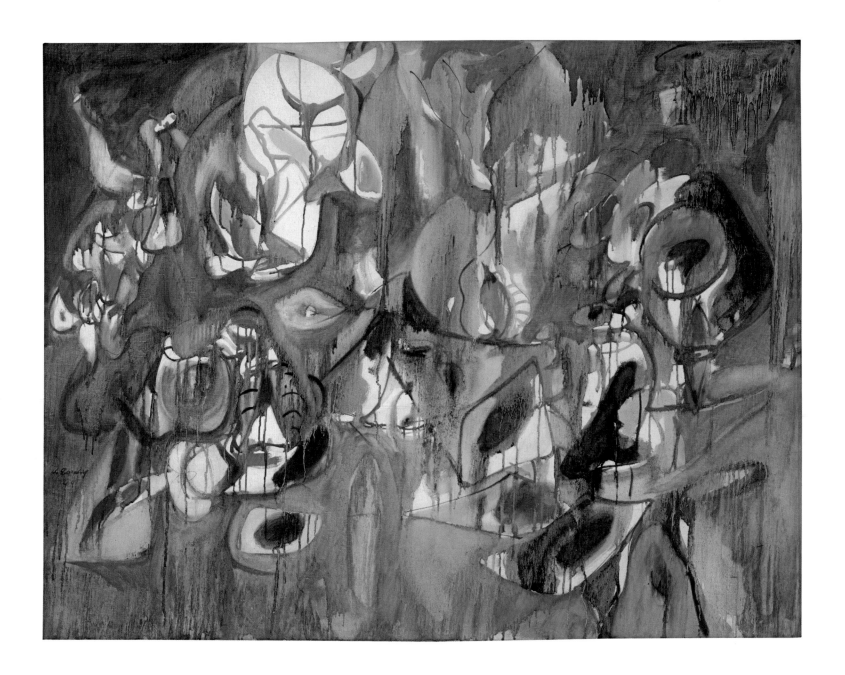

120 *One Year the Milkweed*, 1944
Oil on canvas
37 1/16 x 46 15/16 inches (94.2 x 119.3 cm)
National Gallery of Art, Washington, D.C. Ailsa Mellon Bruce Fund, 1979

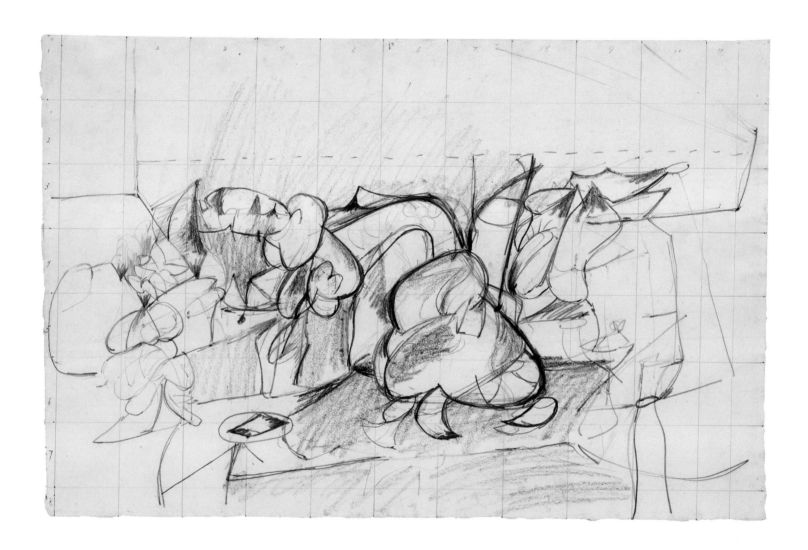

121 *Study for "Scent of Apricots on the Fields,"* c. 1944 *
Wax crayon and graphite on paper
22¼ x 30 inches (56.5 x 76.2 cm)
Private collection

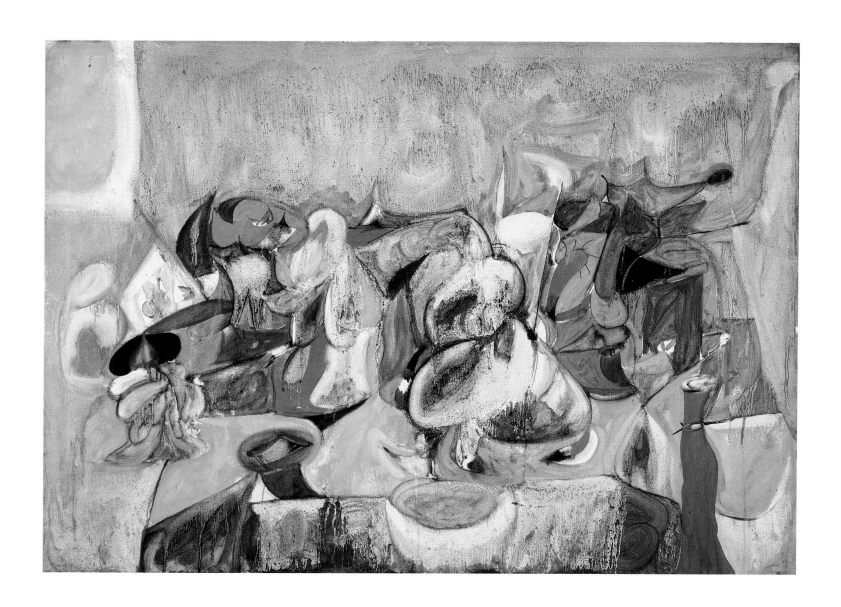

122 *Scent of Apricots on the Fields*, 1944
Oil on canvas
31 x 44 inches (78.7 x 111.8 cm)
Private collection

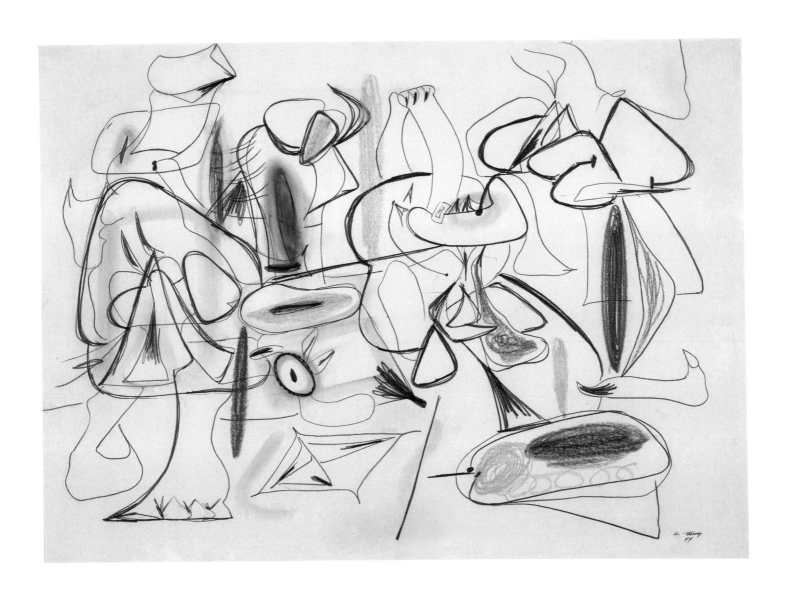

123 *Study for "They Will Take My Island,"* 1944
Wax crayon and graphite on paper
22¼ x 30 inches (56.5 x 76.2 cm)
Brooklyn Museum, New York. Dick S. Ramsay Fund

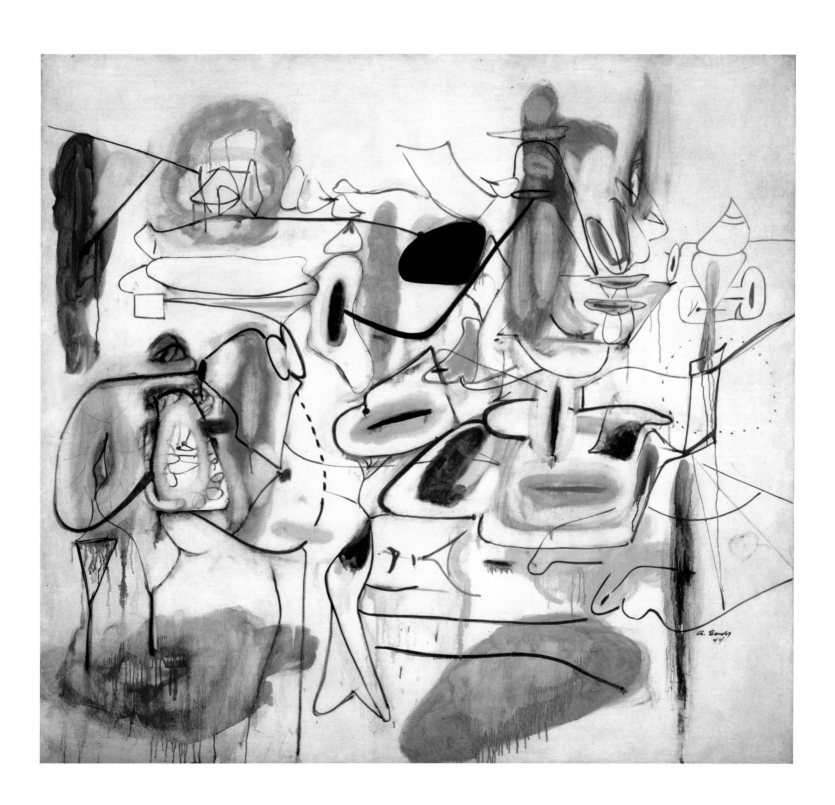

124 *Painting*, 1944
Oil on canvas
65¾ x 70¼ inches (167 x 178.2 cm)
Peggy Guggenheim Collection, Venice
(Solomon R. Guggenheim Foundation, New York)

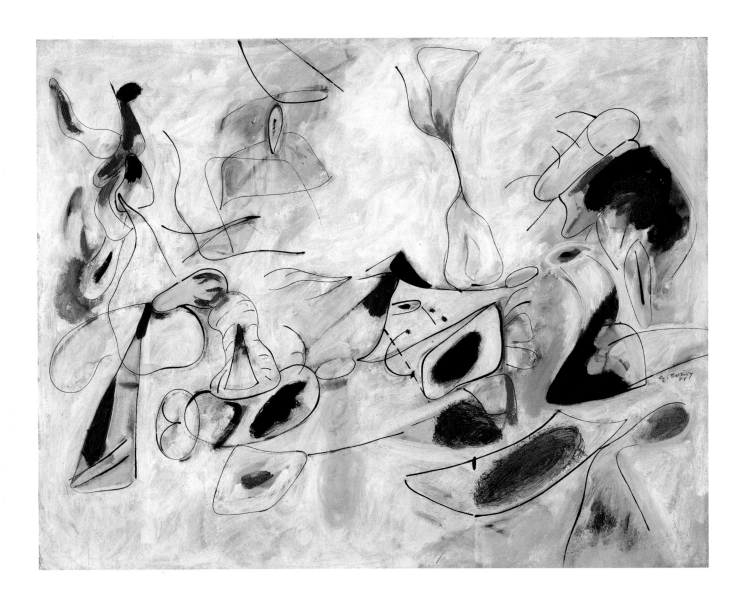

125 *Untitled*, 1944
Oil on cardboard
24 x 30⅛ inches (61 x 76.5 cm)
Glenstone

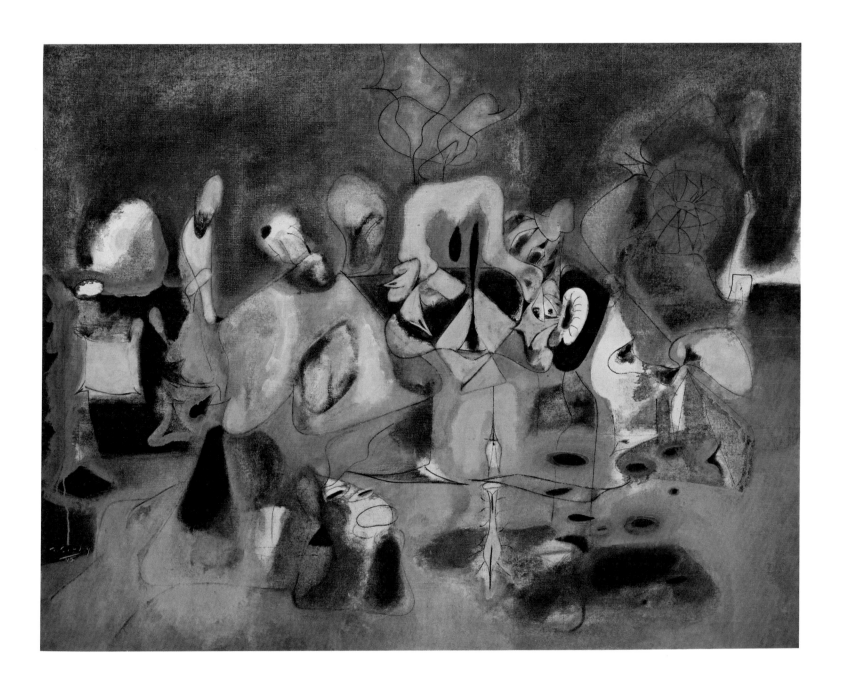

126 *Diary of a Seducer,* 1945
Oil on canvas
50 x 62 inches (126.7 x 157.5 cm)
The Museum of Modern Art, New York.
Gift of Mr. and Mrs. William A. M. Burden, 1985

127 *Untitled (Drawing for "Young Cherry Trees Secured against Hares")*, 1945
Graphite and colored crayon on paper
19 x 24 inches (48.3 x 61 cm)
Kolodny Family Collection

128 *Untitled (Drawing for "Young Cherry Trees Secured against Hares")*, 1945
India ink and gouache on gray paper
12¹⁄₈ x 14³⁄₈ inches (30.8 x 36.5 cm)
Collection of Timothy Baum

129 *Untitled (Drawing for "Young Cherry Trees Secured against Hares")*, 1945
India ink and red crayon on gray paper
9 x 5¾ inches (22.9 x 14.6 cm)
Collection of Doreen and Gilbert Bassin

130 *Untitled (Drawing for "Young Cherry Trees Secured against Hares")*, 1945
Ink and gouache on paper
24 x 18 inches (61 x 48 cm)
Collection of Marcel and David Fleiss, Galerie 1900–2000, Paris

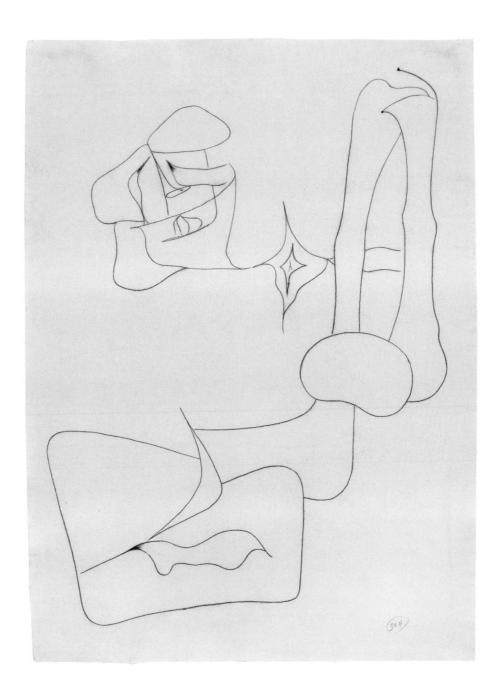

131 *Study for "Nude,"* 1946
Ink on paper
9¹⁄₂ x 6¹⁄₄ inches (24.1 x 15.9 cm)
Private collection

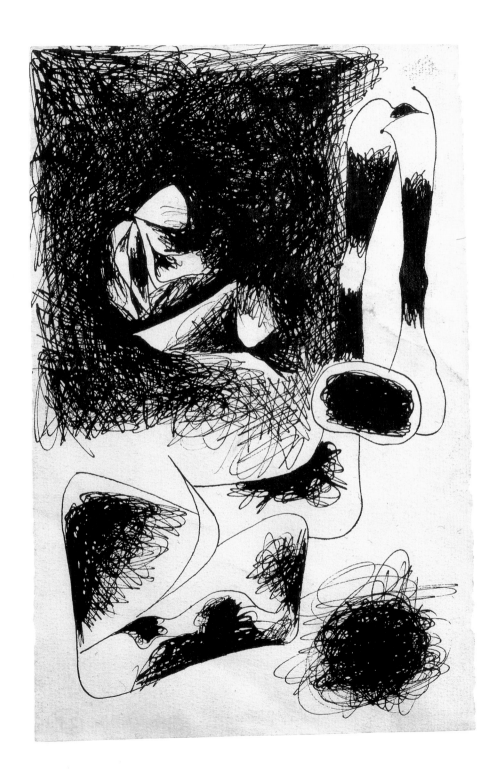

132 *Study for "Nude,"* 1946
Pen and ink on paper
10⅛ x 6⅛ inches (25.6 x 15.5 cm)
Private collection

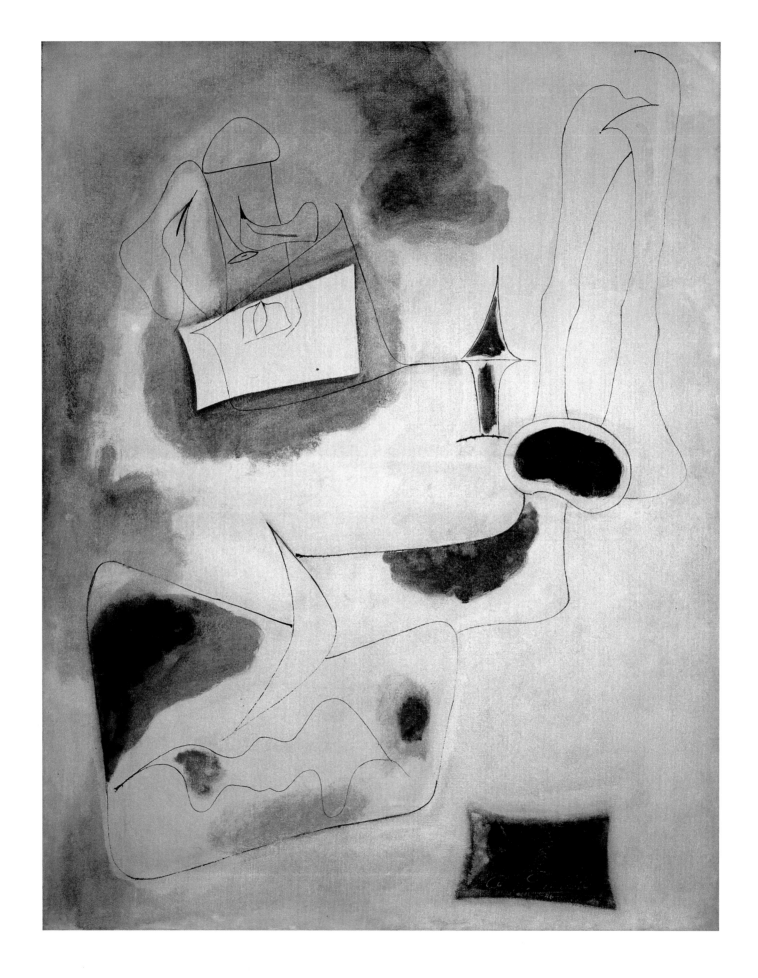

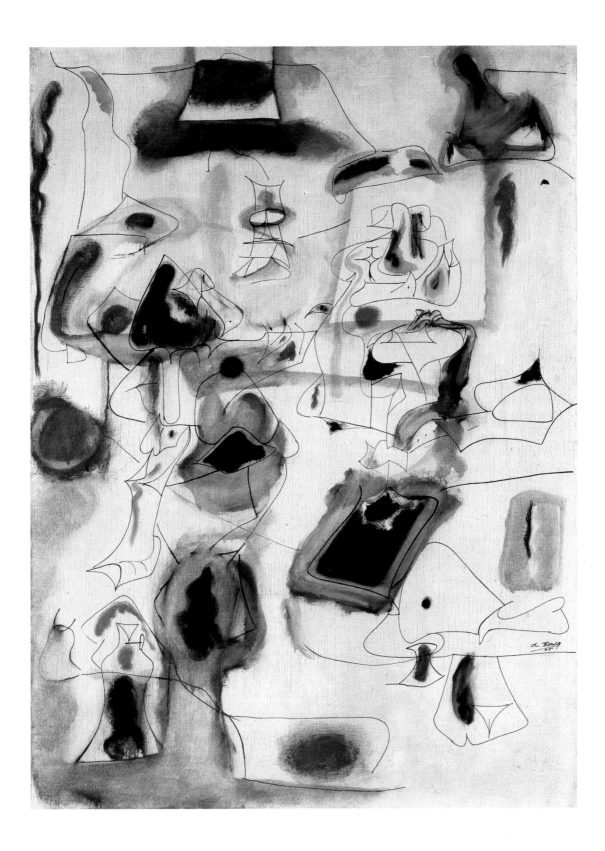

133 *Nude*, 1946
Oil on canvas
50⅛ x 38⅛ inches (127.3 x 96.9 cm)
Hirshhorn Museum and Sculpture Garden, Smithsonian Institution,
Washington, D.C. Gift of the Joseph H. Hirshhorn Foundation, 1966

134 *The Unattainable*, 1945
Oil on canvas
41¼ x 29¼ inches (104.8 x 74.3 cm)
The Baltimore Museum of Art. Purchase with exchange funds from Blanche Adler Bequest,
Frederic W. Cone, William A. Dickey, Jr., Nelson and Juanita Greif Gutman Collection,
Wilmer Hoffman, Mr. and Mrs. Albert Lion, Sadie A. May Bequest, Philip B. Perlman
Bequest, Leo M. Rogers, Mrs. James N. Rosenberg, and Paul Vallotton Fund, 1964

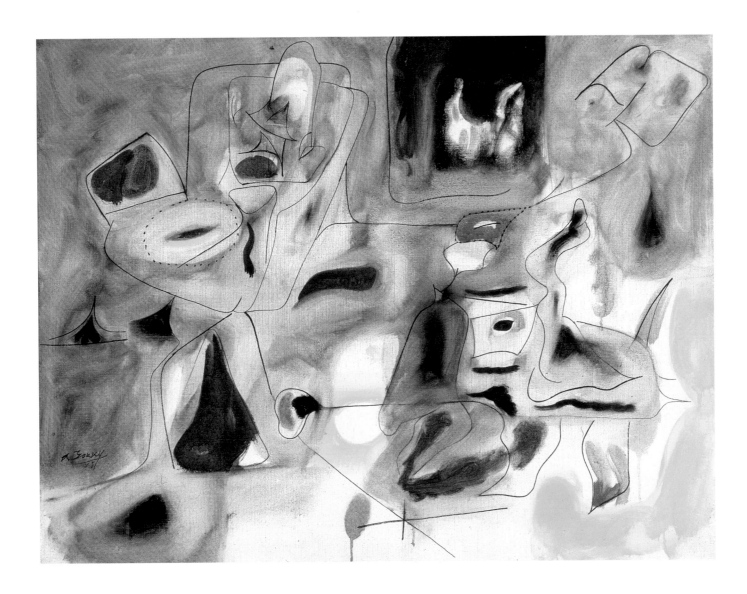

135 *Good Hope Road II (Hugging)*, 1945
Oil on canvas
25½ x 32½ inches (64.7 x 82.7 cm)
Museo Thyssen-Bornemisza, Madrid

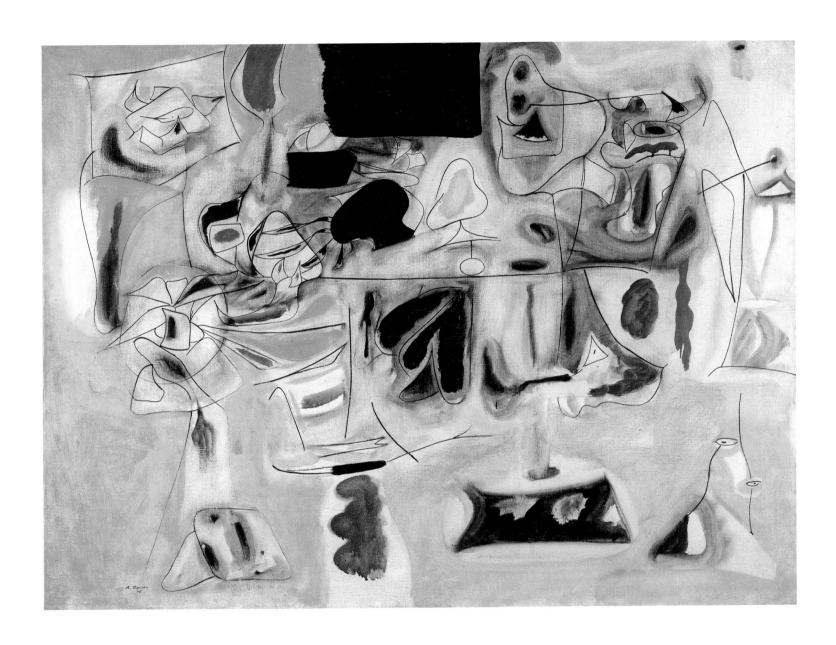

136 *Landscape Table*, 1945
Oil on canvas
36 x 48 inches (91.4 x 121.9 cm)
Musée national d'art moderne, Centre Georges Pompidou, Paris.
Purchased, 1971

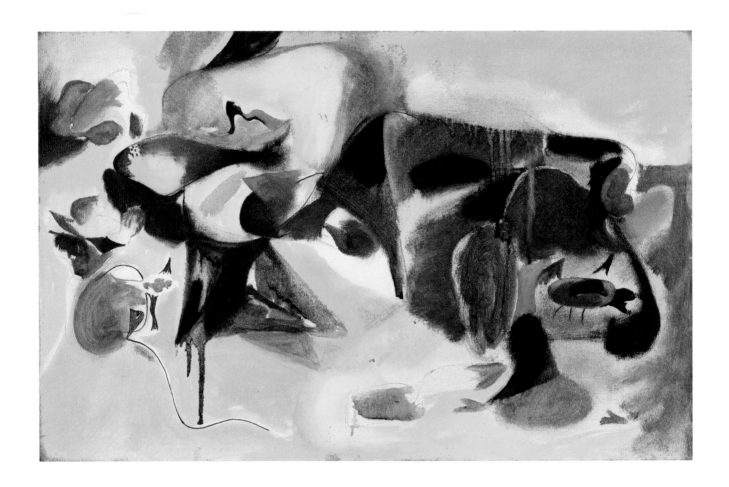

137 *Untitled*, 1944
Oil on canvas
13⅝ x 20½ inches (34.6 x 52.1 cm)
Private collection

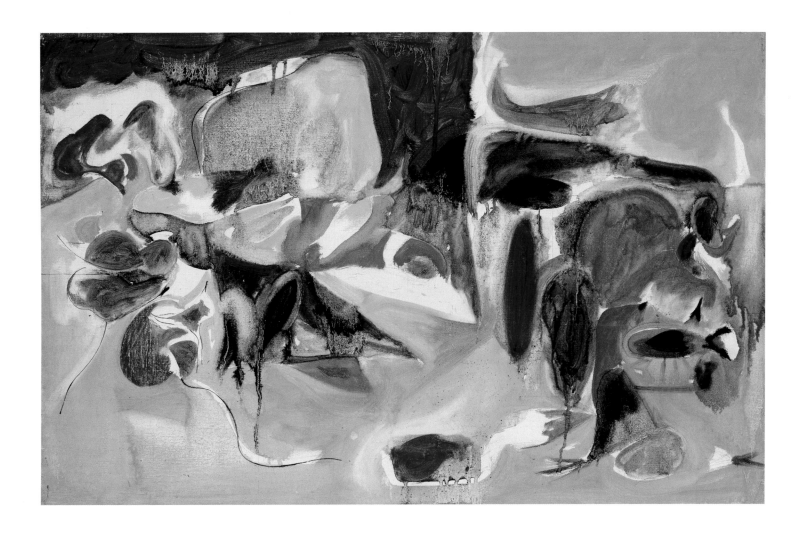

138 *Untitled*, 1944 *
Oil and graphite on canvas
19⁵/₈ x 29⁷/₈ inches (49.8 x 75.8 cm)
National Gallery of Australia, Canberra. Purchased 1972

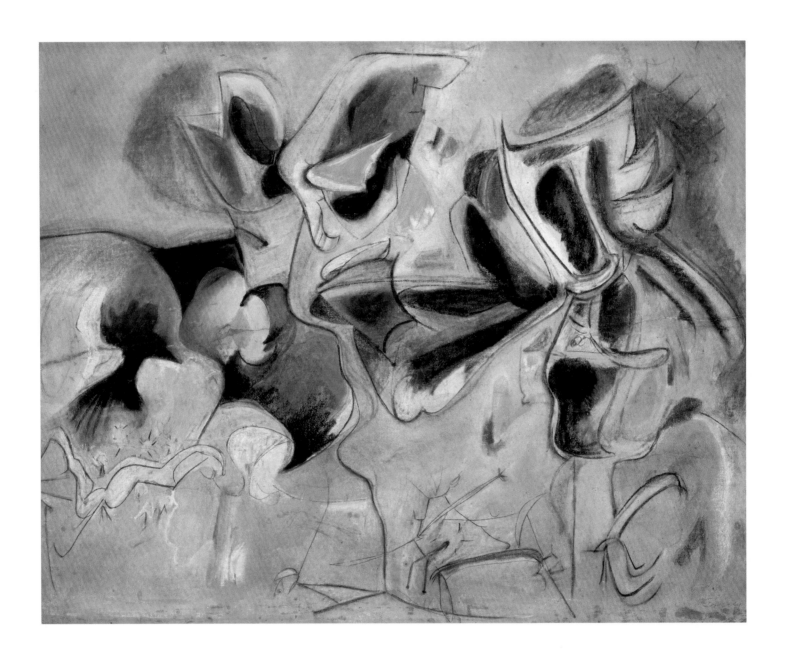

139 *Apple Orchard*, c. 1943–46
Pastel on paper
42 x 52 inches (106.7 x 132.1 cm)
Private collection

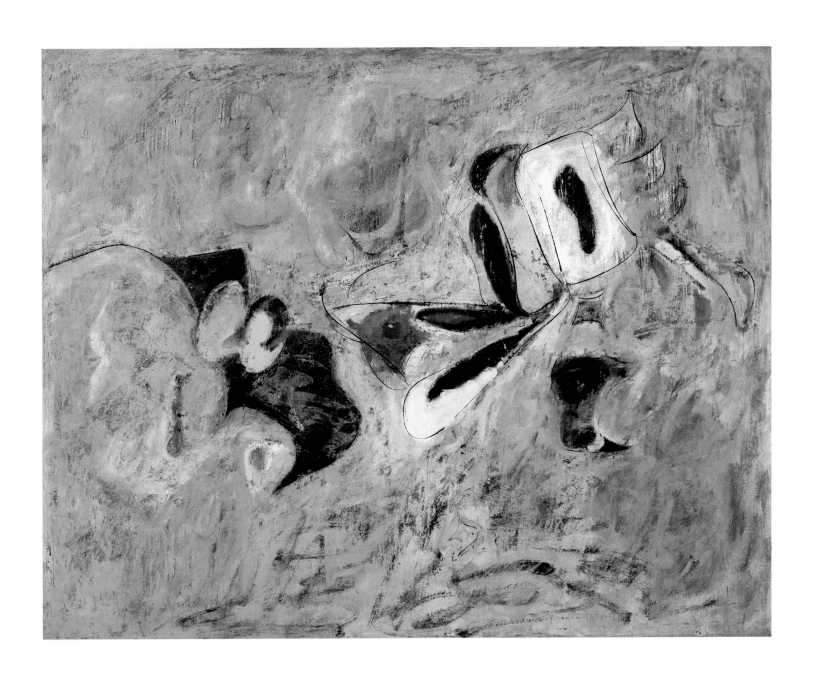

140 *Apple Orchard*, c. 1943–47
Oil on canvas
43³⁄₄ x 53¹⁄₂ inches (111.1 x 135.9 cm)
Collection of Samuel and Ronnie Heyman

141 *Armenian Plow II (Haikakan Gutan II)*, 1945
Wood and aluminum
6^{7}/8 x 24^{1}/8 x 5^{5}/8 inches (17.5 x 61.3 x 14.3 cm)
Diocese of the Armenian Church of America (Eastern) on Deposit at the
Calouste Gulbenkian Foundation, Lisbon

142 *Armenian Plow I (Haikakan Gutan I)*, 1944
Wood
7^{5}/8 x 6^{7}/8 x 4^{9}/16 inches (19.4 x 17.5 x 11.6 cm)
Diocese of the Armenian Church of America (Eastern) on Deposit
at the Calouste Gulbenkian Foundation, Lisbon

143 *Armenian Plow III (Haikakan Gutan III)*, 1947
Wood
8^{1}/8 x 28^{5}/8 x 6 inches (20.6 x 72.7 x 15.2 cm)
Diocese of the Armenian Church of America (Eastern) on Deposit
at the Calouste Gulbenkian Foundation, Lisbon

144 *Study for "The Plow and the Song,"* 1944
Graphite and crayon on paper
19 x 25 ⁵/₁₆ inches (48.3 x 64.3 cm)
Allen Memorial Art Museum, Oberlin College, Ohio.
Friends of Art Fund, 1956

145 *Study for "The Plow and the Song,"* 1945–46
Two kinds of graphite, colored wax crayons, and spatters of oil paint, squared
in graphite and brown crayon, on cream wove paper mounted on masonite
18⅛ x 25⁷⁄₁₆ inches (46 x 64.6 cm)
Harvard University Art Museums, Fogg Art Museum, Cambridge, Massachusetts.
Gift of Lois Orswell, 1993

146 *The Plow and the Song*, 1946
Graphite, charcoal, crayon, pastel, and oil on wove paper
48¹/₁₆ x 59³/₁₆ inches (122 x 150.3 cm)
National Gallery of Art, Washington, D.C. Gift of the Avalon Foundation, 1971

147 **The Plow and the Song II**, 1946
Oil on canvas
52¼ x 61½ inches (132.7 x 156.2 cm)
The Art Institute of Chicago. Mr. and Mrs. Lewis Larned Coburn Fund, 1963

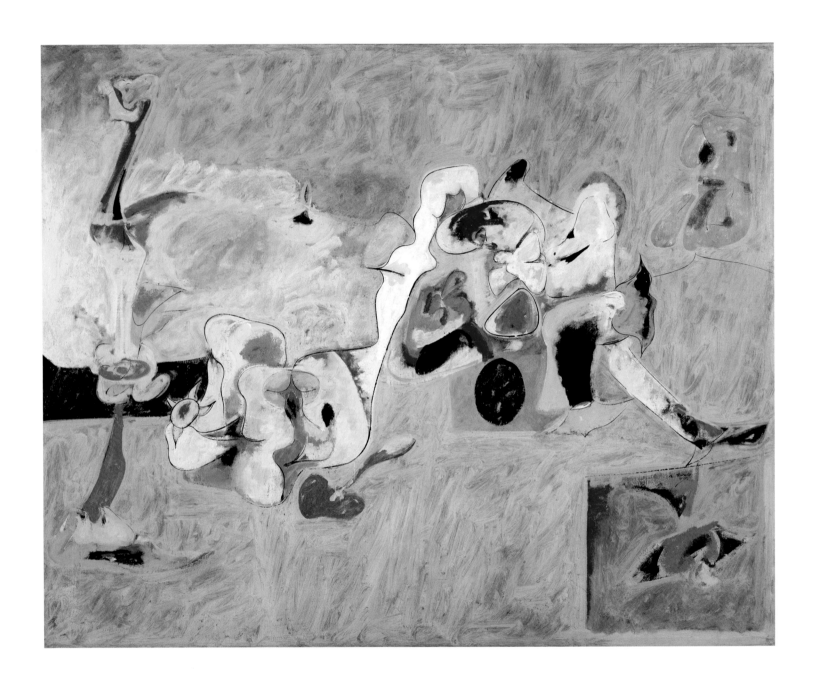

148 *The Plow and the Song*, 1947
Oil on canvas
52⅛ x 64¼ inches (132.4 x 163.2 cm)
Private collection

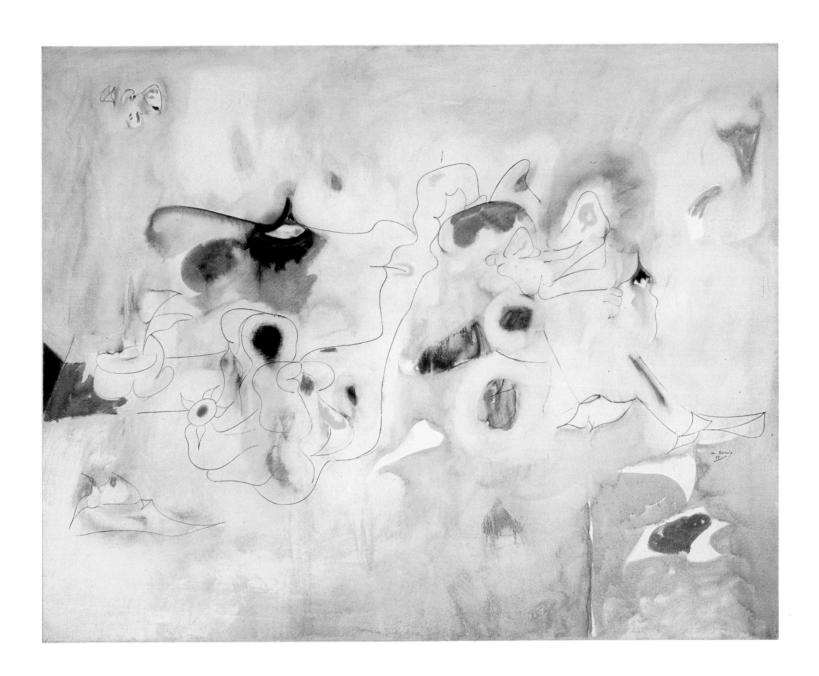

149 *The Plow and the Song*, 1947

Oil on canvas

50$\frac{1}{2}$ x 62$\frac{5}{8}$ inches (128.3 x 159.1 cm)

Allen Memorial Art Museum, Oberlin College, Ohio. R. T. Miller, Jr. Fund, 1952

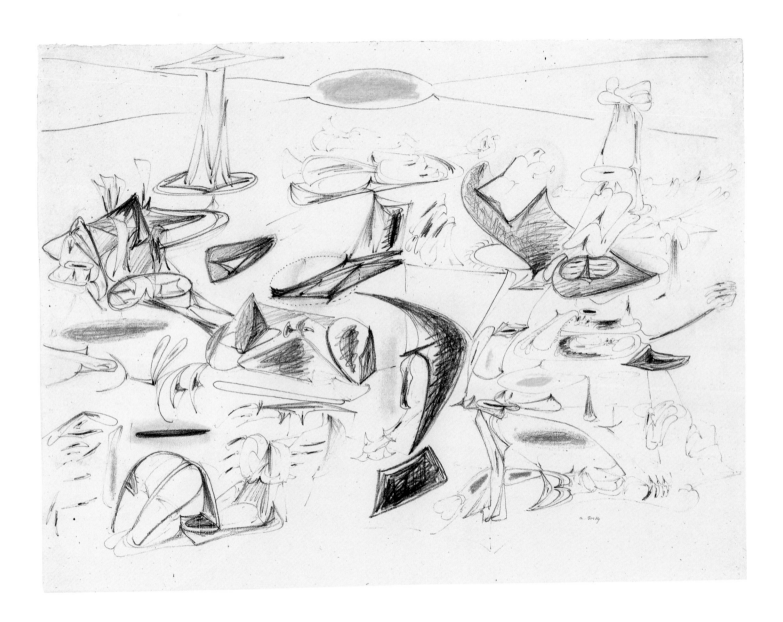

150 *Virginia—Summer*, 1946
Graphite and crayon on paper
18 $^{15}/_{16}$ x 24 $^{3}/_{8}$ inches (48.1 x 62 cm)
The Museum of Fine Arts, Houston. Gift of Oveta Culp Hobby

151 *Untitled*, 1946
Oil pastel and graphite on paper
19⅛ x 24⅞ inches (48.6 x 63.2 cm)
Collection of Harry W. and Mary Margaret Anderson

152 *Drawing*, 1946
Graphite and crayon on paper
18¾ x 22¾ inches (47.6 x 57.8 cm)
Private collection

153 *Untitled*, 1946
Graphite and colored crayon on paper
19 x 25 inches (48.3 x 63.5 cm)
Yale University Art Gallery, New Haven, Connecticut. Frederick B. Benenson
in memory of Charles B. Benenson

154 *Untitled*, 1946
Graphite and crayon on paper
19 x 25 inches (48.3 x 63.5 cm)
Paula Cooper Gallery, New York

155 *Abstract*, 1946
Ink and crayon on paper
19 x 25 inches (48.3 x 63.5 cm)
Indiana University Art Museum, Bloomington

156 *Untitled*, 1946
Graphite and colored crayon on paper
19 x 25 inches (48.3 x 63.5 cm)
Private collection

157 *Fireplace in Virginia*, 1946
Ink and crayon on paper
7 7/8 x 11 inches (20 x 27.9 cm)
Private collection

158 *Fireplace in Virginia*, 1946
Graphite and crayon on paper
21³/₄ x 29¹/₂ inches (55.2 x 74.9 cm)
Collection of Mr. and Mrs. Stanley R. Gumberg

159 *Study for "Agony,"* 1946–47
Pen and ink with crayon on paper
8½ x 11 inches (21.6 x 27.9 cm)
North Carolina Museum of Art, Raleigh. Gift of Mr. and Mrs. John Foushee

160 *Study for "Agony,"* 1946–47
Crayon, graphite, and wash on paper
22¹/₂ x 29⁵/₈ inches (57.2 x 75.2 cm)
Private collection

161 *Study for "Agony,"* 1946
Graphite, wax crayon, and ink on paper
18$\frac{1}{2}$ x 23$\frac{3}{4}$ inches (47 x 60.3 cm)
Solomon R. Guggenheim Museum, New York. Gift, Rook McCulloch, 1979

162 *Study for "Agony,"* c. 1946–47
Graphite and crayon on paper
22⁵/₈ x 28³/₄ inches (57.5 x 73 cm)
Private collection

163 *Study for "Agony,"* c. 1946
Crayon and graphite on paper
18 x 24 inches (45.7 x 61 cm)
Private collection

164 *Two Figures in an Interior (Agony)*, c. 1946–47
Graphite, charcoal, pastel, and gouache on paper
40 x 51 inches (101.6 x 129.5 cm)
Private collection

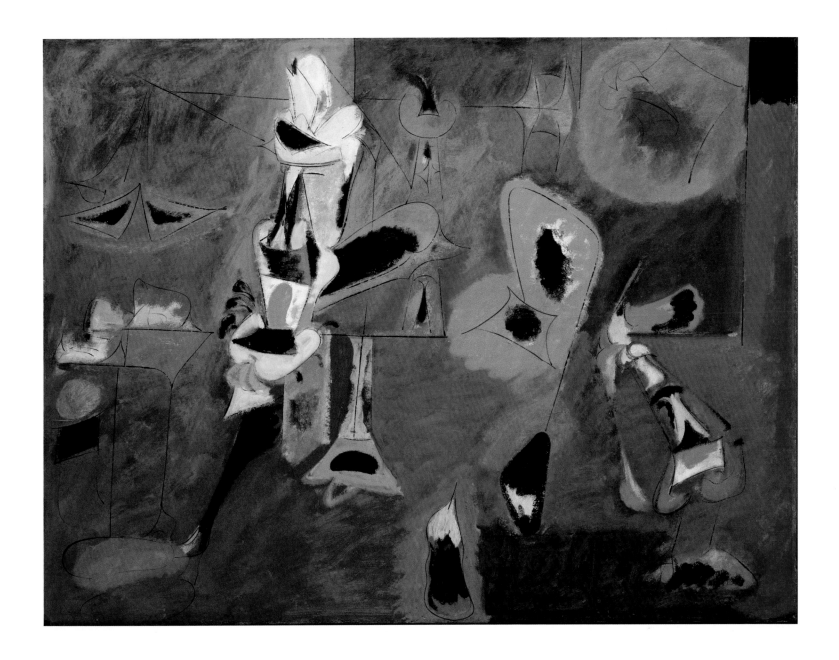

165 *Agony*, 1947
Oil on canvas
40 x 50½ inches (101.6 x 128.3 cm)
The Museum of Modern Art, New York. A. Conger Goodyear Fund, 1950

CHARRED BELOVED

plates 166–68

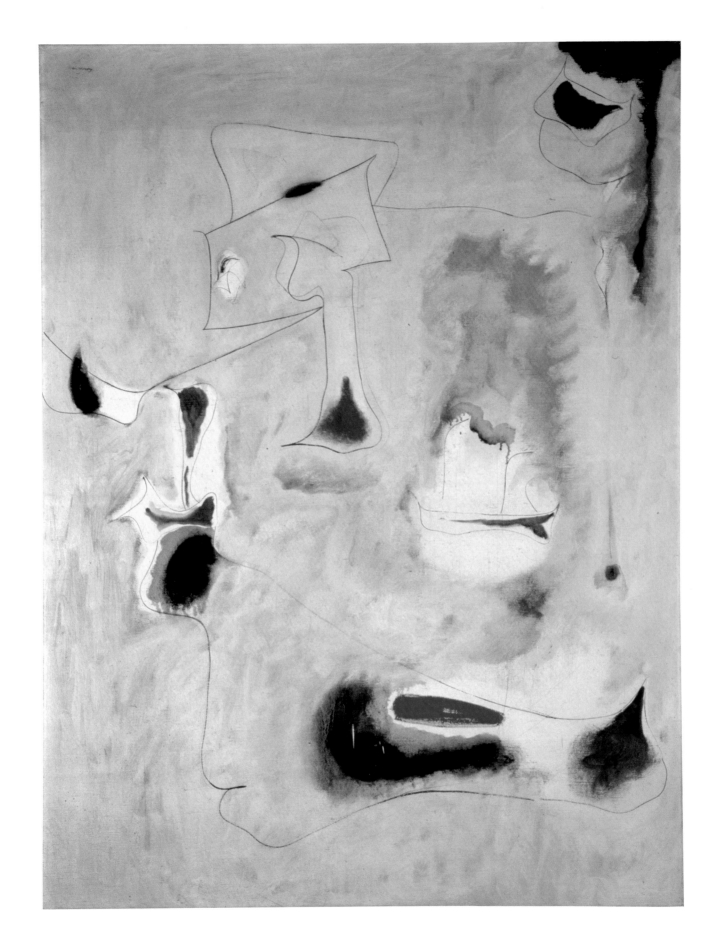

166 *Charred Beloved I*, 1946
Oil on canvas
53$\frac{1}{2}$ x 39$\frac{1}{2}$ inches (135.9 x 100.3 cm)
Collection of David Geffen

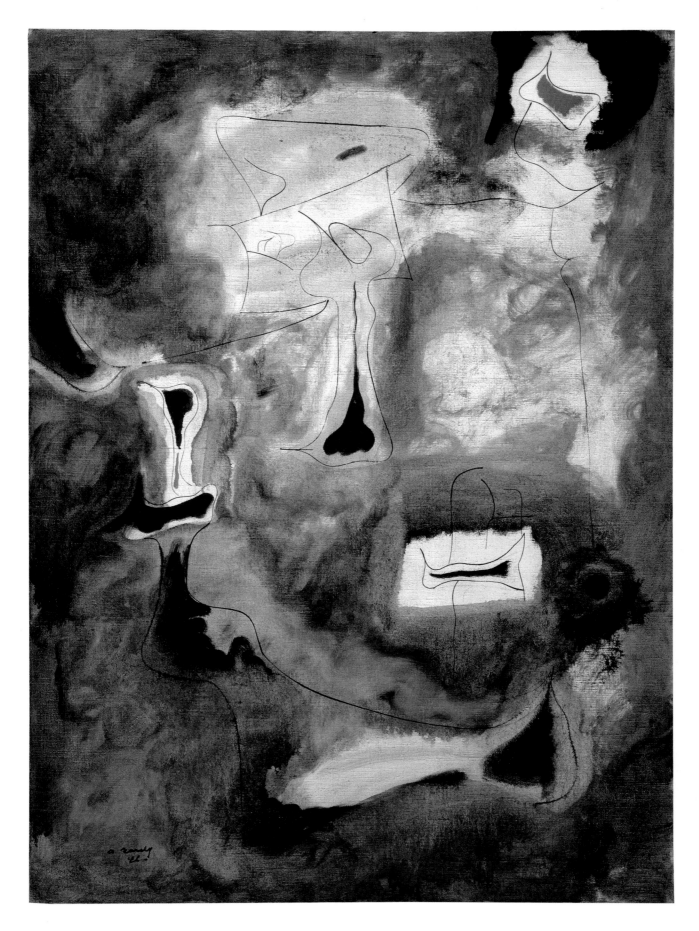

167 *Charred Beloved II*, 1946
Oil on canvas
54 x 40 inches (137 x 101.6 cm)
National Gallery of Canada, Ottawa. Purchased 1971

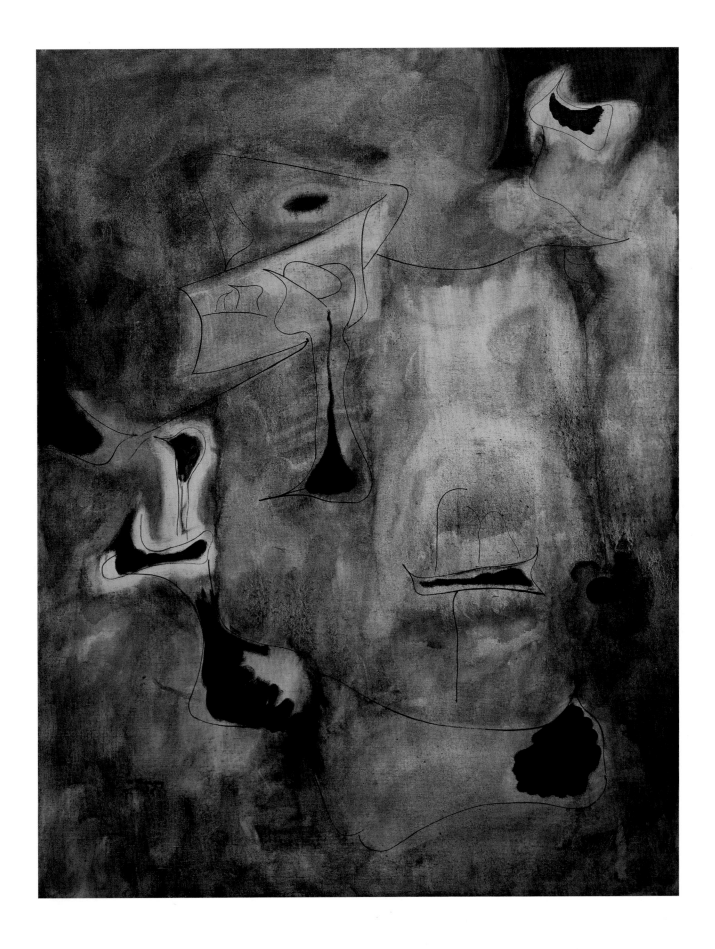

168 *Charred Beloved III*, 1946
Oil on linen
50 x 38½ inches (127 x 97.8 cm)
Collection of Mr. and Mrs. Meredith Long

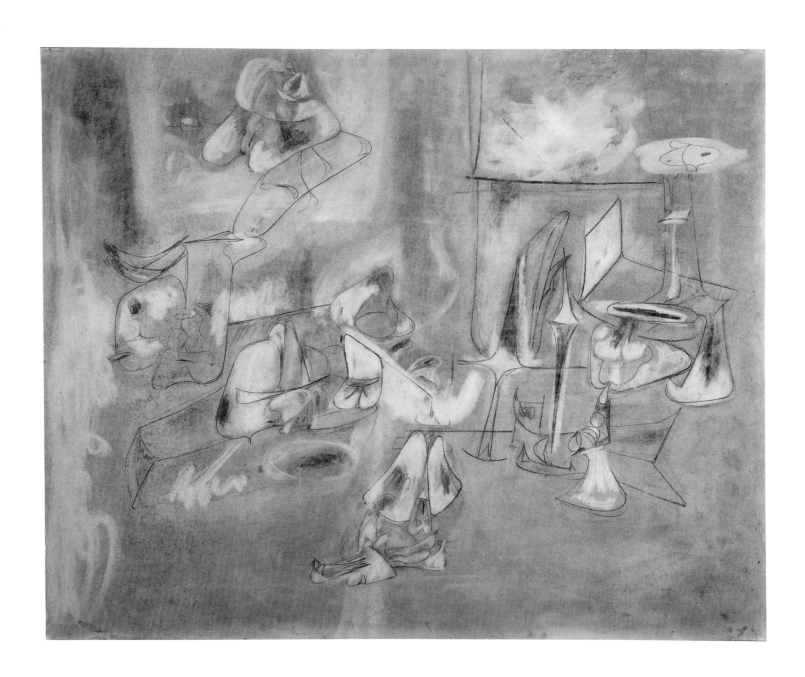

169 *Study for "The Calendars,"* 1946
Charcoal and colored chalks on a ground of rubbed charcoal heavily modeled by erasures,
on off-white wove paper, mounted on Kraft paper and wrapped around a strainer
34⅛ x 41¼ inches (86.7 x 104.8 cm)
Harvard University Art Museums, Fogg Art Museum, Cambridge, Massachusetts.
Gift of Lois Orswell, 1976

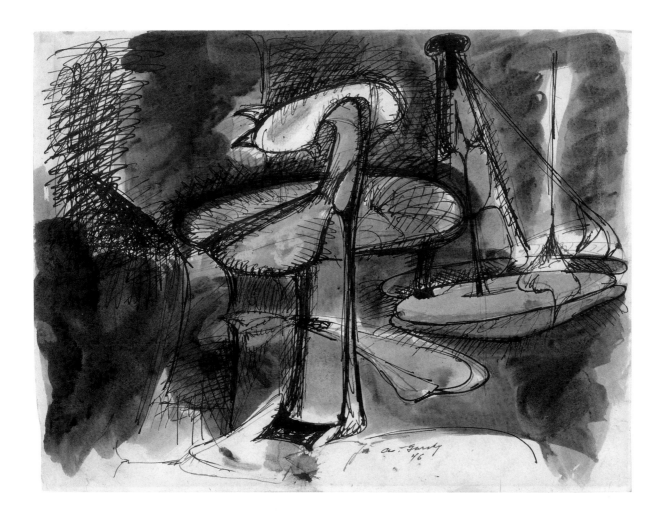

170 *Study for "The Betrothal,"* 1946 *
Watercolor, ink, and colored crayon on paper
8¹/₂ x 10⁷/₈ inches (21.6 x 27.6 cm)
Private collection

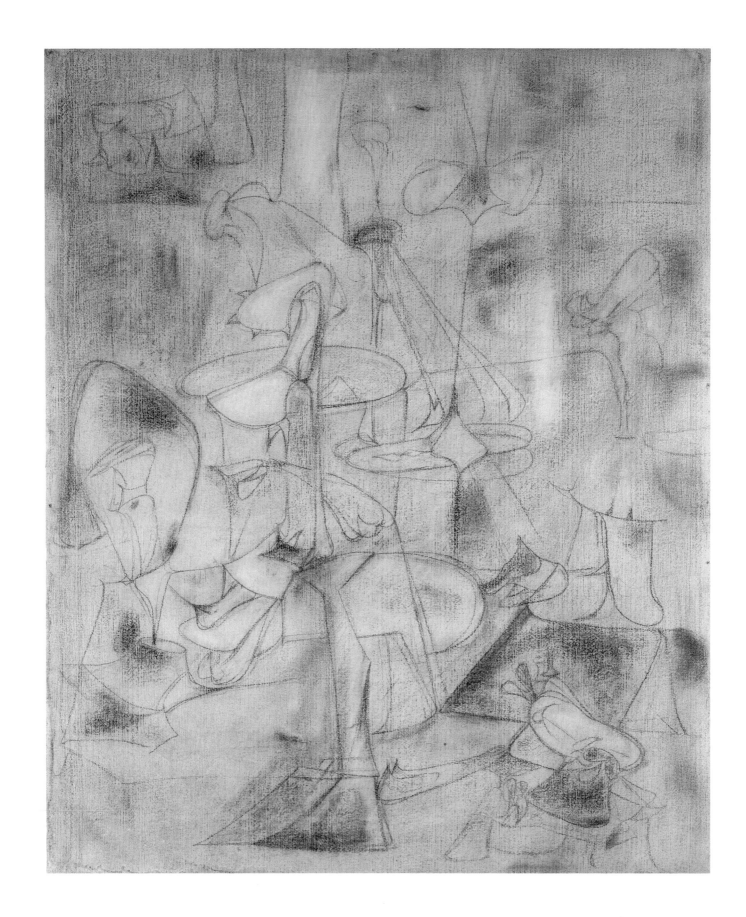

171 *Study for "The Betrothal,"* 1947
Graphite, charcoal, pastel, and crayon on paper
49³⁄₄ x 40¹⁄₈ inches (126.4 x 101.9 cm)
Collection of Donald L. Bryant, Jr.

172 *The Betrothal*, 1947
Oil on canvas
50⁵⁄₈ x 39¹⁄₄ inches (128.6 x 99.7 cm)
Yale University Art Gallery, New Haven, Connecticut.
The Katherine Ordway Collection

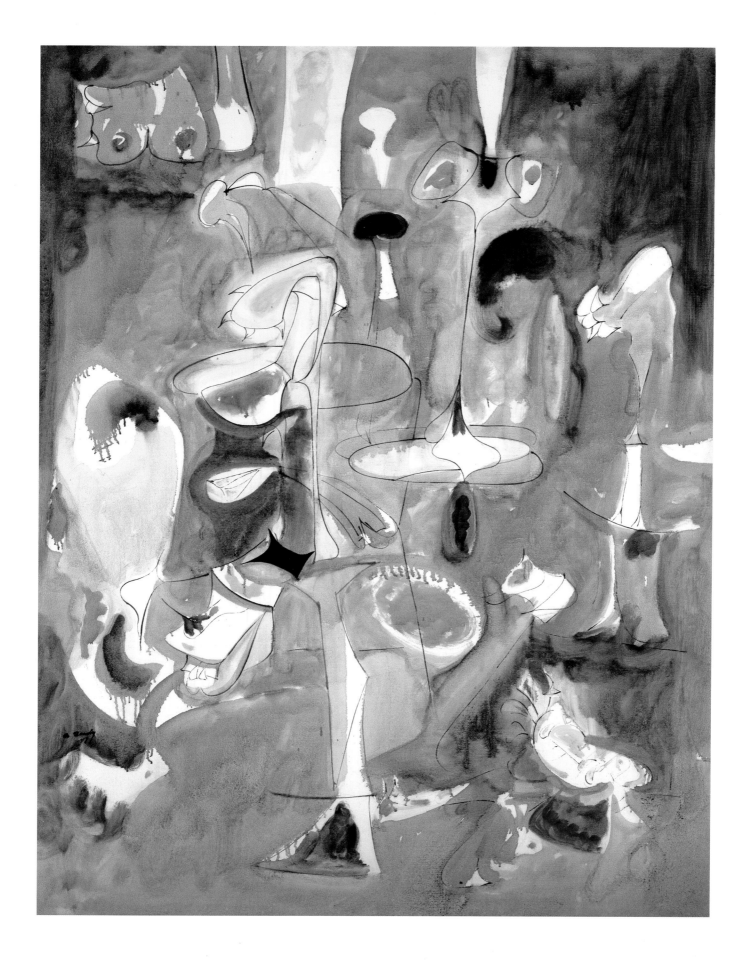

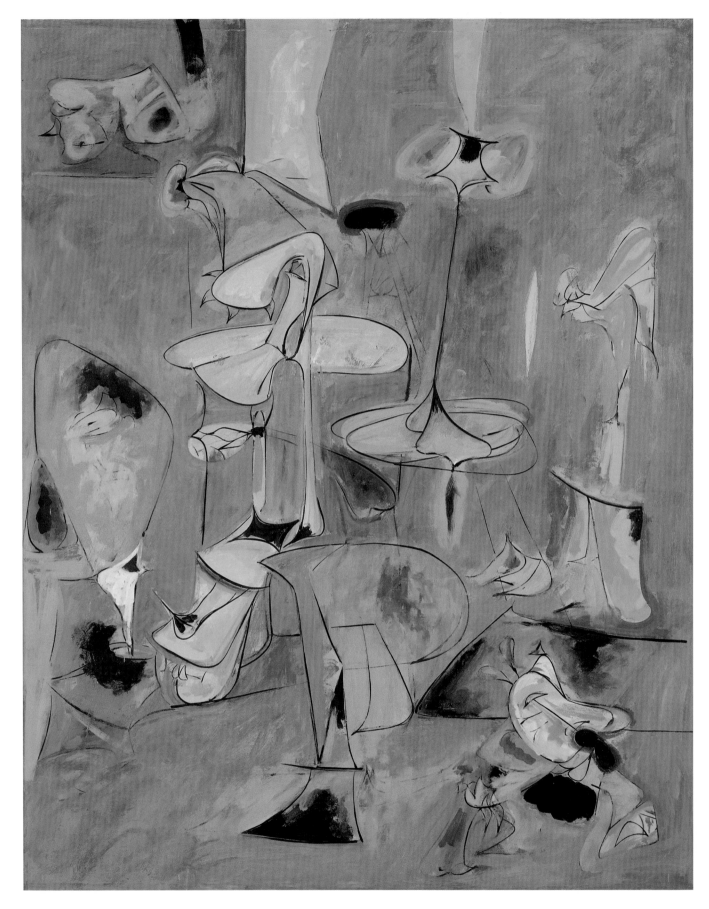

173 *The Betrothal I*, 1947
Oil on paper
51 x 40 inches (129.5 x 101.6 cm)
The Museum of Contemporary Art, Los Angeles. The Rita and Taft Schreiber Collection,
given in loving memory of her husband, Taft Schreiber, by Rita Schreiber

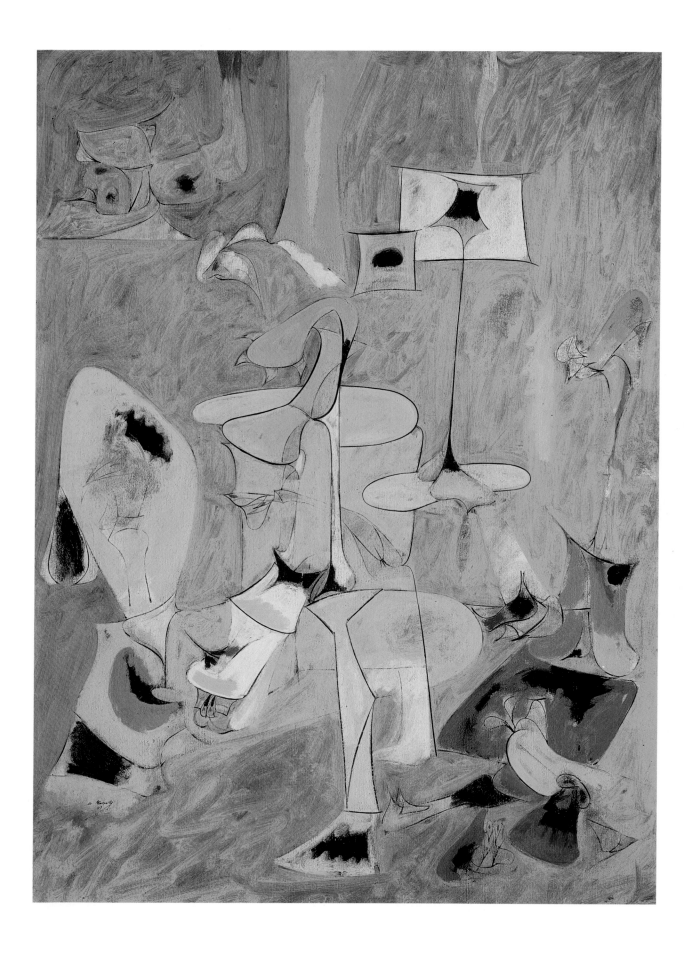

174 *The Betrothal II*, 1947

Oil on canvas

50¾ x 38 inches (128.9 x 96.5 cm)

Whitney Museum of American Art, New York. Purchase

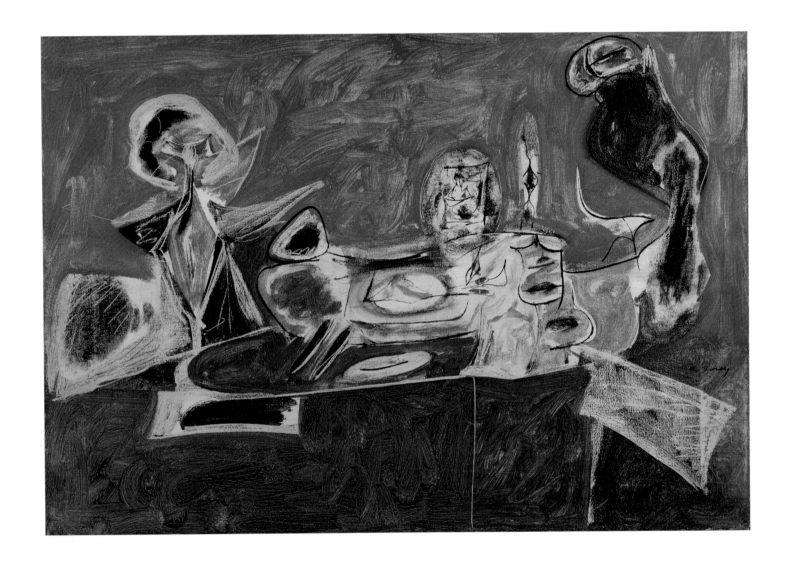

175 *From a High Place II*, 1946
Oil on canvas
17 x 24 inches (43.2 x 61 cm)
Private collection

176 *Painting*, c. 1943–47
Oil on canvas
44⅛ x 54 inches (112 x 137 cm)
Private collection

177 *Study for "Summation,"* 1946
Graphite and crayon on paper
19⅞ x 25½ inches (50.5 x 64.8 cm)
Whitney Museum of American Art, New York.
Gift of Mr. and Mrs. Wolfgang S. Schwabacher

178 *Study for "The Orators,"* c. 1946–47 *
Graphite and crayon on paper
18 x 24 inches (45.7 x 61 cm)
Collection of Basha and Perry Lewis

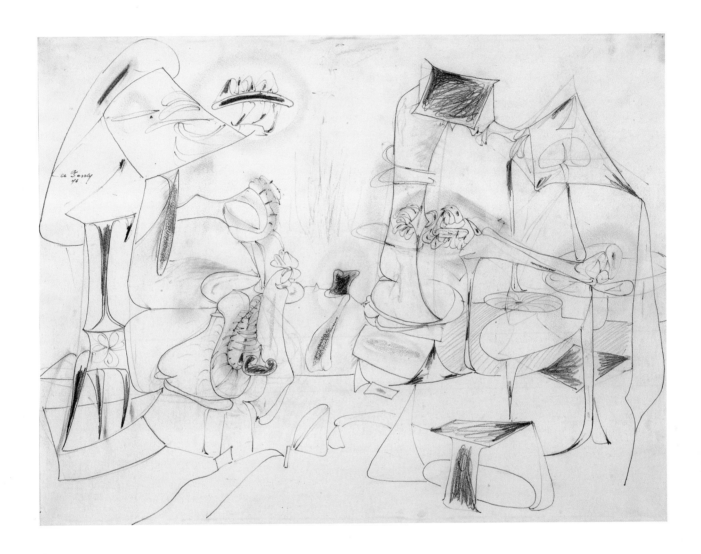

179 *Study for "Soft Night,"* 1946
Graphite and wax crayon on paper
18½ x 23⅝ inches (47 x 60 cm)
Private collection

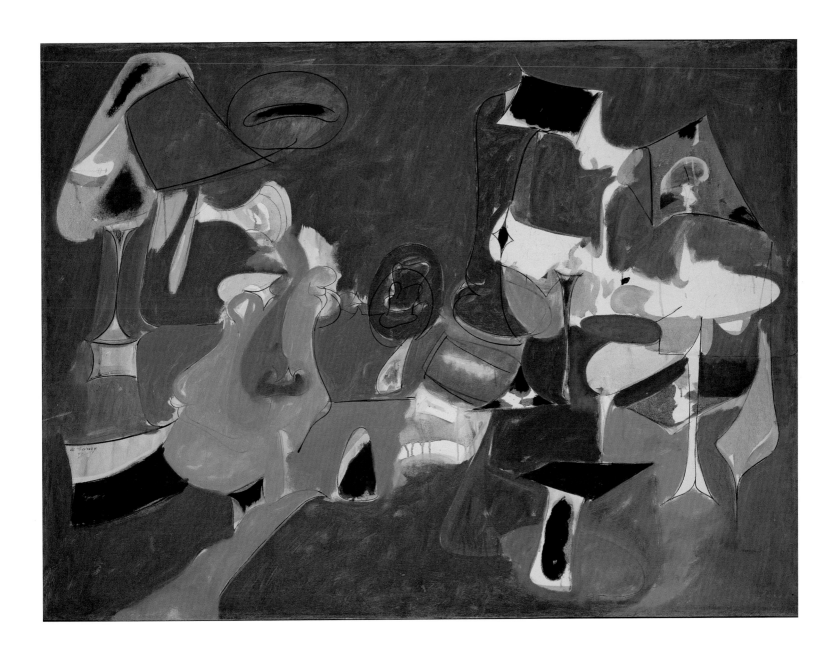

180 *Soft Night*, 1947
Oil, India ink, and conté crayon on canvas
38⅛ x 50⅛ inches (96.8 x 127.3 cm)
Hirshhorn Museum and Sculpture Garden, Smithsonian Institution,
Washington, D.C. The Joseph H. Hirshhorn Bequest, 1981

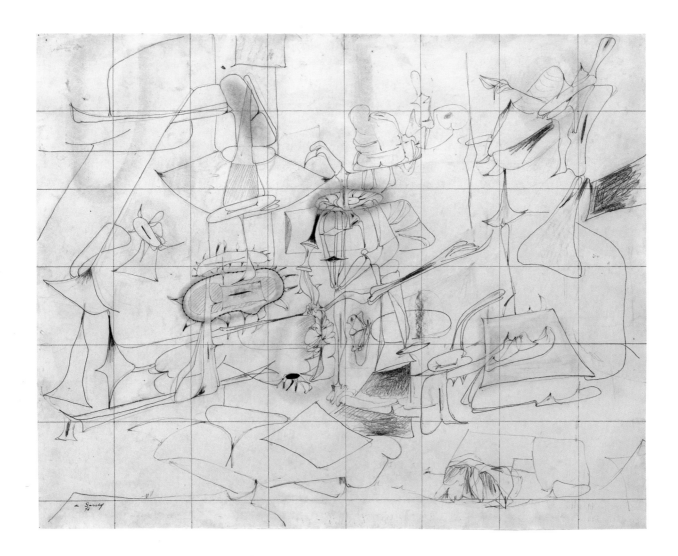

181 *Study for "Dark Green Painting,"* 1946
Graphite and crayon on paper
19 x 24 inches (48.2 x 61 cm)
Private collection

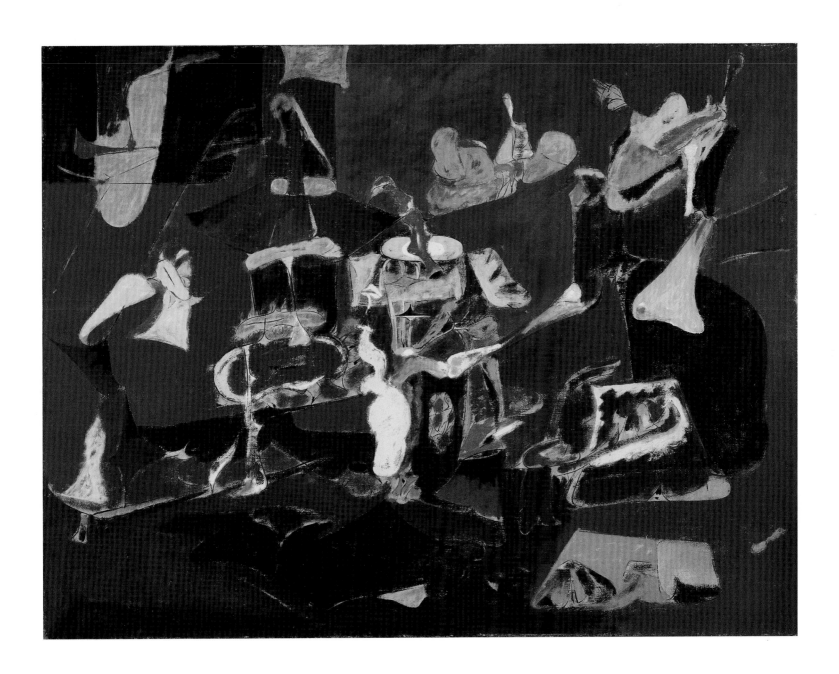

182 *Dark Green Painting*, c. 1948
Oil on canvas
43¾ x 55½ inches (111.1 x 141 cm)
Philadelphia Museum of Art. Gift (by exchange) of Mr. and Mrs. Rodolphe
Meyer de Schauensee and R. Sturgis and Marion B. F. Ingersoll, 1995

183 *The Limit*, 1947
Oil on paper mounted on canvas
50³⁄₄ x 62 inches (128.9 x 157.5 cm)
Private collection

184 *Untitled*, 1943–48
Oil on canvas
54$\frac{1}{2}$ x 64$\frac{1}{2}$ inches (138.4 cm x 163.8 cm)
Dallas Museum of Art. Dallas Art Association Purchase,
Contemporary Arts Council Fund

185 *Dead Bird (Slingshot)*, 1948
Carved wood, twine, colored yarns, and feather
36 x 46½ inches (91.4 x 118.1 cm)
The Menil Collection, Houston

186 *Last Painting*, 1948
Oil on canvas
31 x 40 inches (78.6 x 101.5 cm)
Museo Thyssen-Bornemisza, Madrid

DOCUMENTATION

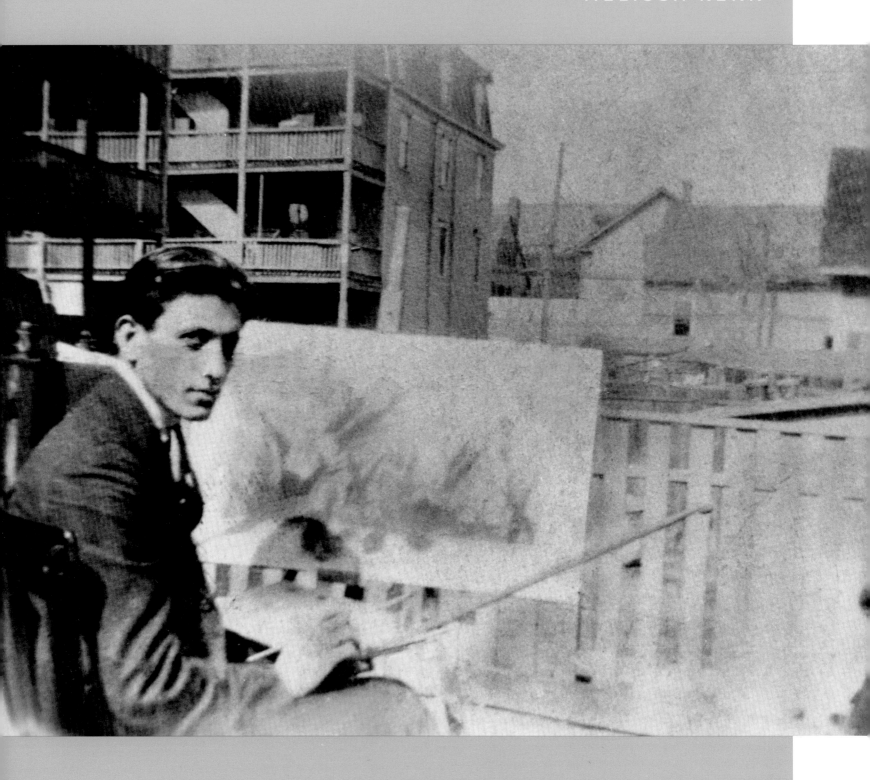

FIG. 128
Gorky painting at his half-sister Akabi's house on
Dexter Avenue, Watertown, Massachusetts, c. 1923.
Courtesy of Maro Gorky and Matthew Spender

FIG. 129 353
Setrag Adoian, Gorky's father, Providence,
Rhode Island, 1910. Courtesy of Maro Gorky
and Matthew Spender

c. 1902

Vosdanig Adoian (Arshile Gorky) is born in the village of Khorkom, within the Armenian province of Van, on the eastern border of Ottoman Turkey.[1] Likely named after his mother's hometown of Vosdan, he is later called Manoog to honor his paternal grandfather.[2] He is the first son of Setrag Adoian, a trader and sometime carpenter, and Shushanig (Shushan) der Marderosian, a descendant of priests of the Armenian Apostolic Church. Setrag and Shushan, who were both married previously and widowed in 1896, are already parents.[3] Setrag has a son, Hagop, and a daughter, Oughaper, and Shushan has two daughters, Sima and Akabi (called Ahko).[4] The couple already have one child together, a daughter named Satenig, born in 1901.[5]

1904/1906

September 27: Vosdanig's sister Vartoosh is born.[6]

1908

During his early childhood Vosdanig begins to draw and carve but is late in speaking. His sister Akabi will later recall: "He used to draw in his sleep. You could see his hand moving."[7]

Setrag Adoian immigrates to the United States, arriving on December 28 at the Port of New York aboard the S.S. *Saint Laurent*. He moves to Providence, Rhode Island, where his son Hagop, who had arrived some months earlier, has settled.[8]

1909–10

Vosdanig studies writing, vernacular Armenian, and drawing in a one-room school attached to the village church of Saint Vardan in Khorkom.[9]

1910

February 10: His half-sister Akabi marries Mkrdich (Muggerdich) Amerian, and the couple move to the city of Van shortly thereafter.

Summer: Hamaspiur der Marderosian, his maternal grandmother, dies. Memories of her funeral will later inform his painting *The Orators* (1947; private collection).

September: Shushan's relationship with her in-laws worsens in Setrag's absence, and she moves with Vosdanig and Vartoosh to Van city, where they rent a one-room apartment on Galjunts Street. Vosdanig and Satenig attend the Husisian (Husisayeen) School, affiliated with the Armenian Apostolic Church. The curriculum includes religion, literature, math, science, geography, history, and the Armenian, Turkish, and French languages.

Two months after relocating to Van, Shushan moves her family to the suburb of Aikesdan, where they rent a house on Chaghli Street. Vartoosh will later describe the street as "very pretty. There were poplar trees and willows.... There were streams everywhere in the streets."[10] Vosdanig and Vartoosh attend the American Mission School, where they are instructed in the English language for the first time.

1912

In Van, Vosdanig poses with his mother for a photograph to send to Setrag in Providence (see fig. 19). This picture will later inspire a number of paintings and drawings on the theme of the artist and his mother (plates 26–33).

1914

August 1: Germany declares war on Russia, marking the beginning of World War I. The Turkish government intensifies the persecution of its Armenian population and readies its campaign of genocide.

Late October: Turkey officially enters the war as an ally of Germany. The following month, robbery and looting are reported in Van province.

1915

April 20: The Turkish army begins a siege of Van City. Armenians living in proximity to Turkish quarters or in mixed neighborhoods evacuate their homes and move to the center of Aikesdan, which is protected by an Armenian defense line. Between four and six thousand Armenians find shelter at the American Mission, including the Adoians.

Summer: In May, Russian forces push back the siege on Van but withdraw from the city in late July, at which time General Nicolaieff orders "all the Armenians of the Van province, also the Americans and other foreigners, to flee for their lives."[11] The Adoians join more than a quarter million refugees on an eight-day, one-hundred-mile journey on foot to Russian Armenia. There are many deaths along the way from exhaustion, starvation, disease, and plundering by the Kurds (see figs. 20, 21). The family stops in Idgir and Ejmiadzin before reaching Erevan (present-day Yerevan).[12]

November: Having lived in temporary lodging since their arrival, the Adoians are finally able to rent a room in Yerevan on the first floor of a house at 18 Kaganovsky Street.[13] Vosdanig attends the Temagan Boys School, a parish school attached to Saint Sarkis Church. To help support the family, he carves combs and also works at an orphanage, a carpentry shop, and a printing press.

1916

October: Mkrdich Amerian, who had previously immigrated to the United States, returns to Yerevan to collect his wife, Akabi, and their son, Gurken (later Jimmy). He also brings money from Setrag Adoian, which is to be used to bring Shushan and her three children to the United States, but the amount is enough for only one ticket. Shushan decides to send her oldest daughter, Satenig, with the Amerians. The four leave Yerevan for the States on the ninth and will eventually settle in Watertown, Massachusetts.[14]

FIG. 130
The S.S. *Presidente Wilson*, the Italian ocean liner that
brought Gorky and his sister Vartoosh to the United States
in 1920. The Statue of Liberty–Ellis Island Foundation, Inc.

1918

May 28: The short-lived independent Republic of Armenia is established.

August: The threat of civil war causes Vosdanig, Vartoosh, and their mother to flee Yerevan for Tiflis (present-day Tbilisi), Russia. Traveling by foot, they are forced to stop just eight miles outside Yerevan in the village of Shahab when Shushan becomes too weak from malnutrition to continue.

1918–19

Winter: Brutal weather conditions and a severe food shortage cruelly tax the Armenian refugee community, and Shusan's condition worsens. In December, Vosdanig and Vartoosh return with her to Yerevan, where they find shelter in an abandoned room with a partial roof.[15]

1919

March 20: Shushan dies of starvation at the age of thirty-nine. Family legend has it that Satenig marries Sarkis Avedisian in Watertown, Massachusetts, on this same day.

May: Vosdanig and Vartoosh begin what they hope will be a journey to the United States, traveling by train to Tiflis with a family friend, Kerza (Kertso) Dikran.[16]

July–August: The siblings arrive in the port city of Batum, where they remain for three weeks. The following month they sail to Constantinople, finding shelter in a refugee camp near the Haidar Pasha railroad station, located within the Uskudar district on the Asian side of the city. A wealthy doctor, Vergine (Verzhinay) Kelekian, and her husband, Setrag, later assist them with lodging, and their son Hambartzum, who works for a shipping company, eventually helps them secure tickets to the United States.[17]

1920

January 25: The two sail to Athens, staying for fifteen days in the port city of Patras.

February 9: They board the Italian liner S.S. *Presidente Wilson*, stopping en route for one day in Naples before continuing on to the States, where they arrive at Ellis Island on February 26. The ship manifest of alien passengers submitted to the U.S. Immigration Officer at Port of Arrival includes "Manouk" and "Vartanouche" Adoian as students.[18] After being detained for several days, they are officially admitted to the United States and are met by Akabi and Mkrdich Amerian, a family friend from Van named Vosgian, and Hagop Adoian.[19]

March 1: They travel to Watertown to stay with Akabi and Mkrdich at their home on Coolidge Hill Avenue.

After living in Watertown for about a month, Vosdanig goes to Providence to live with Setrag and Hagop and his family at 207 Pond Street and later at 22 Cranston Street. He works with his father and half-brother at the Universal Winding Company, which specializes in making winding machines for the textile and electrical coil industries, on Elmwood Avenue in nearby Cranston and also attends the Old Beacon Street School in Providence.

1921

January–June: Vosdanig attends Samuel Bridgham Middle School in Providence, though he is much older than the other students.

Summer: He returns to Watertown to live with Akabi and her extended family at their new home on Dexter Avenue and begins working with Vartoosh and Satenig at the Hood Rubber Company, which employs a large number of Armenians, but he is fired after only two months for drawing on factory equipment.[20]

On his return to Providence in the fall, he attends the Technical High School, a preparatory school for Brown University's School of Engineering.[21] Although most of the curriculum does not interest him, he is able to take art classes.

1922

Vosdanig briefly attends the Scott Carbee School of Art in Boston sometime this year.[22]

1922–23

Winter: He enrolls at the New School of Design and Illustration, located at 248 Boylston Street in Boston. Directed by Douglas John Connah, the school offers courses in drawing, painting, and design. Ethel Cooke, an instructor, later recalls that he "was very well equipped in drawing" and that his renderings "were as good as any of [John Singer] Sargeant's even then when he was 18."[23]

He frequents museums in Boston and finds employment washing dishes at a restaurant and drawing one-minute pictures of presidents between acts at the Majestic Theatre at 219 Tremont Street. He is most likely living on his own during this time.

1923

June 8: Vartoosh marries Moorad Mooradian, a friend of Vosdanig's from Aikesdan.

1924

Vosdanig becomes an assistant instructor for the New School of Design's life-drawing class, his first teaching position. During noon recess one day, he

FIG. 131
Arshile Gorky's *Pietà* (c. 1927–28) reproduced in
the catalogue of the Grand Central School of Art,
New York, 1929–30

FIG. 132
Gorky drawing in New York City, c. 1926.
Courtesy of Hayden Herrera

executes a modest painting in a Post-Impressionist style, *Park Street Church, Boston* (plate 1),[24] signing the work "Gorky, Arshele," the first known use of the pseudonym he will adopt for the remainder of his career. He will try out a number of variations of the two names, including Archele, Archel, and Gorki, before settling on Arshile Gorky in about 1932.

Late in the year, he moves to New York City after accepting a teaching job at a branch of the New School of Design, opened by Douglas John Connah in 1923 at 1680 Broadway. According to Mark Rothko, one of Gorky's students there, he copies paintings by Frans Hals at the Metropolitan Museum of Art and is fond of the work of the French painter Adolphe Monticelli.[25]

1925

January 9: Gorky enrolls at the National Academy of Design at 109th Street and Amsterdam Avenue in a life-drawing class taught by Charles Hawthorne, but leaves after one month for unknown reasons.[26]

October: He registers at the Grand Central School of Art, which is directed by Edmund Greacen and located within the Grand Central Terminal on Forty-second Street. There he takes classes with Nicolay Ivanovich Feshin and soon begins teaching an evening antique class, which consists of making drawings after plaster casts (see plates 3, 4).

1926

September: Gorky becomes a full faculty member of the School of Painting and Drawing at the Grand Central School of Art, where he will remain until 1931. His biography printed in a 1926 school catalogue is almost entirely fabricated: "Born Nizhin Novgorod, Russia. Studied, School of Nizhin Novgorod, Julian Academia, Paris, under [Paul Albert] Laurens, also in New York and Boston. Member: Allied Artists of America. Represented in many exhibitions."[27]

His appointment to the Grand Central faculty generates an article in the *New York Evening Post,* in which he is said to be the cousin of the writer Maxim Gorky, is reported to have a studio on West Fiftieth Street, and is quoted saying, "Cézanne is the greatest artist . . . that has lived."[28] His work will exhibit

the influence of Cézanne for several years, as seen in various still lifes, portraits, and landscapes (plates 2, 5, 7, 8).[29] His extensive knowledge of Cézanne comes not only from direct experience of his work in museums and galleries but also through reproductions of Cézanne's paintings in his treasured collection of books, including Julius Meier-Graefe's critical study *Cézanne und sein Kreis* (1922).[30]

November: Gorky publishes a poem in the *Grand Central School of Art Quarterly* titled "Thirst," whose wording is taken from a work by the Armenian poet Siamanto (Atom Yarjanian), who was killed during the Armenian Genocide.[31] Around this time, he has a portrait and a still life in a traveling exhibition of art by the faculty of Grand Central, perhaps the first time his work is exhibited.[32]

He possibly begins his two versions of the painting *The Artist and His Mother* (plates 32, 33). He will rework the canvases in the years to come by sanding down the surfaces to attain a brushstroke-free porcelain-like finish derived from the paintings of Jean-Auguste-Dominique Ingres, an artist he reveres. Gorky studies the works of Ingres firsthand at the Metropolitan Museum of Art and visits the Frick Collection's *Comtesse d'Haussonville* (1845) after its purchase in 1927.

Late 1920s

Gorky looks to Henri Matisse, Joan Miró, and the Synthetic Cubism of Pablo Picasso and Georges Braque as new sources of inspiration, becoming particularly fascinated with the work of Picasso for the next several years, examining his paintings in New York museums and galleries and also in illustrations in books and periodicals such as *Cahiers d'art.*[33]

1927

He moves to a new studio at 47a Sullivan Street on Washington Square South.[34] From this location he is within walking distance of the recently opened Gallery of Living Art at New York University, which houses A. E. Gallatin's collection of works by living or recently deceased artists, including Picasso, Miró, Giorgio de Chirico, and Fernand Léger. The collection makes a profound impact on him.[35]

Gorky meets the artist Saul Schary, who will become a lifelong friend.

FIG. 133
Gorky as a young instructor at the Grand Central School of Art, New York, c. 1928. Courtesy of Maro Gorky and Matthew Spender

FIG. 134
Gorky with his sister Vartoosh Mooradian and his girlfriend Sirun Mussikian in the Mooradians' backyard, Watertown, Massachusetts, c. 1929–30. Courtesy of Maro Gorky and Matthew Spender

FIG. 135
John Graham and Gorky, New York, 1930s. Photographic print, 10¼ x 8¼ inches (26 x 21 cm). John D. Graham Papers, 1799–1988, Archives of American Art, Smithsonian Institution, Washington, D.C.

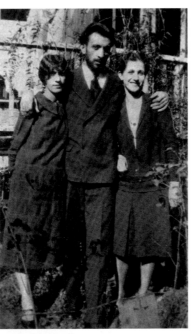

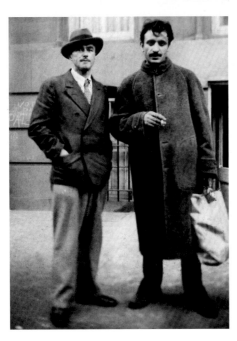

1928

Hans Burkhardt enrolls in one of Gorky's classes at Grand Central, and the next year will begin taking private lessons with him.[36] Gorky also meets Ethel Schwabacher, who will later become his student, patron, and first biographer.

1929

Gorky begins a tumultuous romance with Sirun Mussikian (Ruth March French), an Armenian model from Van. She lives with him for a short time but ultimately choses to end the relationship.[37]

His artistic circle expands. He is now a friend of John Graham (born Ivan Dabrowsky) and, through Graham or Paul Gaulois, meets Stuart Davis. Graham will later write of the trio: "Stuart Davis, Gorky and myself have formed a group and something original, purely american [*sic*] is coming out from under our brushes."[38] He also becomes acquainted with Willem de Kooning (see fig. 32), possibly at the opening of Graham's 1929 exhibition at Dudensing Galleries, or at a party at the apartment of the Russian painter Mischa Reznikoff, and also meets the future dealer Sidney Janis, whose art advisor he will become.[39] And it is probably this year that he first meets the sculptor Isamu Noguchi, although the two will not become good friends until the latter half of the following decade.[40] Gorky is renowned in this group for his deep knowledge and love of art and for his technical abilities. As de Kooning will later report: "He knew lots more about painting and art—he just knew it by nature—things I was supposed to know and feel and understand. . . . He had an extraordinary gift for hitting the nail on the head."[41]

The Museum of Modern Art (MoMA) is founded in New York City by Miss Lillie P. Bliss, Mrs. Cornelius J. Sullivan, and Mrs. John D. Rockefeller, Jr. Alfred H. Barr, Jr., is appointed director.

1930

April 12–26: Gorky shows three still lifes in *An Exhibition of Work of 46 Painters and Sculptors under 35 Years of Age* at MoMA, his first major museum exhibition in New York. His erroneous biography in the accompanying catalogue states that he was born in 1903 in Nizhni-Novgorod and studied with Vasily Kandinsky for three months in 1920. One of the still lifes in the catalogue is listed courtesy of the J. B. Neumann Gallery. Neumann, perhaps through an introduction by Max Weber, becomes his dealer for a short time this year, Gorky's first professional relationship with a gallery.

He moves to a large studio at 36 Union Square in Greenwich Village, which he will keep for the remainder of his life.[42]

1931

January 1–February 10: Gorky presents a work titled *Improvisation* at the Société Anonyme (founded by Katherine S. Dreier and Marcel Duchamp in 1920) for an exhibition organized to celebrate the opening of the new building of the New School for Social Research.

Over the course of the year, he sends the Downtown Gallery in New York a group of works ranging in price from $100 to $450. The exact nature of his relationship with the gallery is unknown.

April: Mrs. John D. Rockefeller (Abby Aldrich Rockefeller) purchases from the Downtown Gallery a Cézannesque still life by Gorky titled *Fruit* (c. 1928–29) for $250.[43]

FIG. 136
Gorky's studio at 36 Union Square with his painting
Portrait (plate 67) on the wall, New York, c. 1939.
Photograph by Ann Dickey

FIG. 137
Gorky's ink and pencil sketch on the cover of the
catalogue for the Wadsworth Atheneum's Picasso
exhibition, 1934. Courtesy of the NY School Art
Gallery, Yorktown Heights

September: In an evaluation of Stuart Davis's work for the magazine *Creative Art*, Gorky reveals his reverence for Cubism: "The twentieth century—what intensity, what activity, what restless nervous energy! Has there in six centuries been better art than Cubism? No."[44]

November 18: The Whitney Museum of American Art opens in New York. It will become a major supporter of Gorky's work.

Fall: Gorky meets Dorothy Miller and Holger Cahill, who study with him for a short time and who will both prove instrumental to his career, Miller as a curator at MoMA, and Cahill as head of the Federal Art Project of the Works Progress Administration (FAP/WPA).

He begins work on the *Nighttime, Enigma, and Nostalgia* series, his largest. Making variations on this theme through the mid-1930s, he will create more than fifty drawings and one painting (see plates 42–49, 51–55).

1932

Winter: The New York gallery owner Julien Levy examines a portfolio of his drawings at the suggestion of John Graham. During this meeting Gorky explains: "I was *with* Cézanne for a long time...and now naturally I am *with* Picasso." Levy replies that he will give him an exhibition "someday, when you are *with* Gorky."[45]

March 3: With Frank Jewett Mather, Jr., the Marquand Professor of Art at Princeton University, he debates "Two Views on Modern Art" at Wells College in Aurora, New York.[46]

May 10: Vartoosh and Moorad return to Armenia, which is now part of the Soviet Union.

1933

December 20: Gorky joins the federal government's Public Works of Art Project (PWAP) at a salary of about $37 a week. Shortly after being accepted into the program, he submits a proposal for a mural, describing his abstract work in a way that will suit the PWAP's requirement that the piece capture the "American Scene": "In the middle of my picture stands a column which symbolizes the determination of the American nation.... My intention is to create objectivity of the articles which I have detached from their habitual surroundings to be able to give them the highest realism."[47]

1934

January: Ethel Schwabacher and Mina Metzger, the latter another future patron of Gorky's, begin private lessons with him three days a week, three hours a day, which they will continue through the summer of 1935. As a part of their studies, Gorky takes them to the Metropolitan Museum of Art, where they make drawings after artists such as Nicolas Poussin and Édouard Manet.[48]

January 17: Gorky informs the PWAP that the subject of his mural will be "1934" and that the work will be appropriate for installation in a technical university, a building for engineering purposes, or the New York Port Authority.[49] He will be dropped from the PWAP roster on April 29, however, and the mural never realized. Existing studies (see fig. 53; plate 44) combine the motifs found within his drawings made around this time—such as *Nighttime, Enigma, and Nostalgia* (plates 42, 43, 45, 46, 48, 49, 52), *Column with Objects* (plates 47, 51, 53), and his abstract anatomical studies—revealing that the design may have been too abstract for the taste of PWAP administrators Juliana Force and Lloyd Goodrich.

February 2: His first solo exhibition opens at the Mellon Galleries in Philadelphia with thirty-seven untitled paintings dating from 1926 to 1930. The exhibition is likely arranged with the help of Gorky's friend and patron Bernard Davis, later the director and founder of Philadelphia's Philatelic Museum, who may have introduced him to the director of the Mellon Galleries, C. Philip Boyer.[50] The review in the *Philadelphia Inquirer* is mixed, calling the work "brilliant of pigmentation" but derivative in nature.[51] Shortly after the show opens, he learns that water damage from extinguishing a fire in Akabi's house in Watertown has destroyed a group of his early paintings, including portraits of Vartoosh and Sirun Mussikian.[52]

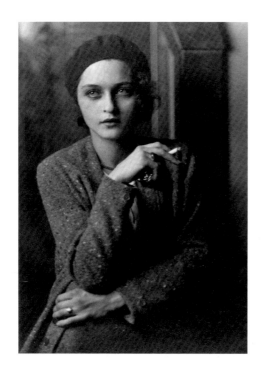

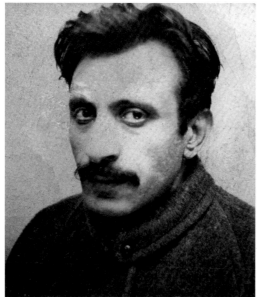

FIG. 138
Corinne Michael West, c. 1930.
Photograph by Jon Boris. Courtesy
of the NY School Art Gallery, York-
town Heights

FIG. 139
Snapshot of Gorky that he gave to
Corinne Michael West, c. 1935–36.
Courtesy of the NY School Art
Gallery, Yorktown Heights

FIG. 140
Gorky at the opening of his exhibi-
tion at the Guild Art Gallery, New
York, December 1935. Behind him
is the *Nighttime, Enigma, and
Nostalgia* drawing purchased by
Katherine Dreier of the Société
Anonyme

February 28: At the opening of the *First Municipal Art Exhibition* at the Forum Gallery in New York, Gorky meets the art student Marny George, and they are married after a brief courtship. Their stormy relationship ends soon afterward, however. As Marny will later recall: "It seems the very moment we were married the battle began....We loved and hated with equal violence."[53] Gorky gives a still life painting to an attorney, Herman A. Greenberg, in payment for preparing the paperwork to annul their marriage.[54]

October 27: He designs and builds a large float—a tower of painted cardboard over a wooden framework, the whole having a Cubist effect—with the artist George McNeil for a demonstration organized by the Artists' Committee of Action to demand a place for artists to show their work (see fig. 56). He also attends meetings of the newly formed Artists' Union during this time but never becomes a member. Stuart Davis later claims that it was Gorky's lack of political commitment that caused their friendship to end this year.[55]

December 25: Vartoosh and Moorad return from Soviet Armenia after Vartoosh becomes ill. They stay with Gorky in his studio for several weeks before going back to Watertown to live with Akabi.

Around this time, he begins a series of stylized portraits of himself and family members that are melancholy in tone (plates 24–41).

1935

Early in the year, Gorky takes in a lodger named Lorenzo Santillo.

February 12–March 22: He is included for the first time in one of the Whitney's exhibitions, *Abstract Painting in America*. The catalogue includes an essay by Ethel Schwabacher and an introduction by Stuart Davis.

He exchanges letters in Armenian with his cousin Ado Adoian in Yerevan during this year and the next.[56]

March: Lorenzo Santillo takes Corinne Michael West, a student of Hans Hofmann's, to meet Gorky one evening at 36 Union Square. The two quickly begin a romance and later maintain a long-distance relationship through letters and visits after West moves to Rochester, New York, the following year.[57]

March 25: Vartoosh gives birth to a son whom they name Karlen, a contraction of the names of Karl Marx and Vladimir Lenin. Later this year, the Mooradians return to New York, where they stay with Gorky until the fall of 1936.

July: Gorky applies to the Emergency Relief Bureau, then a city program, for work and housing relief and begins receiving $24 a month. His status with the bureau qualifies him for a position with the FAP/WPA when it is established one month later under the directorship of his friend Holger Cahill. He is assigned to the mural division, earning a monthly salary starting at $103.40, and begins designing a series of murals titled *Aviation* for Floyd Bennett Field in Brooklyn, which are to incorporate photographs of airplanes and airports taken by Wyatt Davis, Stuart Davis's brother.[58]

September: A selection of his drawings is on view at Philadelphia's Boyer Galleries. Corinne West borrows her father's car, and she, Gorky, Lorenzo Santillo, and a woman named Geraldine drive to Philadelphia to see the show. A local reporter comments that Gorky's abstract works on paper have no "regard for thematic material or the representational."[59]

October: The Guild Art Gallery opens at 37 West Fifty-seventh Street, New York. Although Gorky's name is not included on the inaugural exhibition

FIG. 141
Mayor Fiorello La Guardia, Gorky, and Harry
Knight (WPA District Supervisor of Art and
Public Buildings) at the opening of the Fed-
eral Art Project Gallery, New York, December
27, 1935

FIG. 142
Gorky at work on *Activities on the Field*, his mural
for the Newark Airport Administration Building,
1936. New York Federal Art Project Photo,
Collection Maro Gorky and Matthew Spender

announcement, according to a review in the *New York Times* he is among those represented in the show, where his "handsome abstract decoration...may be said to dominate."[60]

November 12: Gorky signs a three-year contract with the Guild Art Gallery.

November 24: He delivers a lecture, "Methods, Purposes, and Significance of Abstract Art," at the Guild in response to the interest aroused by Fernand Léger's current exhibition at MoMA.[61]

December 16: He presents eighteen works in *Abstract Drawings by Arshile Gorky* at the Guild, his first solo exhibition in New York. Holger Cahill writes a paragraph for the catalogue, citing Gorky's "extraordinary inventiveness and fertility in creating special arrangements both precise and harmonious, ... [which contribute] to contemporary American expression a note of intellectual fantasy." Reviews are mixed, however, with Howard Devree commenting in the *New York Times* on Gorky's "serious attempts to express certain spatial and linear relationships," while Carlyle Burrows, in the *Herald Tribune*, opines: "His is a difficult expression to disentangle from its sources in Picasso, Braque and others, and to tell where originality begins and where inspiration leaves off."[62] Katherine S. Dreier of the Société Anonyme buys one of his *Nighttime, Enigma, and Nostalgia* drawings for $85.[63]

December 27: A sketch for Gorky's airport mural is presented in *Murals for Public Buildings,* an exhibition celebrating the opening of the Federal Art Project Gallery. Mayor Fiorello H. La Guardia, who attends the opening and is photographed speaking with Gorky, is quoted in the paper as saying about the sketch: "I am conservative in my art, as I am a progressive in my politics. That's why I perhaps cannot understand it."[64]

1936

Spring: During a lecture at the Artists' Union, Gorky chastises the Social Realists, calling their propagandistic illustrations "poor art for poor people."[65]

May–September: The New York Art Commission gives preliminary approval to his aviation murals, but by this time the focus of the project has changed.[66]

The murals are now intended for the Newark Airport Administration Building, and the design excludes the photographs of Wyatt Davis. For the final project, Gorky paints ten panels in the seventh-floor workshop of the Federal Art Project Building at 6 East Thirty-ninth Street (see plates 84, 85).

In response to a perceived lack of respect for modernist artists, American Abstract Artists is founded by a group that includes Josef Albers and A. E. Gallatin. Gorky attends several meetings but never joins.[67]

Julien Levy publishes his book *Surrealism.* According to his later recollections, Gorky immediately reads the entire book in the back room of his gallery.[68]

September 14–October 12: One of Gorky's Newark panels, *Activities on the Field,* is shown in MoMA's exhibition *New Horizons in American Art,* which highlights the first year's work done under the FAP/WPA. The exhibition catalogue gives the title of the full mural cycle as *Aviation: Evolution of Forms under Aerodynamic Limitations.*[69]

November 10–December 10: Gorky's painting *Organization* (plate 66) is shown in the *Third Biennial Exhibition of Contemporary American Painting* at the Whitney. Hereafter he will regularly be included in the Whitney's painting and drawing annuals.[70] Sometime during November, the Mooradians move to Chicago.

December 11: He submits an essay about his Newark Airport murals to the Washington office of the FAP/WPA. The text is intended to be one of a number of essays in a national illustrated report (never realized).[71] Besides giving a formal analysis of his panels, Gorky's essay discusses the educational purpose of mural painting: "Since many workers, school children, or patients in hospitals (as the case may be, depending on the type of institution) have little or no opportunity to visit museums, mural painting could and would open up new vistas to their neglected knowledge of a far too-little popularized Art."[72]

December 18: The architect and designer Frederick Kiesler publishes "Murals without Walls: Relating to Gorky's Newark Project," the first magazine article on the artist, in *Art Front.*

FIG. 143
Gorky's sketch, in gouache on cardboard, for his mural at Ben Marden's Riviera Club, Fort Lee, New Jersey, c. 1940. Courtesy of Maro Gorky and Matthew Spender

FIG. 144
Agnes Magruder (Mougouch), c. 1939. Courtesy of Maro Gorky and Matthew Spender

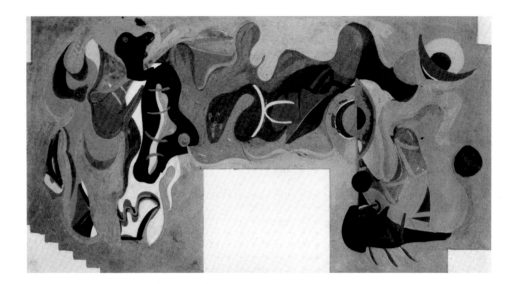

1937

May 12: Gorky writes to Vartoosh from the Wardman Park Hotel in Washington, D.C., mentioning that he is in the nation's capital to give a speech before the American Federation of Arts. According to Vartoosh, the subject of the lecture is camouflage.[73]

June 9: The Newark Airport murals are unveiled. The next day, an article by Gerard Sullivan in the *Newark Ledger* cites the public's reactions, including the assessment that they look "like a hangover after an Atlantic City convention!"[74] Despite the negative reception, the murals are officially accepted by the Newark Art Commission on June 24.

During the remainder of the summer, and through the summer of 1941, Gorky continues as an employee of the FAP/WPA Mural Division, although he is never assigned to another FAP mural project, instead being permitted to make easel paintings in his studio.

August: Gorky begins working on sketches for murals for the 1939–40 New York World's Fair Marine Transportation Building and Aviation Building. By October, his Aviation proposal is accepted, but his project for the Marine Building is rejected in favor of a mural by Lyonel Feininger.[75]

After his inclusion in its fall painting annual, the Whitney purchases one of His works, titled simply *Painting* (plate 71), his first sale to a museum.

John Graham publishes *System and Dialectics of Art*, mentioning Gorky in a section called "Good Taste," along with André Breton, Paul Éluard, Tristan Tzara, and Christian Zervos.

1938

Early in the year, Gorky begins a relationship with the violinist Leonore Gallet (later Portnoff), who becomes the subject of several drawings (plates 39, 40).[76]

He takes a trip to Provincetown, Massachusetts, with the artists Rosaline Bengelsdorf and Byron Browne.[77]

May–July: The Whitney lends Gorky's *Painting* (plate 71) to an exhibition in Paris titled *Trois siècles d'art aux États-Unis* (*Three Centuries of Art in the United States*). Organized by MoMA, this large survey is installed at the Musée du Jeu de Paume. *Painting* is also reproduced in James Johnson Sweeney's article "L'art contemporain aux Etats-Unis" for the 1938 issue of *Cahiers d'art*.

1939

January 16: Gorky temporarily leaves the FAP/WPA to work on his project for William Lescaze's Aviation Building at the New York World's Fair. The finished mural, *Man's Conquest of the Air* (since destroyed; see fig. 64), is unveiled for the fair's opening on April 30.

May 5–27: Picasso's *Guernica* is displayed for the first time in the United States at the Valentine Gallery, New York. Gorky takes part in a panel discussion there with fellow artists Leo Katz and Walter Pach. Dorothea Tanning is in the audience and later recalls that "the controlled passion in his voice…illumined the painting with a sustained flash of new light."[78]

May 20: Gorky becomes a U.S. citizen.

June 9: He is reinstated on the FAP/WPA.

September: World War II begins, and many European artists flee to the United States. The Chilean artist Roberto Matta arrives from Europe this year, meeting Gorky shortly thereafter, possibly at an exhibition of his work at the Julien Levy Gallery in the spring of 1940.[79]

Late in the year, Gorky applies for a John Simon Guggenheim Foundation Fellowship. Holger Cahill and Max Weber act as references, but his application is ultimately rejected.

1940

Gorky begins the series of works titled *Garden in Sochi* (plates 93–97).

Abby Aldrich Rockefeller gives Gorky's lithograph *Mannikin* (1931; see plate 22) to MoMA, its first acquisition of his work. During Gorky's lifetime, the museum will also acquire *Argula* (1938) and *Objects* (1932) in 1941, and *Garden in Sochi* (1941; plate 95) in 1942.[80]

September 3: In a letter to the Mooradians, Gorky mentions a request he has made to teach a class on camouflage at the Grand Central School of Art. Because of the draft, he is told to wait several months to see how many students will be available before offering the class.[81]

Fall: With the help of Isamu Noguchi and the architect William Muschenheim, he receives a commission to paint murals (since destroyed) on the curved walls that flank the stage at the Riviera Club in Fort Lee, New Jersey, owned by Ben Marden. The murals are finished the following summer and are discussed in an article in the *New York Sun* in which Gorky explains: "I call these murals non-objective art, but if labels are needed this art may be termed surrealistic."[82]

December 9: In response to the institution of a new rule, he resigns from the WPA because he has been employed for eighteen months. He reapplies and is back on the project by December 17.

1941

January: Through Elaine Fried (later de Kooning), Gorky meets the woman who will become his second wife, nineteen-year-old Agnes Magruder, at a party.[83] He soon nicknames her Mougouch, an Armenian term of endearment.

January–February: He attends the Surrealist painter Gordon Onslow Ford's lecture series at the New School for Social Research, also visiting Ford's apartment several times to learn more about Surrealism.[84]

April 19–27: His painting *Argula*, now owned by MoMA, is included in the Metropolitan Museum of Art's *Special Exhibition of Contemporary Painting in the United States*, which in June begins traveling in South America as *La pintura contemporana norteamericana*, co-organized by MoMA, the Met, the Brooklyn Museum, the Whitney, and the Coordinator of Commercial and Cultural Relations between American Republics.

July: After his friend Jeanne Reynal arranges to have his work exhibited in San Francisco, Gorky resigns from the WPA on July 2 to drive across the country with Mougouch, Isamu Noguchi, Noguchi's sister, and two other friends, arriving on July 17.

August 9–24: His first solo exhibition at a museum opens at the San Francisco Museum of Art with twenty-one works, including a painting from Reynal's collection, *Enigmatic Combat* (1936–37; plate 75), which she will give to the museum later this year.

Late in the year, Edmund Greacen approves Gorky's class on camouflage at the Grand Central School of Art. The course announcement reads: "An epidemic of destruction sweeps the world today. The mind of civilized man is set to stop it. What the enemy would destroy, however, he must first see. To confuse and paralyze this vision is the role of camouflage. Here the artist and more particularly the modern artist can fulfill a vital function for, opposed to this vision of destruction is the vision of creation."[85] The gallery owner Betty Parsons, who is enrolled in the class, later recalls that Gorky "was witty and brilliant as a camouflage teacher... I think Gorky probably knew more about aesthetics than anybody I ever met in my life, then and now."[86]

September 15: On the return trip from California, Gorky and Mougouch are married in Virginia City, Nevada.[87] They visit the Mooradians in Chicago on September 26, returning to New York in early October.

November 12–December 30: Gorky exhibits two works in the Whitney's exhibition *Paintings by Artists under Forty*.

December 28: He writes to Vartoosh about camouflage and his possible role in the ensuing war: "It seems I too shall be called to do camouflage painting. We artists are getting organized so that if called we shall serve as painters and not as soldiers."[88] However, the draft board later rejects him as too old.

1942

Summer: Gorky and Mougouch spend time at Saul Schary's home in New Milford, Connecticut. Mougouch will write in a letter the next year: "Last summer we spent 2 weeks in the country away from N.Y. and during those two weeks Gorky did some very inspiring drawings from nature which have given him great impetus in his work and something quite new and miraculous is resulting."[89] The country landscape is reflected in such paintings as *Waterfall* (plates 102–4), *Waterfalls* (plate 101), and *Schary's Orchard* (plate 100)

June: In response to a request from Dorothy Miller, he writes a free-form poem on his *Garden in Sochi* paintings, one of which is acquired by MoMA on July 1. In the poem he describes "an enormous tree" from his childhood, a "Holy tree" on which people hung strips of their clothing that they had torn off.[90]

June 30–August 9: He shows *Bull in the Sun*, a rug woven for him by the New York company V'Soske, and two related preliminary studies and a design in gouache in MoMA's exhibition *New Rugs by American Artists*.

December: One of his paintings of his sister Akabi is included in MoMA's exhibition *20th Century Portraits*. Titled in the catalogue "My Sister Ahko," its date is erroneously given as 1917.

1942–43

Winter: Gorky visits relatives in Watertown for what will turn out to be the last time.

1943

February: He and Mougouch host a dinner for Fernand Léger, who maintains a studio on West Fortieth Street during this time. Mary Burliuk, wife of the painter David Burliuk, will later report that Gorky was "overwhelmed with emotion" to have the great artist in his studio.[91]

March 20: Joseph H. Hirshhorn buys seventeen of Gorky's paintings and will add thirteen more to his collection in the following years (see plates 24, 25, 45, 101, 103, 133, 180).[92]

April 5: Gorky and Mougouch's first daughter, Maro, is born.

June 17–July 25: His painting *Garden in Sochi* (1941; plate 95) is included in MoMA's exhibition *Recent Acquisitions: The Work of Young Americans*.

Summer: Gorky travels with his family to Lincoln, Virginia, to stay at Crooked Run Farm, recently acquired by Mougouch's parents, Admiral and Mrs. John H. Magruder II. There he creates more than one hundred drawings before returning to New York in November.[93]

FIG. 145
Crooked Run Farm, Mougouch's parents'
property in Lincoln, Virginia, 1943. Courtesy
of Maro Gorky and Matthew Spender

FIG. 146
Gorky with his daughter Maro and his mother-in-
law, Essie Magruder, Crooked Run Farm, Lincoln,
Virginia, summer 1943. Photograph by Agnes
Magruder Gorky. Courtesy of Maro Gorky and
Matthew Spender

1944

Early in the year, Noguchi introduces Gorky to André Breton, the chief propo-
nent of Surrealism, who becomes a good friend and major supporter of his
work.

April: James Johnson Sweeney's article "Five American Painters" is published
in *Harper's Bazaar*, discussing Milton Avery, Morris Graves, Roberto Matta,
Jackson Pollock, and Gorky, whose latest work, Sweeney writes, "shows his real-
ization of the value of literally returning to the earth."[94] Also in April, Gorky
finishes his masterpiece *The Liver is the Cock's Comb* (plate 114), which is based
on a drawing executed during the previous summer at Crooked Run Farm.
Jeanne Reynal writes to Mougouch shortly after its completion: "Did Arshile
feel satisfied when he painted that great canvas. God knows he well might. I'm
glad it's so successful. Did he really finish it in a week?"[95] Sidney Janis will
include a reproduction of the work in his book *Abstract and Surrealist Art in
America*, published later this year, and cite Gorky's description of the painting,
couched in the Surrealist "automatic" style: "The song of a cardinal, liver, mir-
rors that have not caught reflection, the aggressively heraldic branches, the
saliva of the hungry man whose face is painted with white chalk."[96]

Spring: Gorky returns to Crooked Run Farm with his family, where he draws
and paints prolifically for nine months. Following his return to New York late in
the year, Peggy Guggenheim buys another of his works, titled simply *Painting*
(plate 124), which was executed during this time.

December: He reaches an arrangement with Julien Levy (formalized in a let-
ter from Levy on December 20) to give the gallery twelve paintings and thirty
drawings a year in return for a monthly stipend of $175. Levy also agrees to
give him a one-man show, which he will do annually until Gorky's death.

1945

January: The Gorkys move to Roxbury, Connecticut, where they stay in David
Hare's house for the next nine months while he is away. Their neighbors
include the sculptor Alexander Calder and the French Surrealist painters Yves
Tanguy and André Masson and their wives Kay Sage, an American Surrealist,
and Rose Masson.

March 6: The exhibition *Arshile Gorky* opens at the Julien Levy Gallery, fea-
turing paintings created during the previous year, including *The Leaf of
the Artichoke is an Owl* (Museum of Modern Art, New York), *One Year the
Milkweed* (plate 120), *Water of the Flowery Mill* (plate 118), and *How My Mother's
Embroidered Apron Unfolds in My Life* (plate 115). André Breton, who before the
show had helped Gorky title the paintings, writes a foreword for the catalogue
titled "The Eye-Spring: Arshile Gorky," in which he describes the artist as "the
first painter to whom the secret has been completely revealed!...Here is an
art entirely new...a leap beyond the ordinary and the known to indicate, with
an impeccable arrow of light, a real feeling of liberty."[97] Because Levy had for-
gotten to mail out the announcements on time, almost no one attends the
opening.

March 24: Clement Greenberg's review of Gorky's exhibition in *The Nation*
focuses on what is seen as the derivative nature of his early work: "Until a short
while ago he struggled under the influences of Picasso and Miró. That he fell
under such influences was ten years ago enough proof of his seriousness and
alertness—but that he remained under them so long was disheartening."[98]

Breton's essay "The Eye-Spring: Arshile Gorky" is included in a new edition of his book *Surréalisme et la peinture* (*Surrealism and Painting*), first published in 1928.

May 14–July 7: Gorky is included in the exhibition *A Problem for Critics* at 67 Gallery, New York, along with Adolph Gottlieb, Lee Krasner, Pollock, Rothko, and others. In a statement accompanying the exhibition, the gallery owner Howard Putzel, Peggy Guggenheim's former assistant and advisor, declares: "I believe we see real American painting beginning now."[99]

July 4: He writes to Vartoosh from Roxbury noting that this is the first year he is working without any financial worries.[100]

August 8: His second daughter, Yalda, is born. She is renamed Natasha some months later.

September: When David Hare returns to Roxbury, Gorky moves with his family to Sherman, Connecticut, where they live with their friends the architect Henry Hebbeln and his wife, Jean, who convert a barn on the property into a studio for him.

October 11–December 9: Gorky's painting *How My Mother's Embroidered Apron Unfolds in My Life* (plate 115) is exhibited in the Carnegie International in Pittsburgh.

Late November: He travels with Mougouch to New York for the opening on the twenty-seventh of the Whitney annual, which includes his painting *Diary of a Seducer* (plate 126), and to attend a dinner honoring Breton, who is about to leave on a cultural tour of Haiti. Enrico Donati, Marcel Duchamp, Max Ernst, Esteve Francés, and Frederick Kiesler are among the other artists at the dinner.

1946

January 26: A fire in Gorky's Sherman studio destroys more than twenty paintings, including two on the theme of *The Plow and the Song* (see plates 144–49), several portraits of Mougouch, and works similar in style to *They Will Take My*

FIG. 150
Arshile Gorky, New York, summer 1946.
Photograph by Gjon Mili. Courtesy of
Time & Life Pictures/Getty Images

FIG. 151
Gorky and Natasha, Castine, Maine,
summer 1947. Courtesy of Maro Gorky
and Matthew Spender

Island (Art Gallery of Ontario, Toronto). Many of his drawings and cherished books are also lost.[101]

March 5: Following a diagnosis of rectal cancer, he undergoes a colostomy at Mount Sinai Hospital, New York.

March 19: He receives an art fellowship of $1,000 from the New-Land Foundation in New York. Wolfgang Schwabacher, the foundation's president and Gorky's patron, helps secure the grant.[102]

April 9–May 4: *Paintings by Arshile Gorky* opens at the Julien Levy Gallery. The exhibition includes *Charred Beloved II* (1946; plate 167), which memorializes the works lost in the studio fire earlier in the year, and other recent paintings, such as *The Unattainable* (1945; plate 134) and *Nude* (1946; plate 133). Clement Greenberg has a change of heart, writing in his review in *The Nation*: "Gorky's present show of eleven oils... provides not only reassurance but also some of the best modern painting ever turned out by an American."[103]

Summer–November: Gorky and his family again spend the season at Crooked Run Farm. Shortly before they return to New York, Gorky writes to Vartoosh: "This summer I completed a lot of drawings—292 of them. Never have I been able to do so much work, and they are good too."[104]

September 10–December 8: Dorothy Miller's exhibition *Fourteen Americans* is on view at MoMA. A room devoted to Gorky includes his early masterpiece *The Artist and His Mother* (1926–36; plate 32), as well as paintings from the previous year, such as *Diary of a Seducer* (plate 126), *The Unattainable* (plate 134), and *Landscape Table* (plate 136). Among the other artists represented are David Hare, Robert Motherwell, Isamu Noguchi, Theodore Roszak, Saul Steinberg, and Mark Tobey.

André Breton publishes a book of poems in English and French titled *Young Cherry Trees Secured against Hares / Jeunes cerisiers garantis contre les lièvres*, which includes reproductions of drawings by Gorky and a cover illustration by Marcel Duchamp; a small deluxe edition is also issued, with each of the twenty-five copies including two original drawings by Gorky.

1947

February 15–28: Gorky is included in the exhibition *Bloodflames* at the Hugo Gallery, New York. Organized by the Surrealist poet and art critic Nicolas Calas, the show also features works by David Hare, Wifredo Lam, Roberto Matta, and Isamu Noguchi, among others.

February 18: *Arshile Gorky: Colored Drawings* opens at the Julien Levy Gallery. A review in *ARTnews* is less than glowing, declaring: "As he is in no sense a draftsman, they must be appraised as doodlings, for psychological rather than formal interest."[105]

Joan Miró arrives in New York during the month of February to work on a mural commissioned for the Terrace Plaza Hotel in Cincinnati, Ohio, and the Gorkys host a dinner party in his honor at 36 Union Square.

Summer: Mougouch and the children spend the season in Castine, Maine, with her great-aunt. Except for a short visit to see them in August, Gorky remains in New York, producing such masterpieces as *The Betrothal* (plate 172), *Agony* (plate 165), and the large drawing *Summation* (Museum of Modern Art, New York).

FIG. 152
Gorky at the window of the Hebbeln
"Glass House," Sherman, Connecticut,
1948. Photograph by Ben Schnall.
Courtesy of Time & Life Pictures/Getty
Images

FIG. 153
Gorky wearing an immobilization collar out-
side the "Glass House," Sherman, Connecti-
cut, July 1948. Photograph by Wifredo Lam.
Courtesy of SDO Wifredo Lam

365

CHRONOLOGY

December: The family returns to Sherman, Connecticut, to stay at the Hebbelns's remodeled farmhouse, known as the Glass House. Gorky shows serious signs of depression after the move and begins speaking of suicide.[106]

Late December: His father dies in Providence. He does not attend the funeral.[107]

1948

February: The renovation of the Glass House is the subject of an article in *Life* magazine titled "Old House Made New," which includes photographs of Gorky and his family in the interior.[108]

February 29–March 20: His fourth solo exhibition at the Julien Levy Gallery includes paintings from the previous year, such as *Soft Night* (plate 180), *Making the Calendar* (Munson-Williams-Proctor Arts Institute, Utica, New York), and *The Limit* (plate 183). Greenberg writes in *The Nation*: "Gorky at last arrives at himself and takes his place . . . among the very few contemporary American painters whose work is of more than national importance."[109]

June 17: Under pressure from increasing marital difficulties, Mougouch arranges to have a babysitter watch the children and leaves Sherman for a few days, during which time she has a brief affair with Matta. Shortly after her return, she takes Maro and Natasha to Crooked Run Farm for their grandfather's birthday.

June 26: Gorky spends the day with Julien Levy and his wife. While Levy is driving him home in the rain, he loses control of the car, which skids down a hill, turning over onto its side. Gorky breaks his neck and collarbone, after which he spends more than a week in traction in the hospital, in pain and uncomfortable because of his previous colostomy and the lack of privacy.

July 5: Still in pain and troubled by fears that he will not be able to paint again, he is released from the hospital wearing a leather and metal collar that leaves his painting arm immobilized. He spends a short time alone with Mougouch, convalescing, before the children return.

Mid-July: His depression deepens and his rages and marital troubles worsen, and on July 16, while they are in New York together, Mougouch leaves him, taking the children with her to Crooked Run Farm. She writes to Ethel and Wolfgang Schwabacher on July 18: "The situation looks untenable & I *know* I can no longer hold on."[110]

July 21: After removing his neck brace, Gorky hangs himself in a shed near the Glass House. A note written on a wooden crate nearby reads, "Goodbye My Loveds."[111]

He is buried in a small cemetery on a grassy hill next to a church in Sherman.

1. Gorky's birth date, like that of the rest of his siblings, is uncertain due to the absence of formal birth and baptismal records. It is often cited as April 15, 1904, which is what he declared on his citizenship papers. In a letter to his sister Vartoosh, he reported: "Sweet one, today I received the two letters you had sent in which you had asked what age I have put down in my American citizenship papers. I have written that I was born on April 15, 1904." See Karlen Mooradian, *Arshile Gorky Adoian* (Chicago: Gilgamesh, 1978), p. 265. (This letter was misdated by Mooradian to October 28, 1940, which is too early. Gorky goes on to discuss a camouflage course he is about to teach at the Grand Central School of Art, something he did in late 1941.) A letter from Vartoosh to Gorky's patron Mina Metzger on December 26, 1948, however, cites his birth date as 1905; Arshile Gorky Research Collection, Frances Mulhall Achilles Library, Archives, Whitney Museum of American Art, New York. The manifest of the ship that brought Gorky to the United States lists his arrival date as February 26, 1920, and his age as seventeen, which would place his birth date in 1903; The Statue of Liberty—Ellis Island Foundation, Inc., http://www.ellisislandrecords.org (accessed January 4, 2008). Gorky worsened the confusion by providing galleries and museums with various birth dates and birth places throughout his lifetime. Those that he provided to the Museum of Modern Art, New York, for instance, and that were printed in its exhibition catalogue *Fourteen Americans*, were October 25, 1904 (likely an homage to Picasso, who was born October 25, 1881), and Tiflis (Tbilisi), Russia. See Dorothy Miller, ed., *Fourteen Americans* (New York: The Museum of Modern Art, 1946), p. 23, and Matthew Spender, *From a High Place: A Life of Arshile Gorky* (New York: Alfred A. Knopf, 1999), p. 241, citing a letter from Gorky to Dorothy Miller on June 26, 1942, Museum of Modern Art, New York, Department of Painting and Sculpture, Gorky collection file. Nouritza Matossian reports that his older sisters maintained that he was born in 1902 or 1903 (Vartoosh continued to insist on 1904) and that the date of 1902 is corroborated by other boys his age; Matossian, *Black Angel: The Life of Arshile Gorky* (London: Chatto and Windus, 1998), p. 8. Hayden Herrera believes he was probably born "at the turn of the century," though this seems too early; Herrera, *Arshile Gorky: His Life and Work* (New York: Farrar, Straus and Giroux, 2003), pp. 20–21. Since Shushanig married Setrag in 1899 and the couple had one baby together before Gorky, the 1902 birth date seems most plausible.

2. As Vartoosh recalled: "Though Gorky's baptismal name was Vosdanig our paternal grandfather's name was Manoog, and when he died they called Gorky Manoog after him." Vartoosh Mooradian to Ethel Schwabacher, February 8, 1955, Arshile Gorky Research Collection, Frances Mulhall Achilles Library, Archives, Whitney Museum of American Art, New York.

3. During the years 1894–96, Sultan Abdul Hamid II ordered the annihilation of Turkey's Armenian population. Somewhere between 100,000 and 300,000 Armenians were killed during this time and almost half a million left homeless. Along with relatives on both sides of Gorky's family, Setrag's and Shushan's first spouses were killed.

4. When Shushan married Setrag in 1899, she was forced to give up one of her daughters as part of the arranged marriage. She kept Akabi and sent Sima to an orphanage in Van, where she may have been killed or abducted during one of the raids by Turkish soldiers; see Matossian, *Black Angel*, pp. 20–21.

5. Satenig gave her birth date as 1901, but she may have been born earlier. Armenian village wives were inclined to have children shortly after marriage, as it improved their status with their husband's extended family. See Herrera, *Arshile Gorky: His Life and Work*, p. 638.

6. Like Gorky's, Vartoosh's birth date is uncertain due to a lack of official documentation. Although her son Karlen Mooradian cites her birthday as September 27, 1906, in his publications on Gorky (see the Bibliography, p. 383 below), the manifest from the ship that brought her to the United States in 1920 records that she was sixteen, which would make her birth date 1904; The Statue of Liberty—Ellis Island Foundation, Inc., http://www.ellisislandrecords.org (accessed January 4, 2008).

7. Matossian, *Black Angel*, p. 23. It is often said that Gorky began drawing at the age of three, but since his birth date is unknown, it is difficult to pinpoint the year he began to draw.

8. The ship manifest lists Setrag's last residence as Batsuni [Batumi], Russia, and his age as thirty-five; The Statue of Liberty—Ellis Island Foundation, Inc., http://www.ellisislandrecords.org (accessed January 4, 2008).

9. For Gorky's time at Saint Vardan, I am relying on the dates assigned in Karlen Mooradian's books on the artist (see the Bibliography, p. 383 below). The reader should treat this information cautiously. Gorky's sister Satenig recalled that he did not speak until he was six years old, and thus he may have started school later than most boys his age. See Satenig Avedisian to Mina Metzger, March 31, 1949, Arshile Gorky Research Collection, Frances Mulhall Achilles Library, Archives, Whitney Museum of American Art, New York. If Gorky was born in 1904 and did not speak until he was six, it seems unlikely that he started school in 1909. But since his birth date was probably earlier than 1904, it is also plausible that he began school before 1909.

10. Matossian, *Black Angel*, pp. 46–47. The quotation and the information regarding Gorky's schooling were taken from an interview Matossian conducted with Vartoosh Mooradian in 1990.

11. Viscount James Bryce, *The Treatment of the Armenians in the Ottoman Empire, 1915–16: Documents Presented to Viscount Grey of Fallodon, Secretary of State for Foreign Affairs*, ed. Arnold Toynbee (London: H. M. Stationery Office, Sir J. Causton, 1916), p. 43. This quotation is taken from the contemporary account of Grace Higley Knapp, a teacher at the American School in Van who was present during the siege and evacuation. According to Knapp, the evacuation order was issued on July 30.

12. Vartoosh later reported that they left Van on June 15, stopped in Igdir on June 23, and on June 25 reached Ejmiadzin, where they stayed for three weeks before arriving in Yerevan on July 16. See Karlen Mooradian, "A Sister Recalls: An Interview with Vartoosh Mooradian," in "A Special Issue on Arshile Gorky," *Ararat* 12 (Fall 1971), pp. 10–11. Hayden Herrera has pointed out that they likely departed in early August, which seems accurate, since the mass evacuation was not ordered until late July; Herrera, *Arshile Gorky: His Life and Work*, pp. 83–86, 649.

13. Vartoosh recalled that they lived at 14 Milyonulitz Street until July 30, and then stayed at 39 Vagzalsky Street until November; Mooradian, "A Sister Recalls," p. 11.

14. Karlen Mooradian states that the sisters left on October 9; Mooradian, *Arshile Gorky Adoian*, p. 7, and Mooradian, "Chronology of Vosdanik Adoian (Arshile Gorky)," in "A Special Issue on Arshile Gorky," p. 4. But Vartoosh remembered only that they left in October; Mooradian, "A Sister Recalls," p. 11.

15. Vartoosh reported: "Mother could not work. There was no food and she was starving and her stomach swelled up and she was very weak. And when the winter got worse the ceiling of our room began to leak, and so each morning before Gorky and I went to work we would lift mother up and put her in the window so that she would not get wet from the leaking roof. By evening we would return and mother was the same way"; Mooradian, "A Sister Recalls," p. 12.

16. My source for the timeline of Vosdanig and Vartoosh's journey from Yerevan to Patras is the chronology provided in Mooradian, *Arshile Gorky Adoian*, pp. 7, 10–11, and Mooradian, "Chronology of Vosdanik Adoian (Arshile Gorky)," p. 4. To my knowledge, there are no existing official documents to pinpoint the exact dates of their journey before their arrival at the Port of New York.

17. See Mooradian, "A Sister Recalls," p. 14. Vartoosh stayed in the Kelekian's home in Bebek, but Gorky preferred to stay in the tents outside with his comrades. Vartoosh remembers that after several months he finally came to stay with her in Bebek.

18. Their names are on the second and third lines of the passenger manifest; The Statue of Liberty—Ellis Island Foundation, Inc., http://www.ellisislandrecords.org (accessed January 4, 2008).

19. Karlen Mooradian states that they were held for three days upon their arrival, but Vartoosh recalled that they "stayed there three or four days." See Mooradian, *Arshile Gorky Adoian*, p. 11, and "Chronology of Vosdanik Adoian (Arshile Gorky)," p. 4; also Mooradian, *The Many Worlds of Arshile Gorky* (Chicago: Gilgamesh, 1980), p. 35.

20. According to Vartoosh, Gorky was fired after being caught drawing on the frames used to transport shoe soles. He also angered his employers by drawing on the factory roof. See Mooradian, "A Sister Recalls," p. 15.

21. Ethel K. Schwabacher, *Arshile Gorky* (New York: Macmillan for the Whitney Museum of American Art, 1957), p. 28.

22. Herrera, *Arshile Gorky: His Life and Work*, pp. 116, 652 (Herrera cites an interview she conducted with Will Barnet). According to fellow student Norris C. Baker, Gorky left the class after he was chastised for not adhering to Carbee's methods.

23. Mooradian, *The Many Worlds of Arshile Gorky*, p. 60 n. 23.

24. Katherine Murphy to Elaine de Kooning, July 29, 1951, Arshile Gorky Research Collection, Frances Mulhall Achilles Library, Archives, Whitney Museum of American Art, New York. Murphy recalled that a parishioner from the church offered Gorky five dollars for *Park Street Church* if he would make the figures more distinct and looking less like peasants. He was furious and refused. Murphy purchased the painting for ten dollars.

25. See Mooradian, *The Many Worlds of Arshile Gorky*, p. 197. Rothko was a student in a class for which Gorky served as the monitor. As of 1925, the Metropolitan Museum Art owned several works by Hals: *Young Man and Woman in an Inn* (1623), *Merrymakers at Shrovetide* (c. 1615), *Portrait of a Man* (early 1650s), *The Smoker* (c. 1623–25), and *Portrait of a Woman* (c. 1650). A painting in the style of Hals titled *Malle Babbe*, acquired by the museum in 1871 and originally thought to be by Hals, was likely the source for Gorky's *Copy after Frans Hals' "Lady in the Window"* (private collection). For an illustration of this painting, see Jim M. Jordan and Robert Goldwater, *The Paintings of Arshile Gorky: A Critical Catalogue* (New York: New York University Press, 1982), p. 130, cat. 5.

26. Herrera, *Arshile Gorky: His Life and Work*, pp. 129, 654. When he applied to the National Academy, Gorky used the address of the New School of Design as his residential address and gave his date and place of birth as April 1902 in Kazan, Russia. The date on which he left the academy comes from his file card at the school, which reads, in red ink, "2/9 left."

27. Grand Central School of Art catalogue for the school year 1926–27, p. 19, The Arshile Gorky Foundation Archives.

28. "Fetish of Antique Stifles Art Here, Says Gorky Kin," *New York Evening Post*, September 15, 1926; reproduced in Harold Rosenberg, *Arshile Gorky: The Man, the Time, the Idea* (New York: Horizon, 1962), p. 125.

29. For Gorky's interest in Cézanne and a discussion of the availability of his works in New York at that time, see Michael R. Taylor, "Learning from 'Papa Cézanne': Arshile Gorky and the (Self-)Invention of the Modern Artist," in *Cézanne and Beyond*, ed. Joseph J. Rishel and Katherine Sachs, exh. cat. (Philadelphia: Philadelphia Museum of Art in association with Yale University Press, 2009), pp. 407–31.

30. Julius Meier-Graefe published two works on Cézanne in the early 1920s: *Cézanne und sein Kreis: Ein Beitrag zur Entwicklungsgeschicte* (Munich: R. Piper, 1922) and *Paul Cézanne* (Munich: R. Piper, 1923). A list of books in Gorky's library, compiled by Matthew Spender and now in the Archives of American Art, Smithsonian Institution, Washington, D.C. (Research material regarding Arshile Gorky, 1957–1999, reel 4982), includes the first study (no. 58 in the list). Gorky acquired this book by 1927, if not earlier, according to Revington Arthur, one of his students at Grand Central: "I had at that time never heard of Cézanne. When I went there in 1927, Gorky was already speaking about Cézanne, so we looked at the book by Meier-Graeffe [*sic*], the German critic who wrote on Cézanne." See Matossian, *Black Angel*, p. 151.

31. Schwabacher, *Arshile Gorky*, p. 21; also Spender, *From a High Place*, p. 73.

32. "Grand Central Faculty Show," *ARTnews* 25, no. 20 (February 19, 1927), p. 4. This announcement states that "Archole Gorky" exhibited "a portrait and a study in still life." The exhibition tour included stops at the Manchester (N.H.) Institute of Arts and Science; Bowdoin College, Brunswick, Maine; The Art Institute of Chicago; Memorial Art Gallery, Rochester, N.Y.; Dayton Art Institute, Dayton, Ohio; Cincinnati Museum Association, Columbus, Ohio; Gallery of Fine Arts, St. Petersburg, Fla.; Art Gallery of Tampa, Fla.; and Grand Central Galleries, New York. Since the exhibition ended in New York in February, it seems

likely that the multicity tour began late in 1926, after Gorky's teaching appointment commenced in September.

33. Gorky would have had a variety of opportunities to view Picasso's work in New York. For a comprehensive record of the exhibitions that included works by Picasso during this time, see Julia May Boddewyn, "Selected Chronology of Exhibitions, Auctions, and Magazine Reproductions, 1910–1957," in Michael FitzGerald, *Picasso and American Art*, exh. cat. (New York: Whitney Museum of American Art in association with Yale University Press, 2006), pp. 328–77. Gorky likely also saw books and magazines containing reproductions of Picasso's work during his regular visits to Erhard Weyhe's art bookstore on Lexington Avenue in New York, where he sometimes traded art for books; see Mooradian, *The Many Worlds of Arshile Gorky*, p. 215.

34. Gorky's first residence in New York appears to have been a rooftop studio lent to him by someone named Sigurd Skou; see Jordan and Goldwater, *The Paintings of Arshile Gorky*, p. 94 n. 2. By September 1926, he had moved to West Fiftieth Street (as reported in the *New York Evening Post*), and sometime later that year he moved to a studio at Sixth Avenue and Fifty-seventh Street, which he likely shared with fellow artist Stergis M. Stergis. Nathan I. Bijur, a student and early patron, began taking lessons from Gorky in 1926 and obtained one of his paintings during a class at the Fifty-seventh Street studio; Nathan I. Bijur to Mrs. David Metzger, November 1949, Arshile Gorky Research Collection, Frances Mulhall Achilles Library, Archives, Whitney Museum of American Art, New York. According to Saul Schary, Gorky had moved to the Sullivan Street studio by 1927, the year they met; Mooradian, *The Many Worlds of Arshile Gorky*, p. 203. However, Gorky's pupil Helen Austin recalled that he had this studio "around 1928"; Jordan and Goldwater, *The Paintings of Arshile Gorky*, p. 94 n. 2.

35. Giorgio de Chirico's *The Fatal Temple* of 1914, for example, was probably a source for Gorky's *Nighttime, Enigma, and Nostalgia* series of the 1930s. Albert E. Gallatin ultimately gave his collection to the Philadelphia Museum of Art in 1952.

36. See the Hans Burkhardt interviews, by Paul J. Karlstrom, Los Angeles, November 25, 1974, Archives of American Art, Smithsonian Institution, Washington, D.C., http://www.aaa.si.edu/collections/oralhistories/transcripts/burkha74.htm (accessed May 1, 2008). Burkhardt's letter to Ethel Schwabacher on May 10, 1949, reveals a different timeline: "I therefore enrolled at the Grand Central School of Arts [*sic*], where Gorky was teaching. This was the semester of 1926–27"; Arshile Gorky Research Collection, Frances Mulhall Achilles Library, Archives, Whitney Museum of American Art, New York. Burkhardt studied with Gorky on and off until 1937, when he moved to California.

37. See Karlen Mooradian's extracts from an interview with Mussikian on December 10, 1972, in *The Many Worlds of Arshile Gorky*, p. 223 n. 42, p. 224 n. 49.

38. John D. Graham to Duncan Phillips, December 28, 1931, The Phillips Collection Records, 1920–1960, Archives of American Art, Smithsonian Institution, Washington, D.C.; cited in Spender, *From a High Place*, p. 84.

39. For Janis's memories of meeting Gorky, see John Gruen, *The Party's Over Now: Reminiscences of the Fifties—*

New York Artists, Writers, Musicians, and Their Friends (New York: Viking, 1972), p. 244.

40. Noguchi told Maro Gorky that he met her father just before the stock-market crash of 1929; Spender, *From A High Place*, p. 79. But on another occasion he recalled that he met him "around 1933 or 1934," when he was having "an exhibition at the Marie Harriman gallery on 57th street"; Mooradian, *The Many Worlds of Arshile Gorky*, pp. 180–81. This exhibition of Noguchi's work actually took place slightly later, from January 29 to February 16, 1935.

41. See Barbara Hess, *Willem de Kooning, 1904–1997: Content as Glimpse* (Los Angeles: Taschen, 1959), p. 14.

42. The date of Gorky's move to the Union Square studio was initially published in Schwabacher, *Arshile Gorky*, p. 48. Some sources give a slightly earlier date, but this does not appear to be correct. Gorky's student H. C. Klinger remembered that he obtained drawings from Gorky between 1927 and 1930, and that his studio was then still on Sullivan Street. See H. C. Klinger to Lloyd Goodrich, March 9, 1978, Arshile Gorky Research Collection, Frances Mulhall Achilles Library, Archives, Whitney Museum of American Art, New York. Stuart Davis remembered that Gorky still lived at Sullivan Street when they met in 1929; Davis, "Arshile Gorky in the 1930s: A Personal Recollection," *Magazine of Art* 44, no. 2 (February 1951), p. 56. Dorothy Miller, who met Gorky in the fall of 1931, also recalled that the studio was "quite new to him then for he had just earlier obtained it"; Mooradian, *The Many Worlds of Arshile Gorky*, p. 170.

43. For a reproduction of *Fruit*, see Jordan and Goldwater, *The Paintings of Arshile Gorky*, p. 178, no. 55. Gorky's short-lived relationship with the Downtown Gallery, in 1931, likely came about through Stuart Davis, who regularly exhibited there. The records for the gallery are located in the Archives of American Art, Smithsonian Institution, Washington, D.C., and the Gorky inventory can be viewed on their Web site under Downtown Gallery Records, 1824–1974 bulk 1926–1969, Series 4: Business Records, 1925–1974, Stock Books, Stock, A–N (3 of 5), 1926–1940 (Reel 5604, frame 776). The gallery also included Gorky in three group shows in 1931 (see the Exhibition History in this volume, p. 372 below).

44. Arshile Gorky, "Stuart Davis," *Creative Art* 9, no. 3 (September 1931), pp. 213–17; reproduced in Rosenberg, *Arshile Gorky*, pp. 128–29.

45. Julien Levy, foreword to William C. Seitz, *Arshile Gorky: Paintings, Drawings, Studies*, exh. cat. (New York: The Museum of Modern Art, 1962), p. 7.

46. The debate was likely organized with the assistance of John Graham, who taught at Wells College from 1931 through 1933.

47. Project Card, December 22, 1933, PWAP, Record Group 121, box 4, entry no. 117, National Archives and Records Administration, College Park, Md.; cited in Francis V. O'Connor, "Arshile Gorky's Newark Airport Murals: The History of Their Making," in Ruth Bowman, *Murals without Walls: Arshile Gorky's Aviation Murals Rediscovered* (Newark, N.J.: Newark Museum, 1978), p. 22.

48. "Notes on a conversation between Lloyd Goodrich and Ethel Schwabacher," February 14, 1957, Arshile Gorky Research Collection, Frances Mulhall Achilles Library, Archives, Whitney Museum of American Art, New York.

49. Public Works of Art Project, selected administrative and business records, roll DC 113, frames 287–98, Archives of American Art, Smithsonian Institution, Washington, D.C.; cited in O'Connor, "Arshile Gorky's Newark Airport Murals," p. 22.

50. Boyer would later include Gorky's work in exhibitions at the Philadelphia and New York locations of the Boyer Galleries (see the Exhibition History, pp. 370, 372 below). He would also represent the artist for several years and, according to Dorothy Miller, was an unscrupulous businessman: "That awful man named Boyer stole a great many drawings from him." See Herrera, *Arshile Gorky: His Life and Work*, p. 220.

51. C. H. Bonte, "In Gallery and Studio," *Philadelphia Inquirer*, February 11, 1934.

52. Matossian, *Black Angel*, pp. 220–21.

53. Marny George to James Thrall Soby, March 15, 1951, Arshile Gorky Research Collection, Frances Mulhall Achilles Library, Archives, Whitney Museum of American Art, New York.

54. See Jordan and Goldwater, *The Paintings of Arshile Gorky*, p. 256. As Marny was a minor, the marriage was annulled; Herrera, *Arshile Gorky: His Life and Work*, p. 234.

55. Although Davis was insistent that their friendship ended in the early part of 1934, they may have fallen out with one another later. Corinne Michael West, who became involved with Gorky in 1935, later wrote in a notebook dedicated to their relationship that he "was constantly meeting Stuart Davis at Romany Marie's at 12 o'clock at night." More specifically, she recalled that Gorky met Davis after he had returned with West from seeing his September 1935 exhibition at the Boyer Galleries in Philadelphia: "Finally we reached N. York at about 2 o'clock in the morning—maybe 1 o'clock. . . . After this mind you Gorky went an [*sic*] hurried to Romany Maries to meet Stuart Davis!" I am indebted to Roberta and Stuart Friedman, who shared this notebook with me; Corinne Michael West Archives, NY School Art Gallery, Yorktown Heights.

56. See Adoian's description of their correspondence in Mooradian, *The Many Worlds of Arshile Gorky*, pp. 89–92.

57. See Corinne Michael West's notes dated August 1978, Corinne Michael West Archives, NY School Art Gallery, Yorktown Heights. According to the existing correspondence and telegrams in the West archive, it appears that West moved to Rochester in the summer of 1936. This seems likely, as Gorky began an affair in the summer or fall of this year with the painter Mercedes Carles (later Matter), daughter of the Philadelphia painter Arthur B. Carles. Although Gorky and West eventually parted ways, they kept in touch for several years. For instance, West visited Gorky in New York during the 1939 World's Fair. See "Notes on Gorky—Corinne Michael West," Arshile Gorky Research Collection, Frances Mulhall Achilles Library, Archives, Whitney Museum of American Art, New York.

58. Gorky's salary was reduced in November 1938 and again in August 1939, leaving him with a final wage of $87.60 a month.

59. [C. H. Bonte, "In Gallery and Studio"], *Philadelphia Inquirer*, September 29, 1935; press clipping courtesy of Maro Gorky and Matthew Spender.

60. The exhibition announcement, which can be found in the Guild Art Gallery Records, 1935–1939, Archives of American Art, Smithsonian Institution, Washington, D.C., lists the following artists: Boris Aronson, Don Forbes, Henry Major, Rosa Newman, Philip Reisman, Ben-Shmuel, and Ary Stillman. For Gorky's inclusion in this exhibition, see Edward Alden Jewell, "Pop Hart, the Artist and the Man," *New York Times*, October 13, 1935, sec. X.

61. See the undated press release, Guild Art Gallery Records, 1935–1939, Archives of American Art, Smithsonian Institution, Washington D.C. The following month, at the invitation of the Guild's co-owner Anna Walinska, Léger viewed Gorky's show of drawings at the Guild and also visited his studio. Walinska later asked Gorky about the visit, and he admitted that he had panicked and hid his paintings at the last moment. See Spender, *From a High Place*, pp. 138–39.

62. Guild Art Gallery Records, c. 1935–1939, Archives of American Art, Smithsonian Institution, Washington, D.C.; Howard Devree, "Abstractions," *New York Times*, December 22, 1935; and Carlyle Burrows, "Abstract Drawings," *New York Herald Tribune*, December 22, 1935. James W. Lane, in a review in *Parnassus* 8, no. 3 (March 1936), p. 27, proclaimed: "He is an abstractionist in the style of Miro, but his better-knit compositions have more rhythm and harmony than the Spaniard's."

63. Guild Art Gallery records, c. 1935–1939, Archives of American Art, Smithsonian Institution, Washington, D.C. Gorky did not stay with the gallery for three years. A note on the contract by Margaret Lefranc (co-founder of the Guild Art Gallery; also known as Margaret Schoonover), dated May 1, 1981, states: "The Julien Levy Gallery offered Gorky a contract with a stipend of abt. $25.00 weekly, as we could not match that + we knew Gorky had financial difficulties, we released him of this contract." While the agreement between the Guild Art Gallery and Gorky was indeed dissolved, the reasoning was faulty, as Levy did not offer Gorky a formal contract until 1944. Gorky did, however, receive $700 from Levy in the mid-1930s so that he could continue painting; see Spender, *From a High Place*, pp. 151–52.

64. "W.P.A. Murals Are Too Much for La Guardia," *New York Herald Tribune*, December 28, 1935.

65. See Herrera, *Arshile Gorky: His Life and Work*, p. 258.

66. In fact, the Bennett Field commission was given to Eugene Chodorow, whose more conservative proposal was favored by Mayor La Guardia (see p. 82 above).

67. For Gorky's involvement with this group, see Mooradian, *The Many Worlds of Arshile Gorky*, pp. 109–10, and George McNeil, "American Abstractionists Venerable at Twenty," *ARTnews* 55, no. 3 (May 1956), pp. 64–65.

68. See Julien Levy, *Memoir of an Art Gallery* (New York: G. P. Putnam's Sons, 1977), p. 284, and Levy's foreword to Seitz, *Arshile Gorky: Paintings, Drawings, Studies*, p. 8.

69. Holger Cahill, *New Horizons in American Art* (New York: The Museum of Modern Art, 1936), p. 139.

70. For a list of the works that Gorky included in the painting and drawing annuals and biennials, see Peter Hastings Falk, ed., *The Annual and Biennial Exhibition Record of the Whitney Museum of American Art* (Madison, Conn.: Sound View, 1991), pp. 184–85.

71. By September 1939, the FAP/WPA had suffered a rigorous administrative reorganization, and the book project was eventually liquidated. The manuscript was later resurrected by Francis V. O'Connor in a volume titled *Art for the Millions* (Greenwich, Conn.: New York Graphic Society, [1973]), which includes a history of the planned publication.

72. Besides appearing in O'Connor's 1973 study (ibid.), this essay is reproduced in Bowman, *Murals without Walls*, pp. 13–16.

73. This letter was first published in Mooradian, *The Many Worlds of Arshile Gorky*, pp. 251–52.

74. Gerard Sullivan, "Mr. Gorky's Murals the Airport They Puzzle!" *Newark Ledger*, June 10, 1937; reproduced in Bowman, *Murals without Walls*, p. 39.

75. Gorky to Vartoosh Mooradian, October 12, 1938, Arshile Gorky Research Collection, Frances Mulhall Achilles Library, Archives, Whitney Museum of American Art, New York. Regarding the project, he wrote: "I am beginning on the sketches as soon as my studio is done. I believe they will be acceptable and worth about $3000. These are the murals in the Aviation Building."

76. When Gallet later sold some of the works by Gorky in her collection, she provided signed typed statements that read: "I was a student and friend of Arshile Gorky in the years 1938–40, and bought this drawing during that period," The Arshile Gorky Foundation Archives. Their relationship must have begun early in 1938, as Gorky gave Gallet an inscribed painting as a valentine in February of that year. See *Graham, Gorky, Smith, and Davis in the Thirties*, exh. cat. (Providence, R.I.: Bell Gallery, Brown University, 1977), p. 17.

77. Mooradian, *The Many Worlds of Arshile Gorky*, p. 113.

78. See Herrera, *Arshile Gorky: His Life and Work*, p. 308.

79. Peter Busa recollected that Gorky and Matta met at a small gathering and not at a gallery opening. See Provincetown Art Association and Museum, *Life Colors Art: Fifty Years of Painting by Peter Busa*, exh. cat. (Provincetown, Mass.: Provincetown Art Association and Museum, 1992), p. 51.

80. *Garden in Sochi* (1941; plate 95) entered the collection in exchange for *Khorkom* (now private collection), a painting donated a year earlier by Ethel and Wolfgang Schwabacher. For a reproduction of *Objects* (1932), see Janie C. Lee and Melvin P. Lader, *Arshile Gorky: A Retrospective of Drawings*, exh. cat. (New York: Whitney Museum of American Art, 2003), cat. 11. For a reproduction of *Khorkom*, see Jordan and Goldwater, *The Paintings of Arshile Gorky*, p. 358, cat. 212.

81. Gorky to the Mooradians, September 3, 1940, Arshile Gorky Research Collection, Frances Mulhall Achilles Library, Archives, Whitney Museum of American Art, New York. "The other day," he wrote, "I went to see Mr. Green [Greacen], [to ask] if he would put a classroom at the Grand Central School at my disposal. He said he would be glad to, but since there is a draft going on, he advised me to wait a few months, until he can tell more definitely how large an enrollment he would have."

82. Malcolm Johnson, "Café Life in New York," *New York Sun*, August 22, 1941; quoted in Herrera, *Arshile Gorky: His Life and Work*, p. 317.

83. Author's telephone conversation with Agnes Gorky Fielding, October 14, 2008.

84. See Martica Sawin, *Surrealism in Exile and the Beginning of the New York School* (Cambridge, Mass.: MIT Press, 1995), p. 158. This information was confirmed by Hayden Herrera in a telephone conversation with Ford; Herrera, *Arshile Gorky: His Life and Work*, pp. 382, 696.

85. Brochure for Gorky's camouflage course, 1942, Grand Central School of Art, New York, Arshile Gorky Research Collection, Frances Mulhall Achilles Library, Archives, Whitney Museum of American Art, New York. The biography within the brochure includes the usual falsehoods: "Born in Russia: Studied art at Julian Academy, also at various schools in Paris, Providence, Boston, New York, etc. Studied engineering at Polytechnic Institute, Tiflis, Russia."

86. Parsons, quoted in Mooradian, *The Many Worlds of Arshile Gorky,* p. 188.

87. Arshile and Agnes Gorky to Vartoosh and Moorad Mooradian, September 15, 1941, Arshile Gorky Research Collection, Frances Mulhall Achilles Library, Archives, Whitney Museum of American Art, New York. The telegram, on a card from the Storey County Courthouse, reads: "We just got married and are sending our love to you."

88. Arshile and Agnes Gorky to Vartoosh, Moorad, and Karlen Mooradian, December 28, 1941, Arshile Gorky Research Collection, Frances Mulhall Achilles Library, Archives, Whitney Museum of American Art, New York.

89. In her 1957 biography of the artist, Schwabacher writes that Gorky spent three weeks at Schary's home (*Arshile Gorky*, p. 93), but the trip was probably shorter. Besides Mougouch's recollection, which we have in a letter she sent to Nathalie Campbell on February 1943 (cited in Herrera, *Arshile Gorky: His Life and Work*, p. 394), there is Gorky's letter to Vartoosh, dated February 17, 1943, which mentions a similar duration: "Last summer Agnes and I spent two weeks outdoors, in the sun, and it worked wonders for us"; Arshile Gorky Research Collection, Frances Mulhall Achilles Library, Archives, Whitney Museum of American Art, New York.

90. See Schwabacher, *Arshile Gorky*, p. 66; also Ethel Schwabacher Papers, roll N69-64, Archives of American Art, Smithsonian Institution, Washington, D.C.

91. See Schwabacher, *Arshile Gorky*, p. 102; also Ethel Schwabacher Papers, roll N69-64, Archives of American Art, Smithsonian Institution, Washington, D.C.

92. Phyllis Rosenzweig, *Arshile Gorky: The Hirshhorn Museum and Sculpture Garden Collection, Smithsonian Institution,* exh. cat. (Washington, D.C.: Smithsonian Institution Press, 1979), p. 8. A list in the archives of the Hirshhorn Museum and Sculpture Garden, Washington, D.C., indicates that Hirshhorn purchased the works on March 20, 1943. This list was included in a letter from Wolfgang Schwabacher to Joseph Hirshhorn on December 24, 1948 (also in the Hirshhorn archives), and was presumably made by Gorky's wife. Mougouch recalled seeing Gorky date a number of works in 1942, immediately before Joseph Hirshhorn purchased them, which argues for an earlier date for the transaction. See Jordan and Goldwater, *The Paintings of Arshile Gorky,* cat. 70, p. 196 n. 1.

93. Mougouch recalled about this time: "He'd never seen fireflies before. He'd never seen milkweed before. We were there until late November. We had a change of seasons—the ripening in the fields. . . . He made well over 100 drawings. This summer was the real release of Gorky." See Herrera, *Arshile Gorky: His Life and Work*, p. 414.

94. James Johnson Sweeney, "Five American Painters," *Harper's Bazaar*, April 1944, p. 122.

95. Jeanne Reynal to Mougouch, April 28, [1944], Jeanne Reynal Papers, 1942–1968, roll N69-66, Archives of American Art, Smithsonian Institution, Washington, D.C. This letter was typed and dated April 28 by Reynal, but the year "1943" is handwritten, perhaps by someone else. The subject of the letter, the painting *The Liver Is the Cock's Comb* (plate 114), indicates that it was written in 1944.

96. Sidney Janis, *Abstract and Surrealist Art in America* (New York: Reynal and Hitchcock, 1944), p. 120. This book was published in conjunction with the exhibition *Abstract and Surrealist Art in the United States,* which traveled in 1944 to the Cincinnati Art Museum, the Denver Art Museum, the Santa Barbara Museum of Art, and the San Francisco Museum of Art. A separate, shorter exhibition catalogue, with the same name as the exhibition and also by Janis, was published as well (San Francisco: San Francisco Museum of Modern Art, 1944).

97. See Herrera, *Arshile Gorky: His Life and Work*, p. 478. Only a small number of exhibition catalogues were printed, but a copy of the essay can be found in the Ethel Schwabacher Papers, 1940–1975, roll N69-64, Archives of American Art, Smithsonian Institution, Washington, D.C.

98. Clement Greenberg, "Art," *The Nation* 160 (March 24, 1945), pp. 342–43. After Gorky's death, Greenberg wrote to Wolfgang Schwabacher on December 17, 1948, about this review: "I did not review Gorky's 1947 show of drawings, but I did cover his 1945 show, in *The Nation* of March 24, 1945—and now regret a good many of the things I said, largely out of pedantry." Earlier that year, in a letter to H. B. Bradbury on August 25, Greenberg wrote: "Gorky was among the four or five most important painters alive in this country at the time he died. I would also say that he was one of the most important painters of his generation anywhere in the world and would have more than held his own in Paris, London, and Rome." Both these letters can be found in the Arshile Gorky Research Collection, Frances Mulhall Achilles Library, Archives, Whitney Museum of American Art, New York.

99. Sawin, *Surrealism in Exile,* p. 368.

100. Gorky to Vartoosh Mooradian, July 4, 1945, Arshile Gorky Research Collection, Frances Mulhall Achilles Library, Archives, Whitney Museum of American Art, New York.

101. Gorky's letter to Vartoosh Mooradian on February 5 indicates that the fire occurred ten days earlier, on January 26; Arshile Gorky Research Collection, Frances Mulhall Achilles Library, Archives, Whitney Museum of American Art, New York. But Mougouch wrote to Jeanne Reynal in January 1946 that it happened on Wednesday, January 16, and that Gorky lost "all the drawings of these past 3 yrs except for some few at Juliens—[and] about 20 canvases." See Herrera, *Arshile Gorky: His Life and Work*, p. 505. As Matthew Spender has noted, it is likely that the losses were exaggerated, as Gorky would not have taken his entire cache of drawings to Sherman; Spender, *From A High Place,* pp. 303–4.

102. W. S. Schwabacher to Arshile Gorky, March 19, 1946, Arshile Gorky Research Collection, Frances Mulhall Achilles Library, Archives, Whitney Museum of American Art, New York. The New-Land Foundation was originally founded to assist refugees from Nazi countries.

103. Clement Greenberg, "Art," *The Nation* 162 (May 4, 1946), p. 552.

104. Gorky to Vartoosh Mooradian, November 17, 1946, Arshile Gorky Research Collection, Frances Mulhall Achilles Library, Archives, Whitney Museum of American Art, New York. Gorky wrote that the family would return to New York City the "day after tomorrow," or on November 19.

105. "Reviews and Previews," *ARTnews* 46, no. 1 (March 1947), p. 43.

106. Spender, *From a High Place,* p. 352. Spender interviewed Elena Calas, wife of the Surrealist poet Nicolas Calas, who took a walk with Gorky and his daughters one day after lunch during this time. Gorky, who had brought a rope with him, apparently asked Maro to choose an appropriate tree from which to hang himself. See also Herrera, *Arshile Gorky: His Life and Work*, p. 557.

107. Regarding Setrag's death, Vartoosh recalled: "Our father died about 6 months before Gorky did, but Gorky never learned of this since I didn't want to tell him because of Gorky's condition"; Vartoosh Mooradian to Ethel Schwabacher, February 8, 1955, Arshile Gorky Research Collection, Frances Mulhall Achilles Library, Archives, Whitney Museum of American Art, New York. George Adoian, however, recalled that it was Satenig's job to inform the family, and that she contacted Gorky with the news; Spender, *From a High Place,* p. 398 n. 337.

108. "Old House Made New," *Life*, February 16, 1948, pp. 90–92.

109. Clement Greenberg, "Art," *The Nation* 166 (March 20, 1948), p. 331.

110. Schwabacher, *Arshile Gorky,* p. 144 (emphasis in original).

111. Peter Blume and Malcolm Cowley found Gorky's body, and each had a different recollection of the note he left. Cowley remembered that the wording was "Goodby all my loved," with the idea being that Gorky intended on writing "Goodby all my loved ones," but the chalk had broken. Blume recalled the phrase as being "Goodby my loves." See Mooradian, *The Many Worlds of Arshile Gorky,* pp. 104, 121. In his foreword to the 1962 exhibition catalogue *Arshile Gorky: Paintings, Drawings, Studies,* by William C. Seitz, Julien Levy wrote (p. 9) that Gorky's words in the note were "Goodbye My Loveds," and this has become the form most often quoted.

EXHIBITION HISTORY

SOLO EXHIBITIONS

1930s

Philadelphia, Mellon Galleries. *Arshile Gorky.* February 2–15, 1934.

Philadelphia, Boyer Galleries. *Arshile Gorky: Drawings.* September 29–October 1935.

New York, Guild Art Gallery. *Abstract Drawings by Arshile Gorky.* December 16, 1935–January 5, 1936. Catalogue.

1940s

San Francisco Museum of Modern Art. *Arshile Gorky.* August 9–24, 1941.

New York, Julien Levy Gallery. *Arshile Gorky.* March 6–31, 1945.

New York, Julien Levy Gallery. *Arshile Gorky: Paintings.* April 16–May 4, 1946.

New York, Julien Levy Gallery. *Arshile Gorky: Colored Drawings.* February 18–March 8, 1947.

New York, Julien Levy Gallery. *Arshile Gorky.* February 29–March 20, 1948.

New York, Julien Levy Gallery. *Arshile Gorky, 1905–1948.* November 16–December 4, 1948.

1950s

New York, Kootz Gallery. *Selected Paintings by the Late Arshile Gorky.* March 28–April 24, 1950.

New York, Whitney Museum of American Art. *Arshile Gorky Memorial Exhibition.* January 5–February 18, 1951. Traveled to Minneapolis, Walker Art Center, March 4–April 22, 1951; San Francisco Museum of Art, May 9–July 9, 1951. Catalogue.

New York, Kootz Gallery. *Drawings in Color by Arshile Gorky.* January 23–February 10, 1951.

Paris, Galerie de France. *Regards sur la peinture américaine.* February 26–March 15, 1952.

New York, Kootz Gallery. *Arshile Gorky.* March 28–April 24, 1952. Catalogue.

Los Angeles, Paul Kantor Gallery. *Arshile Gorky: Paintings and Drawings, 1928–1937.* Opened June 12, 1952.

Princeton, New Jersey, The Art Museum, Princeton University. *Arshile Gorky: A Loan Exhibition of Paintings and Drawings.* October 6–26, 1952.

New York, Sidney Janis Gallery. *Arshile Gorky in the Final Years.* February 16–March 14, 1953.

New York, Sidney Janis Gallery. *Drawings for Principal Paintings by Gorky.* September 26–October 22, 1955.

Rome, Galleria dell'Obelisco. *Arshile Gorky.* February 4–18, 1957. Traveled to Bologna, La Loggia, March 28–April 9, 1957.

New York, Sidney Janis Gallery. *33 Paintings by Arshile Gorky.* December 2–28, 1957. Catalogue.

Pasadena, California, Pasadena Art Museum. *Paintings by Arshile Gorky.* January 5–February 2, 1958.

New York, Sidney Janis Gallery. *Late Drawings by Gorky.* September 28–October 24, 1959. Catalogue.

1960s

Minneapolis, University Gallery, University of Minnesota. *Gorky Drawings.* October 27–December 2, 1960.

New York, David Anderson Gallery. *Arshile Gorky Drawings: 1929 to 1934.* February 3–March 1, 1962. Catalogue.

New York, Sidney Janis Gallery. *Paintings by Arshile Gorky from 1929 to 1948.* February 5–March 3, 1962. Catalogue.

Los Angeles, Everett Ellin Gallery. *Arshile Gorky: 40 Drawings from the Period 1929 thru 1947.* April 9–May 5, 1962. Catalogue.

Venice, U.S. Pavilion. *XXXI Biennale internazionale d'arte: Arshile Gorky.* June 16–October 7, 1962. Catalogue.

New York, International Council of the Museum of Modern Art (organizer). *Arshile Gorky: Drawings.* Traveled to New Orleans, Newcomb College, Tulane University, September 23–October 14, 1962; to twelve other venues in the United States; and to Japan, Germany, Great Britain, Belgium, The Netherlands, Austria, Norway, Sweden, Switzerland, Yugoslavia, Italy, Argentina, Venezuela, Colombia, and Mexico, through June 5, 1968.

New York, The Museum of Modern Art. December 19, 1962–February 12, 1963. *Arshile Gorky, 1904–1948.* Traveled to Washington, D.C., Washington Gallery of Modern Art, March 12–April 14, 1963. Catalogue (*Arshile Gorky: Paintings, Drawings, Studies*).

La Jolla, California, Art Center in La Jolla. *Arshile Gorky: Paintings and Drawings, 1927–1937; The Collection of Mr. and Mrs. Hans Burkhardt.* February 21–March 21, 1963. Catalogue.

Milan, Galleria Blu. *Guazzi, pastelli, chine di Arshile Gorky.* January 1964.

London, Tate Gallery. *Arshile Gorky: Paintings and Drawings.* April 2–May 2, 1965.

Berkeley, University Art Gallery, University of California, Berkeley. *Arshile Gorky: Paintings and Drawings, 1927–1937.* May 7–31, 1965. Traveled to San Francisco State College, Gallery Lounge, September 14–October 10, 1965.

Philadelphia, Pennsylvania Academy of the Fine Arts. *Paintings and Drawings by Arshile Gorky.* November 9–December 10, 1967.

Caracas, Venezuela, Museo de Bellas Artes de Caracas. *Sobre papel: Obras de Arshile Gorky* [concurrently with *Sobre papel: Obras de Robert Motherwell*]. January 1968. Traveled to Bogotá, Biblioteca Luis-Angel Arango del Banco de la República (as *Arshile Gorky: Dibujos*), March 26–April 14, 1968; Mexico City, Museo Universitario de Ciencias y Arte, June 1968. Catalogue.

Chicago, Richard Feigen Gallery. *Arshile Gorky: Drawings from the Julien Levy Collection.* March 18–April 26, 1969. Catalogue.

College Park, Maryland, J. Millard Tawes Fine Arts Center, University of Maryland Art Department and Art Gallery. *The Drawings of Arshile Gorky.* March 20–April 27, 1969. Catalogue.

New York, M. Knoedler & Co. *Gorky: Drawings.* November 25–December 27, 1969. Catalogue.

1970s

Detroit, Michigan, The J. L. Hudson Company Gallery. *Arshile Gorky Drawings.* January 7–February 7, 1970. Catalogue.

Hannover, Germany, Galerie Dieter Brusberg. *Arshile Gorky.* June 8–September 12, 1971.

Turin, Italy, Galleria Galatea. *Arshile Gorky.* February 29–March 27, 1972. Catalogue.

Toronto, Dunkelman Gallery. *Arshile Gorky, 1904–1948.* October 14–20, 1972. Catalogue.

New York, Allan Stone Gallery. *Arshile Gorky: Paintings and Drawings.* November 14–December 22, 1972.

New York, Richard L. Feigen and Co. *Paintings and Drawings of Arshile Gorky.* January–February 1973.

Santa Barbara, California, Ruth S. Schaffner Gallery. *Arshile Gorky: Drawings and Paintings from 1931 to 1946.* March 25–April 29, 1973.

Oklahoma City, Oklahoma Art Center (organizer). *Drawings by Arshile Gorky.* October 28–November 25, 1973. Traveled to Little Rock, Arkansas Art Center, December 9–January 6, 1974; New Orleans Museum of Art, January 20–February 17, 1974; Amarillo, Texas, Amarillo Art Center, March 10–April 7, 1974; Normal, Illinois, University Museum, Illinois State University, April 21–May 19, 1974. Catalogue.

Milwaukee, University of Wisconsin. *Arshile Gorky: Drawings and Paintings.* April 29–May 10, 1974.

New York, M. Knoedler & Co. *Arshile Gorky: Works on Paper.* January 9–February 1, 1975.

Austin, University Art Museum, University of Texas. *Arshile Gorky: Drawings to Paintings.* October 12–November 23, 1975. Traveled to San Francisco Museum of Art, December 4, 1975–January 12, 1976; Purchase, New York, Neuberger Museum of Art, State University of New York College at Purchase, February 10–March 14, 1976; Utica, New York, Museum of Art, Munson-Williams-Proctor Arts Institute, April 4–May 9, 1976. Catalogue.

London, Arts Council of Great Britain (organizer). *Arshile Gorky: Paintings and Drawings.* Traveled to Oxford, England, Museum of Modern Art, December 19, 1975–January 16, 1976; London, Serpentine Gallery, March 12–April 11, 1976. Catalogue.

New York, Washburn Gallery. *Arshile Gorky: In Memory.* November 2–28, 1978. Catalogue.

Newark, New Jersey, The Newark Museum. *Murals without Walls: Arshile Gorky's Aviation Murals Rediscovered.* November 15, 1978–March 11, 1979. Traveled to Rochester, New York, Memorial Art Gallery, University of Rochester, July 1–August 6, 1979; Washington, D.C., Hirshhorn Museum and Sculpture Garden, Smithsonian Institution, October 4–November 25, 1979; New York, Queens Museum, September 6–November 2, 1980. Catalogue.

New York, Xavier Fourcade. *Arshile Gorky: Important Paintings and Drawings.* April 3–28, 1979. Catalogue.

Washington, D.C., Hirshhorn Museum and Sculpture Garden, Smithsonian Institution. *Arshile Gorky: The Hirshhorn Museum and Sculpture Garden Collection.* October 4–November 25, 1979. Catalogue.

1980s

New York, Solomon R. Guggenheim Museum. *Arshile Gorky, 1904–1948: A Retrospective.* April 24–July 19, 1981. Traveled to Dallas Museum of Fine Arts, September 11–November 8, 1981; Los Angeles County Museum of Art, December 3, 1981–February 28, 1982. Catalogue.

Lisbon, Fundação Calouste Gulbenkian, Centro de Arte Moderna, José Azeredo Perdigão. *Arshile Gorky: Collection Mooradian.* Opened October 24, 1984. Traveled to Paris, Centre culturel portugais, January–February 1985. Catalogue.

Madrid, Sala de Exposiciones de la Fundación Caja de Pensiones. *Arshile Gorky, 1904–1948.* October 17–December 15, 1989. Traveled to London, Whitechapel Art Gallery, January 19–March 25, 1990. Catalogue.

1990s

Lausanne, Switzerland, Musée cantonal des Beaux-Arts. *Arshile Gorky: Oeuvres sur papier, 1929–1947.* September 21–November 11, 1990. Traveled to Vienna, Graphische Sammlung Albertina, January 16–February 27, 1991; Marseille, France, Musée Cantini, March 15–June 2, 1991; Saint-Étienne, France, Musée d'art moderne de Saint-Étienne, June 20–September 2, 1991; Frankfurt, Frankfurter Kunstverein, September 25–November 10, 1991; Bremen, Germany, Kunsthalle Bremen, November 19, 1991–January 26, 1992. Catalogue.

Santa Fe, New Mexico, Gerald Peters Gallery, in association with John Van Doren, New York. *Arshile Gorky: Three Decades of Drawings.* September 22–October 4, 1990. Traveled to Gerald Peters Galleries in Dallas, October 11–31, 1990, and New York, November 5–21, 1990; Youngstown, Ohio, Butler Institute of American Art, April 7–May 5, 1991. Catalogue.

Beverly Hills, California, Louis Newman Galleries. *Arshile Gorky: Drawings.* February 14–March 5, 1991.

Venice, Peggy Guggenheim Collection. *Arshile Gorky: Works on Paper / Opere su carta.* April–June 1992. Traveled to Rome, Palazzo delle Esponsizioni, October 14–November 30, 1992; Lisbon, Fundação Calouste Gulbenkian, July 21–August 27, 1993. Catalogue.

Paris, Galerie Marwan Hoss. *Arshile Gorky: Quarante dessins, 1931–1943.* May 12–July 24, 1993. Catalogue.

New York, Whitney Museum of American Art. *Gorky's Betrothals* (*Collection in Context* series). October 6, 1993–January 9, 1994. Traveled to New Haven, Connecticut, Yale University Art Gallery, February 1–April 10, 1994; Los Angeles, The Museum of Contemporary Art, April 24–June 19, 1994. Catalogue.

New York, Gagosian Gallery. *Arshile Gorky: Late Paintings.* January 11–March 5, 1994. Catalogue.

New York, Marc de Montebello Fine Art, Inc. *Arshile Gorky: Late Drawings.* March 9–April 15, 1994. Catalogue.

Princeton, New Jersey, The Art Museum, Princeton University. *Arshile Gorky and the Genesis of Abstraction: Drawings from the Early 1930s.* October 29, 1994–January 3, 1995. Traveled to Milwaukee Art Museum, January 20–April 16, 1995; The Baltimore Museum of Art, October 18, 1995–January 21, 1996. Catalogue.

Washington, D.C., National Gallery of Art. *Arshile Gorky: The Breakthrough Years.* May 7–September 17, 1995. Traveled to Buffalo, Albright-Knox Art Gallery (co-organizer), October 13–December 31, 1995; Fort Worth, Modern Art Museum of Fort Worth (co-organizer), January 13–March 17, 1996. Catalogue.

Los Angeles, Manny Silverman Gallery. *Arshile Gorky: Drawings.* January 9–March 1, 1997.

Seattle, Meyerson & Nowinski Art Associates. *Arshile Gorky.* February 13–April 20, 1997.

New York, Gagosian Gallery. *Arshile Gorky: Paintings and Drawings, 1929–1942.* October 27, 1998–January 9, 1999. Catalogue.

2000s

New York, Gagosian Gallery. *Arshile Gorky: Portraits.* March 20–April 27, 2002. Catalogue.

Basel Art Fair. *Arshile Gorky.* June 12–17, 2002. Traveled to Paris, Galerie 1900–2000, June 27–July 26 2002. Catalogue.

London, Calouste Gulbenkian Foundation. *The Perfume of the Apples: Works of Arshile Gorky.* March 27–June 29, 2003.

New York, Whitney Museum of American Art. *Arshile Gorky: A Retrospective of Drawings.* November 20, 2003–February 15, 2004. Traveled to Houston, The Menil Collection, March 5–May 9, 2004. Catalogue.

Los Angeles, Jack Rutberg Fine Arts. *Arshile Gorky: The Early Years.* November 5, 2004–February 26, 2005. Catalogue.

Fresno, California, Armenian Museum and Fresno Art Museum. *Vosdanik Manouk Adoian a.k.a. Arshile Gorky.* April 7–June 4, 2006. Catalogue.

New York, CDS Gallery. *Arshile Gorky: Early Drawings.* September 15–November 11, 2006. Traveled to Charlottesville, University of Virginia Art Museum (as *Arshile Gorky: Drawings, the Early Years*), August 24–October 28, 2007.

Paris, Centre Georges Pompidou and Centre culturel Calouste Gulbenkian. *Arshile Gorky: Hommage.* April 2–June 4, 2007. Catalogue.

SELECTED GROUP EXHIBITIONS

1920s

New York, Grand Central School of Art (organizer). *Grand Central Faculty Show.* Traveled (according to *Art News* 25, no. 20 [February 19, 1927], p. 4) to Manchester, New Hampshire, Manchester Institute of Arts and Science; Brunswick, Maine, Bowdoin College; The Art Institute of Chicago; Rochester, New York, Memorial Art Gallery; Dayton, Ohio, Dayton Art Institute; Cincinnati Museum Association; St. Petersburg, Florida, Gallery of Fine Arts; Tampa, Florida, Art Gallery of Tampa; New York, Grand Central Galleries.

1930s

New York, The Museum of Modern Art. *An Exhibition of Work of 46 Painters and Sculptors under 35 Years of Age.* April 11–26, 1930. Catalogue.

New York, Société Anonyme. *Special Exhibition Arranged in Honor of the Opening of the New Building of the New School for Social Research.* January 1–February 10, 1931.

Buffalo, Albright Art Gallery, Buffalo Fine Arts Academy (presented by the Société Anonyme). *International Exhibition Illustrating the Most Recent Development in Abstract Art.* February 18–March 8, 1931. Catalogue.

New York, The Art Center. *Exhibition of the International Group.* March 16–28, 1931. Catalogue.

Buffalo, Albright Art Gallery, Buffalo Fine Arts Academy. *Twenty-fifth Annual Exhibition of Selected Paintings by American Artists.* April 26–June 22, 1931.

New York, The Downtown Gallery. *Leading Contemporary American Artists.* June 2–22, 1931. Catalogue.

New York, The Downtown Gallery. *Artists' Models: Opening Exhibition of Figure Painting by Leading Contemporary American Artists.* October 5–25, 1931.

New York, The Downtown Gallery. *American Print Makers: Fifth Annual Exhibition.* December 7–31, 1931. Catalogue.

Wilmington, Delaware, Wilmington Society of the Fine Arts. *Exhibition of Russian Painting and Sculpture: Realism to Surrealism.* January 11–31, 1932. Catalogue.

Philadelphia, Boyer Galleries. [Group exhibition]. 1934.

New York, The Forum Gallery, RCA Building, Rockefeller Center. *First Municipal Art Exhibition: Paintings, Sculpture, Drawings, Prints by Living American Artists Identified with the New York Art World.* February 28–March 31, 1934. Catalogue.

Buffalo, Albright Art Gallery. *The Mr. and Mrs. M. Martin Janis Collection.* 1935.

New York, Whitney Museum of American Art. *Abstract Painting in America.* February 12–March 22, 1935. Catalogue.

The Arts Club of Chicago. *Exhibition of the Sidney Janis Collection of Modern Paintings.* April 5–24, 1935. Catalogue.

New York, Guild Art Gallery. [Group exhibition]. Closed October 28, 1935.

New York, Federal Art Project Gallery. *Murals for Public Buildings.* Opened December 27, 1935.

New York, Guild Art Gallery. *Drawings, Small Sculpture, Watercolors.* March 16–April 4, 1936.

New York, Guild Art Gallery. [Group exhibition]. c. May–June 13, 1936.

New York, Boyer Galleries. *Modern American Paintings.* Closed June 15, 1936.

New York, The Museum of Modern Art. *New Horizons in American Art.* September 14–October 12, 1936. Catalogue.

New York, Whitney Museum of American Art. *Third Biennial Exhibition of Contemporary American Painting.* November 10–December 10, 1936. Catalogue.

Newark, New Jersey, The Newark Museum. *Old and New Paths in American Design, 1720–1936.* November 15–December 28, 1936. Catalogue.

Minneapolis, University Gallery, University of Minnesota. *Art Here.* February 18–March 6, 1937. Catalogue.

Dallas Museum of Fine Arts. *Greater Pan American Exhibition: Art of the Americas, Precolumbian and Contemporary.* June 12–October 31, 1937.

New York, Whitney Museum of American Art. *Annual Exhibition of Contemporary American Painting.* November 10–December 12, 1937. Catalogue.

Minneapolis, University Gallery, University of Minnesota. *Third Annual Exhibition of Contemporary American Painting.* February 4–28, 1938.

Paris, Musée du Jeu de Paume. *Trois siècles d'art aux États-Unis.* May–July 1938. Organized in collaboration with the Museum of Modern Art, New York. Catalogue.

Springfield, Massachusetts, The George Walter Vincent Smith Art Gallery. *Collection of the Société Anonyme—Museum of Modern Art: 1920.* November 9–December 17, 1939. Catalogue.

1940s

New York, Whitney Museum of American Art. *Annual Exhibition of Contemporary American Painting.* January 10–February 18, 1940. Catalogue.

New York, Galerie St. Etienne. *Abstract American Art.* May 22–June 12, 1940.

New York, Whitney Museum of American Art. *Annual Exhibition of Contemporary American Painting.* November 27, 1940–January 8, 1941. Catalogue.

New York, The Museum of Modern Art (organizer), in collaboration with the American Museum of Natural History, the Brooklyn Museum, The Metropolitan Museum of Art, the Whitney Museum of American Art, and the Committee of Art of the Office of the Coordinator of Commercial and Cultural Relations between the American Republics. *La pintura contemporánea norteamericana.* Shown at the Metropolitan Museum of Art as *Contemporary Painting in the United States: A Special Exhibition,* April 19–27, 1941. Traveled to Santiago, Chile; Lima, Peru; Quito, Ecuador, June–December 1941 (section I, *Mexico and the West*); Buenos Aires; Montevideo, Uruguay; Rio de Janeiro, July–December 1941 (section II, *East Coast*); Bogotá, Columbia; Caracas, Venezuela; Rio de Janeiro; Havana, July–December 1941 (section III). Catalogue.

New York, Whitney Museum of American Art. *1941 Annual Exhibition of Paintings by Artists under Forty.* November 12–December 30, 1941. Catalogue.

New York, R. H. Macy Department Store. [Group exhibition]. January 5–26, 1942. Organized by Samuel M. Kootz.

St. Louis, Missouri, City Art Museum. *Trends in American Painting of Today: Realism, Romanticism, Expressionism, Fantasy and Surrealism, Abstraction, Primitivism; Paintings by Emigrés.* January 25–February 28, 1942. Catalogue.

Middletown, Connecticut, The Davison Art Rooms of Olin Library, Wesleyan University. *Oil Paintings, Watercolors and Prints Lent by the Yale University Art Gallery from the Collection of the Société Anonyme—Museum of Modern Art: 1920.* February 28–March 31, 1942.

New York, The Museum of Modern Art. *New Rugs by American Artists.* June 30–August 9, 1942.

The Art Students League of New York. *Art Exhibition for the Benefit of Armenian War Relief.* October 19–November 7, 1942.

New York, The Museum of Modern Art. *20th Century Portraits.* December 9, 1942–January 24, 1943. Catalogue.

New York, The Museum of Modern Art, New York. *Recent Acquisitions: The Work of Young Americans.* June 17–July 25, 1943.

New York, Whitney Museum of American Art. *Annual Exhibition of Contemporary American Art: Sculpture, Paintings, Watercolors, and Drawings.* November 23, 1943–January 4, 1944.

San Francisco Museum of Art (organizer, with Sidney Janis). *Abstract and Surrealist Art in the United States.* Traveled to Cincinnati Art Museum, February 8–March 12, 1944; Denver Art Museum, March 26–April 23, 1944; Seattle Art Museum, May 7–June 10; Santa Barbara Museum of Art, June–July 1944; San Francisco Museum of Art, July 1944. Catalogue. Traveled with a separate catalogue (Sidney Janis, *Abstract and Surrealist Art in America*) to New York, Mortimer Brandt Gallery, November 29–December 30, 1944.

New York, The Museum of Modern Art. *Modern Drawings.* February 16–May 10, 1944. Catalogue.

New York, The Museum of Modern Art. *Art in Progress: XV Anniversary Exhibition.* May 24–October 15, 1944. Catalogue.

New York, Julien Levy Gallery. *The Imagery of Chess.* December 12, 1944–January 31, 1945.

The Art Institute of Chicago. *Modern Art in Advertising: An Exhibition of Designs for Container Corporation of America.* April 27–June 23, 1945. Catalogue.

New York, 67 Gallery. *A Problem for Critics.* May 14–July 7, 1945.

San Francisco, California Palace of the Legion of Honor. *Contemporary American Painting.* May 17–June 17, 1945. Catalogue.

Pittsburgh, Department of Fine Arts, Carnegie Institute. *Painting in the United States.* October 11–December 9, 1945. Catalogue.

New York, Hugo Gallery. *The Fantastic in Modern Art presented by View.* November 15–December 15, 1945. Traveled to Los Angeles, La Boutique Gallery, February 1946.

New York, Whitney Museum of American Art. *Annual Exhibition of Contemporary American Sculpture, Watercolors, and Drawings.* February 5–March 13, 1946. Catalogue.

St. Louis, Missouri, City Art Museum. *American Painting: 39th Annual Exhibition.* February 16–March 19, 1946. Catalogue.

New York, The Museum of Modern Art. *Fourteen Americans.* September 10–December 8, 1946. Catalogue.

New York, Whitney Museum of American Art. *Annual Exhibition of Contemporary American Sculpture, Watercolors, and Drawings.* December 10, 1946–January 16, 1947. Catalogue.

New York, Hugo Gallery. *Bloodflames.* February 15–28, 1947. Catalogue.

New York, Whitney Museum of American Art. *Annual Exhibition of Contemporary American Sculpture, Watercolors, and Drawings.* March 11–April 17, 1947. Catalogue.

New York, The Museum of Modern Art. *Drawings in the Collection of the Museum of Modern Art.* April 15–June 1, 1947.

Paris, Galerie Maeght. *Le Surréalisme en 1947: Exposition internationale du Surréalisme.* July–August 1947. Catalogue.

The Art Institute of Chicago. *Abstract and Surrealist American Art: Fifty-eighth Annual Exhibition of American Paintings and Sculpture.* November 6, 1947–January 11, 1948. Catalogue.

San Francisco, California Palace of the Legion of Honor. *Second Annual Exhibition of Painting.* November 19, 1947–January 4, 1948. Catalogue.

New York, Downtown Community School. [Group exhibition]. Opened December 6, 1947.

New York, Whitney Museum of American Art. *Annual Exhibition of Contemporary American Painting.* December 6, 1947–January 25, 1948. Catalogue.

New York, Whitney Museum of American Art. *Annual Exhibition of Contemporary American Sculpture, Watercolors, and Drawings.* January 31–March 21, 1948. Catalogue.

Venice, U.S. Pavilion. *La XXIV Biennale di Venezia: La collezione Peggy Guggenheim.* May 29–September 30, 1948. Catalogue.

The Art Institute of Chicago. *The Fifty-ninth Annual Exhibition of Water Colors and Drawings.* November 4, 1948–January 2, 1949.

Los Angeles Art Association Gallery. *The Artist as Collector.* April 1949.

New York, Samuel M. Kootz Gallery. *The Intrasubjectives.* September 15–October 3, 1949. Catalogue.

Colorado Springs Fine Arts Center. *New Accessions, U.S.A., from Great Britain, the United States and France, with Sculpture from the United States.* November–December 1949.

1950s

Richmond, Virginia Museum of Fine Arts. *American Painting, 1950.* April 22–June 4, 1950. Catalogue.

Philadelphia Museum of Art. *Masterpieces from Philadelphia Private Collections, Part II.* May 2–September 15, 1950. Catalogue.

Venice, U.S. Pavilion. *La XXV Biennale di Venezia: Gorky, de Kooning, Pollock.* June 3–October 15, 1950. Catalogue.

Amsterdam, Stedelijk Museum. *Surréalisme et abstraction: Choix de la collection Peggy Guggenheim / Surrealisme en Abstractie: Keuze uit de Verzameling Peggy Guggenheim.* January 19–February 26, 1951. Traveled to Brussels, Palais des Beaux-Arts de Bruxelles, March 3–28, 1951; Kunsthaus Zürich, April–May 1951 (as *Moderne Kunst aus der Sammlung Peggy Guggenheim*). Catalogue.

New York, The Museum of Modern Art. *Abstract Painting and Sculpture in America.* January 23–March 25, 1951. Catalogue.

New York, Delius Gallery. *Still Lifes and Flowers, Old and New.* March 27–April 28, 1951.

Guadalajara, Mexico, La Galería Arquitac. *Arshile Gorky y arte contemporáneo norteamericano.* April 5–21, 1951.

The Brooklyn Museum. *Revolution and Tradition: An Exhibition of the Chief Movements in American Painting from 1900 to the Present.* November 15, 1951–January 6, 1952. Catalogue.

New York, Sidney Janis Gallery. *American Vanguard Art for Paris.* December 26, 1951–January 5, 1952. Traveled to Paris, Galerie de France, 1952.

New York, Wildenstein & Company. *Loan Exhibition of Seventy XX Century American Paintings Chosen by the Art Critics of Art Digest, ARTnews, Life Magazine of Art, New York Herald Tribune, New York Times, and Time.* February 21–March 22, 1952. Catalogue.

New York, Sidney Janis Gallery. *Season's Resumé.* April 28–May 31, 1952. Catalogue.

Iowa City, State University of Iowa. *Fourteenth Annual Fine Arts Festival: Contemporary Art in Iowa.* June 15–August 1, 1952.

New York, Burliuk Gallery. *Exhibition of Works of Art by Noted American Artists from the Collection of Marussia Burliuk.* November 16–29, 1952.

New York, Wildenstein & Company. *Landmarks in American Art, 1670–1950.* February 26–March 28, 1953. Catalogue.

New Delhi, All-India Fine Arts & Crafts Society. *Second International Contemporary Art Exhibition.* Opened May 5, 1953. Traveled to five cities in India.

New York, Sidney Janis Gallery. *Nine American Painters Today.* January 4–23, 1954.

New York, M. Knoedler & Co. *Paintings and Drawings from Five Centuries: Collection Allen Memorial Art Museum.* February 3–21, 1954. Catalogue.

New York, Martha Jackson Gallery. *Two Lyric Abstractionists: Gorky, Works of the Middle Period / Trökes, Recent Gouaches and Drawings.* March 27–April 24, 1954.

Minneapolis, Walker Art Center. *Reality and Fantasy, 1900–1954.* May 23–July 2, 1954. Catalogue.

Nice, France, Musée des Ponchettes. *Le dessin contemporain aux États-Unis.* January 1955. Catalogue.

New York, International Council of the Museum of Modern Art (organizer). *Modern Art in the U.S.A.* Traveled to Paris, Musée national d'art moderne, March 30–May 15, 1955; Kunsthaus Zürich, July 16–August 28, 1955; with two catalogues to Barcelona, Museo de Arte Moderno, September 24–October 24, 1955; Frankfurt, Städelschen Kunstinstitut, November 13–December 11, 1955; London, Tate Gallery, January 5–February 12, 1956; The Hague, Gemeentemuseum, March 2–April 15, 1956; with one catalogue to Vienna, Wiener Secession Galerie (painting, sculpture, prints, architecture) and Neue Galerie (photography), May 5–June 2, 1956; Belgrade, Kalemegdan Pavilion, July 6–August 6, 1956. Catalogue.

San Francisco Museum of Art. *Art in the 20th Century.* June 17–July 10, 1955. Catalogue.

Milwaukee Art Center. *55 Americans.* September 9–October 23, 1955.

Minneapolis, Walker Art Center. *Expressionism, 1900–1955.* January 26–March 11, 1956. Catalogue.

Ann Arbor, Museum of Art, University of Michigan. *Drawing and Watercolors from the Oberlin Collection.* March 11–April 1, 1956.

Boston, Margaret Brown Gallery. *Benefit Exhibition for the Boston Arts Festival.* May 8–29, 1956.

New York, Sidney Janis Gallery. *Seven Americans.* September–October 1956.

Stamford, Connecticut, The Stamford Museum and Nature Center. *Modern Watercolors and Drawings.* January–March 1957.

Ottawa, National Gallery of Canada. *Some American Paintings from the Collection of Joseph H. Hirshhorn.* January 10–31, 1957. Traveled to Montreal Museum of Fine Arts, March 20–31, 1957; Art Gallery of Toronto, April 12–May 26, 1957; Stratford, Ontario, Stratford Arena, July 1–August 31, 1957; Winnipeg, Manitoba, Winnipeg Art Gallery, October 6–November 3, 1957. Catalogue.

The Brooklyn Museum. *Golden Years of American Drawings, 1905–1956.* January 22–March 17, 1957. Catalogue.

Kansas City, Missouri, William Rockhill Nelson Gallery of Art and Atkins Museum of Fine Arts. *Some Points of View in Modern Painting.* February 10–March 10, 1957.

The Baltimore Museum of Art. *Modern Art for Baltimore.* February 23–March 17, 1957.

New York, Sidney Janis Gallery. *Eight Americans: Albers, de Kooning, Gorky, Guston, Kline, Motherwell, Pollock, Rothko.* April 1–20, 1957. Catalogue.

Buffalo, Albright Art Gallery, The Buffalo Fine Arts Academy. *Contemporary Art—Acquisitions, 1954–1957.* May 15–June 15, 1957. Catalogue.

New York, Poindexter Gallery. *The 30s: Painting in New York.* June 1957. Catalogue.

Hartford, Connecticut, Wadsworth Atheneum. *Connecticut Collects: An Exhibition of Privately Owned Works of Art in Connecticut.* October 4–November 3, 1957. Catalogue.

Dallas Museum of Contemporary Art. *Abstract by Choice.* November 19–December 31, 1957. Catalogue.

New York, Whitney Museum of American Art. *Nature in Abstraction: The Relation of Abstract Painting and Sculpture to Nature in Twentieth-Century American Art.* January 14–March 16, 1958. Traveled to Washington, D.C., The Phillips Collection, April 2–May 4, 1958; Forth Worth Art Center, June 2–29, 1958; Los Angeles County Museum, July 16–August 24, 1958; San Francisco Museum of Art, September 10–October 12, 1958; Minneapolis, Walker Art Center, October 29–December 14, 1958; St. Louis, City Art Museum, January 7–February 8, 1959. Catalogue.

New York, Avant-Garde Gallery. *Gorky, Lanskoy, Gen Paul: Early Paintings.* April 4–May 3, 1958.

New York, International Council of the Museum of Modern Art (organizer). *The New American Painting.* Traveled to Kunsthalle Basel, April 19–May 26, 1958; Milan, Galleria Civica d'Arte Moderna, June 1–30, 1958; Madrid, Museo Nacional de Arte Contemporáneo, July 16–August 11, 1958; Berlin, Hochschule für Bildende Kunste, September 1–October 1, 1958; Amsterdam, Stedelijk Museum, October 17–November 24, 1958; Brussels, Palais des Beaux-Arts de Bruxelles, December

6, 1958–January 4, 1959; Paris, Musée national d'art moderne, January 16–February 15, 1959; London, Tate Gallery, February 24–March 22, 1959; New York, The Museum of Modern Art, May 28–September 8, 1959; (in part) Albany Institute of History and Art, September 25–October 25, 1959. Catalogue.

New York, Sidney Janis Gallery. *X Years of Janis: 10th Anniversary Exhibition.* September 29–November 1, 1958. Catalogue.

The Cleveland Museum of Art. *Some Contemporary Works of Art.* November 11–December 31, 1958. Catalogue.

New York, Sidney Janis Gallery. *Eight American Painters: Albers, de Kooning, Gorky, Guston, Kline, Motherwell, Pollock, Rothko.* January 5–31, 1959. Catalogue.

Kassel, Germany, Museum Fridericianum. *Documenta II: Kunst nach 1945; Internationale Ausstellung.* July 11–October 11, 1959. Catalogue.

Detroit, Archives of American Art (organizer). *American Painting and Sculpture: American National Exhibition in Moscow.* Traveled to Moscow, Sokolniki, July 25–September 5, 1959.

St. Louis, Missouri, City Art Museum (organizer) for the United States Information Agency. *25 Anni di pittura americana, 1933–1958.* Traveled to Naples, Palazzo Reale, October 31–November 25, 1959; Florence, Palazzo Strozzi, December 12, 1959–January 10, 1960; Rome, Galleria Nazionale d'Arte Moderna, January 23–February 22, 1960; Milan, Permanente Gallery, March 5–31, 1960; Berlin, Amerika Haus, April 15–May 15, 1960; Darmstadt, Germany, Landesmuseum, June 1–30, 1960; Göteborg, Sweden, Göteborgs Konstmuseum, July 15–August 7, 1960; York, England, City Art Gallery, August 15–September 15, 1960. Catalogue.

1960s

Winsted, Connecticut, Beardsley and Memorial Library, Litchfield County Art Association. [Group exhibition]. March 1–31, 1960.

Berkeley, University Art Museum, University of California. *Art from Ingres to Pollock: Painting and Sculpture since Neoclassicism.* March 6–April 3, 1960. Catalogue.

Minneapolis, Walker Art Center. *Sixty American Painters, 1960: Abstract Expressionist Painting of the Fifties.* April 3–May 8, 1960. Catalogue.

Minneapolis Institute of Arts. *Drawings, Paintings, and Sculpture from Three Private Collections.* July 13–August 14, 1960. Catalogue.

New York, D'Arcy Galleries. *Surrealist Intrusion in the Enchanter's Domain.* November 28, 1960–January 14, 1961. Catalogue.

New York, Otto Gerson Gallery. *Modern Works Lent by Distinguished Artists, Writers, Architects.* February 28–March 25, 1961.

Sarasota, Florida, The John and Mable Ringling Museum of Art. *The Sidney Janis Painters: Albers, Baziotes, Gorky, Gottlieb, Guston, Kline, De Kooning, Motherwell, Pollock, Rothko.* April 8–May 7, 1961. Catalogue.

New York, Sidney Janis Gallery. *10 American Painters: Josef Albers, William Baziotes, Arshile Gorky, Adolph Gottlieb, Philip Guston, Franz Kline, Willem de Kooning, Robert Motherwell, Jackson Pollock, Mark Rothko.* May 8–June 3, 1961. Catalogue.

Spoleto, Italy, Palazzo Ancaiani. *Mostra di disegni americani moderni.* June 16–July 16, 1961. Catalogue.

New Orleans, Isaac Delgado Museum of Art. *The Magriel Collection of American Drawings.* November 1–December 31, 1961. Catalogue.

New York, Horace Mann School. *American Art.* 1962.

Williamstown, Massachusetts, Williams College Museum of Art. *Works of Art Lent by the Alumni of Williams College.* May 5–June 16, 1962. Catalogue.

New York, Sidney Janis Gallery. *Eleven Abstract Expressionist Painters.* October 7–November 2, 1963. Catalogue.

Des Moines, Iowa, Des Moines Art Center. *Art in Iowa from Private Collections.* October 19–November 24, 1963. Catalogue.

New York, Robert Elkon Gallery. *Selected Paintings and Drawings by Twentieth-Century European and American Artists.* November 1963.

New York, Solomon R. Guggenheim Museum. *20th Century Master Drawings.* November 6, 1963–January 5, 1964. Traveled to Minneapolis, University Gallery, University of Minnesota, February 3–March 15, 1964; Cambridge, Massachusetts, Fogg Art Museum, Harvard University, April 6–May 24, 1964. Catalogue.

Minneapolis Institute of Arts. *Four Centuries of American Art.* November 27, 1963–January 19, 1964. Catalogue.

Washington, D.C., National Gallery of Art. *Paintings from the Museum of Modern Art, New York.* December 17, 1963–March 1, 1964. Catalogue.

New York, Rose Fried Gallery. *Modern Masters.* January 11–February 15, 1964.

New Haven, Connecticut, Yale University Art Gallery. *Max Ernst and Arshile Gorky from the Collection of Julien Levy.* March 19–May 3, 1964. Catalogue.

Saint Louis, Missouri, City Art Museum. *200 Years of American Painting.* April 1–May 31, 1964. Catalogue.

Bloomington, Fine Arts Gallery, Indiana University. *American Painting, 1910 to 1960: A Special Exhibition Celebrating the 50th Anniversary of the Association of College Unions.* April 19–10 May 10, 1964. Catalogue.

Cambridge, Massachusetts, Fogg Museum, Harvard University. *Within the Easel Convention: Sources of Abstract-Expressionism.* May 7–June 7, 1964. Catalogue.

Buffalo, James Goodman Gallery. *Drawings and Sculpture.* Spring 1964.

Kassel, Germany, Alte Galerie, Museum Fridericianum, and Orangerie. *Documenta III: Handzeichnungen*. June 27–October 5, 1964. Catalogue.

New York, Solomon R. Guggenheim Museum. *American Drawings*. September 17–October 22, 1964. Traveled to Ann Arbor, Museum of Art, University of Michigan, November 11–December 13, 1964; Grand Rapids, Michigan, Grand Rapids Art Museum, January 10–February 7, 1965; Minneapolis, University Gallery, University of Minnesota, February 24–March 21, 1965; Seattle Art Museum, April 8–May 2, 1965; Denver Art Museum, June 6–July 4, 1965; Dallas Museum of Fine Arts, July 25–August 22, 1965; Columbus, Ohio, Columbus Gallery of Fine Arts, September 12–October 10, 1965; Champaign, Krannert Art Museum, University of Illinois, November 15–December 5, 1965. Catalogue.

Waltham, Massachusetts, Rose Art Museum, Brandeis University. *The Painter and the Photograph*. October 5–November 1, 1964. Traveled to Bloomington, Museum of Art, Indiana University; Iowa City, The Art Gallery, State University of Iowa; New Orleans, Isaac Delgado Museum of Art; Albuquerque, Art Gallery, University of New Mexico (organizer); Santa Barbara, California, Santa Barbara Museum of Art. Catalogue.

Albuquerque, Art Gallery, University of New Mexico. *Art since 1889 [An Exhibition presented in celebration of the 75th Anniversary of the founding of the University of New Mexico]*. October 20–November 15, 1964. Catalogue.

London, Tate Gallery. *The Peggy Guggenheim Collection*. December 31, 1964–March 7, 1965. Catalogue.

Los Angeles County Museum of Art. *Special Exhibition for the College Art Association*. January–April 1965.

New York, M. Knoedler & Co. *Lawyers Collect: An Exhibition of Painting and Sculpture Selected from the Private Collections of Members of the New York Bar*. January 13–30, 1965. Catalogue.

New York, New School Art Center. *Portraits from the American Art World*. February 2–27, 1965. Catalogue.

Providence, Rhode Island, Providence Art Club. *Critics' Choice: Art since World War II*. March 31–April 24, 1965. Catalogue.

Scranton, Pennsylvania, Everhart Museum. *Non-Objective Paintings from the Michener Collection*. May 1–30, 1965.

The Brooklyn Museum. *The Herbert A. Goldstone Collection of American Art*. June 15–September 12, 1965. Catalogue.

Los Angeles County Museum of Art. *New York School: The First Generation, Paintings of the 1940s and 1950s*. July 16–August 1, 1965. Catalogue.

New York, Allan Stone Gallery. *De Kooning, Pollock, Newman, Gorky, Cornell*. October 26–November 13, 1965.

Santa Barbara, Art Gallery, University of California. *Surrealism: A State of Mind, 1924–1965*. February 26–March 27, 1966. Catalogue.

The Arts Club of Chicago. *Drawings, 1916/1966*. February 28–March 11, 1966.

Saint-Paul de Vence, France, Fondation Maeght. *Dix ans d'art vivant, 1945–1955*. April 9–May 31, 1966. Catalogue.

New York, Public Education Association (organizer). *Seven Decades, 1895–1965: Crosscurrents in Modern Art*. April 16–May 21, 1966. Exhibition divided among New York galleries: Paul Rosenberg and Co. (1895–1904); M. Knoedler & Co. (1905–1914); Perls Galleries and E. V. Thaw and Company (1915–1924); Saidenberg Gallery and Stephen Hahn Gallery (1925–1934); Pierre Matisse Gallery (1935–1944); André Emmerich Gallery and Galleria Odyssia (1945–1954); Cordier and Edstrom (1955–1965). Catalogue.

Minneapolis Institute of Arts. *Treasures from the Allen Memorial Art Museum*. July 21–September 11, 1966.

New York, Sidney Janis Gallery. *2 Generations: Picasso to Pollock*. January 3–27, 1967. Catalogue.

Irvine, Art Gallery, University of California. *A Selection of Nineteenth and Twentieth Century Works from the Hunt Foods and Industries Museum of Art Collection*. March 7–22, 1967. Traveled to University of California, Davis, April 3–28, 1967; University of California, Riverside, May 10–30, 1967; Fine Arts Gallery of San Diego, July 7–October 1 1967. Catalogue.

Trenton, New Jersey State Museum Cultural Center. *Focus on Light*. May 20–September 10, 1967. Catalogue.

New York, Marlborough-Gerson Gallery [benefit exhibition for the New York University Art Collection]. *The New York Painter: A Century of Teaching; Morse to Hofmann*. September 27–October 14, 1967. Catalogue.

Omaha, Nebraska, Joslyn Art Museum. *Private Collection of an Artist: Milton Wolsky*. October 8–29, 1967. Catalogue.

Paris, M. Knoedler & Cie. *Six peintres américains: Arshile Gorky, Franz Kline, Willem de Kooning, Barnett Newman, Jackson Pollock, Mark Rothko*. October 19–November 25, 1967. Catalogue.

Turin, Italy, Galleria Civica d'Arte Moderna. *Le muse inquietanti: Maestri del Surrealismo*. November 1967–January 1968. Catalogue.

Eindhoven, The Netherlands, Stedelijk Van Abbemuseum. *Kompas 3: Schilderkunst na 1945 uit New York / Paintings after 1945 in New York*. November 9–December 17, 1967. Traveled to Frankfurter Kunstverein as *Kompass New York: Malerei nach 1945 aus New York*. December 30, 1967–February 11, 1968. Catalogue.

New York, M. Knoedler & Co. *Space and Dream*. December 5–29, 1967. Catalogue.

New York, The Museum of Modern Art. *The Sidney and Harriet Janis Collection: A Gift to The Museum of Modern Art*. January 17–March 4, 1968. Traveled to the Minneapolis Institute of Arts, May 15–July 28, 1968; Portland, Oregon, Portland Art Museum, September 13–October 13, 1968; Pasadena, California, Pasadena

Art Museum, November 11–December 15, 1968; San Francisco Museum of Art, January 13–February 16, 1969; Seattle Art Museum, March 12–April 13, 1969; The Detroit Institute of Arts, July 14–August 17, 1969; Buffalo, Albright-Knox Art Gallery, September 15–October 19, 1969; The Cleveland Museum of Art, November 1, 1969–January 4, 1970; Basel, Germany, Kunsthalle Basel, February 28–March 30, 1970; London, Institute of Contemporary Arts, May 1–31, 1970; Berlin, Akademie der Künste, June 12– August 2, 1970; Kunsthalle Nürnberg, September 11–October 25, 1970; Stuttgart, Germany, Württembergischer Kunstverein, November 12–December 27, 1970; Brussels, Palais des Beaux-Arts de Bruxelles, January 7–February 11, 1971; Cologne, Germany, Kunsthalle Köln, March 6–April 18, 1971. Catalogue.

Irvine, Art Gallery, University of California. *Twentieth Century Works on Paper*. January 30–February 25, 1968. Traveled to Davis, Memorial Union Art Gallery, University of California, March 26–April 20, 1968. Catalogue.

Austin, Art Museum, University of Texas at Austin. *Painting as Painting*. February 18–April 1, 1968. Catalogue.

New York, Finch College Museum of Art. *Betty Parsons' Private Collection*. March 13–April 24, 1968. Catalogue.

New York, The Museum of Modern Art. *Dada, Surrealism, and Their Heritage*. March 27–June 9, 1968. Traveled to the Los Angeles County Museum of Art, July 16–September 8, 1968; The Art Institute of Chicago, October 19–December 8, 1968. Catalogue.

Washington, D.C., National Collection of Fine Arts, Smithsonian Institution. *Contemporary American Art*. May 3–June 1, 1968.

Venice, U.S. Pavilion. *La XXIV Biennale di Venezia: Linee della ricerca contemporanea*. July 22–October 20, 1968. Catalogue.

Riverside Art Center and Museum, University of California. *Dada, Surrealism, and Today*. October 7–28, 1968. Traveled to San Francisco Museum of Art, November 11–December 8, 1968; University Art Museum, University of Texas at Austin, January 6–27, 1969; St. Cloud, Minnesota, St. Cloud State College, February 14–March 9, 1969; Winnipeg, Canada, University of Manitoba, March 24–April 14, 1969.

New York, Whitney Museum of American Art. *The 1930s: Painting and Sculpture in America*. October 15–December 1, 1968. Catalogue.

New York, Solomon R. Guggenheim Museum. *Works from the Peggy Guggenheim Foundation*. January 16–March 23, 1969. Catalogue.

New York, The Museum of Modern Art. *The New American Painting and Sculpture: The First Generation*. June 18–October 5, 1969.

New York, M. Knoedler & Co. *Gorky, de Kooning, Newman*. June 26–September 20, 1969.

Raleigh, North Carolina Museum of Art. *A Catalogue of Drawings and Watercolors*. Summer 1969. Catalogue.

New York, The Metropolitan Museum of Art. *New York Painting and Sculpture, 1940–1970.* October 16, 1969–February 1, 1970. Catalogue.

Austin, University Art Museum, University of Texas at Austin. *Selected Paintings from the Michener Collection.* November 2, 1969–January 5, 1970. Catalogue.

Pasadena, California, Pasadena Art Museum. *Painting in New York, 1944 to 1969.* November 24, 1969–January 11, 1970. Catalogue.

1970s

Santa Barbara, Art Galleries, University of California. *Trends in Twentieth Century Art: A Loan Exhibition from the San Francisco Museum of Art.* January 6–February 1, 1970. Catalogue.

Wilmington, Wilmington Society of the Fine Arts, Delaware Art Center. *Contemporary American Painting and Sculpture from New York Galleries.* April 2–26, 1970.

New York, New School Art Center. *Museum Leaders Collect: Selections from the Private Collections of Ten New York Museum Directors and Curators.* April 24–May 27, 1970. Catalogue.

New York, The Museum of Modern Art. *Preliminary Drawings* [part of *Three Exhibitions*]. May 23–September 31, 1970.

Minneapolis Institute of Arts. *A Loan Exhibition of Drawings and Watercolors from Minnesota Private Collections.* May 13–June 13, 1971. Catalogue.

Cologne, Germany, Baukunst. *Der Geist des Surrealismus / L'esprit du surréalisme.* October 4–November 20, 1971. Catalogue.

Buffalo, Albright-Knox Art Gallery. *Abstract Expressionism: The First and Second Generations in the Albright-Knox Art Gallery.* January 19–February 20, 1972.

Paris, Musée des arts décoratifs. *Le Surréalisme, 1922–1942.* June 9–September 24, 1972. Traveled to Munich, Haus der Kunst (as *Der Surrealismus, 1922–1942*), March 11–May 7, 1972. Catalogue.

The Cleveland Museum of Art. *Cleveland Collects Contemporary Art.* July 11–August 20, 1972. Catalogue.

College Park, University of Maryland Department of Art. *The Private Collection of Martha Jackson.* June 22–September 30, 1973. Traveled to New York, Finch College Museum of Art, October 16–November 25, 1973; Buffalo, Albright-Knox Art Gallery, January 8–February 10, 1974. Catalogue.

Hartford, Connecticut, Wadsworth Atheneum. *One Hundred Master Drawings from New England Private Collections.* September 5–October 14, 1973. Traveled to Hanover, New Hampshire, Hopkins Center, Dartmouth College, October 26–December 3, 1973; Boston, Museum of Fine Arts, December 14, 1973–January 25, 1974. Catalogue.

Chicago, Museum of Contemporary Art. *20th Century Drawings from Chicago Collections.* September 15–November 11, 1973.

Washington, D.C., National Gallery of Art. *American Art at Mid-Century I.* October 28, 1973–January 6, 1974. Catalogue.

Washington, D.C., National Collection of Fine Arts, Smithsonian Institution. *Two Decades of American Prints, 1920–1940.* June 21–September 8, 1974. Catalogue.

New York, Whitney Museum of American Art. *The 20th Century: Thirty-five American Artists Opening and Closing in Four Stages.* June 24–September 9, 1974. Catalogue.

New York, M. Knoedler & Co. *Works on Paper by 20th Century Masters.* October 31–November 30, 1974.

New York, William Zierler Inc. *American Works on Paper, 1944 to 1974.* November 2–30, 1974. Catalogue.

New York, The Museum of Modern Art. *American Prints, 1913–1963: An Exhibition Commemorating the 25th Anniversary of the Founding of the Abby Aldrich Rockefeller Print Room.* December 3, 1974–March 3, 1975.

Dusseldorf, Germany, Städtische Kunsthalle Düsseldorf. *Surrealität—Bildrealität, 1924–1974.* December 8, 1974–February 2, 1975. Traveled to Baden-Baden, Germany, Staatliche Kunsthalle Baden-Baden, February 14–April 20, 1975. Catalogue.

Cambridge, Hayden Gallery, Massachusetts Institute of Technology. *Drawings by Five Abstract Expressionist Painters: Willem de Kooning, Arshile Gorky, Philip Guston, Franz Kline, Jackson Pollock.* February 21–March 26, 1975. Traveled to Chicago, Museum of Contemporary Art, January 10–February 9, 1976. Catalogue.

New York, M. Knoedler & Co. *American Works on Paper, 1945–1975.* November–December 1975. Catalogue.

Edmonton, Canada, The Edmonton Art Gallery. *The Collective Unconscious: American and Canadian Art, 1940–1950.* December 5, 1975–January 18, 1976. Catalogue.

Cambridge, Massachusetts, Fogg Art Museum, Harvard University. *New York School: From the First Generation.* December 10, 1975–January 6, 1976.

Chicago, Museum of Contemporary Art. *Drawings by Five Abstract Expressionist Painters.* January 10–February 29, 1976.

New York, Solomon R. Guggenheim Museum. *Twentieth Century American Drawing: Three Avant-garde Generations.* January 23–March 28, 1976. Traveled to Baden-Baden, Germany, Staatliche Kunsthalle Baden-Baden, May 27–July 11, 1976; Bremen, Germany, Kunsthalle Bremen, July 18–August 29, 1976. Catalogue.

Cambridge, Massachusetts, Fogg Art Museum, Harvard University. *20th Century American Art.* April 7–May 19, 1976.

Washington, D.C., Hirshhorn Museum and Sculpture Garden, Smithsonian Institution. *The Golden Door: Artist Immigrants of America, 1876–1976.* May 20–October 20, 1976. Catalogue.

New York, The Museum of Modern Art. *The Natural Paradise: Painting in America 1800–1950.* October 1–November 30, 1976. Catalogue.

Milwaukee Art Center. *From Foreign Shores: Three Centuries of Art by Foreign Born American Masters.* October 15–November 28, 1976. Catalogue.

New York, Solomon R. Guggenheim Museum. *Acquisition Priorities: Aspects of Postwar Painting in America with Arshile Gorky: Works, 1944–1948.* October 15, 1976–January 16, 1977. Catalogue.

New York, M. Knoedler & Co. *Works on Paper: Collages and Drawings by Arshile Gorky, Robert Motherwell, and David Smith.* October 19–November 20, 1976.

Hamilton, New York, Gallery Association of New York State (organizer). *New Deal for Art: The Government Art Projects of the 1930s with Examples from New York City and State.* Traveled to Oswego, Tyler Art Gallery, State University of New York College of Arts and Sciences, January 25–February 13, 1977; Hamilton, New York, The Picker Gallery, Colgate University, February 27–March 20, 1977; Albany Institute of History and Art, May 17–June 8, 1977; Wilmington, Delaware Art Museum, July 29–August 28, 1977; Utica, New York, Munson-Williams-Proctor Arts Institute, September 4–25, 1977; Alfred, New York, Foskick-Nelson Gallery, New York State College of Ceramics at Alfred University, October 1977; New York, Grey Art Gallery and Study Center, New York University, November 17, 1977–January 3, 1978; Huntington, West Virginia, Huntington Galleries, January 10–February 3, 1978. Catalogue.

New York, Xavier Fourcade. *Works on Paper, Small Formats, Objects: Duchamp to Heizer.* February 15–March 19, 1977.

New Brunswick, New Jersey, Rutgers University Art Gallery. *Surrealism and American Art, 1931–1947.* March 5–April 24, 1977. Catalogue.

Providence, Rhode Island, Bell Gallery, List Art Building, Brown University. *Graham, Gorky, Smith, and Davis in the Thirties.* April 30–May 22, 1977. Catalogue.

Kunsthaus Zürich. *Malerei und Photographie im Dialog, von 1840 bis Heute.* May 13–July 24, 1977. Catalogue.

Houston, The Museum of Fine Arts. *Modern American Painting, 1910–1940: Toward a New Perspective.* July 1–September 25, 1977. Catalogue.

New York, Whitney Museum of American Art. *20th-Century American Art from Friends' Collections.* July 27–September 27, 1977.

Edinburgh, Royal Scottish Academy. *Modern Spirit: American Painting, 1908–1935.* August 20–September 11, 1977. Traveled to London, Hayward Gallery, September 28–November 20, 1977. Catalogue.

Claremont, California, Montgomery Art Gallery, Pomona College. *Works on Paper, 1900–1960, from California Collections.* September 18–October 27, 1977. Traveled to San Francisco, M. H. de Young Museum, November 11–December 31, 1977. Catalogue.

New York, The Museum of Modern Art. *Abstraction-créa-tion, art non-figuratif.* September 20–December 4, 1977.

San Jose, California, San Jose Museum of Art. *Post War Modernism.* November 4–December 31, 1977.

San Francisco, California Palace of the Legion of Honor. *Graphic Arts Council Members' Exhibition.* January 19–March 5, 1978.

New York, International Council of the Museum of Modern Art (organizer). *Surrealismus und die Erfahrung der europäischen Moderne in Amerika: Werke aus der Sammlung the Museum of Modern Art, New York.* Traveled to Vienna, Museum des 20. Jahrhunderts, February 8–April 9, 1978; Dusseldorf, Germany, Kunsthalle Düsseldorf, April 28–June 4, 1978; Brussels, Musées royaux des Beaux-Arts de Belgique, June 15–July 30, 1978; Kunsthaus Zürich, August 18–October 8, 1978; Oslo, Sonja Henie—Niels Onstad Foundations, October 27–December 3, 1978; Copenhagen, Louisiana Museum, December 19, 1978–February 11, 1979. Catalogue.

Ithaca, New York, Herbert F. Johnson Museum of Art, Cornell University (co-organizer). *Abstract Expressionism: The Formative Years.* March 30–May 14, 1978. Traveled to Tokyo, Seibu Museum of Art, June 17–July 12, 1978; New York, Whitney Museum of American Art (co-organizer), October 5–December 3, 1978. Catalogue.

Wellesley, Massachusetts, Wellesley College Museum. *One Century: Wellesley Families Collect; An Exhibition Celebrating the Centennial of Wellesley College.* April 15–May 30, 1978. Catalogue.

Montgomery, Alabama, Montgomery Museum of Fine Arts. *American Art, 1934–1956: Selections from the Whitney Museum of American Art.* April 26–June 11, 1978. Traveled to Memphis, Brooks Memorial Art Gallery, June 30–August 6, 1978; Jackson, Mississippi Museum of Art, August 21–October 1, 1978. Catalogue.

Montclair, New Jersey, Montclair Art Museum. *Diversity of a Decade: The 1940s.* May 14–June 25, 1978.

Washington, D.C., National Gallery of Art. *American Art at Mid-Century: The Subjects of the Artist.* June 1, 1978–January 14, 1979. Catalogue.

Omaha, Nebraska, Joslyn Art Museum. *European and American Drawings: Selections from the Joslyn Art Museum.* September 30–October 29, 1978. Catalogue.

Buffalo, Albright-Knox Art Gallery. *Art for the Vice-President's House from Northeast Museums.* March 6–13, 1979. Traveled to Washington, D.C., Vice President's House, April 1, 1979–March 31, 1980.

Williamstown, Massachusetts, Williams College Museum of Art. *Documents, Drawings, and Collages: Fifty American Works on Paper from the Collection of Mr. and Mrs. Stephen D. Paine.* June 8–30, 1979. Catalogue.

Dusseldorf, Germany, Städtische Kunsthalle Düsseldorf. *2 Jahrzehnte amerikanische Malerei 1920–1940.* June 10–August 12, 1979. Traveled to Kunsthaus Zürich, August 23–October 28, 1979; Brussels, Palais des Beaux-Arts, November 10–December 30, 1979. Catalogue.

The Cleveland Museum of Art. *The Spirit of Surrealism.* October 3–November 25, 1979. Catalogue.

Chicago, David and Alfred Smart Gallery, University of Chicago. *Abstract Expressionism: A Tribute to Harold Rosenberg; Paintings and Drawings from Chicago Collections.* October 11–November 25, 1979. Catalogue.

Cincinnati, Ohio, The Contemporary Arts Center. *The Modern Art Society: The Center's Early Years, 1939–1954; An Exhibition in Celebration of the Fortieth Anniversary of the Contemporary Arts Center.* October 13–November 25, 1979. Catalogue.

New York, Salander-O'Reilly Galleries. *Works on Paper.* November 7–December 1, 1979.

1980s

New York, Xavier Fourcade. *Small Scale.* January 12–February 23, 1980.

New York, Maxwell Davidson Gallery. *Around Surrealism.* May 3–June 14, 1980. Catalogue.

New York, Whitney Museum of American Art. *Fiftieth Anniversary Gifts and Promised Gifts.* June 3–August 31, 1980.

Potsdam, New York, Brainerd Art Gallery, State University Collection of Arts and Sciences. *The Benefactors: Three Twentieth Century Patrons of the Arts, Solomon R. Guggenheim, Joseph H. Hirshhorn, Roy R. Neuberger.* October 19–November 9, 1980. Catalogue.

Mexico City, Museo del Palacio de Bellas Artes. *La pintura de los Estados Unidos de museos de la ciudad de Washington.* November 18, 1980–January 4, 1981. Catalogue.

Roslyn Harbor, New York, Nassau County Museum of Art. *The Abstract Expressionists and Their Precursors.* January 17–March 22, 1981. Catalogue.

New York, Whitney Museum of American Art (organizer). *American Art of the 1930s: Selections from the Collection of the Whitney Museum of American Art.* Traveled to Cedar Rapids, Iowa, Cedar Rapids Art Center, October 4–November 29, 1981; Chapel Hill, Auckland Art Museum, University of North Carolina, December 16, 1981–February 7, 1982; College Park, The Art Gallery, University of Maryland, February 24–April 18, 1982; San Antonio, Texas, San Antonio Museum of Art, May 5–June 27, 1982; Phoenix Art Museum, July 14–September 5, 1982; St. Paul, Minnesota Museum of Art, September 22–November 14, 1982; Columbus, Ohio, Columbus Museum of Art, December 4, 1982–January 16, 1983; Boise, Idaho, The Boise Gallery of Art, February 17–April 3, 1983; Wichita, Kansas, Edwin A. Ulrich Museum of Art, Wichita State University, April 20–June 12, 1983; Stamford, Connecticut, Whitney Museum of American Art, Fairfield County, July 8–August 31, 1983. Catalogue.

Claremont, California, Montgomery Art Gallery, Pomona College. *Drawings from the Permanent Collection.* November 14, 1981–February 12, 1982.

Los Angeles, Jack Rutberg Fine Arts. *Arshile Gorky and Hans Burkhardt.* January 9–February 27, 1982.

Paris, Musee d'art moderne de la ville de Paris. *Léger and the Modern Spirit: An Avant-Garde Alternative to Non-Objective Art (1918–1931) / Léger et l'esprit moderne: une alternative d'avant-garde à l'art non-objectif (1918–1931).* March 17–June 6, 1982. Traveled to Houston, The Museum of Fine Arts, July 9–September 5, 1982; Geneva, Musée Rath, November 4, 1982–January 16, 1983. Catalogue.

Houston, The Museum of Fine Arts. *Miró in America.* April 21–June 27, 1982. Catalogue.

New York, Whitney Museum of American Art. *Abstract Drawings, 1911–1981: Selections from the Permanent Collection.* May 5–July 11, 1982.

New York, Solomon R. Guggenheim Museum. *60 Works: The Peggy Guggenheim Collection.* November 18, 1982–March 13, 1983. Catalogue.

New Haven, Connecticut, Yale University Art Gallery. *Bob Herbert's Teaching Exhibition.* January–May 1983.

Montclair, New Jersey, Montclair Art Museum. *Landscape: Scene from Within.* January 16–February 27, 1983.

San Francisco, Jeremy Stone Gallery. *Willem de Kooning and Arshile Gorky: A Selection of Drawings and Paintings.* February 1–26, 1983.

Boston, Museum of Fine Art. *The Lane Collection: 20th-Century Paintings in the American Tradition.* April 13–August 7, 1983. Traveled to San Francisco Museum of Modern Art, October 1–December 1, 1983; Fort Worth, Texas, Amon Carter Museum, January 7–March 5, 1984. Catalogue.

Raleigh, North Carolina Museum of Art. *American Works on Paper, 1943–1974.* July 12–October 16, 1983.

New York, Hirschl & Adler Galleries. *Realism and Abstraction: Counterpoints in American Drawing, 1900–1940.* November 12–December 30, 1983. Catalogue.

Davenport, Iowa, Davenport Art Gallery. *American Works on Paper: 100 Years of American Art History.* December 11, 1983–February 12, 1984. Traveled to fourteen venues, through December 29, 1985. Catalogue.

Miami, Center for the Fine Arts. *In Quest of Excellence: Civic Pride, Patronage, and Connoisseurship.* January 14–April 22, 1984. Catalogue.

Chicago, Richard Gray Gallery. *Modern and Contemporary Masters: Paintings, Sculptures, and Drawings.* February 11–March 24, 1984. Catalogue.

New York, Whitney Museum of American Art. *Reflections of Nature: Flowers in American Art.* March 1–May 20, 1984. Catalogue.

Poughkeepsie, New York, Vassar College Art Gallery. *The Artist's Perception 1948/1984: 1948 Between Art and Political Action / 1984 Progress and Access.* March 23–May 6, 1984. Catalogue.

New York, Arnold Herstand & Company. *Surrealism: Works on Paper from De Chirico to Pollock.* May 5–June 30, 1984.

New York, Gallery Schlesinger-Boisante. *American Innovations—Part II.* October 1984.

Utica, New York, Museum of Art, Munson-Williams-Proctor Institute. *Order and Enigma: American Art between the Two Wars.* October 13–December 2, 1984. Traveled to Ithaca, New York, Herbert F. Johnson Museum of Art, Cornell University, February 16–April 7, 1985; Syracuse, New York, Everson Museum of Art, April 27–June 16, 1985; Albany Institute of History and Art, July 12–September 2, 1985; Rochester, New York, Memorial Art Gallery, University of Rochester, September 14–November 3, 1984; Buffalo, Albright-Knox Art Gallery, New York, January 17–March 2, 1986. Catalogue.

Chicago, Museum of Contemporary Art. *Dada and Surrealism in Chicago Collections.* December 1, 1984–January 27, 1985. Catalogue (*In the Mind's Eye: Dada and Surrealism*).

The Art Institute of Chicago. *The Mr. and Mrs. Joseph Randall Shapiro Collection.* February 23–April 14, 1985. Catalogue.

Houston, Institute for the Arts, Rice University. *Twenty-seven Ways to Look at American Drawing.* February 26–April 27, 1985.

Providence, Rhode Island, Bell Gallery, Brown University, and Worcester, Massachusetts, Cantor Art Gallery, College of the Holy Cross. *Flying Tigers: Painting and Sculpture in New York, 1939–1946.* April 27–May 27, 1985. Traveled to Southampton, Long Island, New York, Parrish Art Museum, June 9–July 28, 1985. Catalogue.

Houston, The Menil Collection (organizer). *Cinquante ans de dessins américains, 1930–1980.* Traveled to Paris, École nationale supérieure des Beaux-Arts, May 3–July 13, 1985; Frankfurt am Main, Städtische Galerie im Städelschen Kunstinstitut (as *Amerikanische Zeichnungen, 1930–1980*), November 28, 1985–January 26, 1986. Catalogue.

Coral Gables, Florida, Lowe Art Museum. *Abstract Expressionist American Paintings in Miami Collections.* October 10–November 24, 1985.

Cambridge, Massachusetts, Harvard University Art Museums. *Modern Art at Harvard: The Formation of the Nineteenth- and Twentieth-Century Collections of the Harvard University Art Museums.* October 21, 1985–January 5, 1986. Catalogue.

New York, The Museum of Modern Art. *American Prints, 1900–1960: Recent Acquisitions, Contemporary Prints.* February 7–July 8, 1986.

The Cleveland Museum of Art. *The Art of Collecting Modern Art.* February 12–March 30, 1986. Catalogue.

The Arts Club of Chicago. *Modern Master Drawings: Forty Years of Collecting at the University of Michigan Museum of Art.* March 31–April 26, 1986. Traveled to Grand Rapids, Michigan, Grand Rapids Art Museum, September 20–

November 2, 1986; Ann Arbor, University of Michigan Museum of Art (organizer), February 24–April 5, 1987. Catalogue.

Bridgeport, Connecticut, Museum of Art, Science and Industry. *American 20th Century Watercolors and Drawings from the Wadsworth Atheneum.* April 3–May 25, 1986.

Marseille, France, Centre de la vieille charité. *La planète affolée: Surréalisme; dispersion et influences, 1938–1947.* April 12–June 30, 1986. Catalogue.

The Art Institute of Chicago. *A Tribute to Edwin A. Bergman (1917–1986): Selections from the Lindy and Edwin Bergman Collection.* May 30–August 24, 1986.

Newport Beach, California, Newport Harbor Art Museum. *The Interpretive Link: Abstract Surrealism into Abstract Expressionism; Works on Paper, 1938–1948.* July 16–September 14, 1986. Traveled to New York, Whitney Museum of American Art, November 13, 1986–January 21, 1987; Minneapolis, Walker Art Center, February 21–April 19, 1987. Catalogue.

New York, Associated American Artists. *Abstract Expressionist Prints.* November 28–December 31, 1986. Catalogue.

New York, Xavier Fourcade. *Drawings: Abakanowicz, Berlant, Chamberlain, de Kooning, De Maria, Gorky, Heizer, Henle, Hesse, Mitchell, Morley, Moss, Murphy, Rockburne, Smith, Westermann.* January 9–February 7, 1987.

Whitney Museum of American Art, New York (organizer). *20th Century Drawings from the Whitney Museum of American Art.* Traveled to Washington. D.C., National Gallery of Art, May 21–September 7, 1987; The Cleveland Museum of Art, September 30–November 8, 1987; San Francisco, Achenbach Foundation, California Palace of the Legion of Honor, March 5–June 5, 1988; Little Rock, Arkansas Arts Center, June 30–August 28, 1988; Stamford, Connecticut, Whitney Museum of American Art, Fairfield County, November 17, 1988–January 25, 1989. Catalogue.

Zurich, Thomas Ammann Fine Art. *Impressionist and 20th Century Masters: Selected Works from the Collection of Asher B. Edelman.* June 17–September 18, 1987. Catalogue.

Buffalo, Albright-Knox Art Gallery. *Abstract Expressionism: The Critical Developments.* September 19–November 29, 1987. Catalogue.

Clinton, New York, Fred L. Emerson Gallery, Hamilton College. *Progressive Geometric Abstraction in America, 1934–1955: Selections from the Peter B. Fischer Collection.* September 26–November 7, 1987. Traveled to Amherst, Massachusetts, Mead Art Museum, Amherst College, March 31–May 1, 1988; Chicago, Terra Museum of American Art, October 1–November 27, 1988; Los Angeles, Fisher Gallery, University of Southern California, March–April 1989. Catalogue.

Huntington, New York, The Heckscher Museum. *The Artist's Mother: Portraits and Homages.* November 14, 1987–January 3, 1988. Traveled to Washington, D.C., National Portrait Gallery, Smithsonian Institution, March 26–June 5, 1988. Catalogue.

Buffalo, Albright-Knox Art Gallery. *Intimate Gestures, Realized Visions: Masterworks on Paper from the Collection of the Albright-Knox Art Gallery.* December 12, 1987–January 31, 1988. Traveled as *Masterworks on Paper from the Albright-Knox Art Gallery* to Allentown, Pennsylvania, Allentown Art Museum, March 5–April 24, 1988; Huntington, New York, Heckscher Museum, May 12–June 26, 1988; Oswego, New York, Tyler Art Gallery, State University of New York, September 7–October 10, 1988; Elmira, New York, Arnot Art Museum, October–November 1988; Glen Falls, New York, The Hyde Collection, January–February 1990. Catalogue.

Hartford, Connecticut, Wadsworth Atheneum. *American Drawings and Watercolors from the Wadsworth Atheneum.* January 17–March 6, 1988. Traveled to Huntsville, Alabama, Huntsville Museum of Art, April 2–May 28, 1988; Owensboro, Kentucky, Owensboro Museum of Fine Art, June 25–August 20, 1988; Miami, The Art Museum at Florida International University, September 17–November 12, 1988; Sacramento, California, Crocker Art Museum, December 10, 1988–February 4, 1989; Raleigh, North Carolina Museum of Art, March 4–April 30, 1989; Wausau, Wisconsin, Leigh Yawkey Woodson Art Museum, May 27–July 23, 1989; Albany, Georgia, Albany Museum of Art, September 7–November 5, 1989. Catalogue.

Little Rock, Arkansas Arts Center. *American Abstract Drawings, 1930–1987: Selections form the Arkansas Arts Center Foundation Collection.* February 26–June 19, 1988, and November 3–27, 1989. Traveled to the Arts Club of Chicago, January 8–February 12, 1990; Memphis State University, March 2–30, 1990; Vero Beach, Florida, Center for the Arts, September 8–November 10, 1990. Catalogue.

New York, Acquavella Galleries. *XIX and XX Century Master Drawings and Watercolors.* April 26–May 26, 1988. Catalogue.

Montclair, New Jersey, Montclair Art Museum. *The New York School.* May 29–August 28, 1988.

New York, Janie C. Lee Master Drawings. *Abstract Expressionist Drawings, 1941–1955.* November 5–December 30, 1988. Catalogue.

Stanford, California, Stanford University Museum of Art. *Twentieth-Century Drawings from the Anderson Collection.* November 15, 1988–February 19, 1989. Catalogue.

Little Rock, Arkansas Arts Center. *The Face.* December 1, 1988–January 26, 1989. Catalogue.

Raleigh, North Carolina Museum of Art. *Elements of Surrealism in Modern Art.* February 28–May 28, 1989.

New York, Marisa del Re Gallery. *The Linear Image: American Master Works on Paper.* April 25–May 27, 1989. Catalogue.

New York, Whitney Museum of American Art. *Art in Place: Fifteen Years of Acquisitions.* July 27–October 29, 1989. Catalogue.

Montclair, New Jersey, Montclair Art Museum. *A Museum Collects: Works on Paper.* September 17–November 5, 1989.

Notre Dame, Indiana Snite Museum of Art, University of Notre Dame. *Three Universities Collect: 20th-Century Works on Paper.* September 17–November 10, 1989. Traveled to Bloomington, Indiana University Art Museum, January 13–March 4, 1990; Lexington, University of Kentucky Art Museum, April 1–May 13, 1990. Catalogue.

Coral Gables, Florida, Lowe Art Museum, University of Miami. *Abstract Expressionism: Other Dimensions; An Introduction to Small Scale Painterly Abstraction in America, 1940–1965.* October 26–December 3, 1989. Traveled to Chicago, Terra Museum of American Art, January 23–March 11, 1990; New Brunswick, New Jersey, Jane Voorhees Zimmerli Art Museum (organizer), Rutgers University, March 25–June 13, 1990. Catalogue.

New York, Associated American Artists. *Modern American and European Prints: 55th Anniversary Exhibition.* October 31–December 2, 1989. Catalogue.

Little Rock, Arkansas Arts Center. *Early Twentieth-Century Modernists from the Arkansas Arts Center Foundation Collection.* November 30, 1989–February 11, 1990. No cat.

Las Palmas de Gran Canaria, Spain, Centro Atlántico de Arte Moderno. *El Surrealismo entre viejo y nuevo mundo.* December 4, 1989–February 4, 1990. Catalogue.

1990s

The Baltimore Museum of Art. *The Baltimore Museum of Art Collects: Surrealist Drawings.* February 27–April 29, 1990.

New York, Arnold Herstand & Company. *Surrealism: From Paris to New York.* May 12–Summer 1990. Catalogue.

New York, The Museum of Modern Art. *Master Prints from the Collection.* July 26–November 13, 1990.

Paris, Galerie 1900–2000. *Diversité surréaliste.* January 15–March 2, 1991.

Washington, D.C., National Gallery of Art. *Art for the Nation: Gifts in Honor of the 50th Anniversary of the National Gallery of Art.* March 17–June 16, 1991. Catalogue.

New York, The American Federation of the Arts (organizer). *Graphic Excursions: American Prints in Black and White, 1900–1950; Selections from the Collection of Reba and Dave Williams.* Traveled to Greensboro, Weatherspoon Art Gallery, University of North Carolina, April 6–June 1, 1991; Columbus, Georgia, Columbus Museum, June 29–August 24, 1991; Newark, New Jersey, The Newark Museum, September 21–November 16, 1991; Guelph, Canada, MacDonald Stewart Art Center, December 14, 1991–February 8, 1992; Calgary, Canada, Glenbow Museum, March 28–May 24, 1992; Ames, Brunnier Gallery and Museum, Iowa State University, August 23–October 18, 1992; Huntington,

New York, Heckscher Museum, November 7, 1992–January 10, 1993; Dallas Museum of Art, February 7–April 4, 1993. Catalogue.

New York, Janie C. Lee Master Drawings and Kate Ganz Ltd. *Master Drawings, 1520–1990.* April 13–May 11, 1991. Catalogue.

Paris, Musée national d'art moderne, Centre Georges Pompidou. *André Breton: La beauté convulsive.* April 25–August 26, 1991. Traveled to Madrid, Centro Arte Reina Sophia. Catalogue.

New York, Anthony Ralph Gallery. *Modern Drawings.* October–November 1991.

Roslyn Harbor, New York, Nassau County Museum of Art. *Landscape of America: The Hudson River School to Abstract Expressionism.* November 10, 1991–February 9, 1992. Catalogue.

Oberlin, Ohio, Allen Memorial Art Museum, Oberlin College. *The Body and Other 20th-Century Metaphors.* November 15, 1991–January 12, 1992.

New York, Whitney Museum of American Art at Equitable Center. *American Masters: Six Artists from the Permanent Collection of the Whitney Museum of American Art.* January 10–March 18, 1992. Traveled to Stamford, Connecticut, Whitney Museum of American Art at Champion, April 17–June 17, 1992. Catalogue.

Montclair, New Jersey, Montclair Art Museum. *Immigrant Artists from Smibert to the Present.* December 6, 1992–March 28, 1993.

Atlanta, High Museum of Art. *Abstract Expressionism: Works on Paper—Selections from The Metropolitan Museum of Art.* January 26–April 4, 1993. Traveled to New York, The Metropolitan Museum of Art (organizer), May 4–September 12, 1993. Catalogue.

Canberra, National Gallery of Australia. *Surrealism: Revolution by Night.* March 12–May 2, 1993. Traveled to Brisbane, Queensland Art Gallery, May 21–July 11, 1993; Sydney, Art Gallery of New South Wales, July 30–September 19, 1993. Catalogue.

New York, Jason McCoy, Inc. *Expressive Heads: Including Works by Bacon, Baziotes, Dubuffet, Gorky, Matisse, Moore, Picasso, and Pollock.* May 6–June 12, 1993. Catalogue.

Berlin, Martin-Gropius-Bau. *American Art in the 20th Century: Painting and Sculpture, 1913–1993.* May 8–July 25, 1993. Traveled to London, Royal Academy of Arts and Saatchi Gallery, September 16–December 12, 1993. Catalogue.

New York, IBM Gallery of Science and Art. *Highlights from the Vassar College Art Collection.* July 13–September 11, 1993.

New York, Sidney Janis Gallery. *20th Century Masters.* May 4–June 10, 1994. Catalogue.

Provincetown, Massachusetts, Provincetown Art Association and Museum. *Provincetown Abstract Painting, 1915–1950: From the Penny and Elton Yasuna Collection.* August 5–September 5, 1994. Catalogue.

Cambridge, Massachusetts, Arthur M. Sackler Museum, Harvard University Art Museums. *American Art at Harvard: Cultures and Contexts.* October 1–December 30, 1994. Catalogue.

Bochum, Germany, Museum Bochum. *Armenien: Wiederentdeckung einer alten Kulturlandschaft.* January 14–April 17, 1995. Catalogue.

Roslyn Harbor, New York, Nassau County Museum of Art. *Surrealism.* January 15–April 16, 1995. Catalogue.

Boca Raton, Florida, Boca Raton Museum of Art. *Masterpieces of American Modernism: Selections from the Harvey and Françoise Rambach Collection.* March 10–April 23, 1995. Catalogue.

Houston, The Museum of Fine Arts. *Texas Collects: Willem de Kooning and His Contemporaries.* March 17–May 21, 1995.

Washington, D.C., National Gallery of Art. *Recent Acquisitions of Works of Art on Paper.* July 2–December 31, 1995.

San Francisco, Campbell-Thiebaud Gallery. *Twenty-five Treasures.* September 5–October 7, 1995. Catalogue.

New York, Whitney Museum of American Art. *Picassoid: Collection in Context.* September 29–December 10, 1995. Catalogue.

Roslyn Harbor, New York, Nassau County Museum of Fine Art. *American Vanguards.* January 21–April 28, 1996. Catalogue.

New York, PaceWildenstein. *Master Drawings.* February 2–17, 1996.

Washington, D.C., National Gallery of Art. *The Robert and Jane Meyerhoff Collection: 1945–1995.* March 31–July 21, 1996. Catalogue.

Tokyo, Sezon Museum of Art. *Abstract Expressionism.* June 6–July 14, 1996. Traveled to Nagoya, Japan Aichi Prefectural Museum (organizer), July 26–September 16, 1996; Hiroshima City Museum of Contemporary Art, September 29–November 17, 1996. Catalogue.

East Hampton, New York, Pollock-Krasner House and Study Center. *Michael West: Painter-Poet.* August 1–October 26, 1996. Catalogue.

Houston, The Museum of Fine Arts. *American Images: The SBC Collection of Twentieth-Century American Art.* November 1997–December 1998. Traveled to Austin, Texas, Austin Museum of Art; Corpus Christi, Museum of South Texas; and El Paso, Texas, El Paso Museum of Art. Catalogue.

Athens, Georgia Museum of Art. *Intimate Expressions: Two Centuries of American Drawings from the collection of Dr. Philip L. Brewer.* December 5, 1997–February 1, 1998. Traveled to Columbus, Georgia, Columbus Museum, November 16, 1998–March 1, 1999; Gainesville, Florida, Harn Museum of Art, August 29–November 28, 1999; Columbia, South Carolina, Columbia Museum of Art, June 5, 2000–August 18, 2000. Catalogue.

Laguna Beach, California, Laguna Art Museum. *Defining the Edge: Early American Abstraction; Selections from the Collection of Dr. Peter B. Fischer.* January 10–March 15, 1998. Traveled to New York, Michael Rosenfeld Gallery, March 26–May 30, 1998.

Greenwich, Connecticut, Bruce Museum of Arts and Science. *The Surrealist Vision: Europe and the Americas.* January 17–April 5, 1998. Catalogue.

New York, Gagosian Gallery. *The New York School.* March 17–April 25, 1998. Catalogue.

New York, Mitchell-Innes & Nash. *Master Drawings of the Twentieth Century.* May 5–June 5, 1998. Catalogue.

Saint Petersburg, Florida, Salvador Dalí Museum. *Surrealism in America during the 1930s and 1940s: Selections from the Penny and Elton Yasuna Collection.* November 7, 1998–February 21, 1999. Traveled to Chicago, David and Alfred Smart Museum of Art, University of Chicago, November 19, 1999–January 9, 2000; Dennis, Massachusetts, Cape Museum of Fine Arts, July 19–September 2000. Catalogue.

New York, Pierpont Morgan Library. *New York Collects: Drawings and Watercolors, 1900–1950.* May 20–August 29, 1999. Catalogue.

New York, Gerald Peters Gallery. *American Modernism: The François and Harvey Rambach Collection.* September 30–November 20, 1999. Catalogue.

Cambridge, Massachusetts, Harvard University Art Museum, and Nihon Keizai Shimbun (organizers). *Modern Art at Harvard.* Traveled to Tokyo, Bunkamura Museum of Art, July 31–September 26, 1999; Kagawa, Takamatsu City Museum of Art, October 9–November 14, 1999; Nagoya, Matsuzakaya Art Museum, December 2–27, 1999; Oita Art Museum, January 5–February 6, 2000; Ibaraki, The Museum of Modern Art, February 11–March 26, 2000. Catalogue.

2000s

Strasbourg, France, Musée d'art moderne et contemporain. *Les Surréalistes en exil et les débuts de l'École de New York.* May 12–August 27, 2000. Catalogue.

Cambridge, Massachusetts, Harvard University Art Museums. *A Decade of Collecting: Recent Acquisitions by the Harvard University Art Museums.* June 3–August 27, 2000. Catalogue.

Giverny, France, Musée d'art américain. *American Moderns, 1900–1950.* July 25–October 31, 2000. Catalogue.

San Francisco Museum of Modern Art. *Celebrating Modern Art: The Anderson Collection.* October 4, 2000–January 15, 2001. Catalogue.

Oberlin, Ohio, Allen Memorial Art Museum, Oberlin College. *Collecting the Vanguard: Art from 1900–1970.* August 17, 2001–June 2, 2002.

Washington, D.C., National Gallery of Art. *A Century of Drawing: Works on Paper from Degas to LeWitt.* November 18, 2001–April 7, 2002. Catalogue.

Oberlin, Ohio, Allen Memorial Art Museum, Oberlin College. *Figure to Non-Figurative: The Evolution of Modern Art in Europe and North America.* August 23, 2002–September 16, 2003.

Cambridge, Massachusetts, Harvard University Art Museums. *Lois Orswell, David Smith, and Modern Art.* September 21, 2002–February 16, 2003. Catalogue.

New York, Michael Rosenfeld Gallery. *The Art of Organic Forms.* March 13–May 3, 2003. Catalogue.

Columbus, Georgia, Columbus Museum of Art. *Celebration of Creativity: Three Centuries of American Masterworks on Paper.* May 11–August 31, 2003.

Oberlin, Ohio, Allen Memorial Art Museum, Oberlin College. *Going Modern at the Allen: American Painting and Sculpture, 1950–1980.* September 16, 2003–May 30, 2004.

Rome, Scuderie del Quirinale. *Metafisica.* September 27, 2003–January 6, 2004. Catalogue.

New York, Knoedler & Co.. *Lois Orswell, David Smith, and Friends: Works from the Lois Orswell Collection, Harvard University.* November 14, 2003–January 24, 2004. Catalogue.

Houston, The Museum of Fine Arts. *A Spirited Vision: Highlights of the Bequest of Caroline Wiess Law to the Museum of Fine Arts, Houston.* February 22–April 25, 2004. Catalogue.

New York, Joan T. Washburn Gallery. *Gerome Kamrowski: A Memorial, and the Surrealist Influence.* October 28–December 23, 2004.

Chicago, Thomas McCormick Gallery. *Black.* March 11–April 23, 2005. Catalogue.

Worcester, Massachusetts, Worcester Art Museum. *Printmaking Methods: Lithography.* April 30–July 31, 2005.

New York, National Academy of Design. *Surrealism USA.* February 17–May 8, 2005. Traveled to Phoenix Art Museum, June 5–September 25, 2005. Catalogue.

New York, Michael Rosenfeld Gallery. *Organic New York, 1941–1949.* September 10–November 5, 2005. Catalogue.

Philadelphia, Pennsylvania Academy of the Fine Arts. *In Private Hands: 200 Years of American Painting.* October 1, 2005–January 8, 2006. Catalogue.

Venice, Peggy Guggenheim Collection. *Peggy and Kiesler: The Collector and the Visionary.* October 10, 2005–January 9, 2006. Catalogue (*Peggy Guggenheim and Frederick Kiesler: The Story of Art of This Century*).

Long Island City, New York, The Noguchi Museum. *The Imagery of Chess Revisited.* October 21, 2005–April 16, 2006. Catalogue.

Los Angeles, Hammer Museum. *The Société Anonyme: Modernism for America.* April 23–August 13, 2006. Traveled to Washington, D.C., The Phillips Collection, October 14, 2006–January 21, 2007; Dallas Museum of Art, June 10–September 16, 2007; Nashville, Frist Center for the Visual Arts, October 26, 2007–February 3, 2008; New Haven, Connecticut, Yale University Art Gallery, 2010. Catalogue.

Worcester, Massachusetts, Worcester Art Museum. *Surrealist Works on Paper.* May 6–August 19, 2006.

New York, Berry-Hill Galleries. *Toward a New American Cubism.* May 16–July 7, 2006. Catalogue.

Tulsa, Oklahoma, Gilcrease Museum. *Lines of Discovery: 225 Years of American Drawing.* June 17–August 27, 2006. Traveled to Kalamazoo, Michigan, Kalamazoo Institute of Arts, September 23–December 31, 2006; Little Rock, Arkansas Arts Center, January 26–April 22, 2007. Catalogue.

Oberlin, Ohio, Allen Memorial Art Museum, Oberlin College. *New Frontiers: American Art since 1945.* August 29–December 23, 2006.

New York, Whitney Museum of American Art. *Picasso and American Art.* September 28, 2006–January 28, 2007. Traveled to San Francisco Museum of Modern Art, February 25–May 28, 2007; Minneapolis, Walker Art Center, June 17–September 9, 2007. Catalogue.

Jerusalem, The Israel Museum. *Surrealism and Beyond in the Israel Museum.* February–June 2007. Catalogue.

San Francisco, de Young Museum, Fine Arts Museums of San Francisco. *The Surreal World of Enrico Donati.* June 9–September 2, 2007. Catalogue.

Colorado Springs Fine Arts Center. *The Eclectic Eye: Pop and Illusion—Selections from the Frederick R. Weisman Art Foundation.* August 4–October 28, 2007.

New York, Mitchell-Innes & Nash. *Works on Paper.* May 1–June 27, 2008.

New York, Haunch of Venison. *Abstract Expressionism: A World Elsewhere.* September 12–November 12, 2008. Catalogue.

Moscow, Red October Chocolate Factory. *For What You Are About to Receive.* September 18–October 25, 2008. Organized by the Gagosian Gallery, New York. Catalogue.

Norman, Oklahoma, Fred Jones Jr. Museum, University of Oklahoma at Norman. *American Artists from the Russian Empire: Paintings and Sculptures from Museums, Galleries in the U.S. and Private Collections.* October 4, 2008–January 4, 2009. Traveled to St. Petersburg, State Russian Museum, February 19–May 25, 2009; Moscow, State Tretyakov Gallery, June 10–August 23, 2009; and San Diego Museum of Art, October 10, 2009–January 3, 2010. Catalogue.

Paris, Musée du Luxembourg. *De Miró à Warhol: La collection Berardo à Paris.* October 16, 2008–February 22, 2009. Catalogue.

Philadelphia Museum of Art. *Cézanne and Beyond.* February 26–May 17, 2009. Catalogue.

"Academy Show of Water Colors." *Philadelphia Inquirer*, September 29, 1935.

Akiskal, Kareen K., and Hagop S. Akiskal. "Abstract Expressionism as Psychobiography: The Life and Suicide of Arshile Gorky." In *Depression and the Spiritual in Modern Art: Homage to Miró*, ed. Joseph J. Schildkraut and Aurora Otero, pp. 221–38. Chichester, England: John Wiley and Sons, 1996.

Alloway, Lawrence. "Gorky." *Artforum* 1, no. 9 (March 1963), pp. 28–31.

Anfam, David. *Arshile Gorky: Portraits*. With preface by Matthew Spender. Exh. cat. New York: Gagosian Gallery, 2002.

———. "Arshile Gorky: Tradition and Identity." *Antique Collector* 61, no. 2 (February 1990), p. 27.

Arshile Gorky: Drawings. Exh. cat. London: Arts Council, 1965.

"Arshile Gorky." Special issue, *Arti Visive* 6–7 (Summer 1957).

"Arshile Gorky: A Retrospective." *Drawing* 2, no. 6 (March–April 1981), p. 133.

"Arshile Gorky Dies." *Art Digest* 22, no. 19 (August 1, 1948), p. 27.

"Arshile Gorky Exhibits." *Art Digest* 10, no. 7 (January 1, 1936), p. 21.

"The Artist and His Mother." *Christian Science Monitor*, December 1, 1987, p. 30.

Ash, John. "Arshile Gorky: *How My Mother's Embroidered Apron Unfolds in My Life*." *Artforum* 34, no. 1 (September 1995), pp. 79, 121.

Ashbery, John. "Sweet Arshile, Bless Your Dear Heart." *New York*, February 5, 1979, pp. 52–53.

Ashton, Dore. "New York Commentary." *Studio International* 179, no. 919 (February 1970), pp. 73–74.

Ashton, Dore, Michael Auping, and Matthew Spender. *Arshile Gorky: The Breakthrough Years*. Exh. cat. Fort Worth, Tex.: Modern Art Museum of Fort Worth in association with Rizzoli, 1996.

Avakian, Florence. "As Arshile Gorky's Prestige Grows, His Armenian Experience Must Not Be Forgotten." *Armenian Reporter*, July 5, 2008.

Balakian, Peter. "Arshile Gorky and the Armenian Genocide." *Art in America* 84, no. 2 (February 1996), pp. 58–67, 108–9.

Balamuth, Lewis. "I Met A. Gorky (1938)." *Color and Rhyme* (New York), no. 19 (1949), pp. 2–3.

"Baltimore Museum of Art: Two Works by Arshile Gorky." *Burlington Magazine* 107, no. 742 (January 1965), p. 54.

Barr, Alfred H., Jr. "Seven Americans Open in Venice: Gorky, de Kooning, Pollock." *ARTnews* 49, no. 4 (June–August 1950), pp. 22–23, 60.

Ben-Levi, Jack. "A Sadomasochistic Drama in an Age of Traditional Family Values." In *Abject Art: Repulsion and Desire in American Art; Selections from the Permanent Collection*, pp. 17–31. Exh. cat. New York: Whitney Museum of American Art, 1993.

Bevan, Roger. "Autumnal Gorky." *Art Newspaper* 6 (May 1995), p. 13.

"The Bitter One." *Time Magazine*, February 23, 1962, p. 83.

Bonte, C. H. "In Gallery and Studio." *Philadelphia Inquirer*, February 11, 1934.

Bordeaux, Jean-Luc. "Arshile Gorky: His Formative Period (1925–1937)." *American Art Review* 1, no. 4 (May–June, 1974), pp. 94–108.

Bourdon, David. "Gorky Translated through Tragedy." *Village Voice*, March 1, 1976, p. 99.

Bowman, Ruth. *Murals without Walls: Arshile Gorky's Aviation Murals Rediscovered*. Exh. cat. Newark, N.J.: Newark Museum, 1978.

Brach, Paul. "Gorky's Secret Garden." *Art in America* 69, no. 8 (October 1981), pp. 122–25.

Breton, André. "Arshile Gorky." In *Surrealism and Painting*, trans. Simon Watson Taylor, pp. 199–200. New York: Harper and Row, 1972.

———. "The Eye-Spring: Arshile Gorky." Trans. Julien Levy. In *Arshile Gorky*, n.p. Exh. cat. New York: Julien Levy Gallery, 1945.

B[reuning], M[argaret]. "A Memorial of Arshile Gorky." *Art Digest* 24, no. 13 (April 1, 1950), p. 18.

B[rummer], M[iriam]. "In the Galleries: Arshile Gorky." *Arts Magazine* 44, no. 2 (November 1969), p. 62.

Buettner, Stewart. "Arshile Gorky and the Abstract-Surreal." In "Arshile Gorky," special issue, *Arts Magazine* 50, no. 7 (March 1976), pp. 86–87.

Burliuk, Mary. "Arshile Gorky." *Color and Rhyme* (New York), no. 19 (1949), pp. 1–2.

Burr, James. "Fighting on the Frontiers of Perception." *Apollo*, no. 131 (May 1990), pp. 344–45.

Burrows, Carlyle. "Abstract Drawings." *New York Herald Tribune*, December 22, 1935.

———. "Gorky's Art Show Provocative." *New York Herald Tribune*, December 8, 1957.

———. "In the Art Galleries: Two Surrealists." *New York Herald Tribune*, March 11, 1945.

———. "Memorial Show of Arshile Gorky Art Will Open at Whitney Museum Today." *New York Herald Tribune*, January 5, 1951.

Butler, Doris Lane. "Gorky Drawings Reveal Blend of Real and Unreal." *Chicago Tribune*, November 17, 1963, sec. 5.

Calas, Nicolas. *Calas Presenting Bloodflames 1947: Hare, Gorky, Kamrowski, Lam, Matta, Noguchi, Phillips, Raynal*. Exh. cat. New York: Hugo Gallery, 1947.

———. "Gorky's Garden of Wish-Fulfillment." *Artforum* 14, no. 9 (May 1975), pp. 48–49. Reprinted in Calas, *Transfigurations: Art Critical Essays on the Modern Period* (Ann Arbor, Mich.: UMI Research Press, 1985), pp. 175–77.

———. "A Tough Nut to Crack." *Artforum* 13, no. 9 (May 1975), pp. 48–49.

Clapp, Talcott B. "A Painter in a Glass House." *Sunday Republican Magazine* (Waterbury, Conn.), February 9, 1948.

Coates, Robert M. "Arshile Gorky." *New Yorker*, December 14, 1957, pp. 141, 144–45.

———. "The Art Galleries." *New Yorker*, January 20, 1951, pp. 60–63.

Corgnati, Martina. "Gorky Art." *Panorama*, April 19, 1992, p. 28.

Cotter, Holland. "Suspended between Modernism and an Armenian Past." *New York Times*, April 12, 2002, sec. E.

Cowley, Malcolm. "Arshile Gorky—A Note from a Friend." *New York Herald Tribune*, September 5, 1948, sec. 6.

C[rehan], H[ubert]. "Gorky." *ARTnews* 58, no. 6 (October 1959), p. 12.

Danto, Arthur C. "Doodling towards Armenia." *Times Literary Supplement*, January 22, 1999, p. 18.

Davis, Gene. "Gorky Taught Me That: A Remembrance of Arshile Gorky." In "Arshile Gorky," special issue, *Arts Magazine* 50, no. 7 (March 1976), p. 81.

Davis, Stuart. "Arshile Gorky in the 1930s: A Personal Recollection." *Magazine of Art* 44, no. 2 (February 1951), pp. 56–58.

———. "Handmaiden of Misery." *Saturday Review* (New York), December 28, 1957, pp. 16–17.

de Kooning, Elaine. "Gorky: Painter of His Own Legend." *ARTnews* 49, no. 9 (January 1951), pp. 38–41, 63–66.

de Kooning, Willem. Letter to the editor. *ARTnews* 47, no. 9 (January 1949), p. 6.

Dennison, George. "The Crisis-Art of Arshile Gorky." *Arts Magazine* 37, no. 5 (February 1963), pp. 14–18.

Dervaux, Isabelle. "Arshile Gorky, 1904–1948." In *Twentieth-Century American Art: The Ebsworth Collection*, ed. Bruce Robertson, pp. 108–283. Exh. cat. Washington, D.C.: National Gallery of Art, 1999.

———. "Détail, analogie, et mimétisme: de l'inspiration de la nature dans les abstractions de Arshile Gorky." *Les cahiers du Musée national d'art moderne* 65 (Fall 1998), pp. 54–69.

Devree, Howard. "Abstractions." *New York Times*, December 22, 1935.

———. "By Two Americans." *New York Times*, October 2, 1955.

———. "Diverse Moderns—Gorky in Retrospect." *New York Times*, December 8, 1957.

——. "Gorky's Late Work." *New York Times*, April 2, 1950.

——. "A Memorable Year." *New York Times*, January 7, 1951, sec. 2.

——. "Whitney to Offer Arshile Gorky Art." *New York Times*, January 4, 1951.

Driscoll, Edgar J., Jr. "Artists Work Well Illustrated." *Boston Evening Globe*, March 31, 1968.

"Exhibition Talks Planned by Boyer." *Philadelphia Record*, October 13, 1935, sec. 4.

Feinstein, Sam. "A Gallery Itinerary." *Art Digest* 28, no. 14 (April 15, 1954), p. 21.

"Fetish of Antique Stifles Art Here, Says Gorky Kin." *New York Evening Post*, September 15, 1926.

"Fiery River of Images." *Pictures on Exhibit* (New York) 13, no. 4 (January 1951), pp. 4–5.

Finkelstein, Louis. "Becoming Is Meaning: Gorky as a Draftsman." *ARTnews* 68, no. 8 (December 1969), pp. 44–47, 59.

FitzGerald, Michael. "Arshile Gorky." *Arts Magazine* 55, no. 10 (June 1981), p. 23.

——. "Arshile Gorky's 'The Limit.'" *Arts Magazine* 54, no. 7 (March 1980), pp. 110–15.

Fitzsimmons, James. "The Late Gorky." *Art Digest* 27, no. 11 (March 1, 1953), p. 16.

Frank, Elizabeth. "How Arshile Gorky Finally Became Himself." *ARTnews* 80, no. 7 (September 1981), pp. 168–70.

Frankenstein, Alfred. "Review." *San Francisco Chronicle*, August 17, 1941.

Fried, Alexander. "Gorky Oils of Surrealist School." *San Francisco Examiner*, August 17, 1941.

Fundación Caja de Pensiones and Whitechapel Art Gallery. *Arshile Gorky, 1904–1948*. Exh. cat. Madrid: La Caja, 1989.

Gagosian Gallery. *Arshile Gorky: Late Paintings*. Includes an interview concerning Gorky with Karlen Mooradian and Willem de Kooning. Exh. cat. New York: Gagosian Gallery, 1994.

Galassi, Susan Grace. "Arshile Gorky." *Arts Magazine* 53, no. 6 (February 1979), p. 20.

[Genauer, Emily]. "Gorky, Was He Tops or Second Rate?" *Art Digest* 25, no. 8 (January 15, 1951), pp. 9, 30.

——. "Painting What the Camera Saw." *New York Herald Tribune*, October 25, 1964.

——. "The Whitney's Memorial Exhibit and the Arshile Gorky Tragedy." *New York Herald Tribune*, January 7, 1951, sec. 5.

Gendel, Milton. "The Venice Bazaar, 1962." *ARTnews* 61, no. 5 (September 1962), pp. 20–23, 53–54.

Gibson, Eric. "New York: Arshile Gorky." *Art International* 23, nos. 3–4 (Summer 1979), pp. 74–77.

Glueck, Grace. "Art People." *New York Times*, December 17, 1977, sec. C.

Golding, John. "Always in Exile." *New York Review*, September 25, 2003, pp. 47–50.

Goldwater, Robert. "The Genius of the Moujik." *Saturday Review* (New York), May 19, 1962, p. 38.

Goodnough, Robert. "Reviews and Previews: Arshile Gorky." *ARTnews* 49, no. 10 (February 1951), p. 46.

Goodrich, Lloyd. "Notes on Eight Works by Arshile Gorky." *Magazine of Art* 44, no. 2 (February 1951), pp. 59–61.

Gorky, Arshile. "Garden in Sochi" (June 26, 1942). Manuscript in the Collections Archive, The Museum of Modern Art, New York. Reprinted with one line omitted in Ethel K. Schwabacher, *Arshile Gorky* (New York: Macmillan for the Whitney Museum of American Art, 1957), p. 280.

——. "My Murals for the Newark Airport: An Interpretation" (1936). Typescript, "General Description of Newark Airport Murals," Arshile Gorky Research Collection, Frances Mulhall Achilles Library, Archives, Whitney Museum of American Art, New York. Reprinted in Ruth Bowman, *Murals without Walls: Arshile Gorky's Aviation Murals Rediscovered*, exh. cat. (Newark, N.J.: Newark Museum, 1978), pp. 13–16.

——. "Stuart Davis." *Creative Art* 9, no. 3 (September 1931), pp. 213–17. Reprinted in part in Ethel K. Schwabacher, *Arshile Gorky* (New York: Macmillan for the Whitney Museum of American Art, 1957), p. 280.

"Gorky Drawings at Joplin." *Tulsa World*, February 10, 1963.

"Grand Central Faculty Show." *ARTnews* 25, no. 20 (February 19, 1927), p. 4.

Greenberg, Clement. "Art." *The Nation* 160 (March 24, 1945), pp. 342–43.

——. "Art." *The Nation* 162 (May 4, 1946), pp. 552–53.

——. "Art." *The Nation* 166 (January 10, 1948), pp. 51–52.

——. "Art." *The Nation* 166 (March 20, 1948), pp. 331–32.

——. "Art." *The Nation* 167 (December 11, 1948), p. 676.

——. "Art Chronicle." *Partisan Review* 17 (May–June 1950), pp. 512–13.

Greene, Balcomb. "Memories of Arshile Gorky." In "Arshile Gorky," special issue, *Arts Magazine* 50, no. 7 (March 1976), pp. 108–10.

Hamilton, Chloe. "Captivating a Captive Audience." *The Palette*, Spring 1958, pp. 12–15.

Harris, James C. "Agony." *Archives of General Psychiatry* 61, no. 4 (April 2004), p. 334.

——. "The Artist and His Mother." *Archives of General Psychiatry* 61, no. 3 (March 2004), p. 220.

Heartney, Eleanor. "Reviews: Gorky Drawings." *ARTnews* 89, no. 9 (November 1990), p. 159.

Henning, Edward B. "Arshile Gorky, 1904–1948." In *The Spirit of Surrealism*, pp. 140–48. Exh. cat. Cleveland: Cleveland Museum of Art in cooperation with Indiana University Press, 1979.

Herrera, Hayden. *Arshile Gorky: His Life and Work*. New York: Farrar, Straus and Giroux, 2003.

——. "Gorky's Distant Likenesses." *Art in America* 90, no. 11 (November 2002), pp. 148–51.

——. "Gorky's Self-Portraits: The Artist by Himself." *Art in America* 64, no. 2 (March–April 1976), pp. 56–64.

——. "New York Reviews: Arshile Gorky; Works on Paper." *ARTnews* 74, no. 3 (March 1975), pp. 97, 105.

——. "Review of Exhibitions: Arshile Gorky at Gagosian." *Art in America* 87, no. 5 (May 1999), pp. 151–52.

——. "The Sculptures of Arshile Gorky." In "Arshile Gorky," special issue, *Arts Magazine* 50, no. 7 (March 1976), pp. 88–90.

Hess, Thomas B. "Arshile Gorky Flies Again." *New York*, September 12, 1977, pp. 84–87.

——. "Reviews and Previews: Arshile Gorky." *ARTnews* 49, no. 2 (April 1950), p. 45.

Hoffeld, Jeffrey. "Arshile Gorky: Collecting and Connoisseurship." In "Arshile Gorky," special issue, *Arts Magazine* 50, no. 7 (March 1976), pp. 106–7.

Hughes, Robert. "Intellect and Emotion." *Newsweek*, April 9, 1962, pp. 106–8.

——. "The Triumph of Achilles the Bitter." *Time Magazine*, May 11, 1981, p. 80.

Hunter, Sam. "Chiefly Abstract." *New York Times*, November 21, 1948, sec. 2.

——. "Modernism by Four: Abstraction, Surrealism in Current Shows." *New York Times*, February 29, 1948, sec. 2.

Jewell, Edward Alden. "Pop Hart, the Artist and the Man: Inclusive Memorial Exhibition Opens at the Newark Museum—The College Art Association's Index Show and Others." *New York Times*, October 13, 1935, sec. X.

Johnson, Malcolm. "Café Life in New York: The New Murals at Ben Marden's Riviera as the Artist Sees Them." *New York Sun*, August 22, 1941.

Jordan, Jim M. "Arshile Gorky at Crooked Run Farm." In "Arshile Gorky," special issue, *Arts Magazine* 50, no. 7 (March 1976), pp. 99–103.

——. "Gorky at the Guggenheim." *Art Journal* 41, no. 3 (Autumn 1981), pp. 261–65.

——. *Gorky Drawings*. Exh. cat. New York: M. Knoedler, 1969.

Jordan, Jim M., and Robert Goldwater. *The Paintings of Arshile Gorky: A Critical Catalogue*. New York: New York University Press, 1982.

"Just Arshile Gorky Being Abstract." *Philadelphia Inquirer*, September 29, 1935.

Kainen, Jacob. "Dream-World Art." *New Masses* 17 (November 12, 1935), p. 25.

———. "Memories of Arshile Gorky." In "Arshile Gorky," special issue, *Arts Magazine* 50, no. 7 (March 1976), pp. 96–97.

Karmel, Pepe. "Arshile Gorky: Anatomical Blackboard." *Master Drawings* 40, no. 1 (Spring 2002), pp. 9–23.

Karp, Diane. "Arshile Gorky: The Language of Art." Ph.D. diss., University of Pennsylvania, 1982.

———. "Arshile Gorky's Iconography." In "Arshile Gorky," special issue, *Arts Magazine* 50, no. 7 (March 1976), pp. 82–85.

Kees, Weldon. "Art." *The Nation* 170 (April 8, 1950), p. 333.

Kiesler, Frederick T. "Murals without Walls: Relating to Gorky's Newark Project." *Art Front* 2 (December 1936), pp. 10–11.

Kingsley, April. "New York Letter." *Art International* 17, no. 2 (February 1973), p. 42.

———. "Reviews and Previews: Arshile Gorky." *ARTnews* 72, no. 1 (January 1973), p. 18.

Kiplinger, Suzanne. "Arshile Gorky." *Village Voice*, January 3, 1963, p. 9.

Klein, Jerome. "Gorky Exhibits Abstract Works." *New York Post*, December 21, 1935.

Kozloff, Max. "New York Letter: Gorky." *Art International* 6, no. 3 (April 1962), p. 42.

Kramer, Hilton. "Arshile Gorky: Between Two Worlds." In *The Age of the Avant-Garde: An Art Chronicle of 1956–1972*, pp. 313–15. New York: Farrar, Straus, and Giroux, 1973. Originally published in the *New York Times*, December 7, 1969.

———. "Art." *The Nation* 196 (January 1963), pp. 38–39.

———. "The Case of the Purloined Image." *New York Times*, June 25, 1981, sec. C.

———. "Considering Gorky, It's His Portraits that Really Matter." *New York Observer*, April 22, 2002.

———. "Modernist Show Moves Met Firmly into Art of Twentieth Century." *New York Times*, May 22, 1981, sec. 6.

———. "Month in Review: Drawings from Gorky's Last Years." *Arts* (New York) 30, no. 1 (October 1955), pp. 48–49.

———. "The Pictures in the Paintings." *New York Times Book Review*, June 21, 1981, p. 3.

———. "A Rare Gorky and Prints of Prendergast." *New York Times*, April 13, 1979, sec. C.

———. "Tragedy of Life and Art." *Art and Antiques* 18 (October 1995), pp. 116–17.

Kunitz, Daniel. "Gallery Chronicle." *New Criterion* 20 (May 2002), pp. 48–51.

Kuspit, Donald. "Arshile Gorky: Images in Support of the Invented Self." In *Abstract Expressionism: The Critical Developments*, ed. Michael Auping, pp. 48–63. Exh. cat. New York: Abrams in association with Albright-Knox Art Gallery, 1987.

Lader, Melvin P. *Arshile Gorky*. New York: Abbeville, 1985.

———. *Arshile Gorky: The Early Years*. Exh. cat. Los Angeles: Jack Rutberg Fine Arts, 2004.

———. "Arshile Gorky's *The Artist and His Mother*: Further Study of Its Evolution, Sources, and Meaning." *Arts Magazine* 58, no. 5 (January 1984), pp. 96–104.

———. "Graham, Gorky, de Kooning, and the 'Ingres Revival' in America." *Arts Magazine* 52, no. 7 (March 1978), pp. 94–99.

———. "Three Decades of Drawings." In *Arshile Gorky: Three Decades of Drawings*, pp. 7–11. Santa Fe: Gerald Peters Gallery in association with John Van Doren, 1990.

Lane, James W. "Current Exhibitions." *Parnassus* 8, no. 3 (March 1936), p. 27.

Lanes, Jerrold. "New York." *Artforum* 8, no. 6 (February 1970), p. 74.

Langsner, Jules. "Art News from Los Angeles: Gorky Myth vs. Reality." *ARTnews* 56, no. 10 (February 1958), p. 47.

Lansford, Alonzo. "Concentrated Doodles." *Art Digest* 21, no. 11 (March 1, 1947), p. 18.

Lee, Janie C., and Melvin P. Lader. *Arshile Gorky: A Retrospective of Drawings*. Exh. cat. New York: Whitney Museum of American Art, 2003.

Levin, Gail. "Arshile Gorky (1904–1948)." In *Abstract Expressionism: The Formative Years*, ed. Robert Carleton Hobbs and Gail Levin, pp. 68–73. Exh. cat. Ithaca, N.Y.: Herbert F. Johnson Museum of Art, Cornell University; New York: Whitney Museum of American Art, 1978.

Levy, Julien. *Arshile Gorky*. New York: Harry N. Abrams, 1966.

Loftus, John. "Arshile Gorky: A Monograph." Master's thesis, Columbia University, 1952.

Louchheim, Aline. "Contemporary Art in New York." *Atlantic Monthly*, December 1950, pp. 65–67.

———. "Cubism and Futurism." *New York Times*, August 17, 1952.

———. "One Man Picks and Defends Biennial." *New York Times*, April 30, 1950.

———. "Venice to Glimpse Our Modernists." *New York Times*, May 28, 1950.

MacMillan, Duncan. "The Outsider: Gorky and America." *Art International* 23, nos. 3–4 (Summer 1979), pp. 104–6.

Marshall, W. Neil. "Arshile Gorky." *Arts Magazine* 49, no. 8 (April 1975), p. 71.

Matossian, Nouritza. "Arshile Gorky's Lost World." *Modern Painters* 11 (Winter 1998), pp. 72–75.

———. *Black Angel: The Life of Arshile Gorky*. London: Chatto and Windus, 1998.

McBride, Henry. Review of Memorial Show at Julien Levy Gallery. *New York Sun*, November 17, 1948.

———. "Success at Last." *ARTnews* 52, no. 2 (April 1953), pp. 66–67.

McNeil, George. "American Abstractionists Venerable at Twenty." *ARTnews* 55, no. 3 (May 1956), pp. 64–65.

M[ellow], J[ames] R. "In the Galleries: Late Drawings of Arshile Gorky." *Arts* (New York) 34, no. 1 (October 1959), pp. 55–56.

———. "The Most Elegant Stylist." Review of *Arshile Gorky*, by Julien Levy. *New York Times Book Review*, March 31, 1968, pp. 6–7.

Melville, Robert, and Wiliam Seitz. *Arshile Gorky: Paintings and Drawings*. London: Arts Council, 1965.

"Memorial to Arshile Gorky." *Minneapolis Sunday Tribune*, March 4, 1951.

Mew, Thomas Joseph, III. "The Late Paintings of Arshile Gorky." Ph.D. diss., New York University, 1966.

Miller, Arthur. "Works Hung by 'Artist as Collector.'" *Los Angeles Times*, April 4, 1949.

Miller, Jo. "The Prints of Arshile Gorky." *Brooklyn Museum Annual* 6 (1964–65), pp. 57–61.

Mooradian, Karlen. "Arshile Gorky." *Armenian Review* 8 (Summer 1955), pp. 49–58.

———. *Arshile Gorky Adoian*. Chicago: Gilgamesh, 1978.

———. "The Gardener from Eden." *Ararat* 9 (Winter 1968), pp. 2–13.

———. *The Many Worlds of Arshile Gorky*. Chicago: Gilgamesh, 1980.

———. "The Philosophy of Arshile Gorky (Vosdanik Adoian)." *Armenian Digest* 2, nos. 3–4 (September–October 1971), pp. 52–74.

———. "A Special Issue on Arshile Gorky." *Ararat* 12 (Fall 1971).

———. "The Unknown Gorky." *ARTnews* 66, no. 5 (September 1967), pp. 52–53, 66–68.

Morgan, Robert C. *Organic New York, 1941–1949*. Exh. cat. New York: Michael Rosenfeld Gallery, 2005.

Morgan, S. "Becoming Arshile Gorky." *Artscribe* 31 (October 1991), pp. 16–23.

Oberhuber, Konrad. "The Thousand and One Nights of Arshile Gorky." *Journal of Art* 4, no. 5 (May 1991), p. 13.

O'Connor, Francis V. "The Economy of Patronage: Arshile Gorky on the Art Projects." In "Arshile Gorky," special issue, *Arts Magazine* 50, no. 7 (March 1976), pp. 94–95.

O'Doherty, Brian. "Gorky: Private Language, Universal Theme." *New York Times*, May 10, 1962, sec. 2.

"Old House Made New." *Life*, February 16, 1948, pp. 90–92.

Osborn, Margaret. "The Mystery of Arshile Gorky: A Personal Account." *ARTnews* 61, no. 10 (February 1963), pp. 42–43, 58–61.

"Our Editorial." *Color and Rhyme* (New York), no. 19 (1949), p. 1.

"Out of the Dark." *New Yorker*, February 7, 1994, p. 10.

Parke-Bernet Galleries. *Abstract Expressionist and Other Modern Paintings, Drawings, and Sculptures*. New York: Parke-Bernet Galleries, 1964.

"People in the Art News: Arshile Gorky." *ARTnews* 47, no. 5 (September 1948), p. 56.

Perreault, John. "What the Art Detective Found." *SoHo Weekly News*, December 7, 1978.

P[orter], F[airfield]. "Reviews and Previews." *ARTnews* 53, no. 2 (April 1954), p. 53.

——. "Reviews and Previews." *ARTnews* 54, no. 7 (November 1955), p. 50.

Preston, Stuart. "New York." *Burlington Magazine* 105, no. 719 (February 1963), p. 84.

Princenthal, Nancy. "Line Readings: Arshile Gorky's Drawings." *Art in America* 92, no. 5 (May 2004), pp. 134–39.

Quaytman, Harvey. "Arshile Gorky's Early Paintings." In "Arshile Gorky," special issue, *Arts Magazine* 50, no. 7 (March 1976), pp. 104–5.

Rand, Harry. *Arshile Gorky: The Implications of Symbols*. London: Prior, 1981.

——. "Arshile Gorky's Iconography." Ph.D. diss., Harvard University, 1974.

——. "The Calendars of Arshile Gorky." In "Arshile Gorky," special issue, *Arts Magazine* 50, no. 7 (March 1976), pp. 70–80.

——. "A Drawing by Arshile Gorky." *Annual Report (Fogg Art Museum)*, 1971–72, pp. 45–49.

——. "Gorky in Virginia." *Arts in Virginia* 26, no. 1 (1986), pp. 2–13.

——. "Gorky's *Waterfalls*." *ARTnews* 96, no. 10 (November 1997), pp. 118–22.

——. "Great Expectations (of Style)." *Arts Magazine* 60, no. 3 (November 1985), pp. 58–59.

Ratcliff, Carter. "New York Letter." *Art International* 14, no. 2 (February 20, 1970), pp. 77–80.

Rathbone, Eliza E. "Arshile Gorky: The Plow and the Song." In *American Art at Mid-Century: The Subjects of the Artist*, by E. A. Carmean, Jr., and Eliza E. Rathbone, with Thomas B. Hess, pp. 61–87. Exh. cat. Washington, D.C.: National Gallery of Art, 1978.

R[eed], J[udith] K[aye]. "Salvaged from Fire." *Art Digest* 20, no. 15 (May 1, 1946), p. 13.

Reiff, Robert F. "Arshile Gorky's Object Matter." In "Arshile Gorky," special issue, *Arts Magazine* 50, no. 7 (March 1976), pp. 91–93.

——. "The Late Works of Arshile Gorky: A Critical Estimate." *Art Journal* 22, no. 3 (Spring 1963), pp. 148–52.

——. Review of *Arshile Gorky: The Man, the Time, the Idea*, by Harold Rosenberg. *Art Journal* 22, no. 4 (Summer 1963), p. 274.

——. *A Stylistic Analysis of Arshile Gorky's Art from 1943– 1948*. New York: Garland, 1977.

R[euschel], J[on]. "Arshile Gorky, Art Center at La Jolla." *Artforum* 1, no. 11 (May 1963), p. 47.

Riley, Maude. "The Eye-Spring: Arshile Gorky." *Art Digest* 19, no. 12 (March 15, 1945), p. 10.

Robertson, Bryan. "Figurative Art as a New Abstraction." *Times* (London), May 4, 1965.

Rose, Barbara. "Arshile Gorky and John Graham: Eastern Exiles in a Western World." In "Arshile Gorky," special issue, *Arts Magazine* 50, no. 7 (March 1976), pp. 62–69.

——. "Gorky, Tragic Poet of Abstract Expressionism." *Vogue*, October 1979, pp. 355, 386.

Rosenberg, Harold. "Arshile Gorky: Art and Identity." In *The Anxious Object: Art Today and Its Audience*, pp. 99–106. New York: Horizon, 1964.

——. "Arshile Gorky: His Art and Influence." *Portfolio & ARTnews Annual*, no. 5 (1962), pp. 100–14.

——. "Arshile Gorky: The Last Move." *Hudson Review*, Spring 1960, pp. 102–10.

——. *Arshile Gorky: The Man, the Time, the Idea*. New York: Horizon, 1962.

——. "Art and Identity: The Unfinished Masterpiece." *New Yorker*, January 5, 1963, pp. 70–77.

——. "Books: Vanguard Dealer." *New Yorker*, July 4, 1977, pp. 84–86.

Rosenblum, Robert. "Arshile Gorky." *Arts* (New York) 32, no. 4 (January 1958), pp. 30–33.

Rosenzweig, Phyllis. *Arshile Gorky: The Hirshhorn Museum and Sculpture Garden Collection, Smithsonian Institution*. Exh. cat. Washington, D.C.: Smithsonian Institution Press, 1979.

Rubin, William S. "Arshile Gorky, Surrealism, and the New American Painting." *Art International* 7, no. 2 (February 25, 1963), pp. 27–38.

Rudikoff, Sonya. "Gorky and Tomlin." *Partisan Review* 25 (Winter 1958), pp. 157–60.

Rushing, W. Jackson, III. "Arshile Gorky's Inner Infinity." *Art on Paper* 8, no. 4 (March–April 2004), pp. 64–69.

Russell, John. "Art: The Lost Murals of Arshile Gorky." *New York Times*, November 24, 1978.

——. "Guggenheim Retrospective Charts Arshile Gorky's Passion for Art." *New York Times*, April 24, 1981, sec. C.

Rylands, Philip, and Matthew Spender, eds. *Arshile Gorky: Works on Paper / Opere su carta*. Exh. cat. Venice: Peggy Guggenheim Collection, 1992.

Sarkisian, Mardiros. "Arshile Gorky: A Struggle for Recognition." *Hoorsharar* 45 (February 1, 1958), pp. 6–9.

——. "Gorky." *Ararat* 3 (Summer 1962), pp. 14–22.

Schapiro, Meyer. "Arshile Gorky" (1957). In *Modern Art: 19th and 20th Centuries*, pp. 179–83. New York: George Braziller, 1978.

——. "Gorky: The Creative Influence." *ARTnews* 56, no. 5 (September 1957), pp. 28–31, 52.

Schiff, Bennett. "In the Art Galleries." *New York Post*, December 8, 1957.

S[chuyler], J[ames]. "Reviews and Previews: Arshile Gorky." *ARTnews* 56, no. 8 (December 1957), p. 10.

Schwabacher, Ethel K. *Arshile Gorky*. New York: Macmillan for the Whitney Museum of American Art, 1957.

——, ed. *Arshile Gorky Memorial Exhibition*. Exh. cat. New York: Whitney Museum of American Art, 1951.

Schwartz, Ellen. "The Gorky Murals: A Bit of Detective Work." *ARTnews* 78, no. 2 (February 1979), pp. 136–37.

Seitz, William C. *Arshile Gorky: Paintings, Drawings, Studies*. Exh. cat. New York: The Museum of Modern Art, 1962.

——. "Arshile Gorky's *The Plough and the Song*." *Allen Memorial Art Museum Bulletin* 12, no. 1 (Fall 1954), pp. 4–15.

——. "A Gorky Exhibit." *Daily Princetonian*, October 14, 1952.

——. "Spirit, Time, and 'Abstract Expressionism.'" *Magazine of Art* 46, no. 2 (February 1953), pp. 80–88.

S[ilver], C[athy] S. "Gorky, When the Going Was Rough." *ARTnews* 62, no. 2 (April 1963), pp. 27, 61.

Soby, James Thrall. "Arshile Gorky." *Magazine of Art* 44, no. 2 (February 1951), p. 56.

Somogyi, Lisa Lyn. "Arshile Gorky: Principal Qualities and Developmental Tendencies in His Art." Master's thesis, Washington University, St. Louis, Mo., 1989.

Sourian, Peter. "Forum: Arshile Gorky's Drawing of a Remembered Armenian Arquebus." *Drawing* 15, no. 5 (January–February 1994), pp. 107–8.

Southgate, M. Therese. "Arshile Gorky: The Artist and His Mother." *Journal of the American Medical Association* 245 (1981), p. 1513.

Spender, Matthew. *From a High Place: A Life of Arshile Gorky*. New York: Alfred A. Knopf, 1999.

Spender, Matthew, and Barbara Rose. *Arshile Gorky and the Genesis of Abstraction: Drawings from the Early 1930s*. Exh. cat. New York: Stephen Mazoh, 1994.

Stevens, Mark. "The Great Late Bloomer." *Newsweek*, May 11, 1981, pp. 78–79.

Sullivan, Gerard. "Mr. Gorky's Murals the Airport They Puzzle!" *Newark Ledger*, June 10, 1937.

Sunley, Robert. "Fourteen American Artists." *Critique* 1 (October 1946), pp. 18–21.

Sweeney, James Johnson. "Five American Painters." *Harper's Bazaar*, April 1944, pp. 76–77, 122, 124.

Sylvester, David, Donald Kuspit, Matthew Spender,

and Melvin Lader. *Arshile Gorky: Paintings and Drawings, 1929–1942*. Exh. cat. New York: Gagosian Gallery, 1998.

Tashjian, Dickran. "Arshile Gorky's Armenian Script: Ethnicity and Modernism in the Diaspora." In *Perspective: Art, Literature, Participation*, ed. Mark Neuman and Michael Payne, pp. 144–61. Lewisburg, Pa.: Bucknell University Press, 1986.

Taylor, Michael R. "Learning from 'Papa Cézanne': Arshile Gorky and the (Self-)Invention of the Modern Artist." In *Cézanne and Beyond*, ed. Joseph J. Rishel and Katherine Sachs, pp. 407–31. Exh. cat. Philadelphia: Philadelphia Museum of Art in association with Yale University Press, 2009.

Theriault, Kim S. "Arshile Gorky's Self-Fashioning: The Name, Naming, and Other Epithets." *Journal of the Society for Armenian Studies* 15 (2006), pp. 141–56.

———. "It's What Isn't There That Is: Catastrophe, Denial, and Non-Representation in Arshile Gorky's Art." *Florida Atlantic Comparative Studies* 9 (2006–7), pp. 85–108.

———. "Re-placing Arshile Gorky: Exile, Identity and Abstraction in Twentieth-Century Art." Ph.D. diss., University of Virginia, Charlottesville, 2000.

Tillim, Sidney. "In the Galleries: Arshile Gorky." *Arts* (New York) 36, no. 7 (April 1962), pp. 49–50.

Trois siècles d'art aux États-Unis. Exh. cat. Paris: Éditions des musées nationaux, [1938].

University of Texas at Austin. *Arshile Gorky: Drawings to Paintings*. Exh. cat. Austin: University of Texas Art Museum, 1975.

Vaccaro, Nick Dante. "Gorky's Debt to Gaudier-Brzeska." *Art Journal* 23, no. 1 (Autumn 1963), pp. 33–34.

Waldman, Diane. *Arshile Gorky, 1904–1948: A Retrospective*. Exh. cat. New York: Harry N. Abrams in collaboration with The Solomon R. Guggenheim Museum, 1981

Weil, Rex. "Arshile Gorky." *ARTnews* 94, no. 7 (September 1995), p. 147.

Whelan, Richard. "Arshile Gorky." *ARTnews* 78, no. 1 (January 1979), pp. 139, 144.

"Whitney Honors Gorky." *Art Digest* 25, no. 7 (January 1, 1951), p. 6.

Wilson, Patricia Boyd. "The Home Forum." *Christian Science Monitor*, October 21, 1970, p. 8.

Wilson, William. "In the Southern California Galleries: From Gorky to Ron Davis." *ARTnews* 72, no. 6 (Summer 1973), p. 25.

Wolff, Theodore F. "The Many Masks of Modern Art." *Christian Science Monitor,* May 26, 1981, p. 24.

"W.P.A. Murals Are Too Much for La Guardia." *New York Herald Tribune*, December 28, 1935.

XXXI Esposizione biennale internazionale d'arte. Exh. cat. [Venice]: Biennale di Venezia, [1962].

GENERAL LITERATURE

Ashton, Dore. *The Unknown Shore: A View of Contemporary Art*. Boston: Little, Brown, [1962].

David Winton Bell Gallery, Brown University. *Flying Tigers: Painting and Sculpture in New York, 1939–1946*. Exh. cat. Providence, R.I.: Bell Gallery, Brown University, 1985.

Cahill, Holger. *New Horizons in American Art*. New York: The Museum of Modern Art, 1936.

Ernst, Jimmy. *A Not-So-Still Life: A Memoir*. New York: St. Martin's / Marek, 1984.

Falk, Peter Hastings, ed. *The Annual and Biennial Exhibition Record of the Whitney Museum of American Art*. Madison, Conn.: Sound View, 1991.

Fox, Milton S. "Camouflage and the Artist." *Magazine of Art* 35, no. 4 (April 1942), pp. 136–37, 154, 156.

Gruen, John. *The Party's Over Now: Reminiscences of the Fifties—New York Artists, Writers, Musicians, and Their Friends*. New York: Viking, 1972.

Gurin, Ruth. "'The Museum of Living Art' Reborn: The New York University Art Collection." *Art Journal* 25, no. 3 (Spring 1965), pp. 250–62.

Hess, Barbara. *Willem de Kooning, 1904–1997: Content as Glimpse*. Los Angeles: Taschen, 1959.

Janis, Sidney. *Abstract and Surrealist Art in America*. New York: Reynal and Hitchcock, 1944.

Levin, Gail. "Miró, Kandinsky, and the Genesis of Abstract Expressionism." In *Abstract Expressionism: The Formative Years*, ed. Robert Carleton Hobbs and Gail Levin, pp. 27–40. Exh. cat. Ithaca, N.Y.: Herbert F. Johnson Museum of Art, Cornell University; New York: Whitney Museum of American Art, 1978.

Levy, Julien. *Memoir of an Art Gallery*. New York: G. P. Putnam's Sons, 1977.

Myers, John Bernard. *Tracking the Marvelous: A Life in the New York Art World*. New York: Random House, 1983.

O'Connor, Francis V., ed. *Art for the Millions: Essays from the 1930s by Artists and Administrators of the WPA Federal Art Project*. Greenwich, Conn.: New York Graphic Society, [1973].

Passloff, Patricia, ed. *The 30's, Painting in New York*. Exh. cat. New York: Poindexter Gallery, 1957.

Peppiatt, Michael, and Alice Bellony-Rewald. *Imagination's Chamber: Artists and Their Studios*. Boston: Little, Brown, 1982.

Sawin, Martica. *Surrealism in Exile and the Beginning of the New York School*. Cambridge, Mass.: MIT Press, 1995.

Seitz, William C. *Abstract Expressionist Painting in America*. Cambridge, Mass.: Harvard University Press, 1983.

Le Surréalisme en 1947. Exh. cat. Paris: Maeght, 1947.

Tashjian, Dickran. *A Boatload of Madmen: Surrealism and the American Avant-garde, 1920–1950*. New York: Thames and Hudson, 1995.

Tomkins, Calvin. "Tragedy, Ecstasy, Doom, and So On." In *Off the Wall: Robert Rauschenberg and the Art World of Our Time*, pp. 35–49. Garden City, N.Y.: Doubleday, 1980.

Weber, Bruce. *Toward a New American Cubism*. Exh. cat. New York: Berry-Hill Galleries, 2006.

Wechsler, Jeffrey. *Surrealism and American Art, 1931–1947*. New Brunswick, N.J.: Rutgers University, 1977.

CHECKLIST OF THE EXHIBITION

as of July 22, 2009

Park Street Church, Boston, 1924
Oil on canvas mounted on board
16 x 12 inches (40.6 x 30.5 cm)
The Whistler House Museum of Art. Lowell Art
Association, Inc. (est. 1878), Lowell, Massachusetts.
Gift of Katherine O'Donnell Murphy
plate 1

Study for "The Artist and His Mother," c. 1926
Graphite on squared paper
24 x 19 inches (61 x 48.3 cm)
National Gallery of Art, Washington, D.C. Ailsa Mellon
Bruce Fund, 1979.13.4
plate 29

The Antique Cast, 1926
Oil on canvas
36¹/₄ x 46³/₈ inches (92.1 cm x 117.8 cm)
San Francisco Museum of Modern Art.
Gift of Mr. and Mrs. David McCulloch
plate 3

Study after an Antique Sculpture, c. 1926–29
Charcoal and watercolor on paper
22 x 15¹/₄ inches (55.9 x 38.7 cm)
The Metropolitan Museum of Art, New York. Purchase,
Gift of Sam A. Lewisohn, by exchange, 2005.232
plate 4

Study for "The Artist and His Mother," c. 1926–34
Graphite on paper
11 x 8¹/₂ inches (27.9 x 21.6 cm)
Private collection
plate 26

Two Studies for "The Artist and His Mother,"
c. 1926–34
Ink on brown paper
8¹/₈ x 11 inches (20.5 x 27.9 cm)
Private collection
plate 28

The Artist's Mother, c. 1926–34
Graphite on paper
32³/₄ x 25¹/₂ inches (83.2 x 64.8 cm)
Private collection
plate 31

The Artist's Mother, c. 1926–36
Charcoal on ivory laid paper
24⁷/₈ x 19³/₁₆ inches (63 x 48.5 cm)
The Art Institute of Chicago. The Worcester Sketch
Fund, 1965.510
plate 30

The Artist and His Mother, 1926–36
Oil on canvas
60 x 50 inches (152.4 x 127 cm)
Whitney Museum of American Art, New York.
Gift of Julien Levy for Maro and Natasha Gorky
in memory of their father, 50.17
plate 32

The Artist and His Mother, c. 1926–c. 1942
Oil on canvas
60 x 50 inches (152.4 x 127 cm)
National Gallery of Art, Washington, D.C. Ailsa Mellon
Bruce Fund, 1979.13.1
plate 33

Untitled (Study for "Woman with a Palette"), c. 1927
Graphite on paper
28³/₄ x 19¹/₄ inches (73 x 48.9 cm)
Collection of Stephen Mazoh
plate 9

Staten Island, 1927
Oil on canvas
16¹/₄ x 20¹/₄ inches (41.3 x 51.4 cm)
Collection of Vartkess and Rita Balian
plate 2

Woman with a Palette, 1927
Oil on canvas
53¹/₂ x 37¹/₂ inches (135.9 x 95.3 cm)
Philadelphia Museum of Art. Purchased with funds (by
exchange) from the bequest of Henrietta Myers Miller
and with proceeds from the sale of other deaccessioned
works of art, 2004-187-1
plate 10

Still Life with Skull, c. 1927–28
Oil on canvas
33¹/₂ x 26³/₄ inches (85 x 68 cm)
Private collection
plate 8

Pears, Peaches, and Pitcher, c. 1928
Oil on canvas
17³/₈ x 23³/₈ inches (44 x 59.5 cm)
Private collection
plate 7

Self-Portrait, c. 1928
Oil on canvas
24 x 16 inches (61 x 40.6 cm)
Los Angeles County Museum of Art.
Gift of Mr. and Mrs. Hans Burkhardt, 47.30
plate 6

Still Life (Composition with Vegetables), c. 1928
Oil on canvas
28¹/₁₆ x 36¹/₁₆ inches (71.2 x 91.6 cm)
Blanton Museum of Art, The University of Texas at
Austin. Gift of Albert Erskine to the Mari and James A.
Michener Collection, G1974.6
plate 14

Self-Portrait at the Age of Nine, 1928
Oil on canvas
12¹/₄ x 10¹/₄ inches (31.1 x 26 cm)
The Metropolitan Museum of Art, New York.
Gift of Leon Constantiner, 2002.145
plate 5

Enigma (Composition of Forms on Table), 1928–29
Oil on canvas
33 x 44 inches (83.8 x 111.8 cm)
Collection of the Honorable and Mrs. Joseph P. Carroll
plate 15

Still Life, c. 1930–31
Oil on canvas
38¹/₂ x 50³/₈ inches (97.8 x 128 cm)
Chrysler Museum of Art, Norfolk, Virginia.
Bequest of Walter P. Chrysler, Jr., 89.51
plate 17

Abstraction with a Palette, c. 1930–31
Oil on canvas
48 x 35¹⁵/₁₆ inches (121.9 x 91.3 cm)
Philadelphia Museum of Art. Gift of Bernard Davis,
1942-64-3
plate 21

Nighttime, Enigma, and Nostalgia, c. 1931
Graphite and ink on heavy wove paper
21³/₈ x 30¹/₈ inches (54.4 x 76.4 cm)
Private collection
plate 42

Mannikin, 1931
Lithograph, printed in black, on cream wove paper
14¹¹/₁₆ x 11¹/₄ inches (37.3 x 28.7 cm)
Whitney Museum of American Art, New York.
Purchase, 74.36
plate 22

Nighttime, Enigma, and Nostalgia, 1931
Graphite on paper
19 x 25 inches (48.3 x 63.5 cm)
Collection of Aaron I. Fleischman
plate 46

Painter and Model (The Creation Chamber), 1931
Lithograph, printed in black, on cream wove paper
11¹/₄ x 9⁷/₈ inches (28.6 x 25.1 cm)
Brooklyn Museum, New York. Dick S. Ramsay Fund,
63.116.5
plate 23

Study for "Blue Figure in a Chair," 1931
Charcoal on paper
23 x 17 inches (58.4 x 43.2 cm)
Private collection
plate 18

Study for "Blue Figure in a Chair," 1931
Charcoal on paper
23 x 17¹/₈ inches (58.4 x 43.5 cm)
Private collection
plate 19

387

Blue Figure in a Chair, c. 1931
Oil on canvas
48 x 38 inches (121.9 x 96.5 cm)
Private collection, on long-term loan to the
National Gallery of Art, Washington, D.C.
plate 20

Column with Objects (Nighttime, Enigma, and Nostalgia), c. 1931–32
Graphite on paper
18³/8 x 24¹/2 inches (46.6 x 62.2 cm)
Private collection
plate 47

Column with Objects (Nighttime, Enigma, and Nostalgia), c. 1931–32
Graphite on off-white chain-laid paper
18⁷/8 x 25 inches (48 x 63.5 cm)
Private collection
plate 51

Column with Objects (Nighttime, Enigma, and Nostalgia), c. 1931–32
Graphite on off-white chain-laid paper
18⁷/8 x 25 inches (48 x 63.5 cm)
Private collection
plate 53

Nighttime, Enigma, and Nostalgia, c. 1931–32
Ink on paper
24 x 31 inches (61 x 78.7 cm)
Whitney Museum of American Art, New York.
50th Anniversary Gift of Mr. and Mrs. Edwin A.
Bergman, 80.54
plate 43

Study for Mural (Nighttime, Enigma, and Nostalgia),
c. 1931–32
Pen and black ink over graphite on wove paper
7¹/4 x 26 inches (18.4 x 66 cm)
The Detroit Institute of Arts. Founders Society Purchase
with funds from Mr. and Mrs. Richard A. Manoogian
and K. T. Keller Fund
plate 44

Nighttime, Enigma, and Nostalgia, c. 1931–32
Graphite on off-white chain-laid paper
18¹/4 x 24 inches (46.5 x 61 cm)
Private collection
plate 52

Nighttime, Enigma, and Nostalgia, c. 1932
Ink on paper
20¹/8 x 28³/4 inches (51.1 x 73 cm)
Hirshhorn Museum and Sculpture Garden,
Smithsonian Institution, Washington D.C.
Joseph H. Hirshhorn Purchase Fund, 2000.6
plate 45

Nighttime, Enigma, and Nostalgia, c. 1932
Ink on paper
28¹/8 x 38¹/8 inches (71.4 x 96.8 cm)
Private collection
plate 48

Nighttime, Enigma, and Nostalgia, c. 1933–34
Pen and black and brown inks over graphite on
wove paper
22 x 28³/8 inches (55.9 x 72 cm)
National Gallery of Art, Washington, D.C. Ailsa Mellon
Bruce Fund and Andrew W. Mellon Fund, 1979.21.1
plate 49

Nighttime, Enigma, and Nostalgia, c. 1933–34
Oil on canvas mounted on panel
36 x 47⁷/8 inches (91.4 x 121.6 cm)
The Museum of Fine Arts, Houston. Museum purchase
with funds provided by the Caroline Wiess Law Acces-
sions Endowment Fund, 2005.1157
plate 55

Organization (Nighttime, Enigma, and Nostalgia),
c. 1933–34
Oil on board
13¹/2 x 21⁵/8 inches (34.3 x 54.9 cm)
The University of Arizona Museum of Art, Tucson.
Gift of Edward J. Gallagher, Jr., 1958.2.11
plate 54

Portrait of Myself and My Imaginary Wife, 1933–34
Oil on paperboard
8⁵/8 x 14¹/4 inches (21.9 x 36.2 cm)
Hirshhorn Museum and Sculpture Garden,
Smithsonian Institution, Washington D.C. Gift of the
Joseph H. Hirshhorn Foundation, 1966, 66.2150
plate 24

Portrait of Vartoosh, 1933–34
Oil on canvas
20¹/4 x 15¹/8 inches (51.4 x 38.4 cm)
Hirshhorn Museum and Sculpture Garden,
Smithsonian Institution, Washington D.C. Gift of the
Joseph H. Hirshhorn Foundation, 1966, 66.2148
plate 25

Organization, 1933–36
Oil on canvas
50 x 59¹³/16 inches (127 x 152 cm)
National Gallery of Art, Washington, D.C.
Ailsa Mellon Bruce Fund, 1979.13.3
plate 66

Composition: Horse and Figures, c. 1934
Oil on canvas
34¹/4 x 43³/8 inches (87 x 110.2 cm)
The Museum of Modern Art, New York. Gift of
Bernard Davis in memory of the artist, 1950 (237.1959)
plate 63

Head, c. 1934–35
Oil on canvas
38¹/2 x 30¹/2 inches (97.8 x 77.5 cm)
Collection of Carroll Janis
plate 68

Study for "Image in Khorkom," c. 1934–36
Brush, pen and ink, and graphite on paper,
with some erasing
23³/4 x 28³/4 inches (60.3 x 73 cm)
L & M Arts, New York
plate 56

Study for "Image in Khorkom," c. 1934–36
Graphite and ink on paper
18¹/2 x 24³/8 inches (47 x 61.9 cm)
Collection of Mr. and Mrs. J. Tomilson Hill
plate 57

Study for "Image in Khorkom," c. 1934–36
Ink and wash on wove paper
22³/4 x 30³/4 inches (57.8 x 78.1 cm)
Collection of Ellen Phelan and Joel Shapiro
plate 58

Study for "Image in Khorkom," c. 1934–36
Graphite on paper
8¹/2 x 10¹/4 inches (21.6 x 26 cm)
Private collection
plate 59

Image in Khorkom, c. 1934–36
Oil on canvas
33¹/8 x 42¹/2 inches (84 x 108 cm)
Private collection
plate 60

Study for "Organization," c. 1935
Graphite on paper
48³/8 x 64³/8 inches (123 x 163.5 cm)
Private collection
plate 64

Study for "Organization" II, c. 1935
Graphite on paper
11³/8 x 14¹/8 inches (29 x 36 cm)
Private collection
plate 65

Study for "Aviation: Evolution of Forms under Aerodynamic Limitations" (Newark Airport Mural),
c. 1935–36
Oil on canvas
30 x 35 inches (76.2 x 88.9 cm)
Grey Art Gallery, New York University Art Collection.
Gift of May Walter, 1965.3
plate 76

Study for "Aviation: Evolution of Forms under Aerodynamic Limitations" (Newark Airport Mural), c. 1935–36
Graphite on paper
5⁷/8 x 23 inches (14.9 x 58.4 cm)
Private collection
plate 77

Study for "Aviation: Evolution of Forms under Aerodynamic Limitations" I (Newark Airport Mural), 1935–36
Gouache on paper
6 x 10³/8 inches (15.3 x 26.3 cm)
Diocese of the Armenian Church of America (Eastern) on Deposit at the Calouste Gulbenkian Foundation, Lisbon, DEP-AGp5
plate 81

Study for "Aviation: Evolution of Forms under Aerodynamic Limitations" II (Newark Airport Mural), 1935–36
Gouache on paper
18¹/4 x 12 inches (46.4. x 30.4 cm)
Diocese of the Armenian Church of America (Eastern) on Deposit at the Calouste Gulbenkian Foundation, Lisbon, DEP-AGp6
plate 79

Study for "Aviation: Evolution of Forms under Aerodynamic Limitations" III (Newark Airport Mural), 1935–36
Gouache on paper
18¹/4 x 13¹/2 inches (46.4 x 34.2 cm)
Diocese of the Armenian Church of America (Eastern) on Deposit at the Calouste Gulbenkian Foundation, Lisbon, DEP-AGp7
plate 80

Study for "Aviation: Evolution of Forms under Aerodynamic Limitations" IV (Newark Airport Mural), 1935–36
Gouache on paper
6 x 10 inches (16 x 25.5 cm)
Diocese of the Armenian Church of America (Eastern) on Deposit at the Calouste Gulbenkian Foundation, Lisbon, DEP-AGp8
plate 82

Study for "Activities on the Field," for "Aviation: Evolution of Forms under Aerodynamic Limitations" (Newark Airport Mural), 1935–36
Gouache on paper
18⁵/8 x 36³/8 inches (47.4 x 92.6 cm)
The Museum of Modern Art, New York. Extended loan from the United States WPA Art Program. Fine Arts Collection, Public Buildings Service, General Services Administration, 1939 (EL1939.1811)
plate 78

Self-Portrait, c. 1936
Graphite on paper
9⁷/8 x 8¹/4 inches (25.1 x 21 cm)
Private collection
plate 37

Study for "The Artist and His Mother," c. 1936
Graphite on paper
8³/8 x 6³/4 inches (21.3 x 17.1 cm)
Whitney Museum of American Art, New York. Purchase, with funds from The Lauder Foundation, Evelyn and Leonard Lauder Fund, and the Drawing Committee, 99.49a–b
plate 27

Composition with Head, c. 1936–37
Oil on canvas
76¹/2 x 60¹/2 inches (194.3 x 153.7 cm)
Collection of Donald L. Bryant, Jr.
plate 69

Study for "Mechanics of Flying," for "Aviation: Evolution of Forms under Aerodynamic Limitations" (Newark Airport Mural), c. 1936–37
Gouache on paper
13¹/4 x 16¹/2 inches (33.7 x 41.9 cm)
Whitney Museum of American Art, New York. 50th Anniversary Gift of Alan H. Temple, 80.16
plate 83

Enigmatic Combat, 1936–37
Oil on canvas
35³/4 x 48 inches (90.8 cm x 121.9 cm)
San Francisco Museum of Modern Art. Gift of Jeanne Reynal, 41.3763
plate 75

Aerial Map, from "Aviation: Evolution of Forms under Aerodynamic Limitations" (Newark Airport Mural), 1936–37
Oil on canvas
79 x 123¹/2 inches (200.7 x 313.7 cm)
The Newark Museum, Newark, New Jersey, on extended loan from the collection of the Port Authority of New York and New Jersey
plate 85

Mechanics of Flying, from "Aviation: Evolution of Forms under Aerodynamic Limitations" (Newark Airport Mural), 1936–37
Oil on canvas
111 x 136 inches (281.9 x 345.4 cm)
The Newark Museum, Newark, New Jersey, on extended loan from the collection of the Port Authority of New York and New Jersey
plate 84

Untitled (Study for "Painting"), 1936–37
Gouache on paper
10¹/4 x 12³/4 inches (26 x 32.4 cm)
Property of a gentleman
plate 70

Painting, 1936–37
Oil on canvas
38 x 48 inches (96.5 x 121.9 cm)
Whitney Museum of American Art, New York. Purchase, 37.39
plate 71

Composition, 1936–39
Oil on canvas
29³/4 x 35³/4 inches (75.6 x 90.8 cm)
Minneapolis Institute of Arts. The Francisca S. Winston Fund, 63.14.1
plate 74

Central Park at Dusk, 1936–42
Oil on canvas
24¹/2 x 30¹/2 inches (62.2 x 77.5 cm)
Curtis Galleries, Minneapolis, 1994.02.07.1
plate 92

Portrait of Ahko, c. 1937
Oil on canvas
19¹/2 x 15 inches (49.5 x 38.1 cm)
Private collection
plate 41

Self-Portrait, c. 1937
Oil on canvas
55¹/2 x 34 inches (141 x 86.4 cm)
Private collection, on long-term loan to the National Gallery of Art, Washington, D.C.
plate 34

Portrait of Master Bill, c. 1937
Oil on canvas
52¹/8 x 40¹/8 inches (132.4 x 101.9 cm)
Private collection, on long-term loan to the National Gallery of Art, Washington, D.C.
plate 35

Composition, 1937
Enamel on canvas
29¹/8 x 39⁷/8 inches (73.9 x 101.3 cm)
The Museum of Fine Arts, Houston. Bequest of Caroline Wiess Law, 2004.18
plate 72

Portrait of Willem de Kooning, 1937
Ink on paper
8¹/2 x 5³/8 inches (21.6 x 13.7 cm)
Collection of Carroll Janis
plate 38

Portrait of Frederick Kiesler, c. 1938
Graphite on paper
12¹/₂ x 8³/₄ inches (31.8 x 22.2 cm)
Private collection
plate 36

Portrait, 1938
Oil on canvas
31 x 24⁵/₈ inches (78.7 x 62.5 cm)
Private collection
plate 67

Study for Marine Building Mural (**proposed
for the New York World's Fair**), c. 1938–39
Gouache and mixed media on heavy paper mounted
on ground wood boards
9¹/₈ x 40³/₁₆ inches (23.2 x 102 cm)
National Gallery of Art, Washington, D.C. Gift of the
Avalon Foundation, 1971.59.1
plate 86

Study for "Transport by Air, Sea, and Rail"
(**mural proposed for the Aviation Building,
New York World's Fair**), c. 1938–39
Gouache on paper
28 x 22 inches (71.1 x 55.9 cm)
Private collection
plate 87

Leonore Portnoff, c. 1938–40
Graphite on paper
12¹/₂ x 9¹/₂ inches (32 x 24.3 cm)
The Museum of Modern Art, New York. Kay Sage
Tanguy Bequest (by exchange), 1975 (429.1975)
plate 39

Leonore Portnoff, c. 1938–40
Crayon on paper
13¹/₂ x 10¹/₄ inches (34.3 x 26 cm)
Collection of Ellen Phelan and Joel Shapiro
plate 40

Hitler Invades Poland, 1939
With Isamu Noguchi (American, 1904–1988) and
De Hirsh Margules (American, 1899–1965)
Mixed media on paper
17¹/₂ x 22⁷/₈ inches (44.5 x 58.1 cm)
Private collection
plate 88

Untitled (Measuring the Land), 1939
Graphite and gouache on paper
19 x 24 inches (48.2 x 61.1 cm)
Private collection
plate 73

Garden in Sochi, 1940
Watercolor and gouache on gessoed wood panel
5 x 7⁵/₁₆ inches (12.7 x 18.5 cm)
Collection of Ms. Andrea Balian, Ms. Katherine Balian,
Dr. Bruce Berberian, and Mr. Mark Berberian, on
long-term loan to the Museum of Fine Arts, Boston,
L-R 301.1976
plate 94

Garden in Sochi, 1940–41
Gouache on board
21 x 27³/₄ inches (53.3 x 70.5 cm)
High Museum of Art, Atlanta. Purchase with bequest of
Charles Donald Belcher, 1977.50
plate 93

After Khorkom, 1940–42
Oil on canvas
36 x 47³/₄ inches (91.4 x 121.3 cm)
The Art Institute of Chicago.
Gift of Mr. and Mrs. Howard Wise, 1968.418
plate 61

Untitled, c. 1941
Gouache on paper
14¹/₈ x 11⁵/₈ inches (35.9 x 29.5 cm)
Collection of Gerald and Kathleen Peters
plate 89

Garden in Sochi, 1941
Oil on canvas
44¹/₄ x 62¹/₄ inches (112.4 x 158.1 cm)
The Museum of Modern Art, New York. Purchase Fund
and gift of Mr. and Mrs. Wolfgang S. Schwabacher
(by exchange), 1942 (335.1942)
plate 95

Study for Murals at Rikers Island Penitentiary,
c. 1941–42 (with later additions)
Wash and India ink on paper
22 x 30 inches (55.8 x 76.2 cm)
Diocese of the Armenian Church of America (Eastern)
on Deposit at the Calouste Gulbenkian Foundation,
Lisbon, DEP-Agd6
plate 50

Mojave, 1941–42
Oil on canvas
28¹³/₁₆ x 40¹/₂ inches (73 x 102.9 cm)
Los Angeles County Museum of Art.
Gift of Burt Kleiner, M.64.61
plate 91

Untitled, 1941–42
Gouache on paper mounted on board
17 x 22 inches (43.2 x 55.9 cm)
Frederick R. Weisman Art Foundation, Los Angeles.
Lent in honor of Anne d'Harnoncourt in recognition
of her contribution to the arts community
plate 90

Waterfalls, c. 1942
Graphite and crayon on paper
14⁹/₁₆ x 11³/₈ inches (36.9 x 28.9 cm)
Hirshhorn Museum and Sculpture Garden,
Smithsonian Institution, Washington, D.C.
Gift of Joseph H. Hirshhorn, 1966.2151
plate 101

Garden in Sochi Motif, 1942
Oil on canvas
16 x 20 inches (40.6 x 50.8 cm)
Private collection
plate 96

Schary's Orchard, 1942
Ink and crayon on paper
11³/₄ x 15¹/₂ inches (29.8 x 39.4 cm)
Collection of Carroll Janis
plate 100

The Pirate I, c. 1942–43
Oil on canvas
30 x 36 inches (76.2 x 91.4 cm)
Collection of the Honorable and Mrs. Joseph P. Carroll
plate 98

Garden in Sochi, c. 1943
Oil on canvas
31 x 39 inches (78.7 x 99 cm)
The Museum of Modern Art, New York. Acquired
through the Lillie P. Bliss Bequest, 1969 (492.1969)
plate 97

Waterfall, c. 1943
Oil on canvas
38¹/₈ x 25¹/₈ inches (96.8 x 63.8 cm)
Hirshhorn Museum and Sculpture Garden,
Smithsonian Institution, Washington, D.C.
Gift of Joseph H. Hirshhorn, 1966.2153
plate 103

Anatomical Blackboard, 1943
Graphite and crayon on paper
20¹/₄ x 27³/₈ inches (51.4 x 69.5 cm)
Private collection
plate 107

Study for "The Liver Is the Cock's Comb," 1943
Graphite and crayon on paper
19 x 24³/₄ inches (48.3 x 62.9 cm)
The Museum of Contemporary Art, Los Angeles.
Bequest of Marcia Simon Weisman, 96.118
plate 113

Untitled (Virginia Landscape), 1943
Graphite and wax crayon on paper
22⁷/₈ x 29 inches (58.1 x 73.7 cm)
Glenstone
plate 109

Untitled (Virginia Landscape), 1943
Graphite and wax crayon on paper
20³/₄ x 27⁵/₈ inches (52.7 x 70.3 cm)
Collection Calouste Gulbenkian Foundation, Lisbon,
85DE139
plate 110

Untitled (Virginia Landscape), 1943
Graphite and pastel on paper mounted on board
20¹/₁₆ x 27¹/₄ inches (51 x 69.2 cm)
Collection of Ms. Andrea Balian, Ms. Katherine Balian,
Dr. Bruce Berberian, and Mr. Mark Berberian, on
long-term loan to the Museum of Fine Arts, Boston,
L-R 308.1976
plate 111

Untitled (Virginia Landscape), 1943
Wax crayon and graphite on paper
20 x 26³/₄ inches (50.8 x 67.9 cm)
Solomon R. Guggenheim Museum, New York.
Gift, Rook McCulloch, 1977 (77.2332)
plate 112

Waterfall, 1943
Oil on board
30 x 26 inches (76.2 x 66 cm)
Private collection
plate 102

Waterfall, 1943
Oil on canvas
60¹/₂ x 44¹/₂ inches (153.7 x 113 cm)
Tate Modern, London. Purchased with assistance from
the Friends of the Tate Gallery, 1971
plate 104

The Pirate II, c. 1943–44
Oil on canvas
29¹/₄ x 40¹/₈ inches (74.3 x 101.9 cm)
Private collection, courtesy of Waqas Wajahat Ltd.,
New York
plate 99

Drawing (Virginia Landscape), 1943–44
Graphite and crayon on paper
17 x 23 inches (43.2 x 58.4 cm)
Private collection
plate 108

Golden Brown Painting, 1943–44
Oil on canvas
43¹³/₁₆ x 55⁹/₁₆ inches (111.2 x 141.1)
Mildred Lane Kemper Art Museum, Washington
University in St. Louis, Missouri. University Purchase,
Bixby Fund, 1953 (WU 3841)
plate 106

Housatonic Falls, 1943–44
Oil on canvas
34 x 44 inches (86.4 x 111.8 cm)
Private collection
plate 105

Apple Orchard, c. 1943–46
Pastel on paper
42 x 52 inches (106.7 x 132.1 cm)
Private collection
plate 139

Apple Orchard, c. 1943–47
Oil on canvas
43³/₄ x 53¹/₂ inches (111.1 x 135.9 cm)
Collection of Samuel and Ronnie Heyman
plate 140

Painting, c. 1943–47
Oil on canvas
44¹/₈ x 54 inches (112 x 137 cm)
Private collection
plate 176

Untitled, 1943–48
Oil on canvas
54¹/₂ x 64¹/₂ inches (138.4 cm x 163.8 cm)
Dallas Museum of Art. Dallas Art Association Purchase,
Contemporary Arts Council Fund, 1965.17
plate 184

Armenian Plow I (Haikakan Gutan I), 1944
Wood
7⁵/₈ x 6⁷/₈ x 4⁹/₁₆ inches (19.4 x 17.5 x 11.6 cm)
Diocese of the Armenian Church of America (Eastern)
on Deposit at the Calouste Gulbenkian Foundation,
Lisbon, DEP-AGs1
plate 142

Cornfield of Health, 1944
Oil on canvas
34 x 44 inches (86.4 x 111.8 cm)
Private collection
plate 117

Good Afternoon, Mrs. Lincoln, 1944
Oil on canvas
30 x 38 inches (76.2 x 96.5 cm)
Collection of Barney A. Ebsworth
plate 119

*How My Mother's Embroidered Apron Unfolds
in My Life*, 1944
Oil on canvas
40 x 45¹/₁₆ inches (101.6 x 114.4)
Seattle Art Museum. Gift of Mr. and Mrs. Bagley
Wright, 74.40
plate 115

The Liver Is the Cock's Comb, 1944
Oil on canvas
73¹/₄ x 98 inches (186.1 x 248.9 cm)
Albright-Knox Art Gallery, Buffalo, New York,
Gift of Seymour H. Knox, 1956 (K1956:4)
plate 114

Love of the New Gun, 1944
Oil on canvas
29³/₄ x 37³/₄ inches (75.6 x 95.9 cm)
The Menil Collection, Houston, 80-17 DJ
plate 116

One Year the Milkweed, 1944
Oil on canvas
37¹/₁₆ x 46¹⁵/₁₆ inches (94.2 x 119.3 cm)
National Gallery of Art, Washington, D.C.
Ailsa Mellon Bruce Fund, 1979.13.2
plate 120

Painting, 1944
Oil on canvas
65³/₄ x 70¹/₄ inches (167 x 178.2 cm)
Peggy Guggenheim Collection, Venice
(Solomon R. Guggenheim Foundation, New York)
plate 124

Scent of Apricots on the Fields, 1944
Oil on canvas
31 x 44 inches (78.7 x 111.8 cm)
Private collection
plate 122

Study for "The Plow and the Song," 1944
Graphite and crayon on paper
19 x 25⁵/₁₆ inches (48.3 x 64.3 cm)
Allen Memorial Art Museum, Oberlin College, Ohio,
Friends of Art Fund, 1956 (AMAM 1956.1)
plate 144

Study for "They Will Take My Island," 1944
Wax crayon and graphite on paper
22¹/₄ x 30 inches (56.5 x 76.2 cm)
Brooklyn Museum, New York. Dick S. Ramsay Fund,
57.16
plate 123

Untitled, 1944
Oil on cardboard
24 x 30¹/₈ inches (61 x 76.5 cm)
Glenstone
plate 125

Untitled, 1944
Oil on canvas
13⁵/₈ x 20¹/₂ inches (34.6 x 52.1 cm)
Private collection
plate 137

Water of the Flowery Mill, 1944
Oil on canvas
42¹/₄ x 48³/₄ inches (107.3 x 123.8 cm)
The Metropolitan Museum of Art, New York.
George A. Hearn Fund, 1956 (56.205.1)
plate 118

Armenian Plow II (Haikakan Gutan II), 1945
Wood and aluminum
6⁷/₈ x 24¹/₈ x 5⁵/₈ inches (17.5 x 61.3 x 14.3 cm)
Diocese of the Armenian Church of America (Eastern)
on Deposit at the Calouste Gulbenkian Foundation,
Lisbon, DEP-AGs2
plate 141

Diary of a Seducer, 1945
Oil on canvas
50 x 62 inches (126.7 x 157.5 cm)
The Museum of Modern Art, New York. Gift of Mr. and
Mrs. William A. M. Burden, 1985 (340.1985)
plate 126

Good Hope Road II (Hugging), 1945
Oil on canvas
25¹/₂ x 32¹/₂ inches (64.7 x 82.7 cm)
Museo Thyssen-Bornemisza, Madrid, 1977.94
plate 135

Landscape Table, 1945
Oil on canvas
36 x 48 inches (91.4 x 121.9 cm)
Musée national d'art moderne, Centre Georges
Pompidou, Paris. Purchased, 1971 (AM 1971-151)
plate 136

The Unattainable, 1945
Oil on canvas
41¹/₄ x 29¹/₄ inches (104.8 x 74.3 cm)
The Baltimore Museum of Art. Purchase with exchange
funds from Blanche Adler Bequest, Frederic W. Cone,
William A. Dickey, Jr., Nelson and Juanita Greif Gutman
Collection, Wilmer Hoffman, Mr. and Mrs. Albert Lion,
Sadie A. May Bequest, Philip B. Perlman Bequest, Leo
M. Rogers, Mrs. James N. Rosenberg; and Paul Vallotton
Fund, BMA 1964.15
plate 134

**Untitled (Drawing for "Young Cherry Trees
Secured against Hares")**, 1945
Graphite and colored crayon on paper
19 x 24 inches (48.3 x 61 cm)
Kolodny Family Collection
plate 127

**Untitled (Drawing for "Young Cherry Trees
Secured against Hares")**, 1945
India ink and gouache on gray paper
12¹/₈ x 14³/₈ inches (30.8 x 36.5 cm)
Collection of Timothy Baum
plate 128

**Untitled (Drawing for "Young Cherry Trees
Secured against Hares")**, 1945
India ink and red crayon on gray paper
9 x 5³/₄ inches (22.9 x 14.6 cm)
Collection of Doreen and Gilbert Bassin
plate 129

**Untitled (Drawing for "Young Cherry Trees
Secured against Hares")**, 1945
Ink and gouache on paper
24 x 18 inches (61 x 48 cm)
Collection of Marcel and David Fleiss,
Galerie 1900–2000, Paris
plate 130

Study for "The Plow and the Song," 1945–46
Two kinds of graphite, colored wax crayons, and spatters
of oil paint, squared in graphite and brown crayon, on
cream wove paper mounted on masonite
18¹/₈ x 25⁷/₁₆ inches (46 x 64.6 cm)
Harvard University Art Museums, Fogg Art Museum,
Cambridge, Massachusetts. Gift of Lois Orswell,
1993.229
plate 145

Study for "Agony," c. 1946
Crayon and graphite on paper
18 x 24 inches (45.7 x 61 cm)
Private collection
plate 163

Abstract, 1946
Ink and crayon on paper
19 x 25 inches (48.3 x 63.5 cm)
Indiana University Art Museum, Bloomington, 69.64
plate 155

Charred Beloved I, 1946
Oil on canvas
53¹/₂ x 39¹/₂ inches (135.9 x 100.3 cm)
Collection of David Geffen
plate 166

Charred Beloved II, 1946
Oil on canvas
54 x 40 inches (137 x 101.6 cm)
National Gallery of Canada, Ottawa. Purchased 1971
(16690)
plate 167

Charred Beloved III, 1946
Oil on linen
50 x 38¹/₂ inches (127 x 97.8 cm)
Collection of Mr. and Mrs. Meredith Long
plate 168

Drawing, 1946
Graphite and crayon on paper
18³/₄ x 22³/₄ inches (47.6 x 57.8 cm)
Private collection
plate 152

Fireplace in Virginia, 1946
Ink and crayon on paper
7⁷/₈ x 11 inches (20 x 27.9 cm)
Private collection
plate 157

Fireplace in Virginia, 1946
Graphite and crayon on paper
21³/₄ x 29¹/₂ inches (55.2 x 74.9 cm)
Collection of Mr. and Mrs. Stanley R. Gumberg
plate 158

From a High Place II, 1946
Oil on canvas
17 x 24 inches (43.2 x 61 cm)
Private collection
plate 175

Study for "Nude," 1946
Ink on paper
9¹/₂ x 6¹/₄ inches (24.1 x 15.9 cm)
Private collection
plate 131

Study for "Nude," 1946
Pen and ink on paper
10¹/₈ x 6¹/₈ inches (25.6 x 15.5 cm)
Private collection
plate 132

Nude, 1946
Oil on canvas
50¹/₈ x 38¹/₈ inches (127.3 x 96.9 cm)
Hirshhorn Museum and Sculpture Garden,
Smithsonian Institution, Washington, D.C.
Gift of the Joseph H. Hirshhorn Foundation, 1966.2154
plate 133

The Plow and the Song, 1946
Graphite, charcoal, crayon, pastel, and oil on wove
paper
48¹/₁₆ x 59³/₁₆ inches (122 x 150.3 cm)
National Gallery of Art, Washington, D.C.
Gift of the Avalon Foundation, 1971.58.1
plate 146

The Plow and the Song II, 1946
Oil on canvas
52¹/₄ x 61¹/₂ inches (132.7 x 156.2 cm)
The Art Institute of Chicago. Mr. and Mrs. Lewis Larned
Coburn Fund, 1963.208
plate 147

Study for "Agony," 1946
Graphite, wax crayon, and ink on paper
18¹/₂ x 23³/₄ inches (47 x 60.3 cm)
Solomon R. Guggenheim Museum, New York. Gift,
Rook McCulloch, 1979 (78.2516)
plate 161

Study for "Dark Green Painting," 1946
Graphite and crayon on paper
19 x 24 inches (48.2 x 61 cm)
Private collection
plate 181

Study for "Soft Night," 1946
Graphite and wax crayon on paper
18^{1}/$_2$ x 23^{5}/$_8$ inches (47 x 60 cm)
Private collection
plate 179

Study for "Summation," 1946
Graphite and crayon on paper
19^{7}/$_8$ x 25^{1}/$_2$ inches (50.5 x 64.8 cm)
Whitney Museum of American Art, New York.
Gift of Mr. and Mrs. Wolfgang S. Schwabacher, 50.18
plate 177

Study for "The Calendars," 1946
Charcoal and colored chalks on a ground of rubbed
charcoal heavily modeled by erasures, on off-white wove
paper, mounted on Kraft paper and wrapped around
a strainer
34^{1}/$_8$ x 41^{1}/$_4$ inches (86.7 x 104.8 cm)
Harvard University Art Museums, Fogg Art Museum,
Cambridge, Massachusetts. Gift of Lois Orswell, 1976.78
plate 169

Untitled, 1946
Oil pastel and graphite on paper
19^{1}/$_8$ x 24^{7}/$_8$ inches (48.6 x 63.2 cm)
Collection of Harry W. and Mary Margaret Anderson
(1981.001)
plate 151

Untitled, 1946
Graphite and colored crayon on paper
19 x 25 inches (48.3 x 63.5 cm)
Yale University Art Gallery, New Haven, Connecticut.
Frederick B. Benenson in memory of Charles B.
Benenson, ILE2006.15.1
plate 153

Untitled, 1946
Graphite and crayon on paper
19 x 25 inches (48.3 x 63.5 cm)
Paula Cooper Gallery, New York
plate 154

Untitled, 1946
Graphite and colored crayon on paper
19 x 25 inches (48.3 x 63.5 cm)
Private collection
plate 156

Virginia—Summer, 1946
Graphite and crayon on paper
18^{15}/$_{16}$ x 24^{3}/$_8$ inches (48.1 x 62 cm)
The Museum of Fine Arts, Houston. Gift of Oveta Culp
Hobby, 92.424
plate 150

Study for "Agony," c. 1946–47
Graphite and crayon on paper
22^{5}/$_8$ x 28^{3}/$_4$ inches (57.5 x 73 cm)
Private collection
plate 162

Two Figures in an Interior (Agony), c. 1946–47
Graphite, charcoal, pastel, and gouache on paper
40 x 51 inches (101.6 x 129.5 cm)
Private collection
plate 164

Study for "Agony," 1946–47
Pen and ink with crayon on paper
8^{1}/$_2$ x 11 inches (21.6 x 27.9 cm)
North Carolina Museum of Art, Raleigh.
Gift of Mr. and Mrs. John Foushee, G.63.40.1
plate 159

Study for "Agony," 1946–47
Crayon, graphite, and wash on paper
22^{1}/$_2$ x 29^{5}/$_8$ inches (57.2 x 75.2 cm)
Private collection
plate 160

Agony, 1947
Oil on canvas
40 x 50^{1}/$_2$ inches (101.6 x 128.3 cm)
The Museum of Modern Art, New York. A. Conger
Goodyear Fund, 1950 (88.1950)
plate 165

Armenian Plow III (Haikakan Gutan III), 1947
Wood
8^{1}/$_8$ x 28^{5}/$_8$ x 6 inches (20.6 x 72.7 x 15.2 cm)
Diocese of the Armenian Church of America (Eastern)
on Deposit at the Calouste Gulbenkian Foundation,
Lisbon, DEP-AGs3
plate 143

The Plow and the Song, 1947
Oil on canvas
52^{1}/$_8$ x 64^{1}/$_4$ inches (132.4 x 163.2 cm)
Private collection
plate 148

The Plow and the Song, 1947
Oil on canvas
50^{1}/$_2$ x 62^{5}/$_8$ inches (128.3 x 159.1 cm)
Allen Memorial Art Museum, Oberlin College, Ohio.
R. T. Miller, Jr. Fund, 1952 (AMAM 1952.16)
plate 149

Study for "The Betrothal," 1947
Graphite, charcoal, pastel, and crayon on paper
49^{3}/$_4$ x 40^{1}/$_8$ inches (126.4 x 101.9 cm)
Collection of Donald L. Bryant, Jr.
plate 171

The Betrothal, 1947
Oil on canvas
50^{5}/$_8$ x 39^{1}/$_4$ inches (128.6 x 99.7 cm)
Yale University Art Gallery, New Haven, Connecticut.
The Katherine Ordway Collection, 1980.12.45
plate 172

The Betrothal I, 1947
Oil on paper
51 x 40 inches (129.5 x 101.6 cm)
The Museum of Contemporary Art, Los Angeles.
The Rita and Taft Schreiber Collection, given in
loving memory of her husband, Taft Schreiber, by
Rita Schreiber, 89.19
plate 173

The Betrothal II, 1947
Oil on canvas
50^{3}/$_4$ x 38 inches (128.9 x 96.5 cm)
Whitney Museum of American Art, New York.
Purchase, 50.3
plate 174

The Limit, 1947
Oil on paper mounted on canvas
50^{3}/$_4$ x 62 inches (128.9 x 157.5 cm)
Private collection
plate 183

Soft Night, 1947
Oil, India ink, and conté crayon on canvas
38^{1}/$_8$ x 50^{1}/$_8$ inches (96.8 x 127.3 cm)
Hirshhorn Museum and Sculpture Garden,
Smithsonian Institution, Washington, D.C.
The Joseph H. Hirshhorn Bequest, 1981 (86.2341)
plate 180

Dark Green Painting, c. 1948
Oil on canvas
43^{3}/$_4$ x 55^{1}/$_2$ inches (111.1 x 141 cm)
Philadelphia Museum of Art. Gift (by exchange) of
Mr. and Mrs. Rodolphe Meyer de Schauensee and
R. Sturgis and Marion B. F. Ingersoll, 1995-54-1
plate 182

Dead Bird (Slingshot), 1948
Carved wood, twine, colored yarns, and feather
36 x 46^{1}/$_2$ inches (91.4 x 118.1 cm)
The Menil Collection, Houston, 84-19 DJ
plate 185

Last Painting, 1948
Oil on canvas
31 x 40 inches (78.6 x 101.5 cm)
Museo Thyssen-Bornemisza, Madrid, 1978.72
plate 186

INDEX OF NAMES AND WORKS OF ART

PHOTOGRAPHY CREDITS

ARTISTS' COPYRIGHTS